Why Art Criticism?

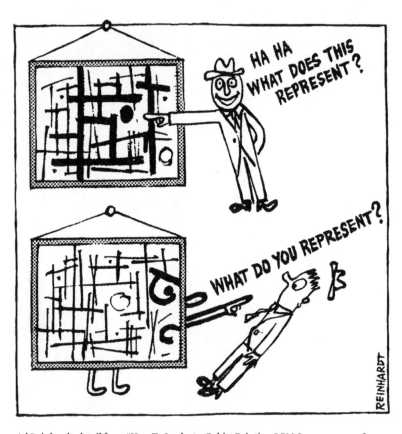

Ad Reinhardt, detail from "How To Look at a Cubist Painting," *PM*, January 27, 1946

Why Art Criticism?

A Reader
Beate Söntgen and
Julia Voss, eds.

HATJE
CANTZ

Commentary	Source Text

Foreword

Studies on art criticism's history and definition—on its protagonists, its significance, its death or at the least its frequently diagnosed crisis—are many and manifold. But few books have gathered the actual raw materials: the critiques themselves, which, after all, are what make the concept of art criticism tangible, lending it concrete form and vitality. This reader thus gives such form to the phenomenon of art criticism via critical exercises and practices. Forty-six voices of art criticism are collected here from across four centuries. The gathered texts have appeared in both analogue and digital form: in newspapers, magazines, journals, and blogs; in popular media, catalogues, and academic publications. From the outset, we wish to avoid any misunderstanding: this reader may begin with the eighteenth century and be arranged in chronological order, but our aim is not to narrate a history or genealogy of art criticism on the basis of particular examples. We are rather seeking to provide a taxonomic account of the variety of art criticism's forms and roles.

From our perspective, the need for a reader of this sort is clear for two reasons. First, art criticism is often discussed in the singular, but it is historically and presently as varied as art itself. Only by setting out the many and manifold roles and forms, styles, modes of writing, genres, and the diversity of its criteria and domains to which it lays claim is it possible to arrive at a more precise notion and definition of art criticism. Second, and from an entirely pragmatic perspective, the reader offers material for examination and analysis in art-historical pedagogy, and as a suggestion or even possible model of contemporary and future forms of art-critical writing.

Soon after we decided to compile a reader several years ago, it became clear that it could only become reality as a collaborative project, undertaken with other experts. The present reader is thus based on an international workshop—Cultures of Critique: Forms, Media, Effects, held at Leuphana University Lüneburg in 2019, to which we invited specialists from various geographical and intellectual backgrounds to offer brief commentaries on the art critics of their choice. They explained why the chosen texts are important to them, what the texts stood for at the time of their writing, and what they stand for now. The approaches taken to the various critical positions are therefore personal ones, as the brief introductions to the source texts in this book show. To avoid resorting to texts already rendered into English and canonized, we chose to commission a number of new translations. While the publication has brought

further art-critical positions into play, we do not seek to provide a systematic index or even a complete overview. Based on the contributors' suggestions, our book encourages readers to engage with points at which art critics of various provenance intersect, and also where they differ from one another. We ask readers delve into texts from eighteenth-century Paris; nineteenth-century London and Dresden; the twentieth century's New York, Buenos Aires, Delhi, Moscow, East Berlin, and Beirut; and the Kinshasa, Nairobi, and Tokyo of the twenty-first. Please also note that while all commentaries consistently use American English, in the source essays we have chosen to retain idiosyncrasies regarding translations, academic citation formats, punctuation, and regional forms of English, all of which underscore the sources' heterogeneity.

Our profuse thanks are due to all the authors collected in this volume for their contributions, both for the art critics they have selected and for the illuminating commentaries they have written. We would also like to thank our publisher, Hatje Cantz, for their keenness to include the reader in their program, and Lena Kiessler for her outstanding support in putting together the volume. Kimberly Bradley has been an inspiring and thoughtful editor. The reliable hands of Catharina Berents held together the many threads of this intricate and complex undertaking. We owe much gratitude to the translators Angela Anderson, Brian Richard Bergstrom, Ralph de Rijke, Tiziana Laudato, Stuart L. A. Moss, Francis Riddle, Matthew James Scown, Bela Shayevich, and Katherine Vanovitch, and to book designer Neil Holt, picture editor Jennifer Bressler, and production manager Vinzenz Geppert. For their support, we would like to thank the student research assistants of Leuphana University's Research Training Group—Jette Berend, Marie Lynn Jessen, David Mielecke, and Katharina Tchelidze—and the group's office manager, Stephanie Braune. Finally, particular thanks are due to the German Research Foundation for its generous financial support.

Beate Söntgen and Julia Voss
Lüneburg, August 2021

Why Art Criticism?

An Introduction

Right now, the voices calling for criticism, value-apportioning evaluation, and intervention are urgent and loud, in both social and academic contexts. "On the life of criticism"—the title of Ruth Sonderegger's[1] study, highlights the topicality, vibrance, and power of criticism while also shifting the focus away from the definition of terms and concepts and toward critical practices. But art criticism—a critical praxis that has mostly sought for and established relations to social phenomena—has had a difficult time of late. Even if no form of criticism is ever without its own crisis, recent attacks have been particularly intense, striking at the very foundations of art criticism. This introduction explores those attacks, with the hope that the panorama of art-critical positions collected within this reader can also vividly demonstrate the value of art criticism for the present time.

A peak in these condemnations occurred in a 2002 round table hosted and printed by—of all publications—the journal *October*;[2] which, since its launch in 1976, has been one of the most important organs for critical reflection on art. *October* does not merely cultivate a politically engaged style; it also defends the use of strong criteria. And it is these which (according to depressing reports) have disappeared, having gone the same way as categories of classification. Some lament that art criticism has lost its independent voice; has become an art-industry mouthpiece and even a scribe to the royal court of the arts; mere applause for the artistic voices that the critic is promulgating. Given the dominance of the market in the artistic field, it has been said that neither discursive space nor knowledge of context are still required. There are no longer any utopian visions, and thus no social ones.[3] Criticism would therefore always participate in inescapably problematic processes of canonization

1 Ruth Sonderegger, *Vom Leben der Kritik: Kritische Praktiken – und die Notwendigkeit ihrer geopolitischen Situierung* (Vienna, 2019).
2 "Round Table: The Present Conditions of Art Criticism," *October* 100 (Spring 2002), pp. 200–28. The discussion featured George Baker, Benjamin Buchloh, Hal Foster, Andrea Fraser, David Joselit, Rosalind Krauss, James Meyer, John Miller, Helen Molesworth, and Robert Storr.
3 In *The New Spirit of Capitalism* (London and New York, 2005), Luc Boltanski and Ève Chiapello go even further in speaking of the recuperation of all critical enterprises within the artistic field. A differing perspective can be found in Helmut Draxler, *Gefährliche Substanzen: Zum Verhältnis von Kritik und Kunst* (Berlin, 2007).

that affirm social conditions and serve the market in equal measure. The skills, responsibilities, and fields of critics, historians, and curators have intermingled; art criticism has allegedly lost its ability to make judgments, reduced at best to interpretation. Many critics are blamed with having literary pretensions that compete with art and seek to seduce through language. Criticism thus either acts in sales mode, or fosters romantic notions of fusing the critical text with the object of critique.

October has made a significant contribution to focusing attention on art's potential to be critical in its own right. The *criticality* of artistic work quickly became the key marker of value in art.[4] Art criticism has perhaps dug its own grave: if art is critical, who needs art criticism? What can it add to art? What can criticism produce that art cannot produce itself? Beyond this, artists themselves also write, framing their work critically and formulating critiques of other artistic positions. The fact that criticality has become a market value in art does nothing to improve things.

This fierce attack from a Western flagship of art criticism is not the only one the latter has been forced to endure. Feminist, postcolonial, and decolonial arguments have, with good reason, cast doubt on one of criticism's core tasks—judgment—while to the same degree raising questions about the related concept of the Enlightenment notion of the subject.[5] The rational, Western, overwhelmingly male subject of criticism has apparently suppressed the physical, sensual, and affective elements of the critical act, disparaging them as purely subjective. An awareness of the ever-varying situatedness of those speaking would therefore be indispensable; this awareness, however, would make it possible to define the generally valid criteria that are required to make a judgment, at least in terms of any potential generalizability. There also remains the urgent question of who is ultimately permitted to speak for whom, and in whose name,[6] especially when it comes to socially engaged criticism.

So what is to be done with art criticism? Especially in view of the widespread diagnosis that the transformative power of (art) criticism is disappearing, Isabelle Graw and Christoph Menke assert its necessity and value; the freedom that can be found in an act of distancing that is

4 See Irit Rogoff, "From Criticism to Critique to Criticality," *transversal* (January 2003), https://transversal.at/transversal/0806/rogoff1/en (accessed August 18, 2021).
5 See Sonderegger 2019 (see note 1); Katy Deepwell, *New Feminist Art Criticism: Critical Strategies* (Manchester and New York 1995); and Deepwell, ed., *Art Criticism and Africa* (London, 1998).
6 See Gayatri Chakravorty Spivak, "Can the Subaltern Speak?," in Lawrence Grossberg et al., eds., *Marxism and the Interpretation of Culture* (Urbana and Chicago, 1988), pp. 271–313.

aware of its own participation and even its entanglement in what is being criticized.[7] The relational concept of criticism they have proposed and that Graw has further pursued in collaboration with Sabeth Buchmann involves reflection on one's own discriminations—both in the sense of discerning and distinguishing differences as part of the critical act, and in terms of the exclusions that each act of differentiation must entail.[8] Given that art criticism refers to a subject matter—the artwork—that is in turn the result of a sensual, reflexive act that articulates itself in specific materials and media, we feel art criticism has a unique potential to take what has often been excluded from the Western notion of criticism—the affective, the physical and sensual, the involved—and showcase it as part of the critical act.

There have been intense discussions in recent years on how to reach transculturally informed understandings of an art that is subject to globalized conditions. Only recently, however, has the significance this expanded art field has for art criticism come into consideration.[9] The journal *Contemporary And* is named here as an example, initially presenting and discussing art from African perspectives. It has since founded a second magazine focusing on Latin America.[10] Our reader is an attempt to bring diverse voices and perspectives into conversation with each other, but to do so without claiming to be comprehensive, nor to provide a systematic index or illustrate the history of art critique through model texts by its most important purveyors. We see this reader neither as an expanded canon, nor as a new anti-canon. Our aim is rather to create a renewed awareness of the historical and contemporary plurality of art critique; to demonstrate its value and diversity as a genre and highlight what is has to offer to social discourses.

Criteria

Among the authors included in this volume, Stefan Germer emphasizes the necessity of forming criteria, even if the problematic nature of generally binding critical yardsticks and normative decrees is very much at the fore. For Germer, art criticism's role and function is to make distinctions

7 See Isabelle Graw and Christoph Menke, *The Value of Critique: Exploring the Interrelations of Value, Critique, and Artistic Labour* (Frankfurt am Main, 2019).
8 Sabeth Buchmann and Isabelle Graw, "Kritik der Kunstkritik," *Texte zur Kunst* 113 (March 2019), pp. 33–52.
9 See, for example, Anneka Lenssen et al., eds., *Modern Art in the Arab World: Primary Documents* (New York, 2018).
10 The two publication platforms *Contemporary And* and *Contemporary And América Latina* launched in 2013 and 2018 respectively; they are accessible at https://contemporaryand.com/ and https://amlatina.contemporaryand.com/.

and review them—and even go so far as to evaluate them—in relation to both artistic-aesthetic questions and sociopolitical ones. This not only addresses the content-form debate—that is to say, the question of how the subject matter of an artwork is determined by the form and medium of representation or placed in a certain light;[11] it also speaks to an aporia, vital among other things to the formation of criteria, that exists within modern art or at least what is regarded as avant-garde. This aporia plays an important role in many of the contributions gathered here: namely, the question of how artistic criteria should be linked to political issues.[12]

Within the avant-gardes of around 1900, there were demands for art to intervene in life—even to merge with it—and to therefore counteract the impotence of an increasingly self-referential art. But to have any kind of potency as art, even the avant-garde must assert a right to autonomy; to an at least relative self-governance and liberation from any other purposes and vested interests. However, this results in a disentanglement from the social and a loss of potency. The question of the relationship between art and politics has vehemently returned to the stage, especially with the attention paid to global entanglements in the artistic field.[13] This is linked to the challenge of defining the criteria that can still be used to assess artistic works, given that the possibility of making normative justifications and the fiction of independent criticism have both reached their ends.

Another important criterion is in which (socio-)political issues are picked up on, made visible, problematized, or criticized in artistic work. Whether sexism (Annemarie Sauzeau-Boetti, Adwait Singh), racism, or post-Fordist labor relations (Melanie Gilligan, Aruna D'Souza); commodity fetishism (Walid Sadek), social change, and environmental destruction (Arlene Raven); territorial struggles (Helia Darabi, Lothar Lang, Marta Traba, Igor Zabel), or war and its cultural consequences (Ješa Denegri, Sadek, Luis Vidales); art criticism's task in each case involves highlighting the means and persuasion with which each of these sets of issues is articulated.

11 See Armen Avanessian et al., eds., *Form: Zwischen Ästhetik und künstlerischer Praxis* (Zurich and Berlin, 2009).
12 Likewise relevant is Peter Bürger, *Theorie der Avantgarde* (Göttingen, 1974).
13 As examples of the recent glut of studies, see Christian Kravagna, *Transmoderne: Eine Kunstgeschichte des Kontakts* (Berlin, 2017); Chika Okeke-Agulu, *Postcolonial Modernism: Art and Decolonization in Twentieth-Century Nigeria* (Durham and London, 2015). On historic conceptions and the problematic nature thereof, see Susanne Leeb, *Die Kunst der Anderen: "Weltkunst" und die anthropologische Konfiguration der Moderne*, (Berlin, 2015).

Art critiques that place form in the foreground of their reflections cannot dispense with commentary on what has been expressed in a particular form, even when they insist on a pitiless self-reflection on artistic materials, media, and procedures. The spectrum ranges from the communication of creative, spiritual power (Ananda K. Coomaraswamy, Roger Fry) or authenticity (Victor Hakim) to expressions of the body (Roland Barthes, Patrick Mudekereza, Francis Ponge) and questioning the appropriateness of a form in relation to its function (Clemens Brentano/Achim von Arnim).

A differently incisive criterion for exploring the interconnection of art and politics is the social value imparted via artistic form and artistic practice. Even where self-exploration through aesthetic experience—as it was understood from an Enlightenment perspective—is seen critically (Gilligan, Peter Gorsen), experiences of community are showcased either through artistic production itself (Coomaraswamy), via collective artistic practices (Raven, Vidales), or via shared experiences in the (self-)perception of artists (Denegri, Sauzeau-Boetti).

From his place on the left of the political spectrum, Peter Gorsen supports the provocative position that art should not be at the direct service of society. Rather than advocating for the rejection of the culture industry, he pleads for pleasure—and explicitly not in the sense of bourgeois pleasure in art. Gorsen instead demands new, (un)productive forms and experiences through art, to be generated within the framework of non-instrumental networks. He thus addresses a criterion utilized in equal measure both by art criticism and in artistic-critical practices: particularly addressing the cultural, institutional, and economic conditions in which art is produced, received, and distributed (Lawrence Alloway, Mary Josephson, Oscar Masotta, Hito Steyerl, Julia Voss).

We have covered only some of the central criteria (and these by no means represent all art-critical criteria) deployed in this volume. They hold their ground with remarkable persistence, from the beginnings of modern criticism in the mid-eighteenth century up until the present, and across cultural, political, and intellectual divides.

Tasks and Roles

Having problematized judgment as a task of art criticism, the question arises of what other or further roles it has, given that many critics remain wedded to judgment as one of criticism's core roles. Hal Foster made a number of suggestions in the aforementioned *October* round table;[14]

14 See "Round Table," *October* 100.

art criticism could, for instance, work archeologically to bring what has been buried, suppressed, and forgotten to light. Not only a memory-related role, but also a political one would therefore be evoked. By changing the focus and shifting the subject of attention, art criticism can also govern processes of canonization—and is also able to shed light on the justifications and categories behind these processes. According to Foster, art criticism can also take an explorative approach, researching figures at the margins of the art field and, in the most high-impact case, even establishing a new paradigm for evaluating art. With such a tableau of tasks, however, the already-blurred line between art criticism and art history becomes even hazier.[15] This reader, however, does not seek to mark boundaries; its aim is rather to make visible the variety of tasks and roles that art criticism could assume.

It remains a key function of each form of criticism and of art criticism in particular to intervene in artistic and social fields and to raise objections against any such restrictions. Given the increased attention being paid to the globality of the art field, many art critics feel it important to give hitherto neglected tendencies and regions their own voices (Darabi, Sadek, Zabel), to probe territories anew (Denegri, Traba, Vidales), to highlight hierarchical structures, power imbalances, and inequalities (D'Souza, Traba), and to unfold new narratives at the same time (Darabi, Allan Sekula, Zabel).[16] Two Latin American critics illustrate how these evaluations of hegemonic structures in the art field can or should be countered. Traba separates the Latin American art scene into open and closed areas; into areas open to Western influence, and ones that have insisted on their own autonomy. While she preferred "closed areas" due to the identity-creating power of art (see also Coomaraswamy), Vidales advocated a generation later for an opening to US artistic practices—an opening the critic hoped would lead to a revitalization of art in Colombia and an increased attention being paid to Colombian art, as part of an art understood as universal. This optimism about globalization is one that Vidales shares with a number of others, such as Zabel or, to a more limited extent, with Darabi. Critiques of humanism can be found from decolonial, feminist, and queer perspectives (Coomaraswamy, Sauzeau-Boetti, Singh, Lynne Tillman). This is a context in which representational

15 See *Zeitschrift für Kunstgeschichte* 78.1 (2015) on "Der Ort der Kunstkritik in der Kunstgeschichte" (art criticism's location in art history).
16 See, for example, Melina Kervandjian and Héctor Olea, eds., *Resisting Categories: Latin American and/or Latino?* (London and New Haven, 2012), which appeared as part of Yale University Press's Critical Documents of 20th Century Latin American and Latino Art series.

or identity-centered arguments are often accompanied with the assertion of stigmatized or neglected categories—the artisanal, material, and spiritual (Coomaraswamy, Sauzeau-Boetti), the affective or the physical (Mudekereza, Raven, Tillman).

Art criticism's mappings of the artistic field often come in the wake of wars and the formation of new political systems (Denegri, Lang, Sadek); here, art criticism is ascribed not only a documentary/archival role (Vardan Azatyan, Hakim, New Culture magazine, Sekula), but also a very diagnostic, politically orienting, or even world-changing one (Alexander Rodchenko, Mark Sinker, Sergei Tretyakov). This empowerment of the collective—against the grain of the humanist, Enlightenment notion of subject-creation through art—is a task frequently assigned not just to art, but also to art criticism: the latter would thus be capable of emphasizing the assembling power of art—its ability to bring people and concepts together—and its transcultural potential, but also its potential to create cultural, national, or political identities (Coomaraswamy, Denis Diderot, Fry, New Culture, Raven, Sauzeau-Boetti, Traba, Vidales) and to create networks (Alloway).

These notions and processes are often viewed critically, however. The social and economic conditions and exhibition politics under which art operates are analyzed from institutional-critical positions, as are the ways the various protagonists understand their own roles. Events behind the scenes are brought to light—how commissions are granted, for instance (Berta Zuckerkandl). Exclusions in the form of gatekeeeping, value-generating network creation (Claire Bishop, Masotta), and infrastructural constraints (Mudekereza) are addressed, as are race, gender, and class discriminations (D'Souza, Josephson, Peter Richter, Sinker, Singh) and questions of representation itself (Darabi, Rodschenko,Traba). Institutional issues are often spoken to in art criticism written by artists; these critiques provide a theoretical background to the artistic works of their authors, while at the same time explaining it, expanding upon it, defending it, or even undermining it (Masotta, Gilligan, Steyerl).

The translation of artistic issues and the strengthening of their impacts was already present as a concern in early art criticism (Diderot, Brentano/von Arnim) and is taken up anew and in different ways in the twentieth century (Barthes, Fry, Julius Meier-Graefe). Others set a different emphasis by observing where artists and critics share common strategies and alliances—whether shared concepts, values, and ideas (Sauzeau-Boetti, Sadek), comparable economic situations (Ponge), or the blurring of lines between roles with the aim of disrupting hierarchies. Some critics focus resolutely on addressing a broader public audience

(D'Souza, Hakim, Lang, Tillman, Traba), something which depends not least on the publication media and also impacts their styles of writing. This also demonstrates how valuable art criticism is in discussions of social structure and urgent societal and political questions.

Styles and Modes of Writing

The question here is which manners, forms, genres, styles, and modes of writing art criticism can use to bring its interventions and its value to bear. All criticism is bound to the forms and media in which its descriptions appear,[17] but criticism does not merely reconstruct its subject matter; it is rather the modes of representation, the styles, and the media that highlight particular aspects of the subject matter and the conditions surrounding it, placing it in a new light. Criticism always spotlights, frames, and illuminates its subject in a specific way; in doing so, it also creates visibility for the process of critiquing and the situation in which it takes place. Criticism thus implicitly or explicitly also addresses the techniques and processes of critical description; these are in turn participants in the constitution of the subject matter as it appears within critique. This means that when the mode of description changes, criticism's subject matter changes, too.

By way of its subject matter alone, art criticism knows the power of representation, as one of its tasks is evidently to describe and examine that very power. One of this reader's aims is to highlight the diversity of art-critical modes of description and/or representation and their effects; we thus asked the authors of the commentaries to speak to the peculiarities of the various styles and modes of writing they selected. According to Roland Barthes, these differ in the following ways:[18] style is a "self-sufficient language"[19] which, based on linguistic conventions and grammatical norms, unfurls from within the writer. Regarding the mode of writing—Barthes's translators called this *literary form*—we speak rather of the relation between the written and the social; Barthes speaks of "literary language transformed by its social finality,"[20] the "morality of form."[21] Art criticism refers to an artwork, to a materialized approach to the world that has taken form; and it addresses an audience. This means that art criticism is writing that refers to an outside in two ways, yet can be shaped by an author's will to write in a particular style.

17 See Sami Khatib et al., eds., *Critique: The Stakes of Form* (Berlin and Zurich, 2020).
18 See Roland Barthes, "What Is Writing?," in *Writing Degree Zero*, trans. Annette Lavers and Colin Smith (Boston, 1985), pp. 9–18.
19 Ibid., p. 10.
20 Ibid., p. 14.
21 Ibid., p. 15.

The relationship between self-sufficient modes of expression and reference to the subject matter, world, or society always varies in how it plays out. In the early days of art criticism around 1800, it was often understood as a space in which the artwork resonated (Diderot, Brentano/von Arnim); a notion that one hundred years later is taken up again in the specific literary form of *Kunstschriftstellerei* (Meier-Graefe), whose German appellation can only loosely be translated as "literary art writing"; but it is also deployed in critiques that understand form as a medium of communication (Coomaraswarmy, Fry). Here, the authors are concerned with amplifying the message hidden within the work of art, doing so via expression that is both linguistically adequate and conscious of form. This is proof at the same time of the author's will to pursue style; of the author's descriptive skill. Last but not least, a form of criticism that linguistically reinforces the qualities of an artistic work in this way also serves as a testament to the validity of the author's own understanding of art; discussed in emphatic terms, the work demonstrates the impact art can have, with the impact corresponding to the critic's own criteria (Diderot, Meier-Graefe). Another form of resonance is the recording of bodily, affective reactions to an artistic work; reactions that are then showcased as a factor within the critique (Barthes, Mudekereza, Raven, Richter, Tillman). Ponge, for his part, anthropomorphizes painting to highlight parallels in the material, social, and economic contingencies of criticism and its subject matter.

During the twentieth century, there emerged a demand to find (or invent) new modes of writing that would be adequate to developments in contemporary art, thus enabling art criticism to play a greater role in debates beyond art (Bataille, Raven, Sekula). This can come in the form of modes of writing not previously regarded as criticism, such as autofiction or fictional criticism (Sinker, Tillman); text/image constellations (Bataille, *New Culture*, Sekula); or unusual print type, via which the changes in criteria, argument, and modes of writing are also shown visually. Another tried and tested method is for the critic to write in voices other than their own. With his alter ego Mary Josephson, Brian O'Doherty exposes the patriarchal power structures of the art field. With Berta Zuckerkandl's leak, it is not the critic herself who provides information; rather, it is letters sent by figures whose cultural policies are being denounced by their own writing.

Differing modes of writing are also conditioned by varied political contexts. In times of revolution and upheaval, art criticism can become a form of agitation, bringing art itself along with it in pursuit of shared political goals (Tretyakov). In political systems that make offensive

interventions into the artistic field, smart language games can evade the censor, without abandoning the mission of criticism. Ultimately, and as previously outlined, the mode of writing in each form of art criticism is ultimately produced by its media and genres.

Genre and Media

Art critiques can diverge massively in style. They can be written dispassionately or vehemently, descriptively or as judgments, exuberantly or minimally, academically or lyrically. There are whole worlds between— for example—the passionate literary style of Denis Diderot in the eighteenth century, the consciously adopted first-person perspective of Lothar Lang in twentieth-century East Germany, and the matter-of-fact analyses of Patrick Mudekereza in the twenty-first century. Some authors are keen to distance themselves from the artists they write about, whereas others, like Viktor Hakim in Beirut, speak about them in more informal terms and call them by their first names.

New approaches to writing have continually been introduced and tested throughout the history of art criticism, with the differences of form being at times so pronounced that it pays to divide the texts into genres. Examples of this are numerous in this reader: the Yugoslavian critic Ješa Denegri chose the interview as a way to do formal justice to the diversity of art currents in Yugoslavia in 1989, both in one-on-one dialogue and in conversation with larger groups. In 1808, German poets Clemens Brentano and Achim von Arnim invented a fictitious dialogue in order to approximate a painting by Caspar David Friedrich. Around a hundred years later, Zuckerkandl in Vienna got involved in a dispute about paintings Gustav Klimt had been commissioned to create by the city's university; for this she chose the form of the leak, publishing excerpts from letters addressed from the ministry to Klimt and not intended for public consumption. Yet another hundred years later, Australian art critic Jennifer Higgie deployed the serial format to give visibility to women artists: on Instagram, she posts an image of a female artist every day, to an audience of 60,000 followers. Even the recommendations website Yelp has been used as a platform for art criticism.[22]

By looking at genre, it becomes possible to avoid the trench warfare in which different approaches to art criticism have been pitted against each other. One example of this being how value-apportioning art criticism was elevated to the status of art criticism's definitive genre, with less

22 In 2014, Brian Droitcour briefly used Yelp, a platform typically used for rating restaurants and shops, as a home for pithy critiques of museum exhibitions in New York. Droitcour is now an editor at *Art in America*.

normative approaches being interpreted as signs of decline.[23] There is no doubt that the review is an important genre; it is represented here by a Julia Voss article on an exhibition by the painter Markus Lüpertz. Other genres still have value, however; in a catalogue text for the artist Bernard Réquichot, for example, Roland Barthes gave up on any form of distancing and instead sought forms of intense empathy in the work, body, and life of the artist. In this instance, we feel it makes sense to also designate catalogue texts as a possible form of art criticism. Often, these are bound too closely to requirements set by those commissioning them—galleries or museums—for them to count as art criticism; Barthes's catalogue texts, however, went well beyond friendly, scholarly contemplation; in doing so, he created the genre of immersive, literary, bodily resonance. This is quite different to the genre of the chronicle as represented by the critic Hakim and his gesture of plain description, largely absent of empathy and value judgment.

The various genres and formats—interview, fictional dialogue, leaks, serial chronicles, catalogue texts, reviews—are closely interlinked with the platforms they appear on. The form is made possible by developments in the media landscape, from the emergence of magazines and daily newspapers to the mass media and social media. Each new medium opens possibilities that were not present before, thus also begetting new genres. To name another example from this reader: in the Netherlands, "Anonymous" (an unnamed female blogger) nestled herself exclusively in the comments section of articles published online, where she trolled against the poor representation of women. These interventions took place within the literary field, but could easily be transferred into the art field and have thus been included here. The expanded prospects of a "hypermediatized" cultural journalism are set out by Kenyan author Enos Nyamor.

A look further into the past shows that the media history of art criticism began unfolding long ago. The changing alliances that emerged in the wake of the varying forms of publication are also reflected in this reader. We begin with one of the founding figures of art criticism, Denis Diderot, who wrote his critiques on behalf of Friedrich Melchior Grimm and for a select, mostly courtly audience across Europe. He was guided in this by the notion that exhibitions, like theater, served to educate the people and nurture good citizens.[24] It was no longer members of art academies and rather laypersons, like Diderot himself, who selected the

23 See James Elkins, *What Happened to Art Criticism* (Chicago, 2003).
24 Eva Kernbauer, *Der Platz des Publikums: Modelle für Kunstöffentlichkeit im 18. Jahrhundert*, (Göttingen, 2011)

criteria of discernment and judgment. The example of art would thus be used as a means of training critical thinking and public debate. This is an idea that also appears in the bourgeois salon culture that emerged around 1800, modeled on the courtly culture.[25] Their mouthpieces were journals and newspapers such as the *Berliner Abendblätter* that Bretano and von Arnim wrote for, and later the *Wiener Allgemeine Zeitung*, in which texts by Zuckerkandl appeared. Fin-de-siècle art critics had other organs of publication at their disposal, from art trade catalogues to specialist art journals.[26]

The so-called *Kunstschriftsteller*innen*—art writers of a more literary bent—are a consequence of this publishing boom, which also included art books issued in large editions. The excerpt from *The Indian Craftsman* by Ananda K. Coomaraswamy means that academic publishing as a possible medium of art criticism is also represented in the reader.

Further stages come into play over the course of the twentieth century. The fact that artworks can now be easily and affordably reproduced in high quality has spawned an international glut of new, specialist art magazines with various aims, from entertainment to scholarly debate. The latter has long been typified by *Artforum*, founded in 1962 and the journal in which Claire Bishop's essay originally appeared.

Art critics' careers can also be boosted by visual media like television, as with Argentine critic Marta Traba. The explosion of media in which art is critiqued or at the very least reported on was recounted a few years ago on the basis of the Documenta exhibition series, founded in 1955 in Kassel. By the time Okwui Enwezor curated the eleventh edition of Documenta in 2002, 15,000 journalists from Germany and around the world were accredited to cover the event.[27] Those keen to take the trouble to index these journalists' pieces by media and genre would have had much material to discover.

The transitions between old and new media are fluid at times; almost all publications that began in analogue form now also have digital versions. Still, there are a number of differences that must be sketched

25 Richard Wrigley, *The Origins of French Art Criticism: from the Ancien Régime to the Restoration* (Oxford, 1993); overviews of the history of art criticism can be found in Kerr Houston, *An Introduction to Art Criticism: Histories, Strategies, Voices* (Boston, 2013); Lionello Venturi, *History of Art Criticism*, (New York, 1936); and Gérard-Georges Lémaire, *Histoire de la critique d'art* (Paris, 2018).
26 On the significance of art criticism in the second half of the nineteenth century, see Cynthia A. White and Harrison C. White, *Canvases and Careers: Institutional Change in the French Painting World* (New York, 1965).
27 See Jasmin Schülke and Jürgen Wilke, "Multiple Medialisierung: Eine Fallstudie zur Kasseler documenta (1955–2007)," *M&K Medien & Kommunikationswissenschaft* 59 (2011), https://doi.org/10.5771/1615-634x-2011-2-235 (accessed August 23, 2021).

out, at least in brief. With digitization and social media, voices previously unable to get past the editorial departments of printed publications are now able to have their say. This has led to debates previously pushed to the margins of art criticism being returned back to the center. Founded in 2009, the online art magazine *Hyperallergic* offers a daily-updated and explicitly politically engaged art criticism that tackles issues of race, gender, and classism as a matter of course. Generally, it can be said that digitization has brought with it a widespread politicization of art criticism. Activism and art criticism are also moving closer together.[28] Given these developments, it seems to us all the more necessary to examine to what extent and for which reasons the various genres can be regarded as art criticism.

The Art Market and Networks

At an art criticism conference, Jörg Heiser spoke of the "sink-or-swim" strategy that accompanies gentrification. People who work in the "worst-paid artistic fields," he claimed, "are compelled to keep the greatest possible number of fields of activity open and to slip into changing roles."[29] This pressure clearly also weighs on art criticism. Cities with particularly high densities of art institutions are often particularly expensive; rents in many instances have risen astronomically in recent years, while the fees paid to art critics have continued to fall. With the exception of the small number of editors on long-term contracts, very few people can make a living by writing about art. Art historians have often sprung into this gap, teaching at universities in the daytime and moonlighting as writers for art magazines. This necessarily leads to academization of art criticism, both in its style and in its content.[30]

There are also many freelancers who curate in galleries, museums, or at biennials, while writing art criticism at the same time. According to one widespread view, these many subordinations and precarious relations have made art criticism less polemic, less up for the fight. The texts in our reader shed a different light on the situation. Critics like

28 Julia Voss and Norman L. Kleeblatt, "Art, Criticism, and Institution," in Danièle Perrier, ed., *Art Criticism in Times of Populism and Nationalism: Proceedings of the 52nd International AICA Congress, Cologne/Berlin 1–7 October 2019*, Heidelberg: arthistoricum.net, 2021, pp. 187–202.

29 Jörg Heiser, "Strategischer Multi-Optionalismus: Untiefen eines postkritischen Konzepts," in Ines Kleesattel and Pablo Müller, eds., *The Future Is Unwritten: Position und Politik kunstkritischer Praxis* (Zurich, 2018).

30 On the relationship between art criticism and university art history departments, see the spirited early plea made by Gustav Friedrich Hartlaub, "Wie werde ich ein Kunstkritiker," in Ruperto Carola: *Zeitschrift der Vereinigung der Freunde der Studentenschaft der Universität Heidelberg* 13 (1961), no. 29, pp. 107–111.

Lawrence Alloway have taken networks as the subject matter of their writing, addressing at the same time their own entanglements within them. Other critics like Marta Traba, Annemarie Sauzeau-Boetti, and Arlene Raven call for nothing less than the formation of new networks or collectives, allowing them to become more assertive, more vocal, or more just. Finally, there are also tactics in which the author's own identity is discarded; this can be read as a creative means of escaping the constraints of subjugation. Within our reader, the alter ego Mary Josephson and Anonymous could be cited as examples of this.

Just a few years ago, a foreword to an art criticism essay would have been obliged to include a statement on how collectors' strong financial capital had long since replaced the power of critics' opinions. A new generation of collectors had been described as mega-collectors, their emergence coming hand-in-hand with an increasing number of private museums. The intensive economization of the art field and the rise of art as an asset class have been described many times.[31] Nevertheless, the situation has developed in an unexpected manner: on the one hand, because the relation between art and money has been anything but a niche topic, having been set out and analyzed in many ways by Bishop and other writers. The need for business models and art production to be examined in tandem is shown with great humor, via the example of the Japanese scholar Yuriko Furuhata.

On the other hand, we have witnessed how trustees at large museums have been compelled to resign and how institutions have refused to accept donations due to overwhelming criticism. Without the internet and activists' digital platforms, these phenomena would be inconceivable. These activisms are accompanied by an art criticism that, taking its cure from institutional critique, examines economic relations and connections in far greater detail than in previous decades. In this reader, Gilligan elaborates on what the cultural logic of financialization means for art production, while D'Souza examines economic inequalities and the degree to which institutions practice what they preach.

As comprehensive as it has become, this reader is still pieced together from fragments of a multifaceted phenomenon. In constellation, however, we hope that they still shed some light on the value of art criticism, both within and beyond the artistic field.

31 There is an enormous range of literature on this. See, for example, Heike Munder and Ulf Wuggenig, eds., *Das Kunstfeld: Eine Studie über Akteure und Institutionen der zeitgenössischen Kunst*, (Zurich, 2011); Noah Horowitz, *Art of the Deal: Contemporary Art in a Global Financial Market* (Princeton, NJ and Woodstock, Oxfordshire, 2011); and Georgina Adam, *Dark Side of the Boom: The Excesses of the Art Market in the 21ˢᵗ Century* (London, 2017).

Passion, Performance, and Soberness: Denis Diderot

Beate Söntgen

The *Salons* written by Denis Diderot (1713–84) are considered to be founding texts of modern art criticism. He wrote them on behalf of Friedrich Melchior Grimm for his publication *Corréspondance littéraire, philosophique et critique*, a handwritten magazine that was distributed to a select circle throughout Europe by diplomatic post in order to evade censorship. His writings were detailed commentaries on the Salons, the yearly exhibitions of the Académie Royale de Peinture et de Sculpture (Royal Academy of Painting and Sculpture) from 1665 onward, which were held in the Louvre's Grande Galérie starting in 1699. Diderot's art criticism represented only a small part of his work; he also wrote novels and stories, as well as dramatic theory and stage works. With Jean-Baptiste le Rond d'Alembert, he organized and authored the *Encyclopédie*. His conviction that empirical and rational observation should be accompanied by a sensual approach to the world that includes perception can be found in all of his writing, which distinguishes itself through its brilliantly rhetorical approach.

Between 1759 and 1781, Diderot wrote a total of nine articles under the title "Salons"; the densest are those from the seventeen-sixties. The fact that Diderot did not have the works in front of him while writing led to some imprecision. The form was not that of today's art criticism, which is written for a large and anonymous newspaper audience. His readership was Europe's political and intellectual elite, who were collectors as well, like Catherine II and Friedrich the Great. Diderot did not hesitate to recommend his most

beloved artists to potential collectors. Diderot himself was on a threshold. While coming from a culture of the emphatic contemplation of paintings, he was committed to the Enlightenment agenda of critical, distanced reflection. In his Salons, forms of passionate involvement with the subject are interwoven with cool observation, self-reflexively illuminating both the artists' and his own practice. Diderot advocated for a kind of painting that would, like theater, portray everyday bourgeois life as an example, because the representation of what is familiar to the viewer touches them more profoundly and thus can better instruct them.

One of Diderot's distinctive characteristics is the relationship of his writing style to the representations of the images he critiques. His writing adapts to what is being portrayed. His linguistic expressions evoke the themes, structures, and effects of the images in question, accentuating their particularities. The images thus become the expressive proof of Diderot's theories of representation. It was in this way that Diderot's impassioned descriptions of Jean-Baptiste Greuze brought out the emotionality of the viewer that he demanded, while showing how this was used for "moral education." In the Salons on Chardin, however, a different, dispassionate speech oriented toward techniques of painting prevails, in which sociological aspects of art such as studio know-how and the conditions of production and exhibition become relevant. The focus here is on paint instead of subject matter, and new optical discoveries amalgamate with topoi from classical art literature, such as proximity to nature and vitality.

For Diderot, art criticism is not only the passionate and considered writing about an object. In his texts, which are arranged like theatrical scenes, the emotional entanglements in the image are presented just as convincingly as the reflexive refractions when passing judgment. Diderot articulates contradictions in imaginary dialogues, and in monologues he observes his own emotional reactions. The salons are a form of performative critique that shows itself and makes its methods transparent. To this effect, they conform to an ideal of self-reflexivity as a characteristic of modern culture, but without excluding sensual and even physical implementations of aesthetic experience and the writing on them.

There are three particular qualities in these texts that for me constitute an inspiring model for contemporary writing on art: First, the polyphony with which Diderot multiplies the perspectives on a particular work; second, his regard for the corporal in his reflection and writing; and third, his knowledge that the form of critique plays a role in the constitution of its object.

Essays on Painting

Denis Diderot

from the Salon of 1763: Jean-Baptiste Greuze

This Greuze here is really my kind of person....

Most of all, I like the genre. It is moral painting. What, has not the paint-brush been devoted long enough to debauchery and vice? Should we not be content to finally see it compete with verse drama to touch us, to teach us, to correct us, to invite us to be virtuous? Have courage, my friend Greuze! Moralize in painting, and do so always. When you are about to leave this life, there will not be a single one of your compositions that you will not be able to recall with pleasure. For were you not at the side of this young girl who, gazing at the head of your *Paralytic*, cried out with a delightful vivacity *Oh, my Lord, how he touches me; but if I look upon him again, I believe I will cry*; if only this young girl were mine! I would have recognized her by this wave of emotion. When I saw this eloquent and pitiful old man, I felt, like her, my soul becoming tender and tears ready to fall from my eyes....

Everything is related to the main figure and what is being done in the present moment, and what was done in the previous moment....

From the top to the bottom, there is nothing that does not evoke the pity felt for the old man.

There is a large sheet hanging on a rope, drying. This sheet has been very well conceived, for the subject of the painting and for the effect of the art. One suspects that the painter was quite deliberate in painting it with such broad dimensions.

Everyone present has precisely the degree of purpose that corresponds to their age and character. The number of figures gathered in a relatively small space is very large; however, they are present without confusion, because this master excels above all in ordering his scene. The color of the flesh is true. The fabrics are well cared for. There is no unease of movement. Each person is focused on what they are doing. The youngest of the children are cheery, because they have not yet reached the age when one feels. The shared feeling of sadness among the older ones is expressed very powerfully. The son-in-law seems to be the most affected, as it is to him that the patient addresses his speech and his gaze. The married girl seems to listen with pleasure rather than pain.

If not extinguished, the attention of the old mother is at least desensitized; and that is entirely natural. *Jam proximus ardet Ucalegon* ("Close by, Ucalegon's house is already burning"—Virgil, *Aeneid*). She can no longer promise herself any consolation other than the same tenderness from her children, for a time not far away. And then comes the age that hardens the fibers, dries out the soul.

Some say that the paralytic is leaned too far back, that it is impossible to eat in this position.

He does not eat, he speaks, and one would be ready to raise up his head.

They say it was his daughter's duty to present him with food, and his son-in-law's to raise his head and pillow, because skill is asked of one and strength of the other. This observation is not so well founded as it seems at first. The painter wanted his paralytic to receive aid marked by the one he was least entitled to expect it from. This justifies the good choice he made in favor of the girl; it is the real cause of the tenderness on her face, her gaze, and of the speech he addresses to her. Displacing this figure would have meant changing the subject of the painting. To put the girl in the son-in-law's place would have been to overthrow the whole composition: there would have been four women's heads in a row,

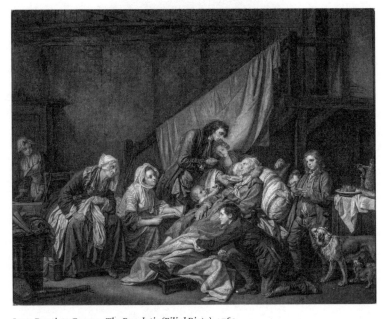

Jean-Baptiste Greuze, *The Paralytic (Filial Piety)*, 1763

and the succession of all these heads would have been unbearable....

It is said that this artist lacks fertility; and that all the heads of this scene are the same as those of his painting *The Village Bride*, and those of his *The Village Bride* the same as those of his *Peasant Reading to His Children*....

If (the artist) encounters a head that strikes him, he will get down on bended knees before the owner of this head to lure them into his studio. He observes constantly, in the streets, in the churches, in the markets, in shows, on walks, in public meetings. When he meditates on a subject, he obsesses over it, follows it everywhere. His very character suffers as a result. He takes his character from his painting; he becomes brusque, sweet, subtle, caustic, gallant, sad, cheerful, cold, hot, serious or crazy, depending on the thing he projects....

Ah, Monsieur Greuze, that you are different from yourself, when it is tenderness or purpose that guides your brush. Paint your wife, your mistress, your father, your mother, your children, your friends; the others, however, I advise you to send back to Roslin or Michel Van Loo.

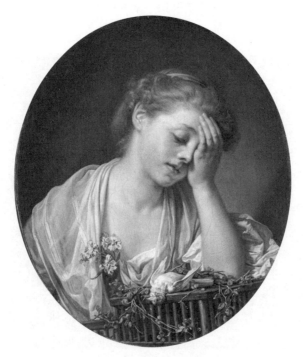

Jean-Baptiste Greuze, *Girl with Dead Canary*, 1765

Denis Diderot

What a pretty elegy! What a pretty poem! What a fine idyll Gessner[1] would make of it! It could be a vignette drawn from this poet's work.

A delicious painting, the most attractive and perhaps the most interesting in the Salon. She faces us, her head rests on her left hand. The dead bird lied on top of the cage, its head hanging down, its wings limp, its feet in the air. How natural her pose! How beautiful her head! How elegantly her hair is arranged! How expressive her face! Her pain is profound, she feels the full brunt of misfortune, she's consumed by it. What a pretty catafalque the cage makes. How graceful is the garland of greenery that winds around it!

Oh, what a beautiful hand! What a beautiful hand! What a beautiful arm! Note the truthful detailing of these fingers, and these dimples, and this softness, and the reddish cast resulting from the pressure of the head against these delicate fingers, and the charm of it all. One would approach the hand to kiss it, if one didn't respect this child and her suffering. Everything about her enchants, including the fall of her clothing, how beautiful the shawl is draped! How light and supple it is! When one first perceives this painting, one says: Delicious! If one pauses before it or comes back to it, one cries out: Delicious! Delicious! Soon one is surprised to find oneself conversing with this child and consoling her. This is so true, that I'll recount some of the remarks I've made to her on different occasions.

Poor little one, how intense, how thoughtful is your pain! Why this dreamy, melancholy air? What, for a bird? You don't cry, you suffer, and your thoughts are consistent with your pain. Come, little one, open up your heart to me, tell me truly, is it really the death of this bird that's caused you to withdraw so sadly, so completely into yourself? ... You lower your eyes, you don't answer. Your tears are about to flow. I'm not your father. I'm neither indiscreet nor severe. Well, well, I've figured it out, he loved you, and for such a long time, he swore to it! He suffered so much! How difficult to see an object of our love suffer! ... Let me go on; why do you put your hand over my mouth? On this morning, unfortunately, your mother was absent; he came, you were alone; he was so handsome, his expressions so truthful! He said things that went right to your soul! And while saying them he was at your knees; that too can easily be surmised; he took one of your hands, from time to time you felt the warmth of the tears falling from his eyes running the length of your arm. Still your mother

1 Johann Matthias Gessner (1691–1761). German humanist and translator/adaptor of Latin literature.

didn't return; it's not your fault, it's your mother's fault ... My goodness, how you're crying! But what I say to you isn't intended to make you cry. And why cry? He promised you, he'll keep all his promises to you.

When one has been fortunate enough to meet a charming child like yourself, become attached to her, give her pleasure, it's for life ... And my bird? ... My friend, she smiled ... Ah, how beautiful she was! If only you'd seen her smile and weep! I continued: Your bird? When one forgets oneself, does one remember one's bird? When the hour of your mother's return drew near, the one you love went away. How difficult it was for him to tear himself away from you! ... How you look at me! Yes, I know all that. How he got up and sat down again countless times! How he said goodbye to you over and over without leaving! How he left and returned repeatedly! I've just seen him at his father's, he's in charmingly good spirits, with that gaiety from which none of them are safe ... And my mother? ... Your mother, she returned almost immediately after his departure, she found you in the dreamy state you were in a moment ago; one is always like that. Your mother spoke to you and you didn't hear what she said; she told you to do one thing and you did another. A few tears threatened to appear beneath your eyelids, you either held them back as best you could or turned away your head to dry them in secret. Your continued distraction made your mother lose her patience, she scolded you, and this provided an occasion for you to cry without restraint and so lighten your heart. Should I go on? I fear what I'm going to say might rekindle your pain. You want me to? Well then, your good mother regretted having upset you, she approached you, she took your hands, she kissed your forehead and cheeks, and this made you cry even harder. You put your head on her breast, and you buried your face there, which was beginning to turn red, like everything else. How many sweet things this good mother said to you, and how these sweet things caused you pain! Your canary warbled, warned you, called to you, flapped its wings, complained of your having forgotten it, but to no avail; you didn't see it, you didn't hear it, your thoughts were elsewhere; it got neither its water nor its seeds, and this morning the bird was no more ... You're still looking at me; is it because I forgot something? Ah, I understand, little one, this bird, it was he who gave it to you. Well, he'll find another just as beautiful ... That's still not all; your eyes stare at me: and fill up with tears again. What more is there? Speak, I'll never figure it out myself ... And if the bird's death were an omen . . . what would I do? What would become of me? What if he's dishonorable? ... What an idea! Have no fear, it's not like that, it couldn't be like that ... —Why my friend, you're laughing at me; you're making fun of a serious person who amuses himself by consoling a painted child for having lost her bird, for

Denis Diderot

having lost what you will? But also observe how beautiful she is! How interesting!

I don't like to trouble anyone; despite that, I wouldn't be too displeased to have been the cause of her pain. The subject of this little poem is so cunning that many people haven't understood it; they think this young girl is crying only for her canary. Greuze has already painted this subject once. He placed in front of a broken mirror a tall girl in white satin, overcome by deep melancholy. Don't you think it would be just as stupid to attribute the tears of the young girl in this Salon to the loss of her bird, as the melancholy of the other girl to her broken mirror? This child is crying about something else, I tell you. And you've heard for yourself, she agrees, and her distress says the rest. Such pain! At her age! And for a bird! But how old is she, then? How shall I answer you, and what a question you've posed. Her head is fifteen or sixteen, and her arm and hand eighteen or nineteen. This is a flaw in the composition that becomes all the more apparent because her head is supported by her hand, and the one part is inconsistent with the other. Place the hand somewhere else and no one would notice it's a bit too robust, too developed. This happened, my friend, because the head was done from one model and the hand from another. Otherwise this hand is quite truthful, very beautiful perfectly colored and drawn. If you can overlook the small patch that's a bit too purplish in color, it's a very beautiful thing. The head is nicely lit, as agreeably colored as a blonde's could be; perhaps she could have a bit more relief. The striped handkerchief is loose, light, beautifully transparent, everything's handled with vigor, without compromising the details. This painter may have done as well, but he's never done anything better.

This work is oval, it's two feet high, and it belongs to Monsieur de La Live de La Briche.

After the Salon was hung, Monsieur de Marigny did the initial honors. The Fish Maecenas[2] arrived with a cortege of artists in his favor and admitted to his table; the others were already there. He moved about, he looked, he registered approval, disapproval; Greuze's *Girl With Dead Canary* caught his attention and surprised him. That is beautiful, he said to the artist, who answered him: Monsieur I know it; I am much praised, but I lack work. —That, Vernet interjected, is because you have a host of enemies, and among these enemies there is someone who seems to love you to distraction but who will bring about your downfall. —And who is this enemy? Greuze asked him. —You yourself, Vernet answered.

2 *Poisson Mécene*: Marigny's family name was Poisson, which means "fish" in French.

Here is the real painter; here is the true colorist. There are several small paintings by Chardin in the Salon. Almost all of them depict various fruits surrounded by the accessories of a meal. They are nature itself; the objects all stand out from the canvas in such a way that the eye is ready to take them for reality itself. The one you see as you walk up the stairs is worth particular attention. On top of a table, the artist has placed an old Chinese porcelain vase, two biscuits, a jar of olives, a basket of fruit, two glasses half-filled with wine, a Seville orange, and a meat pie. I feel I need to make myself another pair of eyes when I look at other artists' paintings; to see Chardin's I need only keep those that nature gave me and use them well.

If I wanted my child to be a painter, this is the painting I should buy. "Copy this," I should say to the child. "Copy it again." But perhaps nature itself is not more difficult to copy. The fact is, that porcelain vase is made of porcelain; those olives really are separated from the eye by the water they are immersed in; you have only to put out your hand and you can pick up those biscuits and eat them, that orange and cut it and squeeze it, that glass of wine and drink it, those fruits and peel them, that meat pie and slice it.

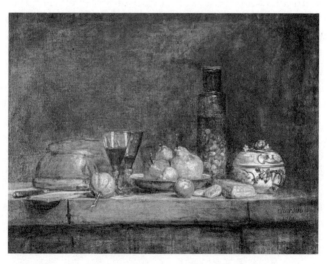

Jean-Baptiste Simeon Chardin, *Still-Life with Olive Glass*, 1760

Denis Diderot

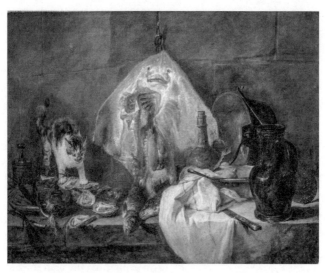

Jean-Baptiste Siméon Chardin, *The Ray*, 1728

Here is the man who truly understands the harmony of colors and their reflections. Oh, Chardin! It is not white or red or black you mix on your palette, it is the very substance of things themselves, it is air and light that you take on the point of your brush and apply to your canvas.

After my child had copied and recopied this piece of work, I should set him to work on the same master's *The Ray*. The object itself is disgusting, but that is the fish's very flesh, its skin, its blood: the real thing would not affect you otherwise. Monsieur Pierre, (you are a famous painter), but when next you go to the Academy, look carefully at this canvas and learn, if you can, the secret of using your talent to redeem the distastefulness that is present in certain natural objects.

This magic is beyond our understanding. There are thick layers of paint in some places, laid one on top of the other, that make their effect by glowing through, from the bottom upward.

In other places, it is as though a vapor had been breathed onto the canvas; in others still, a light foam has been thrown across it. Rubens, Berchem, Greuze, Loutherbourg could all explain this technique to you better than I, for all of them can also make your eyes experience its effects. If you move close, everything becomes confused, flattens out, and vanishes. Then as you move back, everything takes shape and re-creates itself again. I have been told that Greuze, upon coming into the Salon and noticing the Chardin painting I have just described, looked at it, then heaved a profound sigh as he walked on: a eulogy both briefer and more valuable than mine.

In Conversation: Clemens Brentano, Achim von Arnim

Johannes Grave

On October 13, 1810, the newspaper *Berliner Abendblätter* published a review which later aroused lasting interest, particularly in more recent art historical and literary studies. The subject of the short text was Caspar David Friedrich's painting *Monk by the Sea*, which at the time was being shown at the annual exhibition of the Berlin Academy. While Kleist's review is quite famous, the first draft of this text, written by Clemens Brentano and Achim von Arnim, has remained to this day in the shadow of the more pointed, finally published version. Their text exemplarily stands for an art criticism that does not focus on explaining the characteristics, qualities, and shortcomings of a work of art; neither does it concentrate on describing the viewer's experience in front of the painting as precisely as possible. Rather, the two authors have chosen the strategy of finding verbal and literary equivalents for essential moments of this aesthetic experience—and these equivalents gain their profile and quality precisely through being conscious of the fundamental difference between linguistic text and vivid picture.

In a few words, "that which I should have found within the picture I found instead between the picture and myself, namely a claim that my heart made on the picture, and a rejection that the picture did to me by not fulfilling it," Brentano and Arnim plainly state that Caspar David Friedrich's painting was not conceived to aim at illusion or even immersion, but unambiguously revealed itself as a picture—a flat, confined, painted, man-made artifact. It is only in this context that Kleist's monstrous metaphor, which

was added later—"the viewer feels as though his eyelids had been cut off"—wins its explosive force. In the combination of Brentano's, Arnim's, and Kleist's observations, a fundamentally new concept of the power of pictures emerges. The picture no longer wins power over its viewers through deceptively similar depiction, production of effects of presence, or seductive fidelity to reality, but rather gains this effect as an artifact that ostentatiously reveals its status as a painting, instead of veiling it in favor of the depicted subject's appearance. While Kleist's text only affirms this fundamental insight, Brentano's and Arnim's dialogues attempt to make this partial loss of control accessible and tangible to readers. Using linguistic and literary devices, they recreate and regenerate what the observer can experience in the sensory perception of the picture itself, with three important verbal and literary strategies: 1) phonetic and semantic shifts, 2) figures of supplementation, and 3) moments of shifting from external references to self-reference; or from the depicted objects to the means of depiction.

1) Especially in the first dialogues, Brentano and Arnim deliberately, almost obtrusively, work with equivocations, ambiguous references, and confusion between phonetically similar but connotatively different words. In the first dialogue, a gentleman characterizes the painting as "infinitely deep and sublime." His companion, however, transfers the attributes from the medium of representation and the painter's supposedly expressed "sensibility" to the depicted subject, in this case

the sea—a shift of reference that also implies a shift in meaning of the attribute "deep." Such shifts are conspicuously frequent in the dialogues. They are not mere gimmicks. Rather they draw attention to the fact that the relations between sign and signified become uncertain, and demonstrate how the material of language itself, the sounds and letters, begins to become independent. Through genuinely linguistic devices, the *glissements* reproduce what the viewer can also experience in front of the picture. The viewer's perception is prompted to shift between the experience of a space of indeterminate depth, and the view of the picture plane structured by strips of color. Phonetic and semantic shifts in the dialogues indicate that what is said and meant is diverted to the material of language and its own inherent dynamics.

2) Friedrich's picture is empty in a disturbing or provocative way. Brentano's and Arnim's dialogues address this emptiness by imagining the ways in which viewers try to remedy this deficiency by supplementing it—one beholder thinks of amber fishers in the foreground. Then the scenery is temporalized, so that noise and gusts of wind can be heard and felt, the sun can flash at least briefly, and a sail appears. Thus, the dialogues act out how, almost painfully, gaping blanks are filled. At the same time the conversations show that these fillings are entirely contingent, even arbitrary. Again, a dialectic of claim or appeal, and rejection or refusal, is at work.

3) External references turn into self-reference, in which attention is directed from the depicted to the depiction itself. The dialogues' efforts to come to an apt interpretation

or establish a reliable connection between what is portrayed and its deeper meaning, do not guide the reader from the picture to an external context, but to seemingly circular self-references and figures of mise en abyme. The text accentuates that Friedrich's painting requires the observer to consciously perceive and reflect on its status as an image.

These strategies demonstrate the new power of images in emphasizing that the perception of the picture has to be regarded as a temporally extended, often self-contradictory process with incalculable performative effects, in which the oscillation between the represented and the mode of representation is of particular importance. The task of evaluating the work of art is subordinated to the aim to recreate, through literary means, the specific form of aesthetic experience in front of Friedrich's painting.

For today's reflection on art criticism, the text is of interest because it aims to activate, in correspondence with Walter Benjamin's concept of Romantic art criticism, the temporal and performative effects of literary representation in order to find an equivalent to comparable effects in painting.

In Front of a Friedrich Seascape with Capuchin Monk

Clemens Brentano, Achim von Arnim

It is a magnificent thing to gaze off into a boundless watery in infinite solitude by the sea, under a sullen sky; and this has to do with having travelled there, having to return, yearning to cross over, finding one cannot, and while missing all signs of life, nevertheless hearing its voice in the roar of the surf, the rush of the wind, the drift of the clouds, the lonely crying of birds: it has to do with an appeal from the heart, which nature herself rejects. All this however is not possible in front of the picture, and that which I should have found within the picture I found instead between the picture and myself, namely a claim that my heart made on the picture, and a rejection that the picture did to me by not fulfilling it, and so I myself became the Capuchin monk, the picture became the dune, but that across which I should have looked with longing, the sea, was absent completely. To come to terms with this strange feeling I listened carefully to the remarks of the various observers around me, and pass them on as appropriate to this picture, a backdrop in front of which there must always be activity, in that it allows of no response.
[A lady and gentleman approach, he apparently highly intelligent. The lady looks in her program.]
LADY: Number two. Landscape. Oils. How do you like it?
GENT: Infinitely deep and sublime.
LADY: You mean the sea. Yes, it must be very deep, and the monk is indeed very sublime.
GENT: No, Frau War Minister. I mean the sensibility of our incomparably great Friedrich.
LADY: Is it so old that he too could have seen it?
GENT: Ah, you misunderstand. I mean Friedrich the painter. *Ossian's harp is audible in this picture.*[1] [They pass.]
[Two young Ladies]
FIRST: Did you hear that, Louise? That is Ossian.
SECOND: No no! You misunderstand. That is the *ocean.*
FIRST: But he said it was playing a harp.
SECOND: I see no harp. It is really quite grisly to look at. [They pass.]
[Two Connoisseurs]
FIRST: Grisly indeed. It's all completely gray, as this man paints only the driest subjects.

1 Asterisk and italics signify phrases used by Kleist.

SECOND: You mean, this man paints wet things very drily.

FIRST: I'm sure he paints them just as well as he can. [They pass.]

[A Tutoress with two *demoiselles*]

T: That is the sea at Rügen.

FIRST D: Where *Kosegarten* lives.

SECOND D: Where the groceries come from.

T: Why must he paint such a sad air? How beautiful if he had painted an amber fisher in the foreground.

SECOND D: I'd like to fish up a beautiful amber necklace of my own somewhere. [They pass.]

[A young mother with two blond children and two gentlemen]

FIRST GENT: Magnificent! Only this man can express a soul in his landscape. What great individuality in this picture: the high truth, the solitude, the gloom of the melancholy sky. He certainly knows what he paints.

SECOND GENT: And paints what he knows, feeling and thinking and then painting.

FIRST CHILD: What is it?

FIRST GENT: It is the sea, my child, and a monk walking beside it and feeling very sad not to have a clever little boy like you.

SECOND CHILD: Why isn't he dancing around in front of it? Why doesn't he wag his head like the ones in the lantern shows? That would be even more beautiful.

FIRST CHILD: Is he like the monk that tells the weather outside our window?

SECOND GENT: Not exactly, my child, but he too tells the weather in a way. He is Oneness amid the All-encompassing, *the lonely center in the lonely circle.*

FIRST GENT: Yes, he is the heart and soul and consciousness of the whole picture in itself and of itself.

SECOND GENT: How divinely inspired the choice of that figure is, nor merely a relative measure for the vastness of the scene, he himself is the subject, he is the picture, and as he appears to be dreamily lost in the view as in a sorrowful reflection of his own isolation, the enclosing sea, void of ships, which binds him like an oath, and the barren dune, as joyless as his own life, seem to be symbolically drawing him out again, like some desolate, self-prophetic plant of seashore.

FIRST GENT: Magnificent! To be sure. You are quite right. (*To the Lady*) But, my dear, you have said nothing at all.

LADY: Oh, I was feeling so at home with this picture, it is so touching, so genuine in its effect, but while you spoke it became just as obscure as

Clemens Brentano, Achim von Arnim

when I went for a walk by the sea with our philosophical friends, hoping for nothing more than a fresh breeze and a sail, and for a glimpse of the sun and the thunder of the surf; but now it's all like one of my nightmares and longing for my homeland in my dreams. Let us go on. It is too sad. [They pass.]

[A Lady and her Escort]

LADY: Great, inconceivably great! *It is as though the sea were thinking Young's Night Thoughts.

ESCORT: You mean, as though the monk were immersed in them?

LADY: If only you weren't always making jokes and disrupting everyone else's feelings. Secretly you feel exactly the same way, but you like to ridicule in others what you revere in yourself. I said it is as though the sea were thinking Young's Night Thoughts.

ESCORT: And Mercier's Bonnet de Nuit and Schubert's Glimpses of Nature's Night-side, as well.

LADY: I can only answer with a parallel anecdote. When our immortal Klopstock wrote for the first time in his poems that "the rosy dawn was smiling," Madame Gottsched said, when she read it, "What sort of a mouth does she have?"

ESCORT: Certainly none as beautiful as yours when you tell it.

LADY: What a bore you are!

ESCORT: Then Gottsched placed his mouth on hers in return for the bon mot.

LADY: And I'll give you a night-cap for yours, you tiresome man.

ESCORT: I'd prefer a view of your nature from its "night-site."

LADY: How vile!

ESCORT: Oh, if only we two were standing there like that monk.

LADY: I'd leave you and go to him.

ESCORT: And beg him to unite us in marriage?

LADY: No, to throw you into the sea.

ESCORT: And you would remain with the monk and seduce him and disrupt the whole picture, as well as all his "night-thoughts." Women! In the end, it is you yourselves who destroy what you feel. By telling so many lies you eventually utter the truth. If only I were that monk, gazing so eternally alone at that dark, forbidding sea, which *lies before him like the Apocalypse! Then, dearest Julie, I would eternally long for you and eternally miss you, for this longing is the only fine emotion in affairs of love.

LADY: No, my dearest! In art as well! If you say such things, I'll leap into the water after you and leave the monk all alone! [They pass.] All this while a tall, mild-mannered gentleman had been listening with signs of impatience. I stepped accidentally on his toe, and as though I had thereby

solicited his opinion, he answered: "How fortunate it is that the pictures have no ears. They would have drawn their veils long ago. The public seem to suspect a lurking immorality, as though the pictures were pilloried here for some crime or other, which the viewers must guess at." "But what do you think of the picture?"

"It pleases me to see that there are still landscape painters who attend to the wonderful conjunctions of season and sky, which produce such gripping effects even in the most barren of regions. But of course I would much prefer for the painter to have not only the right feeling but the talent and training as well to reproduce it faithfully; and in this respect he stands as far behind certain Dutch painters of similar scenes as he surpasses them in the mood of his conception. It would not be difficult to mention a dozen pictures where sea and shore and monk are better painted. The monk from any distance looks like a brown smudge, and if I had wanted to paint one at all, I would have stretched him out in sleep, or placed him kneeling in all the humility of prayer or contemplation, so as not to obstruct the view of the spectators, on whom the sea obviously makes a stronger impression than that tiny figure. If someone then decided to look about for inhabitants of the shore, he could still have expressed such opinions as some people here, with presumptuous familiarity, so loudly imposed on everyone else."

These words so pleased me that I tagged along home with the gentleman and shall remain there indefinitely.

Feelings Before Friedrich's Seascape

Heinrich von Kleist

from *Berliner Abendblätter*, October 13, 1810

A magnificent thing it is, in infinite solitude by the sea, under a sullen sky, to gaze off into a boundless watery waste. But this has to do with having travelled there, having to return, yearning to cross over, finding one cannot, and, though missing all signs of life, yet the very voice of life, in the roar of the surf, the rush of the wind, the drift of the clouds, the lonely crying of birds: this one does hear. It has to do with an appeal from the heart and a rejection, so to speak, from nature herself. This however is not possible in front of the picture, and that which I should have

Clemens Brentano, Achim von Arnim

found within the picture I found instead between the picture and myself, namely an appeal from my heart to the picture and a rejection by the picture; and so I myself became the Capuchin monk, the picture became the dune, but that across which I should have looked with longing, the sea, was absent completely. Nothing could be sadder or more discomfited than just this position in the world: the single spark of life in the vast realms of death, the lonely center in the lonely circle. The picture with its two or three mysterious objects lies before one like the Apocalypse, as though it were thinking Young's *Night Thoughts*, and since in its uniformity and boundlessness it has no foreground but the frame, the viewer feels as though his eyelids had been cut off. Yet the painter has doubtless opened a new path in the field of his art; and I am convinced that, through his powers, a square mile of Prussian sand, with a barberry bush and a crow beruffled forlornly in it, would have the effect of an Ossian or a Kosegarten. Yes, were such a painting made with its own chalk and water, the foxes and wolves, I believe, would be set howling by it, which is doubtless the strongest praise one could lavish on this kind of landscape. But my own feelings about this wonderful picture are too confused; and therefore, before daring to speak them out more fully, I have tried to learn something by listening to the comments of those who, in pairs, pass before it continually from morning to night.

Caspar David Friedrich, *The Monk by the Sea*, 1808–1810

Emotional Collectivities: Julius Meier-Graefe

Stephanie Marchal

In many ways, Julius Meier-Graefe (1867–1935) was a transgressor of borders. His life and works oscillated between Germany and France, between various arts, media, and materials, and between tradition and avant-garde. The terrain on which his activity was most sustained was art and cultural critique. During the days of the German Empire and the Weimar Republic, he categorized and canonized the increasingly diverse range of artistic streams, using art to seismograph the condition of society and seeking to offer a way of orienting worldviews and aesthetics in times of national rivalries. Friendships with artists like Edvard Munch, Henry van de Velde, and Max Beckmann, fruitful collaborations with collectors, art dealers, and museum directors, and his indefatigable commitment to Art Nouveau, Impressionism, and Neo-impressionism made him an influential agent of modernism.

In the following passage, the critic describes with his typical literary verve his encounter with Édouard Manet's *Le déjeuner sur l'herbe* (The Luncheon on the Grass) (1863). This passage is to be found in his powerful *Entwicklungsgeschichte der Modernen Kunst* (1904) *(Modern Art: being a contribution to a new system of aesthetics*, 1908); with this, his magnum opus, he attempted in the early twentieth century to raise German readers' awareness of French modernism. The dense passage gives an impression of his art-critical style.

Before our internal reader's eye, Meier-Graefe unfolds a scene and in doing so trenchantly highlights the case-by-case nature of the act of criticism. He performs his contemplation of the artwork, showing himself in

the process of viewing as a perceiving and reflecting subject. He attempts to comprehend what is capturing his attention and why, entering into a conversation with himself about what he faces. The monologue conducted is not one that digresses from the artifact, with the painting merely providing an occasion for solipsistic digression. The artifact instead challenges a specific experience that it decisively shapes: in order to sensitize to this specificity, Meier-Graefe lets the painting speak— quite literally—in its own voice.

For Meier-Graefe, what the painting expresses is the experience of alienation. But rather than explicitly stating this and describing it in terms of concepts and metalinguistics, Meier-Graefe demonstrates that same mode of sensation and perception in his scenic presentation. He is himself the flaneur who discovers this "outdoor scene" from which he, despite his sympathetic participation, keeps his distance: a distance he requires to be able to reflect on what has been experienced, to appraise it, and ultimately to carry it into a personal, communicable form, into a scene like the one unfurled here.

By showing the work in its effect, description results in value judgments. What Meier-Graefe demonstrates is the painting's capacity to communicate even the most personal, subjective experiences. Key to this is the ability of the artist (and ultimately also that of the critic mediating the artwork) to mediate participation and distance to each other, to objectify feeling into form.

In this oscillation between distanced reflection and emotional participation, the open-end or "spiral" structure of critique (Michel Foucault) becomes visible—underlined by Meier-Graefe's remark that Manet's painting always remains enigmatic to him, though he feels himself to know it "like an intimate friend." He thus opens a space of negotiation for points of view. More than a means of producing and communicating knowledge, criticism is a medium of persuasion and assumption of perspectives: its "how," its modes of mediation, are crucial. By narrativizing an object that is before everyone's eyes, a shared reference point common to all, Meier-Graefe exhibits points of view as points of view. Subjectivity and objectivity thus become discussable as positings and concepts. As a symbolic space, "art" functions as a test tube for mediating the diversity of modern perspectives and, by aiming at tentative agreement, for creating (temporary) emotional communities.

Kunstschriftstellerei—a specific critical practice that in the German-speaking world began around 1900 to build on the French art criticism of the eighteenth and nineteenth centuries and which remained tremendously impactful in the Anglophone world until Clement Greenberg—has played a significant role in shaping the Western canon of modern art. It can be described as a resonance phenomenon in which the negotiation of ego and alterity is central. To conduct this negotiation process, *Kunstschriftstellerei* has developed a repertoire of persuasive strategies, helping to shape an emotional culture of which it was an indispensable part.

Fellows in Reality

Julius Meier-Graefe

from *Entwicklungsgeschichte der Modernen Kunst: vergleichende Betrachtungen der bildenden Künste, als Beitrag zu einer neuen Aesthetik*, (*Modern Art: being a contribution to a new system of aesthetics*), 1904

I. *Le Déjeuner sur l'herbe* (The Luncheon on the Grass)

Each of us has often sat resting in the forest, and this memory ensures our trust in Manet.

... Outside, under trees, two friends and a girl sit together, chatting with each other. One speaks; the others dream. Nothing in particular occurs, but the girl happens to be nude. No one notices, as the conversation and the musings of the listeners drift elsewhere. The situation appears so natural that it would not even require a second girl, who is seen in the background emerging from a swim. The scene is serious, simple, and perfectly appropriate. The very thing that we expect least in this motif is present in overflowing abundance—dignity. A severe, masculine, and very rational dignity that gains its beauty precisely from those elements that seemingly strive against it. Again and again, we perceive anew the mystery, the contradiction of this effect, even if we believe we know the painting as well as an intimate friend. Improvised like all our leisure, a picnic somewhere in the woods becomes a poignant symbol. Two men from a nearby town, a nude girl, nothing more; everything else in the painting is too much. And this absence of legend inspires awe. We tread lightly, keeping a pious distance, not speaking. As if this idyll were a legend of saints....

The functions of the idyll were love, dance, song, enchantment. This severe, entirely masculine, wholly rational dignity does not belong to prior notions of an idyll, being entirely removed from ecstasy. Manet's idyll is ours. None of its forms would be conceivable at any other time; certainly not the idea of painting them. This idyll, beside the others, is sober and cold and born of an incomparably more heated devotion. Here, the arousal that renders the old idyll into charming forms seems to be held together in the heart of the painting and hardly cracks a smile. Being, as it is, at the highest point of arousal, it is very cold. Be silent, be silent! it says; see, see! And it is odd how one is silent and descends into sight, and how the quietude becomes greater than all earlier

Edouard Manet, *Le Déjeuner sur l'herbe* (The Luncheon on the Grass), 1863

idylls. Momentum, in the painting having been brought to standstill, only ignites exuberance within us, and it is as if joyful spirits who once dwelled in the woods, river gods and satyrs, were performing jubilant dances while we gaze as motionless and indifferent as the three in the painting....

It is the idyll to which improvisation belongs as a necessary gesture because it cannot bear a pose: our idyll. We can only ever arrive at celebration with improvisations, gaining tranquil moments from so many forms of turmoil. Our idyll's possibilities lie in the conversational lulls of our addiction, in trembling glances that grasp at serendipitous peace, in flowing trivialities that only a sensation familiar to chance, transcending the ephemeral, is able to hold fast; that is, to preserve them in chance form. They seldom become real: our world is devilishly un-idyllic. But should it succeed, no price is too high. The plainest serenity then becomes a monumental gesture, and a *Le Déjeuner sur l'herbe* becomes classic on an entirely different magnitude to a Raphaelist engraving of Marc Antony with the river gods....

The Leak:
Berta Zuckerkandl

Julia Voss

When Berta Zuckerkandl published her article "The Klimt Affair" on April 12, 1905, she brought a journalistic approach into art criticism for which an appropriate label would only arise much later—the leak. Some parts of the correspondence, which she spread over an entire page of the *Wiener Allgemeine Zeitung* without having received prior authorization, originated from Austria's Education Ministry. The letter's addressee—whom Zuckerkandl quoted publicly—was Gustav Klimt, the painter, cofounder of the Vienna Secession, and a friend of the journalist. The conflict raging between Klimt and the Ministry concerned a commission the artist had received more than ten years prior. His task was to create several ceiling paintings for the university's festival hall, depicting allegories of philosophy, medicine, and jurisprudence. Once completed, however, each of these paintings met with substantial resistance, both among the public and in the university. When the Education Ministry ultimately demanded changes, Klimt resolved to withdraw the paintings and refund all monies that had already been paid to him. The Ministry refused even this offer—until Zuckerkandl made the affair public.

The debate on the "Faculty Paintings" has been well researched, studied, and reappraised. Its lesson for art criticism is the innovative form that Zuckerkandl gave to it: Rather than defending Klimt with incandescent praise, she resorted to a strategy which had up until that point been a part of political journalism's repertoire. By making public what was meant to remain behind the scenes, she pushed Klimt's

opponents to expose themselves. Klimt bore witness to the readership on the arguments with which the Ministry sought to justify the withdrawal of his paintings. Simultaneously, the public was able to read up on how his return request had been refused. Zuckerkandl presented the original, stilted tone of the language in which Klimt was three times addressed as "Your Honor" (*Euer Hochwohlgeboren*, literally "your high-born"), with artistic considerations not playing any role. "One forgot," commented Zuckerkandl dryly, "that it was in fact ultimately about artworks, not something like deliveries of bathing trousers for the municipal baths...."

It is unsurprising that Zuckerkandl was shrewd in terms of political journalism. When she was three years old, her father Moritz Szeps bought a pro-government newspaper in Vienna and lent it a new, liberal-left direction. At seventeen, Zuckerkandl was running political errands, delivering messages her father exchanged with the progressive Crown Prince Rudolf. Upon Rudolf's death by suicide in 1889, hopes for a better future for the Austrian monarchy had been dashed. From her childhood onward, Zuckerkandl was present in a political system that was hostile to her beliefs. As an art critic, she consequently placed herself alongside those who advocated for change—including Gustav Klimt, Otto Wagner, and Josef Hoffmann. She maintained close contacts with France and held a renowned salon, supported by her husband, anatomist Emil Zuckerkandl. Plans for the Vienna Secession and the Wiener Werkstätten ("Viennese Workshops") are said to have been forged at the Zuckerkandls' villa.

Zuckerkandl's articles were shadowed by the sneering comments of Karl Kraus, editor of the newspaper *Die Fackel*, who opposed almost all the artists she promoted in her writing. Fortunately for us, her judgment prevailed. As a Jew, she was forced to flee in 1938 when the Nazis marched into Vienna. Two years later, she was also forced to leave Paris, once again to incoming German troops. She moved to Algiers to live with her son, who had emigrated there at an early age. She died in October 1945 in Paris.

The Klimt Affair

Berta Zuckerkandl

from *Wiener Allgemeine Zeitung*, April 12, 1905

"The principal reasons that led me to take back the ceiling paint-
ings ordered by the Education Ministry"—explained Gustav Klimt to
me—"are not to be sought in any displeasure that may have been elic-
ited in me by the attacks from various parties. These impacted very little
upon me at the time and I did not lose my joy at the commission. I am
very much impervious to any kinds of attacks. But I am rather more sus-
ceptible in those moments where I feel my commissioner is not satisfied
with my work. And this is precisely the case with the ceiling paintings.
The Minister has in all his attacks only ever maintained legal advocacy
of his point of view, with the artistic moments, despite being of prime
importance here, being touched upon only in the most cautious manner;
rather than any kind of defence one could in fact observe a rejection of
the artistic qualities. Via countless hints, the Ministry led me to under-
stand that I may have become an embarrassment for that party. There
are then no circumstances more embarrassing for an artist—I stretch
this term to its limits, of course—than to create works for a commis-
sioner who is not fully on side with the artist in both heart and mind, and
to accept money from him in return. This is something to which I can in
no way resolve myself and I had already sought for all possible means to
free myself from these circumstances, which I feel to be entirely humil-
iating in respect to any true artistry. As long as eight years ago, the same
feeling drove me to act in this way. This was already so when my sketches
of the ceiling paintings were presented to the Art Commission. The
following was requested of me at the time: Philosophy should be set to a
darker tone; Jurisprudence should be restricted to 'calmer lines'; and for
Medicine, the unclothed female figure must be either painted over with
a man, or the lady should be given clothing. I wished at that moment
to withdraw immediately and it was only via the arbitration of Baron
Weckbecker in the Education Ministry, who drafted a very reasonable
contract permitting me full liberty as an artist, that I permitted myself to
set about my work.

Since the unfortunate 'state commission,' it has become custom in
Vienna to hold Minister v. Hartel responsible for each one of my other
works. Bit by bit, the Minister of Education seems to have genuinely

Wiener
Allgemeine Zeitung.
6 Uhr-Blatt.

Abonnement: [...]

Nr. 8120. Wien, Mittwoch, 12. April. **1905**

3 Worte . . .
„Altvater" Gessler
Jägerndorf.

Los vom Staat!
(Zum Fall Klimt.)

Wien, 11. April.

Gustav Klimt, der vielumstrittene Künstler, ist in Konflikt mit dem Staat geraten und will für diesen sonst so geschätzten und unsymmetrischen Künstlernatur nicht mehr arbeiten. [...]

"The Klimt Affair," *Wiener Allgemeine Zeitung*, April 12, 1905

formed the impression that he bears such responsibility. I am thus subject to unprecedented levels of interrogation at many exhibitions. At my large oeuvre exhibition, for example, I was dissuaded from exhibiting a painting that aroused 'fear.' I did so as I wished to avoid any inconvenience for the association. I would have vouched for my work, however. In Düsseldorf, where our Austrian exhibition was an official one, the Education Ministry urged the removal of *Goldfisch* prior to the opening, as the German Crown Prince, who was set to perform the opening, may have been shocked. This did not happen in the end, but you see what is possible. From the same fearful feeling sprang the hard rejection of the exhibition project the Secession had designed for St. Louis. No, I have always and everywhere been a terrible embarrassment to the Minister and, by the step I am now taking, I am now once and for all relieving him of the bizarre protectorship that has grown to watch over me. I will likewise never, and certainly not under this Ministry, be in an official exhibition unless my friends compel me to do so. Enough of censorship. I will take the matter into my own hands. I wish to extricate myself. I wish to get back to freedom, away from all these unedifying absurdities that hinder my work. I reject any kind of state support. I renounce it all.

I declare that I have a right to paintings. I have been told all too often that the paintings would not be put in their proper place as ceiling paintings. Via the fact of the ten pendentive paintings that had been ordered from me the previous year having been transferred by mutual agreement to Matsch for the same festival hall and the Education Ministry taking back the advance sum I had been given for them, the coherence of the commission granted to me was ripped apart. The paintings would be exhibited under quite different conditions to those for which I created them. Even in the face of the Ministry's bizarre declarations, they are not yet to be regarded as finished, as they are absolutely not in harmony with one another and it is only possible for an artist to complete ceiling paintings once they have been installed in place. I am also protected by a passage in the contract which explicitly states: "Should it for any reason be not possible for one of the artists to deliver the work, another must take over part of the commission." Just such a case has now occurred. I am not in a position to deliver works that do not meet with the commissioner's expectations, will return the money, and retain the images. I cannot be dependent on somebody against whom I must fight.

But all that I have here said to you is of lesser importance. The principal issue is that I wish to make a stand against the manner in which, in the state of Austria, in the Education Ministry, matters of art are

Berta Zuckerkandl

handled and settled. With each and every matter, it assaults real art and real artists. It is only the weak and the wrong that are protected. Many things have come to pass against serious artists; I wish not to list them here but will do so one day. I want to take up arms for them, create clarity for once. There must be a clear divorce. The state should not play the patron of the arts where it at best doles out charity. The state should not baselessly assume the role of dictator of the exhibition system and artist debates where its only duty should only be to act as mediator and a commercial party, leaving the artistic initiative entirely to the artists. Civil servants should not force their ways into the art schools and usurp the artists, as is happening now in the most arrogant manner, unless they at least take the strongest possible stand against such an art policy. If, as occurred at the most recent Budget Committee meeting, a speaker attacks the Secession in the most humiliating, libelous way and the Minister feels unmoved to say a single word in reply, the least that should be done is to find an artist who, by way of a single act, demonstrates that true art no longer wants to have anything to do with such authorities, with such parties. It was not the spirit of togetherness that brought this about, as the planned demonstration by the artist associations did not take place. So let the individual do it instead. It is not because I want nothing more to do with commissioners so far removed from real art and real artists that I am not handing over my paintings.

I note in passing that you can here see the response I just received from the Education Ministry. The tone of the letters is of such a nature that I am only now seeing how correct I was in tearing away each and every bond between myself and these parties. All that I have said here has been said only to inform the public and my friends about the reasons for my actions—on no account whatsoever to give account to the Ministry. I will hand over the paintings only upon use of brute force."

Klimt's letter to the Education Ministry

To the Imperial and Royal Ministry of Culture and Education:

Ten years ago, when I received the university auditorium commission, I went to work with great enthusiasm on the grand task that had been granted to me. As it is well known, my many years of earnest labors have earned me wealth of abuse that, on account of their sources, were unable to dull my zeal. This, however, has changed over the course of time. Via a series of communication, His Excellency Minister Dr. Hartel made it clear to me that my works had begun to cause discomfort for the commissioners. If my years-long work is to reach a stage of completion at all, I must first find joy in it again; and this joy will be completely absent for me so long as I must regard it as a state commission under the present circumstances. I am thus confronted with the impossibility of completing a commission that has already come so far. I have already given up on one part of this, the pendentive paintings, as the Ministry has noted and approved of. In consequence I will now resign the entire commission and will commence by gratefully returning the entire advances that I have received over the years. I request information as to the account into which I should pay this money.

Respectfully, Klimt.

In the response of the Ministry to the artist it is stated that the Ministry is absolutely unwilling to give up its claims to the paintings, claiming that the sums accepted by Klimt over the years are to be seen not as advances but as payments in and of themselves. Klimt would thus be legally obliged to deliver the paintings to the state. These paintings, which are currently again located in the artist's studio, were in fact only loaned to him by the Ministry for the purpose of their exhibition.

The Ministry's letter culminated with this sentence:

"… As, however, Your Honor likewise declares in the aforementioned letter that you presently are unable to complete the paintings, I allow myself the honor to address to Your Honor the urgent and earnest entreaty that each of the three ceiling paintings in question be immediately sent to this Ministry, under observation of all the required precautionary measures, in the same form in which they were delivered to Your Honor."

Berta Zuckerkandl

At a time when it is being made so difficult for the artist to document pride in their own person, Klimt's words here take on a far-reaching significance. In this full-blooded espousal of the ideals and rights of artistic pursuits lies a prophetic power. Klimt's act, just as every free, bold, and selfless act of the public, will bring about an elevation and invigoration of culture. We believe the days of civil-service art are numbered.

Crafts and the Spiritual: Ananda K. Coomaraswamy

Monica Juneja

The book *The Indian Craftsman* by Ananda K. Coomaraswamy, from which the following extract has been chosen, addresses a seminal question about processes of artistic creativity. In doing so, the author chooses not to privilege European humanist concepts and the values they transport—canons that have long enjoyed the claim to universal validity within art history. Coomaraswamy's approach is rather anti-modernist and anti-industrialist. Like all his writings, it makes a strong case for grasping the dynamics of Indian art not through the lens of form alone, but rather based on prior knowledge of iconography, philology, theology, and metaphysics. *The Indian Craftsman* is framed along a binary axis that posits materialism against spiritualism, while the text's critique of industrial modernity valorizes collective labor and social cohesion as vital aspects underpinning art production. At the same time, the work relies on an ethnographic method of direct observation that contrasts to the philological approach and philosophical abstraction that mark the author's later work. Although the anti-colonial framing of Coomaraswamy's writings has meant that they are frequently couched in a language of a nativist nationalism, the possibilities inherent in an approach that conceives of art as a holistic, ethical praxis, which lives from a connection between the hand and mind, merit investigation.

The choice of this text stems from an interest in making its content productive for an art history informed by a notion of critical globality—in other words, a perspective that aspires to make insights from regions beyond the Western European–North Atlantic

axis globally intelligible and capable of being critically worked back into the mainstream discipline. Can an approach that counters the idea of art as representation and urges us instead to look at art as making, as contingent on skilled ways of knowing that conjoin materiality with knowledge and experimentation, help in rethinking art history in a global context? Coomaraswamy's critique of modernity shows the way to questioning existing distinctions, such as art versus artifact, that downgrade or exclude many historically and aesthetically significant kinds of objects and practices from consideration. Further, making materiality central to the experience of art, to its production and reception, helps pluralize our understanding of concepts such as vision, by making art history more capacious for notions of sight that go beyond the purely ocular and prevail in different world cultures. Drawing our attention to skills of art making is an important reminder that processes of knowledge production are as much material as they are textual. In the context of South Asia—though probably applicable to other traditions in the world—it is important not to fall into the trap of considering canonical texts, for example in Sanskrit, as manuals for artists. These instead were composed as a set of abstract norms, were often transmitted orally, and most importantly, learned as skills translated into practice.

Coomaraswamy's insights serve as a basis to argue that a society's conceptual knowledge about art was not produced exclusively within lexical repositories; it was equally reconfigured through practice and experiment, and percolated through and within workshops. The art-critical potential of Coomaraswamy's text that views the significance of a work of art beyond the intentionality of its maker lies in a kind of artisanal epistemology. It describes art making as an ensemble of manual skills, technical procedures, material practices—often indirectly transmitted—together with other sources. Artisanal epistemology sensitizes us to look for a distributed agency that takes us beyond the individual artist, whom art history, conditioned during its formation by an evolutionist logic, tends to canonize as the pinnacle of creativity.

Pursuing these insights today could lead us towards a non-totalizing, transcultural approach to art history that must also consider migration as a logical condition of art making. For materials and technologies, and—not least—the craftsmen themselves were important links in a network of connectivities among things, peoples, and ideas from all time periods and geographical locations. Studying these beyond national units will allow us to negotiate existing gaps and discontinuities within art-historical understanding that we continue to grapple with.

The Indian Craftsman

Ananda K. Coomaraswamy

excerpted, first published by Probsthain & Co., London 1909

CHAPTER VI. EDUCATION.

I have spoken more than once of the "hereditary craftsman," a phrase justified by the hereditary fixity of social function under the caste system. But it is worthwhile to consider the point in greater detail. It is often assumed that the skill of the "hereditary craftsman" depends upon the direct inheritance of his father's individual skill. But this skill is an acquired character, and it is almost universally agreed by scientists that there is no such thing as the inheritance of an acquired character; a man who loses one leg does not have one-legged children; a man who learns to play well on the piano does not transmit that skill; nor can the craftsman transmit his acquired capacity for carving wood or chasing metal. On the other hand, of course, if it be supposed that large groups of craftsmen are descended from a common ancestor who originally possessed innate artistic genius (a different thing from actual skill in handicraft), it may be argued that this capacity is inherited, and this would be the case. Personally, I should be inclined to attach little value to the likelihood of the actual existence of such authentically superior race of craftsmen; one would think, indeed, that the absence of selection and elimination in an hereditary caste might lead rather to degeneration than to a preservation of standard. As a matter of fact, all these considerations are of small weight beside the question of education and environment, conditions of supreme importance, and implicit in the expression "hereditary craftsman" as ordinarily used. The important facts are these: *the young craftsman is brought up and educated in the actual workshop, and is the disciple of his father.* No technical education in the world can ever hope to compensate the craftsman for the loss of these conditions. In the workshop, technique is learnt from the beginning, and in relation to real things and real problems, and primarily by service, personal attendance on the master. And it is not only technique that is learnt; in the workshop there is life itself, that gives to the pupil both culture and metaphysics, more essential to art than technique itself; for what use is it to speak well if you have nothing worth saying? I have been struck, in contrast, by the inefficiency of the great Technical Schools in London, the pride of the County Council. Their watchword, like that of the British in the

East, is indeed efficiency; but this means that the Professor is hauled up before a committee if he is late in attendance, not that his personality is a first consideration.[1] It means, too, that he is expected to be intensely practical, and to go through some curriculum leading to certificates and prizes; woe betide him if he should waste time in giving to his pupils a metaphysic or teaching them medieval romance. Small wonder that the pupils of these schools have so little to say; they cannot, indeed, put more into their work than there is in themselves. But in speaking of the Eastern system of craft education, I used the term *disciple* advisedly; for in the East there is traditionally peculiar relation of devotion between master and pupil, and it is thought that the master's secret, his real inward method, so to say, is best learnt by the pupil in devoted personal service; and so we get a beautiful and affectionate relation between the apprentice and the master, which is impossible in the case of the busy professor who attends a class at a Technical School for a few hours a week and at other times, when engaged on real work, and dealing with real problems, has no connection with the pupils at all.

The master need not be the boy's father; he may be an elder brother, or even unrelated; but in any case, once chosen, he is the ideal of the pupil, from which he never wavers. There are often trade secrets, simple enough it may be, but valuable as much in the idea as in the fact; these the master reveals to the faithful pupil only after many days, and when he has proved himself worthy. Devotion and respect for the teacher remain throughout life; I have seen a man of thirty receive wages in the presence of an elder brother, his teacher, and hand them to him as the master with the gentlest possible respect and grace; and as gently and delicately they were received, and handed back, waiving the right to retain; and this same elder brother had an aged father, a great craftsman in his day, and he never returned home with wages without offering them to him in the same way. I have seen few things in East or West more suggestive of entire gentleness than these expressions of reverence for the teacher.

1 In this exaltation of administrative ability over creative gifts, which are much rarer and more precious, our institutions share the weakness which pervades our industrial establishments, where the manager or superintendent usually gets larger pay and is regarded as more important than the most expert craftsman. In both we see the same striving for a certain sort of efficiency and economy of operation, and for the attainment of a completely standarised product. This tends in both cases to the elimination of individuality and to sterility.... I would that there might be displayed in the administrative offices of every institution of higher education this testy remark, once made by an eminent scholar: "You cannot run a university as you would a saw-mill!" Address by Prof. F. L. Nicholls to the American Association for the Advancement of Science, 1908. *Nature*, January 14th, 1909.

I need not point out what a perfected instrument for the transmission of a living tradition such an education forms. And if, to return to the Technical School of to-day, one may make a suggestion, it would be this: that supposing the aim be to train up a generation of skilled and capable craftsmen, it were better to appoint living master craftsmen as the permanent servants of the community, endowed with an inalienable salary, or better, a house, and demand of them that they should carry out the public works undertaken by the community, and that they themselves should keep apprentices, choosing out of them one to be their successor in the position of Public Craftsman. Such a system would do more to produce skilled craftsmen, and to produce good work, than would twice the money spent on Technical Schools and on competitive design for great undertakings.[2]

There are few, if any, places in India where the traditional methods of instruction are maintained in every detail. But a brief account of the system as surviving in Ceylon, almost to the present day, may be useful here. We may suppose that a young boy, son of a caste craftsman, has been apprenticed to or is the son of a younger brother of the master or the teacher. His attitude is one of discipleship and deep respect. If not a relation, he has been brought to the craftsman's home, with presents of betel leaves and perhaps an offering of money or cloth, and given into the master's charge. During his years of instruction he will live with and be fed and clothed by his master and teacher, and when at last his education is complete, be given the last secrets of the art and perhaps some heirloom or gift of a design drawn by a famous painter generations back.

The boy is given first a wooden panel, primed with a preparation of iron slag, quart sand, coconut-shell charcoal, tamarind seed, and the leaves of *Eclipta erecta*. Upon this panel he learns to draw, using as pencil a sea urchin spine or a piece of pointed wood.

It is of interest to note that this method of instruction is so far practically identical with the method of drawing on a primed panel, prescribed for beginners by Cennini.[3] The forms drawn upon the panel are certain peculiar curves, gradually elaborated into very complex studies in applied ornament.

Drawing from nature is never taught. After the hand and eye and memory have been trained in the use of the fundamental curves in this fashion, traditional ornament, repeating patterns, and the like are

2 See A. J. Penty, "Restoration of the Guild System"; and C. R. Ahsbee, "Craftsmanship in Competitive Industry," Campden, 1908.
3 See translation by Mrs. Merrifield, London, 1894.

Ananda K. Coomaraswamy

taught, then mythical animals and designs with men and beasts in them. The pupil is also taught to use the brush, and assists his master in practical work in temples, at first by grinding the colors and general personal service, then by priming the surfaces, applying a ground colour, and by preparing and taking care of brushes and pigments, and lastly, by filling in outlines sketched by the master for completion by the pupil. Experience is thus gamed in practical work. There is nothing *dilettante* about the young craftsman's education. It begins early and is exceedingly thorough.

While it is in progress he has, in addition to his ordinary education, to learn by heart various Sanskrit works on art, with their meaning. These technical works, composing what is called the *Silpa Sastra* or "science of the arts," describe various kinds of images, the characters of mythical animals, the measurements of images and buildings, the kinds of jewellery proper for kings, the proportions of various tools and utensils.

A point of interest is the extreme simplicity of the craftsman's tools and methods. The painter's brushes, for example, are made of the awns of various grasses, of squirrels' hair, of roots, or fibre, and he is always able to replace them or modify them at need. The repousser's tools he makes himself to suit the work in hand, and he does not hesitate to make a new tool out of an old one for a special purpose. The value of this simplicity lies in the fact that the craftsman relies upon himself rather than upon his tools, and at the same time is completely master of them, adapting them exactly to the requirements of the moment. So with the pigments and mediums. There is no mystery, and success depends on thoroughness and patience rather than on any secrets of the trade. It would be easy to give further details of technique and methods here, but the purpose of the present work being rather to portray the craftsman than to describe his work, the reader is referred for such details to such works as "Mediaeval Sinhalese Art," by the present author, "Industrial Arts of India," by Sir George Birdwood, "Indian Art at Delhi," by Sir George Watt, and the pages of the "Journal of Indian Art and Industry." It may also be remarked that Mr. Percy Brown, Director of the School of Art in Lahore, has there collected a valuable series of exhibits illustrating the traditional methods of instruction in the various crafts still, or until recently, practised in the district. It is of the utmost importance that further work of this kind should be undertaken before it is too late. While anthropologists and sociologists are busy studying savage tribes, there is much of the organized life of the ancient civilizations slipping away for ever, which it is of far more importance to study and record.

To conclude with the craftsman himself: perhaps there is nothing more striking about his position in society, whether as a villager, a

guildsman, or a feudal servant than this—the assurance of his position, and the assurance of his purpose and value. It is only in the absence of anxiety as to the immediate future, that that quality of leisure so characteristic of true works of art and craft can appear in them. The serenity and dignity of his life are things which we cannot overlook, as Sir George Birdwood says, if we are rightly to understand the Indian craftsman.

"He knows nothing of the desperate struggle for existence which oppresses the life and crushes the very soul out of the English working man. He has his assured place, inherited from father to son for a hundred generations, in the national church and state organization, while Nature provides him with everything to his hand, but the little food and less clothing he needs, and the simple tools of trade.... This at once relieves him from an incalculable dead weight of cares, and enables him to give to his work, which is also a religious function, that contentment of mind, and leisure, and pride and pleasure in it for its own sake, which are essential to all artistic excellence."[4]

The craftsman had this leisure for thought, and even for dreaming, and his economic position made him secure against oppression or want. He had no need to accumulate wealth, and we do not find that the wage asked by the traditional craftsman in unspoilt districts to-day represents more than a bare living for self and family.

Too often we forget that industry, *per se*, is of little or no value to humanity, if the results are valueless. But the true craftsman will often work overtime if he is interested. I have had Sinhalese craftsmen who insisted on working by lamplight far into the night. But the same craftsmen demand the right on other occasions to come and go at their will, and it would be quite vain to expect any particular piece of work done within a fixed time. The artistic and the commercial methods are thus radically different; and the artistic result cannot be attained on commercial lines, nor *vice versa*.

The current rate of wages for all depended much more on the general cost of living than on the degree of skill required for this special craft or the other. The craft was much more a "calling" than a trade, and to this day Sinhalese craftsmen care more for congenial work, and personal appreciation, than for money payments. And as we have seen, in the most typical cases, the craftsman received no money wage at all, but was repaid in other ways. Many a British workman would be glad to exchange his money wage for such security and appreciation as belonged to the Sinhalese craftsman of a hundred years ago. Presents, indeed, were

4 Sir George Birdwood, "Industrial Arts of India."

Ananda K. Coomaraswamy

expected, even grants of land, but these were for faithfulness and excellence; not a payment at so much a yard or so much an hour for such and such kinds of work. For the work was art, not commerce, and it would have been as idle to demand that a carpet like the Ardebil carpet should be designed and made at so much per square foot, as to expect, academy pictures to be done in the same way; indeed, I think it would be more reasonable to sell these by the square yard, than to suppose that the works of the Mediaeval Eastern craftsman could be valued in such a way.

If now, in conclusion, we endeavour to sum up the results to which we are led by this study of the Indian craftsman, and by a correlation of his position in society with that of the craftsman in periods of good production in the Western world, and in other parts of Asia, we find that no really great traditional art has ever been produced, except under the following conditions: Freedom of the craftsman from anxiety as to his daily bread; legal protection of the standard of work; his art not exploited for profit. These are the material conditions; even more important is that spiritual conception of the serious purpose of art, which we find expressed in the work of true craftsmen of whatever age or place, but perhaps more in India than anywhere else. In other words, it has only been when the craftsman has had the right to work, the right to work faithfully, a right to the due reward of his labour, and at the same time a conscious or subconscious faith in the social and spiritual significance of his work, that his art has possessed the elements of real greatness. And so we can hardly avoid the conclusion that these will always be conditions necessary for the production of fine art and craft.

Practical Formalist: Roger Fry

Beate Söntgen

The critic, curator, painter, and interior design workshop founder Roger Fry is considered a formalist in art history. This title is not meant as an embellishment, considering that the term denotes a focus on questions entirely immanent to art, to the exclusion of social issues. Only recently has the perspective on this tireless writer and orator shifted, with emphasis now being placed on the communicative potential and societal functions of Fry's notion of form. According to Fry, the process of production, the characteristics and manipulation of the material, as well as the joy of creation itself are retained in form and conveyed to the viewer. This transmittance of creative momentum led to the spiritualization of daily life, which, in Fry's perspective, had been rendered desolate by commercialization and consumerism, as well as to the healing of individual and societal wounds caused by the war.

Post-Impressionism, the term Fry used to describe French painting around 1900, with its emphasis on the autonomy of form, order, rhythm, and sensually induced joy, served as his leitmotif. In England, it was primarily the paintings of Vanessa Bell that materialized this kind of understanding of art. Beauty in painting is not an end in itself, but rather an effect of the sincere, unconscious expression of feelings that resonate with their viewers and inspire their own creativity. The tacky Lawrence Alma Tadema appears here as a negative counterpoint, whose glossy paintings constituted part of the materialistic, commercial culture against which artists were expected to compete. The Futurists

shared Fry's notion that art should manifest one's approach to life, as a figurative echo of mental visions. But their methods of countering their own, and in any case dubious, claims to originality were conventional, tending toward painted theory rather than genuine expression. Fry, who came from a wealthy London Quaker family, began as a curator specialized in early Italian painting, which shaped his understanding of modern painting. After working at the Metropolitan Museum in New York, he returned to London in 1910 and organized an exhibition of Post-Impressionist paintings. With the founding of the egalitarian and collectively organized artisanal craft workshop Omega in 1913, Fry wanted to incorporate the representational styles of the Post-Impressionists into everyday design, an undertaking which in itself invalidated all accusations of formalism.

Other members of Omega included Vanessa Bell and Duncan Grant, who were also part of the Bloomsbury group, with whom Fry maintained intense working, friendship, and love relationships. In the collective design and use of houses, such as the Charleston Farmhouse, as well as in the collective artisanal production of furniture and everyday utilitarian objects, alternative forms of life that restructured community relations materialized. Chosen family, artistic, intellectual and erotic bonds, as well as shared projects were at their foundation. Fry developed the criteria for his art criticism from these diverse artistic, artisanal, curatorial, teaching, and entrepreneurial practices. He discloses these criteria non-polemically, with a rhetorical elegance that employs wordplay, incisive anecdotes, and irony. Fry reveals where he stands in his texts, thus defending himself against the accusation of conflating aesthetics and ethics through a nuanced account of his notion of artistic morality. Taking the review of the Futurists as an example, it becomes clear how artistic processes can become social models; by communicating interior life as it is conveyed through form, and through the reciprocal relationships of parts of the whole.

The Futurists

Roger Fry

excerpted, from *The Nation*, March 9, 1912

At the Sackville Gallery is to be seen a small collection of work by this group of Italian painters. The catalogue contains a manifesto of their aims and beliefs. This, at least in the English translation, is by no means closely reasoned or clearly expressed; it might have been better to allow us the assistance of the original Italian.

It is interesting to find painters who regard their art as a necessary expression of a complete attitude to life. Whatever one thinks about the content of their strangely Nihilistic creed, one must admit that they hold it with a kind of religious fervor, and that they endeavor to find an expression for it in their art. Fortunately, too, their dogmas appear to allow of great variety of treatment or method, so that, as yet, no stereotyped formula has been evolved, and each of those artists pursues his researches along individual lines. None the less, admitting as one may the sincerity and courage of these artists and their serious endeavor to make of art a genuine expression of spiritual experience, I cannot accept without qualification their rash boast of complete and absolute originality, even supposing that such a thing were in itself desirable. Rather what strikes one is the prevalence in their work of a somewhat tired convention, one that never had much value and which lost with the freshness of novelty almost all its charm, the convention of Chéret, Besnard, and Boldini. It is quite true that the Futurist arranges his forms upon peculiar and original principles, breaking them up into fragments as though they were seen through the refracting prisms of a lighthouse, but the forms retain, even in this fragmentary condition, their well-worn familiarity.

Apparently what is common to the group is the belief in psychological painting. The idea of this is to paint not any particular external scene, but, turning the observation within, to paint the images which float across the camera obscura of the brain. And these images are to be made prominent in proportion to their significance, while their relations one to another have the spacelessness, the mere contiguity of mental visions. Thus, in rendering the state of mind of a journey, the artist jumbles together a number of more or less complete images of the home and friends he is leaving, of the country seen from the carriage window, and of anticipations of his journey's end.

These pictures are certainly more entertaining and interesting than one would expect to result from such an idea, and one or two of the painters, notably Boccioni (in his later works) and Severini, do manage to give a vivid pictorial echo of the vague complex of mental visions. If once they give up preconceived ideas of what sort of totality a picture ought to represent, most people would, I think, admit the verisimilitude of several of these pictures—would own that they do correspond in a curiously exact way to certain conditions of consciousness. Unfortunately, the result is much more of a psychological or scientific curiosity than a work of art, and for this reason that the states of mind which these artists investigate are not really at all interesting states of mind, but just those states of quite ordinary practical life when the images that beset us have no particular value or significance for the imagination.

The idea of painting from the mental image is no new one, though it is one that artists might well practise more than they do. Blake roundly declared that to draw from anything but a mental image was vain folly; but he drew from mental images only when, stimulated by some emotional exaltation, they attained to coherence and continuity of texture. Probably a great many of Rembrandt's sketches are the result of distinct mental imagery, but it was a mental imagery stimulated by reading the poetical prose of the Bible. The fact is that mental visions, though they tend always to be more distinctly colored by the visionaries' own personality than external visions, are almost as various in their quality, and are, as often as not, merely accidental and meaningless. Doubtless the Futurists aim at giving them meaning by their relations to one another, and in this they aim at a direct symbolism of form and color. Here, I think, they have got hold of a good idea, but one which it will be very hard to carry out; as yet their work seems for the most part too merely ingenious, too scientific and theoretic, too little inspired by concrete emotion. It is the work of bold and ingenious theorists expressing themselves in painted images rather than of men to whom paint is the natural, inevitable mode of self-revelation. One artist of the group, Severini, stands out, however, as an exception. He has a genuine and personal feeling for colors and pattern, and the quality of his paint is that of an unmistakable artist. His *Pan Pan* is a brilliant piece of design, and really does, to some extent, justify the curious methods adopted, in that it conveys at once a general idea of the scene and of the mental exasperation which it provokes. For all its apparently chaotic confusion, it is not without the order of a genuine feeling for design. Here, as elsewhere, the worst fault is a tendency to lapse into an old and commonplace convention in individual forms.

His *Yellow Dancers* is another charming design. The statement in the catalogue that it exemplifies the destruction of form and color by brilliant light, shows the curious scientific obsession of these people. Such a fact is aesthetically quite irrelevant, and the picture is good enough to appeal on its own merits. The same is true of his *Black Cats*, a novel and curious color harmony, which gains nothing from the purely autobiographical note in the catalogue. Whether Signor Severini arrived at his design by reading Edgar Allan Poe or not is immaterial; the spectator is only concerned with the result which, in this case, is certainly justified.

No amount of successful exposition of theory will make bad painting of any value, and, on the other hand, a good picture is none the worse because the artist thinks he painted it to prove a theory, only in that case the theory has served its turn before the picture was painted, and no one need be troubled with it again.

Apart from individual failures and successes, one result of these efforts stands out as having some possibilities for the future of pictorial design, namely, the effort to prove that it is not necessary that the images of a picture should have any fixed spatial relation to one another except that dictated by the needs of pure design. That, in fact, their relation to one another may be directly expressive of their imaginative importance....

What the Futurists have yet to learn, if their dogmas still retain the power of growth, is that great design depends upon emotion, and that, too, of a positive kind, which is nearer to love than hate. As yet the positive elements in their creed, their love of speed and of mechanism, have failed to produce that lyrical intensity of mood which alone might enable the spectator to share their feelings.

The Case of the Late Sir Lawrence Alma Tadema, O. M.

Roger Fry

excerpted, from *The Nation*, January 18, 1913

It is a curious case. If it were not for the familiarity of its general outline, one would call it incredible, but its oddity was brought home to me by an incident. I was talking to a leading politician who has taken up the question of the nation's relation to art with characteristic energy and public spirit, and an allusion was made by him to the late Sir Alma Tadema.

The word "late" struck oddly upon me, and without thinking of what a ridiculous position I put myself in, I said: Is he dead? So little had he been alive to me that though I had undoubtedly seen his death in the papers, I had completely forgotten it. And this was the artist whom of all others the nation delighted to honor, and I was a man of average intelligence, whose chief business in life was the pursuit and study of art.

The historian of this time will have to take note of the fact, then, that there exist, side by side, two absolutely separate cultures, so separate that those who possess one culture scarcely ever take any notice of the products of the other. The converse of my lapse of memory occurred the other day. In the "Times" review of the year, under the rubric Art, the writer stated that there had been no noteworthy exhibition held during the year, that the public had "done" the galleries with a weary sense of duty. Apparently he was quite oblivious of the fact that the Post-Impressionist Exhibition had drawn a far larger public than any recent exhibition of modern art.

And so the two cultures go on side by side, every now and then expressing their mutual incompatibility, but for the most part ignoring each other. The culture of which the late Sir Alma Tadema was so fine and exuberant a flower may perhaps be defined as the culture of the Sixpenny Magazine. It caters with the amazing industry and ingenuity which we note in all Sir Alma Tadema's work for an extreme of mental and imaginative laziness, which it is hard for those outside it to conceive.

This culture finds its chief support among the half-educated members of the lower middle-class. Its appeal to them is irresistible, because it gives them in another "line" precisely the kind of article which they are accustomed to buy and sell.

Sir Lawrence Alma-Tadema, *The Roses of Heliogabalus*, 1888

Sir Lawrence's products are typical of the purely commercial ideals of the age in which he grew up. He noticed that, in any proprietary article, it was of the first importance that the customer should be saved all trouble. He wisely adopted the plan, since exploited by the Kodak Company, "You press the button, and we do the rest." His art, therefore, demands nothing from the spectator beyond the almost unavoidable knowledge that there was such a thing as the Roman Empire, whose people were very rich, very luxurious, and, in retrospect at least, agreeably wicked. That being agreed upon, Sir Lawrence proceeded to satisfy all the futile inquiries that indolent curiosity might make about the domestic belongings and daily trifles of those people. Not that he ever makes them real people; to do that would demand an effort of imagination on the part of his spectators altogether destructive of the desirability of the article. He does, however, add the information that all the people of that interesting and remote period, all their furniture, clothes, even their splendid marble divans, were made of highly-scented soap. He arrived at this conclusion, not as a result of his profound archaeological researches, but again by reference to commercial customs.

He noticed that, however ill-constructed a saleable article might be, it had one peculiar and saving grace—that of "shop-finish." The essence of this lies in the careful obliteration of all those marks which are left on an object by the processes of manufacture. This grace is often a difficult one to obtain. It requires great ingenuity and inventive skill, for instance, to remove completely the marks made upon a vessel by the potter's hands. But I believe that no piece of pottery is worthy to be presented to the general public until this has been done, and the surface reduced to dead mechanical evenness.

Sir Lawrence set his active brain and practised hand to the problem, and learnt to lick and polish his paint, so that all trace of expression, all remnants of vital or sensitive handling that there may have been—the drawings make it seem unlikely that there ever were—were completely obliterated. He gave his pictures the expensive quality of shop-finish....

His work is like very good, pure, wholesome margarine, and for all we know, Sir Lawrence put it forward as such, and never had an opportunity of correcting the little misunderstanding on the part of the public which insisted on calling it butter....

As I say, this would be astonishing if we could get enough outside of contemporary habits of thought to make some sort of true valuation of spiritual things; as things are, the case of Sir Lawrence Alma Tadema is only an extreme instance of the commercial materialism of our civilisation. Against that, the artist is and must always be in revolt, and while it

Roger Fry

lasts, he must be an Ishmaelite. He must expect a quite instinctive but none the less reasonably grounded suspicion and dislike from the social organism which is governed by a desire to prolong its life.

Another explanation of the case, of course, occurs to one, and would rise naturally to the lips of the successful trader in art, namely, that the artist is a duffer, and his indifference to the glorious career of an Alma Tadema but the expression of his affected belief in the sourness of the grapes. Doubtless most real artists covet honestly enough a tithe of Sir Lawrence's money. That does not smell. But his honors! Surely by now, that is another thing. How long will it take to disinfect the Order of Merit of Tadema's scented soap?

Independent Gallery: Vanessa Bell and Othon Friesz

Roger Fry

excerpted, from *The New Statesman*, June 3, 1922

The first quality of Vanessa Bell's painting is its extreme honesty. I have been taken to task by "the adversary" for calling a painter's work honest on the ground that I am confusing esthetics and ethics. But I cannot see how one is to deny certain moral qualities which are advantageous to the production of the best esthetic work. They are not necessarily the same moral qualities as bring a man respect in common life, though it is not impossible that they may be combined. There is, for instance, a certain artist who is a thief and a lair in ordinary life. He will even pick his friend's pocket, which certainly is a breach of moral standards, but he is none the less qua artist moral in that his work is free from insincerity and humbug. On the other hand, there are many respected and honoured members of society whose word no one would doubt, whose debts are scrupulously paid, who are good husbands and fathers, and yet are immoral artists in that they take money for pictures which are not what they pretend to be. In their work they are not honest about their sentiments, making out that they are more interesting, impressive, noble or what not, than they really are.

Honesty in this sense, as in the other, is a relative term; every artist must at one time or another be tempted to cover up some gap in his design by a plausible camouflage, and even if he is in the main honest, he has probably more than once fallen. Now, it seems to me that

Vanessa Bell comes very high in the scale of honesty, and in her case the virtue shines with a special brightness because she has no trace of what would ordinarily be called cleverness in a painter. I take cleverness to mean the power to give an illusion of appearance by a brilliant shorthand turn of the brush. Hals, for instance, is a very clever painter; Sargent was at one time, and how many more who have succeeded him in popular favour. This is the quality which of all others is the most rapturously acclaimed by the public, while artists themselves are not insensible to its charm. Now, Vanessa Bell is not only not clever but she never makes the slightest attempt to appear such. She follows her own vision unhesitatingly and confidingly, without troubling at all whither it may lead her. If the result is not very legible, so much the worse; she never tries to make it out any more definite or more vividly descriptive than it is.

It is the same with the quality of her painting. She has worked much with Duncan Grant, who is distinguished for the charm and elegance of his "handwriting." Her "handwriting," though it is always distinguished, is not elegant. It is slower, more deliberate, less exhilarating. But she seems to have made no effort to acquire a more pleasing manner; she realises that it is only the unconscious charm of gesture which counts in the end. She has, in fact, entirely avoided a mistake which almost always besets English artists at some period of their career, namely, the research for beautiful quality as an end in itself. She knows that "handling" and quality of paint are only really beautiful when they come unconsciously in the process of trying to express an idea.

Although the unfortunate obsession of quality as an end in itself is, as I think, peculiarly common in England, it is by no means unknown in France, and two pictures by Couture at the Burlington Fine Arts Club supply examples of the falsity and unreality which results from thus putting the cart before the horse. Anyhow, Vanessa Bell is singularly free from this artistic insincerity. One feels before her works that every touch is the outcome of her complete absorption in the general theme. So complete is this devotion to the idea that she seems to forget her canvas and her métier. In fact, she is a very pure artist, uncontaminated with the pride of the craftsman. How much harm, by the by, the honest craftsman has done to art since William Morris invented the fiction of his supposed humility!

To say that Vanessa Bell is not clever may perhaps give a wrong impression, for she is a very accomplished artist; there is nothing amateurish or haphazard about her work. The very absence of any anxiety about the effectiveness of what she does produces a refreshing sense of security and repose. She is never emphatic; she is genuinely classic

in the sense that she allows the motive to unfold itself gradually to the apprehension. And the attention is held at once by the peculiar charm and purity of her colour and by the harmony of her designs. In these she always shows an admirable sense of proportion. I do not think she makes any great or new discoveries in design, but it is always rightly adjusted and almost austerely simple and direct. She shows, indeed, a keen sense of the underlying architectural framework. But adequate as the design is, it seems to me that in this direction her development is not yet complete: that in this she has not yet quite discovered her personal attitude. Among her early works I remember one or two that suggested a peculiarly personal feeling for the architectural opposition of large rectangular masses and bare spaces. There was a gravity and impressiveness in these which I miss in her present work. What she has gained in the meantime is immense. It lies in the command of a far richer, more varied and more coherent, texture of tone and colour. It may well be that what I take to be her instinctive bias in design will again reassert itself now that she has gained the control of her means of expression. I suspect it is in this question of design rather than elsewhere that the influence of Duncan Grant's more playful and flexible spirit shows itself.

But, after all, it is as a colourist that Vanessa Bell stands out so markedly among contemporary artists. Indeed, I cannot think of any living English artist that is her equal in this respect. Her colour is extraordinarily distinguished. It has even more than her drawing and design measure and proportion. Look at the *Still Life (No. 8)* of aubergines and onions lying on a table before a grey wall.... Vanessa Bell has indeed found that the secret of colour lies not in vehemence but in maintaining the pitch throughout. She never puts in a touch of merely non-committal or nondescript colour. However apparently neutral or unimportant a tone of grey shadow may appear, its pitch is as exactly found as if it were a piece of brilliant local colour. Every note has indeed its full resonance and effect in the total harmony.

It is curious how little the human figure makes its appearance in Vanessa Bell's work; her rooms are empty and her landscapes lonely. This suits, I expect, her habitual mood of grave but joyous contemplation....

This exhibition ought, I think, to prove how high a place Vanessa Bell is entitled to in contemporary English art. I come back to the fact that the feeling of grave, untroubled serenity and happiness, which is the dominant mood of the exhibition, comes from the singular honesty and purity with which she accepts and expresses her vision....

Agitation:
Sergei Tretyakov

Valerija Kuzema

Sergei Tretyakov (1892–1937) has a reputation as one of the most active and versatile members of the avant-garde of the nineteen-twenties and thirties in the Soviet Union. He has frequently been characterized as a poet, author, photojournalist, and travel writer, and he also worked on several cinematic productions. Yet little attention has hitherto been paid to his activity as an art critic. His art criticism is particularly interesting, however, because these writings were formulated under new political conditions and in the expectation that every field would break with tradition. At the same time, Tretyakov's art criticism reflects his conceptual and political thinking and his participation in various artistic movements, and these influenced the character of his style and terminology.

In the post-revolutionary climate of the Soviet Union, art criticism acquired a new function. Alexander Bogdanov, the theoretician behind the *Proletkult* implemented by the Bolshevik Party, ascribed it a steering, regulating role in *Iskusstvo i rabochiy klass* (art and the working class), a volume published in 1919. He also argued there that art criticism should see its primary task as defining the boundaries of proletarian art to prevent its contamination by the art of the "old world." In keeping with this aim, Soviet art criticism began to acquire the character of art theory in the early twenties. In a similar vein, the two selected texts by Tretyakov exemplify how early Soviet art criticism turned away from bourgeois society and the art market as traditional addressees. They affirm the goals of the socialist revolution and pursue a politically driven program.

They instruct, agitate, and with the aid of rhetorical devices such as metaphor and short questions convey the dynamism and determination of the twenties in the Soviet Union.

The magnitude of the project to which the proponents of the artistic avant-garde had subscribed is illustrated by a book published with writer Nikolai Aseyev in the Siberian city of Chita in 1922, which devotes 26 pages to the Cubo-Futurist painter Viktor Palmov. Tretyakov does not confine his thoughts here to the work of Palmov, or to urban centers such as Moscow and Saint Petersburg, but extends them to the development of painting up to and including the transformation of the entire realm of art and the role of the artist. At the end of his text, Tretyakov draws on the widespread vocabulary of war to portray the current situation in art: here art is a "front line" where forces advance, attack, and engage in battle, just like a military avant-garde. Since 1913, Tretyakov had been an active member of Futurist groups and doubtless saw himself as part of this "artistic combat."

In 1923 in Moscow, he joined with Vladimir Mayakovsky, photographer Alexander Rodchenko, and others to found the Left Front of the Arts (LEF). Its print media—the journal *Lef* (1923–25) and later *Novyi Lef* (1927–29)—offered the group an opportunity for experiments and the conception of what became known as "factography," an artistic strategy for using words and photography to document reality. Factography was intended to ensure maximum authenticity and to agitate through the montage of diverse "facts." Tretyakov's "Photo Notes" of 1928 can be read within the context of *Novyi Lef* objectives.

As a basis, he draws on his own facts—travel jottings, diary, reportage, or anything directly recorded—and on his own person as a photographer. He integrates dialogues with amateur photographers, describes moments in factories, and "assembles" these to endorse his line of argument. In reflecting on the methods of photography, therefore, he was testing a concept he championed: the "literature of fact." The text demonstrates how art criticism can itself become a field for literary experiment.

The Work of Viktor Palmov

Sergei Tretyakov

from *Artist V. Palmov*, Chita 1922

A battle between two ideologies is raging in the left wing of contemporary Russian visual art (painting, sculpture), between the nonobjective and the productionist tendencies. The crux of their conflict concerns value, the so-called "aesthetic state"—i.e. a very specialized concern related to how a work of art is experienced. Here, the work is conceptualized as its own special world, imbued with its own value. The finished work is a world comprised of the traces of the artists' conquest over his materials (paint, solid matter).

The lifelike little world contained within a painting, which reflects reality or the nearly real imaginings of the artist, has long ago been blasted to smithereens by the continual attacks of art workers beginning with the Impressionists, who were the first to reprioritize the "how" of painting over the "what." Their incursions were primarily focused on material elements: color, surface (*faktura*), the relationship between these, and the approaches to working with them for the purpose of making the most expressive visual impression possible.

Cézanne first established the principle of "visual contemplation," the use of color that creates material form by means of color and color juxtaposition. Cézanne's discovery, a method for conveying the muscular and tactile sense of the mass, weight, and resistance of objects, inspired artists to demonstrate power relationships between masses in their work with forms. This led to the emergence of Cubism, in which the entire world is nothing more than the interweaving of hulks in the simplest forms. The artist admires and becomes intoxicated on the literally just-discovered sense of weight, flexibility, and hardness, which he conveys through color.

Material relationships inspire interest in power relationships. The sense of material moving through breakage rather than adhesion represents a shift; the interest in conveying all power sensations inspired by an object gives rise to Futurism in the narrow, painting context with its founder, Picasso. Artists turn their focus to objects in motion; the principle of indivisibility is shattered along with the principle of the single, unified viewpoint.

The object is depicted from multiple angles at once, a method that had already existed in icon painting, Chinese art, and the work of

children. The greatest plenitude of sensation created by the object inspires the most interesting interventions in the play of the paint and other developments on painting surfaces. It is no longer compulsory to paint the object in a motionless pose or a split-second view. Instead, the artist fixes snapshots of an object in motion onto the motionless canvas and even creates these movements, whether they be general or partial. The artist introduces the fourth dimension, time, capable of making even the most solid objects penetrable and interpenetrable, like crystals growing out of crystals. The painting becomes an integrated mechanism, a kind of machine that moves through the interaction of the objects and forces within it, conveyed to the viewer via the tactile effects of color and *faktura*.

Little by little, the old purpose of painting—to be a window into a world reflected by the artist for viewers to admire while frozen before it in terrified or ecstatic contemplation—gives way to the new: to comprehend the painting, following the path of the combination of colors, lines, and surfaces constructed by the artist, appreciating the organization of materials and arrangement of elements to achieve material or energetic tension.

Paint on the surface is no longer enough. The artist now employs everyday materials (tin, wood, metals, paper), arranging them on various planes in relation to the primary one. This gives rise to counter-reliefism, which completely departs from the painting's main plane and works over the materials, intertwining, bending and cutting them. The color of the auxiliary materials that the Futurists introduced into painting completely supersedes the color of the paint. The artist begins to chisel, drill, solder, screw. In Russia, it was Tatlin who pursued this most dimensionally and logically, whose counter-reliefs are reminiscent of the models of objects such as cars, machinery, and industrial tools.

The artist regains his sensitivity and love for the materials that practical, necessary things are made of—sensations endemic to the craftsman, technician, and builder.

One more step in this direction and the artist will be known as one who, loving and knowing materials and expert at working with them, organizes and "shapes" these materials, using all of his inventiveness in order to create forms that aren't exclusively for contemplation, but have practical applications. Thus, the artist becomes one with the craftsman and the technician. The painting as a window into another world, the world of "art," is no longer needed because the "world of art" will have become our everyday, practical world. These are indeed the claims of the productionists, summarizing the achievements of the leftist movement

in art: Futurism, which brilliantly destroyed the painting from within, annulling it as an object of aesthetic pleasure and developing the sensibilities of the "arrangers of materials" to the maximum extent.

Pure art is dead because no more leisure time needs to be filled up by it. Leading the mind out of the world of "art," they say, "Long live production art, in which the old principle of 'the beautiful' now coincides with the hated principle of the 'useful' into a new concept: 'constructive.' This movement is closely tied to the reorganization of the human psyche on the basis of the reorganization of economic and productive life—i.e. the task of social revolution. Within this movement, there is a developing dream of creating a new kind of man—an organizer, constructor, and inventor, a man rejoicing in the active conquest of matter and the elements through joint, concerted efforts: a man who forms matter (form) to answer the demands (content) of humanity.

I thought it was important to include this introduction in order to illuminate the web of interconnected realms in art, so that, with this in mind, we can answer the question of the art of Palmov (or, to put it more precisely, in order to avoid the flavor of sacrimony that comes with the word 'art'—Palmov's work or constructions).

Palmov is a Futurist, or rather, a Cubo-Futurist. His paint constructions solve problems related to the interaction of masses and forces using particularly emphatic and inventive color and texture.

Is he a productionist? For the moment, no, but he will doubtlessly also pass through this phase, considering his rapid path from influence to influence, from Cézanne, to Picasso, Gleizes, Metzinger, Le Fauconnier, and then from construction to construction. Is this bad?

It is only natural if we take into account the power Palmov wields over the medium of paint, the power color itself has over him, and the incredible diversity of his output, in which it's surpassingly rare to find even two or three repetitions of the same approaches and materials.

If we roughly divide Palmov's work into periods spanning his life in the Far East until today, we can speak of the Vladivostok, Pacific, and Chita periods.

In Vladivostok, his palette was still relatively muted. He was working out the problem of movement through shifts, finding an interesting, linearly-shifted picture. Movement was created by means of shifted perspective (a house, a barbershop), shifted masses and planes (Burliuk's family portrait). The associative method (especially applicable to Burliuk) for depicting ideas about complicated processes and extracting only the most characteristic phenomena from the given process onto the canvas, phenomena, objects, and motions (*Shven, Tanets, Perevorot*).

Sergei Tretyakov

The attempts to introduce colorful material marks to the canvas through the incorporation of pieces of fabric, boxes, and paper. The latter method in the black-violet palette led to the exemplary *Skorb*, perfect and icon-like, in which the angles of the face create a psychological effect that hits the mark directly on the head.

Japan and the Pacific Ocean: the viewer's contemplation is refined, the artist masters a bright and expressive palette, focusing on blue-green, the oceanic mass of water. The sense of materiality is sharpened. Human bodies seem to be made of sheet metal or soldered iron pipes. His water is hard, stony crystal. His air is blue, fantastically forged steel. For him, the world takes on a special material hardness in which he, like a sculptor, carves out routs, sharp-ribbed and taut, with the strikes of his brush. We see this kind of metallic world in his *Rybake, Kapitan parokhoda, Yapontsy s rakovinoi*, and *Progulka po ulitse*. The artist develops a particular economy and precision toward every part of the painting. At the same time, the shifting of dozens of perspectival planes in each painting don't make them look like frozen crystal fields, but moving swells of a solid sea, splashing with sharp waves.

With this particular kind of rendering, the flatness of the painting shatters, transforming from a "window" into a kind of arranged "pile," that needs to be investigated from all angles at the risk of cutting the clamoring eye on the sharp edges of objects and materials.

The tropical Pacific islands also intensify the powerful colors of Palmov's paintings. His metal, sharp and complex as ever with its teeth and ledges, becomes molten, red-hot. Wild tropical greenery and crimson volcanic earth go head-to-head in a furious battle of color on color. The clusters of trees and feathered palms, provide an excuse to create green and blue glass bubbles and spheres that shine through each other, establishing equivalences between the artist's beloved glass-metal and the eternal shaggy-haired wood (recall Levitan's green water on tree trunks).

In Chita, the paintings' tone grows harsher. Our harsh era makes itself felt. The molten, crystallized metal gives way to renderings of heavy broadcloth, sackcloth, felt, soldered metal and sawtooth. Snow white patches appear. The *faktura* is developed. Sparkling glass and metal are introduced—silver paper. This creates matter-object organisms on a plane dressed in sharp, shiny skin. That which is usually referred to as background undergoes a special, intense working over. Decorative ornamentation is applied, and among the ornamental "embroidery" dancing across the canvas, in front of the background, filled with constructions, the tensed ribcage of the subject (in the literary sense) chirrs, most often

in a symbolist and revolutionary manner. The metallic background and color and the textured edges attracted to it create something analogous to icon painting. The artist paints completely subjectless—that is, un-titleable paintings—colorful assemblages and mountings with bright and linear centers of gravity, whose subject lies in the battle or, on the contrary, within the solid cooperation between areas of color and *faktura*.

The impulse of the inventor and constructor and the ability to lovingly admire material and conquer it through shaping drives the artist forward, keeping him from staying in any one place, as I have described above, among his already accomplished combinations. Each painting is but an intensification of the artist's methods for working with his materials which paves the way for the next one. Beyond this demand, the individual painting has no other value.

"So is any of this necessary?" one may ask. It is. The work of the Futurist artist on a framed surface has not yet been perfected, and meanwhile, the call of the productionists has been sounded. The longing for paintings that are windows one wants to fall through onto soft meadows of "different worlds" "created" by the artist has not yet been wrested from human hearts. The charm of "recreating reality" has not yet been lost. People have not yet completely trained themselves to approach paintings the way they approach blueprints in order to repeatedly overcome all of the efforts undertaken by artists who create colorful, plane-studded organisms.

It's understandable why everyone seeking the subject in Palmov's paintings is so overwhelmed by the materialization of such things as air and water, that metallic outfitting of space with brushstrokes. They are swept off their feet and out of their reason by the need to climb over all of the swirls and cracks in the painting's structure with their eyes. After all, for Palmov, the subject is not the purpose, but the means—his excuse to call out a handful of habitual perceptions and then, with his shifted planes, by leading the eye and attention away into the very thick of his "working over of the material," he forces the viewer to seek out the system of forces and approaches invented and employed for this illumination rather than the "illuminated object" itself. Of course, after having held the viewer under this psychological checkmate of constructions and conquests, he leaves him lost and bewildered. All that is left for the viewer is to weep from the depths of his sentiment, feeling insulted on behalf of tradition and his natural right to "calm contemplation," uttering the sacramental phrases, "it didn't move me," and "I don't get it!"

Palmov is one of the great battering rams smashing apart the idea of the self-sufficient, aesthetically hermeneutic painting from within while

Sergei Tretyakov

Viktor Palmov, *Horse Taming*, 1927

also attacking the passive, layman's psychology of "perceiving" but not desiring to "conquer."

And if the productionists make up the frontlines, attacking head on with their demands that artistic practice and aesthetics submit to the needs of building a new life in solidarity, in the name of the new man, the constructor, then Palmov the Futurist is a partisan in the enemy camp. He is entirely in the picture plane. However, at the same time, these are no longer paintings at all, but construction sketches. He constructs bridges of mutual understanding between the painting and the viewer, whose only choice is to either retreat to the vaults of what had once been considered "great" art or push through the breach down the path of solving the constructive problems expressed in painting.

This work by this Futurist artist is particularly valuable and necessary. It is no less necessary than the work of the productionists, for it is through their joint efforts that the principle of the relative assessment of revolutionary tension leads to the development of coherent methods for conquering stagnation, both material and psychological, brought into the consciousness of the masses awash in revolution.

Everything that can be brought into the realm of human conquest must be. Critical thought, intense inventiveness, tactical flexibility, the

joy of solidarity in shaping musty or elemental material—these are the paths that the revolution takes into people's psyches and how it becomes entrenched in them.

Palmov's work is a battlefield within a giant front fighting to neutralize the war between a millions-strong army of passive viewers against a small group of specialists, the artistic innovators, and unite these factions into a single mass of humanity, in solidarity with one another in labor, imbued with a common and universal joy at seeing the world in a new way, in a unified, inventive onslaught of the expressive construction of everything that humanity needs.

Photo-Notes

Sergei Tretyakov

from *Photography in the Modern Era: European Documents and Critical Writings* (1989), 1913–40; first published as "Fotozametki," in *Novyi Lef*, no. 9, 1928

When I was in Kislovodsk, a photographist came up to me (I won't say "photographer" because that usually suggests a professional practitioner) who wanted to work in the *Lef* style.

He told me that a local photographer had begun to take portraits "from way below" and that, consequently, this fellow now thought he was making leftist art.

So I explained that this kind of "ersatz *Lef*" does not make us especially happy (we immediately punned on the theme of "*pod Lef*" [ersatz *Lef*] and "opodlev" [having become mean]). It's the application of our constructive principles to aesthetic ends.

There is no such thing as *Lef* photography. What matters most is how you go about setting it up, the aim (purpose) of the photograph and why you have to take it, and then finding the most rational means for the actual photographing and the points of view—that's the *Lef* approach.

We started to talk about portraiture. The photographist said:

"*Lef* once wrote that a man's portrait should be composed of an entire range of snapshots taken of him in his normal environment."

We came to the conclusion that there are portraits and portraits, i.e., there are different goals. If we want to form an impression of a fellow in his everyday reality, well, there's no better approach. People generally conceal their real, ordinary selves and have themselves photographed

looking unusual, very special, heroic. Naturally, heroes need Rembrandt shadows, a clean-shaven face, a youthful air, a special twinkle in the eye, and smart clothes. So all warts, pimples, and wrinkles are carefully removed. But there's also the kind of portrait where it's important to record these very same details, I mean the I.D. No Rembrandt shadows, no snapshots of the ordinary environment, either—just an exact description of the face. Those are the kind of portraits used by the Department of Criminal Investigation.

The ability to pinpoint a necessary feature of detail assumes particular importance when the portrait is a scientific commission. Medicine has no interest in likeness, but on the other hand will demand the exact rendering of an eczematous texture; anthropology will demand the close-up of a cranial construction; eugenics needs to see the elements that resemble ancestral portraits; while a reporter will reproduce a face against the background of the sensational event which he is describing in his telegram.

In struggling against the professional photographer we are fighting against the habit people have of lying about themselves. We are struggling against the widespread opinion that individualistic and false self-promotion is the synthetic (aggregate) truth about this or that person.

The Kislovodsk fellow is photographing geological sections in precipices. But he forgets to put a human being or tree next to the precipice. So the result is a precipice devoid of scale—it could be either a piece of geology or a slice of layer cake.

As we analyze these geological photographs, let us take into account the possible mistakes. We might enthuse over the play of light and shadow and enjoy an effect like that of a nice landscape photograph; but the shadows traversing the strata or cast next to them confuse the viewer, creating the impression of varieties of rock strata which actually are not there.

Could there ever be a reason to set up a landscape and photograph it so that it looks nice?

Yes, there could, if the purpose was to attract the kind of idle tourists who exclaim "Marvelous!" at a particular sight. But *Lef* is for the re-education of the tourist, and feels that this kind of purely picturesque delight is characteristic of the bourgeois—not the Soviet—tourist.

Delight in nature "untouched by the blasphemous hand of man," in "virgin" forest, in "chaos," in the great masses of tree trunks rotting irresponsibly and unmethodically, is just a belch of reactionary Romanticism. Would it not be more correct to express interest in nature

organized to human advantage? In the fields plowed and sown, in the forests cleared and cultivated, in the rivers locked in the casemates of dams turning the hydroelectric turbines?

The poster. The book cover. The postcard. The atlas. The guidebook. The textbook. All these are different kinds of useful objects that dictate to the photographer different methods of photographing. The photographer's worth lies not in his inventing his own particular "style" of working, but in the fact that he executes every commission with maximum expedience and ingeniousness, making it accessible to the consumer.

I took a lot of photographs in an agricultural commune, and I had to conduct one of the photography sessions in the repair workshop. This involved a good deal of self-control; the workers were forced to pose against their will. They crowded around a disassembled tractor engine, and one of them grabbed a ruler in one hand and calipers in the other so as to measure the thickness of the shaft. But the calipers appeared at the very edge of the foreshortening focus and would have looked in the photograph like a piece of cotton thread. So I asked the worker to point the calipers at another shaft, so it would appear bigger.

The reply was exhaustive:

"You want to make a fool of me? That shaft can never be measured with a pair of calipers."

For this man it's the opinion of his fellow technicians that is important. He wants to be photographed as an engineer, not as a hero.

When I was photographing a work scene at a brick factory, I pointed the camera at a woman who was turning some bricks. When she saw this she immediately took off her kerchief, and to my question why she had done that, she replied:

"Why should I come out looking like an old woman?"
This reluctance to be photographed during working hours is characteristic (especially of women): "This is an old dress." "My hands are dirty." "I have to look at what I'm doing, you won't see my face."

The method I used in order to bring people out of their stiff posing was to turn their attention to some defect in their work, and while they were straightening it out, to photograph them—before they had a chance to adopt a pose. They were usually full of regrets:

"What? You've already taken me? And I had my hand on my hip."

On Sunday one of the commune men dropped by to have himself and his family photographed. His wife was in her Sunday best and held a

kerchief in her hand. The youngest son was holding a toy horse. They explained that this was precisely how a photographer from the town had photographed them before.

I let them make themselves comfortable as they thought fit. Basically it was the typical pose: one sitting, another standing alongside with a hand on the other's shoulder and looking straight ahead. The children were arranged around them.

The mother instructed the little boy with the toy horse to look straight into the lens and insisted that he not screw up his eyes from the sun. Another boy wearing a jacket and long trousers held a puppy (people don't like being photographed empty-handed, they just have to be holding something—an apple, a pigeon, a chicken, any old object, an instrument, a branch, and if worse comes to worst, even a handkerchief). When the family members had already grouped, the mother suddenly shouted to the boy with the dog:

"Take off your shirt and roll up your trousers!"
All the family helped him to roll up his trousers and then pronounced with great satisfaction:

"Now you're wearing shorts. You'll look like an athlete. In any case, the dog will come out better against the white body."

Snapshot:
Alexander Rodchenko

Margarete Vöhringer

Alexander Rodchenko's 1928 essay "Against the Synthetic Portrait, For the Snapshot" was intended to offer a theoretical classification of his work while also repositioning it politically. In just four years as a photographer, Rodchenko had developed a visual language still considered genuinely avant-garde today: close-ups, surprising perspectives, extreme cropping, and abstracting montages appeared in exhibitions and magazines, on posters, and as book illustrations. In expanding into everyday space, Rodchenko's photographs were already characterized by the aesthetics of the new, revolutionized society of the nineteen-twenties. At the same time, they stood for his radical concept of art, in which artists in the aftermath of the October Revolution were regarded as role models for the entire Russian population: freed from decorative art, artists were obliged to depart from their traditional view of reality and instead learn to see in a new way. The goal was not something like a mere critique of obsolete art, but rather biopolitics—through aesthetic change, people themselves would be able to change.

At the height of these developments and at a time when Rodchenko's aesthetic had been broadly established in Russia, his essay was published, offering a rejection of his own success. It began with an analysis of present conditions: given the abundance of newspapers and articles constantly updating knowledge and the abundance of technologies and sciences whose achievements changed on a daily basis, it would be impossible to formulate any aesthetic that could claim supratemporal validity. Of all things, Rodchenko cited

as his example a portrait of Vladimir Lenin that had been the subject of dispute for several years. Documentary forms were opposed to idealized, pseudo-realistic forms, multiperspectivity against iconic veneration, avant-gardists against realists. To resolve these conflicts, Rodchenko made a proposal: establishing an archive containing all representations of Lenin. To make clear "that ... it cannot be a matter of any one single everlasting portrait," there was a need for "a portfolio of photographs, showing him at work and at leisure, an archive of his books, writing pads, notebooks, shorthand reports, film recordings, gramophone recordings."

Rodchenko's text appeared in the magazine *Novyi Lef* (New Left Front of the Arts), for which he was also image editor. With his photomontages, he sought to develop a method for representing a reality based on facts rather than fictions. Key to this factographic representation was the observer not being separated from the object, with the singular perspective of the author remaining visible.

Rodchenko was advocating for this involved and enlightened approach to reality at a precarious moment: Stalin's consolidation of power was largely complete, the first five-year plan had been adopted with industrialization as the key state doctrine, and what Stalin later called the year of the "great change" began, focusing on a planned economy after a phase of experimentation. In addition, criticism of Rodchenko's aesthetics was growing ever louder. His works were vilified as plagiarisms of foreign photographs that caused confusion rather than enlightenment. And even if Rodchenko took part in the

disputes, they seemed like shadow battles given the critiques of representation he published around the same time. Ultimately, he was seeking not to position his own aesthetics and rather to use an opposites-subverting archival concept that would allow him to remain active as a photojournalist, even in the face of the unrest around him. He succeeded in this.

With his essay and its genuine political commitment, Rodchenko sought to resolve conflicts over the representation of power. It is thus instructive for the present: first, given the conjuncture of multiperspectivity in both postcolonial studies and exhibition practices; second, with respect to archiving the material world through globally networked databases; and third, on the question of representing facts in the post-truth age.

Against the Synthetic Portrait, For the Snapshot

Alexander Rodchenko

From *Novyi Lef* No. 4, April 1928

I was once obliged to dispute with an artist the fact that photography cannot replace painting in a portrait. He spoke very soundly about the fact that a photograph is a chance moment, whereas a painted portrait is the sum total of moments observed, which, moreover, are the most characteristic of the man being portrayed. The artist has never added an objective synthesis of a given man to the factual world, but has always individualized and idealized him, and has presented what he himself imagined about him—as it were, a personal summary. But I am not going to dispute this; let us assume that he presented a sum total, while the photograph does not.

The photograph presents a precise moment documentarily.
It is essential to clarify the question of the synthetic portrait; otherwise the present confusion will continue. Some say that a portrait should only be painted; others, in searching for the possibility of rendering this synthesis by photography, follow a very false path: they imitate painting and make faces hazy by generalizing and slurring over details, which results in a portrait having no outward resemblance to any particular person—as in pictures of Rembrandt and Carrière.

Any intelligent man will tell you about the photograph's shortcomings in comparison to the painted portrait; everyone will tell you about the character of the Mona Lisa, and everyone forgets that portraits were painted when there was no photography and that they were painted not of all the intelligent people but of the rich and powerful. Even men of science were not painted.

You need not wait around, intelligentsia; even now AKhRR[1] artists will not paint you. True—they can't even depict the sum total, let alone .001 of a moment.

Now compare eternity in science and technology. In olden times a savant would discover a truth, and this truth would remain law for about twenty years. And this was learned and learned as something indisputable and immutable.

Encyclopedias were compiled that supplied whole generations with their eternal truths.

1 The Association of Artists of Revolutionary Russia.

Does anything of the kind exist now? ... No.

Now people do not live by encyclopedias but by newspapers, magazines, card catalogues, prospectuses, and directories.

Modern science and technology are not searching for truths, but are opening up new areas of work and with every day change what has been attained.

Now they do not reveal common truths—"the earth revolves"—but are working on the problem of this revolution.

Let's take:
aviation
radio
rejuvenation,[2] etc.

These are not mere platitudes, but constitute areas that thousands of workers are expanding in depth and breadth, thanks to their experiments.

And it is not just one scientist, but thousands of scientists and tens of thousands of collaborators.

And hence there will never be eternal airplanes, wireless sets, and a single system of rejuvenation.

There will be thousands of airplanes, motorcars, and thousands of methods for rejuvenation.

The same goes for the snapshot.

Here is an example of the first big collision between art and photography, between eternity and the moment. Moreover, in this instance photographs were taken casually, but painting attacked photography with all its heavy and light artillery—and failed miserably....
I mean Lenin.[3]

Chance photographers took his picture. Often when it was necessary, often when it was not. He had no time; there was a revolution on, and he was its leader—so he did not like people getting in his way.

2 The term refers to the Soviet emphasis on mass gymnastics and health exercises, which were particularly stressed during the 1920s and 1930s. Rodchenko himself was an avid sportsman and photographed many scenes of sports activity, including calisthenics, diving, and parachuting.

3 Lenin was a favorite subject for Soviet photographers. The file that Rodchenko refers to is probably the *Albom Lenona. Sto fotograficheskikh snimkow* (Lenin Album: A Hundred Snapshots), compiled by Viktor Goltsev and published by the State Press in 1927. Rodchenko himself also photographed Lenin; one of his portraits served as the cover of *Novyi Lef*, no. 8/9 (1927).

Nevertheless, we possess a large file of photographs of Lenin.

Now for the last ten years artists of all types and talents, inspired and rewarded in all sorts of ways and virtually throughout the world and not just in the USSR, have made up artistic depictions of him; in quantity they have paid for the file of photographs a thousand times, and have often used it to the utmost.

And show me where and when and of which artistically synthetic work one could say: this is the real V. I. Lenin.

There is not one. And there will not be.

Why not? Not because, as many think, "We have not yet been able to, we haven't had a genius yet, but certain people have at least done something."

No, there will not be—because there is a file of photographs, and this file of snapshots allows no one to idealize or falsify Lenin. Everyone has seen this file of photographs, and as a matter of course, no one would allow artistic nonsense to be taken for the eternal Lenin.

True, many say that there is no single snapshot that bears an absolute resemblance, but each one in its own way resembles him a bit.

I maintain that there is no synthesis of Lenin, and there cannot be one and the same synthesis of Lenin for each and everyone.... But there is a synthesis of him. This is a representation based on photographs, books, and notes.

It should be stated firmly that with the appearance of photographs, there can be no question of a single, immutable portrait. Moreover, a man is not just one sum total; he is many, and sometimes they are quite opposed.

By means of a photograph or other documents, we can debunk any artistic synthesis produced by one man of another.

So we refuse to let Lenin be falsified by art.

Art has failed miserably in its struggle against photography for Lenin. There is nothing left for it but to enlarge photographs and make them worse.

The less authentic the facts about a man, the more romantic and interesting he becomes.

So that is why modern artists are often so fond of depicting events long past and not of today. That is why artists have enjoyed less popularity when they have depicted contemporaneity—they are criticized, it is difficult to lie to their faces ... and they are acknowledged afterward when their contemporaries have died off.

Alexander Rodchenko

Tell me frankly, what ought to remain of Lenin:
- an art bronze,
- oil portraits,
- etchings,
- water colors,
- his secretary's diary, his friends' memoirs—
- or a file of photographs taken of him at work and rest,
- archives of his books, writing pads, notebooks,
- shorthand reports, films, phonograph records?

I don't think there's any choice.

Art has no place in modern life. It will continue to exist as long as there is a mania for the romantic and as long as there are people who love beautiful lies and deception.

Every modern cultured man must wage war against art, as against opium.

Photograph and be photographed!

Crystallize man not by a single "synthetic" portrait, but by a whole lot of snapshots taken at different times and in different conditions.

Paint the truth.

Value all that is real and contemporary.

And we will be real people, not actors.

Alexander Rodchenko,
Cover of *Novyi Lef* magazine,
No. 8–9

Decomposition:
Georges Bataille

Malte Rauch

In Georges Bataille's (1897–1962) multifaceted work, which cuts across disciplinary boundaries and resists attempts at stable classification, the idea of criticism occupies a singular place. Throughout his career, Bataille used the role of the critic to position himself in contemporary debates, radically reconfiguring the received understanding of a critical *écriture* in the course of these interventions. The programmatic significance of criticism for Bataille is particularly evident in his founding of the French journal *Critique* in 1946. Mostly dedicated to book reviews, yet strictly opposed to any disciplinary compartmentalization, the journal quickly established itself as an important voice in French intellectual life and continues to be published today.

For Bataille, the idea of criticism is not, however, limited to a critique of the written word, as evinced by the articles published here. In his early work, Bataille's criticism traversed a variety of fields, especially in the texts he wrote for the short-lived journal *Documents*. Although much remains uncertain about its genesis, it is clear that Bataille had a central role in founding and editing the journal, which was published in fifteen issues between 1929 and 1930. A hub for dissident Surrealists, *Documents* was characterized by its use of unexpected text-image constellations and its heterogeneous contents, which spanned, according to the magazine's cover, "Doctrines, Archeology, Fine Art, and Ethnography" ("Variety" was later exchanged for "Doctrines").

Under the appearance of a high-gloss journal, *Documents* became what Michel Leiris—a close friend of Bataille's and one of the journal's

contributors—described as a "war machine against established ideas." In this vein, Bataille's essays demarcate a domain of what is "wholly other" to contemporary culture: its negative underside, constituted by all that has been excluded and repressed. Two of the texts included here—the essay on *Les pieds Nickelés* and the review of Joan Miró—are from the fourth and seventh issues, respectively, of the 1930 volume of *Documents*. Eschewing a literal understanding of negation, these interventions suggest that the dismemberment of the human figure, the scattering of random marks, and the obscuring of vision in Miró's painting is more prone to invoke and materialize this otherness than the anti-artistic strategies of Dada. Although Bataille was never formally a member of the group, his writings can be understood as an attempt to shift and radicalize the Surrealist aesthetic, which he depreciated for its persistent idealism. The third text published here—a review of works by André Breton, Paul Éluard, and Tristan Tzara from 1932—reveals how Bataille's criticism continued to grapple with Surrealism as an intimate enemy and crucial interlocutor.

While the art-theoretical reception of Bataille's early work by Rosalind Krauss, Yve-Alain Bois, and Georges Didi-Huberman has established the importance of his notion of the "formless," the essay on Miró employs an equally important concept in his critical lexicon: the notion of "decomposition," understood in the dual sense of declassification and decay, the latter referring to the rotting corpse as a marker for what culture must repress in order to constitute itself.

The transformation that the idea of criticism undergoes in Bataille's work could be seen in accordance with this twofold operation. Criticism as practiced by Bataille is not a form of judgment according to established criteria. On the contrary, it is an undoing of established criteria, a form of writing that vindicates decomposition and destruction as constitutive elements of contemporary art, and also seeks to perform such a decomposition of meaning in the text.

What Bataille's writing shares with the Enlightenment tradition of French art criticism is the privilege granted to the sensuous experience of art. Yet, for Bataille, the experience of art should not be distanced and pleasant; it should be shocking, violent, and transgressive. In contradistinction to the Enlightenment subject of critique, which affirms its autonomy through acts of judgment, Bataille's criticism is keyed to an experience of desublimation and alterity that unsettles the viewer's sensibility. Aside from the historical importance of Bataille's work, the enduring relevance of his criticism consists in its attempt to problematize and transform dominant forms, rather than to stabilize and implement them. In so doing, Bataille's writing poses the exigent question about the criticality of art criticism: can critique operate on the side of the wholly other?

Critiques

Georges Bataille

from *Œuvres Complètes*, Paris 1970, first published in 1932

André Breton, *Le revolver à cheveux blancs* (The White-Haired Revolver);[1] Tristan Tzara, *Où boivent les loups* (Where the Wolves Drink); Paul Éluard, *La vie immédiate* (The Immediate Life), Paris, Cahiers libres, vol. I, 1932.

These three collections of poems are just about this year's only testimony to the diminished activity of Surrealism, and it is certainly in keeping with the will of their authors to study them not from a vague and more or less bluntly literary point of view and rather from a point of view that they themselves have sought to define.

It was not exactly into literary existence, considered as a specialized domain, but rather into existence as such that Surrealism sought to introduce a mode of activity that exceeds limits—those fixing law and those fixing custom—that atrophy to the same extent as thought and its expression; acts and attitudes. Critiques formulated on all sides have only avoided insignificance to the degree that they have documented the various outcomes in pursuit of this declared goal.

In the latter case, they happily deride those literati who have only barely managed to escape the degradation of an intellectual life that, for the very reason of its broad development, has debased itself ever closer to the point of inanity.

But it must be recognized that it is not enough to ironically note the discrepancy between effort and outcome. It is certain that all activity worthy of interest requires a radical rupture from the world of impoverished vanity, of rarefied thought, in which the current excitement of the literary bourgeoisie is to be found. It remains possible to assign vital importance to the representation of humanity before its own eyes and to refuse entirely those conditions of expression which, as a matter of obligation, make of this representation a senile farce, a little pretense here, a little perversity there. For this determination to reach a region perfectly estranged from this world of petty hypocrisies has been now expressed by the Surrealists with a certain force, and it is thus that their

1 This and the subsequent two collections have never appeared in English translation.

maneuvers, their impoverished precocities, their conventional provocations that have responded to this resolution without perceptible reward, cause little mirth given that they now warrant a pessimism more or less without reserve.

André Breton publishes under the title *Le revolver à cheveux blancs* a collection of poems that, written between 1915 and the present year, at least has the merit of not insisting on promises too loosely kept. On the contrary, its entire poetic activity is situated in keeping with a French literary tradition typified best by Stéphane Mallarmé and to which even Paul Valéry reattaches himself. Surrealism's own contributions to technique, tasked with subverting expression and via expression life itself, appear reduced to their proper scale: a method just as impoverished as those others in a series of efforts characterized by a search for method having replaced the vulgarity of poetic inspiration.

Within this series, however, it is possible to consider the Surrealist method as a denouement after which all novelty of the same kind would be untenable from the very start. It would thus have the merit of a perfect demonstration: the systematic search for modes of expression has the outcome of coming closer to an increasingly *estranged* image of poetry, but to a degree this image has emptied itself of its human significance in that it has rid itself of certain elements that are in immediate contact with elements essential to life. *Revolver à cheveux blancs* is situated entirely within this impasse.

The collection is preceded by a sort of preface in which André Breton himself comes to speak of puerility and which is certainly the most degenerate product of Surrealist literature: having reached this extremity of dullness, it is difficult to observe any difference from the nauseating horticultures of Jean Cocteau.

Tristan Tzara's poems are tinged with an incontestable grandeur. And if they appear estranged and situated outside of life, this character of isolation, far from introducing impotence, is undoubtedly the only thing that exists in the most blinding of worlds. Within the limits of poetry, expression reaches a point of extremity. But at the same time, it reveals itself to be incapable of changing the course of any kind of existence or of responding to the base need expressed by Surrealism. As seductive as it may be, rupturing from life in its entirety remains nothing more than the culmination of the impoverished tendencies of Mallarméan poetry. It emerges with particular clarity in Tzara's work—precisely because of a real force of expression—that Surrealism cannot have any meaning other than to carry to their extremes the exhaustion, emptiness, and despair that give modern societies' mental existence its deepest meaning. In no

case would he be able to keep the promise made to effect an exit from that existence, being incapable of creating a connection between poetry and life.

Paul Éluard's poetry is keenly appreciated by a class of enlightened amateur enthusiasts of modern literature, but it has nothing to do with poetry. The author himself, who must suffer on account of this, does not hesitate to treat those who enjoy his writing as "men smaller than nature."

Joan Miró: Recent Paintings
The set of Joan Miró's paintings that we publish here represents the most recent development of this painter, with this present evolution being of particular interest. Miró commenced with a representation of objects so minute that to some degree, it turned reality to dust; a kind of sunlit dust. Subsequently these very objects, infinitesimal as they are, liberate themselves individually from any kind of reality, appearing like a throng of elements decomposed and all the more agitated. Ultimately, Miró having himself confessed his desire to "kill painting," the decomposition was forced to a point at which nothing other than a few formless stains remained on the lid (or tombstone, if one prefers) of its box of tricks. The small, enraged, and alienated elements then once more force violent entry, before again disappearing here in these paintings, leaving behind nothing more than traces of who knows what disaster.

Les Pieds Nickelés
A Mexican god such as Quetzalcoatl, amusing itself by sneaking down from atop the mountains in small, illustrated form, seems to me more than any other thing explicable with the miserable repertoire of common words to have always been a *Pied Nickelé*:[2] In its evident sadness and gratuitousness, any observation of this kind is nothing other than another small effort to denounce the pathetic stubbornness with which an insect colony of intellectuals, set in motion by an overwhelming imperative, repairs small holes in a hive wall that threatens to allow a pernicious light to pass through. It is in fact vital to the strength of the edifice upon which our intellectual existence depends that a certain part of human activity, falling, if we like, within the purview of *moral freedom*, cannot be defined by any term. It is already many years since the coughing and spluttering Dada (also rather courteous in the final analysis, making itself available rather quickly as an object of laughter) was ditched by its

2 The comic *Les Pieds Nickelés* took its name from a French pejorative, "nickel-plated feet," used to designate people perceived as evading or unable to work.

own makers. On the other hand, and in spite of a number of equivocations, it remains out of the question to speak of Surrealism, especially at that very moment where it seeks to culminate in nothing other than a morose obscurity.

It would be vain to seek direct remedy to such a state of affairs: it is evidently impossible at present, in any intellectual form at all, to permit sufficient freedom to the figures of the Mexican Valhalla, at once bloodied and dying with laughter. Today, it is easier to find their hilarious puerility and their scorn for grandiosity in the mocking faces of the *Pieds Nickelés*. The *Pieds Nickelés*, all in all, do nothing more than what small boys do to entertain themselves and, likely not knowing how to spit in the wind, no one would have the effrontery to clearly and loudly declare that the suffering we endure, the work performed the world over, the banks, the ministries, the hospitals, and the prisons have any goal other than to be the object of three especially ugly rascals' delirious laughter.

The adventures—or misadventures—of the *Pieds Nickelés* gang, composed wholly of the characters Croquignol, Ribouldingue, and Filochard, have appeared since 1908 and without pause in one of the main illustrated children's weeklies, *L'Épatant*. On sale before the war for just a few pennies, this weekly magazine was aimed at children from the classes referred to, with a singular cynicism, as underprivileged. Its enduring success and, we might say, the extraordinary fame of the *Pieds Nickelés* are of an essentially *populaire* (working-class) character. The exploits of the *Pieds Nickelés*, however, are very much familiar across the whole social ladder.

It is curious to once again note that to find the lowest of the likable bandits, it suffices to lose one's *seriousness* (whereby a person old before their time cannot fail to rival the most terrible child). The social order may originate with a burst of laughter; children can be entertained by representations of this order being scorned by beings of perfect grotesqueness: they are never going to be anything other than people of the utmost honesty. Teachers and mothers effectively tell astonished children—not without the most comic gravity—that "life is not a burst of laughter." With a soft hand, they give the children *Pieds Nickelés* for immediate enjoyment—before taking them back away from them with another.

But I imagine that in a sad mind clouded by that mysterious conditioning, a still-shimmering paradise can emerge from the formidable noise of breaking crockery: somewhere, in those extravagant stores where a jacketed specter armed with the notorious *Do not touch* sign moves around only to collapse with a cry like that of a duck whose throat

has been cut in a hideous trap. Idiocy and wrongheadedness receiving outrageous reward, ugliness, the New Prometheus turned to a grimace, ripping from the sky not fire, but rather a burst of laughter; and finally, overflowing with joy, grinning angels of marvelous beauty reduced to decorating canned peas or camembert: unrestrained entertainment makes use of all the products of the world, and all discarded objects must be broken like playthings.

I cannot help but be crudely delighted at the thought that when they find no such paradise in reach, people—somewhat wild—generously permit one to puppets elevated to the status of gods, reducing themselves to the role of a plaything, looking curiously, but with the help of a large knife, at what is contained within the belly of that screeching plaything.

It is perhaps possible to push this timid pleasure a little further via a seemingly naïve assumption: when an individual is not a plaything, they are a player, unless they are both at the same time.

And if we lend to entertainment a sufficiently "Mexican" meaning, that is to say an intervention which is more or less always out of place in the most serious of domains, entertainment still runs the risk of appearing to be idealism's sole reduction. A simple dream analysis can indicate, ultimately, that *entertainment* is the most desperate of needs and, of course, the most terrifying one in human nature.

Decolonizing Art History: Ananda K. Coomaraswamy

Parul Dave Mukherji

What is the urgency today of revisiting art criticism by Ananda K. Coomaraswamy (1877–1947), one of the great art historians of the twentieth century, when the world seems to be hurtling toward an uncertain future? Coomaraswamy has had an enduring presence across time. In him, we see not only a strident critic of cultural imperialism but even a proto-globalist for whom terms currently in use, Global North and Global South, were prescient. With his proficiency in Greek, Latin, Sanskrit, Pali, Persian, and Chinese, he had access to different knowledge systems in the world. His art criticism may be situated in the first half of the twentieth century when art, art history, and metaphysics became a means for asserting the intellectual autonomy of the Global South.

Born of a Ceylonese-Tamil father and English mother, he was educated in England. Early in his life, he abandoned a career in geology to devote full attention to the study of "Eastern" culture. During his field trips to Sri Lanka to study its rocks and minerals, his attention shifted to its people and culture. This turn from physical sciences to culture brought his biracial identity to the fore and made him acutely aware of cultural differences. His first book *Mediaeval Sinhalese Art* (1908) became a plank from which to delve deeper into aesthetics, literature, mythology, folklore, religion, and metaphysics of South and Southeast Asia and also develop an abiding investment in comparativist projects. His acute awareness of the pitfalls of modernization—premised on rapacious capitalism and its attendant inequalities—made him extremely

97

critical of modernity and respectful of tradition. Given that he addressed audiences from both the East and the West (to use his favored binary), modernity and traditionalism were like two hats that he seemed to be forever alternating. When in Sri Lanka and India, he would write as a cultural nationalist and be lauded as a defender of Asian art against colonial misrepresentation; while in the West, he spoke eloquently of avant-garde modernism, especially photography, which he considered as the most authentic genre, least burdened by egoistic individuality.

Given his eclectic cosmopolitanism, his art criticism addressed both specialist and general audiences. Despite being a vociferous critic of modernity, his writing ironically embraced judicious art criticism. He developed an unambiguous yardstick for judging art calibrated around the quotient of spiritualism. Despite his anti-modernism, there is something uncannily contemporary about both his vision of the public role of art and museums and his critique of the art market. The other takeaway from Coomaraswamy is his persistent doubt of whether modernism was purely European, a claim that his comparativism served to resist. Modernism never emerged in splendid isolation from the East, but in a dialogue with it, most visible in the repressed site of the sacred.

Today, Coomaraswamy's relevance to our globalized world lies in the salience that he attached to what I call discursive equality between the East and the West: the need to enter into the difficult terrain of intellectual discourse of each other's philosophy, language, and aesthetics so that conceptual frameworks travel from one cultural context into another without epistemic violence. That his writings resonate with us now is partly because of his perspicacity, and partly because the power relations across the so-called periphery and the margins have not fundamentally altered. It is little wonder that even today, after decades of political sovereignty of the formerly colonized countries, decolonizing art history has resurfaced as a hot topic in contemporary art discourse—an area that compels us to revisit Coomaraswamy in our increasingly complex and fraught world.

Why Exhibit Works of Art?[1]

Ananda K. Coomaraswamy

from *Studies in Comparative Religion*, Summer 1971;
first published in *New Blackfriars*, September 1942

What is an Art Museum for? As the word "Curator" implies, the first and most essential function of such a Museum is to take care of ancient or unique works of art which are no longer in their original places or no longer used as was originally intended, and are therefore in danger of destruction by neglect or otherwise. This care of works of art does not necessarily involve their exhibition.

If we ask, why should the protected works of art be exhibited and made accessible and explained to the public, the answer will be made, that this is to be done with an educational purpose. But before we proceed to a consideration of this purpose, before we ask, Education in or for what? a distinction must be made between the exhibition of the works of living artists and that of ancient or relatively ancient or exotic works of art. It is unnecessary for Museums to exhibit the works of living artists, which are not in imminent danger of destruction; or at least, if such works are exhibited, it should be clearly understood that the Museum is really advertising the artist and acting on behalf of the art dealer or middleman whose business it is to find a market for the artist; the only difference being that while the Museum does the same sort of work as the dealer, it makes no profit. On the other hand, that a living artist should wish to be "hung" or "shown" in a Museum can be only due to his need or his vanity. For things are made normally for certain purposes and certain places to which they are appropriate, and not simply "for exhibition"; and because whatever is thus custom-made, i.e., made by an artist for a consumer, is controlled by certain requirements and kept in order. Whereas, as Mr. Steinfels has recently remarked, "Art which is only intended to be hung on the walls of a Museum is one kind of art that need not consider its relationship to its ultimate surroundings. The artist can paint anything he wishes, any way he wishes, and if the Curator and Trustees like it well enough they will line it up on the wall with all the other curiosities."

1 An address delivered before the American Association
of Museums in May and October, 1941.

We are left with the real problem, Why exhibit? as it applies to the relatively ancient or foreign works of art which, because of their fragility and because they no longer correspond to any needs of our own of which we are actively conscious, are preserved in our Museums, where they form the bulk of the collections. If we are to exhibit these objects for educational reasons, and not as mere curios, it is evident that we are proposing to make such use of them as is possible without an actual handling. It will be imaginatively and not actually that we must use the mediaeval reliquary, or lie on the Egyptian bed, or make our offering to some ancient deity. The educational ends that an exhibition can serve demand, accordingly, the services not of a Curator only, who prepares the exhibition, but of a Docent who explains the original patron's needs and the original artists' methods; for it is because of what these patrons and artists were that the works before us are what they are. If the exhibition is to be anything more than a show of curiosities and an entertaining spectacle it will not suffice to be satisfied with our own reactions to the objects; to know why they are what they are we must know the men that made them. It will not be "educational" to interpret such objects by our likes or dislikes, or to assume that these men thought of art in our fashion, or that they had aesthetic motives, or were "expressing themselves." We must examine *their* theory of art, first of all in order to understand the things that they made by art, and secondly in order to ask whether their view of art, if it is found to differ from ours, may not have been a truer one.

Let us assume that we are considering an exhibition of Greek objects, and call upon Plato to act as our Docent. He knows nothing of our distinction of fine from applied arts. For him painting and agriculture, music and carpentry and pottery are all equally kinds of poetry or making. And as Plotinus, following Plato, tells us, the arts such as music and carpentry are not based on human wisdom but on the thinking "there."

Whenever Plato speaks disparagingly of the "base mechanical arts" and of mere "labor" as distinguished from the "fine work" of making things, it is with reference to kinds of manufacture that provide for the needs of the body alone. The kind of art that he calls wholesome and will admit to his ideal state must be not only useful but also true to rightly chosen models and therefore beautiful, and this art, he says, will provide at the same time "for the souls and bodies of your citizens." His "music" stands for all that we mean by "culture," and his "gymnastics" for all that we mean by physical training and well-being; he insists that these ends of culture and physique must never be separately pursued; the tender artist and the brutal athlete are equally contemptible. We, on the

Ananda K. Coomaraswamy

other hand, are accustomed to think of music, and culture in general, as useless, but still valuable. We forget that music, traditionally, is never something only for the ear, something only to be heard, but always the accompaniment of some kind of action. Our own conceptions of culture are typically negative. I believe that Professor Dewey is right in calling our cultural values snobbish. The lessons of the Museum must be applied to our life.

Because we are not going to handle the exhibited objects, we shall take their aptitude for use, that is to say their efficiency, for granted, and rather ask in what sense they are also true or significant; for if these objects can no longer serve our bodily needs, perhaps they can still serve those of our soul, or if you prefer the word, our reason. What Plato means by "true" is "iconographically correct." For all the arts, without exception, are representations or likenesses of a model; which does not mean that they are such as to tell us what the model looks like, which would be impossible seeing that the forms of traditional art are typically imitative of invisible things, which have no looks, but that they are such adequate analogies as to be able to remind us, i.e., put us in mind again, of their archetypes. Works of art are reminders; in other words, supports of contemplation. Now since the contemplation and understanding of these works is to serve the needs of the soul, that is to say in Plato's own words, to attune our own distorted modes of thought to cosmic harmonies, "so that by an assimilation of the knower to the to-be-known, the archetypal nature, and coming to be in that likeness, we may attain at last to a part in that 'life's best' that has been appointed by the Gods to man for this time being and hereafter," or stated in Indian terms, to effect our own metrical reintegration through the imitation of divine forms; and because, as the Upanishad reminds us, "one comes to be of just such stuff as that on which the mind is set," it follows that it is not only requisite that the shapes of art should be adequate reminders of their paradigms, but that the nature of these paradigms themselves must be of the utmost importance, if we are thinking of a cultural value of art in any serious sense of the word "culture". The *what* of art is far more important than the how; it should, indeed, be the what that determines the how, as form determines shape.

Plato has always in view the representation of invisible and intelligible forms. The imitation of anything and everything is despicable; it is the actions of Gods and Heroes, not the artist's feelings or the natures of men who are all too human like himself, that are the legitimate theme of art. If a poet cannot imitate the eternal realities, but only the vagaries of human character, there can be no place for him in an ideal society,

however true or intriguing his representations may be. The Assyriologist Andres is speaking in perfect accord with Plato when he says, in connection with pottery, that "It is the business of art to grasp the primordial truth, to make the inaudible audible, to enunciate the primordial word, to reproduce the primordial images—or it is not art." In other words, a real art is one of symbolic and significant representation; a representation of things that cannot be seen except by the intellect. In this sense art is the antithesis of what we mean by visual education, for this has in view to tell us what things that we do not see, but might see, look like. It is the natural instinct of a child to work from within outwards; "First I think, and then I draw my think." What wasted efforts we make to teach the child to stop thinking, and only to observe! Instead of training the child to think, and how to think and of what, we make him "correct" his drawing by what he sees. It is clear that the Museum at its best must be the sworn enemy of the methods of instruction currently prevailing in our Schools of Art.

It was anything but "the Greek miracle" in art that Plato admired; what he praised was the canonical art of Egypt in which "these modes (of representation) that are by nature correct had been held for ever sacred." The point of view is identical with that of the Scholastic philosophers, for whom "art has fixed ends and ascertained means of operation." New songs, yes; but never new kinds of music, for these may destroy our whole civilization. It is the irrational impulses that yearn for innovation. Our sentimental or aesthetic culture—sentimental, aesthetic and materialistic are virtually synonyms—prefers instinctive expression to the formal beauty of rational art. But Plato could not have seen any difference between the mathematician thrilled by a "beautiful equation" and the artist thrilled by his formal vision. For he asked us to stand up like men against our instinctive reactions to what is pleasant or unpleasant, and to admire in works of art, not their aesthetic surfaces but the logic or right reason of their composition. And so naturally he points out that "The beauty of the straight line and the circle, and the plane and the solid figures formed from these... is not, like other things, relative, but always absolutely beautiful." Taken together with all that he has to say elsewhere of the humanistic art that was coming into fashion in his own time and with what he has to say of Egyptian art, this amounts to an endorsement of Greek Archaic and Greek Geometric Art, the arts that really correspond to the content of those myths and fairy tales that he held in such high respect and so often quotes. Translated into more familiar terms, this means that from this intellectual point of view the art of the American Indian sand-painting is superior in kind to any

Ananda K. Coomaraswamy

painting that has been done in Europe or white America within the last several centuries. As the Director of one of the five greatest museums in our Eastern States has more than once remarked to me, From the Stone Age until now, what a decline! He meant, of course, a decline in intellectuality, not in comfort. It should be one of the functions of a well organized Museum exhibition to deflate the illusion of progress.

At this point I must digress to correct a widespread confusion. There exists a general impression that modern abstract art is in some way like and related to, or even "inspired" by the formality of primitive art. The likeness is altogether superficial. Our abstraction is nothing but a mannerism. Neolithic art is abstract, or rather algebraic, because it is only an algebraical form that can be the single form of very different things. The forms of early Greek are what they are because it is only in such forms that the polar balance of physical and metaphysical can be maintained. "To have forgotten", as Bernheimer recently said, "this purpose before the mirage of absolute patterns and designs is perhaps the fundamental fallacy of the abstract movement in art." The modern abstractionist forgets that the Neolithic formalist was not an interior decorator, but a metaphysical man who saw life whole and had to *live* by his wits; one who did not, as we seek to, live by bread alone, for as the anthropologists assure us, primitive cultures provided for the needs of the soul and the body at one and the same time. The Museum exhibition should amount to an exhortation to return to these savage levels of culture.

A natural effect of the Museum exhibition will be to lead the public to enquire why it is that objects of "museum quality" are to be found only in Museums and are not in daily use and readily obtainable. For the Museum objects, on the whole, were not originally "treasures" made to be seen in glass cases, but rather common objects of the market place that could have been bought and used by anyone. What underlies the deterioration in the quality of our environment? Why should we have to depend as much as we do upon "antiques"? The only possible answer will again reveal the essential opposition of the Museum to the world. For this answer will be that the Museum objects were custom made and made for use, while the things that are made in our factories are made primarily for sale. The word "manufacturer" itself, meaning one who makes things by hand, has come to mean a salesman who gets things made for him by machinery. The museum objects were humanly made by responsible men, for whom their means of livelihood was a vocation and a profession. The museum objects were made by free men. Have those in our department stores been made by free men? Let us not take the answer for granted.

When Plato lays it down that the arts shall "care for the bodies and souls of your citizens," and that only things that are sane and free, and not any shameful things unbecoming free men, are to be made, it is as much as to say that the artist in whatever material must be a free man; not meaning thereby an "emancipated artist" in the vulgar sense of one having no obligation or commitment of any kind, but a man emancipated from the despotism of the salesman. If the artist is to represent the eternal realities, he must have known them as they are. In other words an act of imagination in which the idea to be represented is first clothed in an imitable form must have preceded the operation in which this form is to be embodied in the actual material. The first of these acts is called "free," the latter "servile." But it is only if the first be omitted that the word servile acquires a dishonorable connotation. It hardly needs demonstration that our methods of manufacture are, in this shameful sense, servile, or can be denied that the industrial system, for which these methods are indispensable, is unfit for free men. A system of "manufacture," or rather of quantity production dominated by money values, pre-supposes that there shall be two different kinds of makers, privileged "artists" who may be "inspired", and under-privileged laborers, unimaginative by hypothesis, since they are asked only to make what other men have imagined. As Eric Gill put it, "On the one hand we have the artist concerned solely to express himself; on the other is the workman deprived of any self to express." It has often been claimed that the productions of "fine" art are useless; it would seem to be a mockery to speak of a society as free, where it is only the makers of useless things, and not the makers of utilities, that can be called free, except in the sense that we are all free to work or starve.

It is, then, by the notion of a vocational making, as distinguished from earning one's living by working at a job, regardless of what it may be, that the difference between the museum objects and those in the department store can be best explained. Under these conditions, which have been those of all non-industrial societies, that is to say when each man makes one kind of thing, doing only that kind of work for which he is fitted by his own nature and for which he is therefore destined, Plato reminds us that "more will be done, and better done than in any other way." Under these conditions a man at work is doing what he likes best, and the pleasure that he takes in his work perfects the operation. We see the evidence of this pleasure in the Museum objects, but not in the products of chainbelt operation, which are more like those of the chain-gang than like those of men who enjoy their work. Our hankering for a state of leisure or leisure state is the proof of the fact that most of us are working at a

Ananda K. Coomaraswamy

task to which we could never have been called by anyone but a salesman, certainly not by God or by our own natures. Traditional craftsmen whom I have known in the East cannot be dragged away from their work, and will work overtime to their own pecuniary loss.

We have gone so far as to divorce work from culture, and to think of culture as something to be acquired in hours of leisure; but there can be only a hothouse and unreal culture where work itself is not its means; if culture does not show itself in all we make we are not cultured. We ourselves have lost this vocational way of living, the way that Plato made his type of Justice; and there can be no better proof of the depth of our loss than the fact that we have destroyed the cultures of all other peoples whom the withering touch of our civilization has reached.

In order to understand the works of art that we are asked to look at it will not do to explain them in the terms of our own psychology and our aesthetics; to do so would be a pathetic fallacy. We shall not have understood these arts until we can think about them as their authors did. The Docent will have to instruct us in the elements of what will seem a strange language; though we know its terms, it is with very different meanings that we nowadays employ them. The meaning of such terms as art, nature, inspiration, form, ornament and aesthetic will have to be explained to our public in words of two syllables. For none of these terms are used in the traditional philosophy as we use them today.

We shall have to begin by discarding the term *aesthetic* altogether. For these arts were not produced for the delectation of the senses. The Greek original of this modern word means nothing but sensation or reaction to external stimuli; the sensibility implied by the word *aisthesis* is present in plants, animals, and man; it is what the biologist calls "irritability." These sensations, which are the passions or emotions of the psychologist, are the driving forces of instinct. Plato asks us to stand up like men against the pulls of pleasure and pain. For these, as the word passion implies, are pleasant and unpleasant experiences to which we are subjected; they are not acts on our part, but things done to us; only the judgment and appreciation of art is an activity. Aesthetic experience is of the skin you love to touch, or the fruit you love to taste. "Disinterested aesthetic contemplation" is a contradiction in terms and a pure nonsense. Art is an intellectual, not a physical virtue; beauty has to do with knowledge and goodness, of which it is precisely the attractive aspect; and since it is by its beauty that we are attracted to a work, its beauty is evidently a means to an end, and not itself the end of art; the purpose of art is always one of effective communication. The man of action, then, will not be content to substitute the knowledge of what he likes for an

understanding judgment; he will not merely enjoy what he should use (those who merely enjoy we call 'aesthetes' rightly); it is not the aesthetic surfaces of works of art but the right reason or logic of the composition that will concern him. Now the composition of such works as we are exhibiting is not for aesthetic but for expressive reasons. The fundamental judgment is of the degree of the artist's success in giving clear expression to the theme of his work. In order to answer the question, Has the thing been well said? it will evidently be necessary for us to know what it was that was to be said. It is for this reason that in every discussion of works of art we must begin with their subject matter.

We take account, in other words, of the *form* of the work. "Form" in the traditional philosophy does not mean tangible shape, but is synonymous with idea and even with soul; the soul, for example, is called the form of the body.[2] If there be a real unity of form and matter such as we expect in a work of art, the shape of its body will express its form, which is that of the pattern in the artist's mind, to which pattern or image he moulds the material shape. The degree of his success in this imitative operation is the measure of the work's perfection. So God is said to have called his creation good because it conformed to the intelligible pattern according to which he had worked; it is in the same way that the human workman still speaks of "truing" his work. The formality of a work is its beauty, its informality its ugliness. If it is uninformed it will be shapeless. Everything must be in good form.

In the same way *art* is nothing tangible. We cannot call a painting "art." As the words "artifact" and "artificial" imply, the thing made is a work *of* art, made by art, but not itself art; the art remains in the artist and is the knowledge by which things are made. What is made according to the art is correct; what one makes as one likes may very well be awkward. We must not confuse taste with judgment, or loveliness with beauty, for as Augustine says, some people like deformities.

Works of art are generally *ornamental* or in some way ornamented. The Docent will sometimes discuss the history of ornament. In doing so he will explain that all the words that mean ornament or decoration in the four languages with which we are chiefly concerned, and probably in all languages, originally meant equipment; just as furnishing originally meant tables and chairs for use and not an interior decoration

2 Accordingly, the following sentence (taken from the *Journal of Aesthetics*, I, p. 29), "Walter Pater here seems to be in the right when he maintains that it is the sensuous element of art that is essentially artistic, from which follows his thesis that music, the most formal of the arts, is also the measure of all the arts" propounds a shocking *non sequitur* and can only confuse the unhappy student.

Ananda K. Coomaraswamy

designed to keep up with the Joneses or to display our connoisseurship. We must not think of ornament as something added to an object which might have been ugly without it. The beauty of anything unadorned is not increased by ornament but made more effective by it. Ornament is characterization; ornaments are attributes. We are often told, and not quite incorrectly, that primitive ornament had a magical value; it would be truer to say a metaphysical value, since it is generally by means of what we now call its decoration that a thing is ritually transformed and made to function spiritually as well as physically. The use of solar symbols in harness, for example, makes the steed the Sun in a likeness; solar patterns are appropriate to buttons because the Sun himself is the primordial fastening to which all things are attached by the thread of the Spirit; the egg and dart pattern was originally what it still is in India, a lotus petal molding symbolic of a solid foundation. It is only when the symbolic values of ornament have been lost, that decoration becomes a sophistry, irresponsible to the content of the work. For Socrates, the distinction of beauty from use is logical, but not real, not objective; a thing can only be beautiful in the context for which it is designed.

Critics nowadays speak of an artist as *inspired* by external objects, or even by his material. This is a misuse of language that makes it impossible for the student to understand the earlier literature or art. "Inspiration" can never mean anything but the working of some spiritual force within you; the word is properly defined by Webster as a "supernatural divine influence." The Docent, if a rationalist, may wish to deny the possibility of inspiration; but he must not obscure the fact that from Homer onwards the word has been used always with one exact meaning, that of Dante, when he says that Love, that is to say the Holy Ghost, "inspires" him, and that he goes "setting the matter forth even as He dictates within me."

Nature, for example in the statement "Art imitates nature in her manner of operation," does not refer to any visible part of our environment; and when Plato says "according to nature," he does not mean "as things behave," but as they should behave, not "sinning against nature." The traditional Nature is Mother Nature, that principle by which things are "natured," by which, for example, a horse is horsey and by which a man is human. Art is an imitation of the nature of things, not of their appearances.

In these ways we shall prepare our public to understand the pertinence of ancient works of art. If, on the other hand, we ignore the evidence and decide that the appreciation of art is merely an aesthetic experience, we shall evidently arrange our exhibition to appeal to the

public's sensibilities. This is to assume that the public must be taught to feel. But the view that the public is a hard-hearted animal is strangely at variance with the evidence afforded by the kind of art that the public chooses for itself, without the help of museums. For we perceive that this public already knows what it likes. It likes fine colors and sounds and whatever is spectacular or personal or anecdotal or that flatters its faith in progress. This public loves its comfort. If we believe that the appreciation of art is an aesthetic experience we shall give the public what it wants.

But it is not the function of a museum or of any educator to flatter and amuse the public. If the exhibition of works of art, like the reading of books, is to have a cultural value, i.e., if it is to nourish and make the best part of us grow, as plants are nourished and grow in suitable soils, it is to the understanding and not to fine feelings that an appeal must be made. In one respect the public is right; it always wants to know what a work of art is "about." "About what," as Plato asked, "does the sophist make us so eloquent?" Let us tell them what these works of art are about and not merely tell them things about these works of art. Let us tell them the painful truth, that most of these works of art are about God, whom we never mention in polite society. Let us admit that if we are to offer an education in agreement with the innermost nature and eloquence of the exhibits themselves, that this will not be an education in sensibility, but an education in philosophy, in Plato's and Aristotle's sense of the word, for whom it means ontology and theology and the map of life, and a wisdom to be applied to everyday matters. Let us recognize that nothing will have been accomplished unless men's lives are affected and their values changed by what we have to show. Taking this point of view, we shall break down the social and economic distinction of fine from applied art; we shall no longer divorce anthropology from art, but recognize that the anthropological approach to art is a much closer approach than the esthetician's; we shall no longer pretend that the content of the folk arts is anything but metaphysical. We shall teach our public to demand above all things lucidity in works of art.

For example, we shall place a painted Neolithic potsherd or Indian punch-marked coin side by side with a Medieval representation of the Seven gifts of the Spirit, and make it clear by means of labels or Docents or both that the reason of all these compositions is to state the universal doctrine of the "Seven Rays of the Sun." We shall put together an Egyptian representation of the Sundoor guarded by the Sun himself and the figure of the Pantokrator in the oculus of a Byzantine dome, and explain that these doors by which one breaks out of the universe are the same

Ananda K. Coomaraswamy

as the hole in the roof by which an American Indian enters or leaves his *hogan*, the same as the hole in the center of a Chinese *pi*, the same as the luffer of the Siberian Shaman's *yurt*, and the same as the foramen of the roof above the altar of Jupiter Terminus; explaining that all these constructions are reminders of the Door-god, of One who could say "I am the door". Our study of the history of architecture will make it clear that "harmony" was first of all a carpenter's word meaning "joinery," and that it was inevitable, equally in the Greek and the Indian traditions that the Father and the Son should have been "carpenters," and show that this must have been a doctrine of Neolithic, or rather "Hylic," antiquity. We shall sharply distinguish the "visual education" that only tells us what things look like (leaving us to *react* as we must) from the iconograph of things that are themselves invisible (but by which we can be guided how to *act*).

It may be that the understanding of the ancient works of art and of the conditions under which they were produced will undermine our loyalty to contemporary art and contemporary methods of manufacture. This will be the proof of our success as educators; we must not shrink from the truth that all education implies revaluation. Whatever is made only to give pleasure is, as Plato put it, a toy, for the delectation of that part of us that passively submits to emotional storms; whereas the education to be derived from works of art should be an education in the love of what is ordered and the dislike of what is disordered. We have proposed to educate the public to ask first of all these two questions of a work of art, is it true? or beautiful? (whichever word you prefer) and what good use does it serve? We shall hope to have demonstrated by our exhibition that the human value of anything made is determined by the coincidence in it of beauty and utility, significance and aptitude; that artifacts of this sort can only be made by free and responsible workmen, free to consider only the good of the work to be done and individually responsible for its quality: and that the manufacture of "art" in studios coupled with an artless "manufacture" in factories represents a reduction of the standard of living to subhuman levels.

These are not personal opinions, but only the logical deductions of a lifetime spent in the handling of works of art, the observation of men at work, and the study of the universal philosophy of art from which philosophy our own "aesthetic" is only a temporally provincial aberration. It is for the museum militant to maintain with Plato that "we cannot give the name of art to anything irrational."

Advocating
the Collective:
Luis Vidales

Camilo Sarmiento Jaramillo

Luis Vidales, a Colombian poet, statistician, and art critic, was born in Calarcá in 1900 and died in Bogotá at the age of ninety. He rose to fame with the 1926 publication of *Suenan Timbres*, a book of poems that broke with all the classical schemes that prevailed in Colombian early twentieth-century poetry, the only poetry in the country considered avant-garde. He traveled to Paris in 1926, where he learned firsthand about avant-garde movements such as Cubism and Surrealism. On his return, he began to work as a professor of art history and frequently published texts on aesthetics and art criticism in the local media. This selection presents two of the texts written in the forties, when the aesthetic debate moved between attachment to nineteenth-century academia and the attempt to understand the modern-day ventures of some of Colombia's young painters.

The first piece, titled "The Aesthetic of Our Time," was published in the first issue of the magazine *Espiral*, launched in 1944 and serving as a point of convergence for those voices responsible for revitalizing art and literature in Colombia in the middle of the century. In this article, Vidales defends the disappearance of the paradigm of individuality that dominated Western art since the Renaissance, and announces the emergence of a new type of art based on the collective and the common. He then attempts to apply this reasoning to the Colombian art of the time, to explain the emergence of alternative canons of beauty to those defended by the advocates of traditional art. With this, he supports the modernization of Colombian art,

which had been slowly forging since the early thirties.

The second text, "Colombian Painting," was published in the newspaper *El Tiempo* on April 19, 1942. In it, Vidales emphasizes the period of learning in Colombian painting, and relates it to the general statism that characterizes the country's social life. To do so, he uses examples taken from different moments in the history of art such as Renaissance, Romanticism, or Baroque. The most redeemable aspect of this article is his interest in interpreting the work of art as a manifestation of social conditions, which implies the appearance of a sociological analysis in the country's artistic field, a methodological innovation that could not be overlooked at the time.

Through a discourse based on artistic examples and concepts, the two writings seek to examine the panorama of art at a given point in the country's history, where the edifying visions of art are in conflict with those that attempt to explain the emergence of new forms of expression. The author faces positions anchored in the past and, using measured and precise language, defends the advent of a new art that goes beyond imitation and the individual genius celebrated by academia. His arguments are taken from the history of universal art: Gothic, Medieval, or Romantic, which validates his reflection and inserts it into the critical dynamics of his time. Reading Vidales today reveals how art criticism in Colombia became detached from a celebratory and political tone to delve into the aesthetic and historical considerations of modern art criticism. In 1946, this author published his *Treatise on Aesthetics*, in which he attempted to analyze the works of the philosophers Hippolyte Taine (1828–93) and Benedetto Croce (1866–1952) to theoretically justify critical judgment. Vidales's critical work enables a transversal reading of the art critique written by modern poets in Colombia, which broadens the spectrum of the art historian and introduces a gradual change in the discourse in a particular moment of high political strife that enabled the consolidation of modern art in the country.

The Aesthetic of Our Time

Luis Vidales

from *Espiral. Revista de Artes y Letras*, April 1944

We are living through the greatest era known to humanity, one incomparable to any other culminating moment of man on Earth. It is true that poetic content originates in the human heartbeat of each historical period, as, it seems, has been sufficiently proven since its first mention by Homer to the present day. In the history of retrospective, there is and can be no poetic material of such magnitude as that presented in the contemporary era in its unfading grandeur.

To this day, poetic schools and trends have emerged first as local phenomena, which then extend through nations. History has moved locally, but now it moves universally, and the universal is also, obviously, the human horizon of poetry.

Those who maintain that our era is prosaic, as has been recently affirmed by Rafael Maya, have to base their thinking on the defence of poetic goals that are now being discarded, precisely because they are considered narrow and inadequate for the magnitude of the poetic phenomena of our present.

If we observe what occurs at the heart of our times through historical criteria, we have to accept that in all orders, including the poetic, everything that in past eras was most valuable to man is now being abandoned. But historical practice teaches us that these changes have taken place periodically, not in detriment to art and poetry nor to fall into prosaic periods, but rather, to then give rise to the appearance of new, unpublished forms.

Maya, for example, attributes the undeniable fact that woman is no longer the source of inspiration to the prosaism of our time, but this does not in any way contradict today's art and poetry. Quite the contrary. There have been grand and brilliant eras of spiritual culmination in which the central focus of people's inspiration has not been woman, but rather the gods. Woman only appears as an inspiration to poetry and art in easily discernible periods in human history—as we can see without the need to elaborate—in Egypt and Greece, and, more recently, in the emergence from the religious culture of the Middle Ages, when she was enthroned on altars in dedication to the Virgin Mary, at the same time as urban life grew in Europa and the bases were set for the formation of the national empires of the sixteenth century.

History does not lie. It cannot be taken as a mere—dead and cold—element of erudition. But the experimental methodology, which is not based on abstract concepts of the mind, peremptorily demands the verification of our ideas in historical practice, as the only way to overcome the pretentious, arbitrary, and ungraspable personal attitude, and as the only way possible to have concrete knowledge of the orientation and value implicitly acting on the spiritual currents of our time.

It is not possible, from any perspective, without first falling into the most absolute darkness, to hold as the only, non-interchangeable, and eternal aesthetic canon that has been held since a relatively recent period, only valid since the Renaissance.

Four centuries are not enough to confirm the eternity of an aesthetic.

Previously, and for eras that were much more extensive, there were other aesthetic canons contrary to the one we have inherited from the universal forms of individualism into which the Middle Ages dissolved. If we glimpse at the history of "beauty" with an unguarded but attentive spirit, we will see that this acts in generic and individual stages, with remarkable regularity, without the possibility for our aesthetic criteria to judge one as beautiful and the other as ugly, without falling into error.

We cannot say that "beauty" has ceased to exist, or that prosaism has seized the era, just because the modes and forms of the expression of spiritual values have transformed. At most, we can say that we are witnessing a change of objectives and elements that used to constitute the repertoire of our aesthetic, for others that are completely different and in which a new aesthetic is forging.

Those who lack the essential mental position to approach the set of spiritual values that are galvanizing, not without difficulty, in the bosom of our time, from this organic and vital perspective, will be bewildered at witnessing the birth of the most immeasurable stage of beauty that the centuries have seen. It will be very difficult to make these individuals understand that every form of artistic creation possesses its own form of creator, and almost all current aesthetic problems are reduced to the growing opposition presented by the individual, isolated creator vis-à-vis a nascent aesthetic that, as has occurred in other eras, requires, given the amplitude of its content, other forms of the "creator of art."

Forgetting that there had already been great expressive monuments of the common and anonymous work of the people, they will not remember the poetry and the art of the eras of the individual "genius," because it is all they understand as "culture." I, as an educator, am witness to the near impossibility of the individualist being to understand that much of the poetry and art that we admire today has been created collectively,

as expressions of the common "genius" of the species. At most, they accept this for the past, because they cannot deny it; but when they see the symptoms of this same phenomenon in the present, they cannot find their bearings, and in the midst of the confusion brought by such phenomena, they resolve to talk about decadence.

Today, it is broadly accepted that we are in a period of transition and that after the war life will no longer be as it was. But, if we refer to the same phenomenon no longer in the political plane but rather in an aesthetic one, there will always be people that judge as "ugly" what is nothing other than a new form of beauty, without being able to embrace that the so-called "ugliness" has appeared in the history of literature and art whenever this transition has emerged. It was there, not only as a particular branch of Romanticism, when absolutism allowed the reins of power to be taken from its hands by the Republic.

Previously to that, in the Hellenistic period of Greek dissolution, artistic "ugliness" was recreated in expressions of old age, and of the maimed and mutilated. In the Nile Valley, 1,500 years before Christ, there was already a period of "ugliness" in the forms of artistic creation, in Amarna, between the two Theban periods. All ages, without exception, bring "ugliness" as an ineluctable historic law, during the death of a society and the birth of another. Why cannot our time also be part of the history of man and, thus, obey in its artistic creation, profound laws of already well-known, aesthetic composition?

Those that see this "ugliness" in contemporary art and literature, considering only the aesthetic criteria that has prevailed in very recent centuries, would not understand the profound meaning enshrined within it, because this deformity attributed to painting and sculpture, for example, is nothing other than the rupture of the traditional models of art in place since the Renaissance, to forms that are broader than the merely personal. Today, we contemplate with admiration and aesthetic enjoyment those periods of art in which, because of the fact that the three plastic arts were together, painting and sculpture lacked autonomy and, in their entirety, orbited within abstract architectonic forms. But when we see the "ugliness" of the art of our days, we cannot begin to understand that its abstract and subjective representations move together toward the non-representational, as already happened every time that the plastic arts were twinned. Egyptian painting and sculpture lack perspective and have a particular form that characterizes them because beyond the mere independent representation of the body, they had to address the stylation imposed by the subjective architectural structure, which was resolved in the pyramid. The same happens with Gothic statuary, whose

Luis Vidales

figures often extend beyond the proportions of the human body, to suit the norms of the building for which it was sculpted.

In poetry and literature, in general, we can see that this same rupture of the models of the Renaissance, in which a new broader organic structure breaks with tradition which corresponded entirely to the anatomical vision of the world and forms, and instills a collective vision of things in the contemporaneity of the collective, of the common.

The thinker is obliged to know how to find his bearings in the midst of chaos and in that midst discover—not letting himself be attracted by all the elements of dispersion that the great epochs entailed—the essential laws whose vitalism in history provide full guarantee of guidance to understand the real meaning of the culture of his time and unravel his future.

If work is undertaken in this way, a poem or piece of art will no longer be required to possess a diametrically opposed future that continues through the old aesthetic canons, nor will there be anything serious in the name of which to condemn the new forms of beauty.

It is nevertheless odd that it is a trait of the mental structure of the master Maya that defends the individualist aesthetic, daughter of the sensualism of the Renaissance. And that it is we who unravel the appearance of an aesthetic that—as much as it shifts away from the forms of the religious culture of the Middle Ages, is similar to it in its collective aspect. While it is true that, as stated by a politician as skillful as he was unfortunate, the frontiers between the parties are being erased, the frontiers of aesthetics, in contrast, are increasingly visible on the universal horizon of contemporary culture.

Colombian Painting

Luis Vidales

from *El Tiempo, Suplemento Literario*, April 19, 1942

The individuation and specialization that appear at certain points in history have an impact on art techniques and it is only with the help of sociology that we can understand the origin that, on the canvas or statue, gives life to certain elements at the expense or the death of others.

The presence of the individual claiming its privileges over the collective may be situated in the sixteenth century, with Baroque, at least for

what concerns the modern world. In the High Renaissance, let's say, just to take a point of comparison, shape, line, and color intervene in unison in pictorial work. Nevertheless, in it, there is already a school that looks at light, paints that of Venice, and lets its drawing run free.

To understand the father-son relationship that painting acquires through the specializations of the modern world, by the end of the Renaissance, all we have to do is to focus on the individualism that among the elements of the work of art governs the creation of the artist. If the branches of knowledge become autonomous and we witness the arrival of specializations that lead to the loss of the harmonious compilation of the totality in which the universe is expressed in the work of men, and the technician touches but an isolated set of knowledge, the artist will, in parallel, be a colorist to the detriment of the rest of the pictorial values or will be concerned only with the plastic, decoration, drawing, or the composition of strictly luminous conditions.

A relationship could, in the strict sense, be found between this artistic lateralization and the function of the mere producer that is solely concerned with part of the fabrication of common merchandise, in contrast to the laborer of the mercantile era, who envisioned the product of his ingenuity, initiative, or creative mental function as a whole and finished product.

This mimicry with the conditions of society seen in the work of art is one of the most notorious aspects of current Colombian painting.

If the mentality of the painter is expressed in the cited anarchic qualities, based on which every artist is different from all other artists, all of our painters are identical in that they are absent from the proper mimesis of the elements that concur to the equilibrium of the artwork. Even through the most indirect paths, the work of art reproduces a "camouflaged" picture of the social state of the country in which it is born.

The prominence of the figure on the landscape in today's Colombian painting is easy to observe. Furthermore, this is one of the features of universal contemporary painting.

From the Renaissance onward, it seems that the periods of pictorial landscapes coincide with the moments of transition in social and political spheres or, on occasion, as reactions against social media, which, for having only recently reached its peak, involve aspects of bad taste or trends of an exclusive material practicality. Romanticism corresponds to the latter, as it was, in essence, a return to the provincial influence in art, to the peasant *endroit*, when what triumphed was "national life" and the city as the center. Romanticism was the *bon vieux temps*, deifier of memories, which camouflaged in its exaltation of cantonal niches (with

Luis Vidales

its silly landscapes of streams, willows, country paths, the moon, and provincial girlfriends) the hate for the bourgeoisie and the longing for the old regime. The same could be said about Impressionism; this landscape painting embedded in the industrial triumph of the Third Republic.

Landscape painting is, on the other hand, a point of arrival for art that serves as a transit to realism, to the emergence from art dedicated to the gods. This is how it was in the Hellenistic era, and after the Carolingian and Gothic worlds. It is the essential step of art in search of man.

All ages of humanist development coincide with societies that find themselves in turbulent periods, and with this, landscapes slip into the background in artistic activity. The atmosphere of warm humanity, in which the universe is enfolded, shows landscape its place in this drastic hour of man.

An overview of the work of artists can tell us a lot about the general repose seen in current Colombian painting. Could we perhaps assume that this quietism forms part of the country's current state? But to not get wrapped up in the historical verification of this law of "coincidences," between art and the material world, that smarts the proclaimers of the "individual genius," as free as glucose, and considering the issue solely from a perspective of the problems of artistic procedure, it is unquestionable that between the absence of movement, struggle, or drama observed in current Colombian painting and our artists' manner of creating—in general they produce studio work—there is a relationship that is not only apparent.

The repose of the model has to somehow influence the artwork. And although it is certain that academia is not disconnected, the work of creation and the interplay of technical values of the creator can, in it, go up to where is possible or wanted, it is also certain that a particular quiescence is an uncontrollable element for the artist under such conditions.

It can be said that it is in this procedure that we can find *ab ovo* the condition of the insularity of Colombian painting in the American art scene. Almost all the media of our countries has expanded beyond the model and reached a situation in which art begins to be made with elements of experience, as a path to enter a broader sphere of creative activity.

This procedural issue irradiates toward an immeasurable and broader problem: that of the craft and its relationship with the artist's capacity for universal understanding.

In other eras, an artist could simply be a man in possession of his craft, regardless of the value of his individual creative function. Had

Phidias added anything to the corporal or spiritual attributes of Athena Parthenos, he would have shifted away from the social religious concept. Today, on the other hand, the artist has to add to his craft his understanding of the orientation, solidity, and future of the work of art. Whatever he was provided with in other eras by the social milieu, today he has to arbitrate by his intellectual reasoning and by his comprehension of the way in which art has evolved through history. It is from here that he must extract the laws to know what future art will be, and, therefore, it is from here—and not from anywhere else—that he will extract his own artist's path.

Velásquez could create a composition by repeating a model in the same painting, as in *Apollo in the Forge of the Vulcan*. Today, the mere interpretation of the human body is overrun by the vastness and complexity of modern life, whose universal amplitude has not been set out by the history of any other memento. Say what they may, an artist without a position of responsibility concomitant with this phenomenon, will only produce an art that is hollow, and it will be increasingly difficult for them to find motifs and issues no matter how great their technical skill. Art is a fusion, a galvanization of the universe. Real art has never included anything that is rethought, flashy, contrived, preconceived, artifactual, or academic.

The more general attitude toward Colombian painting is that of learning the craft. From there, its academicism. But it is worth asking: would it not be better for the artist to attempt to learn this craft directly in life?

Materialism and Proximity: Francis Ponge

Isabelle Graw

Francis Ponge's "Note on the Hostages, Paintings by Fautrier" is not criticism in the narrow sense of the term. Neither a review nor a metacritical essay, this text could be described as something of an elliptical poetic artifact. Originally written for a catalogue published to accompany Jean Fautrier's first exhibition of his Hostages paintings in the Galerie René Drouin in 1945, it ended up not being used for that volume— a text by André Malraux was selected instead. But Ponge's essay was later published as a separate book by Éditions Seghers in 1946.

Ponge's writing on Fautrier manages to do something that art criticism rarely does: it reflects upon its own material conditions *and* simultaneously captures the specific materiality of Fautrier's paintings.

The text's historical circumstances—primarily World War II, and more specifically war crimes—do resonate quite strongly, as for example, when Ponge describes Fautrier's tête d'Otages paintings, with their pastel-colored *haute pâte* constructions, as "mutilated, tortured faces." Such an anthropomorphic reading of Fautrier's paintings points to the context of their creation: they refer to those victims of Nazi executions in the woods outside Paris near Châtenay-Malabry, where Fautrier had his studio during the war. Due to his proximity to the French Communist Party, Ponge may have well been influenced by the Marxist credo that one should render one's own conditions of production transparent. In his case, it is the financial arrangements underlying his text that are (seemingly) brought to light when he mentions "the little bit of money"

119

and "one or two" of Fautrier's paintings that he supposedly received as a payment for his work. Ponge reminds us rather playfully of the different financial evaluations of writing and painting. He also points to the widespread practice of "payment in kind" in the art world; often done but rarely spoken of. Furthermore, as a (probably fictional) owner of two paintings by Fautrier—"Mine are called 'R. L.' and M. P.',", he writes—Ponge also shows himself to be biased and compromised. Considering that his writing will possibly one day increase the market value of Fautrier's paintings, the paintings in Ponge's possession would also theoretically benefit from such an increase in value. Ponge thus toys with the idea of being implicated in this process of financial speculation, but instead of attempting to hide the resulting conflict of interests, which is what most critics and art writers tend to do, he actually spells them out and makes them tangible for his readers.

Next to economic conditions, Ponge also hints at the underlying social conditions in his text when he speaks of friendship as the driving force behind his essay. Although he defends the special knowledge that friends have of one another's work, he also concedes that those close to the painter are often "condemned to confused or absurd expressions." The proximity resulting from friendship can thus produce both confusion *and* expertise.

Ponge's *aesthetic* approach to Fautrier's paintings, and his writing in general, could be described as a kind of "New Materialism" avant la lettre. Like in New Materialism, a kind of self-active materiality is assumed that

has a life of its own, an agency even. Ponge treats his objects—and this is especially true for the way he considers Fautrier's Hostages paintings— as quasi-subjects, with recourse to an almost animistic language. This is evident when he speaks of Fautrier's Hostages paintings as if they were actual human bodies, "yet, in the cramping of the fusilladed body, one can see a challenge, a protest; in the faces, an expression of painful and sometimes scornful stupefaction." The paintings not only depict physical terror according to Ponge (the Nazis' torture methods against innocent people during occupation); they *are* the "mutilated, cramped, bloody, dismembered body that is a crushed, deformed, swollen, tumescent head."

But while anthropomorphizing the works, Ponge nonetheless reminds us that they are, in fact, paintings: paintings that consist of dead matter that he describes in quite great detail. Ponge's doubly materialist approach to Fautrier's paintings is still methodologically valid for art criticism today, a materialist sensibility for the particular surface of Fautrier's paintings combined with a Marxist insistence on those economic and social conditions that ultimately inform them.

Note on the Hostages, Paintings by Fautrier

Francis Ponge

first published as *Note sur les Otages, peintures de Fautrier*, 1946

What do painters who ask you to write about their painting want?
They want their works (exhibition, collection of paintings), in addition to appearing before the world's eyes, to also ring in the world's ears at the same time.

They want words about their painting to bring about a sort of prescription for thought. That one furnishes words (in bulk) to those who will visit the exhibition or flip through the album.

They also want the connoisseur to say: "Indeed, there is this or that in so-and-so's painting," or rather, "No, there is not this, nor that, but instead this and that."

Of course, there is (at least) another thing at play: there are real objects, namely canvas and paint.

Above all, they want the connoisseur to be struck that one can think and say so many things about the works of the painter in question, because for the connoisseur this seems a guarantee. Is good painting, then, that which we talk a lot about, and that which we will always talk about a lot? That which will provoke controversies, explanations, for a long time? Or, on the contrary, would it be the painting that gives us the (immediately obvious) impression that it would be wrong to say anything about it, that it ridicules in advance any attempt at explanation? That one must limit oneself to proclaiming: how pretty or beautiful it is, how agreeable it is to have close by?

In any case, good painting is that about which, in every attempt to say something, one could never say anything satisfactory.

Does it make sense then to speak a lot and in an unsatisfactory fashion?

Isn't this falling into the trap?

Are there words for painting? One can ask oneself this (here is the proof). And answer: Of course, we can speak about everything.

But, in order to begin, mustn't one avoid asking this and instead enter into the game right away?

Or answer oneself more simply: let's see ... let's try, we shall see.
Or, on the contrary: no, obviously not, no words of worth; painting

is painting, literature is something else, and it is clearly for literature that words are made, not for painting.

But, looked at this way, there are words for everything and there are words for nothing. We have hardly advanced.... And besides, nobody cares anyway. Let's see your words, one resigns to think.

What are we getting ourselves into?

Painters, or their dealers, seem to want nothing more than for their paintings to give rise to words. One could, however, very well imagine that things happen quite differently. As follows, for example: paintings are exhibited in a gallery. The public does not come or, on the contrary, comes, looks. What they see does not please them, or it does, and they buy. The paintings are taken down (thousand-note bills are pocketed), then hung in the homes of the connoisseurs who look at them at leisure. There it is, that's all.

But no, things ought to be slightly more complicated. Because one must (anyway, this seems not only tolerable, but useful), one must *attract* the public. One could decide to simply let the public come on its own, to tell oneself: it will come if it wants, it just needs to remain unbiased. Leave

Jean Fautrier,
Head of a Hostage No. 17,
1944

Francis Ponge

it to the contingency (or law) of curiosity, of *flânerie*, or of the painting's need for a crowd.

No, we think it better to attract the public. Fine. Well, one could do so differently than with literature, or even with words. For example, one could limit oneself to distribute reproductions on small pieces of paper. Without a word (except for the address of the gallery).

One could even forbid any speech in a gallery, accept only thousand-note bills, and the gesture of taking the painting away.

But no, the more words, the bigger the audience.

So, here is the public at the gallery. The public (sometimes) still makes up its mind on the basis of an idea as much as on appearances. One tells the public: this is good for this or that reason. One gives it reasons for expressing itself to itself and its friends. This is necessary. We are among men, after all. A talkative, garrulous species, a species that exchanges opinions through words. A species not too sure of its desires or pleasures. A deceived species that knows from experience it will take pleasure tomorrow (and then always) in what displeases it (most vehemently) today. But then again, if it knew that, it would not need words. But it forgets, and one must remind it.

Now, even so, when one buys an (expensive) painting, isn't it better for it to please you tomorrow and always, or even in three months and always, rather than today and maybe only today?

So, listen to these literati gentlemen and friends of the painter. If they have become friends, it might be, of course, for many reasons (varied, diverse). It could have served their self-interest, of course. One must keep that in mind. But, in the end, the world is not necessarily so bad, so simply, so outright mean. There could have been worthy reasons (I mean worthy for you as well) for these friendships, a veritable *sympathy* for one another. So, this too must be kept in mind.

Listen, then, to these literati gentlemen and friends of the painter: people of taste by definition, who have already earned their (literary) spurs. Because they have carried these paintings home, they have kept them for a good long time. That is a guarantee. And they say good things about them. Perhaps this is the decisive factor. No?

But still … Don't we, literati friends of painters, fall into a clumsy trap? Aren't we condemned to confused, absurd expressions? Aren't we only going to serve as helots, as a negative counterpoint? Well, then! Let's regard it as a defeat.

Or rather, let's accept it just like asceticism (out of masochism?).
In any case, it will be a good exercise.
And it should bring us a little bit of money (very useful, money, if only to allow us to write other things, writings of another sort).
Some money, and one or two of these paintings.
To stare at them all one's life.
So, let's go! It is worth the effort: *I like Fautrier's paintings*.
If I said only one thing, it would be: *I like Fautrier's paintings*.
But let's enter further into the game. Let's look for words. Let's take up the challenge seriously.

When it dies, the human body comes to experience various fates: the *simplest* (and I would say the most common, were I not writing in the time in which I write) is aging and death by aging or by sickness. This gives rise to feelings, reflections, and numerous representations, certain of which contain a kind of revolt against the human condition, and we do not want to say that this protest or revolt is totally unjustified (if not vain). But man has also tried acquiescence and praise against the inevitable and inescapable necessities of his condition. For example, there exist highly reassuring and consoling portraits of the elderly, and even of (recent) cadavers.

As for the human body's fate after death, it is passed over in silence. There is hardly any literature or painting of decomposition. On the other hand, the skeleton is an admittedly well-known, oft-used aesthetic object. *Less common* is death by accident: the human body in all its youth, power, vitality, is brutally stopped, cut to the quick, broken, crushed. Then blood flows out: a glimpse into life's inner vitality. In this way we have a cross section of life, from which stems a feeling of both pride and injustice.

But it seems that the accidental aspect of such an event removes all its aesthetic interest. I am unaware of artistic representation of such disfigurement. Here there is something indifferent, fortuitous, without cause (or else a *destiny* or an individual fatality for which we have no strong feeling, which is not very moving). Chance is not poetic, not tragic; it has a hard time appearing tragic.

Still less common is murder. Here, too, it is a matter of an anecdote whose cause is more or less fortuitous, but with an added element of melodrama that makes it rather too "considerable as a work of art." Nevertheless, passionate murder could be an option. The woman murdered because she was too beautiful. The man murdered because his wife was too beautiful and he was annoying her. But the motive for murder is

Francis Ponge

usually sordid, and (I forgot to say that) there is only a wound (and usually not mutilation); the human body is not reduced to a pulp.

Furthermore, we discover another fate:

It is war, the horrors of war (see Goya, etc.). Here are corpses, here is a fatality to which we react strongly, and here is our miserable human existence. This is what is worthy of an artist's brush in a given epoch. However, it is worth noting the usually anecdotal character of these representations.

There is also death for an idea (*Liberty Leading the People* by Delacroix, etc.). But there again, it is instead a fate of the entire human species, a sort of epidemic (*The Plague Victims of Jaffa*) or collective rage. There is no space for such a protest, there is nothing so tragic as what we have known for a few years.

I would just like to mention surgery and its effects (the peg-legged beggars by Breugel, or his blind). These are good mutilations, beneficial mutilations that prolong life.

Finally, let's come to our last fate, the most recent one.

People became—almost—indignant, at the very least they made fun of the accounts on Russian radio calling the Nazis *cannibals*. However, one must accept the evidence. Objectively, the Russians were right. Not even the Middle Ages experienced such collective barbarism (except, perhaps, during the Inquisition).

But hostages, Nazis? There we really are dealing with cannibalism. Bourgeois cannibalism. Of course, since the repression of the Commune, we had an idea of what the bourgeoisie were capable. We had not yet seen them in the guise of their handymen, the *Nazis*.

Neither you, dear connoisseur, nor I, are savages. Yet, barbarism is among us, it floods the century. Dear connoisseur, we are living in the middle of barbarism.

How can it be? Aren't we accomplices? At least to the extent to which we do not recognize it, or do not denounce it strongly enough.

Perhaps to the extent to which we occupy ourselves with something else (but one must distract oneself and live).

How does one behave before the idea of hostages?

One might say that this is one of the epoch's main questions.

The usual reaction is indignation, cursing, and a desire to kill the torturer as a dangerous enemy of humankind.

Vengeful anger is the reaction.

In the face of the idea of torturing the human body, one normally reacts

with a complex feeling in which shame is mixed with a certain disgust over living in these conditions, but above all with stupefaction, then anger and the desire to kill (without torturing) the torturer, to annihilate him in one single blow.

The torturer's desire—not taking into account a certain sadism that develops, apparently, in the exercise of torture—is to provoke confessions (consequently, to justify the torturer), denunciations—that is, to progress with the action he considers his justice; in short, to inspire a salutary terror—that is, to assure his power and his peace.

It is remarkable that these procedures generally do not succeed. For every noble soul, the idea of torturing others inspires horror and vengeful anger much more than it does terror and panic. And there are always enough noble souls to pull history along.

For the most intelligent or the most ambitious, it inspires the resolution to do everything possible to eradicate the deeper cause of such atrocity at its root or at its source, to change the world and to change man so that he is no longer capable of such crimes. Lastly, it can incite one to capture this in valid formulas on a painting.

Reproach must be included in the expressions of my faces and my bodies (I do not know what kind of rancor, painful surprise, contempt, what disdainful or simple pardon, perhaps)—because they are not dead, they have not been disfigured, dismembered, damaged by accident. And, for sure, illness or accidents cause similar mutilations. But the entire gravity of these mutilations stems from the fact that they are the work of man (of the enemy that looks like a man) and that each torturer intended them for each victim, intended them from nearby, from close up. And, even more, they were not perpetrated in the tumult and fire of battle, but in the silence and cold-bloodedness of *occupations*. And, even more, on hostages; that is, by definition, on the innocent, on abused innocents, who have surrendered without resistance (and at first almost without consciousness), without complaints, without possible struggle: the weak.

Something had to oppose the intolerable idea of the torture of man by man himself, the idea of the body and human face disfigured by the work of man himself. One had to stigmatize and immortalize the horrible by stating it.

One had to recreate it in reproach, in loathing; one had to transform it into beauty.

No gestures. No gesticulation. Stupefaction, reproach. No movement, except the movement of the image that invades the field of the mind; of the tortured visage that rises from the depths of shadow, that approaches

Francis Ponge

in close-up; except the gyrating movement of the martyrs' faces in our sky, like stars, like satellites, like moons.

Physical torture—that is a mutilated, cramped, bloody, dismembered body; that is a crushed, deformed, swollen, tumescent head. Mental torture at the same time, because it is about righteous and innocent people—and so is the expression of these bodies and these faces. An expression I hardly dare to speak about for fear of misinterpretation. Yet, in the cramping of the fusilladed body, one can see a challenge, a protest; in the faces, an expression of painful and sometimes scornful stupefaction. And something more presumptuous and proud than reproach: something like a rather haughty observation.

We first talked about physical torture, and I would like to come back to that; for, after all, what else besides the physical could be painted? But painted in such a way (with such passion, such emotion, such rage) that one cannot say it is only a matter of observation. Of course, it is not the same excitement as that which can accompany the sharp eye from which a painting arises: it is the strong sensation from which the idea of such a deed or suffering in the soul grows.

Compare this with other forms of expression inspired by terror or war (for example, the works brought together in the "Vaincre" collection). There are no gestures (moreover, no limbs: heads, trunks), no theatrical poses. Not the act of torture, not the suffering in torture, is described or evoked. It is the result of all this, the lifeless or still twitching object: it is the corpse, the stump, the part. This is the horrible result, this is the corpse, the stump of the limb, the inhuman, unbearably crushed face with its ugliness, its beauty, its language of horror and injustice, of remorse, rage, and resolution.

Not one portrait. And thus, we do not feel sympathy for a particular being, but a much more poignant, irresistible necessity. A (general) religious or metaphysical sensation, combined with rage and resolution.

These faces, they are also moons and I suppose that each connoisseur who has one hung in his home will also look at it that way, will have one of those martyred heads circle forever around his head like a satellite face that remains inseparable from him forever.

Morally speaking, it is a good thing. Everyone will want to have their own satellite. There might be some who will have many. Mine are called R. L. and M. P. Sometimes in the morning, when I wake up looking at my

"head of a hostage," I have a very strong impression of the *sanguine*, with the viridian white and black as complementary to blood, to red.

Obliterated by torture, partially clouded over by blood. Darkened by a vile fog, red as blood, a fog as sticky as blood.

The deformation of the human face by torture, its obscuration by its own blood that has escaped from within, by the blood that, hidden at first, now pours itself out, is suddenly released.
Each face is darkened by its own blood.

Negro masks, Michelangelo's *Slaves*, Picasso's *Guernica*, crucifixions, descents from the cross, the faces of the holy.

They are religious paintings; this is an exhibition of religious art.

The fusilladed replaces the crucified. An anonymous man replaces the Christ of paintings. Elsewhere, they are holy faces, certain of which very much recall Veronica's cloth (the one that retained the imprint of Christ's face).

And just as the artists of the Middle Ages and the Renaissance rarely painted the torturers of Christ, just as we do not see the act of the crucifixion figured in their paintings (I mean that we don't see soldiers with hammers nailing the body to the cross or with hoists bearing up the cross) and just as they have, on the other hand, very often, at every moment, on all occasions, depicted the victim's body, taking it as a pretext for their nude studies, no doubt because they considered Christ to be the perfect man and his body the perfect male body and, as such, they naturally identified with him, like them—although it surely would have been more logical and easier to stigmatize Nazi cruelty by showing the act of torture, so as to leave no doubt as to the origin of, the cause of, responsibility for these mutilations—Fautrier had no inclination to paint the torturer, did not feel up to it in heart and soul; therefore it was not in his power. Whereas the victim, the victim, oh, I know with my heart and soul that it could have been me.

Here, then, we stand before a new subject, of such (negative) signif-icance that a new mythology, a new religion, a new human resolve can emerge from it. This religion is not entirely one of freedom: it is that of humanity, with all its voluntary discipline and also, with regard to its exe-cutioners and their accomplices, the unforgiveability that belongs to it.

Francis Ponge

Anti-German unanimity, humanist unanimity against such atrocities, has given us a common soul—as in the Middle Ages—a soul that we do not have to look after, that goes without saying.

Since the artists of the Middle Ages worshiped Christ, the Virgin, and the Saints, there was no question that this was their natural and readily outlined subject, their unique subject, a subject they painted with immediate, unquestionable, self-evident fervor, about which there was nothing to prove, nor anything to say. This, on the other hand, allowed them to consider these subjects only as pretexts, and to devote themselves entirely to properly painterly problems and techniques—so it goes for this new national, international and human unanimity and for Fautrier.

In this way, Fautrier has no fear of the subject. He has a passion for expression (for the tube of paint). He did not take up painting to say nothing, or to say just anything. That is his achievement.

How is this possible? How is it possible for me to recognize here the horror and compassion instilled in me elsewhere by the torture of human flesh, the deformation of human bodies and faces; horror, remorse, and, at the same time, the will to triumph, the determination? Fautrier shows us tumescent faces, crushed profiles, bodies cramped by gunshots, dismembered, mutilated, eaten by flies.

He is right, for here it is about the most important cause of the century: the cause of the Hostages.

And secondly, he shows it to us as he must: in a *manner* so gripping (which becomes increasingly more gripping over time), and so irrefutable, so beautiful, that it will last for centuries. (Because, even of horror, man only retains those images that please him.)

Shall we now say that the faces painted by Fautrier are pathetic, moving, tragic? No, they are pastose, drawn with thick strokes, strongly colored; they are painting. This can be said, because one cannot say that they are flesh. They are not poor copies of flesh. Paint comes out of the tube, it spreads out in some places, elsewhere it is applied thickly; the drawing draws its lines, takes shape; each from its own side, each for its own part. It is a whole species, a family of new feelings, that Fautrier offers us: they range from eye's delight to horror, to the eye's terror.

We said it: it would be vain to attempt to express in language, with adjectives, what Fautrier has expressed through his painting. Adjectives, words, do not do Fautrier justice. What Fautrier has expressed through his painting cannot be expressed in any other way. How might one get

around this difficulty? Perhaps one might try a song of praise on zinc white coming out of a tube? A song of praise on pastel crushed in primer, on oil paint?

If the end justifies the means? We see the result: nameless and nearly faceless atrocities.

Well! If *in art* at least the end justifies the means? For the sake of this result: beauty.

Fautrier's works tend to distance themselves more and more from painting and approach something else. Especially because of the pasty structure. What is quite remarkable, by the way, is that, properly speaking, it is not a pasty application of color, as one might believe at first. It is white applied pastily. It is a thick layer that is worked in with a brush or a knife and has a certain shape or is at least defined. By what means? By the artist's taste and the requirements of the subject. There is a relief to this layer as well. It is not the same everywhere. It is applied in this way or that way. Most often it appears as superimposed petals, but sometimes it is deeply ridged, or gathered in craters, ravines, fissures. On this basis, or better on this primer, the color is usually applied in a very thin layer.

... (Continue by elaborating on the development of the application of color. The role of this layer in catching light reflexes or serving other purposes, depending on the concept of the painting.)

The parts of the canvas that are not covered with this thick layer of colored white are treated in another, quite unusual way. Here, a *special* glossy primer is applied warmly and, lastly, ground pastel powder is applied onto this still warm primer. According to the artist, this powder incorporates itself into the primer so as to constitute a material even more resistant than oil paint. The whole thing takes on a strange appearance: brilliant and granular at the same time, like stucco on a varnished surface.

His very special technique subjects the artist's work to its own conditions. He takes a long time preparing for the painting he will create, but this preparation is quite Platonic. In contrast, the execution must be fast and intense. On the day he will paint the intended painting, Fautrier gets up before dawn. He begins by stretching his canvas onto the frame, then he glues one or more layers of paper to this canvas as firmly as possible. Now the primer is heated and applied and the pastel dust immediately worked into the primer. Finally, tubes of white are taken to hand, expressed, brought onto the canvas, then the work with the brush and,

at the same time, with the surface coloration of white with colored oils begins. (A layer thinner than the epidermis.)

The work should be finished in a few hours and, in any case, within the same day. It is good or bad. At any rate, you see it costs Fautrier dearly. For some parts (where the white layer is especially thick), it takes up to a year to dry.

One of the ways Fautrier responds to those who think they compliment him by saying he has gone beyond easel painting, that he paints for the wall, for architecture: "No! For the wall limits the work too much, there is the light, there is the wall itself, which one has to deal with. Fernand Léger, he would be a marvelous fresco painter."

It is clear that Fautrier has a different ambition. He wants to break through the wall. He considers painting an artistic being of a higher order, as Rembrandt or da Vinci might have, for example.
Like a meteor, like music (psalm), like the moon.

Fautrier is subject to many inner constraints: He has very high expectations (on the one hand), but on the other hand he is so full of inner scruples that he has no need to impose further external ones. His passion is enough for him.

Thus, his passion is imposed on him by the passion of others, of anonymous humanity.

Censorship and the Authorial "I": Lothar Lang

Valerie Hortolani
and Valerija Kuzema

From 1957 on, Lothar Lang (1928–2013) observed the developments within the art scene of the German Democratic Republic (GDR) as an art historian, art critic, and curator. Lang's texts illustrate the thematic and literary scope for writing about art in an authoritarian political system. They testify to his active commitment to making the artistic diversity and quality publicly visible within a clearly defined geographical and political landscape. Through the written word, he enabled a broad readership to experience this art. Lang's prolific written output, which continued after the GDR era, still provides an important insight into art production and the response to it in the GDR. His archive is kept at the Art History Seminar at the University of Hamburg.

Of particular note are the exhibition reviews and accounts of studio visits that Lang wrote as a freelance art critic for *Die Weltbühne*, a magazine founded in 1905 and edited before World War II by, among others, Kurt Tucholsky and Carl von Ossietzky. It was revived in the GDR as a weekly forum for politics, art, and economic issues. Lang did not confine his virtuoso literary prose to the artworks of numerous visual artists. Through detailed descriptions of those he portrayed or anecdotal recounts of entire conversations, Lang also relayed intimate insights into creative worlds. He displayed his expertise with stylistic and art-historical classifications. When selecting artists, he prioritized artistic value and innovation—whether in the continuation of stylistic questions of modernism or in implementing a broad interpretation of

a Socialist Realist concept of art. By highlighting his subjective approach and consistently applying his first-person perspective, Lang managed to feature artists who were at very different points along the spectrum of proximity to the GDR's official art system. Among his subjects were artists with generous state backing such as Werner Tübke and Bernhard Heisig, proletarian revolutionaries such as Hans Grundig, the "Berlin Cézannist" Harald Metzkes, and the abstract artist Hermann Glöckner. A selection of thirty-seven studio visits appeared in book form in 1975 as *Encounters in the Studio*.

The entangled biographies of many individuals in the GDR's cultural sector were complicated after German unification, when evidence emerged of their role as unofficial informants for the Ministry of State Security (Stasi). Lang was no exception, as Hannelore Offner and Klaus Schroeder were able to reconstruct on the basis of various documents in their 2000 study "Eingegrenzt–Ausgegrenzt. Bildende Kunst und Parteiherrschaft in der DDR 1961–1989" (Isolated–Excluded: Visual Art and Party Rule in the GDR 1961–1989). According to this study, Lang had been instructed to keep an eye on the artist Roger Loewig, who suffered severe persecution in the GDR and left for West Berlin in 1972. Lang also reported on his cultural contacts in Western countries. Without this willingness to cooperate, it is unlikely that he would have directed the GDR's contribution to Documenta 1977 in Kassel. The other side to this coin is the appreciably critical attitude to the GDR's culture policy in Lang's writings.

In this respect, his dealings with the Stasi were symptomatic of an attempt at balancing his professional aspirations, a desire to expand his personal and professional radius (including the opportunity to travel abroad), and his active advocacy for art production in the GDR, which Lang played a major role in illuminating.

In 1979 Lang submitted his programmatic essay "Fragments on Art Criticism" to the art magazine *Bildende Kunst* as part of a written debate in the wake of a resolution adopted two years earlier by the Politbüro of the Socialist Unity Party (SED) on the "Tasks of Literary and Art Criticism." Lang argued here in favor of a lively art criticism as an "inspiring dialogue partner in the art process," both for those who produced art and for those to whom it was addressed. Although Lang made the case for this "processual character" and against the formulation of dogma, his idea of art criticism was nevertheless compliant with the system insofar as he saw its function as serving an art system that took Socialist Realism as its model. His piece offers important reflections on the mission and potential for art criticism not only in the GDR, but also, given its mediating function and its interdisciplinarity, beyond this original socialist context.

Annotations on Painting in Leipzig, with an Update on Tübke

Lothar Lang

excerpted, from *Begegnung und Reflexion. Kunstkritik in der Weltbühne;*
first published in *Die Weltbühne*, 1965

... And today? Does Leipzig have any fine art worth mentioning in our own times? Answers can be found not only at the exhibition *500 Years of Art in Leipzig*, but at the Seventh District Art Exhibition, which has made its home at the Neues Messehaus am Markt. Sculpture, if we ignore the early Walter Arnold, does not weigh much in the balance; the weight of the prints and paintings is all the greater. To leap ahead: Leipzig's District Art Exhibition is emphatically more diverse and interesting than its Berlin counterpart (*Berlin heute*), especially as—singling out the best— some works on show call for exhaustive exploration, for they tread closer on the heels of our time than those Berlin can display, and are closer to our time in an intelligent sense. These themes are not naïve or fatuous and lack neither imagination nor ideas; they give rein to a narrative element. They are heirs to a great line of tradition stretching from the Old Masters of the Early Renaissance to the Surrealists.

Two stylistic trends can be observed at the Leipzig exhibition: a sequel (highly varied by dint of very different methods) to New Objectivity, and an art located among principles and techniques from the ambit of "Fantastic Realism"; ideologically, however, neither can be identified with those movements. Painters operating more or less consciously within the New Objective tradition include Thiele, Dornis, Richter, Pötschig, Kuhrt, and most prominently Wolfgang Mattheuer, who reveals the palpable influence of Beckmann, even of Picasso, say in *Cain*, the most impressive painting to stem from that artist. The doyen of the other group—although strictly unlike all the others in terms of technique—is Werner Tübke; other adherents are Heisig (not all his works!), Ebersbach, Ruddigkeit, and Zander....

When I wrote a longer study of Werner Tübke (1929–2004) in 1959 (*Die fünf Erdteile. Über die 10 Wandtafeln von Werner Tübke im Astoria-Hotel zu Leipzig*, in: *Junge Kunst*, Berlin 1959, no. 8), I highlighted the methodical rigor of this artist, who has turned to his own account the composition and technique of the old hands, not least Hans Baldung Grien, Grünewald, Multscher, or Piero della Francesca, Giorgione, and Carpaccio, and I noted moreover his affinity to magical realism. In 1962,

I described Tübke's style as an estrangement of everyday life (*Tübkes Zeichnungen und die Lust am Erkennen*, in *Die Weltbühne*, August 13, 1962). The painter works with surreal alienation, the details (observed or constructed) which he forms with such old-masterly precision appeal primarily to the *ratio*. The *Livestock Brigadier Bodlenko*, that equestrian portrait at the Fifth German Art Exhibition, remains in my opinion a weak effort—and I have just confirmed that impression again in Leipzig—because it uses those brilliantly executed objects to immediate end and is entrapped in the simulacrum, however masterfully it is crafted. It may well be that through this and associated works, Tübke has made progress in his painterly appropriation of thing-objects, but I have the feeling that his art is withdrawing from time....

It will not have escaped the attention of any close observer of international art events that discussion has lately turned more frequently to works expressing political commitment. In literature, this includes plays by Walser, Hochhuth, and Weiss, in fine art it is sculptures, paintings, and prints in the exhibitions *Signale, Manifeste, Proteste im 20. Jahrhundert* in Recklinghausen, *Arte e resistenza* in Bologna and Turin, and recently the exhibition of anti-racist paintings in London in which Guttuso and Sartre were involved. Tübke's painted oeuvre is particularly

Bernhard Heisig, *Christmas Dream of the Incorrigible Soldier*, 1975/77

important in this context as a contribution to a contemporary form of *l'art engagé* that combines political implacability with artistic mastery, albeit a contribution that comes across in these parts as a novelty with its formal idiom that is as old-masterly as it is surreal. Besides, in Germany the principles of surreal composition have never really taken root; Max Ernst, Richard Oelze, even Franz Radziwill are the exceptions. In recent years, this technique has found a center in Vienna. I am certain that the "Fantastic Realists" (Rudolf Hausner, Ernst Fuchs, Wolfgang Hutter, Anton Lehmden, Erich Brauer, et al.) in the Austrian capital would applaud Tübke if only, instead of a clear-cut class standpoint, he had added a strong dose of Freudian psychoanalysis, an obsession with the subconscious, an enigma of inscrutability. But it is above all his specific class standpoint that is Tübke's distinguishing feature...

After Tübke, the most interesting painter in Leipzig is doubtless Heisig, but he is not so sure-footed, there are fluctuations in his quality that are not easy to explain. It is hard to understand his fashionable portraits of women, dime-a-dozen stuff found in abundance in any gallery in Munich or Vienna, neither original nor remarkable. But alongside them are very striking canvases, such as the *Christmas Dream of the Soldier Who Never Learned* (1964) and the third version of his *Paris Commune*, and some equally competent drawings and lithographs. His painting owes much to the best pieces by Oskar Kokoschka, and for that reason there are brushings with the work of the Viennese artist Georg Eisler, although now and then with the immediacy of an action painting by Willem de Kooning.

Hermann Glöckner

Lothar Lang

from *Begegnungen im Atelier*, 1975

He had been described to me as a person of few words who liked to keep his distance. I only knew him from the drawing that Bernhard Kretzschmar made in 1933 of a meeting of the Dresden Secession: Glöckner next to Dr. Löffler at the head of the table with a champagne glass in front of him.

The man now opening the door is tall and gaunt, wears linen trousers and a plain shirt, both white. He greets me without exuberance but with the relaxed amicability of someone who has given great thought

to himself and the world. I am led into the tall, spacious studio. It is dominated by a desk standing opposite the enormous window and by five easels bearing works by the artist. I also note a variety of three-dimensional architectural models, suggesting that Glöckner has been addressing structural problems. I am immediately struck by the rule of order in this room: The brushes lie carefully waiting, tools for painting and drawing have been thoughtfully positioned—through their place, the things reveal that the artist need not look for them, they are at hand when he needs them.

We begin without preamble. Hermann Glöckner sets out the works he wants to show me. As I have not seen much in exhibitions, this will take a few hours. The artist has prepared for the visit and has compiled nothing less than an educational program so that I will have a graphic account of his path thus far. His early work—landscapes, portraits, buildings—is bare and austere, and yet the colors blossom with an intense restraint reminiscent of the culture of Old Masters. Glöckner's experience of landscape is essentially a spatial one of arrangements and constructions; his works soon emerge as a place for geometry. There is an emphasis on the cubic, angular triangularity, the rhombic, and the rectangular. The muted colors are graded within an underlying tone, not least by a final timbre added roughly, sometimes a little like relief. A firmness and quietness speak from such compositions. The landscape's tranquility and the portraits' archaic feel testify to an endless human desire for harmonious moderation and perfected order. One of his works hangs in the Albertinum at Dresden alongside paintings by Schlemmer and Feininger; this proximity underpins relationships, evoking the place in art history and the status of the painter.

Glöckner has been systematically examining the geometric scaffolding of painting since 1931 (his first attempts date to 1919). Over the years, this has resulted in a compendium of educational plates that samples the options for painterly composition. I see entire developmental sequences that express the grammar of painting. For these investigations, the painter has resorted not only to the brush, but has applied stencils to create variations in series: modifications to a constantly recurring base—a procedure, by the way, remotely reminiscent of the technique of fugue.

I ask about his life. There is no theatricality about it. This coming January he will turn eighty. He studied under Gussmann, but mainly under the Old and New Masters in the Dresden gallery.

"The usual prizes, travels, and bursaries were not wasted on me," he says with a faint smile. I manage to steal a look at him now and then as he shows me his work. His distinctive, donnish head with the long white

hair cuts a dignified figure. Add to this his unhurried movements, his considered diction, and the knowing light in his eye as he handles the pictures. "I worked on most of them over the years," he says. That is evident from the works; there is something classical about them in the sense of a finality, there is no expressive excitement here. Only quietness. Sometimes he is asked about his relationship to the Bauhaus. While there are affinities rooted in the constructive principle, the differences prevail: for all his compositional logic, Glöckner always remains a man of sensibility and painterly culture, and in that respect a true Dresdener.

The artist shows me a few more works hanging in his apartment. We enter little chambers full of nooks and crannies, some of them reached by stairs: Glöckner has made his home in the city's House of Artists on Pillnitzer Landstrasse, notorious for its quirky structural irregularities. There is a bower with a balcony. I step outside, at my feet a fine old grave-yard stretching along the river meadows, then the Elbe itself, and far away in the background the hills of Saxon Switzerland.

On the way home, I think about the reasons for the significance of this quiet artist, this subtle, simple man who never made much of a fuss about himself, but has stuck firmly to principles throughout his life and is fortunate in his advanced years to know that many collectors appreciate him. His works hang not only in museums but also in homes in Dresden, Halle, or Berlin. I believe that Hermann Glöckner has sought in his art to fathom the laws of beauty that are revealed in the painterly image. There have always been painters who followed the Pythagorean trail and explored the mathematical order in art, not unlike those architects, composers, or poets who attempted to capture the fundamental laws of their labor within a strict canon.

The Hans Grundig Exhibition, 1973

Lothar Lang

excerpted, from *Begegnung und Reflexion. Kunstkritik in der Weltbühne*; first published in *Die Weltbühne*, 1973

... His art is not a vacuum that needs filling with little stratagems of ideological interpretation in order to unfold its credibility. Here the class standpoint is not merely intended or added as a sloganizing veneer, but

is inherent in every composition, every pictorial idea, even when it is grotesque, fantastical, or allegorical; it inspires the line as much as the precisely defining and symbolically blazing color. Work against which to gauge afresh the serviceability of our criteria. This third major Hans Grundig exhibition clearly establishes the artist as a classic exemplar of our socialist art....

The catalogue stewarded by the Academy of the Arts opens with a very personal foreword. It comes from one of the most gifted pens among our art historians, that of Günter Feist, and it reminds us of the year 1958. Although Grundig was not unknown, that was the year of his true discovery. For many of us starting out on our jobs as art critics (and granted friendly encouragement by the artist), the exhibition of the two Grundigs (first in Dresden, then in Berlin) was a revelation. We recognized that art, in its intellectual content and in the artistic power of its language, surpassed almost everything that governed the opportune everyday stage at the time.

Grundig's art was contested. There were adversaries who could warm to it little, if at all. Today that sounds incredible. In my exhibition review back then (*Die Weltbühne* 23/1958), I had made a considered choice to include the designation "artist of Socialist Realism" in the heading. At that time, the term was usually applied in its crudest form, although writers were not yet dispensing it quite so catchily as in later years. But when freed of flippant prejudice it accurately expresses the essence of this art which, in turn, helped over time in dialectical fashion to hone this concept so pivotal to our aesthetic. Grundig was a perfect example for how artistic practice is certainly richer than theory and how ridiculous critics are therefore bound to seem if they believe they can ignore this practice in its undiminished breadth and differentiated variety, as has often enough been the case in art....

Grundig, a man who was as politically active as he was artistically uncompromising, knew that even in art, as Becher once said, the stakes are supreme, for it is about life and death. Hence these sights set upon the whole; hence the sustained vision behind his work; hence the depth of his gaze and the beauty of his painting. They are also the reasons why I am pleased that the current exhibition in Berlin will move to Leipzig, for that city has become a center for young artists. That is where Grundig belongs. As a silent participant in a conversation about the worthiness or unworthiness of that trend in painting which, in revisiting Old German traditions and New Objective techniques, visually steels reality.

Why is Hans Grundig so topical in this dispute? The answer is simple: he too resorted to the Old Masters, invoked Grünewald and Bosch,

and his early work took shape in the entourage of that verism widely and often erroneously labelled New Objectivity. Grundig too, for all his fantasy, is accurate and precise. But his art is not historicist. It sees not only Grünewald's forms but also the passion of his colors, or to be more accurate: Grundig studied the form and color used by the old painters and by his contemporaries in order to let them speak in a new way. His art became the art of a Communist.

He painted a KPD (Communist Party of Germany) meeting (1932), truthfully, objectively—but what poetry! (And how many pictures of meetings were painted afterwards that did not remotely come up to this standard?) Hans Grundig did not depict; he took a stance. He did not illustrate with paint, but created with and from it. He was not trying to be novel and different at any price, because he had far too high a concept of artistic quality. His art proved to be the most direct extension of his feelings and thoughts, became their visual materialization.

One cannot imitate Grundig (what a horrifying idea), but with the aid of his work one can delve more deeply into the potential for visual art, one observes our present scene with a sharper and more critical eye. Rarely has an exhibition been so relevant to the debate about art as this one.

Harald Metzkes at the Nationalgalerie, 1978

Lothar Lang

excerpted, from *Begegnung und Reflexion. Kunstkritik in der Weltbühne*; first published in *Die Weltbühne*, 1978

The major Metzkes exhibition at the Nationalgalerie Berlin is a triumph for this realist and at the same time for the powerful yet sensitive painting which has been labelled "Berlin School." More than ten years ago, a skirmish among critics blew up around the artist, badly ruffling his feathers but leaving him intact as a painter. Today, it is an established fact that Harald Metzkes, born in 1929, ranks among the significant forces of the "second generation of GDR artists." Within it he is the most talented proponent of a realism schooled by Cézanne and Courbet, which takes its cue principally from sensory impressions (not cognitive constructs), or to be more precise, from what people's eyes allow them to see and perceive....

Thirteen years ago, I wrote in this magazine (*Die Weltbühne* 33/1965) that Harald Metzkes and his friends are not innovators, but traditionalists

in the positive sense of the word. I really have nothing to add, except perhaps for this postscript: it always ends badly when anyone tries to play off "innovators" and "traditionalists" against each other. Art needs both. And many an "innovator" has come a cropper when it turns out that they have not been inventing, but cribbing. Even a "traditionalist" is a man of progress in art as long as his work reflects neither conservatism nor provincialism (and no one can accuse Metzkes of that).

Metzkes's position in Berlin painting might for once be compared with that of Max Liebermann, albeit a Liebermann invigorated by Courbet and Cézanne (and that in itself flags up the considerable difference from the style of the German Impressionists), but he will always be characterized as a guardian (and grower) of a highly realistic culture of painting. Every age has a need for such figures if Delacroix's maxim that painting should be a feast for the eyes is to be saved from oblivion.

Fragments on Art Criticism

Lothar Lang

from *Bildende Kunst*, 1979

My thoughts on art criticism remain fragmentary. They take as given the resolution by the Politbüro of the SED Central Committee on "Tasks of Literary and Art Criticism," published in *Sonntag* no. 48/1977, acknowledging its conclusions and consequently not repeating it here.

*

Writing about art is not automatically art criticism. Writing about art embraces many journalistic formats, including the review, reportage, portrait, interview, comment. Other texts that fall under the heading include those intended to educate about art or to popularize it, including sophisticated contributions to art historiography, the analysis of an oeuvre, a catalogue raisonné, or even art theory; the following thoughts refer solely to criticism.

*

Criticism only makes sense if it functions as a constant, inspiring partner in dialogue (for producers and addressees) in the art process. Anything else, even if it calls itself criticism, seems to me superfluous. Unfortunately, much is published that is superfluous.

Criticism must help art which it recognizes as valuable and important to establish a footing. This journalistic commitment calls for both passion and courage (including the courage to admit mistakes: no critic is infallible). Criticism combats retrograde elements in the aesthetic consciousness of those for whom the art is made. Criticism must be governed by interdisciplinary (intermediary) thinking. A critic of fine art must hence not be clueless when faced with the processes and problems of the other arts (nor of aesthetics and culture policy).

*

Criticism that offers nothing but praise is dysfunctional. Criticism must not presume to know the absolute truth—nevertheless, it has a duty to express judgments; it must set values. But criteria (especially new criteria) are established by works of art, not by critics. The most complicated, difficult thing about criticism is to be open-minded about what is new. The scope for error is demarcated not by the radius from works that are weak or mediocre, but by the "boundaries" of art pushed out by artists. Errors, then, arise in the recognition of what is good or exceptional. A critic who cannot detect poor artistic quality is in the wrong job.

*

Criticism here and today has (as ever) a strategic and a tactical function. Strategy: It plays its part in the ever deeper and richer formulation of a realist art in socialist society. Tactics: It focuses on what is possible, achievable at the moment—in this respect it fosters talented artists knowing that their works are not the non plus ultra of Socialist Realist art (and in any case there is no such thing).

*

Serious criticism is creative. This is revealed in the way it tracks down artistic significance, and likewise in the manner in which the case for art is made. Criticism must be readable; its language should fascinate. Those who cannot wield a pen must learn to do so—if they fail to acquire this skill, socialist society offers them other opportunities to make an impact.

*

Writing criticism calls for the specific sensibility and emotionality which also distinguish an artist. A critic must be able to see and feel artistically, must have an artistic disposition. (Criticism is not "frozen mathematics," Kurt Tucholsky.)

*

Criticism is formulated at the desk. It is only possible (and productive), however, as a result of broad practice; in other words, of a thorough knowledge of works (the art studio as a second home; it follows that one does not graduate from university as an art critic).

*

Criticism should at once be science, and literary (journalistic) prose (essay, feuilleton). (Ludwig Justi was proud to call himself an art writer).

*

Criticism should be science and literary stance does not seem possible to me *(sic)*. But it must of course accept artistic opposites as long as they display quality. Criticism will repel haphazard opinion and taste (without expunging the latter). Criticism must interpret from within the social and art-historical (and art-contemporary) context: this cannot dispense with comparison. Criticism must not wear itself out in description (this can at best only approximate to the work), but must read meaning. What constitutes artistic quality is a question of existential importance to the critic. It can only be answered dialectically. There are many criteria feeding into the assessment, such as the principle underlying the relationship between the parts and the whole (quite apart from the craft aspect). But answering that question would require writing a book on the subject. I do not yet have the time for that.

*

Criticism acts as a go-between. It deals with the ever-fresh conflict between the horizons of public expectation and the intentions freshly formulated by the artist in a new work. Criticism, in this context, cannot always explain everything from scratch all over again: professional critics (they are few in number, we have more amateur or occasional critics) address an audience (not a random reader) which follows their work (like the work of an artist).

*

A more or less objective judgment about art/artworks only emerges from the (in part historically composed) sum of eligible criteria. A single critical voice, important and indispensable as it may be, is only—in comparative terms—a trigonometric point; it is not in itself enough, to stick with the metaphor, to chart the landscape of art. Here lies the analogy with art: the art of an age does not equate to a single style, a single movement, a single manner of doing things, but to the totality, the ensemble of all creative individualities.

*

Critics, like artists, must be allowed to develop. Over the years their work will become more precise, more polished, more subtle, more apposite (but they must have no fear of the—often foolish—feedback from the artists who are their subjects). Criticism, then, is by nature a process. If it were not, it would ossify like dogma.

Trespasser of Gatekeeping: Oscar Masotta

Juli Carson

Oscar Masotta's "I Committed a Happening" had a seismic effect on me when I first encountered it in 2008. I'd been residing in Buenos Aires, studying Argentina's reception of Lacanian psychoanalytic theory over the sixties and seventies. It turns out that Masotta—the Porteño artist, critic, and politico—had introduced Lacan to the Argentine *campo* a full decade before it would be introduced to the Anglophone northern hemisphere by the very artists, art historians, and cultural critics I'd been researching for some twenty years then. Mary Kelly, Griselda Pollock, Jacqueline Rose, Laura Mulvey, and Parveen Adams were key players on that front. But what Masotta added to the mix was a programmatic triangulation of art, theory, and politics—a defiant stance against the real-time fascism then gripping his home country on the eve of the United States–backed Argentine Dirty War (1976–83). For him, Jacques Lacan's destructuring of "self and other," taken together with Allan Kaprow's happenings—wherein the distinction between audience and performer were similarly dissolved—aptly combined for the kind of moral-social intervention of which Jean-Paul Sartre had conceived in his seminal 1947 text "Situations."

That said, Masotta was disinterested in normatively "committed" political art, in any *realist* sense of the word. "I Committed a Happening" is at once a deconstruction of Sartre—a call for "autonomous" aesthetic action—in that it is a *reconstruction* of the philosopher's political imperative. Hence Masotta's self-interpellation—*I committed a happening*—as a performative gesture

denoting his transgressive "crime" of aesthetically trespassing the Left's political gatekeepers. This doesn't let the art world off the hook, however, because Masotta argues that cultural institutions offer a space for critique inasmuch as they do complicity. So when a contemporaneous professor—purportedly speaking on behalf of the Left—challenged the political efficacy of happenings, Masotta countered that the choice between happenings or Left politics was a dialectical siren song. Instead, Masotta not only insisted on producing happenings under dictatorship, he doubled down on committing conceptual happenings. When his friends on the Left challenged him as to this artwork's meaning, Masotta obliquely answered: "My happening … was nothing other than '*an act of social sadism made explicit*.'" For Masotta's happening ethically sought to expose the manner in which the sadist gaze, ubiquitously occupying the Argentine campo, was virulently latent within the very aesthetic milieu that opposed it.

Accordingly, the first-person form of "I Committed a Happening" was not incidental. Masotta aimed at fomenting the same kind of trouble within his academic milieu that he did within the imbricated world of art and politics. This was not without risk, as Theodor W. Adorno's "The Essay as Form" (1958) warns, for "… to praise someone as an *écrivain* is enough to keep [them] out of academia." Why? Because the essay form—inherently autobiographical, experimental, and methodologically non-Cartesian—tenaciously holds out against the academy's hardline distinction between art and science. This, most likely, was Masotta's initial attraction to Lacan. For just like the *écrivain*, Lacan, too, had been famously expelled from the International Psychoanalytic Association, whose "central committee" had denounced his controversial practice in 1963, by way of evoking Science with a capital "S." Analogously, Masotta's seditious essay form—one triangulating Sartrean situational politics, Kaprow's heterological happenings and Lacan's self-reflexive impulse—was a willful and fearless shout against the institutional expulsion then being threatened against noncompliant Argentine critics. His type of writing is woefully needed today, ensnared as the art world is within a similar global syndicate of authoritarian state leaders and corporatist financial markets. Today's art critics—those seeking to trespass the canon's cultural gatekeepers—would therefore be wise to heed Masotta's interdisciplinary call to action.

I Committed a Happening

Oscar Masotta

first published as "Yo cometí un Happening," in *Happenings*, Buenos Aires, 1967

When, in the December 16 edition of the newspaper *La Razón*, I read Professor Klimovsky's condemnation of intellectuals who "concoct" a Happening, I felt directly and personally implicated. If I am not mistaken, the number of people in Buenos Aires who fulfill such conditions can be counted on half the fingers of one hand. And since Klimovsky recommended "abstaining" from Happenings and "investing" the powers of the "imagination in lessening this tremendous plague" (of "hunger"), I have to admit, seriously, that I felt ill at ease, even a bit miserable. So I said, "I committed a Happening" to quell this feeling.

But I was quickly able to regain my composure. The choice of "either Happenings or Left politics" was false. At the same time, is Professor Klimovsky a man of the Left?[1] It was enough to recall another either/or—of the same kind—that Klimovsky proposed in his prologue to the book by Thomas Moro Simpson,[2] where one reads: "We are much given to existentialism, phenomenology, Thomism, Hegelianism, and dialectical materialism; by contrast analytic philosophy is almost absent from the curricula of our philosophy schools The causes of this state of affairs are diverse, reflecting the unusual preponderance of these latitudes of ... certain religious or political traditions." Finally, one must reply in the negative: No, Professor Klimovsky is not on the Left. First, because of the explicit tendency to assimilate the political to the religious, as we read in the preceding paragraph. Second, because in the context, when Klimovsky says "political" he directly denotes "dialectical materialism," i.e., this philosophy of Marxism. Third, because these two lines of assimilation seek only to persuade one of the truth of the false, right-wing choice: "either Marxism or analytic philosophy." And fourth, because it was anecdotally, i.e. historically, false that there existed at the moment when

1 That he is not, in truth, would not prove much. The same prejudices with respect to this word—"Happening"—can be found in a Marxist intellectual or party militant. Nor is it a matter of trying to disarm the adversary's arguments by drawing attention to what he *is not*. I introduce the question of the Left here for expository reasons, to set things up more rapidly.

2 Thomas Moro Simpson, *Formas lógicas, realidad y significado* (Buenos Aires, 1964).

Klimovsky wrote this prologue any preponderance in the teaching of the "Marxist tendency" in Argentine halls.

I said that the two choices are of the same kind—in both, one of the opposing terms does not belong to the same level of facts as the other. Analytic philosophy (the philosophy of science + modern logic + the analytic study of the problem of meaning) does not include any assertion about the development of history, the origin of value labor, the social determination of labor, or finally the social process of production or the necessity of revolution that can be read in this process. It could then additionally be said that insofar as Marxism includes proposals concerning the origin, value, and scope of ideas, for example, it includes analytic philosophy, while the reverse is impossible. Marxism can certainly integrate the results of the analytic study of propositions and strengthen its methodology with the contributions of the logic and philosophy of science; while, on the contrary, if analytic philosophy claimed to include Marxism, it would simply dissolve eighty percent of the assertions of Marxism, which, being proposals about society as a whole and about the totality of the historical process, are effectively synthetic, if not dogmatic.[3] We then see that there exist two perspectives from which to look upon the relation between Marxism and the philosophy of science. If one does so from the viewpoint of Marxism, there is no exclusive choice but a relation of inclusion and complementarity. If, on the other hand, we look from the viewpoint of the philosophy of science, the terms become contradictory and the choice is exclusive.

The same holds true for the choice between the Happening and the concern with hunger.... Given that the Happening is nothing but a manifestation of the artistic genre, the surest and easiest way of answering, using words in their proper meaning, is to say that by extension this choice would also include musicians, painters, and poets. Must one then look in Klimovsky's words for indications of his totalitarian vocation? I do not think so. Professor Klimovsky is surely a liberal spirit, of whom, I am sure, one could say the same as Jean-Paul Sartre once said of Bertrand Russell some years ago—that in truth, for him, intellectuals and science are *all that exist*. But what must have certainly occurred is much simpler: Professor Klimovsky was caught off guard by the phenomenon

3 Dogmatic in the positive sense of the word. This is what Sartre sees at the outset of his "critical" investigation of "dialectical reason." But in the reverse, one must certainly take precautions to not to make Marxism into a romantic philosophy of totality and synthesis. The category of totality, its indiscriminate use, has more to do with a specifically spiritualist philosophy than with the strict discipline demanded by the Marxist idea of "science."

of the increasing use of the word "Happening" that Madela Ezcurra has discussed. This mistake—whether intentional or not—is in itself revealing.

The growing connotation of the word "Happening" in the mass media originates in certain presuppositions conveyed by these messages which, when not analyzed, tend to determine their contents. In truth, these presuppositions are nothing other than "ideas of communication," as Roberto Jacoby writes; that is, ideas concerning society as a whole, which include, fundamentally, decisions with respect to the "place" in society to which each sphere of activity should belong. Now, it is certain that no journalist, whatever his level of information, can ignore the fact that, as its very basis, the word is associated with artistic activity, thus a certain apparently positive ambivalence in the degree to which what the word means is taken seriously or jokingly. This is because the idea of Art with a capital "A" carries a lot of weight for these journalists. What comes to pass—and the whole matter is not much more complicated than this— is that through its conservative groups, society establishes the connection between this "place" (a receptacle of hierarchical ideas, of judgments concerning the relative value of the results of every kind of activity) and each sphere of social activity by fixing on the particular activity's "materials." Thus, the prestige of the artist's activity should be systematically linked with certain properties of the material he uses. In this way the idea historically arises that bronze or marble are "noble materials." During the time of Informal Art, and also before then, we have seen the painters react against this idea, but the results were not particularly negative.

And yet the quarrel with respect to the nobility of the material is completely outdated today, and for that very reason it is possible that it has attained a certain degree of vulgarization. Works made with "ignoble" materials are accepted on the condition, I would say, of leaving the very idea of material in place; that is, the idea that the work of art is recognized by *its* material support. To say it another way, there is still a humanism of the human, since the idea of material is felt to be the "other" of the human (and it is granted transcendence for this reason). There is a fundamental opposition of human subjectivity on one hand, sensible material on the other. If one carried the analysis further one might see that as in Claude Lévi-Strauss's description of the myth, this binary is correlated with another: outside-inside. Now, in traditional art (and particularly in painting, sculpture, and theater), what is outside of what is outside, man can only have contact with sensible material because he is a body. And on the contrary, sensible material can only

Oscar Masotta

Participants in Oscar Masotti's Happening, 1966

convey an aesthetic image on the condition of *not* encompassing the condition of its existence, i.e. the human body. This could be the reason why, as Lévi-Strauss says, there is a problem of dimensions in the very constitution of the work of art: in some way it is always a *miniature* of what it represents.[4] But what, then, shall we think of the Happening? As it tends to neutralize these oppositions and homogenize people and things, the Happening begins by making the very notion of "material" more improbable, more difficult, as art it is then an activity whose social "place" is difficult to establish, and perhaps Allan Kaprow is right to proclaim that the Happening is the only truly "experimental" art.

From January to March of 1966, and while in quite close contact with Happening-makers such as Kaprow, Dick Higgins, Al Hansen, Carolee Schneeman, and German artist Wolf Vostell, I was able to be present in New York at some ten Happenings. Two particularly impressed me. Both had this in common: they included the physical presence of the artist and the "public" did not exceed, in either of them, more than two hundred persons. But they were totally different. It could be said that one was made for the senses, while the other spoke to the intellect.

4 See the opening chapters of Claude Lévi-Strauss, *The Savage Mind* (Chicago, 1996).

The author of the second Happening was La Monte Young. At the time I was not very familiar with the American "scene," and so I paid attention to the opinions of everyone else. Young: a disciple of Cage, Zen, close to the "cool" painters, into the drug scene. The Happening (or musical work?) was held at the house of Larry Poons, an excellent painter promoted by Leo Castelli. I don't remember the exact address; it was downtown, on the West Side, in a "loft," one of those enormous shed flats that you can find in New York for two hundred dollars a month, and which after painting them totally white are lived in by some painters and simply used as a studio by others. It was on the third floor, and one had to go up via broad stairways that came out in shed apartments like the final one, but totally empty. Only in certain corners, set discreetly on certain walls, could one distinguish canvases: these must have been Poons's pictures. After climbing the last staircase, one was assaulted by and enveloped in a continuous, deafening noise, composed of a colorful mix of electronic sounds to which were added indecipherable but equally constant noises. Something, I don't know what, something Oriental, was burning somewhere, and a ceremonious, ritual perfume filled the atmosphere of the space. The lights were turned out; only the front wall was illuminated by a blue or reddish light, and I don't remember if the lights changed (perhaps they did, switching from red to green to violet). Beneath the light, and almost against the wall, facing the room and facing the audience, which was seated and arranged throughout the space, there were five people also sitting on the ground, one of them a woman, in yoga position, dressed in what was certainly Oriental clothing, and each of them holding a microphone. One of them played a violin, while, seen from my position, not much more than five yards distant, the four others remained as though paralyzed, with the microphones almost glued to their open mouths. The very high-pitched and totally homogeneous sound had at first kept me from seeing the cause of these open mouths, which was that the four, stopping only to breathe, were adding a continuous guttural sound to the sum of the electronic sounds. The violinist slowly moved the bow up and down, to draw a single sound from the strings, which was also continuous. Before them, between these five and the public, could be seen the naked spectacle of a tape recorder playing a tape loop and the cables of an amplifier device. In this timeless spectacle was a deliberate mix—a bit banal for my taste—of Orientalism and electronics. Someone, pointing to the first of the five, told me that it was Le Monte Young himself, and that he was "high."[5] Surely they were

5 In the language of the "junkie," it means being strongly affected by the drug.

Oscar Masotta

right; and the others as well. The event had begun at nine at night and was programmed to last until two in the morning. Among the audience were one or two people who exhibited something like a possessed state, in a rigid meditation position.

In all this there was something that escaped me, or that wasn't to my taste. I don't like Zen, or rather, even while it gives rise in me to a certain intellectual curiosity, since in it there are certainly valuable intuitions about language, it disgusts me as a social phenomenon in the West, and even more as a manifestation within a society so dramatically capitalist as the American one. But I knew neither the practice of Zen, nor the complete theory; and additionally, in this sum of deafening sounds in this exasperating electronic endlessness, in this mix of high-pitched noise and sound that penetrated one's bone and pummeled one's temples, there was something that probably had very little to do with Zen. Since I had entered the room, the physiological condition of my body had changed. The homogenization of the auditory time, through the presence of this sound at such a high volume, had practically split one of my senses away from all the others. I felt isolated, as though nailed to the floor. The auditory reality now went "inside" my body, and didn't simply pass through my ears. It was as though I were obliged to compensate with my eyes for the loss in the capacity to discriminate sounds. My eyes opened wider and wider. And all they found in front of them, enveloped in the quietude of their bodies in the light, seated, were the five performers. How long would this last? I was not resolved to pursue the experience to the end; I didn't believe in it. After not more than twenty minutes, I left.

Two or three days afterwards I began changing my opinion. When you took away the connotations of Zen, Orientalism, etc., there were at least two profound intentions in the Happening by La Monte Young. One of them, that of splitting a single sense away from the others, the near destruction, through the homogenization of a perceptual level, of the capacity to discriminate on that level, brought us to the experience of a difficult restructuring of the total perceptual field. Simultaneously, the exhibition of the performers in their quietude, beneath the bath of colored light, transformed the entire situation into something very similar to the effects of LSD. The situation was therefore something like an "analogue" of the perceptual changes produced by hallucinogens. But the interesting thing, in my opinion, was that this "analogue," this "similitude" of the hallucinatory condition, did not end up turning into one. The rarefaction of the perception of time was not sufficient to transform it into an actual hallucination because it had too much real

weight to become unreal: the hallucination could not go beyond the state of induction. This is the idea that I took to "commit" my Happening five months later in Buenos Aires. But there was another idea in the work of La Monte Young. Through the exasperation caused by a continuum, the incessant sound at high volume, the work transformed itself into an open commentary, naked and express, of the continuous as continuous, and thereby induced a certain rise in consciousness with respect to its opposite. Or, it could also be said that La Monte Young pushed us to undertake a rather pure experience by allowing us to glimpse the degree to which certain continuities and discontinuities lie at the basis of our experience of our relationship to things.

When I returned to Buenos Aires in April of '66, I had already resolved to do a Happening myself. I had one in mind. And its title, *To Induce the Spirit of Image*, was an express commentary on what I had learned from La Monte Young. On disordered sheets of paper, and on the edges of my habitual ("intellectual") work, I noted both the general framework of his actions and their details. From La Monte Young I retained, unaltered, the idea of "putting on" a continuous sound, the product of a sum of electronic sounds, at an exceedingly high volume, for two hours (three fewer than he). As to the arrangement of the performers and the audience, it would be the same: the performers in the front of the room, lighted, and the audience facing the performers in the shadows occupying all the rest of the space. Thus the audience would be obliged to see and indeed to look at the performers bathed in light for the duration and under the high volume of the electronic sound. I, however, would not have five performers, but thirty or forty; and they would not be sitting in a yoga position, but seated motionless in a motley array, on a platform. I then thought that I would recruit them among the downtrodden proletariat: shoeshine boys or beggars, handicapped people, a psychotic from the hospice, an impressive-looking beggar woman who frequently walks down Florida Street and whom one also meets in the subway of Corrientes, with shabby clothes of good cut, varicose veins but skin toasted by the sun; this woman was the perfect image of a person of a certain economic status who had suffered a rapid and disastrous fall. Finally, I thought that at the right moment I would have some money to pay these people, whom I had to find somehow by going out into the street to choose them or search for them. For the rest, the details that accompanied this central situation were not so numerous. I would start off the Happening by talking to the public, telling them the origin of the Happening, that it was inspired by Le Monte Young, and that in this sense I had no qualms about confessing the origin. I would also tell them what was going to happen next: the continuous

Oscar Masotta

sound, the light illuminating the motley-colored downtrodden-looking group of the platform. And I would also tell them that in a sense it was as though the overall situation had been carefully designed by myself, and that in this sense there was an intellectual control over each one of its parts. That the people of the audience could proceed according to their own will, remaining seated on the floor or still. And if they wanted to leave at any moment they could, only they would have to follow a rule to do so. I would distribute little flags among them, and if anyone wanted to leave they had to raise a flag; then I would have this person accompanied to the exit (later I revised the details of the little flags; they softened the situation, and my idea was that the Happening had to be spare, naked, hard). I would go on talking about the idea of control, about the fact that everything had been foreseen. I would repeat the word "control" to the point of associating it with the idea of a guarantee. That the public would have guarantees, even physical guarantees, that nothing could happen. Nothing, except one thing: a fire in the room. But a fire could happen in any other room, in any other theater. And in any event, precautions had been taken, and for this reason I had equipped myself with a quantity of fire extinguishers (which I would have with me at this time and would show to the audience). Finally, to give more guarantees, to reinforce the image of the fact that everything or almost everything had been foreseen, and even designed or controlled, I myself would discharge a fire extinguisher immediately. And I would do it for two additional reasons. On the one hand, because not many people have ever seen a fire extinguisher in action—except those who have been in a fire—and therefore there exists some doubt as to whether, in the case of a fire, the fire extinguishers that we see hanging from the walls will work or not. And on the other hand, for the aesthetic side of the question. Because the discharging of a fire extinguisher is a spectacle of a certain beauty. And it was important for me to exploit this beauty.

Once the fire extinguisher had been discharged, the electronic sound would begin, the lights illuminating the sector of the platform with my performers would go on, and the situation would then be created. For two hours. Later I changed the duration, reducing it to one hour. I think that was a mistake, which reveals, in a way, certain idealist prejudices that surely weighed on me: in reality I was more interested in the *signification* of the situation than in its *facticity*, its hard concreteness. (Think of the difference with La Monte Young, who brought this concreteness to the very physical and physiological limits of the body.)

In April I called together a group of people, plastic artists in the majority, to plan a festival of Happenings: Oscar Palacio, Leopoldo

Maler, David Lamelas, Roberto Jacoby, Eduardo Costa, Mario Gandelso-nas. I invited them to make a successive set of Happenings, in a relatively limited space of time. They accepted; we then planned that various art galleries—Bonino, Lirolay, Guernica, etc.—would each have to take the responsibility of presenting an artist. The group of Happenings would in its turn be presented and presided over by the Museo de Arte Moderno of the City of Buenos Aires. We spoke with Hugo Parpagnoli, the director of the museum, and with the gallerists: everyone agreed. By acting in this way—i.e., by planning out Happenings within an official framework: the presence of the museum—I intended to work according to what may be called pedagogical ends. I was attracted by the idea of definitely introducing a new aesthetic genre among us. For this, our Happenings had to fulfill only one condition: they must not be very French, that is, not very sexual. I was thinking of accomplishing purely aesthetic ends, and I imagined myself a bit like the director of the Museum of Stock-holm, who from within an official institution had opened up to all the avant-garde exhibitions and events. But Buenos Aires is not a Swedish city. At the moment during which we planned the two-week festival there came the coup d'état that brought Juan Carlo Onganía to power; and there was an outburst of puritanism and police persecution. Scared, we abandoned the project: what is more, it was a bit embarrassing, amid the gravity of the political situation, to be creating Happenings ... In this respect—embroiled in a sentiment of mute rage—I now think exactly the contrary. And I am also beginning to think the contrary with respect to those "pedagogical" ends: about the idea of introducing the dissolving and negative aspects of a new artistic genre through the positive image of official institutions.

It was only recently, in November at the Instituto Torcuato Di Tella (ITDT), that I would effectively succeed in carrying out my Happening. The imminence of the date had made me think about my own "image"—about the idea that others had of me and about the idea I had about this idea. Something would change: from a critic or an essayist or a university researcher, I would become a Happening-maker. It would not be bad, I thought, if the hybridization of images at least had the result of disquiet-ing or disorienting someone.

In the meantime, the central situation of the planned Happening had undergone a modification. Instead of people of a downtrodden condi-tion, it would use actors. But you will see, this was not too great a com-promise, nor a tribute to artificiality in detriment to reality. It came about because of a performance that Leopoldo Maler presented at the ITDT. In it he used three older women who had caught my attention: at one

Oscar Masotta

moment they came onto the stage to represent a radio or television show of questions and answers. The women each had to sing a song in order to get the prize. I remembered the aspect of the women, grotesque in their high heels, holding their purses in their hands, in a rather ingenious position. These people very clearly denoted a social origin—lower middle class. It was exactly what I needed: a group of around twenty persons indicating the same class level, men and women. Maler then gave me the telephone number of a woman who could engage this number of people. It was somebody who had something like an agency for placing extras. I called her, she listened to me very courteously, and we agreed that there would be twenty. She asked me to explain what kind of persons I needed, what physical aspect. I summed it up: older, looking badly off, poorly dressed. She said she understood. I would have to pay each person four hundred pesos.

As for the fire extinguishers, I had no difficulty obtaining them. I put myself in contact with an industry that made them, and spoke with the sales manager. Very courteously he accepted my request. He would lend me twelve fire extinguishers for one day. He also gave me instructions about different kinds of fire extinguishers to cover the possibility of various dangers. I would use one that produces a dense white smoke. When I tried it out, before the Happening, I also realized that it produced a quite deafening noise. I would use it as a bridge between my words and the electronic sound.

At five in the afternoon, October 26, the first of the twenty hired people began to arrive. By six all twenty had arrived. Men and women from the ages of forty-five to sixty years old (there was only one younger person, a man of thirty to thirty-five). These people came to "work" for four hundred pesos; it was temporary work, and supposing—although impossible—that they obtained something similar every day, they would succeed at pulling in more than twelve thousand pesos a month. I had already understood that the normal job of almost all of them was to be hawkers of cheap jewelry, leather goods, and "variety articles" in those shops that are always on the verge of closing and that you find along Corrientes Street, or in some areas of Rivadavia or Cabildo. I imagined that with this work they must earn even less than I was going to pay them. I was wrong.

I gathered them together and explained what they were to do. I told them that instead of four hundred I would pay them six hundred pesos: from that point on they gave me their full attention. I felt a bit cynical: but neither did I wish to have too many illusions. I wasn't going to demonize myself for this social act of manipulation which in real society

happens every day. I then explained to them that what we were going to do was not exactly theatre. That they had nothing to do other than to remain still for an hour, motionless, shoulders against the wall of the room; and that the "play" would not be carried out in the normal theater, but in a large storage room that I had expressly prepared. I also told them that there would be something uncomfortable for them: during this hour there would be a very high-pitched sound, at very high volume, and very deafening. And they had to put up with it, there was no alternative. And I asked whether they accepted and they were in agreement.

One of the older ones seemed to pull back, but they all consulted each other with their eyes, and finally, with mutual solidarity, they answered yes. As I began to feel vaguely guilty, I considered offering them cotton plugs for the ears. I did so, and they accepted, and I sent someone off to look for the cotton. A quite friendly atmosphere had already sprung up between us. They asked me about the costumes (each of the old people held a sack or a suitcase). I told them that they should dress as poor people, but they shouldn't use make-up. They didn't all obey me completely; the only way not to totally be objects, totally passive, I thought, was for them to do something related to the profession of the actor.

Soon it came time for the Happening to begin. Everything was ready, the tape loop (which I had prepared in the ITDT's experimental music lab), the fire extinguishers. I had also prepared a little armchair on which I would remain with my back to the public, to say the opening words. I then went down with everyone to the storage room, and explained to them how they were to sit against the back wall. I had also prepared the lights. All that remained was to pay the extras: for this I began to distribute cards with the secretary of the Audiovisual Department of the Institute. The old folks surrounded me, almost assaulting me, and I must have looked like a movie actor distributing autographs. I saw that the first persons had arrived: two of them seemed to be happy. I continued with the cards; when I turned my head again, the room was full of people. Something had begun, and I felt as though something had slipped loose without my consent, a mechanism had gone into motion. I hurried, arranged the old folks in the planned position, and ordered the lights off. Then I asked the people who had arrived not to come forward and just to sit down on the floor. There was quite a sense of expectation and they obeyed.

Then I began to speak. I told them, from the chair, and with my back turned, approximately what I had planned. But before that I also told them what was happening when they entered the room, that I was paying the old folks. That they had asked me for four hundred and I had given

Oscar Masotta

them six. That I had paid the old people to let themselves be seen, and that the audience, the others, those who were facing the old folks, more than two hundred people, had each paid two hundred pesos to look at them. That in all this there was a circle, not such a strange one, through which the money moved, and that I was the mediator. Then I discharged the fire extinguisher, and afterward the sound appeared, rapidly attaining the chosen volume. When the spotlight that illuminated me went out, I myself went up to the spotlights that were there to illuminate the old people and I turned them on. Against the white wall, their spirit shamed and flattered out by white light, next to each other in a line, the old people were rigid, ready to let themselves be looked at for an hour. The electronic sound lent greater immobility to the scene. I looked toward the audience: they too, in stillness, looked at the old people.

When my friend on the Left (I speak without irony: I am referring to people with clear heads, at least on certain points) asked me, troubled, about the meaning of the Happening, I answered them using a phrase which I repeated using exactly the same of orders of words each time I was asked the same question. My Happening, I now repeat, was nothing other than "an act of social sadism made explicit."

Embedded Chronicler: Victor Hakim

Monique Bellan

Little is known of one of the most active art critics in Lebanon, Victor Hakim (born in 1907 in Alexandria— died in 1981 in Beirut), who wrote extensively on art starting in the late forties. He was neither a professional critic nor specialized in arts, but had studied law in Cairo and Beirut. While still in school, he started to write poetry and literature, an interest he cherished even later in life and one that shaped his journalistic writing. Hakim, who primarily worked as a lawyer, had a second life as a journalist and writer. As such, he published many articles on literature, politics, poetry, and arts, while his literary writing remained largely unpublished. He was known for his elegant style, infused by his poetic leanings, and a discreet sense of humor. In 1948, on the occasion of the third general UNESCO conference in Beirut, Hakim published an overview of Lebanese art from ancient history to the present. His study, titled "Tableau de la peinture libanaise," was published in the Lebanese newspaper *L'Orient* between November 17 and December 4, 1948 (republished in Michel Fani, *L'Art au Liban*, Grenoble 2007, pp. 315–56) and established him as an authority on art.

In his special column "La vie artistique et littéraire" in *La Revue du Liban et de l'Orient arabe* (founded in Paris in 1929 and relocated to Beirut in 1943), which he started writing in 1949, Hakim regularly discussed current exhibitions in Lebanon and sometimes exhibitions of Lebanese artists abroad, as well as literature. He can be considered the chronicler of Lebanon's artistic life for more than three decades. His short pieces informed the public on the

latest exhibitions in Beirut's cultural spaces, modern hotels, and private art galleries, which steadily increased from the mid-fifties onward. Exhibition openings were also important social events and the accompanying pictures in *La Revue du Liban* often focused as much on this aspect as they did on the art and the artists. The purpose of these articles was mainly to inform. As such they were part of an emerging art system that comprised the rise of art galleries, art critique, and a public with a growing interest in art and local artists.

Hakim is representative of an early art critique in Lebanon at a time when art and authenticity were highly debated. The search for the genuinely "Lebanese" in art was coupled with a quarrel about figurative versus abstract art. While many journalists, writers, and artists regularly bemoaned the lack of a genuine artistic discourse, to an extent as to call local capability for aesthetic reflection and expression into question (in a special issue of the journal *Al-Ādāb* from January 1956, an editorial by Suhail Idriss asks if "we are maybe lacking an artistic sensibility"), Hakim seems to be primarily driven by the criterion of novelty in the artistic approach. The examples chosen for this reader date from the late sixties and early seventies, when these debates had shifted more generally in the direction of a politically engaged art. Hakim's approach seems to completely lack such concerns. His style is highly subjective, often imbued with psychological reasoning and with fragments of his own personality blended in. His articles evoke the impression of an intimate and rather confined artistic circle where the persona of the artist is in the foreground, not his or her work. This is underpinned by the author's transgression of frontiers and the dominance of biography over individual artistic achievement: Hakim addresses the discussed artists either by their first name and status ("Juliana," "the refugee") or speaks in terms of a possessive relation ("our Fadi Barrage"). Huguette Caland's family background, for example, immediately puts her in a specific context and relativizes her art. Only Amin Elbasha seems to escape such narrow judgment. Hakim's articles are characterized by a lack of distance, and therefore belong less to the field of art critique, where the work and its aesthetic dimensions are highlighted, but are rather tailored to the cultural event's rubric with the aim of introducing the reader to specific artists and artistic styles. However, on a more formal level and in defense of Hakim, the narrow confines of a commercial journal must be taken into consideration.

The Artistic and Literary Life:
Reviews from *La Revue du Liban et de l'Orient Arabe*

Victor Hakim

"Amin Elbasha at Dar el Fan" from no. 485, 1968

Dar el Fan is increasingly turning to artists who have a coherent, consistent body of work.

Amin Elbasha, whose work I have been familiar with since its earliest evolutions, has always oscillated between the abstract and the figurative, and I recall his painting entitled *Le Quartier* in which he sets out, as upon a map, the main landmarks of a landscape as seen from the boundaries of streets and houses; a kind of ideological panorama. A cerebral operation precedes the pictorial execution, then.

Today, his exhibition at Dar el Fan, composed of watercolors, gouaches, and collages of drawings, is playing its part in a new concept. But first, a few words on his biography: born in Beirut in 1932, he attended the Lebanese Academy of Fine Arts, took part in the Salon d'Automne, and received a prize from the French Embassy. Having gone to Paris, he has since made intermittent visits to Beirut, pursuing a double career in Lebanon and France.

Thus came about his exhibition at the Salon des Surindépendants in 1964 and then the Salon des Réalités Nouvelles in 1966. His new exhibition is notable for a careful use of hue in the watercolors, where he proceeds with marks and separated strokes, allowing the white of the paper to do its work while suggesting seascapes, scenes of intimacy, and French and Lebanese landscapes. All very light, airy.

He largely uses a process of transposition in his gouaches, illustrating musical themes like those of Eric Satie to establish a correspondence between image and sound, but the color here is pushed further forward and he inquisitively uses a sort of parallelism in the forms he imagines. His Parisian shadows complement these effects.

Constructed with skill, very interesting collages cast a spell on pieces of card, prints, programs, musical scores, and letters: they are complemented with drawings. The result of this is highly intriguing, as a sense for aesthetics is united with a keenness to attract the eye and suggest enigmas to it. Here, this is something of a revival of the work of the miniaturist. But his true novelties, his investigations extending in parallel, lie in his detailed drawings, where he proceeds with knowing interweavings,

birthing coincidences that satisfy the eye. He draws letters, but he does so for their visual qualities, in natural and inverted positions.

There is a great deal of method in the composition and rhythm of what he paints and draws: his native Orientalism is mixed with Occidental discipline. He is both a Cartesian and a mystic of the East. A great deal of play exists in his art, which at one and the same time calculates conscious structure and organized chance. What appears inventive and free seems to always have as its center an illumination that emanates from a real object. Amin Elbasha can thus present himself as an innovator within the context of the evolution of Lebanese painting, just as well as in recent western painting.

"Juliana Séraphim at Cassia" from no. 572, 1969

Juliana Séraphim exhibits her new drawings at Cassia. With the greatest sincerity, she lends them titles in harmony with their true subject: "The Erotization of Hermes," "Masochism," "Temptation," "Oedipus," "The Lovers." The register here is entirely suggestive, voluntarily Freudian.

Other subjects are borrowed from a parallel world: "The Mythical Journey," "The Horse and the Rose," "The Tower of Light." In a Surrealist manner, she is obsessed with the machine, a kind of tense anatomy of iron and steel, a steel of the kind we find in Juliana's eyes. And then there is the aeroplane, a kind of ornamentally cloaked dragonfly, and a historical fairytale suggesting "The Wedding of the Sea."

It easily gives way to a taste of overload, Rococo style. Some drawings, on the contrary, are line diagrams where you follow the skill of this hand, hypnotized by the line of Venus, certain of its appearance.

The exhibition as a whole is indiscreet like a revelatory dream. It floats disturbingly on the surface of these drawings, as a denunciator, the actual gaze and face of the painter.

I had stated the thought there had been a manifestation of narcissism, without musing upon the fact (as revealed to me when reading the catalogue) that one of these drawings, portrait number 1, was titled "Narcissus." And I tell myself that Juliana was forced to stop having mirrors in her house: she was literally engrossed in her own gaze. I made this reflection aloud, on the way home, in front of a soon-to-be doctor: passionate about psychiatry, he pointed out to me that the multiplication of the gaze in Juliana's compositions betrayed less an emanation of narcissism and rather a sentiment of culpability.

I do not feel I absolutely agree with the author of this judgment. For otherwise, it would not have occurred to the painter to challenge us with this refined elegance, this lively abundance of elocution.

But in her case perhaps, the challenge of or even desire to confess corresponds to a true feeling of veiled revolt, the revolt of a refugee who overcame her fate and whose resolve is also shown in the wearing of brocade or openwork lace of brilliant whiteness.

"Hugette Caland at Contact Art Gallery" from no. 734, 1972

The head of this place, Waddah Farès, the Iraqi humorist adopted by the capital's avant-gardes, welcomed friends of Huguette and the press. The critic John Carswell proceeded to the exhibited works and young Lebanese-Americans sat on the floor, shared whisky around the ceremony, enhanced by the presence of the still very lively Georges Schehadé, alongside Helen el-Khal and other Beiruit dignitaries.

Huguette Caland's paintings tend toward the abstract, but they change in nature along the way to reveal details of human anatomy. At times it is a mouth that opens; sometimes another, more indiscreet fissure of the human body. We even encounter cells that fragment and bring us to the intimacy of an atom.

In her attempt to reconstruct a face from a melange, the artist has us witness a series of creative blinks; eye leads to eye, hair to hair, and then … only a sullen mouth. What a shame I am not sexual, she seems to be saying. I do note, however, that in this body-in-formation the eyes face down.

Next to these paintings, as opulent as they are, the drawings in colored pencil lose face. They appear rather more like preparatory work.

Huguette Caland, whose uncle Michel Chiha was an official representative of classical humanism, has chosen the broadest paths of contemporary audacity and is keen to be resolutely of her time. The fact is that she always evolves on her own terms and from her dreams, wishes, and experience, gives us translations that are ever more distinct and diversified. Here the research bias does not forego an expression of the health of body and spirit, even if to my mind, there is a little too much natural curvaceousness in her prized works. It is true that they are intended much more as decorative motifs than as signs of obsession. It is for this reason that I have said this ensemble is a healthy one. And the ambiguity saves it from monotony.

La Vie Artistique

Par Victor HAKIM

BARRAGE
‹R EL-FAN ›

Barrage, du temps qu'il exposait au salon "Orient ›, rue Trablos, des peintures agré- de textes bien tournés, gravitait entre la e et la peinture. Son style, considéré alors cérébral et aristocratique, comportait sur- e recherche de la couleur et l'exploitation

de la sincérité juvénile, dans un souci d'expansion.

Dans sa toute récente exposition de « Dar El-Fan ›, il se révèle tout autre. Le papillon est sorti de chrysalide... pour y revenir en exploraleur des sources de la vie. Remontant aux origines, il dé-chiquète le corps huma n et en étale sans pudeur les zones érogènes. Son style est dominé par une recherche effrénée du dessin une sorte de virtuosité

fatale de sorte qu'il aurait pu dans sa démarche réaliser l'accord parfait de ses fragments anatomi-ques, sans nécessairement mettre l'accent sur « ce que l'on ne saurait voir ».

A-t-il voulu sacrifier à la mode ambiante ? ou bien, cédant à une sorte d'atavisme de grainetier, pousser sa quête du mystère jusqu'à la molécule essentielle. La partie la plus secrète et en même temps la plus révélait ce de sa manière n'est-elle pas consacrée à ces semences qu'il interroge et décorti-que avec la précision d'un horloger ?

Oui, Fadi Barrage a quelque chose à nous dire, lui qui s'interroge sur le sens de la vie et les arcanes de la génération. Mais c'est déjà l'apanage de l'âge mûr, qui donc nous rendra notre Fadi Barrage à la voix blanche, discret dans ses propos, pudique dans sa peinture ?

Du point de vue esthétique, il se place au point de rencontre entre un certain structuralisme et la démarche surréaliste. En outre, il pratique un certain ascétisme de la couleur, réduite à quelques tons. Il nous conduit directement à la terre au lieu de nous faire planer et de nous imposer un état second.

Son dessin astuc eux aurait pu le seconder dans une telle entreprise. Au feu du sourire complice des amateurs d'équivoque, il lui aurait attiré l'au-d ence de ceux que Barrès appelait « les délicats ».

Viktor Hakim's review on artist Fadi Barrage in *La Revue du Liban et de l'Orient Arabe.*

"Fadi Barrage at Dar el Fan" from no. 686, 1972

Fadi Barrage, since the time he exhibited paintings with well-executed texts at the Salon de l'Orient on Trablos Street, has gravitated between literature and painting. His style, then regarded cerebral and aristo-cratic, involved more than anything a search for color and the exploita-tion of youthful sincerity, with a concern for expansion.

In his most recent Dar el Fan exhibition, he reveals himself to be entirely different. The butterfly has emerged from its chrysalis ... to return as an explorer of the sources of life. Going back to his origins, he tears apart the human body and immodestly flaunts erogenous zones. His style is dominated by a frantic pursuit in drawing, a kind of fatal virtuosity, of such a kind that with his approach he could have achieved perfect harmony with his anatomical fragments, without necessarily emphasizing "that which cannot be seen."

Did he want to sacrifice to the general fashion? Or, giving way to a kind of budding atavism, to push his quest for mystery toward the essential molecule? Is not the most secret and simultaneously the most

revealing part of his method devoted to these seeds, which he interrogates and dissects with the precision of a watchmaker?

Yes, Fadi Barrage has something to tell us; he who questions himself about the meaning of life and the mysteries of generation. But this is already the privilege of middle age—and with his flat voice, what will Barrage, discreet in his words and modest in his painting, give to us?

From an aesthetic point of view, it is to be found at the meeting point between a certain structuralism and the Surrealist approach. He also practices an asceticism of color, reduced to a few strokes. He leads us directly to the earth rather than having us float and imparting to us a new state of being.

His clever drawing could have assisted him in such an enterprise. In place of the knowing smile of the lovers of equivocation, he would have attracted an audience of those Barrès called "the delicate ones."

Undisciplined:
Peter Gorsen

Thorsten Schneider

"All post-Auschwitz culture, including its urgent critique, is garbage." This sentence from Theodor W. Adorno's *Negative Dialectics* (1966), as pointed as it is controversial, hints at how contentious the significance of art and culture was in sixties Germany. After art criticism had been harnessed as an "art report" (Joseph Goebbels) for fascist propaganda within Nazism, hopes of making a significant contribution to postwar democratization by rehabilitating modernism were increasingly disappointed. Evocations of a humanistic canon of values, of the "beautiful, true and good," lacked credibility among the younger generation. Belief in emancipation through art was called into question by a critique of the culture industry.

It is in this context that Peter Gorsen (1933–2017) developed an anti-normative art criticism that argued forcefully against any kind of role as a disciplinary technology or gatekeeper of an art-historical canon. Starting from the central premises of critical theory, he developed an art criticism that radically questions established concepts of art and aims to highlight such concepts' implicit conflicts around social recognition and exclusion. His preference was to focus on subaltern social groups whose practices challenged both artistic and social conventions. The latter were, however, not taken up in service of a better society—either as subcultures or as revolutionary subjects—but were rather recognized in their individuality. Gorsen avoids their idealization as utopian pioneers or models of suffering. To this degree Gorsen's criticism is comparable to Michel Foucault's in *Madness and*

Civilization (1961) but ensues more directly as an analysis of the present. Gorsen critiques the aesthetic experience of bourgeois art reception as a disciplining ideology—just as much as is the ascetic critique of the culture industry, hedonism, and commodity aesthetics when this critique rejects any pleasure in art as antisocial, deferring it to a post-revolutionary society. His sympathy and sensitivity are directed at those unproductive forms of life that are not exhausted in the contradiction between autonomous art and its social functions.

With Gorsen, this goes beyond being a research approach that describes artifacts with analytical distance. It is rather an approach based on a mindset that also questions the praxis of its own theorization. His focus is on situated knowledge that in its "subjective statements" does not shy away from the danger of what Gorsen calls "academic suicide." In his texts, his relationships with artists, activists, feminists, sex researchers, and patients go far beyond economic exploitability; they enrich those texts with empirical knowledge that surpasses intellectual reflection. Gorsen is thus just as much a "model participant in a social interaction, both as a producer and as a recipient of a socially meaningful process" as those artists he describes as "border crossers."

The texts selected here critique the opposition of autonomy to functionality. Gorsen shows how artistic autonomy, with an exclusionary psychopathology of outsiders and invalids, combines with the ethical containment of "perverted" *Sexual-ästhetik* (Sexual Aesthetics, 1987) to socially construct a disciplining normality. The various editions of *Frauen in der Kunst* (Women in Art, 1980), coedited with Gislind Nabakowski and Helke Sander, show how this also occurs as discrimination against women artists. Gorsen regards the "dissolution of autonomy" in functional aesthetics as wrong: proletarian art in particular would no longer be available for enjoyable reception if it were limited purely to a specific purpose. *Zeitschrift für Ästhetik und Kommunikation* (Journal for Aesthetics and Communication), cofounded by Gorsen in 1970, brings together nondogmatic, transdisciplinary criticism that allowed hopes to arise that in Germany, too, there could be a cultural studies-like dissolution of the boundaries that surround disciplinary discourses on visual cultures. Save for exceptions such as Kerstin Stakemeier's references to Gorsen's ideas, these hopes have not been fulfilled. With regard to a non-disciplinary and anti-normative art criticism, Gorsen's pugnacious texts are indispensable for keeping alive both the necessity and joy of permanent contradiction.

Prolegomena to a Hedonistic Enlightenment

Peter Gorsen

from *Das Bild Pygmalions Kultursoziologische Essays*, 1969

*"When there is a high degree of political awareness,
even antisocial works of art can be enjoyed."*
—Bertolt Brecht

As a symbol of the experience of happiness has been handed down to us
an artist overpowered by passion for his own fantasy. Pygmalion falls in
love with a sculpture he himself created, a female statue, and is capable
of bringing this autonomous artistic creation to life: the dead substance,
the finished form, succumbs to his lovestruck gaze—the statue spreads
out its stone arms and pulls her creator down towards herself in ani-
mate, sensual pleasure. The cultural barbarism of a mindset that, in
exchange for a brief sensual moment of understanding, jeopardizes the
spiritual authority of artwork, its autonomy and its extra-temporality,
seems today to no longer be a barbarism. To an age in which the relation-
ship of the viewer to art is dominated by a custom of pleasure and only
the unfinished, active, immediate experience of pleasure in a work of
art seems to justify its continuity into the present—imagined as eternal
and unforgettable—it causes no fear. That which is complete, reliant
on the interest and memory of the living, ages towards its own eclipse
on the dumping ground of culture. Would Pygmalion, the man in love
with the living moment of the sensual, thus only be an unscrupulous
fellow traveler within competing artists' struggle to be loved by their own
time—that is, to be consumed and to endure? This would underestimate
Pygmalion's relationship to sensuality, equating it entirely with a con-
sumer's relationship to pleasure. The misuse of the eudaimonic maxim
by consumer society almost commands that this maxim be advertised
and its aspirations to luxury be maintained in the face of forms of sense-
less indulgence.

Herbert Marcuse himself, in his intransigent critique of the subjec-
tive claim to happiness, to hedonism,[1] never went so far as to conclude
that if pleasure is entangled with consumption, it is untrue. When a

1 Herbert Marcuse, "Zur Kritik des Hedonismus," in *Zeitschrift für Sozialforschung*
V11/1-2 (1938), quoted in Herbert Marcuse, *Kultur und Gesellschaft I* (Frankfurt am
Main, 1965).

philosopher calls for hedonism to be overcome, it is because there is not enough pleasure. For those experiencing pleasure, their forced conformity to a bad social reality lends power to attempts to resist a pleasure that involves alignment, to oppose the feeble happiness thus achieved with the repressed premises of eudaemonia. "The untruth of hedonism does not lie in the fact that the individual should seek their happiness within a world of injustice and misery. Rather, the hedonistic principle as such rebels quite openly enough against this order and, should it ever be able to take hold of the masses, they would barely be able to bear the lack of freedom and be so thoroughly corrupted as to be unsuitable for any kind of heroic domestication."[2] The theoretical vilification of the consumption in which pleasure has been imprisoned and to which it has been reduced would be just as wrong as its apotheosis; what matters is to "distinguish between true and false needs and interests, between true and false pleasure."[3] The irreconcilability of pleasure with consumption is what lends the critique of hedonism its incontestable validity. Its thought undoes the domestication of happiness. It thinks in opposition to bad praxis, without having to remain nonactive in practice. This is something that can be seen in the avant-garde art of our day. Against the cultural forms of repression, it mobilizes those of abandon; against the commandments of industrial effort and progress it mobilizes the forces of inactivity and regression; against patriarchal infantilization of the viewer of art, it mobilizes a matriarchal desire for sensitivity. There are political doubts as to whether it will succeed in this and penetrate through to the masses or whether it is condemned to live impotently in a merely private happiness—the accusation of aestheticism cannot decisively impact upon the hedonistic spirit of contradiction. Making the academic point that a lack of success in the face of the object of critique would result, objectively, in acquiescence to that object; that prevailing social law retains power over revolutionary tantrum; that the process of productive social forces must originate from within itself, converted within the illegal boundaries of legality—all this confirms the impotence of subjective protest before it can become effective. Its freely undertaken risk achieves little. Abandon, infantility, sensual mollycoddling, and plain abnormality do not necessarily immediately signify a pale imitation of the general deformation, merely repeated in the involuntary needs and social defects of individuals; they rather signify an artistic reorientation towards a happiness that is socially tabooed, the unredeemed reward of the great hedonistic utopias.

2 Ibid., p. 136.
3 Ibid.

Peter Gorsen

This much is correct in the "critique of hedonism": a personal happiness can be experienced as absolute and be yet false, as it does not know itself to be better than it already is. The fetishist's unique experience of happiness, for example, is real and doggedly opposed to the view that fetishistic happiness is not natural and can, on the contrary, itself be a form of renunciation, a surrogate, in which a bad generality reproduces social coexistence. This happiness would be the wrong happiness, as it finds its fulfillment in non-freedom and is subject to social conditions opposed to the eudaimonic ideal. Given the state that social productive forces have reached, a happiness accessible to all could long since have come into being—a happiness different to that exclusive happiness of the fetishist, whose false subjective bliss is indebted to society. When this state of affairs is obscure even to the very person concerned and when in the fetishist's case, they find their most ardent defender within themselves, there is an additional blunting of that suppressed happiness. The fetishist may here be opposed to the historical progress of any praxis that seeks to work towards the fulfillment of their happiness and to annihilate the false reconciliation between individual happiness and general unhappiness. To make matters worse, the fetishist would thus also be the furnisher of the ideology that is meant to smother their suffering, their refusal, or to excuse it as passion. It should however be asserted at the same time that the fetishist's regressive refusal, as illustrated in the hedonism critiqued by Marcuse, can stand in conflict with exactly that socially depraved notion of happiness, in response being categorized as diseased by its caregivers, psychologically isolated for reasons of social hygiene and, where possible, cured—that is to say, re-socialized into the social whole. The hedonistic self is not to be found in false solidarity with the bad generality because it withdraws from it rather than changing it. That which is critiqued as social alignment is also ambivalent. It succumbs to alignment insofar as, in objective terms, it cannot change anything. It does not succumb to alignment insofar as it escapes via passivity from a functioning praxis and invents a socially unproductive mindset that does not merely facilitate an orderly flow of praxis—it instead includes its systematic destruction.

While the effort-oriented society, in controlling each differentiated impulse of human beings, raises people to repress themselves, the "perverted," "infantile" regard of the hedonist remains limited to the self. The hedonist takes the self more seriously than the collective egoism of the production society would prefer. That the hedonist collides with that society's subjectless interests is what defines the social-pathological core of the hedonist's objectionable regression. Sterile and anti-ascetic

in one, their introverted self reaches the forbidden zone of unproductive happiness. The self remains powerless against the prevailing social factuality, *but it still does not work*. The self's transgression is *practical*. Its deliberate unfitness, honored by no one, is described with the negative criteria of the amoral, the antisocial, even the pathological, and taken seriously only from the perspectives of resocialization and curative treatment: deviation from the norm. Admittedly even an antisocial, more perfected defiance on the part of the hedonist, as is already present today, cannot simply exit the closed circle of objective social self-preservation; it nevertheless espouses a position that is hostile to alignment and aggravates the social whole. If this position is built upon and if the aggravation becomes so substantial that the recipient can "no longer afford it" and makes it the object of their own interest, the hedonistic mindset may rightly credit itself with its first practical victory. That mindset's impotence would have been overcome. Patience and accommodation towards the weaker party, no matter the violence with which they had been met, would be at an end. It is precisely here that is to be found the weaker party's chance to influence the social management of happiness: the antisocial self must step out of its impotent, inpatient-like isolation and claim the freedom of happiness amongst the masses. At this hour, in whose name could anyone be permitted to diagnose hedonistic happiness as merely imaginary? Most likely not in the name, as Marcuse wishes, of a revolutionary *praxis* that fights for a new, true generality against the existing bad society and forces its change,[4] and instead only in the name of a revolutionary concept. Critique of the hedonist's private happiness has its impact today not in the service of progressive praxis. Contrary to its own intention, it serves the prevailing, depraved collectivity that is interested in the resocialization of its outsiders towards a frictionless work in the service of the whole. Within the socially consolidated inability to experience pleasure, within consumption's exploitation of pleasure, sensualism and egotism both take on an entirely different status in hedonism. The modes in which hedonism's appearances have been reduced to negative, abnormal instincts such as fetishism and pygmalionism must be considered in connection with social attempts to contrive a unilateral happiness, based on the image of collective effort and productivity—that is to say, of self-asceticism. Against the latter, each perversion of instinct, any excess on the side of the perversely abnormal or sick is justified—to the degree that they strengthen theoretical defenses against social leveling. The hedonistic

4 Ibid., p. 147, 159ff.

Peter Gorsen

notion of "self-actualization" does not have as its ideological horizon the spiritual health, maturity, and protection that delimit positive individualism, nor is the "desublimation involved"[5] always and necessarily "itself repressive inasmuch as it weakens the necessity and the power of the intellect, the catalytic force of that unhappy consciousness which does not revel in the archetypal personal release of frustration-hopeless resurgence of the id which will sooner or later succumb to the omnipresent rationality of the administered world—but which recognizes the horror of the whole in the most private frustration and actualizes itself in this recognition,"[6] as Marcuse recently suspected, most likely in a rejection of the cult of the Happening.

To suspect the hedonist's anti-sublimation self of private debauchery, their desired repression of being in essence politically blind and irrational—Marcuse had previously never gone this far. He must be here met with the objection that the philosophical critique of hedonistic self-indulgence—being of no use to anyone, not even to the self, it has no idea what happiness is unless everyone shares in it—serves much more to critique society's social parasitism and the luxury of antisociality and to prepare the ground for the pain of social leveling than to animate those latent forces whose hedonistic protest presses for the liquidation of the administered world. Its enlightening, praxis-changing possibilities, of whose anti-cultural gestures the contemporary artistic avant-garde contains much evidence, were underestimated by Marcuse. "That there is any happiness at all in a society governed by blind laws is a mercy: it allows the individual to still feel protected within it, safeguarded from the ultimate despair. Rigorist morality sins against the austere figure in which humanity has survived; in the face of this, *all hedonism is just*."[7] In the face of the feeble remnants of the happiness left over for blameless individuals within the general unfreedom, it is the amoral rigorism of a view that only despair could still rescue us that is untrue, not the philistine delusion of being able to escape despair, of nothing more being able to withstand the merciless de-ideologization; and it is these remnants that—we must expand upon Marcuse here—could still lend material support to passive resistance against social training towards self-asceticism. The whole, real happiness would of course have long ago been possible given the state achieved by the social productive forces.

5 Herbert Marcuse, "Repressive Toleranz," in Robert Paul Wolff, Barrington Moore, Herbert Marcuse, *Kritik der reinen Toleranz* (Frankfurt am Main, 1966), trans. as *A Critique of Pure Tolerance* (Boston, 1965).
6 Ibid., p. 126.
7 Marcuse 1938 (see note 1), p. 159.

Similarly, the moral rigorism of the ascetic—you have either complete happiness accessible to all, or no happiness at all—reflects a moment of domination stemming from the bad generality, believing it can escape the latter by denial. Renouncing happiness, even on the most rigorous grounds that a critical theory can put forward, results practically in the same alignment to the austere figure of the social whole that the latter also demands due to economic egoism. In the face of this objective state of affairs, it is of no relevance whether an argument is made against happiness because its uniqueness is reconciled with general unhappiness or simply because it is unproductive in terms of collectivity. In rejecting the eudaimonic principle, the rigorous rejection of thought based in social effort and apologism thereof harmonize with each other—contrary to their own intentions. Even conscious despair, itself still a relic of positive individualism, cannot save us from conformity. The latter rather permits only a choice between despair without or *with the help* of passion—an anti-sensual despair via asceticism or hedonism. The compulsion to reflect the social law of egotism is something the ascetic's refusal escapes just as little as does the merely subjective happiness of the hedonist. Both being forms of "unhappy consciousness" in the consolidated, patriarchal production society, it is a matter merely of determining the greater resistance amongst the two modes of consciousness and then taking sides against the one which offers the least prospect of achieving actual change in the present, unhappy whole. *Here lie the prospects for hedonism and the injustice of the current critique thereof.* Morality, obstinate puritanism, and the theory of self-despair have thus far had no significant impacts on that dominant praxis that is to be the subject of change. Such change in fact requires going further than arguing for an illegal intelligence that does not divest itself of happiness even in the decayed form of its antisociality and which instead bears its deformation and social inaptitude, using them as instruments with effective impact on the socially functioning forms of pleasure-as-consumption. The difficult differentiation between which form of pleasure is right and which is wrong has better prospects of popular success if, in its preparations, it practices rather an enlightening empirical proof of the various forms of deprived happiness, of social class happiness, than an abstract reference to an ideal world condition in which the particular interests of individuals were no longer in contest with the general interest in preaching utter deprivation to the consuming masses. The unhappiness of people in consumer society ranges from the conscious perversion of suffering into passion—an undoubtedly deformed, unfree self-indulgence that is however for this very reason not yet accessible to all and rather tabooed

as abnormal, perverse, sick—to the listless exhaustion of the "worker animal" unsensitized to that sophisticated distinction between suffering and passion in suffering: masochism. Measured against the sensually experienced diversity and class-based variety of that kind of suffering that must go without true happiness, the abstract commandment of refusal comes seriously into question. Where no accommodation is found for the sensual, mass-specific communication of eudaimonism, the verbally incited fantasy will be satisfied with the aggressive drama of assassination, plundering and arson. *The repressed hedonistic side of revolutionary protest becomes manifest in anarchy.* It is here that its nonsensical academicism takes its revenge. Reclaiming true happiness in the medium of pure reflection robs non-reflective people of the best and only effective means of advertising themselves for this happiness, which cannot be experienced in a way that is separated from its sensual sphere. For the aristocratic philosophical idea that it may one day be possible for knowledge to no longer interrupt passion, and that it perhaps could even become passion itself, the necessary conditions are absent among all those who would be keen on doing so. The only thing that is truly experienced is the antagonism between knowledge and passion: that too little passion and too much knowledge is too much work. That which is widely held as a source of their reconciliation would only be able to reap mistrust amongst the spiritually uneducated: with regards to themselves, they fear less passion and more knowledge, an increase in deprivation. But is it possible for that which itself remains impotent and singular— permanently a theory about praxis—to still claim itself to be true?

Doubts about this make reflection realistic. In striving for a society-changing utopia, the deformed and merely subjective passion of the hedonist cannot be abandoned. A mutilated happiness is better than none when the sacrifice of refusal achieves almost nothing. Utopia for its own sake is not worth giving up on a present, reduced pleasure in life. If socially transformative praxis is replaced by mere hope thereof, then hedonistic-negative self-actualization must be understood as a project potentially more controversial than the moral rigorism of asceticism. The negative hedonistic approach to sabotaging social alignment, namely in the pathological extant forms of egoism or social parasitism, vagabondage, addiction, sexual "maladjustment" (Giese), promiscuity, planned sterility, the work-averse loafing of the modern flaneur, their external debauchery in lumpen fetishism, the discovery of new "artificial paradises" (think of the epidemically increasing enjoyment of marijuana); the practical contradiction, the antisocial "negativism" of all these dispositions contains more objective compulsion to active

self-examination and more social-revolutionary explosive material than the most perceptive academic argument, in so much as it is condemned to linger within the amoral limits of the legal protest set by the very society it criticizes. The critical power of hedonistic self-indulgence only arises in its condemnation by the prevailing consumer consciousness, with the latter being forced to recognize in competition with all others that it is being spoon-fed by consumption and that it is no less removed from the eudaimonic ideal than the hedonist self that rebels against it and that in this fashion, it recognizes the deception, the economic pattern of its own needs, otherwise felt to have been voluntary. The provocative success of the hedonistic enlightenment lies in its *exaggeration of enjoyment both stimulated and unsatisfied, in the arrived hypertrophy of abundance,* that is to say in the hubristic art of demoralizing the consumer ethos by asserting a right to more pleasure than even the most luxurious consumption permits or that it can commercially exploit or is ever permitted to for reasons of "public health" to extract. Hedonistic provocation of such exorbitance signals that which the discerning consumer, against their own better judgement, cannot afford as it is not provided for by a consumer society's logic of self-preservation; it must prevent any decline in the "drive to earn" and against reluctance to work, against weak consumption power, passivity, depression, and any disease that harms the spiritual and physical productivity of individuals and deprives the production process of valuable labor and of consumers alike. There is a place in which the social tolerance limit of self-indulgence is exceeded, however, and in both directions: in enjoying too much and too little of the permitted consumer happiness, where the taboo of unrestraint or material abstinence promises a particular kind of pleasure, the otherwise impotent hedonistic self attracts the copious attention it needs for the public to concern itself with that hedonistic self's rebellion. Eroding the prevailing depraved pleasure with the depraved pleasure of the discontented social refuseniks, attacking *social repression with the revolutionized regression*—these are the principles by which subjective hedonistic strike action could, bit by bit, come to terms with bad praxis.

The models for a hedonistic view of art are provided by the viewer's experience of happiness in the face of the cultural exhibition value of the viewed work itself, which is recognized as timeless. Questions are asked not about its readiness for the museum but rather about the problem, thus far ignored by art-historical research, of enjoying art from within consumer society. This task, more art-sociological than art-archaeological, includes the reified and merely projective interest of

Peter Gorsen

the ownership and pleasure-fixated human being in art just as much it takes into account the remarkable occurrence of *eroticization, desublimation* (Marcuse) or *de-aestheticization of the aesthetic*,[8] which are gaining increasing importance in the modern concept of art and especially in the artist's self-image and which can be understood both as a sign of education falling into disrepair due to consumption and as the emancipation of pleasure—an emancipation namely from those handed-down prejudices which took the demands of a sensual interaction with arts and reduced them to a formative cultural experience, to pure reception of value.[9]

8 In this regard, it is worth drawing attention to the thesis, advocated by Odo Marquand, according to which "a theory of a no-longer-beautiful art" whose vital "tendency towards the *restriction of what is capable of being art*" is implied in Hegel's aesthetics, would be the "Hegelian theory," "systematically argued and pushed beyond Hegel himself, of the romantic form of art." In *Die nicht mehr schönen Künste, Grenzphänomene des Ästhetischen*, ed. H. R. Jauß (Munich, 1968), p. 382.

9 In this respect, my deliberations here can be understood as a continuation of an earlier essay on eroticism in modern art in Armand Mergen, *Sexualforschung, Stichwort und Bild* (Hamburg, 1963), pp. 447–518. I wrote this in 1963, admittedly without having foreseen the virulence and verve with which the phenomenon of eroticization would assert itself in the newly emerging art and its reception: "The body-fantasy complex is capable of much more precise nuance, even to the point of sophistry, than positive art history and humanities believe it to be capable of even today. The little-articulated clump of corporeality, the res extensa abstracted from the cognitive as opposed to the in-principle more nuanced and more highly organized realm of thought is a prejudice of idealistically oriented interpretation ... It is the very lowest level of that which is to be known and it is not only the future of art and philosophy that depends on whether we finally lower ourselves to its level." Readers can find an explanation and continuation of this idea in my study *Das Prinzip Obszön. Kunst, Pornographie und Gesellschaft* (Reinbek, 1969).

In Drag:
Mary Josephson

Astrid Mania

To write about Mary Josephson, a critic who only exists in print, seems weirdly apt in these coronavirus-ridden times of social distancing; of virtual, body-less encounters. Mary Josephson is one of the altogether four alter egos of artist-theorist Brian O'Doherty, and his only feminine persona. She also seems to be the first fictitious female art critic conceived of by a man. Active in 1971–73, she wrote nine essays and reviews for *Art in America* under the auspices of O'Doherty, then the magazine's editor. In 1988, Josephson appeared in the April issue of *Artforum* with her conte "The History of X." Its protagonist, an art critic, finds his passion in deleting a little-known nineteenth-century *animalier* from the annals of art history. (All of Josephson's writings were republished in 2019 by myself and Thomas Fischer.) In the original issues of *Art in America*, Josephson is usually credited with a—fictitious—volume of poems by the title *Degree Below Zero*; she has, however, produced a short story titled "The Wrinkle in the Carpet," which still awaits publication.

Josephson put down her pen in the late nineties, after O'Doherty casually outed her in conversation. It is only then that she made a brief appearance in front of a camera, for the photographs "First Sketch for Five Identities" (1998) and the group portrait "Five Identities" (2002), featuring O'Doherty as himself and his others: painter Patrick Ireland, writer Sigmund Bode, poet William Maginn, and critic Mary Josephson. These remain Josephson's only physical manifestations, relating her more closely to Roland Barthes's notion of the author who comes

alive in and with his text—Barthes's seminal essay "Death of the Author" first appeared in 1967 in the double issue 5+6 of *Aspen* magazine, edited by O'Doherty—than to Rrose Sélavy, the more outgoing female alter ego of O'Doherty's friend Marcel Duchamp.

Mary Josephson, the name an obvious allusion to O'Doherty's staunch Catholic upbringing, is mostly a product of his curiosity and desire to free himself from what he calls "limiting malehood," offering a different voice and thus a kind of independence from his own thinking and writing on art. But while O'Doherty claims that Josephson was a feminist, her texts speak of no such affiliations and focus on male visual artists and their shows in a nineteen-seventies New York. Yet Josephson's persona allowed for opinions and words unrestricted by any social, artistic, or intellectual attachments O'Doherty might have felt. And so she reflected on, for instance, a show by Raphael Soyer, a figurative painter who had been largely ignored by other critics because, as Josephson remarks, his oeuvre was so different from that of his contemporaries that he provided no opportunity to either elevate or debase another position in the game she calls "network criticism." Her reflections on architect Morris Lapidus, "the builder of kitsch hotels," among them Miami's Eden Roc Hotel, are another testimony to Josephson's idiosyncratic perspective in that she recommends him for serious cultural debate.

Josephson's brilliant essay "Warhol: The Medium as Cultural Artifact," which first appeared in the May–June 1971 issue of *Art in America*, was prompted by two publications on the artist she dismissed for their "dialectic of excessive acceptance and excessive rejection." As Warhol's practice was beyond categorization and therefore beyond modernist art criticism, Josephson introduces the notion of the medium in both a spiritualist and an artistic sense to describe the artist and the work. Rather than subscribing to narratives of Pop as either affirmative or critical, she foregrounds Warhol's "neutrality," in moral, emotional, and aesthetic terms, relating his face to a "pane of glass." We know a medium only through what is done with it, she concludes, describing Warhol as a Nietzschean creature, a creature that is being thought. Josephson's essay was written at a time when Warhol had already turned into an icon. We feel that her iconoclastic and at the same time reverent words are just as original and insightful today as they would have been nearly fifty years ago.

Warhol: The Medium as Cultural Artifact

Mary Josephson

from *Art in America*, 1971

*If you want to know all about Andy Warhol, just look at the surface of my
paintings and films and me, and there I am. There's nothing behind it.*
—Andy Warhol

The artificial fascinates me, the bright and the shiny.
—Andy Warhol

Andy Warhol has not yet been written about with much cogency, despite
the large quasi-literature that has piled up since he showed at the Stable
Gallery in 1962 and became a star overnight. In two books published
last year (both imaginatively entitled *Andy Warhol*),[1] John Coplans and
Rainer Crone expounded, with more ingenuity than wit, on Warhol's
place in history, while Hilton Kramer, reviewing both books in the *Times
Book Review*, brought them up to point out that they were not worth his
attention. Warhol was, in the end, ill-served. This dialectic of excessive
acceptance and excessive rejection has clear precedents—that do not,
however, seem to prevent its repetition. This underlines, in my opinion,
an inability of our usual critical practices to deal with any phenomenon
(and it is as phenomenon, as the inexplicable, that Warhol—in a far
from easy paradox—invites explanation) that transcends their area of
discourse. Within these areas Coplans and Kramer are extremely intel-
ligent, even if at times that intelligence seems a bit of a liability. Both
stand for particular vested interests—Coplans for the over-explication
and acceptance of the new (his role is that of the pioneering critic with a
mission to convert), Kramer for the preservation of standards, usually to
the extent that new ideas are grudgingly acknowledged and rarely admit-
ted to revise his own. Coplans is the avant-garde, Kramer the conserva-
tive critic. Both, of course, are Establishment, and both seem irrelevant
to the wider significance of Warhol's achievements.

Warhol is perhaps the avatar of the sixties, a decade implicated in
contradictions and currents that we have, I feel, hardly begun to under-
stand. Indeed, Warhol and his decade are so intimately interfused one

1 John Coplans, *Andy Warhol* (Greenwich, Connecticut: New York Graphic Society, 1970).
Rainer Crone, *Andy Warhol* (New York: Praeger, 1970).

hardly knows if he is a passive product or shaper of his period. Warhol's brief career cuts across usual categories (art, film, society, "life") with sufficient authority to demand a revision of categories of criticism—the increasingly narrow one of the avant-garde or the increasingly codified one of conservative standards. Warhol's career, in its active passivity (or vice versa), demands from us a multiple and energetic attack devoid of these two kinds of pathetic fallacy—the criticism that competes with and imitates the work, and the criticism that competes with and imitates criticism.[2]

To what areas has Warhol contributed? These seem to me four in number:

1) The evolution of a personal mythology by means of an extremely consistent persona, occasionally aided by astute gestures.
2) The achievement of a relatively interesting group-life-style, with a distinct coloration and high sexual lability. I am not dealing with this here.
3) The art and the films (much more similar than has been pointed out, and which convert art into film, space into time, with a brilliant translator's sense of languages). In both media Warhol's undeniable formal inventiveness—the most revolutionary of any Pop artist's—is somewhat disguised by his subject matter and his myth. On this occasion, however, I am not primarily concerned with his art or films.
4) A body of ideas which in themselves make a literary contribution. It is not as important as Roussel's, or Jarry's, or Duchamp's, but it is of the same order. Its rawness (a dispensing-with-taste that becomes almost a form of American taste for the raw) obscures Warhol's miraculous nature. If he were French our universities would have embraced him in innumerable theses. As it is, his apotheosis is taking place in Germany.

All four contributions draw from two main sources—from the "culture" around him in all its haphazardness, and from the narrow tradition of avant-garde art. He has succeeded in forcing both sectors to certify his authenticity by turning their assumptions back on themselves. The

2 Art criticism seems particularly liable to the pathetic fallacy, especially in those exhibition catalogues with "appreciative" introductions. But it's not an easy issue. The art generally offers intimations of critical approaches, but such subtleties seem to me to be part of the work and should be dealt with as such. The other pole of the pathetic fallacy—the criticism that imitates criticism—is to my mind a deeper corruption of criticism in that its essential smugness makes it convincing to many; and thus its deficiencies are masked by its "authority."

Andy Warhol,
*Marilyn Monroe
(Marilyn)*, 1967

permissions of avant-garde art in the early sixties were so set up that they would serve any artist who transgressed them in a way that fulfilled their definition of new art. This is a large subject. Suffice it to say here that in Warhol's time (he and Frank Stella are alike in this) the mode of transgressing the convention was itself not yet a convention (now it so conventionalized that avant-gardism itself is ossified). Abstract Expressionism reformed the conventions of its time through "expression" or "intuition" or some such workable illusion. Warhol and Stella replaced the tradition of the divine blunder (creativity) with working strategies in the art "game," and so codified the channels for "making it" in the sixties.[3]

Similarly Warhol hooked the press on its own degraded curiosity by means of acts or phrases of an astuteness amounting to epigrammatic genius. ("I want to be a machine" and "Anyone can do my work" were some of the first of these.[4]) This is a kind of Wildean gift; just as Wilde's epigrams were repeated by his contemporaries in drawing rooms, Warhol's are retold in the gossip column, the drawing room of the masses. (It is the press, not television, that gave Warhol celebrity status. He has not yet displayed an unerring instinct for television.) Like Wilde, Warhol has a quality that has not, to my knowledge, been much remarked on—

Mary Josephson

a dignity that, whatever may rage below the surface, is maintained with mild and steely gentleness.

Warhol is thus a touchstone for our culture, both in its popular and elitist complexions—specifically in the manner he has elicited its reflexes and mirrored its narcissistic vulnerability. He is an example, I think, of the artist as perfect *medium*—both in the spiritualist and artistic sense. A medium, like a mirror, is defined by what it reflects, what is put into it, or done with it. But it remains itself essentially unchanged, though inhabited by this translucent and infinite sense of potential. More than any other artist, Warhol has maintained a *neutrality* through which all passes or is reflected and given back, but in the process is subtly altered in ways still dealt with in terms of epistemological chic about reality and "reality." Indeed, Warhol's intuitive grasp of such matters is of a very high order. One's search for an image or metaphor (mirror, translucent substance, transparency, water, refraction and reflection) to carry on one's discourse is itself a matter of subtle avoidance. Warhol is both mirror and pane of glass, and his journey through the sixties might be compared to Léon's train trip to Rome in Michel Butor's *La Modification*. Here Butor used the glass of the carriage window as a metaphor for the medium, reflecting the narrator as it darkened, suddenly transparent with bursts and streaks of light, thus brilliantly telescoping the medium's dual function.[5] Warhol can be seen as Butor's narrator, but in a peculiar act of genius Warhol has made his own face the pane of glass and mirror, the "medium" for his medium—the context through which he maintains his absolute psychic neutrality, moral, emotional, esthetic.

This neutrality is at the center of Warhol's esthetic and social success, and it has provoked a mythopoetic literature of its own, usually with reference to Warhol's blankly daemonic saintliness.[6] Such a literature correctly recognizes that Warhol's cool posture has indeed a spiritual status

3 This is not meant as a criticism. Any way of making art is fine if it works. Modernism could be seen as a series of diminishing options. The sixties were characterized by an immense hysteria over the diminishing points of entry and access—indeed the attempt to disrupt categories and forms was a sign of this. Thus Stella's finding the "right" answer to historical inevitability through some superb dialectical footwork opened the last possible route (which gives him historical importance), and closed it (because everyone quickly learned the "game" and surfeited us with cool, paradox, irony, "thingness," and reductive and modular virtuosity).

4 Warhol's anyone-can-do-it idea is deeply connected to his donation of charisma to the average. By establishing this common base with the average citizen (and thus complimenting him) and at the same time being exceptional (being a "character"), Warhol showed a perfect understanding of the dialectics of celebrity.

and does constitute a mystery. As Warhol has said, however, the mystery is only our own projection, and its iconography rather than its solution is matter for inquiry, particularly in terms of the mass culture Warhol has appropriated. I am speculating here on the history of Warhol's *face*, which, as Coplans acknowledges, is as much a construct as his art.

There is little doubt to my mind that Warhol is a *naïf*, with the naïf's shrewdness and intuitive magic. This raises the question of both hysteria (which occurs in its purest forms in the naïve) and innocence, no matter how shrewdly that innocence is directed. And indeed Warhol has directed his innocence with much the same inspiration as his camera. He appeared to his early contemporaries [7] as a naïf. His early posture, with its implacable sweetness and ability to humiliate himself for sympathy's sake (he wandered around purposefully to ad agencies in rags and sneakers), was that of the ingenue. (His early commercial art—children's book illustrations, cherubs, shoe paintings—is also very pure and sweet, but at a distance, where the sweetness sports with a kind of shrewd silliness recalling seventeenth-century poetic uses of Elizabethan pastoral conceits.) Warhol's facial expression—his face—is a brilliant construction, and its early relationship to the ingenue's vagueness is instructive.

For Warhol's mature physiognomy is directly appropriated from the stars of the forties—Dietrich, Crawford, Hayworth. There is the slightly open mouth, the lidded gaze, the blankness that encourages projection in a triumphant form of servitude. This blankness is much more than a device; it is an iconographic signature with a high symbolic content. Its suggestiveness depends on its *superficiality*; any hint of expression, of inner life, immediately withdraws from the image its iconic status and returns it to the banalities of everyday living. In discussing seventeenth-century Dutch portraits, Roland Barthes referred to an unconscious expression shared by all of them irrespective of feature or face— a shrewd imprint that illuminated that society's material transactions. This he called a "numen." Warhol's numen, drawing on the powerful icon of stellar vacancy, sharply contrasts with other photographs of his contemporaries, which range from Rauschenberg's happy faces to Johns's guarded mask. Warhol's genius in composing his own face is

5 See John K. Simon's brilliant essay, "View from the Train: Butor, Gide, Larbaud," in *The French Review*, XXVI (1962), pp. 161–166.
6 The article that established Warhol's "saintly" myth was Jack Kroll's "St. Andrew," *Newsweek*, 7 December 1964.
7 See Calvin Tompkins essay "Raggedy Andy" in Coplans' *Andy Warhol* (first reference). Tompkins's piece, by the way, is an example of the pathetic fallacy (it's written in a bright-eyed "innocent" prose) being used to undercut the subject.

that there is nothing *behind* it. The numen of the ingenue-star is pure surface; all energies are translated to that surface to preserve its integrity. From that surface one's glance skids and slides and returns. Warhol's own sense of surface—and of himself as surface—is confirmed by his early gesture of spraying his hair silver, and surrounding himself, like a silver fish in a silver bowl, with a silver-foiled studio in which light slipped from wall to wall like water.

Everything that can violate that surface must be kept out. Everything that could translate its passivity into activity must be deflected—no motivations, no psychologies, no beliefs, no hint of an effect that contains a traceable cause. Thus the immense (and paradoxical) tension on such a surface, on which insults are deflected in infinite radiations (much the same way a Fuller dome responds to stress). Thus it can receive any projection, and return it with interrogative blankness to the observer. Warhol's face and Rothko's canvases share this odd indeterminacy. Warhol's face, whose neutrality can mysteriously influence and transform, is closely related to his mediumistic quality. His face has been consciously added to his art and serves to authenticate its status, even when that status is artificial, unreal and spurious—words devoid of pejorative intent when applied to Warhol's art. For part of the exhausted dialectic of paradox his work conducts is that the real is unreal, and you have to fake it (be unreal) to make it *look* real—which is to say, to give it the proper sense of surface. No one has amplified this etiolated moral order as a basis for criticism of his work (i.e., when fake it is real, when real it is fake), even though it is used particularly to maintain the low metabolism of his films.

Indeed, in the seventies certain moral judgments are about to be introduced to the criticism of Pop art; history underlines that the subject matter was chosen, whatever the artist's subsequent attitude. The hoax of Pop being in love with popular culture or mass advertising (which contemporary advertising used to promote Pop and its own self-parody) is now untenable. As Pop becomes an episode in the history of the sixties, its hostility toward the culture from which it appropriated its images begins to appear. This is partly because the passage of time introduces content in Pop's subject matter—and thus the beginnings of moral judgment.

So Warhol's infallible sense of rightness in choice of subject is being questioned. His electric chair for instance, very popular in its day (1963–67), is just a shade too campy. The famous Campbell's Soup cans and the repetitive all-overs seem less important than they did—their

point (repetition and its implications) is now accepted, and the work, more than most work, has lost something through assimilation. His car crashes fare better (the great variation of quality in Warhol's work has not been clarified). His masterpieces seem to me to be in the area of history painting; alone among his colleagues Warhol has an eye for the contemporary event. The car crashes are the baroque ruins and mobile charnel houses of our culture, and no one has celebrated them with such presentational acumen as has Warhol. His masterpieces, for me, are his schmaltzy portraits of Marilyn—an image of heartbreaking power. He repeats it enough to acknowledge its commodity value, and defines it enough to realize its personal anguish. Marilyn's face, like Warhol's, is quintessential surface; but its peculiar anguish lies in the fact that, since there was nothing behind Marilyn's face either, the anguish is experienced on the surface, that is, uncomprehendingly. Thus the Marilyn is an unusual coincidence in Warhol's oeuvre of brute suffering and glamor facade. (Just as his Jackie becomes the stunned medium of tragic feeling, her washed-out face a map neutral enough for us to fill in.)

The Marilyn is to my mind a great portrait, as great as his other work is often trivial. Part of the pathos of that portrait is, of course, its mechanical method—the dollops of color placed in the vicinity of correctness, which as a kind of ghastly cosmetology, add to the foolishness of the star subjected to the imperatives of male fantasy. (All his greatest portraits by the way are of women, and all can be seen as sharing a certain transcendent hysteria.) Beside Warhol's shrewd sweetness lies a brutal honesty (by his own definition, of course, unreal) which contains a great deal of hostility—evidenced by his choice of subject matter and his childlike desire to shock (note the headlines copied from the New York Post which, in an irony too pat for fantasy, finally appropriated Warhol himself).

But it remains to attempt to define Warhol as medium. There is the perfect surface, the neutrality, the lucid, almost luminous presentation (those works influenced by Rauschenberg tend to blur this). There is again the negative force that effects change but remains itself unchanged—which is, however, the kind of *watchfulness* in which poets receive the germs of their poetry. A medium remains mysterious no matter what we do with it—yet we can only know it through what is done with it. Therefore its definition is infinite. It can be described but not defined in terms of process (the current belief that process is or explains the medium is in my view suspect). The medium, a vague neutrality of infinite potential, is neither life nor art. It aspires to both;

Mary Josephson

both also describe but do not define it. If this suggests that the medium is an old-fashioned metaphysical soul hovering around somewhere, it is not. What I am really saying is that the medium does not exist except in potential; it is always about to become, it never is—for the very action or work that describes it in turn prevents its definition.[8]

If we apply this to Warhol as medium, we realize that anything can be done through him, but nothing defines him. He exerts his influence, his charisma, through his passivity, a passivity that draws everything to it, but remains alienated from everything that passes through. Warhol has been criticized for being unable to originate anything.[9] Most of his works are other people's suggestions. Far from being a criticism, I see this as confirming Warhol's mediumistic status. The perfect medium appropriates events, people, ideas, other media. In describing the medium they partake of its mystery (this is the dynamic that holds Warhol's group, like Manson's, together—though Warhol's is perfect passivity and Manson's is apocalyptic hocus-pocus). Also the medium (Warhol) does not accept everything. The element of choice in Warhol's career amounts in itself to a kind of inspiration.

It is then as mirror, as surface, as some translucent substance, that Warhol exerts his undeniable autocracy. It mimics the iconography of perfect blankness, and is in fact a kind of death in life. It is a style of necrophilia. This is not melodramatic. For Warhol is a Nietzschean creature who questions the idea of consciousness through his personal style and his art (the repetitions should be connected with this numbing of self-consciousness as a route to transcendence). Warhol's consciousness is Nietzschean in its implicit view of criticism as a corruption of consciousness, of intellectual formulations as masks of weakness and avoidance. His most fundamental relations, it seems to me, are not with his Pop contemporaries, but with other minds of similar cast—Roussel, Lautréamont, even Rimbaud. What is it that fascinates us about all these marvelous charismatics? It isn't only their work. It is the sense of their consciousness as medium. And what is it about all of them that seems to offer a solution? Not so much their work as their **silence**, those moments

8 Rauschenberg's often-quoted remark that he wanted to work "in the gap between art and life; neither can be made" seems to me a perfect description of the medium. Indeed Rauschenberg's work could be seen as a kind of "mediumizing" rather than art-making. Also note Randall Jarell's brilliant comment in "A Sad Heart at the Supermarket," Daedalus (Spring 1960), on the medium: "The Medium is half life and half art, and competes with both life and art. It spoils its audience for both; spoils both for its audience."
9 See Thomas Albright's review of the Andy Warhol books (first reference) in The Art Gallery (November 1970).

in their careers and histories when their minds are closed to us.

It is Warhol's consciousness that fascinates us as much as his art—and his silence will, if he is lucky, become as enigmatic as Duchamp's (though Duchamp, it must be said, unwisely broke that silence in the last decade of his life, thereby undoing some of his mysterious hagiography). Warhol's silence now is different in kind and quality from his initial passivity, which released an immense burst of creativity between 1962 and 1967—when the event that confirmed Warhol's fame as well as ending his "life" (it is appropriate that it should be in quotes) occurred. Again it was a gesture of passivity: being shot. This semi-martyrdom completed his iconography. He will carry it around with him like a saint's branch in a Renaissance painting. (That bullet also was, in its anatomical tunnelings and general Cook's tour through Warhol's insides, an unbearable violation of surface.)

It also confirmed his mediumistic status, since the action was that of a demented girl who wished to eliminate that powerful passivity through which he "controlled" her. (Perhaps she might have succeeded if she had used a silver bullet.) This event, coinciding with a distinct lessening of Warhol's creative industry, seemed somehow ordained, a release from the untenable banality of decline in a world which was, by the end of the sixties, no longer going Warhol's way, and was more and more revealing the violence beneath the infantilism of much mod culture. Warhol's consciousness is now left in suspension, and it constitutes a not unimportant enigma and presence on the New York art scene.

Self-Reflective Connectivity: Lawrence Alloway

Beatrice von Bismarck

When Lawrence Alloway published "Network: The Art World Described as a System" in *Artforum* in 1972, he was already among the key players in the field of contemporary art in the United States, both recognized and notoriously outspoken. Since the fifties he had made a name for himself in a succession of roles as critic, curator, and teacher, a reputation that was closely linked to current developments in art discourse, first in Britain and later in North America. Since his early work with the Independent Group that culminated in his involvement in their exhibition *This is Tomorrow* at the Institute of Contemporary Arts in London in 1956, by seeking to break down borders between artistic disciplines, professional roles, and high and popular culture, he laid the foundations for his subsequent notion of the art world as a system. With this concept, Alloway shifted the focus from individual works to the context within which art acquires its meaning, economic value, and status within society. When he published his collected writings in 1984, he began with "Network: The Art World Described as a System," reflecting the importance he accorded within his own practice to his thinking on art in relation to the concepts of network, world, and system and had been developing since 1966.

The text's publication coincided with a sea change both in art criticism in the United States and in art as an expanded field: *Artforum* was celebrating its first decade. All editors had pieces in the anniversary issue, and Alloway's was at the forefront of the magazine's radical reorientation toward societal issues. Made

possible by postwar prosperity, the rising numbers of art institutions and the art market's expanding role went hand in hand with a differentiation of professions within the art field, in turn provoking challenges to existing borders between disciplines, media, and roles. Technologization and mobility, mass mediality and the associated dictates of visibility, the "crisis of the author" and the growing importance of the economic third sector also developed into crucial factors contributing to competition. In this context, the concept of the network allowed Alloway to discuss the changing, contested position of all of the actors in terms of the relationality of their constitutive processes.

Alloway was neither the only nor the first person in the sixties to use the concepts of "world," "system," or "network" to characterize conditions in the field of art. Compared to writers like Jack Burnham, Howard Becker, or Arthur Danto, however, Alloway conceives of people, artworks, and artifacts, discourses, institutions, and events as equally involved. Even when his texts focus on single participants, he always describes them in their entanglement with others. This is true for his aesthetic analyses as well as discussions of museums, magazines, and exhibitions, and of the tasks of critics, art historians, and curators. For the artists he exhibited in the 1966 show *Systemic Painting* at the Guggenheim Museum in New York—including Agnes Martin, Frank Stella, Elsworth Kelly, and Robert Ryman—he stressed that their contributions could not be understood as individual works but only on the basis of their sequencing, in their spatiotemporal dimension, and thus within a system. Treating the relations of reception as part of the artworks, he emphasizes their communicating, channeling functions and privileged "transmission" over "production" with regard to the accessibility of art and its ephemeral meaning that changes as it moves through spaces and media. In his insistence on social interplay, he sees not art history but sociology as the source of appropriate approaches to curatorial activity, advocating for the previously marginalized, such as female artists and independent spaces, to be granted their place within theory and practice.

A key aspect of his writings is that he always understands himself as part of this network. He reflects on the position from which he speaks in any given case, and provides information about the conditioning and interests that caused him to adopt it. His nonhierarchical understanding of the roles of "artist," "critic," and "curator" thus becomes accessible. For Alloway, art criticism, tightly interwoven with his teaching, curating, art history, and art theory, was part of an overall practice that allowed him to do two things: examine the art world from different angles, and repeatedly embody that world with its individual relationally defined components in his own person. That this approach anticipates central demands on cultural labor in the twenty-first century—such as mediation, connectivity, conflictual self-administration, and negotiation—both describing and reflectively exemplifying them, constitutes the particular relevance Alloway's writing still has today.

Network: The Art World Described as a System

Lawrence Alloway

excerpted, from *Network: Art and the Complex Present, 1984,* first published in
Artforum, September 1972

The first exhibition of a newly made work of art is in the studio. This first
audience of the artist's friends views the art in the workplace in which it
was created, in the artist's presence and associated with the rest of his
life. The satisfactions of his contact are obvious, both to the privileged
group and to the artist in touch with his peers. The second exhibition, as
a rule, is in an art gallery where it is seen by a larger but still specialized
section of the public. (The average attendance at an art gallery during a
show is rarely more than a thousand people.) From the gallery the work
may be purchased by a collector, travel to other galleries or museums, or
be actually acquired by a museum. Each change of milieu will encourage
different expectations and readings by a changing audience. A fourth
context is literary, the catalogues and magazines in which the work
of art is no longer substantially present as an object, but is the subject
of information.

By this point in a work of art's distribution a description in stages
is no longer sufficient; it has acquired a record, not simply in terms of
places shown and changing hands, but an aura of esthetic interpreta-
tion as well. It belongs in the context of the art world, with its special
opportunities for comparison and meditation for analysis and pleasure.
The density that a work accrues as it is circulated means that it acquires
meanings not expected by the artist and quite unlike those of the work's
initial showing in the studio. Although wide distribution is the modern
equivalent for classical fame, there is an inbuilt alienating factor. Wide
distribution can separate the work from the man who produced it as the
variables of other people's readings pile up and characterize the object.

The alienation by distribution effect is not to be avoided except by
withdrawal from the art world, for art is now part of a communications
network of great efficiency. As its capacity has increased a progressive
role-blurring has taken place. Before World War II, for example, muse-
ums worked at a fixed distance from the art they exhibited, which was
either of some age or could be regarded as the latest form of tradition of
acknowledged historicity. Most American museums have abolished the
time lag that previously regulated their policies and now present not only

new work but new artists. Though on a different scale and with different motives, such activity connects intimately with private galleries, whose profits can be affected by museum shows of their artists. The Alan Solomon-Leo Castelli collaboration at the Jewish museum in the early sixties, the Rauschenberg and Johns retrospectives, at the ages 38 and 34 respectively, is a remarkable example of the convergence of intellectual interest and high profits. Art historians prepare catalogues raisonnés of living artists, so that organization of data is more or less level with their occurrence. Critics serve as guest curators and curators write art criticism. The retrospectives of de Kooning and Newman at the Museum of Modern Art were both arranged by the editor of *Art News*, Thomas B. Hess. (A crossover in the opposite direction was made by John Coplans, former curator of Pasadena Art Museum and now editor of the magazine.) William Rubin, a curator at the same museum wrote a monograph on Frank Stella; he is also a collector and lent a Newman to the retrospective. In ten years I have been a curator, a teacher and an art critic, usually two at a time. The roles within the system, therefore, do not restrict mobility; the participants can move functionally within a cooperative system. Collectors back galleries and influence museums by acting as trustees or by making donations; or a collector may act as a shop window for a gallery by accepting a package collection from one dealer or one adviser. All of us are looped together in a new and unsettling connectivity....[1]

In 1910 Apollinaire described attendance at the opening of the annual exhibition of the Société des Artistes Français: "lovely ladies, handsome gentlemen, academics, generals, painters, models, bourgeois, men of letters, and blue stockings."[2] This was written for a newspaper so the 19th-century typology is journalistically apt but the assumption of a recognizable art world is clear. Painters and models were solidly legible in their roles and their supposed system was equally clear—generals, young couples, writers. The art world now is neither as clear nor as simple as it seemed then. Not only has the group of artists expanded in number but art is distributed to a larger audience in new ways, by improved marketing techniques and by mass media. What does the vague term art world cover? It includes original works of art and reproductions; critical, historical, and informative writings; galleries, museums, and private collections. It is a sum of persons, objects, resources, messages, and ideas. It includes monuments and parties, esthetics, and openings,

1 This passage derives from the author's "Art and the Communication Network," *Canadian Art*, June, 1966, pp. 35–37.
2 *Apollinaire of Art*, ed. LeRoy C. Breuing, trans. Susan Suleiman, New York, 1972, p. 51.

Lawrence Alloway

Avalanche and *Art in America*. I want to describe it as a system and consider what effects it has on art and on our understanding of art. Let me state at once that the system does not mean merely "establishment"; as Tomás Maldonado has pointed out,[3] system is often used as a synonym for regime, which vulgarizes an exceedingly useful term.

Recognition of recent art, the art of the sixties, induces a sense of product proliferation. An example from industry is the big airplane, the DC-10, being followed by the short haul DC-9 in two different versions. Artists use their own work and each other's in this way, rapidly, and systematically following up new ideas. In addition, the written criticism of the period has supplied visual art with instant commentary. There has been therefore a considerable increase in the number of short term orderly projections and their improvised interpretation. The effect is, to quote Henri Lefebvre, of an "enormous amount of signifiers liberated or insufficiently attached to their corresponding signifieds."[4] In reaction to this has been widespread discontent with the existing system of information-handling in the arts. The problem of art for the educated has taken on acute significance with the emergence of an alienated audience, for instance, the youth market and the black community. Reassessment by the artists and their role in society parallels their audience's doubt about art's centrality. The market or exchange value of art has been discussed since 1960, not as a source of prestige but as the taint of corruption. Art is a commodity in a part of the system but not in all of it, and at this point I am more interested in differentiation than reduction.

The art world can be viewed as "a shifting multiple goal coalition."[5] It is, to continue regarding it as an organization, a "'negotiated environment.' That is, long contracts with suppliers and customers, adherence to industry wide pricing, conventions, and support of stable 'good business' practice."[6] The contracts are usually less formal in art and good business practice is pretty vague, but the parallel is there. Decisions in art galleries, museums, magazines, and publishing houses are made close to the working base of each enterprise, as in decentralization. Thus we have a network, not a hierarchical structure. As H. J. Leavitt points out, apropos of individual in a network: "It is enough, in some cases, if they are each touched by some part of a network of communication

3 Tomás Maldonado, *Design, Nature and Revolution*, trans. Susan Suleiman, New York, 1972, p. 51.
4 Henri Lefebvre, *Everyday Life in the Modern World*, trans. Sacha Rabinovitch, New York, 1971, p. 56.
5 D. S. Pugh, D. J. Hickson, C. R. Hinings, *Writers on Organizations*, Harmondsworth, 1971. Paraphrasing Richard M. Cyert and James G. March, p. 81.
6 Ibid., p. 83.

which also touches each of the others at some point."[7] Such a pattern of partial information fits the complex movement of messages and influences in the art world. Raymond D. Cattell has referred to "the principle of 'simple structure', which assumes that in an experiment involving a broad and well sampled set of variables; it is improbable that any single influence will affect all of them. In other words, it is more 'simple' to expect that any one variable will be accounted for by less than the full complexity of all the factors added together."[8] This should be borne in mind for it is absolutely against my intention to reduce the art world to any single influence by describing it as an organization. On the contrary, it is only in this way that its complexity can be kept clear.

"The organization as a system has an output, a product, or an outcome, but this is not necessarily identical with the individual purposes of group members," observe D. Katz and R. L. Kahn.[9] What is the outpost of the art world viewed as a system? It is not art because that exists prior to distribution and without the technology of information. The output is the distribution of art, both literal and in meditated form as text and reproduction. The individual reasons for distribution vary: with dealers it can be assumed to be the profit motive at one remove. Art galleries, museums, universities, publishers are all part of the knowledge industry, producing signifiers whose signifiers are works of art, artists, styles, periods....

The essential figure in the system is of course the artist. His is the product on which the system depends. In addition to his initiating act of production the artist has a privileged social role. The prestige of the position was earned by the Abstract Expressionists originally, by the existential and seerlike attitudes with which they confronted a society not then ready for their art. It has continued into the sixties, but on a changed basis: early success and media coverage give artists, or some of them, considerable control over their work, and tax problems replace money worries. Artists and their works have changed less than the system by which their art is distributed. The conditions of consumption, in which one is faced with the abundance of world art, have changed more than the conditions of production....

In connection with the early Pop art term "fine art-pop art continuum"[10] was used to describe the interconnections of cultural levels,

7 H. J. Leavitt, "Some Effects of Certain Communication Patternson Group Performance," in *Organization Theory*, ed. D. S. Pugh, Harmondsworth, 1971, p. 72.
8 Raymond B. Cattell, "The Nature and Measurement of Anxiety," *Scientific American*, 208, 3, 1963, p. 96.
9 D. Katz, R. L. Kahn, "Common Characteristics of Open Systems," in *Systems Thinking*, ed. F. E. Emery, Harmondsworth, 1969, p. 88.

Lawrence Alloway

"low" and "high," unique or mass-produced, in nonhomogeneous groups. It included the esthetic appreciation of mass-produced goods, the appropriation of popular materials by artists (Pop art), and the mass media's interest in art. In the sixties, however, it became clear that the art world itself had become subject to a similar nonhierarchic connectivity. The mass media covered prominent artists or museum shows; the occasions of high culture became the subject of publicity. Abstract paintings in the *House and Garden* features on collectors, or the Park Place Gallery photographed with fashion models among the sculpture, are two examples. Here the works of art become a part of the lively flow of signs and symbols that populate the environment.... The literature of art now runs copiously beyond the reviewing of exhibitions by critics as art is assimilated to the sphere of consumption. Thus there exists a general field of communication within which art has a place, not the privileged place assigned to it as humanism as a time-binding symbol or moral exemplar, but as part of a spectrum of objects and messages.... Though art may be a private act in its origins, this is not what we can be expected to see as art becomes part of a system of public information. Art is a public system to which we, as spectators or consumers, have random access.

A work of art consists of at least two levels of information: one that can be translated into other media for reproduction, or that other artists can use, and one that is identified solely with the original channel.[11] Any work of art contains both special channel characteristics (unique) and transmissible information (repeatable). The stratification is not mechanically arrived at, but is a consequence of the interaction of the artist's intention and the spectator's interpretation. One may be more interested in the unique component than the other, but to restrict the work's meaning solely to that is restrictive. In addition, it goes against all one's experience of art to presume that exhausted interpretation is possible. A consequence of the incorporation of art into the fine art-pop art continuum is that the variable responses inevitably evoked by art have been made more fully visible....

One work that has been submitted to mass production in a curious way is Jackson Pollock's *Convergence*, 1952. The original painting is in the Albright-Knox Art Gallery, Buffalo; it has been reproduced in the form of a jigsaw puzzle. It is therefore an extreme example by which we

10 The concept of the fine art-pop art continuum is given in the author's "The Long Front of Culture" *Pop Art Redefined*, ed. John Russell, Suzi Gablik, New York, 1969. Originally published in *Cambridge Opinion*, 17, 1959.
11 For a wider discussion of translatability, see the author's "On Translation," *Arts*, Summer, 1971.

can test what remains when art is treated not as a self-evolving process but as something added to the continuum of moving daily signs. The original is not destroyed when the colored reproduction is cut up into little Arp-like free form units. The painting is a Herculean late work, one of the two major efforts Pollock made to recapture and extend the big drip paintings of two years earlier (the other is *Blue Poles*). Is it degraded by its ludic form? I think not, inasmuch as any transmissible image is subject to re-contextualization, whether it is the lion's feet, derived from Egypt, on Napoleonic furniture, or a Coca-Cola sign in a South American jungle. The continuum of translated messages requires acts of continuous estimation before a succession of alternatives. Is the person who successfully completes the puzzle stimulating the work of the artist and hence being brought close to a creative process? Obviously not, for the arrangement of standardized parts does not resemble Pollock's way of painting, but it might be like making a Sol LeWitt ("the process is mechanical and should not be tampered with. It should run its course").[12] The variables of context and interpretation released by 20th-century communications have become the subject of this mass-produced object. A connection can be made between the puzzle: the image of the labyrinth, a structure with blocked routes, continually evoked by writers on Pollock, is appropriate to the initial unordered scatter of the bits; and when it is terminated it becomes a sign for the painting, *Convergence*.

The sixties was a brilliant decade in which an exceptional number of young artists emerged, without the tentative or inhibitory starts of their predecessors. Their work, along with the continued work of slower developing older artists, helped to make the decade one of numerical and stylistic abundance. There was undoubtedly a sense of relief and ebullience at having got out from under the gestural form of Abstract Expressionism which dominated the fifties. The escape from de Kooning opened out a series of options which had been excluded by the esthetics and operational lore derived from him. For museums it marked an efflorescence of retrospectives, or their equivalent. Not only were exhibitions on a large scale, there was lavish duplication, such as two different Liechtenstein exhibitions in two years, and big short-term expenditures, such as Morris' colossal piece at the Whitney museum or Serra's at Pasadena. Museums cooperated in the realization of artists' projects on a vast scale. In the catalogues there is a convergence of art history as a methodology and art criticism as a response to present art. Thus there has been a

12 Sol LeWitt, "Sentences On Conceptual Art, 1968" *Conceptual Art*, ed. Ursula Meyer, New York, 1972, p. 175.

Lawrence Alloway

complexity of data available about living artists. For publishers the sixties included a number of monographs on, to name a few, Johns (Kozloff), Oldenburg (Rose), Stella (Rubin), Warhol (Coplans, Crone), Lichtenstein, Kelly (both Waldman), Frankenthaler (Rose). The support system of the knowledge industry was firmly lined up behind the artists.

It was in the sixties, starting with Pop art, that regular mass media coverage of art began. Previously magazines and newspapers had treated individual stories, often in detail, but now art was recognized as a theme of leisure which was itself named as a subject in this decade. Instead of occasional pieces on defaced statues or extravagant collectors, art was steadily covered as a constituent of culture. *Life* and *Time*, for instance, had reproductions of and statements by Pop artists long before the specialized art journals got around to them. Later in the sixties, however, it is true that the art magazines and general press share the same subjects much of the time. (It is the promptness of the coverage that is one of the reasons for the corrosion of the concept of an avant-garde. A group's lead-time in new ideas is of almost negligible duration now.) When I wrote a piece on Rosenquist for *Artforum* recently, selection of the color illustrations was delayed until we could find out which of the transparencies available from the Whitney Museum were being used by *Time* and *Newsweek*. Although my article was longer and later, it was essentially no less occasional than Robert Hughs' and Douglas Davis' pieces. I did not time the article myself; the Whitney Museum did. It is a weakness of the art magazines that many of the articles are as much reviews as the shorter pieces acknowledged as such. Color reproductions in the catalogue are reused in the magazines, a convenience that ties later uses closer than ever to the initial occasion. The effect of criticism as reviewing is to produce a series of suddenly uniform topics in the journals, which gives the appearance, to suspicious provincials, of a rigged scene.

To all this must be added the prosperity of the decade. There was money for museums (new plant, new acquisitions) and for investment in private art galleries (Scull's backing of the Green gallery, for instance, or the support that several supporters gave the Park Place Gallery which raised cooperatives to a new luxurious space). There was as well a willingness to pay high prices for new art, subject to elaborately negotiated discount: Harry Abrams, Leon Kraushaar, John Powers, Scull were among those who attached the principle of conspicuous consumption to the newest art. By the end of the sixties, however, the cluster of social injustice, Vietnam, and inflation had destroyed the favorable situation, for the art world as other sub groups. Robert K. Merton has proposed a method of studying social change: it is "the concept of dysfunction,

which implies the concept of strain, stress, and tension on the structural level,"[13] of an organization. The smoothly functioning art world of the sixties exhibits numerous dysfunctions now. The price and turnover of goods at galleries are down. The deficits of museums all over the country are getting harder to make up, sometimes resulting in violent abbreviation of services.

The confidence produced by the simultaneous success of two generations of American artists, the delayed recognition of the older and the accelerated recognition of the younger generations coming together, promoted a sense of common identity. At first this amounted to little more than a loose agreement to being part of a professional group in a situation sufficiently stable not to demand continual conscious participation. By the late sixties, however, artists had developed a sharper sense of themselves as a permanent interest. Typical of a new intransigence and desire to modify the form of distribution of art were the Art Workers coalition and the short-lived emergency Cultural Government, both of which presumed the need for reform of the market and institutions of the art world. Another sign is the move to protect the artist's power of copyright by the Artist's Reserve Rights Transfer and Sale Agreement, a contract that a number of artists require their collectors to sign. (It provides for future remuneration if a work is resold at a higher price.) What has occurred, of course, is that the revival of ideology has extended to the art world. It takes two forms: first, an increase in one's own political commitment and, secondly, a fundamental skepticism concerning other positions. Ideology as a method or argument is corrosive in that it substitutes *my* interpretation for *your* motive. The discontent of many artists with galleries and museums therefore may amount to a fundamental re-orientation of attitude to the entire system that encloses their work....

It is worth remarking that a majority of writers and curators were trained as art historians. In fact, critics without art historical training often claim the role when all that is meant is an increase in the account of verifiable facts. (Speaking personally, what I write is art criticism with footnotes.) The profession of art historian now shares its own crises with other academic disciplines. It is orientated towards a set methodology suitable for research by graduate students whose incorporation in society afterwards is no longer assured. In the immediate future the important issues may be the devising of alternate methodologies and goals, including analysis of the teaching of undergraduates (who, for one thing, arrive at university with a built-in mastery of the fine art-pop art

13 Robert K. Merton, *Social Theory and Social Structure*, Glencoe, Illinois, 1949.

Lawrence Alloway

continuum). It seems possible that the art historian is being displaced as a model for critics, for the reasons given and also because of the activation of conscience by recent political events. This has led to an ideological evaluation of historians' supposedly objective techniques.

Both the status of art as an object and the validity of the gallery exhibition as a unit have been questioned. The first sign of the problem may have been in the fifties when Pollock, Newman, and Rothko made their large paintings. After initial consternation, however, the paintings were assimilated into small spaces, like a gallery or apartment, because the artists wanted intimate, participatory contact. Happenings, though sometimes producing residual objects, like Oldenburg's, were outside gallery limits; even more so were Events, which could be imperceptible, except to participants, dispersed, and protracted or momentary. Earthworks, which substitute terrain for the object, were originally supported by galleries notably Virginia Dwan's, and what was shown in the gallery was usually the documentary evidence of work in New Jersey or Nevada. The new expansion of scale was wittily stated by Morris when he observed of his *Los Angeles Project, 2* (air conditioning and heating equipment buried in a square mile of earth) that there would be "a little more weather in the area." Smithson's dialect of the site and non-site

Photograph taken by Alexander Liberman of a gathering at his home around 1965.
From l. to r.: Lawrence Alloway, Tatiana Liberman, Barnett Newman, Sylvia Sleigh, Helen Frankenthaler (standing), Robert Motherwell, Annalee Newman

Self-Reflective Connectivity

set up a network of signs between the absent signified and the present signifiers, a procedure which assigns the gallery a partial role, as a container of rock samples, maps, and photographs. Andre's "post-studio art" has the potential, not followed by Andre himself, of going straight from inventory to site, which would make it post-gallery art, needing no middle stage of display. Conceptual art, when it consists of photographs, schedules, lists, maps, and instructions is better viewed in books and catalogues than when mounted and framed on the wall where it subsides into tacky graphics. Finally performance art, such as Vito Acconci's, deals with states of low visibility, interaction, exhaustion, vulnerability which dissolve the usual day-long solidity of spectacle at an art gallery.

In conclusion we must ask what is likely to follow from the crisis of confidence that artists (some artists) feel in the distribution system. There is a basic continuity from (1) the public consumption of prints that started on a big scale in the 17th century and (2) the public display of heterogeneous uncommissioned art in annual exhibitions that started in the 18th century to the sixties. The continuous assumptions are that art is translatable and that public access to new art is desirable. For any development in the seventies to introduce a real difference, these ideas or one of them, would need modification. It is highly unlikely that any change will originate with the galleries which have never been remarkable either for "degree of flexibility" or "span of foresight" to quote the two criteria of M. P. Schutzenberger's for evaluating behavior.[14] To judge by the recent record, museums do not seem a likely source of new forms of distribution, subject as they are to their own institutional traditions and to the ceiling imposed by wages and overheads. Any change would need to originate with the artists, though the difficulty of making viable changes is suggested by the underlying assumption of public access which I take it nobody wants to abridge. However the cumulative effect of post-studio, site-based, and conceptual art forms is a clear sign of stress, requiring changed forms of presentation. The problem is that search-bias, the tendency to look for a new solution to the old solution,[15] is pronounced in the art world, because we all tend to conceive the world in the fixed image of our vocation.

14 M. P. Schutzenberger, "A Tentative Classification of Goal Seeking Behavior," in Emery, *Systems Thinking*, pp. 205–213.
15 Pugh, Hickson, Hining, *Writers*. Paraphrasing Cyert and March, p. 84.

Vulnerability and Resistance: Marta Traba

Florencia Malbrán

Marta Traba's book, *Two Decades of Vulnerability in Latin American Visual Arts, 1950–1970*, published in 1973, is a pivotal text for the study of Latin American art. Traba was born in 1923 in Buenos Aires, Argentina, where she completed her undergraduate studies and became part of the group of critics around Jorge Romero Brest, focused on promoting avant-garde art. In Paris she met her first husband, Alberto Zalamea, a Colombian journalist, with whom she moved to Bogotá in 1954. There she became an authority on Colombian art. Traba had a radio program, was the producer and host of a television show dedicated to the visual arts, and wrote more than a thousand articles analyzing the local art scene. And she was an initiator and early director of Bogotá's Museum of Modern Art, founded in 1962.

Traba's seminal book was a call to transcend all forms of dependency and subjugation. She encouraged artists to overcome the conditionings of the United States, which exerted aesthetic imperialism. Addressing vulnerability, she developed a "theory of resistance," aimed at stopping the homogenization of art and the "cultural, economic, and political invasions" to "save certain modes that constitute a way of life."

Although the book was written over several journeys and even during a period in exile, Traba first envisioned it after visiting Havana, where she was enthusiastic about the promises of the Cuban Revolution, which ended in 1959. When in 1968 the military took control of Colombia's National University, Traba publicly expressed her disgust

and was expelled from the country, accused as a foreigner intervening in national affairs. The local artistic milieu reacted strongly and she was ultimately offered a reprieve, but she chose to leave anyway. With her new partner, the renowned Uruguayan literary critic Angel Rama, she lived in Uruguay, Venezuela, Puerto Rico, the United States, and France, until both died in a plane crash near Madrid in 1983.

Already in the seventies, Traba was offering a new critical framework for Latin America, an understanding of modernity as a fractured, multiple process rather than one exclusively driven by the idea of progress or the forces of colonialism and cultural domination—crucial issues in our globalized age. She framed her views around the discourses of Theodor W. Adorno as well as Umberto Eco, Henri Lefebvre, Herbert Marcuse, and other intellectuals, but she tended to eliminate many of their primary topics (the loss of creativity, alienation) and instead favored provocative arguments about cultural co-option and resistance. Traba traced a new map of Latin America, charting a "open area" that included capital cities like Buenos Aires, São Paulo, Caracas, Santiago de Chile, and Montevideo, and was defined as "updated" with a "drive toward civilization" manifested in the flows of immigrants, the glorification of capitalism, and an insistence on making progress. The "closed area" encompassed mainly Colombia, Peru, Bolivia, Paraguay, Puerto Rico, and the Caribbean and was "provincial," facing "deep-rooted conditions of life" due to low immigration, a strong Indigenous or Black tradition, and societies divided into castes with low social mobility. This zone is where artists could create genuine artworks; they could intervene in a specific locale and explore a history that belonged to them. Such "resistant artists" challenged the technological notion of time as an arrow pointing to the future. Rather, their works made the past present, creating rhythms specific to Indigenous Amerindian peoples, as did Peruvian painter Fernando de Szyszlo (1925–2017). His paintings from the series Apu Inca Atawallpaman (1963) are based on a sixteenth-century Quechua poem lamenting the death of the Inca Atahualpa, and therefore foregrounded the importance of Inca Art.

Later, after Traba's death, Szyszlo suffered from a negative image. He bore the burden of an artist that had entered into the *mainstream* of Peru and had accepted the privileges of official culture. This image may have overshadowed Traba's posthumous reputation.

Traba's most profound effect on art critique is her transformation of the historical narrative, stating that, instead of a seamless evolution of forms of art, dictating a single history, it was urgent to understand culture in broader terms. Traba challenged critics (and artists) working in the tradition of the Western academy to step outside the fabric of its ideas. Her call to action is welcomed today, a time in which we are "worlding the world of art."

Two Decades of Vulnerability in Latin American Visual Arts 1950/1970

Marta Traba

from *Two Decades of Vulnerability in Latin American Visual Arts*,
first published as *Dos decadas vulnerables en las artes plasticas
latinoamericanas 1950-1970*, 1973

First Position: The United States versus Latin America

The study of visual arts in a highly industrialized consumer society such
as that of the United States in the period from the end of the Second
World War up to now places art within a strictly delineated sociological
context that leaves no margin for error or ambiguous interpretation. This
context is notably more decisive than the one that frames the European
"–isms" from the end of the century up to the Second World War—set-
ting aside the many links to German Romanticism, idealism, progress,
indeterminate violence, the purist frenzy, etc.—over which glides an
unfading and unyielding individualism.

In the United States, artistic activity is derived from the choices offered
by consumer society and is as faithful to the optimism of the New Deal as
to the moral depression and the latent disappointments of the post-war
period, becoming, paradoxically, more disconnected from its own society
the more it proclaims its freedom and unfurls the vast expanse of its pro-
gressive debauchery. In this way, art affirms its servitude to a technology
capable of exerting so much control that it leads to totalitarianism, can-
celing out the possibility of speaking an autonomous language that could
lead to, as Marx dreamed, the fullest employment of creativity.

Marcuse's critique of technology shines a light on the trap that US artis-
tic freedom has fallen into. Technology that has lost its "technical" neu-
trality, defended by Francastel, technology clearly tainted with totalitarian
ideology, will produce a robot-individual who obeys the imposed order
with a learned docility and who rejects their own "interior dimension."

At the same time, the interior dimension lost to man in consumer
society cannot exist outside what Lefebvre calls "a general code," which
is to say, a global system erected by society in order to create generally
accepted signs and signifiers, the mutual understanding of which estab-
lishes harmony between man and his community.

What kind of shared language can be derived from the technology
that prevails in a consumer society? There are those, such as Marcuse

who refer to it as "ritual authoritarian language"; others, such as Roland Barthes, would classify it as "a language specific to all authoritarian regimes;" or, according to Lefebvre—already doubtful of our ability to assign specific meaning to an image—consumer society is incapable of creating anything other than "traffic signals" along any road. The common critique across these views is the same: the tyranny of technology. Technology, skillfully transformed into ideology by those who would manage it as a tool for power, has penetrated the cultural unity of consumer society and has been dispersed far and wide.

As the common code that allows us to share signs disappears, hermetic compartments are created, moving, as Lefebvre states, in accordance with operationalism, functionalism, and structuralism, and increasingly separating us from the ideal notion of a shared code.

This *loss of shared code* has not occurred without resistance, just the opposite, the resulting miserable and chaotic state of the cultural industry has been denounced in the United States by critics as penetrating, sharp, and implacable as McDonald and Greenberg. But, despite the lucidity of intellectual arguments, technological manipulation has led to polysemy, to arbitrary interpretations, and exasperatingly personal language, to the disappearance of norms and a false sense of total freedom which Marcuse himself denounces as our greatest disconnection.

It is logical, therefore, that in the face of this chaos, the rift between artists and the public will widen day by day, to the point that the famous notion of "participation" no longer has anything to do with the initial game of transforming the spectator into "accomplice," devolving into a demand, something ridiculous and dramatic.

The most obvious effect of "ideological technology" on US visual arts is the replacement of what we could call a traditional aesthetic with an *aesthetic of decay*. If the ultimate goal of traditional aesthetics consisted in achieving the permanence of a work of art beyond the contingencies of time and trend to become a coordinate of style, the aesthetics of decay, on the other hand, discards or openly defies both concepts. The goal consists of *not enduring* at all and in *not setting standards* of any kind.

In recent years, US art, with the exception of the "minimal," granted US citizenship in 1966, has been devoted to anti-proposals or projects governed by this decadent trend. Movement and change, which sealed the fate of so many splendid artists in the 1950s and 60s, come to a halt with the artistic genocide of the 1970s, with the improvisation of an ephemeral product, followed by its immediate destruction, not carried out by the artist, but by a stranger, the public.

This doesn't exactly mean that the work of art is rejected, but that it is explained in ways that are contradictory to traditional explanations. While Cézanne wanted to endure, through his self-portrait, in the form of an unassailable rational construction, Rafael Ferrer (Puerto Rico), on the other hand, has no intention other than to offer a sporadic (and melancholic) show, as he climbs on and off a stool. Without the possibility of enduring, without seeking any structure of permanence, art condemns itself to the same fate as any product in consumer society: as soon as it begins to wear out, once it has met its clients' expectations and has left them temporarily satisfied, it is discarded.

Just as in the case of the critical objection referred to previously, this process is not without its tragedies. For example, the notorious fistfights of Willem de Kooning (member of a generation of sacrifice—Gorky and Rothko's suicides, Pollock's near-suicide), symbolize the struggle to save the interior dimension from the dominant aesthetic of decay, resulting in both magnification and eclipse of the artist, excluded from the game that, with the emergence of "pop" (Rauschenberg, Noland, Oldenburg, Dine, Johns), has come to rule all US art.

De Kooning's generation (Pollock, Motherwell, Kline, Newmann, Rothko) had the strength to reject the proposal that would later be accepted unconditionally, that of converting art into a fragment of the *technological project* that dominates consumer society, standardizing it; touting its unlimited freedoms; demanding convenient and collective happiness to serve as collective therapy; converting art into a vehicle for aggression, and, therefore, into something dangerous to the individual. Art is transformed, in sum, into a perfectly prefabricated catharsis whose triple powers to divert, liberate, and destroy have been exercised with terrible and terrifying regularity.

This process can be seen quite clearly in the work of some of the greats of contemporary US art. Let's take the case of Rauschenberg, for example, one of the most fascinating personalities due to his deep understanding of art's poetic function. If we begin with the extraordinarily poetic tone of his first collage works of 1955, where the totalizing effects of his "action painting" could be felt with notable intensity, moving later to *Tracer* in 1964, where, as in all the work of that time, fragmentation prevails, albeit lacking the ingenuity of the surrealist associations fifty years prior (1913, Duchamp's *Bicycle Wheel*), and we jump to his light boxes in '69, where erotic photography is an attempt to fill the void of the signified, we see that, successively, Rauschenberg diverts, liberates, and destroys, mirroring the extent to which technological ideology imprints these directives on contemporary art.

A common explanation of US pop art (61-64 Leo Castelli, New York; Rauschenberg, Johns, Lichtenstein, Chamberlain, Warhol) inserts it in the "American way of life" that emerged during a decade populated with Marilyn Monroes and Campbell Soups. In the same way, a clear parallel can be drawn between the furious rejection, as the 70s approached, of wellbeing, comfort, and material objects (epitomized by "beatnik-hippie culture") in the "happenings" and "anti-museum" installations that Messer characterized as the maximum fusion of art and nature, art and existence, art and nothing that has been achieved up to now.

But it would be a mistake to take these occurrences as fundaments of style, when they are precisely the opposite. The elements of style, which as a whole make up the body of a determined *culture*, are transmittable; but the behavior we are addressing here, which responds in every way to the peculiarities of a specific *civilization*, cannot be transmitted without converting them into a vehicle for that very civilization. The transmission of culture implies, at the same time, the transmission of a system of thought, an organization of man and his relationships not only with society but also with history. The transmission of civilization, on the other hand, is preoccupied with the imposing of customs, practical ways of life and behavior that, lacking a persuasive internal force, must find a way to impose themselves. And, one last reflection, just as the transmission of culture is characteristic of non-imperialist groups, the imposition of a system of civilization is typical of imperialists.

If ideological technology has destroyed, in the US, the *general code* and created a new aesthetic trend of *decay*, where and how do we classify the many artists, generally very talented and imaginative, of recent decades?

Modern art in the US has without a doubt resigned itself to becoming an *area of technology*. In the moment this was accepted, any possible *global* interpretation of the society was lost. The culture can only be seen from the angle conceded by technology. For this reason, when the "pop" artists, or some of the "op-art" artists maintain their absolute lack of critical intent and de-authorize the theorists who see them as subtle and caustic critics of consumer society, they establish a new and nevertheless true criteria, as much as it may seem unbelievable from the perspective of European aesthetics, where art without intentions or objectives is inconceivable.

For this reason the energy deployed by the new US artists is, typically, a *productive energy*, more than a creative force with its *a priori* requirements. It is an energy which, giving in to technology's progressive provocations, does nothing more than reinforce its service to consumer

society. There is no other way to interpret Dan Flavin's space lit by neon light or Andy Warhol's bright orange electric chair.

US art, an area of active technological production which races to meet the urgent demands of consumer society, emits the *signals* corresponding to each new invention.

The *signal*, which replaces the *sign* in the relationship between signifier and signified in global language, is incomparably poorer than the sign. If we take as a given that a work of art is a *"system of systems,"* some of which do not reference the formal internal relationships of the work, but the relationships between the work and its viewers and between the work's references and the historical cultural context in which it originated, the signal is a mere mechanical indicator, a poor substitute for language as it simply allows passage down the road to be followed but fails to give way to any complex structure of meaning.

The signal, then, much poorer than language, is what we receive from US art; it is emitted and immediately received and complied with ever more diligently, as will be seen in our analysis of these two decades of vulnerability. This habit, now common practice, of working with a pseudo-culture full of readjustments and reorganizations has made receptors numb to the simultaneous production of the same artistic creations as those being exhibited in New York, a good (or bad) example of which was the visual arts section of the Instituto Di Tella in Buenos Aires.

It seems cliché to say that our continent has not overcome colonialism; Spanish cultural dominance during the 17th and 18th centuries, and the French and European in the 19th and early 20th centuries, was, precisely that, a dominance. American civilization is now able to control our traffic signals because of our history of "semi-everything": semi-independent, semi-dependent, semi-developed, semi-underdeveloped, semi-cultured.

Whatever name we give to our society, it is certain that the specific nature of our "acculturation" has left us, irredeemably, as receptors of "mother cultures." But I would like to clarify that the danger is not in becoming a receptor but in confusing *traffic signals* with *language*.

It could even be claimed, recalling so many splendid cases of hybridization and fruitful artistic mixings in the history of Latin American art, that the European influence, whether transmitted through the Baroque, Romanticism, or Modernism, more than merely providing models to be followed, established the prestige of formal invention. Art was received as language, and also as speech, malleable and easily manipulated. In its cultured artistic creations, subservient to the model, as well as in its spontaneous and primitive creations, Latin American art has always

been a reflection of the outside emission. I'm thinking of the Mexican Baroque, of Indio Condori, of Aleijadinho, of the primitive republicans poking fun at the Romantic and Neo-Classical academies; but I also think about the modern geniuses such as the Venezuelan Reverón, who in the 1930s undid the entire theory of the impressionist "moment," or the Cuban Lam passing like a refreshing tropical breeze among the polished surrealist painters, in the same decade.

The reception of an outside language, therefore, does not put a culture at risk as long as said language only represents a group of signs that can be utilized to different ends. What is ludicrous is the acceptance of an outside *traffic signal*. Or, to put it less "pop-metaphorical" terms, a signal emitted by a highly industrialized consumer society cannot be integrated by societies that have been classified by sociologists as archaic, feudal, semi-colonial or fully colonial, experiencing pre-Capitalist situations, lacking internal market, marked by oligarchic control, economic instability, marginalization of entire populations, parochialism, paternalism, etc. To emphasize the importance of the simple movement of signals, we could point to the fact that US art references "urban" circumstances, objects, and perspectives and it can only be transplanted to other urban areas. Here, it is necessary to point out that the notion of urban life is misleading in reference to Latin American cities, where almost a third of the so-called urban population is a result of forced migration or rural exodus and these people experience living conditions defined by unemployment, anomie, and disadaptation, factors which exclude them from any possibility of participation in cultural life.

Art was aptly defined by Marx as an expression of man's creative capacity that does not look to external reality to copy it in an automatic way, but that constructs said reality through this creative capacity. This is true of modern US art, given that it constructs an American reality, but it instantly stops being art the moment it is extracted from the context of the United States. The Latin American vanguard in visual arts, however, increasingly follows signals emitted by the United States. It is true that, as we will see later on, the behaviors are not identical and some differences stand out, as forms of resistance are abandoned. But this does not undo the fact that visual arts across the continent perpetuate the colonial perspective, and the seriousness of this fact increases as it is more widely accepted.

It is possible that we have now reached an open acceptance of the colonial state, that we in fact desire to be colonized and feel comfortable being colonized, and that, therefore, an analysis of the United States' increasing colonization of Latin American art seems irrelevant.

Marta Traba

But, to put this wholly pessimistic possibility in perspective, we can turn to the words of Sartre: "when people have no other recourse than to choose their means of death, when they have received from their oppressors one solitary gift, desperation, what else do they have to lose? Their disgrace becomes their courage; it will become an eternal rejection that opposes colonization through the absolute rejection of colonization." However, to achieve this absolute rejection, it must be established beforehand that being an "artistic colony" is a disgrace, which is something that not everyone believes. Neither is it so easy to perceive this implicit disgrace, given that the signal is emitted and received under the most attractive and innocent of circumstances. The very innocence of the artistic project is the Trojan horse gifted to us by technological society. Like all successful products, the signals are bright, quick, perishable, and exchangeable. They cast aside transcendence in favor of playfulness. In the same way that Marcuse speaks of "ideological technology" we should also speak of the "ideological play" present in art whose purpose, of course, is to win the game, by distracting, neutralizing, "homogenizing" its opponent.

The molding of Latin American visual arts to the standard set in the United States further dupes us into believing that simultaneous artistic achievements, almost in parallel, constitute a true "coalition of cultures."

The theory of cultural coalition, developed by Lévi-Strauss and which at first glance seems.to bestow the cultures he calls "savage" with greater access to "civilized" thinking, has always been heatedly defended by Latin American critics whose approval legitimizes the behavior of local artists. Any mistrust of cultural coalition is considered provincial and resentful; and the fact, disgracefully true, that the only support for regional culture came from informal groups of nativists and folk artists, has contributed to the discredit of said support. In order for artists to gain back so much lost time, in order for them to enter into the orbit and express themselves without regional complexes within a universalist conception, cultural coalition is championed without question, thereby legitimizing all production that has been approved by the North American central emissary.

A look at the artistic output of Latin America over the last two decades should prove that cultural coalition is disadvantageous, that universalism is a false and outmoded concept, and that our production of forms identical to those generated by a consumer society is an unpardonable abdication of the exercise of creative activity.

The very disadvantage of cultural coalition is pointed out by Lévi-Strauss and his commentators, when they affirm that said alliances will

necessarily result in a *similarity* between the resulting cultural products. It is also obvious that the stronger member of the coalition will prevail over the weaker; no one thought to speak about Picasso in terms of African sculptures but—tangentially, as a form reworked by the creative genius—they spoke about the African sculptures in terms of the faces of *Les Demoiselles d'Avignon*. It must be mentioned that, in the period in which Picasso painted *Les Demoiselles*, African cultural references, as well as Japanese imagery and representations of the primitive lifestyle of the Pacific Isles circulated like a common language, like elements detached from their respective societies to be utilized in the late Romantic repertoire.

Currently, on the other hand, the tyranny of technology keeps cultural references from becoming part of any linguistic structure. Pop art, for example, is a means of dividing vision into fragmented effects, yielding to the demands of propaganda; creating clearly differentiated centers of attention. They cease to be seen as groupings of things (even in the environments or spaces where composition disappears), to be seen as a single thing; the object itself is not taken as a whole but as a fragment; not broken into independently valid parts but fragmented arbitrarily, in an attempt to stand out (like a movie filmed in close-up, *Bullitt*, for example). Conceived of under such parameters, art no longer worries about being a form of knowledge but instead races to make an impact. If for example, we move between a baseball game by Ben Shahn, any section of a work by Rosenquist, depicting windshield wipers, or a pair of sunglasses, etc., it becomes clear that, through so many successive cuts and approximations, the global panorama has been entirely lost, along with any understanding of the signifier. What is glorified is the fragment, the signal of the expressive project impelled by technological society. We need not understand, only "see;" we need not add up the parts but break them down, not think but receive, not reflect but accept. Within this context, any attempt to convey meaning or any desire to take a global perspective represents an unacceptable archaism and a flagrant betrayal of the mandates of the signal.

The technological progression of our time will lead, fatally, to the artistic supremacy of North America, where rationality and the desire to express meaning are notably weaker than in Europe.

After forty years of fervently testimonial art, a decade of emotional evasions to the East, proclaiming, simultaneously, the irrational values of the material, we have turned, in the last two decades, to the aesthetic of decay and have seen the vanguard succumb to the tyranny of technology.

Marta Traba

A cultural coalition with the United States, therefore, is nothing more than a game with a great fragmented player, hemmed tightly inside the limits of his own references. For this reason the notion that a coalition with US culture will facilitate access to universalism is completely flawed. North American art has never had universal aspirations. Its genuine and therefore more respectable nature, which has turned American art into a classification of American life, is the very proof of its regionalism. The progressive advance of technology has done nothing more than reinforce said regionalism, since the references remain inextricably linked to the capricious fluctuations of mass communication and consumer goods. For this reason the image of Marilyn Monroe died with her death, Jacqueline's image ends at her apogee, just as singers and products are continuously replaced. In the same way, the launch of a new synthetic material can establish a new pattern of forms.

If we can conceive of the United States and Latin America in a relationship between *cultural region* and *cultural region*, the cultural dominance exerted on us by imperialist technology seems as inexplicable as it is shocking. Whereas we should merely view US art as an admittedly enthralling spectacle, entirely foreign to our own solutions and the formulation of our projects, we instead find ourselves subjugated to its imagery and willing to reflect it in an inconceivable act of imitation. However, it is not the North American artists, or critics, or even the galleries or museums, who have tried to subjugate us, but the *cultural manipulators* who need docile constituents and epigone trends so that nothing will interfere with the general plan of eradicating any notion of the artist as dissident. The *homogenization* of Latin American art in the last two decades is not even an homage to the great inventive spirit of many artists from the north; it is a sad and feeble falling in line behind the cultural manipulators.

Fellow-Feeling:
Roland Barthes

Sarah Wilson

Roland Barthes's "Réquichot and His Body" is a noncanonized and noncanonical text, lost to his biographers. It relates to work which metaphorically reproduces a generic body of viscera, the throb of the heart, muscles, digestive organs, the movements of excrement or of orgasm: in Barthes's terms, *jouissance*. It is a *travail du prefacier*, a commissioned "work of prefacing" for a catalogue raisonné of 1973, and an essay, inscribed within Barthes's own modes, styles, chronologies, and writing rhythms (themselves quasi-peristaltic, regulated by meals and digestive pauses). It follows *Mythologies* (1957), which demonstrated his brilliant grasp of visual signage in everyday life: his trip to Japan in 1966, an encounter with what he would call the *Empire of Signs* (1970), and Bakhtinian and dialogical inspirations thanks to his friendship with Julia Kristeva. Barthes's eclectic writings on art, from Arcimboldo to Saul Steinberg, have been commemorated in two exhibitions in Paris, *Le Texte et l'image*, 1986; and *R/B*, the Centre Pompidou retrospective of 2002. Bernard Réquichot's works are displayed in this National Museum; a show of 2019 at the Galerie Alain Largeron marks a reentry into the public domain.

In 1973, Barthes published reflections on the "automatic writing" of surrealist André Masson, Réquichot, and later Cy Twombly's painterly scribbles, all relating to *The Pleasure of the Text*. Barthes's 1974 trip to China, and *Roland Barthes by Roland Barthes* (1975) were to follow. The cover of this autobiography revealed Barthes's drawing practice (abstract colored lines): a bodily link to "his"

artists and Réquichot's own "invisible writing." Barthes called Réquichot's collages *papiers choisis*. His own intertextual references ("chosen papers"), acknowledge Réquichot's texts and quasi-lettrist poetry. This preface is a *tombeau*: a funeral hommage mirrored by Réquichot's hinged "reliquary" structures. Réquichot's first works had been copies of religious paintings; his early modernist style was close in some aspects to the grid-contained figurations of the late Cubist Jacques Villon. *Skull* (1954) takes the traditional motif of the *vanitas*—the artist's life's work may be considered as such. Barthes uses the Bataillean concept of potlatch for "offering up" Réquichot's oeuvre, but prefers the word "sumptuary," evoking expenditure and excess. Indeed, Réquichot's baroque Catholicism constantly fights Barthes's protestant decorum. What Barthes calls the *agonie de la peinture* means painting's "last gasp." Here, painting's suicidal plunge into matter heralds its dematerialization: the birth of conceptual art.

"Réquichot and His Body" challenges the Mallarméan premises of Barthes's "Death of the Author" (an essay printed in *Aspen* 5–6 in 1967), published within a "box of texts" already containing Duchamp, Minimalism, and Conceptualism. Réquichot's art subsumes the photographic (food and dog-muzzle collages). Proliferation, the repetition of motifs, and the dispersion of the gaze are devices which are antithetical to Barthes's celebrated photographic *punctum*, a concentration of meaning which pricks to the point of tears in 1980's *Camera Lucida*, his reflection on photography as mourning. Finally

this preface precedes the revelation by Philippe Sollers, in the 1983 novel *Femmes* of "Werth's" (Barthes's) homosexuality. The sexualizing of the text on Réquichot is reflected in the mirror-initials: RB–BR. Barthes's fellow-feeling and speculation regarding Réquichot's Catholic self-repression may be implicit here.

Above all, Barthes is reading and writing "Réquichot" as a post-suicidal text, framed by his knowledge of the young artist's dramatic death two days before his important 1961 exhibition at the Galerie Daniel Cordier. It is also a potentially "presuicidal" text on the part of Barthes (who comments on Réquichot's anorexia), anticipating his own, much-debated demise. Finally "Réquichot," the name, as an "emblem of present writing," explodes the concept of signature, as when Barthes says (on Proust) it is legitimate not to *compare* himself but *identify* himself with the object of his writing. Theoretical and critical orthodoxies explode here, too.

Réquichot and His Body

Roland Barthes

from *The Responsibility of Forms*, (1985) 1991, first published in *Bernard Réquichot*, 1973

Je ne sais pas c'qui m'quoi.

The Body
Inside
Many painters have reproduced the human body, but that body was always someone else's. Bernard Réquichot paints only his own: not that exterior body the painter copies *looking at himself sidelong*, but his body from inside; his interior comes outside, but it is another body whose violent ectoplasm suddenly appears as a result of these two colors' confrontation: white of the canvas, black of closed eyes. A generalized revulsion then seizes the painter, revealing neither viscera nor muscles but only a machinery of thwarting and ecstatic movements. This is the moment when substance (raw material) is absorbed, abstracted in viscous or extra-acute vibration: painting (let us continue to use this word for all kinds of treatments) becomes a *noise* ("The extreme shrillness of noise is a form of sadism"). This excess of materiality is what Réquichot calls the meta-mental. The *metamental* is what denies the theological opposition of body and soul: it is the body without opposition and therefore, so to speak, without meaning; it is the *inside* assaulted like a slap from *within*.

Thereby representation is disturbed, and grammar, too: the verb *to paint* regains an odd ambiguity: its object (what one paints) is sometimes what is looked at (the model), sometimes what is covered (the canvas): Réquichot does not accept an object: he questions even as he corrupts himself. He paints himself like Rembrandt, he paints himself like a Redskin. The painter is simultaneously an artist (who represents something) and a savage (who daubs and abrades his body).

The Reliquaries
Yet the Reliquaries, being boxes at the bottom of which *there is something to see*, resemble certain endoscopic machines. Is it not the body's internal magma which is placed here, at the limit of our gaze, as a deep field? Does not a baroque and funereal concept govern the exhibition of the anterior body, *the body before the mirror-stage*? Are not the

Reliquaries open wombs, profaned tombs ("What touches us very closely cannot become public without profanation")?

No, this aesthetic of vision and this metaphysic of secrecy are immediately confused if we know that Réquichot was reluctant to show his painting, and especially that it took him years to make a single Reliquary. This means that for him the box was not the (reinforced) frame of an exhibition but rather a kind of temporal space, the enclosure in which his body worked, worked itself over—withdrew and added itself, rolled and unrolled itself, discharged itself: *took pleasure*: the box is the reliquary not of saints' bones but of Réquichot's pleasures....

The Tongue

In certain collages (around 1960) many muzzles, snouts, and tongues of animals appear. One critic calls this respiratory anguish. No, the tongue is language: not civilized speech, for that passes through the teeth (dentalized pronunciation is a sign of distinction—the teeth supervise speech), but the visceral, erectile language: the tongue is a phallus that talks.... It is also, within the body, on the level of the tongue that Réquichot represents a total language in his lettrist poems and in his snout-collages.

The Rat-King

Réquichot's investigations concern a movement of the body which also fascinated Sade (though not the sadist Sade); this movement is *repugnance*: the body begins to exist where it *repugnates*, repulses, yet wants to devour what disgusts it and exploits that taste for distaste, thereby opening itself to a dizziness (vertigo is what does not end: vertigo disconnects meaning, postpones it).

The fundamental form of repugnance is agglomeration: it is not gratuitously, for mere technical experimentation, that Réquichot turns to collage; his collages are not decorative. They do not juxtapose, they conglomerate, extending over huge surfaces, thickening into volumes. In a word, their truth is etymological, they take literally the *colle*, the glue at the origin of their name; what they produce is the glutinous, alimentary paste, luxuriant and nauseating, where outlining, cutting-out—i.e., nomination—are done away with.

A rhetorical instance: what Réquichot's collages agglomerate are animals. Now, it seems that the conglomeration of creatures provokes in us a paroxysm of repugnance: swarming worms, nests of serpents, hives of wasps. A fabulous phenomenon (is it as yet scientifically proved? I haven't any idea) summarizes the entire horror of these animal

Bernard Réquichot, *Untitled*, date unknown

agglomerations: this is the *rat-king*: "In their natural state," says an old zoological dictionary, "rats are occasionally subject to the strangest disease. A great number join together by the tail and thus form what is commonly known as the *rat-king*.... The cause of this curious phenomenon is still unknown to us. It is supposed that there is a special exudation of the tail which keeps these organs stuck together...." Metaphorically, Réquichot has not stopped painting this rat-king, pasting together this collage which does not even have a name; for what exists, in Réquichot, is not the object, nor even its effect, but its trace. Let us understand this word in its locomotor meaning, bursting out of the tube of paint, the worm is its own trace, much more repulsive than its body.

Erection

Disgust is a panic erection: it is the entire body-as-phallus which swells, hardens, and collapses. And this is what constitutes painting: it gets a hard-on. Perhaps we are here faced with an irreducible difference between painting and discourse: painting is "full"; the voice, on the contrary, establishes a distance, a void, in the body; every voice is "white"— succeeds in taking on color only by pitiable artifices. Hence, we must take literally this declaration of Réquichot's, describing his work not as

Roland Barthes

an erotic action (which would be banal enough) but as an erectile move-ment *and what follows*. "I am talking about that simple rhythm which for me makes a canvas start up slowly, then gradually become more involv-ing, and by a thrilling crescendo leads me to an effervescence on the order of an orgasm. At this climax, the painting abandons me, unless it is I, at the limits of my power, who let it go. If I then know that my painting is finished, my need to paint is not, and this paroxysm is followed by a great disappointment." Réquichot's work is this *detumescence* of the body (which he sometimes calls by the very word some use to designate pulsion: *drift*).

The Two Sources of Painting
Writing and Cooking
… Let us imagine, outside all history, a double origin of painting.

The first would be writing, the tracing of future signs, the exercise of the tip (of the brush, of the pencil lead, of the awl, of what striates and hollows out—even if it is the artifice of a line deposited by color). The second would be cooking, i.e., any practice which aims at trans-forming substance according to the complete scale of its consistencies, by various operations such as inspissation, liquefaction, granulation, lubrification, producing what in gastronomy is called the coated, the thickened, the creamy, the crisp, etc. Thus, Freud contrasts sculpture—*via di levare*—with painting—*via di porre*; but it is in painting itself that the opposition appears: the opposition between incision (the "line") and unction (the "coating").

These two origins could be linked to the two gestures of the hand, which sometimes scratches, sometimes levels, sometimes hollows out, sometimes smooths over; in a word, to the finger and to the palm, to the fingernail and to the mount of Venus. This double hand divides up the whole realm of painting, because the hand is the truth of painting, not the eye ("representation," or figuration, or the copy, are but a secondary and incorporated accident, an alibi, a transparency laid over the network of lines and coatings, a shadow cast, an inessential mirage). Another history of painting is possible, which is not that of works and artists but that of tools and substances; for a very long time, the artist, among us, was not distinguished by his instrument, which was, uniformly, the brush. When painting entered its historical crisis, the instruments were multiplied, and the raw materials as well. There has been an infinite journey of inscribing objects and of their supports; the limits of the pic-torial tool have been continually pushed back (even for Réquichot: razor,

coal shovel, polystyrene rings). One consequence (still to be explored) is that the tool, no longer coded, partly escapes commerce: art-supply stores can no longer keep up, they now distribute their merchandise only to docile amateurs; it is in the department stores, in the housewares section, that Réquichot goes looking for his raw materials. Commerce is *pillaged* (to *pillage* means to appropriate without respect to use). Painting, then, loses its aesthetic specificity, or rather that (age-old) specificity proves fallacious: behind painting, behind its splendid historical individuality (the sublime art of colored figuration), is *something else*: the movements of the fingernails, of the glottis, of the viscera, a projection of the body, and not only a mastery of the eye.

Réquichot holds in his hand the fierce reins of painting. As an original painter (here we are still speaking of a mythical origin: neither theological nor psychological nor historical: pure fiction), he constantly returns to writing and to food.

Cooking
Foodstuffs
Have you ever watched the preparation of a Swiss dish called raclette? A hemisphere of raw cheese is held vertically above the grille; it melts, swells, and sizzles; the knife gently scrapes *(racle)* this liquid blister, this runny surplus, from the shape; it falls, like a white dung; it hardens, it yellows on the plate; with the knife, the amputated area is smoothed out; and then the process begins all over again.

This is, strictly speaking, an operation of painting. For in painting, as in cooking, *something must be allowed to drop somewhere*: it is in this fall that matter is transformed (deformed): the drop spreads and the foodstuff softens; there is production of a new substance (movement makes matter). In Réquichot's work, all states of alimentary substance (ingested, digested, evacuated) are present: the crystallized, the crackled, the stringy, the granular—the dried, earthy excrement, the oily iridescence, the carbuncle, the intestine. And to crown this specter of the digestive bolus, in the large collages, in the last Reliquaries, the material origin is explicitly alimentary, taken from household magazines. Here are Franco-Russian dishes, here are pastas, cutlets, strawberries, sausages (mixed with coils of hair and dogs' muzzles); but it is the scrambling together which is culinary (and pictorial): the strewing, the interlacing, the stew (Japanese sukiyaki is a painting systematically developed in time).

Here Réquichot brings us back to one of painting's mythic origins: a good half of it belongs to the nutritive (visceral) order. If we are to kill the alimentary sensuality of the thing painted, we must dismiss painting

Roland Barthes

itself: you can neither eat nor vomit Joseph Kosuth's *Thing*; but also there is no painting left (no coating, no scratching): the painter's hand and the cook's are amputated at one and the same time. Réquichot, however, is *still* a painter: he eats or doesn't eat, digests, vomits. His desire for painting is the very great representation of a need.

No Metaphor

We might still say that food is Réquichot's neurotic center (he did not like red meat, and let himself starve to death), but this center is not certain. For once food is imagined in its trajectory from aliment to excrement, from the mouth (the one that eats, but also the one that is eaten: the snout) to the anus, the metaphor shifts and another center appears: the cavity, the interior sheath, the intestinal reptile is an enormous phallus. Hence, to conclude, thematic inquiry becomes futile: we realize that Réquichot is saying only one thing, which is the very denial of all metaphor: the whole body is in its inside; this *inside* is thus both erotic and digestive. An inhuman anatomy governs pleasure and the work itself: this anatomy is to be found in the last abstract objects Réquichot produced: these are (all abstraction resembles something) seashells, uniting in themselves the spiral's "graphism" (a theme of writing) and digestive animality, for these molluscs (patellas, fissurellas, annelidae furnished with locomotor bristles) are gastropods: if they walked, it would be with their stomachs. It is the interior that produces movement.

Cast-off

Around 1949, at the beginning of his work, Réquichot made a charcoal drawing of a shoe: the holes in the uppers are empty; only a fragment of shoelace remains; for all its rather soft forms, this shoe is a *warped* object. Here begins, for Réquichot, a long epic of the *cast-off* (it was appropriate that the shoe should be at the origin of this epic: seeking to invert the civilized order, Fourier makes the worn-out shoe, a major cast-off equal to rags and refuse, into a flamboyant object). What is the cast-off? It is the name of what *has had* a name, it is the name of the denominated; we might develop here what will be said later on: the labor of de-nomination, of which Réquichot's oeuvre is the theater; better for now to reattach the cast-off to the foodstuff. The cast-off disfigures the foodstuff because it exceeds its function: it is what is not ingested; it is the foodstuff projected outside of hunger. Nature, i.e. the outskirts of farms, is full of cast-offs, the very ones which fascinated Réquichot and which he put into certain compositions (chicken and rabbit bones, feathers, whatever came to him from these "country encounters").

The things which enter into Réquichot's painting (the things them-selves, not their simulacra) are always cast-offs, out-of-the-way supple-ments, abandoned objects: what has *fallen away* from its function: the vermicelli of painting cast straight onto the canvas as into the garbage pail upon emerging from the tube, magazine photographs cut up and disfigured, their origins unrecognizable (journalism's vocation is to be cast off), crusts (of bread, of paint). The cast-off is the only excrement the anorexic can permit himself.

Oil

Oil is a substance that augments the foodstuff without fragmenting it: which thickens without hardening it: magically, with the help of a thread of oil, the egg yolk assumes a growing volume, and this *to infinity*; it is in the same way that the organ grows, by intussusception. Now, oil is that same substance which serves for food and for painting. To abandon oil, for a painter, is to sacrifice painting itself, the culinary gesture which mythically establishes and sustains it. Réquichot has experienced the historical agony of painting (he could do this because he was a painter). This means that he has been very far away from oil (in his collages, ring sculptures, ball-point drawings), but also that he has been constantly tempted to return to it, as to a vital substance: the ancestral milieu of foodstuffs. Even his collages without oil obey the principle of thickened proliferation; that of an infinite mayonnaise. For years, Réquichot *grows* his Reliquaries as one develops a body organized by the slow ingestion of a juice.

Writing
Spiral

… In Réquichot's work, semiography no doubt appears around 1956, when he draws with a pen (let us note the instrument) certain clusters of coiled lines: sign, writing come with the spiral, which will not henceforth be absent from his work. The symbolism of the spiral is the opposite of that of the circle; the circle is religious, theological. The spiral, a kind of circle distended to infinity, is diaectical: on the spiral, things recur, but *at another level*: there is a return in difference, not repetition in identity (for Vico, an audacious thinker, world history followed a spiral). The spiral governs the dialectic of the old and the new. Thanks to it, we need not believe: *everything has been said*, or: *nothing has been said*, but rather: nothing is first, yet everything is new. This is what constitutes Réquichot's spiral: by repeating itself, it engenders a displacement. The same thing happens in poetic language (I mean prosodic and/or

metrical): since the signs of this language are very limited in number and infinitely free to combine, novelty here, more than elsewhere, consists of very close-set repetitions. In the same way Réquichot's spiral compositions (we might take for example his *War of Nerves*) explode in all directions, starting from a repeated and displaced element, the whorl (here related to lines, stems, splashes); they have the same mode of explosive generation as the poetic phrase.... What constitutes writing, ultimately, is not the sign (analytic abstraction), but, much more paradoxically, *the cursivity of the discontinuous* (what is repeated is necessarily discontinuous). Make a loop: you produce a sign; but shift it forward, your hand still resting there on the receptive surface, you generate a writing: writing is the hand which bears down and advances or hangs back, *always in the same direction....*

Illegible
In 1930, the archaeologist Persson discovered in a Mycenean tomb a jar bearing certain "graphisms" on its rim; imperturbably, Persson translated the inscription, in which he had recognized certain words which resembled Greek; but later on, another archaeologist, Ventris, established that this was not writing at all, merely an incised pattern; moreover, at one end, the drawing ended in purely decorative curves. Réquichot takes the converse direction (on the same path): a spiral composition of September 1956 (that month when he constituted the reservoir of his final forms) ends, at the bottom, in a line of writing. Thus is born a special semiography (already practiced by Klee, Ernst, Michaux, and Picasso:) illegible writing. Fifteen days before his death, Réquichot writes in two nights six indecipherable texts, which will remain so forever; yet no doubt buried under some future cataclysm, these texts will find a Persson to translate them; for History alone institutes the legibility of a writing; as for its Being, writing derives that not from its meaning (from its communicative function) but from the rage, tenderness, or rigor with which its strokes and curves are drawn....

Illegible testament, Réquichot's last letters say several things: first of all that meaning is always contingent, historical, *invented* (by some overconfident archaeologist): nothing separates writing (which we believe communicates) from painting (which we believe expresses)— both consist of the same tissue, which is perhaps quite simply, as in very modern cosmogonies, speed (Réquichot's illegible writings are as runaway as certain of his canvases). Also: what is illegible is nothing but *what has been lost*: to write, to lose, to rewrite, to establish the infinite play of *under* and *over*, to bring the signifier closer, to make it a giant, a

monster of presence, to diminish the signified to imperceptibility, to unbalance the message, to retain memory's form but not its content, to make the impenetrable *definitive*—in a word, to put all writing, all art in a palimpsest, and to make this palimpsest inexhaustible, what *has been written* continually returning in what *is written* in order to make it super-legible—i.e., illegible....

Representation
Substance
On Réquichot's worktable (indistinguishable from a kitchen counter), bunches of curtain rings bought at some department store: they will make, later on, the *Plastic Sculptures*, the *Glued Rings* ...
Réquichot's rings, when he takes them, are *already* utilitarian (manu-factured) objects, which happen to be perverted from their function: the work then departs from a previous past, the myth of Origin is shaken, painting's theological crisis begins (with the first collages, the "ready-mades"). This brings the pictorial (or sculptural) work—the transfor-mation of raw material will soon require another name—closer to the (so-called literary) Text; for the Text, too, takes utilitarian words, "manu-factured" with a view to ordinary communication, in order to produce a new object, outside usage and hence outside commerce.

The Loupe (magnifying glass)
Just as in a palimpsest there is writing in writing, so in a "picture" (it mat-ters little whether or not the word is accurate) there are several picpic-tures: not only (in Réquichot) because canvases are rewritten or replaced as partial objects within new ensembles, but because there are as many works as there are levels of perception: isolate, enlarge, and treat a detail, you create a new work, you cross over centuries, schools, styles, out of the very old you can make the very new. Réquichot has practiced this tech-nique on himself: "Looking at a picture very closely, you can see future pictures in it: it has happened to me, I've cut up big ones and tried to isolate the parts that look interesting." (...)

Name
Let us take two modern treatments of the object. In the ready-made, the object is *real* (art begins only at its periphery, its framing, its museogra-phy)—hence it has been possible to refer it to petit-bourgeois realism. In so-called conceptual art, the object is *named*, rooted in the dictionary—which is why it would be better to say "denotative art" than "conceptual art." In the readymade, the object is so real that the artist can permit

himself the eccentricity or the uncertainty of denomination; in conceptual art, the object is so precisely named that it no longer needs to be real: it can be reduced to a dictionary entry (Joseph Kosuth's *Thing*). These two apparently opposed treatments derive from one and the same activity: classification.... Réquichot's effort ... seeks neither object nor language. What it aims at is to undo the Name; from work to work, it proceeds to a generalized ex-nomination of the object....

The Artist ...
Faust

... just as the Renaissance painters were *also*, very frequently, engineers, architects, hydraulic engineers, Réquichot utilized another signifier, writing: he wrote poems, letters, a private diary, and a text entitled, precisely, *Faustus*: for Faust is still the eponymous hero of this race of artists. Their knowledge is apocalyptic; they carry out at one and the same time the exploration of making and the catastrophic destruction of the product....

The Signature
Réquichot

For a good while now I have been writing not *on* Réquichot but *around* him; this name "Réquichot" has become the emblem of my present writing. I no longer hear in it anything but the familiar sound of my own work; I say *Réquichot* as I have said *Michelet*, *Fourier*, or *Brecht*. And yet, awakened from its usage, this name (like any name) is strange: so French, even so rural, there is in it, by its hissing sound, by its diminutive termination (in French), something gourmand (quiche!), something of the farm (clogs), something friendly (the little chap). There is something in it of the name of a *good classmate*. We can transfer this instability of the major signifier (the proper name) to the signature. In order to disturb the law of the signature, there may be no need to suppress it, to imagine an anonymous art; it is sufficient to displace its object: Who *signs what*? Where does my signature stop? At what support? At the canvas (as in classical painting)? At the object (as in the "ready-made")? At the event (as in the happening)? Réquichot has perceived this infinity of the signature, which releases its appropriative link, for the further the support extends, the further the signature is removed from the subject: to sign is only to cut off, to cut oneself off, to cut off the other. Why, Réquichot supposed, could I not sign, beyond my canvas, the muddy leaf which has moved me, or even the path where I saw it stuck? Why not put my name on the mountains, the cows, the faucets, the factory chimneys (*Faustus*)?

The signature is no more than the fulguration, the inscription of desire: the utopic and caressing imagination of a society without artists (for the artist will always be *humiliated*), in which, however, each of us would sign the objects of his pleasure. Réquichot, quite alone, has momentarily prefigured this sublime society of *amateurs*. To recognize Réquichot's signature is not to admit him to the cultural pantheon of painters, it is to possess an additional sign in the chaos of the enormous text which is written without interruption, without origin, and without end.

Documentation
as Dialogue:
Allan Sekula

Michael F. Zimmermann

Allan Sekula is known as a documentary artist and photographer, but also as one of the most inspiring critics of historical and contemporary photography. In 1975, he published his well-known essay "On the Invention of Photographic Meaning" in *Artforum*. The essay was reprinted in 1984, in *Photography Against the Grain*, edited by Robert Wilkie und Benjamin Buchloh. While with the original publication the author distinguished himself as a leading intellectual of historically grounded, critical reflection of photography, the book was indeed "against the grain." A first part—a series of theoretical and historical texts—is followed by a series of socially engaged photo documentations, a photo book.

The text compares two photographs devoted to emigration from Europe to the United States—a quintessentially modernist photograph, Alfred Stieglitz's *The Steerage* (1907) is contrasted with a photograph by Lewis Hine, a paradigm of socially engaged documentation. Sekula demonstrates that by basing an analysis on stylistic qualities, or on narrative dramaturgy, his judgment remained arbitrary. He could appraise the pictures only after having a look at contexts such as the strategic goals of the journals in which the photographs were published: primarily artistic in the case of Stieglitz, primarily social activist in the case of Hine.

The essay identifies dialogue as a central, ethical-political characteristic of documentary photography, according to Sekula. However, dialogue is made a keyword only in 1984, in the "Introduction" to *Photography Against the Grain*. In a meta-reading of his earlier texts, the artist realizes that socially engaged art has to be produced

from a perspective of participation. He made this point only after having read a book *Marxism and the Philosophy of Language* written in 1927–28 (and published in English in London in 1973) by the linguist Valentin Voloshinov who had been a member of Mikhail Bakhtin's circle in St. Petersburg in the nineteen-twenties. Voloshinov inquires into the means by which another person's discourse can be integrated into a speaker's own statements—from quotation to indirect discourse and other types of reported speech. He presents participation and dialogue by no means as idyllic ideas based on fictions of equality, but as strategies to grant the other a place within one's own speech (or imagination).

In 1976, Sekula dismisses the idea that photography is a "natural" medium of representation, totally *transparent* (in Louis Marin's sense) toward its subject, regardless of the "discourse" it is or was part of. To understand a discourse instead of merely acting within it, Sekula thought that it had to be envisioned from the *outside*. In 1984, he turned away from this structuralist approach. Now he is convinced that documenting social life means that the photographer and the persons he shows are always involved in a common situation. Since this turn, he aims at retrieving the dialogical aspect of the medium instead of objectifying or aestheticizing "life worlds." In modern sociological terms: a praxeological observation of "fields" of action or impact now supersedes any attempt at objectively reconstructing situations as thoroughly transparent systems or subsystems. As a critic, Sekula bases his judgment on how a photographic oeuvre integrates material such as text to refer to complex social experience, and on its dialogical qualities, on how it allows for the people represented to stage themselves instead of merely being staged. While Martha Rosler stands for these qualities, he dares to criticize Diane Arbus, universally acclaimed after her suicide in 1971, for having projected her own psychic torment onto the people she photographed.

Sekula's work as a photo artist is linked to his criticism. His first series, reprinted in *Photography Against the Grain*, is devoted to his own middle-class family; to the struggle for his parents' social survival seen as an "art." "This art here is about other people's art," he once stated, describing his endeavor. Having initiated his dialogical work by disclosing his own offspring and habitus, he would continue it after the late eighties by focusing on the objectified constraints of the global circulation of goods—symbolized by the container—and confronting it with people speaking of their lives within and along global circuits. In a period marked by a constraint to aestheticize and market the self (as the sociologist Andreas Reckwitz sees it), "art about other people's art" remains a necessary utopia.

On the Invention of Photographic Meaning

Allan Sekula

excerpted, from *Artforum*, January 1975

I

The meaning of a photograph, like that of any other entity, is inevitably subject to cultural definition. The task here is to define and engage critically something we might call the "photographic discourse." A discourse can be defined as an arena of information exchange, that is, as a system of relations between parties engaged in communicative activity. In a very important sense, the notion of discourse is a notion of limits. That is, the overall discourse relation could be regarded as a limiting function, one that establishes a bounded arena of shared expectations as to meaning. It is this limiting function that determines the very possibility of meaning. To raise the issue of limits, of the closure effected from within any given discourse situation, is to situate oneself *outside*, in a fundamentally metacritical relation to the criticism sanctioned by the logic of the discourse....

All communication is, to a greater or lesser extent, tendentious; all messages are manifestations of interest.... With this notion of tendentiousness in mind, we can speak of a message as an embodiment of an argument. In other words, we can speak of a rhetorical function. A discourse, then, can be defined in rather formal terms as the set of relations governing the rhetoric of related utterances. The discourse is, in the most general sense, the context of the utterance, the conditions that constrain and support its meaning, that determine its semantic target.

This general definition implies, of course, that a photograph is an utterance of some sort, that it carries, or is, a message. However, the definition also implies that the photograph is an "incomplete" utterance, a message that depends on some external matrix of conditions and presuppositions for its readability. That is, the meaning of any photographic message is necessarily context determined. We might formulate this position as follows: a photograph communicates by means of its association with some hidden, or implicit text; it is this text, a system of hidden linguistic propositions, that carries the photograph into the domain of readability....

Photographic "literacy" is learned. And yet, in the real world, the image itself appears "natural" and appropriate, appears to manifest an illusory independence from the matrix of suppositions that determines its readability.... Implicit in this argument is the quasi-formalist notion that the

photograph derives its semantic properties from conditions that reside within the image itself. But if we accept the fundamental premise that information is the outcome of a culturally determined relationship, then we can no longer ascribe an intrinsic universal meaning to the photographic image.

But this particularly obstinate bit of bourgeois folklore—the claim for the intrinsic significance of the photograph—lies at the center of the established myth of photographic truth. Put simply, the photograph is seen as a re-presentation of nature itself, as an unmediated copy of the real world. The medium itself is considered transparent....

The photograph is imagined to have a primitive core of meaning, devoid of all cultural determination. It is this uninvested analogue that Roland Barthes refers to as the denotative function of the photograph. He distinguishes a second level of invested, culturally determined meaning, a level of connotation. In the real world no such separation is possible. Any meaningful encounter with a photograph must necessarily occur at the level of connotation. The power of this folklore of pure denotation is considerable. It elevates the photograph to the legal status of document and testimonial. It generates a mythic aura of neutrality around the image.... Every photographic image is a sign, above all, of someone's investment in the sending of a message. Every photographic message is characterized by a tendentious rhetoric. At the same time, the most generalized terms of the photographic discourse constitute a denial of the rhetorical function and a validation of the "truth value" of the myriad propositions made within the system. As we have seen, and shall see again, the most general terms of the discourse are a kind of disclaimer, an assertion of neutrality; in short, the overall function of photographic discourse is to render itself transparent. But however the discourse may deny and obscure its own terms, it cannot escape them.

The problem at hand is one of *sign emergence*; only by developing a historical understanding of the emergence of photographic sign systems can we apprehend the truly *conventional* nature of photographic communication. We need a historically grounded sociology of the image, both in the valorized realm of high art and in the culture at large. What follows is an attempt to define, in historical terms, the relationship between photography and high art....

II

I would like to consider two photographs, one made by Lewis Hine in 1905, the other by Alfred Stieglitz in 1907. The Hine photo has been captioned *Immigrants going down gangplank, New York*; the Stieglitz photo

Allan Sekula

is titled *The Steerage*. I am going to assume a naive relation to these two photos, forgetting for the moment the monumental reputation of the Stieglitz.... Viewed together, the two photographs seem to occupy a rather narrow iconographic terrain. Gangplanks and immigrants in middle-European dress figure significantly in both. In the Hine photo, a gangplank extends horizontally across the frame, angling outward, toward the camera. A man, almost a silhouette, appears ready to step up onto the gangplank. He carries a bundle; his body is bounded by the left edge of the photo. Two women precede the man across the gangplank. Both are dressed in long skirts; the woman on the right, who is in the lead, carries a large suitcase. Given this information, it would be some-what difficult to identify either the gangplank or the immigrant status of the three figures without the aid of the legend. In the Stieglitz photo, a gangplank, broken by the left border, extends across an open hold and intersects an upper deck. Both this upper deck and the one below are crowded with people: women in shawls, Slavic-looking women in black scarves holding babies, men in collarless shirts and worker's caps. Some of the people are sitting, some appear to be engaged in conversation. One man on the upper deck attracts my eye, perhaps because his boater hat is a highly reflective ellipse in a shadowy area, or perhaps because his hat seems atypical in this milieu. The overall impression is one of a crowded and impoverished seagoing domesticity. There is no need even to attempt a "comprehensive" reading at this level. Although rather deadpan, this is hardly an innocent reading of the two photographs. I have constructed a scenario within which both images appear to occupy one end of a discourse situation in common, as though they were stills from the same movie, a documentary on immigration perhaps. But sup-pose I asserted the autonomy of each image instead. For the moment, I decide that both images are art and that a meaningful engagement with the two photographs will result in their placement, relative to each other, on some scale of "quality." Clearly, such a decision forces an investment in some theory of "quality photography;" already the possibility of any-thing approaching a neutral reading seems to have vanished.

Undeterred, I decide that quality in photography is a question of design, that the photograph is a figurative arrangement of tones in a two-dimensional, bounded field. I find the Hine attractive (or unat-tractive) in its mindless straightforwardness, in the casual and repetitive disposition of figures across the frame, in the suggestion of a single vector. And I find the Stieglitz attractive (or unattractive) for its complex array of converging and diverging lines, as though it were a profound attempt at something that looked like Cubism. On the other hand,

Lewis Hine, *Immigrants going down gangplank, New York*, 1905

suppose I decide that quality in photographic art resides in the capacity for narrative. On what grounds do I establish a judgment of narrative quality in relation to these two artifacts, the Hine and the Stieglitz? I like/ dislike, am moved/unmoved by the absolute banality of the event suggested by the Hine; I like/ dislike, am moved/unmoved by the suggestion of epic squalor in the Stieglitz. The problem I am confronted with is that every move I could possibly make within these reading systems devolves almost immediately into a literary invention with a trivial relation to the artifacts at hand. The image is appropriated as the object of a secondary artwork, a literary artwork with the illusory status of "criticism." Again, we find ourselves in the middle of a discourse situation that refuses to acknowledge its boundaries; photographs appear as messages in the void of nature. We are forced, finally, to acknowledge what Barthes calls the "polysemic" character of the photographic image, the existence of a "floating chain of significance, underlying the signifier." In other words, the photograph, as it stands alone, presents merely the *possibility* of meaning. Only by its embeddedness in a concrete discourse situation can the photograph yield a clear semantic outcome. Any given photograph is conceivably open to appropriation by a range of "texts," each new discourse situation generating its own set of messages....

Allan Sekula

Through *Camera Work* Stieglitz established a genre where there had been none; the magazine outlined the terms under which photography could be considered art, and stands as an implicit text, as scripture, behind every photograph that aspires to the status of high art. *Camera Work* treated the photograph as a central object of the discourse, while inventing, more thoroughly than any other source, the myth of the semantic autonomy of the photographic image. In this sense, *Camera Work* necessarily denied its own intrinsic role, as text, in the valorization of the photograph....

In 1942, a portion of Stieglitz's memoirs was published in Dorothy Norman's journal *Twice-A-Year*, including a short text called "How The Steerage Happened":

Early in June, 1907, my small family and I sailed for Europe. My Wife insisted upon going on the "Kaiser Wilhelm II"—the fashionable ship of the North German Lloyd at the time.... How I hated the atmosphere of the first class on the ship. One couldn't escape the nouveaux riches....

On the third day I finally couldn't stand it any longer: I had to get away from that company. I went as far forward on deck as I could....

Alfred Stieglitz,
The Steerage, 1907

As I came to the end of the deck I stood alone, looking down. There were men and women and children on the lower deck of the steerage. There was a narrow stairway leading up to the upper deck of the steerage, a small deck right at the bow of the steamer.

To the left was an inclining funnel and from the upper steerage deck there was fastened a gangway bridge which was glistening in its freshly painted state. It was rather long, white, and during the trip remained untouched by anyone.

On the upper deck, looking over the railing, there was a young man with a straw hat. The shape of the hat was round. He was watching the men and women and children on the lower steerage deck. Only men were on the upper deck. The whole scene fascinated me. I longed to escape from my surroundings and join these people....

I saw shapes related to each other. I saw a picture of shapes and underlying that of the feeling I had about life. And as I was deciding, should I try to put down this seemingly new vision that held me—people, the common people, the feeling of ship and ocean and sky and the feeling of release that I was away from the mob called the rich—Rembrandt came into my mind and I wondered would he have felt as I was feeling....

I had but one plate holder with one unexposed plate. Would I get what I saw, what I felt? Finally, I released the shutter: My heart thumping. I had never heard my heart thump before. Had I gotten my picture? I knew if I had, another milestone in photography would have been reached, related to the milestone of my "Car Horses" made in 1892, and my "Hand of Man" made in 1902, which had opened up a new era of photography, of seeing. In a sense it would go beyond them, *for here would be a picture based on related shapes and on the deepest human feeling, a step in my own evolution, a spontaneous discovery.*

I took my camera to my stateroom and as I returned to my steamer chair my wife said, "I had sent a steward to look for you...." I told her where I had been.

She said, "you speak as you were far away in a distant world," and I said I was.

"How you seem to hate these people in the first class." No, I didn't hate them, but I merely felt completely out of place.

As I see it, this text is pure symbolist autobiography.... An ideological division is made; Stieglitz proposes two worlds: a world that entraps and a world that liberates. The first world is populated by his wife and the nouveaux-riches, the second by "the common people." The photograph

Allan Sekula

is taken at the intersection of the two worlds, looking out, as it were. The gangplank stands as a barrier between Stieglitz and the scene. The photographer marks a young man in a straw hat as a spectator, suggesting this figure as an embodiment of Stieglitz as Subject. The possibility of escape resides in a mystical identification with the Other: "I longed to escape from my surroundings and join these people." ... the final Symbolist hideout is in the Imagination, and in the fetishized products of the Imagination. Stieglitz comes back to his wife with a glass negative from the other world. For Stieglitz, *The Steerage* is a highly valued illustration of this autobiography. More than an illustration, it is an embodiment; that is, the photograph is imagined to contain the autobiography. The photograph is invested with a complex metonymic power, a power that transcends the perceptual and passes into the realm of affect. The photograph is believed to encode the totality of an experience, to stand as a phenomenological equivalent of Stieglitz-being-in-that-place. And yet this metonymy is so attenuated that it passes into metaphor. That is to say, Stieglitz's reductivist compulsion is so extreme, his faith in the power of the image so intense, that he denies the iconic level of the image and makes his claim for meaning at the level of abstraction. Instead of the possible metonymic equation: common people = my

Lewis Hine, *Neil Gallagher*, New York, 1909

alienation, we have the reduced, metaphorical equation: shapes = my alienation. Finally, by a process of semantic diffusion we are left with the trivial and absurd assertion: shapes = feelings....

Hine stands clearly outside the discourse situation represented by *Camera Work*.... While *The Steerage* is denied any social meaning from *within*, that is, is enveloped in a reductivist and mystical intentionality from the beginning, the Hine photograph can only be appropriated or "lifted" into such an arena of denial. The original discourse situation around Hine is hardly esthetic, but political. In other words, the Hine discourse displays a manifest politics and only an implicit esthetics, while the Stieglitz discourse displays a manifest esthetics and only an implicit politics....

A photograph like *Immigrants going down gangplank* is embedded in a complex political argument about the influx of aliens, cheap labor, ghetto housing and sanitation, the teaching of English, and so on ... characteristic of liberal reform.... *Neil Gallagher* is standing next to the steps of what looks like an office building. His right hand rests on a concrete pedestal, his left leans on the crutch that supports the stump of his left leg. About fifteen, he wears a suit, a cap and a tie. He confronts the camera directly from the center of the frame. Now I would argue that this photograph and its caption have the status of legal document. The photograph and text are submitted as evidence in an attempt to effect legislation. The caption anchors the image, giving it an empirical validity, marking the abuse in its specificity. At the same time, *Neil Gallagher* stands as a metonymic representation of a class of victimized child laborers. But the photograph has another level of meaning, a secondary connotation. *Neil Gallagher* is named in the caption, granted something more than a mere statistical anonymity, more than the status of "injured child." Hine was capable of photographing child workers as adults, which may be one of the mysteries of his style of interaction with his subject, or it may be that these laborers do not often display "childish" characteristics. The squareness with which Gallagher takes his stance, both on the street and in the frame, suggests a triumph over his status as victim. And yet the overall context is reform; in a political sense, everyone of Hine's subjects is restored to the role of victim. What is connoted finally on this secondary level is "the dignity of the oppressed." Neil Gallagher, then, functions as two metonymic levels. The legend functions at both levels, is both an assertion of legal fact and a dispensation of dignity to the person represented. Once anchored by the caption, the photograph itself stands, in its typicality, for a legally verifiable class of injuries and for the "humanity" of a class of wage laborers. What I am suggesting is

Allan Sekula

that we can separate a level of *report*, of empirically grounded rhetoric, and a level of "spiritual" rhetoric.

Introduction

Allan Sekula

from *Photography Against the Grain*, 1984

I

This is a book about photography. This is also a book of photographs, a book that speaks within and alongside and through photographs. Here is one way in which this book brushes photography against the grain: normally separated tasks—of writer and photographer, of "critic" and "visual artist"—are here allowed to coexist, perhaps uneasily, between the covers of a single volume....

What unites these tasks, what lends this book its "unitary" character as a text, is a concern with photography as a *social practice*. Thirteen years ago, when I first began making photographs with any seriousness, the medium's paramount attraction was, for me, its unavoidable social referentiality, its way of describing—albeit in enigmatic, misleading, reductive, and often superficial terms—a world of social institutions, gestures, manners, relationships. And the problematic character of this descriptive power is itself compelling, compounded by the fact that the life world that beckons is one in which the photographer is already a social actor, never a completely innocent or objective bystander. At that time photography seemed to me to afford an alternative to the overly specialized, esoteric, and self-referential discourse of late modernism, which had, to offer only one crude example, nothing much to say about the Vietnam War.

So, somewhat naively perhaps, I began to try combining words and groupings of photographs in ways that sought to incorporate and to invite a political dialogue. Such dialogue seemed possible in theatre and cinema, especially in the work of Bertolt Brecht, Jean-Luc Godard, and Peter Weiss, but more difficult to imagine for the nonliterary visual arts, which are dialogical only in the very important sense that one work might "answer" or respond to another. One attraction and challenge of photography was its dumb resistance to language, its way of suppressing in a static moment its often dialogical social origins....

I wanted to construct works from *within* concrete life situations, situations within which there was either a covert or active clash of interests and representations. Any interest I had in artifice and constructed dialogue was part of a search for a certain "realism," a realism not of appearances or social facts but of everyday experience in and against the grip of advanced capitalism. This realism sought to brush traditional realism against the grain. Against the photo-essayistic promise of "life" caught by the camera, I sought to work from within a world already replete with signs....

II

My interest in the history and theory of photography emerged from and closely paralleled problems encountered in practice. Having begun to photograph as a way out of a late modernist cul-de-sac, I also realized that photography was in the process of being assigned a new position within the late modernist system of the arts. This was enough to spark both caution and historical curiosity.

Perhaps it is significant that I began, innocently enough, by looking at published photographs, and not at museologically preserved specimens. Thus I was more quickly impressed than might otherwise have been the case by the extreme degree to which photographic meaning was dependent on context. Here was a visual art for which, unlike cinema, discontinuity and incompletion seemed fundamental, despite attempts to construct reassuring notions of organic unity and coherence at the level of the single image. Thus the problem of reception, the problem of what Walter Benjamin termed the "afterlife" of the work of art, becomes especially important for photography. And thus also the category of the author is especially fragile and subject to editorial revision.

When one encounters the photographs of Lewis Hine in the *Survey*, and those of Alfred Stieglitz in *Camera Work*, it becomes difficult to sustain the belief that their differences are primarily stylistic, for those two historically coincident journals constituted such radically different discursive contexts: one devoted to a developing politics and professionalism of social welfare and the other to a vehemently anti-utilitarian avant-garde. Could the photographs of Hine and Stieglitz be understood independently of their mode and context of address? And could either photographer be considered an "artist" independently of his affiliation with these discourses? These were the questions that I set out to answer in "On the Invention of Photographic Meaning." Beyond this, my primary aim was to sketch out the limits of a discursive field using

their works and reputations as exemplars, to examine the way in which the twentieth century discourse of photography oscillates between the need for "Hine"—the model of liberal-utilitarian realism, and a need for "Stieglitz"—the model of autonomous esthetic endeavor....

My early critical interests, then, were antagonistic to the formalist closure inherent in the American modernist project, a closure that would regard Hine and Stieglitz as authorial embodiments of stylistically opposed tendencies in photographic history. And, on a more theoretical level, while I was clearly indebted to structuralism, and particularly to Roland Barthes's early essays on photography, the isolation of an abstract language system from social language, from language use, seemed to have produced a related kind of closure, more "scientific" perhaps than that effected by modernist criticism, but closure nonetheless. Walter Benjamin's emphasis on the historical specificity of the "age of mechanical reproducibility" was an important counter to the tendency to think of photography in overly synchronic or ahistorical terms. It was impossible to think about photography without recognizing the importance of historical shifts in the meaning, function and cultural status of photographic representation. Furthermore, in 1975, I discovered the very early Marxist critique of the "abstract objectivism" of Soviet literary scholars and semiologists: V. N. Voloshinov's *Marxism and the Philosophy of Language* (1929). The aim of M. M. Bachtin and his associates was to establish a sociology of literature based on a recognition of the "heteroglossia" of "living language," on a recognition of discourse as an arena of ideological and social difference and conflict. Voloshinov sought to supersede not only the abstract objectivism of Saussurian linguistics, but also the "individualistic subjectivism" of linguistic theories ... which stressed the individual creativity inherent in the speech act....

If we look at contemporary cultural studies in the United States, we discover a curious echo of the reverberations between Voloshinov's "two trends in the philosophy of language." On the one hand, structuralist and post-structuralist models asserts the autonomous determining force of language, its priority over human subjects. On the other hand, a more conservative and institutionally entrenched "humanist" paradigm claims to defend the autonomy of the creative subject. For those of us who are involved in photography, the polarities of this debate are quite evident, both in theory and in practice....

Deculturization: Annemarie Sauzeau-Boetti

Sabeth Buchmann

"Negative Capability as Practice in Women's Art" is an elaborate example of the debates conducted in the seventies around the notion of female art. This essay by Annemarie Sauzeau-Boetti, born in the early forties, relates back to the then still young French post-structuralism, while at the same time resonating with the gender discourse of the Italian theorist Carla Lonzis (1931–82). In her polemic *Sputtiamo su Hegel* (Let's Spit on Hegel), 1970, the former art critic and cofounder of the Rome-based feminist group Rivolta Femminile (Women's Revolt) had cited the master-slave dialectic, then popular among the left, as being responsible for the exclusion of the issue of women's rights from the 1968 revolts. It is against this backdrop that I follow from curator Ilse Lafer and the central conceit of her *Doing Deculturalization* exhibition, shown at Museion in Bolzano in 2019: Lafer took Sauzeau-Boetti's thoughts on how dominant aesthetic values should be simultaneously appropriated and negated, and juxtaposed them against Lonzi's credo of an action-centered "deculturalization," doing so as the precondition for a "collectivity of a non-male type."

The January–February 1976 issue of the art journal *Studio International*, subtitled *Italian Art Now*, saw the publication of Sauzeau-Boetti's article critiquing how the concept of culture—one also common among women artists—reinforces a belief in the asexual absolute, a belief also characteristic of male humanism. The author sets this against a hidden but collectively experienced "incongruence" that places women in a fundamentally different relationship

to the world—a relationship not in correlation to that patriarchal logic. In her article, which focuses on the works of Carla Accardi, Iole de Freitas, Marisa Merz, and Ketty La Rocca, the author thus emphasizes the importance of collective self-awareness among women artists, and reads gender-determined incongruence as the expression of a consciousness torn between cultural assimilation and lived discrimination. When done so as a negative appropriation of avant-garde aesthetics, Sauzeau-Boetti sees artistic exploration of the female body as something that counters the marginalization of women and their codification in patrilinear natural and cultural history—a nexus key to feminist discourse. A circumvention of this would be possible by reaching for forgotten, suppressed, and undervalued crafts, materials, techniques, and rituals.

The key argument here is the derivation of a "negative capability as practice in women's art." An ambivalence emerges, brought along by reference to a feminine (pre-) defined by either biology or culture. Described by Sauzeau-Boetti as the expression of an "alien culture," female practices signify a systematic act of treason against the structurally male avant-gardes to which female artists do, however, strategically align themselves. A "double space of incongruence" thus emerges—a territory, traversed with fault lines, of aesthetic forms of action and representation. Whereas in Lonzi's concept of "deculturalization," the (conceptual) preconditions for female art lay not in categorical destruction but rather in the negation of established aesthetics and values. In the works she discusses, Sauzeau-Boetti sees potential for collectively valid symbolizations of the feminine. She edges toward Lonzi's demand for the establishment of a "collectivity of a non-male type" that aims for a post-patriarchal reconceptualization of intuition and cognition; of desire and intellect. Sauzeau-Boetti therefore confronts reformist thoughts of integrating the "basic disunity, 'negativity' and OTHERNESS of women's experience" with a "subject in the negative who wants to displace the horizon, not to alter it." Sauzeau-Boetti's antinomic construction of appropriation/negation, however, makes no claim to an avant-garde that is superior to society and moves it forward. It instead advocates a struggle for a different, non-patriarchal relationship to the world. This can succeed in the form of culture-critical art by women, creating the conditions needed for a disintegrative aesthetic subjectivization. The value of art and its subject-forming potential are thus preserved, without fixing it within a male-occupied form of subjective evaluation.

Negative Capability as Practice in Women's Art

Annemarie Sauzeau-Boetti

from *Studio International: Journal of Modern Art*, January/February 1976

'I would call "feminine" the moment of rupture and negativity which conditions the newness of any practice.'
—Julia Kristeva

'Let's be careful to remain in the margin: on this side of it, ideology catches us again. But beyond it, archangelism threatens to catch us.'
—Alain Robbe-Grillet

In Italy, like anywhere else, many women artists still deny the idea of a female art. They feel either offended or frightened by a hypothesis which seems to imply a deliberate fall back into the gynaeceum…. If the word "feminine" frightens these artists it is because they are not confident about the possibility of filling it with a reality which is different from the metaphorical womanhood invented by men. They say, and they are convinced, that art is good or bad, but has no sex. It is a fact that their artistic research is often so perfectly in line with the cognitive order of male culture, that their work (at its best and its worst) has no substantially different connotation from man's art. If we assume that culture is an asexual absolute, it means that women have just one problem, historical backwardness, which will be overcome with time, with the general social evolution and the demonstrative anticipation of an emancipated female elite. Between this theory and women's traditional docile reverence, there is no opposition but a great deal of agreement: male humanism remains the yardstick of value and strength.

In Italy today we frequently find male art critics or amateurs who make a great show of accusing themselves of having excluded women from the mainstream of artistic activity. They exalt the consecration of great women artists who had been either forgotten (for instance Marisa Merz) or eclipsed after a brilliant first stage of their career (Carla Accardi); they exalt the entry or re-entry of these artists into the economy of artistic expression. There is still no declared group situation in Italy among the artists who are aware of their historical condition as women, and their awareness is much more of a private identification than a move towards self-vindication and promotion (as it appears in the radical

politics of USA feminist artists). These Italian artists who behave differently within their profession (whether because they are forced to do so by discrimination, or whether they do so through a genuine difference in their way of being), evince many different approaches to their experience of life and to the process of art. I don't mean "different" in the context of the dominant artistic situation (as a pluralist reference to 'schools' Optical, Pop, Conceptual, Narrative, Wild, etc.), but inside their more or less concealed but communal incongruence, that is in their relationship to a different experience of the world (existence in the feminine and assimilated male culture).

The primary approach is connected to the rediscovery and exploration of the body (specific biology, physical boundaries, sexuality) conveyed through privileged and recurrent materials, shapes, colours, rhythms, gestures, internal/external spatial relationships. The body theme has not as yet become too explicit, it is not 'translated' into a codified imagery—a conditioning and ambiguous 'iconography' on the verge of mythology— as has been happening in California in the Womenspace situation (see Judy Chicago's book *Through the Flower*). The biological and uterine themes are ambiguous, because they exalt a 'natural' identity, whereas woman's history is mainly cultural and it is in the name of 'nature' that she has been kept away. In Italy (let us say in Europe) this body matter can be traced in many women's work, but usually as a substratum of their artistic expression, and far less gratifying than the explicit female iconography. This characteristic appears particularly clearly in body-art: it deals with blurred figures and the confused roots of woman's physical and mental lack of identity—with narcissist pleasure and self-denial, with silence and fragmentation. (About women's art and body, see Iole de Freitas).

Another approach (I am schematic) to existence and art deals with woman's ancestral second nature: the oppression and negation which are also self-oppression and self-negation. An historical example of conjunction between the expressive/repressive impulse: the thousands of lace doilies, more maniacal than modest, that always radiate like spiderwebs ... It is not a question of reproposing lace doilies but of recalling them as examples of the atrophied expression of a culture which remains authentic (although smothered). Women's art sometimes starts on this pilgrimage of rediscovery and vindication of traditional gestures. Having been rescued in art mechanisms, some memorized gestures free themselves from atavism and obsession; they are actually exorcised from a spell and become a free inventive activity, once their matter-of-fact function has been cancelled and their value, as a trace of some deep intimacy

Marisa Merz, *Untitled*, 1975

between body and mind, has been restored. Here, 'free' does not mean perjury, it implies respect and a sense of belonging to the obsessive pleasures of some feminine moves and rituals (such as knitting, patch-working, candle-melting, fable-telling and warding off the evil eye ...), an occult space now open to free imagination and invention. (About women's art and traditional gestures, see Marisa Merz).

Other artists tackle the difficult task of the most rarefied cognitive and creative processes in male art, the least existential and for that reason particularly demanding for women (emancipation as a third nature?). I am alluding to the activities that require the greatest mobilization of the abstracting and sublimating faculties (abstract art in the fifties, pro-grammed and optical art in the sixties, conceptual art starting in the late sixties). Now, when the woman artist lives profoundly as a woman in her profession and strongly enough in her mastery of the means she is man-aging. It is my belief that a gradual differentiation from this 'father' art occurs. It does so in the daily dialectic between intuition and cognitive mobilization, between desire and intellectualism, between the female and male polarities existing in her as a human being. Her relationship with the technique and artistic field she deals with, her very language, changes when she reaches the point of exercising her ability to symbolize

Annemarie Sauzeau-Boetti

areas of life which have been historically unexpressed (and sheltered) for so long. In this case she enters the double space of *INCONGRUENCE*, by which I mean that she can still be read and appreciated through the cultural criteria of the avant-garde, formal quality and so on, BUT also through another criterion, as a landmark of an *ALIEN* culture, with reference to other values and mind schemes (a Fourth World, Susan Sontag would say). This represents an indirect and difficult path through the territory of art (with the risk of getting lost) a certain appropriation/negation of languages and expressive media. (About this 'traverse' practice of art, see Carla Accardi.)

Some young artists and feminist supporters think that feminist art can exist as a new artistic language. I remember a small show in Trieste last spring called 'Feminists'. In the presentation, such art was praised as 'accusatory, violent, hard, crude' (in contrast to the gentle conciliating tradition of women). Indeed, a woman is liable to feel violent and crude (if not alien and lost) when she 'seizes the word,' since the daily abuse of her existence has been violent and crude. It is also true that her redeemed creativity cannot exist in a pure state, outside history, all shadow-cultures or exiled cultures being related to the revolution which prepares their return home. Nevertheless, ideological and pamphletarian matter as such cannot build up a creative expression. The explicit figurations or references to feminist themes (anger, body expropriation, body rediscovery, etc.) are by themselves no guarantee of a diverse relation with the instruments of expression. What is more (and worse for art), ideology is reassuring: as a political project it supplies a goal and gives a positive validity to accusation; when applied to artistic expression it is usually anti-revolutionary whenever it does not succeed in being IMPLIED in the very language, since it directs expressive research into the didactic and illustrative processes we all know (all the party and state forms of art). So, when women's art explicitly accuses and vindicates, it re-enters the LEGIBLE cultural space as militancy; and in order to be antagonistic (a type of dialogue), it has to recompose itself artificially (for instance through a 'provocative' use of Pop technique), which means betraying the basic disunity, 'negativity' and *OTHERNESS* of woman's experience. I do acknowledge feminist group expression as a rich militant instrument in the way Chilean and Portuguese 'murales' are a renewed political praxis; but I don't believe in 'feminist art' since art is a mysterious filtering process which requires the labyrinths of a single mind, the privacy of alchemy, the possibility of exception and unorthodoxy rather than rule.

Woman's exclusion is historical, not natural. She has been absent from history because she has never given MEANINGS OF HER OWN through a LANGUAGE OF HER OWN to culture (and to herself as part of it). Instead, she has assumed those established by man (for instance she has complied with his metaphorical vision of her real self). The new meanings cannot be conveyed through an 'old' language (for instance the explicit and coherent reference to these meanings—the bad joke of filling a smelly pot with fresh water). But what is of greater importance is that these new meanings CANNOT BE AFFIRMED AT ALL through any alternative positive management of the artistic language, because these meanings refer to a scattered reality, to a subject in the negative who wants to displace the horizon not to alter it; who wants to go through all the resources of *'NEGATIVE CAPABILITY'* (Keats and Duchamp let their own feminine identity bloom quite freely). The actual creative project of woman as a subject involves *BETRAYING* the expressive mechanisms of culture in order to express herself through the break, within the gaps between the systematic spaces of artistic language. This is not a matter of accusation or vindication, but of *TRANSGRESSION* (closer to madness than to reason). The cuts and waves in the braided transparent material (Carla Accardi), the waiting needles around the curled void knitting (Marisa Merz), the absent and broken body reflected back from the other side of life (Iole de Freitas), the quivering hands that 'embroider' their own shape with calligraphy and attempt to save themselves from metaphor and unreality (Ketty La Rocca), are examples, among many others, of such languages in the 'negative'. This kind of project offers the only means of objectivizing feminine existence: not a positive avant-garde subversion but a process of differentiation. Not the project of fixing meanings but of breaking them up and multiplying them.

Coming Together: Demas Nwoko and *New Culture*

Azu Nwagbogu

Any effort to understand, define, or circumscribe the ontological roots of African modernism in design, art, literature, music, and culture as a transdisciplinary assemblage starts with the work and practice of Demas Nwoko and his magazine *New Culture: A Review of Contemporary African Arts*. I stress the word assemblage, that is, as a collection or gathering of ideas, things, and people.

New Culture was a short-lived but highly influential publication that reflected the stimulating interaction between the creative energies and preoccupations of an array of artists with an emerging consciousness of a Pan-African artistic and cultural destiny and the sociopolitical realities of their respective postcolonial states.

In early 1977, Lagos, Nigeria, hosted the Second World Black and African Festival of Arts and Culture, commonly known as FESTAC 77. Black artists, historians, producers, and cultural critics from every part of the world were invited to participate in the festival in the areas of music, fine art, performance, philosophy, literature, drama, dance, and traditional religion, all transmitted to the world for four weeks. *New Culture* launched shortly after FESTAC 77 to sustain the critical discourse in contemporary visual culture and the arts in relation to Africa and its diaspora. The first edition appeared in November 1978 and the eleventh and final issue in October 1979.

Founder Nwoko—a painter, sculptor, architect, and stage designer—assembled a cross-disciplinary editorial team comprising African and diaspora artists such as Uche Okeke (Nigeria), Kojo Fosu and Melvin Edwards (United States),

and Taiwo Jegede (United Kingdom). They were later joined by art historian and critic Ola Oloidi and members of the Mbari Artists and Writers Club, with Nobel laureate Wole Soyinka and Chinua Achebe as local contributors.

The publication, which had a strong visual arts focus, emerged organically from New Culture Studios, which Nwoko had designed and built in Ibadan, Nigeria, in 1967, initially as a residential villa and personal studio for painting and sculpture. When the pioneering Mbari Artists and Writers Club relocated to the site, a publishing house was established at the premises, which enabled printing the magazine along with other art and culture publications.

New Culture revised the concept of Natural Synthesis, which Nwoko had developed with fellow artist Okeke in the late fifties as a framework for blending African traditions with the teachings of their European instructors in the visual arts, design, and architecture. *New Culture*'s philosophy was a celebration of an African and diasporic creative sector that served Indigenous needs in line with established evolving local customs that embraced the materiality of traditional materials where possible. This approach represented an evolution of the Natural Synthesis vision, which implicitly accepted the necessity of synthesizing African art and culture with foreign admixtures. For Nwoko, contemporary African creative expression had become in itself a valid cultural and technical benchmark by the mid-seventies, irrespective of the presence or absence of foreign influences.

New Culture expressed a bias toward design as a form of artistic expression. An extract from the editorial in the third edition reads: "We do not have to become a nation of fancy dreamers." It prescribed, "To be exact, one dreamer to eight executors."

What is remarkable about reading *New Culture* magazine today is how contemporary, relevant, and prescient its contents were for society now, especially given our current pandemic conditions. A focus on ecology, design for survival, environmental design, as well as the need for a new Black aesthetic and representation in painting, mass media, photography, and film are all propositions that are still debated today. Tendentious reviews and essays in which themes of identity, postcolonialism, the aesthetics of African art and culture and the role of history and tradition in informing contemporary Blackness recur. The magazine promoted women in the arts as well as exhibitions and performances featuring Black artists; it also ran listings of global arts events. *New Culture: A Review of Contemporary African Arts* represents a high watermark of contemporary art critique. It is also a tragic reminder of the need to support noncommercially viable content in the arts. Such publications catalyze the crystallization of a new language, and situate and sharpen the focus of artistic ideas. They serve as libraries of information, and necessary archives.

Architecture and Environmental Designs

Bob Bennett

from *New Culture: A Review of Contemporary African Arts*, 1979

The Development of Nigerian Architecture,
Pre-History to Colonial Role: An Overview

Architecture as a profession incorporates the cumulative knowledge of man, his environment and his technology and uses this knowledge to conceive a suitable "Artificial" Environment within which man can function.

Through the centuries, particularly in Africa, the role of the Architect has evolved. During prehistory and even up to the twentieth century, in Nigeria the Architect (the Designer) and the builder were synonymous. In fact, building designs during this era were highly standardized. These designs were also the point product of trial and error and were evolved around the physical and social environment of the people.

Environmentally, the architecture of Africa (and Nigeria) had to protect the individual from the elements of sun and the driving rains. There was also a problem of temperature: hot and humid or hot and dry. In the areas bordering the Sahara there was the problem of extreme temperature changes, as much as 50°Ft., over relatively short periods of time; say 5 hours. The environment also brought problems of available natural resources which can be used for building purposes. The materials used in building construction were manual ones, not fabricated. In the tropical rain forest and surrounding areas, laterite soil was available. This laterite was to form the basis of wall construction. Some variations of laterite usage were developed, as the consistency and mineral content of the laterite differed from region to region. In some areas laterite mixed with water and sun, dried, were used. In areas close to the desert it was necessary to use additives to laterite for reinforcement (additives included materials such as straw and even cow dung, where cattle was available.) In many riverine areas, such as the Niger Delta, laterite was not available. Consequently local wood was used for construction in lieu of soil.

Nature also provided foliage. This was used for roofing although in some areas of Northern Nigeria laterite was used for roofs. The foliage differed from region to region, and this resulted in various types of thatch roofing.

The architecture of Africa also paid deference to the life style of the people. Farming communities had different life styles and living requirements from nomadic herding tribes, who required temporary and mobile living accommodation. The elites of society, such as natural rulers, also had different living requirements, as did the urban dwellers of Timbuctu, Ibadan, Kano or Benin.

Possibly the three most significant influences on Nigerian Architecture are: The expansion of Islam to Northern Nigeria, the colonial domination by Great Britain, and the return of the Brazilian slaves. These events significantly influenced the indigenous Architecture.

The expansion of Islam into Northern Nigeria has been manifested, in Architecture, in at least three ways. Islam required a new type of Building– the public building the mosque. This building not only served religious purposes, but also accommodated a number of social activities such as education and the dispensing of Koranic Justice. The Mosque replaced the Central Meeting Square and the central shade tree or "Meeting Hall" where the local decision makers deliberated over important issues. Second, Islam being a religious movement, was opposed to paganism and Idol worship. One of the rules of this religion was the ban on representations of any living things (animals or people). This ban which was possibly to discourage any idol worship, resulted in the use of geometric designs in building ornamentation. The third influence of Islam on Nigerian Architecture is the use of form and visual expression. Heretofore, indigenous Architecture had basically adhered to standard rectangular or circular forms. The visual impressions (elevations) were basically standardized with variations found mostly in small scale ornamentation. Islamic Architecture had developed a technique of combining rectangle (or square) with the circle, largely through the use of domed roofs. With respect to the visual impression, the Islamic influence virtually imported the Architectural Style which was prevalent in the Middle East at that particular time. This style was a significant departure from the indigenous style of the era.

Colonial Era

The return of many Yoruba ex-slaves from Brazil has also had a significant influence on Nigerian Architecture. These former slaves returned to their ancestral home with skills in the building trades. These skills which were learned while in bondage were new to Southern Nigeria.

In addition to these skills in the building trades, the 'Brazilians' introduced what is probably still today the only urban, multi-storey adaptation of compound living–the 'Brazilian House'. The Brazilian House uses the principle of the double loaded corridor (a corridor with rooms on both

sides). The corridor serves as the interior courtyard and a communal space. Although a cooking area is provided in the rear of the house, with the advent of smoke-less fuel many people now prefer to cook in the corridor close to their rooms. As in the rural areas where expansion was possible by adding more rooms–or huts–the Brazilian House allows for 'expansion' simply by the tenant's acquisition of adjacent rooms (which are normally connected by internal doors). As an urban solution, the Brazilian House also made provisions for trading through the utilization of street side rooms and verandahs. Generally it can be said that the Brazilians brought with them a sense of space relationships which was extremely useful, particularly in Urban situations.

The third influence introduced by the Brazilians was a new dimension in ornamentation. The use of reliefs, flower designs, cornices, and colour (even today Brazil is still renowned for its use of color in design) were largely Brazilian innovations of the nineteenth century.

Possibly the most significant development which has influenced Nigerian Architecture is the advent of colonialism. Colonialism brought with it not only new people, but new life styles, living habits, building materials and construction techniques: the colonial influence in fact is the foundation of the Nigerian Architecture of today.

The initial instrument of colonial architecture was the Public Works Department (P. W. D.) of the former colonial administration. The P. W. D. was initially staffed by engineers, civil and engineering technicians from the metropolitan country. Their major area of concern was public works projects such as roads, offices and other public buildings. Out of necessity however, they had to engage in the development of residential areas for the expatriate staff.

Although the P. W. D. Engineers were not specifically trained in Architecture, they did engage in building design. The Designs were normally the result of their interpretation of the African environment plus the requirements of a living style, unlike their natural habitat that they created for themselves. They also brought with them new building materials (cement) and fixtures (toilets, windows). They also introduced electricity and the extensive use of movable furniture.

In their interpretation of the African environment the colonialists were guilty of some misinterpretations. Possibly the two major fallacies were the understanding of the malarial mosquito and theories on ceiling heights. Based upon a French theory, the British thought that malaria (from the French meaning of 'bad air') was directly related to the level at which air enters the room. It was assumed that mosquitos breed and live at ground level. Consequently the colonials thought that

if the habitable rooms were above ground level they would eliminate, or at least reduce the chances of contracting malaria. This belief resulted in the storey building with kitchen and store (for use by Africans) downstairs, and habitable rooms (for use by Europeans) upstairs. This fallacious misinterpretation helped encourage the use of the storey building.

The second major fallacy concerned ceiling heights. It is a well known thermal principle that hot air rises. To reduce room temperature therefore, the colonials felt that high ceilings would serve to reduce the overall room temperature. In theory this is true, but in practice the heat differential is so negligible that it is not actually recorded by the human body.

The colonials introduced relatively new building and construction techniques to Africa. This is normally referred to as 'Conventional' building techniques and is the foundation of the construction methods that are still used today. This technique required various skilled artisans (carpenters, masons, electricians). This created a new cadre of worker–the skilled worker–which was heretofore not available in the country.

The colonial era also introduced new materials into building construction. Although where necessary they would use laterite for walls, they preferred to bake the laterite into bricks when possible. Where sand was available, they mixed the sand with cement to get what we today call sancrete blocks. Totally unsatisfied with thatch as a roofing material (it was used by peasants in England), the colonials imported corrugated roofing sheets. For the African, the colonial architecture was generally appealing (as a novelty and sign of wealth) but it was not totally sympathetic to the African life-style. The colonial residences were not meant to accommodate children as most of the colonial officers were either childless, or left their children in England for schooling. The colonial Houses were also designed for a monogamous marital structure while at the time polygamy was prevalent in Africa. Also, the colonial House was designed for colonial and not African social realities and life style.

In general, colonial architecture was functional for the users (i.e. the colonials). It also attempted to make itself adaptable to the environment (with various degrees of achievement). Unlike indigenous architecture which developed as an evolutionary process, colonial architecture was a direct imposition of style and methods of space utilization. It is this imposition which has possibly prodded the evolution of an indigenous style of architecture and has led Nigeria into the vernacular or adaptive area.

Gathering Voices, Feeling Relations: Arlene Raven

Oona Lochner

One of the key figures of the Los Angeles feminist art scene of the seventies, Arlene Raven (1944–2006) was an art historian, art critic, and educator. With artist Judy Chicago and designer Sheila Levrant de Bretteville, she founded the cultural center the Woman's Building and its educational program, the Feminist Studio Workshop. There, Raven worked to create an empowering infrastructure and community for women artists while straining to integrate (lesbian) feminist theory and experience into writing about art. She was a cofounder and editor of *Chrysalis: A Magazine of Women's Culture*, which published essays on art as well as poetry and seminal texts by feminists like Audre Lorde, Adrienne Rich, or Jo Freeman.

Raven's text about Helen Mayer Harrison and Newton Harrison and their multimedia eco-art appeared in the West Coast magazine *High Performance* shortly after she left Los Angeles for New York to become chief art critic at the weekly *Village Voice*. The text marks how, in the eighties, Raven's art writing expanded from feminism to issues of race, social change, and environmental concerns. She was invested in (as is the title of one of her books) "Art in the Public Interest," much along the lines of what her longtime friend Suzanne Lacy was to call New Genre Public Art.

In her essay, Raven focuses on the Harrisons' collaborative process, as rooted in their personal relationship. She also highlights how their installations interweave different artistic and activist formats, connecting ecological research with poetry, performance with communal activism, and local histories with the artists'

own mythologies. Both notions are paralleled in Raven's writing. Many of her texts interlock her own voice with artists' statements, reviews, and interviews; with poetry and pamphlets. She uses typography and the page layout to arrange different strands of text, along with images and captions, into a dialogic structure. Turning her writing into a polyphonic collage, Raven considers her task to be "writing alongside" the art and giving artists a voice, making dialogue and collaboration a principle of thought. This also affects the reader. By cracking linearity, Raven's texts continually interrupt the flow of reading, forcing readers to pause, reorient, and fill the gaps with their own associations, references, and thoughts. Raven thus creates a space for the reader to join the concert while becoming aware of how they always participate in the production of meaning.

As did the Harrisons, Raven often shared personal, sometimes romantic, relationships with her collaborators. At the Woman's Building, she had developed collaborative work modes based on community and shared experience. This was not only a means of laying open her entanglements. Having the contingency and messiness of personal relationships seep into her texts, Raven undercuts hegemonic (masculine) concepts of authorship as well as the mind-body split they reproduce. Instead, she elevates the affective overload of the personal to a source for a different kind of knowledge production. The climate crisis, as foregrounded in the Harrisons' eco-installations, has never been more pressing than it is today, and it is increasingly present in the arts. Raven's text demonstrates how art criticism, in dialogue with the artwork, can take part in addressing the urgency for change, not only in art. Moreover, her writing sets an example of a situated art criticism that highlights the interestedness, relationality, and contingency of thought and (aesthetic) judgment—an art criticism working to challenge hegemonic narratives and to open spaces for additional, and more diverse, voices and forms of knowledge.

Two Lines of Sight and an Unexpected Connection: Helen Mayer Harrison and Newton Harrison

Arlene Raven

from *High Performance*, 1987

Helen Mayer Harrison and Newton Harrison's installations contain a variety of artworks that together document projects the Harrisons have carried out in cities, rural regions and even in bodies of water all over the world. Their two-decade artistic collaboration and much longer marriage is their basic model for discourse. As two voices, they engage in Socratic questioning that becomes a method for developing their works.

In presenting their projects, the Harrisons wish to open their discussion. Their documents in art spaces stand for the sites they describe and also become sites in which a significant interchange can take place. Conversation that re-establishes human exchange about the social and physical environments is the primary aim of the Harrisons' work.

This article describes the approach the Harrisons take as artists, an approach that differs from those of other professionals who tackle environmental problems. Helen and Newton Harrison use the artist's tools of myth and metaphor. Their eco-feminism and eco-aesthetics, as well as their New Age optimism (that transformation of the environment and human consciousness is necessary and possible) are philosophical underpinnings for works that have had practical applications and measurable impact on their sites. They have reclaimed waste land, saved a species, halted erosion. They have worked with city governments and planners to enact transformations that are unique to their vision. Their imaginative solutions to ecological problems have sometimes succeeded when planning professionals have failed even to apprehend that a problem existed. Although they have made what can be called products, their work rests in a process of mutual thinking and imaginatively engaging with and in the world.

Introduction

What is art in the environment supposed to be or do? Can such art just sit there, surrounded by nature? Or hang in galleries in the art environment and simply refer to ecological issues? Does environmental art have to be ecological? If so, what—in practical terms—does that mean? By what standards should it be said to have accomplished or not accomplished its purpose? And by whom? Art critics, environmentalists, scientists, or the public?

Helen Mayer Harrison and Newton Harrison make now claims to answer these questions, to fit into any established categories of art and environment, or to fulfill any standards but their own. They insist that their work, at its core, shifts fundamental designs in human perception and calls an observer to participate in recreating a dynamic, healing balance between nature and people. The Harrisons are artists who rediscover and recreate physical, social, philosophical and mythic environments—with artistry, originality, and exemplary integrity.

I.

Helen Mayer Harrison and Newton Harrison began a conversation in 1970. After eighteen years, their discourse continues uninterrupted. Mutual thinking, the basis for all of their collaborations, contextualizes works to such an extent that they titled a recent interview about new projects, "Nobody Told Us When to Stop Thinking." They embark **"… when we perceive an anomaly in the environment that is the result of opposing beliefs or contradictory metaphors. It is the moment when belief has become outrageous that offers opportunity to create new spaces, first for the mind and thereafter in everyday … always compose[d] with left-over spaces and invisible places."**[1]

II.

We did a work for an exhibition called "Land Art" … at Bard College … we took a look at the coffee pot. You know, we like good coffee. It was so encrusted with salt from the drinking water you could hardly believe it. So we developed a work about cleaning the water. The ironic part of it was that the water purification would be done right there in the gallery. Therefore, the only place on campus where you could get pure water would be in the art gallery.[2]

The Socratic dialogue which distinguishes the Harrison relationship appears as myth and metaphor in their work. *The Lagoon Cycle*, created over a period of twelve years, opened at the Los Angeles County Museum of Art on November 18, 1987. It is a poetic meditation, asking questions and mulling over these questions together as "Lagoonmaker" and "Witness." As Carter Ratcliff observed,

One meets the Witness and the Lagoonmaker in the introductory panel of the Cycle. That is the first of numberless occasions for wondering to what degree the Witness is Helen Mayer Harrison and the Lagoonmaker is Newton Harrison …. From the start the Lagoonmaker

Arlene Raven

and the Witness treat large questions of creation and self-creation, will, and belief and action …. The Witness and the Lagoonmaker have learned to improvise. As they create the Lagoons through which they travel, they accept the "discourse of lagoon life" as a metaphorical guide. Or at least they struggle toward that acceptance. If our culture undertakes the same struggle and accepts the same guide, perhaps we'll find ways to adapt even to ecological disaster. Our adaptation may even be, in the Harrisons' word, "graceful."[3]

But the relationship of Harrison to Harrison is also a concrete comradeship within a marriage that has endured thirty-five years. Domestic, everyday. And an intriguing aspect of the two personas of *The Lagoon Cycle* is their clarifying fidelity to aspects of male and female, nature and culture. They weave their colloquy to reconnect these personas and thus initiate a healing that stands against the antagonism of mechanistic culture for unruly nature. As metaphor and example, their collaboration also reconsiders the plunder of world ecology and the fissure between men and women. Their eco-feminism and -aesthetics spring from this point of departure.

III.

In light of their unusual approach to artmaking on the one hand, and their commitment to artistic identity on the other, the Harrisson's view of the function of art in contemporary society is complex. For Helen, **"The structure underlying our work is different because the assumptions underlying our work are more complicated."[4]**

Referring to a historical example, Newton reasoned that "if you go to look at the Parthenon, you see a truly astounding work of art. But those artists were totally at the service of the culture's imperialistic impulses. If I took the Parthenon as a model, I'd say it was the job of the art to glorify that culture."[5]

"Conversely," Helen adds, "earlier art was probably at the service of religious cults or impulses, although we can only theorize what such impulses might be that could lead to such diverse expressions in time and space as fecundity figures like the Venus of Willendorf or delicately carved miniatures like the head of Our Lady of Brassempouy or the Bulland Vulture figures of Catal Hayük or the covered skull from Jericho with its inlaid cowry shell eyes."

THE FIRST LAGOON: THE LAGOON AT UPOUVELI
This image, from *The Lagoon Cycle* originated in 1985 at the Johnson Museum of Cornell University, Ithaca, New York, and was installed most recently at the Los Angeles County Museum of Art in 1987.

The Lagoon Cycle is a narrative installation that features seven lagoon projects described in maps, drawings, and photographs created by Helen Mayer Harrison and Newton Harrison. The images contain handwritten texts that trace the processes and consequences involved in the projects.

The Lagoon Cycle is named for the estuarial lagoons that are endangered everywhere. The lagoons are used as a metaphor for life itself.

The story is that of two characters called the Witness and the Lagoonmaker who begin a search for a "hardy creature wo can live under museum conditions" and become transformed by their search. (Courtesy the Herbert F. Johnson Museum of Art, Cornell University, Ithaca, New York.)

Commenting on modernism, Newton said, "Art, like all aspects of modernism, is fractured, bifurcated and rebifurcated, in little bits and pieces. We have decorative art, deconstructionists, Duchamp leftovers. Various

Arlene Raven

forms of realism, conceptualism. Our work is influenced by all of them. In truth, we go back to the story of the place's becoming and if we can be part of that story, enhance it. I don't know or care if that is 'far out.'"

In contrast to current emphasis on product, he explained that:

> **I don't think about our art as product at all. As a guiding thought, "product" is counterproductive.** Every once in a while we will make an array of images. We hope people buy them. But generally we make installations which stand for the place and as meeting ground for discourse, which are models for how to perceive and enact our work. We pack our "products" in boxes and tubes and hope some day somebody will put them up somewhere. But the most important parts of our work are nonproducts. In the reshaping of a place, our work exists in bits and pieces of the planning process of the place. In a gallery, those parts are attributed to us. But when enacted in the real environment, we become anonymous. We are both bigger than our plan, and more anonymous.

Helen Harrison underlined that, in contrast to city planners, the two had no vested interest in nor any sense that they must choose between loyalty to either art or the environment. "One of the things that happens to people, even the best of the planners, is that they have a vested interest in getting *something* done."[6]

Rather, the question of conflict "comes up when money is made available," said Newton. "We will take that project over a little better project which is unfunded. And that's the only conflict—when someone else is trying to modify our participation."

The Harrisons have been compared and contrasted in almost every interpretation of their work to earth artists, survivalist artists, conceptual and performance artists, and even the Hudson River School of landscape painters active in the nineteenth century, and earlier twentieth century social realists. Musing about Michael Heizer, Helen admired "the vast energy put into those early big cuts and shapes in the desert that are inherently gestural, simply primary structures in another context. They are transactional with museum spaces, not with the earth. They are involved primarily with forms."

In "Earth Art: A Study in Ecological Politics" (*Art in the Land: A Critical Anthology of Environmental Art*, edited by Alan Sonfist), Michael Auping says of Heizer: "Heizer has often argued that it is naïve to criticize his work from an ecological standpoint, given the fact that modern industry

is rearranging the landscape on a scale that dwarfs any of his endeavors."

Quipped Newton: "No art is as intrusive as a freeway intersection. I'd love to see Heizer take up 10 percent of Los Angeles. I'd vote for him."

"Christo's contribution was to 'redefine how big you can get,' added Helen. "His *Running Fence* didn't do more to the environment than a picnic. The ecological balance can readily restate itself. James Turrell makes a very small move, not taking your now for granted. That's economy of means at a very high level."

IV.
***Cruciform Tunnel* is a work of art that proposes one single move that will engender three consequences of simultaneous value to the urban and natural communities within the boundaries of the city of San Diego. If a tunnel is cut under Genesee, reconnecting the presently divided canyons, and this tunnel is constructed in such a manner as to permit a bicycle path, the intermittent flow of water, the movement of small game, and of people on foot, these remarkable opportunities emerge ...**

The Harrisons have an idea for San Diego, where they live and work. *Cruciform Tunnel* would extend under Genesee Drive, rejoin two nature reserves (the Torrey Pines Reserve and the UCSD nature reserve), the Penasquitos Lagoon and the Pacific Ocean. Water from the UCSD campus would now be channelled to the Penasquitos Lagoon. And a new bicycle path from their campus at UCSD to Sorrento Valley would be created.

Cruciform Tunnel is, indisputably, ecological art-art concerned with (improving) the environment. But the Harrisons are not primarily motivated by the need for a bicycle path or even increasing the overall ecological value of the site for *Cruciform Tunnel*. Nor are they mainly concerned with the aesthetics of the tunnel or the resulting beauty of the landscape, though these might be desirable and even necessary results of their work. **Rather "We go to places, anywhere!, and engage in the story of the place. We make a representation of the story, of its own becoming. We add a story to it. Our work is, as best we can make it, the poetry of the whole."**

Newton Harrison's explanation of concerns is headily abstract, and poetic itself. Yet the Harrisons' works have practical applications, require careful research and have often had a measurable impact on their sites. How do their concerns differentiate their works from standard ecological research?

Arlene Raven

"When did standard ecological research," responded Newton, "begin with a medical metaphor, turn itself into poetry, turn back into a proposal, shift into a performance, and then begin a process of nagging a city council? Standard ecological researchers made a series of experiments with canyons of San Diego. We then did a work based on this research, and proposed *Cruciform Tunnel*. A lot of our work depends on illuminating ecological research by others, which sits in limbo, in an untransformed state."

V.

"We have also done standard ecological research," said Newton. "For the Second Lagoon ["Sea Grant," for which an artificial environment for crabs was constructed], we did environmental and habitat studies, as well as observed and concluded through observation that cannibalism [in crabs] reduces itself when the environment is complicated."

Our 1973 Sea Grant crabs laid out experimental grounds [for the development of a commercial aquaculture system for the crab]. Our method is available and can be used. We believe in theoretical research. Although our work points in certain theoretical directions, we haven't engaged in theoretical research.

> **But**
> **the tank is part of an experiment**
> **and the experiment is a metaphor for a lagoon**
> **if the metaphor works**
> **the experiment will succeed**
> **and the crabs will flourish**
> **after all**
> **this metaphor is only a representation**
> **based on observing a crab in a lagoon**
> **and listening to stories**[7]

However, when it becomes necessary to do original research, we can and have. Nonetheless there is a big difference between original research and a work of art and our focus is on the work of art. But we define art broadly.

VI.

The fluidity of professional roles and tasks with which the artists are able to move through researching, planning, proposing and carrying out their projects in their own minds has very often become problematic when the process of their work is thrust into the nuts-and-bolts world of sponsors, agencies, sites and workers. When the Harrisons attempted to male earth and plant a meadow on top of forty acres of rock pile—according to them, **"a physical act of reclamation,"** called *Spoils Pile* (1977) and planned for the refilled old canyon quarry at Artpark—they were forced by Artpark authorities to stop after twenty acres were covered with soil, ostensibly due to the (too large) scope of their project.

Meditations on the Sacramento River, the Delta and the Bays at San Francisco (1977) was based on the same principle of reclamation. Said Newton, **"We made a work projected to impact the level of public awareness."**

"Our work was an extended argument in many media," added Helen, "from billboards to posters to radio and newspaper spots, to a museum mural. Heads of environmental agencies later quoted our own words in the newspapers without crediting us."

In 1982, they created *Thinking about the Mangrove and the Pine* (their working title for *Barrier Islands Drama*), a site-specific work for the John and Mable Ringling Museum in Sarasota, Florida. They considered the pines that were brought in from Australia to Florida for decorative purposes. The pines had unbalanced the native ecology, taking up mangrove root and sun space. As the mangroves disappeared, the pines took over water's edge.

> **Take Longboat Key, for instance**
> **Where**
> **That pushy shallowrooted immigrant**
> **That exotic and graceful pine from Australia**
> **Colonizes behind that oceanic nursery of mangrove roots**
> **When**
> **Displacing the mangrove**
> **Gaining water's edge**
> **It topples in the wind** [8]

How can their voices be consistently aligned with their values when they are not in complete control of the process by which their projects are realized? In fact, they cannot. Also, as Helen noted,

"We cannot really know the consequences of our actions. That is why we really need environmental impact studies, even on creativity."

Arlene Raven

THE SECOND LAGOON: SEA GRANT

But
the tank is not a lagoon
nor is it a tidal pond
nor does the mixing of fresh and salt
waters
make it an estuary
Filters are not the cleansing of the tides
water from a hose is not a monsoon
lights and heaters are not the sun
and crabs in a tank do not make a life web

 —The Witness
 text from "The Second Lagoon"

(Courtesy the Herbert F. Johnson Museum of Art,
Cornell University, Ithaca, New York)

IMAGE FROM BARRIER ISLANDS DRAMA, 1983

Barrier Islands Drama (Wenger Gallery, San Diego, California) describes in ballad form the destruction of the fertile mangrove nurseries by the encroaching Australian pine, introduced into the Sarasota, Florida, area in 1938. The mangrove and the pine are metaphors for attitudes toward the land and the environment.

Spoils Pile was a 40-acre reclamation project at Artpark in Lewiston, New York. The Harrisons collected topsoil and organic matter in autumn to make soil and later plant a meadow (a three-year project). After 3,000 truckloads were gathered and half the area was covered, the directors of Artpark stopped the project because it was too large.

Meditations on the Sacramento River, the Delta and the Bays at San Francisco argues that over time a land division system, which destroys topsoil, and a river-polluting system have been invented to develop the Central Valley of California for industrial farming. The Harrisons see the system as exploitive and self-cancelling, with a dust bowl the outcome.

—*The Lagoon Cycle*, texts from the chronology by Ann Trautman

Arlene Raven

The Harrisons' Text:

1983
At first seeing herons feeding in a
little river next to the Performing Arts
Center only blocks from downtown,
we realized that this river, despite all
odds, was still alive, so we wrote

To the Mayor and the City Council:
Can it be you have forgotten your
 river?
There appears to be no comment
 on it in your city plan
This river, the Guadalupe River,
 which meanders neglected ...
Be
Cleansed by greater releases at its
 headwaters, dredged
Where silt build-up
Has damned the flow, have its
 ecology restored, its bridges
 restated,
A serpentine walkway designed for
 its banks and extensions
Made to the
Refugia area wherever there is
 vacant land
"The refugia will be to the city as
 the hedgerow is to the field"

1987
Finally we saw the new plan for the river and realized that, although they
had taken our language of meander and park and refuge, the city had
decided that they could do that and still put the river in concrete. Thus
where the herons used to feed became concrete platforms with steps and
trees planted in neat holes and we wrote

To the Mayor and City Council:
Can it be you have forgotten what
 a river is?

There appears to be no space for
 one in your plan for water
 features
Therefore we propose
That
In the last available space for a
 park in Silicon Valley
The space between the railroad
 tracks
And the airport
Between the Guadalupe Express-
 way and Coleman Avenue ...

Let a new riverbed be cut
A new meander for the Guadalupe
 waters
That replaces the length of river to
 be put in concrete
Let the old channel remain as now
 planned for flood control
But let this new section of river be
 the meander and the refugia
That the old river once was and
 could again be.
"Again the refugia will be to the
 river as the hedgerow is to the
 field."

VII.

I was in Sao Paulo putting up a piece in the last Biennale when someone
told me there was a place nearby where babies were born in the usual
numbers but some of them without brain parts. I asked the obvious and
he said it was the smog. I was told that in Cubatao life was cheap. People
told me that the city was surrounded by multinational chemical compa-
nies where the chemical outfall into the bay and nearby canals was so
bad that the surface of the water caught fire last year killing many in the
adjoining favella.

I asked if there were environmental laws and he said there might be.

—text from *Breathing Cubatao*, a work by the Harrisons

Arlene Raven

The Harrisons' art participates in the "New Age" and in its optimism that transformation of the environment and human consciousness is necessary and possible.[9] With eco-feminists and environmentalists, they reexamine the European scientific revolution and simultaneous rise of our modern market culture. But while utilizing contemporary technology, they question the model of the cosmos as a machine rather than an organism, a (machine) model which has for centuries sanctioned, de facto, domination over nature and women. The existence of the Harrisons' work calls for the contributions of the "fathers" of modern science—Francis Bacon, William Harvey, Rene Descartes, Thomas Hobbes, and Isaac Newton—to be reevaluated in light of the mechanistic roots of their modernism. Most important, the Harrisons' work both presents and suggests alternative organismic paradigms which must temper the catastrophic contemporary consequences of the long-running machine age if humans and nature are to survive and thrive.[10]

VIII.

Baltimore Promenade consisted of mural-size photographs of the area with text. An organized walk on December 13, led by the mayor of Baltimore, other officials, and the president of the Maryland Institute, dramatized the Harrisons' proposal.

—text from the chronology by Ann Trautman, "Baltimore Promenade," Maryland Institute, College of Art

Their particular blend of aesthetics and politics evolved from their working process and their focus on conceptual, artistic and ethical issues. **"[A]n aesthetic exists always in interaction with, and in commentary on, a larger social context [T]o isolate an aesthetic and attempt to make it unrelated to other things is impossible."**[11] With their connections between their aesthetics and the social context for producing art in mind, it seems natural that the Harrisons would name as imperialist and unjust the disruption of social intercourse and physical movement as artistic "problems" to be confronted. Their propensity for making and altering maps—appropriately enough, a preoccupation of visual artists during the Renaissance—can also be traced to their aesthetics from which originates the impulse to restore the relationship between the physical ground and the humans inhabiting that ground. They want to create actions that not only stand beside but work to undo domination and manipulation of nature in the service of man-made hierarchical systems.

The environments for their environmental art are, therefore, the human and societal environments, in a dialogue with physical environ-

ments. The Harrisons are never motivated by a sentimental love of trees or animals or unspoiled rivers, but of justice, balance, good sense and people. When addressing problems of city planning in San Jose, Atlanta or Baltimore, they observe when basic human activities–in these cases, walking—have been disrupted because urban planning served other needs. They unearth the cultural values embedded in systems of domination that make "other needs" priorities, rather than simply battling in the realm of politics and law.

In the service of their central concern—reestablishing discourse—through their central method—opening dialogue—they proposed a promenade for Baltimore based on their conviction that

> a promenade is both an activity and a place, a stage on which people in a community meet and mix.... A promenade is marked by people physically tuning to common movement and rhythm. A promenade is an activity common in all urban ecologies, a basic homeostatic or self-regulating mechanism by which the community as a whole maintains awareness of the well-being of the individuals who comprise it, and by which the sense of community is reaffirmed collectively.[12]

The city's Baltimore Harbor Project was already established when the Harrisons took up their analysis. They proposed connecting the Harbor Project to the city's cultural center in one direction, and to a park, which already existed, in the other. As Susan Platt put it,

> They visualized this connection by simply pointing out that, by means of two twenty-minute promenades, people could move out of the self-contained nucleus of the harbor, surrounded by its eight-lane noose of highways, to the surrounding city. All that the artists suggested was a walk that made use of the city as it already existed—they simply drew a line on a map to mark the walk. The total cost to the city was that of moving one bridge and adding a stoplight, and the result was "Baltimore Promenade/a concept for making a Baltimore walkable (again)/a proposal inviting involvement and action."[13]

And, as Helen Harrison says, "The ideas about redevelopment that we had went into the city plan and are occurring in city time—that is in scores of years—but they are happening."

Arlene Raven

IX.

If one accepts (and I do) the fully artistic and fully ecological nature of the art of Helen Mayer Harrison and Newton Harrison, then they are legitimately creative resources for identifying the most pressing environmental concerns and suggesting the opening phrases of our communion with our earthly surroundings.

"We have focused a fair amount on water," they said. "Water is a very critical bio-indicator. If water remains pure, and rivers are maintained, then many other good things happen. Pollution into oceans can be reduced, for instance. One can just as well spend time on trees. Or the stork, as we did in Kassel [Germany, for Documenta 8, 1987]."

We're really not messianic. We're just two people putting one foot in front of another, asking for reasonably ethical behavior. We've empowered ourselves through our work. And our greatest concern is establishing models wherein anybody can start anywhere and radiate out change and transformation by engaging the discourse. The most important thing is to begin anywhere, and get cracking.

1 Statement, *Helen Mayer Harrison and Newton Harrison: New Projects*, Grey Art Gallery, New York, March 17–April 18, 1987, reprinted in "Nobody Told Us When to Stop Thinking," *Grey Matters: The Quarterly Bulletin of The Grey Art Gallery and Study Center* (New York University, N.S.) 1, no. 2 (Spring, 1987).

2 Helen Harrison, statement, paraphrased in *Grey Matters*.

3 Carter Ratcliff, "A Compendium of Possibilities," *The Lagoon Cycle* (Ithaca, N.Y.: Herbert F. Johnson Museum of Art, 1985), p. 13.

4 Helen Harrison, *Grey Matters*.

5 Newton Harrison, interview with Arlene Raven, October 1987. All quotations of Newton Harrison and Helen Harrison unless otherwise cited are from this interview.

6 Helen Harrison, *Grey Matters*.

7 Text from *The Lagoon Cycle* by Helen and Newton Harrison.

8 Text from *Barrier Islands Drama* by Helen and Newton Harrison.

9 See Linda McGreevy, "Improvising the Future: The Eco-aesthetics of Newton and Helen Harrison," *Arts Magazine*, 62, no. 3 (November 1987): 68 for a discussion of "New Age" philosophies and the therapeutic aspect of the Harrisons' work.

10 See Carolyn Merchant, *The Death of Nature: Women, Ecology, and the Scientific Revolution* (San Francisco and New York: Harper & Row, 1980).

11 Newton Harrison, interview with Michael Auping, in *Common Ground: Five Artists in the Florida Landscape* (Sarasota, Fla.: The John and Mable Ringling Museum of Art, 1982).

12 Helen and Newton Harrison, from their statement about *Baltimore Promenade*.

13 Susan Platt, "Helen Mayer Harrison and Newton Harrison: An Urban Discourse," *Artweek*.

Drawing Another Line:
Ješa Denegri

Maja and Reuben Fowkes

Born in Split, Croatia, in 1936, Ješa Denegri studied art history in the Yugoslav capital of Belgrade in the fifties. His formative years were marked by the establishment and rapid growth of Yugoslavia, which after the Tito-Stalin split of 1948 developed a distinctive version of self-managed socialism and through the founding of the Non-Aligned Movement in 1961 strategically positioned itself between the Cold War's ideological blocs. From the mid-sixties, he published reviews of exhibitions held across the decentered art scenes of the federative country and was a promoter of Conceptual Art, or "New Art Practice" in the local terminology. Through his influential Other Line theory, he proposed an overarching narrative of modern Yugoslav art history, which traced a thread of influence and connection from the Yugoslav avant-garde artists of the nineteen-twenties to the New Art Practice of the late sixties and early seventies, through pivotal groups and movements such as EXAT 51, Art Informel, Gorgona Group, and New Tendencies. Conceived at the time as an alternative to both conservative national and socialist modernist art narratives, Denegri's Other Line frames the museological display of Yugoslav art in the region and internationally.

In a socialist country where mainstream art criticism was generally hermetic, ornate, and full of jargon and phraseology, Denegri stood out as an art critic for his clear and rational way of explaining local artistic phenomena and for sharing his well-informed views about international currents. Although he described the act of writing art criticism as a solitary endeavor,

he also saw it as founded on direct encounters with artists and works. Collective experience informed the individual response of the critic, who acted as a conduit for critical opinions formed in dialogue with other members of the art world. Denegri's writing from the period conveys the exuberant atmosphere of neo-avant-garde art scenes in Yugoslavia and the intimacy of alternative cultural circles. His texts can also be instructively read today for what they reveal about the nonmonetary character of many artistic exchanges that took place in the non-market conditions of the socialist art system.

"A New Turnaround" takes the form of an interview, complicating its status as art criticism, since here the critic vocalizes his point of view within the frame of a dialogue rather than composing an individual critical response to an artwork or exhibition. Published in 1989, the piece attempted to review the artistic pluralism of the eighties in a country that was falling into ever-deeper crisis. As such, his discussion of the controversies at the time around IRWIN group's artistic strategy of repurposing totalitarian ideology and overidentification with Slovenian nationalism bears witness to the decline of the multiethnic principles of Yugoslav culture following the death of Josip Broz Tito in 1980. The critic also records the increasing international isolation of the Yugoslav art scene during the decade, reflecting the economic dysfunctionality and declining geopolitical influence of a country that with its brand of third-way self-managed socialism had aspired to lead the Non-Aligned world. The text is also indicative of the limits of Denegri's Other Line thesis, which as the critic himself conceded, lost strength and relevance in light of the anachronistic, postmodern practices of the eighties. The "new turnaround" in the title refers to the notion, which Denegri here disputes, that the eighties saw a generational rejection of the conceptualism of the New Art Practice and reactionary return to traditional media. Indicative of the unpredictability of the social and artistic upheavals that the nineties would bring was his view that "on the basis of the current situation" it would be "difficult to expect any turnarounds" on the scale of those that occurred at the turn of the seventies or even the eighties.

A New Turnaround

Ješa Denegri
interviewed by Ervin Dubrović

from *Rival*, 1989

How do you see the relation between the events of the eighties and the leading figures in them, and the art and events of the seventies?

At the moment of first appearances, influenced by the visible differences in the expressive procedures (because of the dominance of painting in the art of the early eighties over the application of the technical media of photography and video that had been frequent in the art of the seventies), and then because of the influence of certain interpretations of the postmodern—which have taken up critical, in fact, pronouncedly negative, attitudes to the inheritance of modernism—it looked as if the beginning of the eighties was going to make a sharp break with the preceding decade: a cut was going to present a new turnaround, as expressly stated in the title of an exhibition.

Indeed, a number of particularities in the language, mentality and behaviour of artists in the reception of art in the social milieu suggest that differences between these periods of art do incontestably exist. But today there are, increasingly, perceptible particularities that have continued and endured uninterruptedly. Some of the primary figures in the art of the seventies and the new personalities that appeared in the eighties can be found in the close interpersonal contacts, in the mutual respect paid, and shared events. And on the scene today completely equally with them are artists who started in the sixties, even in the late fifties, and have kept up as authors and as personalities. We might take as examples Knifer, Kožarić, Seder, Kulmer, Olga Jevrić, and Damnjan. Some of the sharp breaks or cuts between artistic phenomena that came out in these periods and gave them their prevailing markers are essentially smaller than when this is looked at from a certain, primarily theoretical, not to say, ideological, position. A constant that in these periods is not lost but indeed links them is contained in the personality of the artist. The work of the artist, the goings-on and the results in artistic practice, are basic indicators of the situation. Only from them would it be worthwhile drawing conclusions about the nature of the processes that unfolded in art at the turn of the last two decades, and during them.

How do you see the trends in Yugoslav art as compared with happenings in the world at large? How much were events in Yugoslavia involved in world currents and how much were we connected with them?

There is no doubt that in the character of expression, goings-on in contemporary art in Yugoslavia were an integral part of the European context. Yugoslav artists were, in their strivings and understandings, included in world trends. In no way accurate is the claim often heard that Yugoslav artists blindly follow or uncritically adopt fashionable world and European lines in art. Naturally, we are determined in our defence of artists who possess the mentioned virtues of personality. The problem of the position of contemporary Yugoslav art as against European and worldwide events is getting more fraught, primarily because of the obvious absence of our artists from big international events, from the global international art scene. It is quite painful to see that in these areas there are either no Yugoslav artists at all (that is, those who work in their home country) or else they are just infrequent guests. The reason for this, it seems, needs looking for, primarily in the distance of the whole of the Yugoslav social and political (and consequently cultural and artistic) space from the important integrating processes that are going on right now in the European continent. Put simply, because of its foreign policy options, because of its internal situation, its overall and general crisis, it is a foreign body in contemporary Europe, and a consequence of this is that there is not much demand for artists—painters and sculptors—from this milieu. That a Yugoslav artist working abroad has as much chance as other artists, artists from all settings, is shown by a number of examples. Braco Dimitrijević and Marina Abramović show that it is possible to parlay this opportunity into a salient position in international terms. Conditions could be amended or at least much alleviated if our leading museum-gallery institutions were professionally linked (and for this they need, certainly, to have a much better financial position) with corresponding establishments in most of the European countries, and if they kept up regular and equal working links with them. And then the situation would also be improved by the existence of a larger number of galleries like Equrna in Ljubljana, especially if there were to be a development of a private art market, which, along with a negative, has also more than one positive side. There are suppositions that some forces in Yugoslav society are aiming at a radical redirection of previous social-political orientations, at the activation and initiation of personal initiatives, rivalry, and competition, the introduction of European criteria for work and behavior. These are, certainly, criteria particular to the nature of art. Art owes knowledge of these criteria to nobody, and not even to

progressive social and political tendencies. But for a normal life, for its own development it needs and requires a social underpinning that at the moment does not exist in Yugoslavia to an extent that would enable existing (and future) artistic values to be shown and make reputations for themselves in an appropriate manner in the European cultural space.

What would you say about the connection of art institutions, critics and artists with the Italian transavantgarde, the American New Image, Neo-Expressionism, and similar phenomena?

At the moment of the first insights into artistic happenings at the beginning of the eighties, it was worth getting to know the basic phenomena in the European and American contexts, and hence that there was a certain reliance of our artists and critics on the work of the New Image, Neo-Expressionism and the transavantgarde is understandable. The outstanding work of Bonito Oliva, the whole of his campaign that he launched as part of the promotion of a handful of then young and later it was to be seen powerful, artists, his very subjective theory about the phenomenon of the transavantgarde raised in this country at once resistance and acceptance, but in any case indicated the conduct of one "militant" critic at the moment of the inauguration of the then new artistic atmosphere. Along with Oliva's exhibition *Transavantgarde* in Zagreb, the concurrent events on the Italian scene were presented in Belgrade with the exhibition *Vocation of Painting* by Antonio d'Avosa and *Kryptoniana* of Ida Pannicelli.

Some artists and their works from the realm of the New Image were seen at the show *The 1970s: New American Painting* in Belgrade and Zagreb in 1979 and had a stimulating effect on the awareness of the need for a pluralistic vision of artistic trends then making their appearance. Contacts with the new German Expressionism were, though, only sporadic: the exhibition *Young Art of Berlin*, with Fetting, Middendorf, Zimmer and others took place only in Osijek in 1982, and the exhibition of Georg Baselitz in 1986 was certainly an event which occurred only as a result of the efforts of Andrej Medved from the Obalne Galerije (Coastal Galleries) in Piran and Kopar. All the contacts were indubitably positive, took place at the right time, and constituted a direct link with European art circles. But it would have been more useful if they had produced not only our reception of foreign events but at the same time the promotion abroad of the achievements of Yugoslavia at that time.

What would you say about the work of Neue Slowenische Kunst and the Irwin group from Ljubljana, about the New Image in Zagreb, the

Alter group in Belgrade, and what other major phenomena could you add here?

Irwin is a phenomenon on its own in Yugoslav art of the eighties, and the appearance and ideology of this group should be looked at in the context of similar happenings in music, the theater and design in the same setting and generation. They appear with a marked and straightforward retro-standpoint and do not hide the ideological dimension of their commitments. In the character of this complex there is an irrevocable highlighting of their belonging to a national cultural setting (Neue Slowenische Kunst). Not without weight are arguments of a thesis that sees a kind of "imaged ideology" rather than an actual artistic vocation in the whole phenomenon. For certain there is here none of the lightness and playfulness of the artistic imagination; it is a work that is born out of erudition, will, and persistence: in the language and in the behavior of the Irwin group a line of perhaps excessive wishing prevails; a contortion, a deadly seriousness, a constant wish to persuade of the rightness of the way they have chosen. I would like there to be more spirit, wit, and soul in all of this. But Irwin is a certain characteristic product of this time, perhaps one of its most faithful indicators. An exceptional flair for media promotion and the favorable reception it has met with in certain

Irwin at Švicarija Studio, 1984

Drawing Another Line

271

Irwin, *Malevich Between Two Wars*, 2004

circles abroad make Irwin one of the few phenomena of the Yugoslav art of the eighties that have a reputation on the international scene.

The appearance of the New Image in Zagreb is a characteristic phenomenon in the art of the early eighties. There were various individual approaches, much prompted by the international expansion of painting of a similar kind, choices that were often hasty and thus fairly short-lasting, but with a talent for facile and free painting, in some cases with the characteristic markings of "women's writing." The Belgrade group Alter Imago belongs to and shares the fate of other phenomena at that historical moment. It did not last long, and today comes down to the artistic couple of Alavanja–Lušić. What holds true for their painting is primarily the theoretical premise contained in the name of the phenomenon. Undoubtedly Irwin, the Zagreb New Image and Alter Imago will continue to figure in the chronicle and history of Yugoslav art events of the eighties, but along with a multitude of other personalities, certainly superior in painting terms, and more lasting artistically. It is hard to briefly present and give an account of all the other "major phenomena" as the question says, but I am inclined to see these phenomena more in some older and more experienced individuals than in the temporarily highlighted proponents of the artistic climate of a given time. The names that naturally

Ješa Denegri

come up here are Seder, Kulmer, Bernard, Damnjan, Salamun, Iljovski ... Or younger artists who are working from the middle-ground— Gorenec, Kapus, Rakoci, Kipke ... among the sculptors, Sambolec, Počivavšek, Vodopivec, Bajić ... And all those changes in the spirit of the time of the eighties don't hinder Knifer, Kožarić and Šoškić from still being among the leading artists of the decade. I don't include Marina Abramović and Braco Dimitrijević in this group because they have long been working abroad, but they are certainly constants that put Yugoslav art (if they still belong to it) in the shortlist among the currents of contemporary international artistic events and the appropriate evaluative criteria.

How much influence have big world events like the Venice Biennale and the Kassel Documenta had on events in our country?

The absence of Yugoslav artists from major international events like the Documenta in Kassel or the exhibition in the central pavilion of the Venice Biennale increasingly led to these events becoming for them mere distant affairs that they are informed about by a few reporters. And yet these events are there mainly to be taken part in, not to be followed from outside, so that what has been achieved there can be absorbed and subsequently transferred. The reverberation of such an event, which at that moment could have had certain consequences in the way of instigating artist events in our milieu at the beginning of the century, is shown by the exhibition *Aperto 80* that was part of the Venice Biennale in 1980. After that, the situation became more complex, the process of artistic production was stepped up, and it was increasingly difficult to follow given direct sources of influence. It is essential, naturally, that these influences are not direct; there are certain (common to all artists) feelings and understandings of the moment of the epoch, built into the highest possible independent and individual artistic expressions.

How do you see the phenomenon of anachronism, of "cultivated painting" and citationality in our conditions? Would you agree that as against the organization and the vociferous appearance of the New Image there was no equally intrusive and strong anachronism as movement and intellectual formation, or at least, the anachronists were not equally as influential.

Anachronism, or the painting of memory, *Pittura Colta*, the *Nuova Maniera*, and so on are very distinctly Italian phenomena, and so similar things in other cultural settings, and so in this country, would be simply impossible, at the given moment, and in the original sense. You have to

have behind you a strong tradition of historical Mannerism, Giorgio de Chirico, the Novecento, for certain artists with full conviction and knowledge of the whole symbolic and linguistic organisation to be able to embark on work like that of the cultivated painters. Of course, there are exceptions (like Garust, but is he a real anachronist?). However, it is hard to speak of anachronism outside Italy. This is the real border of this artistic ideology: it is, after all, a local occurrence and with the exception of some individual cases (primarily of Mariani) there is no suggestion that it is going to keep its place in the value shortlist of the art of the eighties. In our conditions, more than echoes of anachronism, it is useful to think about individual cases like Vaništa; after the very experimental Gorgona phase, what does the concentration of this artist on motif, on perfect drawing, the conscious recollection of certain artists of the past actually mean? It is a complex example, but it is clear that it has its own reason for coming into being and is in no way an echo of the reception of some recent "style."

What do you think about the end of the eighties, the end of the century? Do you see some new phenomena on the horizon, are the intellectual phenomena of the seventies appearing again, close to conceptualist practice? What do you think about the geometrical tendencies?

As early as from the middle of the decade it has been clear that the artistic trends or orientations it started with have been lost; that is one of the conclusions of the exhibition *Art—Criticism in the Eighties*, held in Sarajevo in 1986. It can really be said of the contemporary, momentary situation on the art scene getting on for the end of the decade that it is pluralistic, but what does this largely worn-out term imply, what does it actually mean? Perhaps, on the scene today, individuals of several generations are present, as discussed earlier. But in recent times there have been the phenomena of the groupings of young painters according to similarities in their orientations, for example, those who refer to the work of Informel or Lyrical Abstraction; they were presented by the exhibition *Controlled Gesture* in Rijeka's Museum of Modern Art. The appearance of the new geometrical artists in Zagreb has been expected and is completely natural, and it is characteristic that they are being headed by certain leading artists of the early eighties, like Edita Schubert, Nina Ivančić, Sokić. I am afraid I haven't had the chance to see the works of the new generations of geometrical artists (Alivojević, Babić, Ivana Keser) but since they are going to be featured in a series of solo shows in the Nova Gallery, it can be assumed that soon it is precisely they that will characterise the art scene of their milieu. The revival of Conceptual

Ješa Denegri

Art is not happening in the same procedures as in the heroic time of its first appearance, but the mental approaches are involved in procedures that lead to the final stage of the material artistic object. And without the presence of that mental component it is actually impossible today to conceive of a vital work of art. And so one can say that the whole of current art that is worth paying attention to is in its very nature self-reflexive, self-referential, in other words, in its way also essentially conceptual. All these events are a characteristic of late artistic and cultural periods (end-of-decade, fin-de-siècle), which have mostly been devoid of the identity of any kind of "strong style," as against which there is an ultimate dispersal, dissemination of positions, in terms of problems and individuals, that are fundamentally equal (which does not a priori mean in value terms).

Shall we soon have a new turnaround, the beginnings of which we are now sensing, some people, for example, saw them at the recent Aperto exhibition, among the young artists who exhibited in the Venice Biennale last year?

Naturally, it is dangerous in the area of contemporary art to predict things with any certainty, but on the basis of the current situation, that of today, it would be difficult to expect any turnarounds like those that occurred at the end of the sixties and in the early seventies, and even at the beginning of the eighties. I would say that *Aperto 88* at the last Venice Biennale rather represented the continuation of a certain climate than any major change; it did, indeed, put forward a number of young and new artists, lesser known, completely unknown, but mainly along the lines of the work of previous years. A similar conclusion would be suggested by the exhibition *Young Art from the Federal Republic of Germany*, opened in mid-March in the Museum of Contemporary Art in Belgrade. I would thus look for help in the statement of the commissioner of this exhibition, Ulrich Krempel, who said about the situation on the youthful art scene in his own milieu: "Less than ever before is there any firm commitment to any style and manner of work, but possible more than ever before are parallel personal styles and personal strategies of the most diverse arts. In this breakthrough of the young, various models and predecessors are still alive."

Chronopolitical Intervention: Mark Sinker

Ana Teixeira Pinto

As far as I know, the term Afrofuturism first emerged during an interview with Samuel Delany, Greg Tate, and Tricia Rose, published in the *South Atlantic Quarterly* in 1993. But the previous year Mark Sinker had already described the specificity of Black science fiction in his article "Loving the Alien In Advance Of The Landing," published in the British experimental music magazine *The Wire* in February 1992. In contradistinction to white eschatology, "the central fact in Black Science Fiction," Sinker argued, "is an acknowledgement that Apocalypse already happened." Alien abduction—abduction by inhuman beings possessing superior technology—is a cipher for the plight of those who survived the transatlantic voyage in the hulls of slave ships to be sold to plantations, mines, or the construction industry. The slave ships "landed long ago," Sinker writes, and "already laid waste to whole societies, abducted and genetically altered swathes of citizenry, imposed without surcease their values." Within the whirlwind the triangular trade unleashed, "Africa and America—and so by extension Europe and Asia—are already in their various ways Alien Nation."

Science fiction became the central literary vehicle for the articulation of Afrofuturism because, as Kodwo Eshun—a crucial author in Afrofuturism's theorization—argues, the very conventions of the genre focus on the experience of alienation and displacement; on being at odds with the social order. Sun Ra, the experimental composer who is credited as the father of Afrofuturism, said he came from Saturn. For Eshun, the experience of the enslaved, as the subject forced to

partake in the condition of the object, bankrupts the notion of "humanity"; modernity, rather than enabling a civilizing project, instituted a decivilizing void. Authors like Samuel Delany or Octavia Butler write about the worlds that emerge from the dehumanizing motions of the Atlantic trade and what Sinker describes as the "modalities of identity without hope of resolution" it engenders.

In her performance lecture "Afrogalactica: A Brief History of the Future," The Franco-Canadian artist Kapwani Kiwanga examines an enigmatic scene in *Space is the Place*, the 1972 science-fiction film written by Sun Ra. Over a game of cards he plays against a character called the Overseer, Sun Ra wagers the future of the Black race. Kiwanga points to the symbolic confrontation between two incommensurable worldviews: Whereas for the pimp-like character salvation can only be attained via inclusion in the marketplace (hence urging Black folk to rise from their community rather than with it), Sun Ra aims to resettle Black life on another planet. The flying saucer, in Kiwanga's view, is the space-age iteration of a recurring motif in the Afro-American imaginary, the "celestial chariot," which can be traced to the spiritual written by Wallis Willis circa 1862, "Swing Low, Sweet Chariot," describing an angel-sent ship "coming for to carry me home." Here, the theme of fugitivity acquires a twofold dimension, conjuring both the Underground Railroad (a secret network of havens to help slaves escape from the South) and the transcendental realm of sonic sanctuary, a soundscape able to comfort and assuage fear and hurt.

A recent preoccupation with the future, or lack thereof, has given rise to many claims the future was stolen, stalled, or otherwise evacuated—and hence must be reclaimed. Apocalyptic projects tend to dramatize the epic dimension of salvation and dismiss survival. But the opposite of annihilation is not salvation. It is endurance, the myriad ways in which people somehow make it—a form of resilience without redemption, constituting and reconstituting the terms of an orphaned collective life, burdened by centuries of persecution. Instead of putting forth an image of the future as blank canvas upon which alternate visions can be projected, or burning the old in order to birth the new, Afrofuturism is a chronopolitical intervention that seeks to rearticulate the relation of time to the racialized Black subject. Arguably the most important aesthetic movement of the postwar period, the term Afrofuturism is something of a misnomer, which forces the genre into a kinship with Italian Futurism, and by extension fascism. As Sinker recounts, Sun Ra, dressed as an Egyptian deity, recounts his cosmic encounters, but then "because he is Le Son'y Ra, and not as other corny tale-spinners … tells how he turned down the offer of Messiahship."

Loving the Alien in Advance of the Landing

Mark Sinker

from *Wire*, February 1992

"In the meantime," he said, speaking relentlessly but mesmerically softly, as gurus will, "I finally went to Chicago. I determined not to be a musician—and the next thing you know, I had these space experiences."

"The first experience, I wrote it down. Very graphically: it's impressed on my mind. I did go out to space through what I thought was a giant spotlight shining on me. I was told that they wanted me to go somewhere, that I had the type of mind that could do something to help the planet. I was going out, but it was a very dangerous journey—I had to have a procedure and a discipline, I had to go up there like that"—and the old man holds his arms out in front of him, like a zombie or a mummy—"in order to prevent any part of my body from touching the outside, because I was going through time-zones, and if any part of my body touched the outside I couldn't get it back."

Softly, till you have the habit of compulsive silence and listening attention yourself, Sun Ra mumbles on: "So this spotlight—it seemed like a spotlight, but now I called it the energy car—it shined down on me, and my body was changed into beams of light. Now you see, when a spotlight shines, you can see little specks of dust. It gave that appearance, it could see through myself, and I went up at terrific speed to another dimension, another planet."

All across middle America, cheerful, hopeful nutball folkart celebrates the coming invasion; the unearthly saucermen who'll save the world's bacon: plastic, chrome and concrete rocket-sculptures dot the landscape, dwarfing trailerparks and diners countrywide. If it isn't speaking with Jesus or sighting Elvis, it's men from Mars, and every week since the Atom Age began, someone else has come forward who's been kidnapped and trained in ways and means and returned to save the Earth.

"So then they called my name, and I realised I was alone, a long way from here, and I don't know what they wanted of me—and I stayed up in the dark. And they called my name again, but I refused to answer. And all at once they teleported me down to where they were. In one split second I was up there; next I was down here. So they got that power. Then they talked to me, they had antennas, and they had red eyes that glow like

that. And they wanted me to be one of them, and I said no, it's natural for you to be like that, but it might hurt me if you gave me some. Anyway, they talked to me about this planet, and the way it was headed and what was going to happen to teenagers, and governments, and people. They said they wanted me to talk to them. And I said I wasn't interested."

That's the difference. It hardly matters whether the story's true or figurative, hallucination or bad neural wiring, that's the point where the Jazzman breaks away from the standard riff and makes up his own melody. Here, in his front room, all cluttered up with disciples' pictures of himself as Egyptian deity, as cosmic explorer, as mystic messenger, he tells the ordinary story of an ordinary abduction by aliens and then— because he is Le Son'y Ra, and not as other corny tale-spinners—he tells how he turned down the offer of Messiahship.

The Hour of Chaos

"What are the roots that clutch, what branches grow/Out of this stony rubbish?" Eliot's Wasteland was cultural, a blasted reach of dead fragments (the narrative borrows its drive—and key items of its imagery— from Bram Stoker's Dracula). "Your home is my home/Welcome To The Terrordome!" Public Enemy's Wasteland seems very real and very present: whole blocks burned in the black ghettos in the 60s, and in many the rubble's still there, the dominant feature in the crack hammered badlands.

But 'Welcome To The Terrordome', Chuck D's hurtling, desperate masterpiece, while it masquerades as one more PoMo collage of Pop-Cultural bits and pieces (James Brown slammed into *The Price Is Right*), in fact has its own utterly present momentum. Its portrait of urban life—as combined videogame warzone and unlicensed gameshow-without-letup ("Come on down! Get down!")—owes much to comic book science fiction, sure. HipHop is in the grand syncretic tradition of bebop, not ashamed to acknowledge that technological means and initial building material are always simply what falls to hand: but that meaning is nonetheless a matter of energetic and visionary redeployment, not who first owned or made this or that fragment.

The triumph of black American culture is that, forcibly stripped by the Middle Passage and Slavery Days of any direct connection with African mother culture, it has nonetheless survived; by syncretism, by bricolage, by a day-to-day programme of appropriation and adaptation as resourcefully broad-minded as any in history. But still, the humane tradition— of warmth, community hope and aspiration—central to the gospel roots soul of the southern black tradition is, if treated as the principle

that underlies all, a way of hiding from these facts in plain sight: that this tradition is no more uniquely "African" than the Nation of Islam is "Islamic", that this culture is still—in its constituent parts—very much a patchwork borrowing; necessary of course for physical and psychic survival, but not an unarguable continuity.

The advantage of Science Fiction as a point of cultural departure is that it allows for a series of worst-case futures—of hells-on-Earth and being in them—which are woven into every kind of everyday present reality (on a purely technical level, value in SF is measured against the fictional creation of other worlds, or people, believable no matter how different). The central fact in Black Science Fiction—self-consciously so named or not—is an acknowledgement that Apocalypse already happened: that (in PE's phrase) Armageddon been in effect. Black SF writers—Samuel Delany, Octavia Butler—write about worlds after catastrophic disaster; about the modalities of identity without hope of resolution, where race and nation and neighbourhood and family are none of them enough to obviate betrayal ("Every brother ain't a brother cause a colour/Just as well could be undercover" raps Chuck D in 'Terrordome').

In its Golden Age, white science fiction promised itself—*The Shape Of Things To Come*—a world without war, hurt or hunger (also, tactless enough, without black folks). In its paranoid phase—*Invasion Of The Body Snatchers*—the political hysteria (being swamped by Red or Yellow perils) is endlessly animated by an unease only memorably articulated by PE two years back: *Fear Of A Black Planet*. In its present form—Cyberpunk—white SF, or anyway its radical leading edge, is arguing that the planet, already turned Black, must embrace rather than resist this: that back-to-nature pastoralism is intrinsically reactionary, that only ways of technological interaction inherited from the jazz and now the rap avant garde can reintegrate humanity with the runaway machine age.

Cyberjunky Spiritworld

The image of black music which the first and most influential hipster-translators—the Beats—gave us (black musicians as long on passionate suffering, unmarred by intellectualism) leaves little room for any of Science Fiction's concerns. This same idea sells the cutting edge of today's black music short indeed.

One observer, though, dispensed with the "Noble Savage" of Kerouac's or Mailer's beatnik sentimentality: William Burroughs' future-present nightmares—lurid with violence, weird sex, streetpunk survival strategies and intensely technologised underworld economies, where meaningless additions are fostered by cynically amoral authorities—may not, for

Sun-Ra performing in the seventies

the longest time, have chimed with the best hopes and intentions of the bebop revolutionaries. In retrospect it seems not only horribly, sardonically prescient ('Welcome To The Terrordome'), but very much in keeping with the bitter, most self-destructive edge of bop's alien tongues.

Such brazen and courageous celebration of doomed difference is the flipside of assimilation, of being all that you weren't expected to be. Monsters from a nation's Id suddenly and justly demanding equal time as thinking and dreaming and sexual citizens. Hot, weird, different and better: the thrill and the threat of these Beings from Another Place wasn't that they'd be utterly unlike and intolerably horrible, but they'd be like us, only more so.

Cyberpunk's other acknowledged forebears—Delany and Philip Dick—constantly ask the question Slavery first posed: what does it mean to be human? Incapable of sentimentality, Burroughs provides a terrible answer: it means addiction. Because Junkies have needs only this utterly debased and evil system can provide, Separatism can never be an option. But the only way "up" is pull everyone else "down": "My home is your home".

Which of course may not tell you everything about such restlessly question black SF visionaries as Coltrane or Braxton (or Miles or Wayne

Shorter), but it tells you more than the already far-too-comfortable Great Soul myth (where it only you the listener could crack the expressive code, you'd be transported to planes of higher something or other). If flight is one part of their creative metaphor, then it's always flight from a social disaster that's keeping pace with them as they flee.

There is no rest in Coltrane's Interstellar Space—the Space Race is no more Boys Own fun for him than it was for his most important teacher, Ra (the man who weaned him off his addiction, or anyway rerouted it from chemistry to metaphysics). Think of that late late recording, the interminable and maddening 'Saturn', where inner and outer space fuse as he warp-drives to the core of the galaxy and the core of the soul: Coltrane is incomprehensible unless you see him as Ra's greatest pupil, terminally impatient with limits, with the trivial categories and opposites within Earthly language, and yet inhumanly patient with the fact that such things won't be transcended down here on this plane.

Others find it easier. Not all Black Science Fiction is so ironboned and bleak as Coltrane: Hendrix the utterly fluid spacepoet glided somewhere beyond black and white, masculine and feminine, noise and grace, while Earth Wind and Fire's 31st Century Egyptology at least pretends, in its silly hermetic way, to possible heavens here below.

We Are the Robots
In Miami, rap is strongly influenced by the closeness of Cuba and Jamaica; in Orange Country, young Vietnamese-American girls are forming gangs like the Dirty Punks, following an age-old tradition of new immigrants but expressing it in a form that Hollywood tells us is exclusively Black and Hispanic. Bill Adler—rap archivist, writer and publicist—has written that "HipHop's present-day cultural nationalists argue that so-called 'blackness' is as much a matter of cultural identification as it is of skin colour and that, by that measure, there are millions of suspiciously light-skinned young black teens roaming around right now, undetected and unsupervised." (David Toop, *The Rap Attack II*)

When Afrika Bambaataa dropped the melody from Kraftwerk's 'Trans Europe Express' into Soul Sonic Force's 'Planet Rock', he let loose something so big he could hardly keep up with it (none of the founders of what became HipHop have really continued to flourish: they had too completely transformed the world they knew how to move in). Kraftwerk, that is, who only half-ironically celebrate the excellence of robot-being (robot: from a Czech word meaning "worker"—or "slave"). Kraftwerk, whose cool cyborg glide could surely not be more European/Palladian. Techno, Detroit's 80s/90s black electrowave, explicitly and contemptuously

refused community with Motown and motorcity gospel from Gary "Me I Disconnect From You" Numan. And yet, as a wordless total immersion culture of beat-pleasure, where the warehouse party functions as purely temporary paradisiac freedom, beyond sexual rules or racial boundaries, Techno admits a yearning for these impossible SF futures.

HipHop and Techno between them—genres that focus on wharf-rat underclass individuals seizing on the most up-to-date technology, to combat some ever more monolithic, globally interlinked InfoTec state—are Cyberpunk come to life, by turns grindingly bleak (as chroniclers of the present) and deliriously optimistic (as harbingers of the future). Whereas music generally reaches for its emotional truths into the past, nonetheless it's invariably a species of jazz that functions as the trans-galactic common entertainment language to come. Think of the bar scene in *Star Wars*: and recall that Steve Coleman has cited this—or a dream-version of it—as a primary influence on the direction his music has to take.

The ships landed long ago: they already laid waste whole societies, abducted and genetically altered swathes of citizenry, imposed without surcease their values. Africa and America—and so by extension Europe and Asia—are already in their various ways Alien Nation. No return to normal is possible: what 'normal' is there to return to? Part of the story of black music (the affirmative, soul-gospel aspect) has always been this— that losing everything except basic dignity and decency is potentially a survivable disaster.

The other part—as told so obliquely by Ra, Coltrane, Braxton, Delany, Ishmael Reed, and doubtless many others less easily seen than this—is that staying true to the best in yourself may mean when everything can so cunningly imitate everything else, talking in dark, crazed, visionary tongues for a season.

A Drifting Mind:
Lynne Tillman

Isabel Mehl

Madame Realism is a fictional art critic created by United States-based writer Lynne Tillman in 1986. With her, Tillman explores and represents (female) critical subjectivity and its preconditions. Tillman also wrote and codirected the film *Committed* (with Sheila McLaughlin, 1980–84) that premiered at the Berlin International Film Festival in 1984. She has published three essay collections; several short story collections, and six novels, the most recent being *Men And Apparitions* (2018).

The bulk of Tillman's Madame Realism stories (seventeen in total) was originally published in *Art in America*, and all of them, apart from the one provided here (an accident, Tillman assures me), have been collected in *The Complete Madame Realism and Other Stories*, published in 2016 by Semiotexte and edited by writer and cultural critic Chris Kraus, as was its 1992 predecessor *The Madame Realism Complex*. The character Madame Realism is Tillman's vehicle to respond to art as a fiction writer and liberate herself from the expectations of traditional art criticism and its usual contexts—like the one in *Art in America*. While all of the stories take artworks or exhibitions as their starting points (e.g. Jeff Koons, Haim Steinbach, Silvia Kolbowski), the relevance of the specific artwork differs, and sometimes an artwork is not even mentioned. Madame Realism has a home "she could afford to leave and return to voluntarily." She drifts through New York but she also travels to Tangier, London, or Normandy. She feels hungry while looking at Renoir paintings—and at an opening at the New Museum, she cannot find an ashtray.

In "The Matisse Pages from Madame Realism's Diary," Madame Realism is reluctant to plan her trip to the Matisse show at the Museum of Modern Art. It is, especially, the show's framing—art by a "genius"—that annoys her. But, characteristic of Madame Realism's drifting, contradictory mind, she attends nevertheless. And for her visit, she far from accidentally chooses election day: Bill Clinton vs. George H. W. Bush vs. Ross Perot. In her first museum visit to a Renoir retrospective in Boston in 1986 she already underlines the relation between the institution of the museum and politics: "She knew, for instance, that in Boston the arts were led by the Brahmins, the Irish dominated its political machine, and the black population was fighting hard to be allowed anything at all. But in an institution, such as a great museum, where lines of people form democratically to look at art, such problems are the background upon which that art is hung."

Madame Realism is obsessed with context: of the exhibition, the artwork's, the artist's, and her own. She is in constant exchange with the outside world, with what she sees, with what others see, and thus becomes the stage for the moving contradictions we perceive in our everyday lives. Hence, the Madame Realism stories are better understood as cultural criticism because these texts frame art, as well as books, films, or TV series as communicative objects. Still, art is a specific object that one first experiences with one's eyes and then through the words that translate that experience. Tillman's choice of words, the way she builds a sentence, articulates and condenses the complexity of experiencing art and the world. Madame Realism doesn't offer answers, but she makes us question the way we understand and narrate the (our) world. Tillman employs Madame Realism to rethink the way in which one's perspective and blind spots are dependent upon one's situatedness. In this process, she questions both her own subjectivity and the one she encounters in the arts. As a reader, one begins to understand the way Matisse, by being positioned or by positioning himself as "master," subordinates others. The first lines of Tillman's "Madame Realism's Diary: The Matisse Pages" reflect the situation we found ourselves in in November 2020, hoping "thing," as Tillman calls the then-president of the United States, would be voted out of office.

Madame Realism's Diary:
The Matisse Pages

Lynne Tillman

from *Art in America*, Volume 81–5, May 1993

October 12 Staying home, not returning telephone calls, reading, watching TV; am somewhat edgy, anticipating terrible news. Election returns. All of NYC holding its collective breath. Am turning into myself or upon myself, or anyway inward, like hibernating bear, if bears do turn inward. But eager to go out at night, more like a vampire, current metaphorical rage, than a bear, which would be cumbersome. Reading the newspaper closely. Should arrange for ticket to Matisse show. Resent need to plan. Would like to stroll in and see it alone. Reminds me of the line in Preston Sturges's *The Palm Beach Story*, when train porter, who was tipped just ten cents by Claudette Colbert's companion, tells Joel McCrea that Colbert's "alone but she don't know she's alone." Don't want to go and yet would like to see it. Is it that Matisse's "genius," proclaimed throughout the land, along with precious attention to his wives and mistresses, his taste in food, drink and habitats, forces one to engage in a joke at one's own expense? Entry into show will be entry into joke, whose punchline is the trivialization of one's existence. Or is this only anticipatory anxiety, future fear of wounded narcissism? Which reminds me of a Dutch idiom, *Je bent de sigaar*, which means, literally, you are the cigar, but which means, idiomatically, you are the butt of the joke. Might write a book called *The Idiom*.

October 18 Dinner at Indian restaurant. Ordering dishes becomes more complicated when sharing food appears indicative of character, nebulous but damning. Conversation about whether one is or is not willing to visit Matisse show because of nauseating promo. Talk of Matisse and Madonna's *Sex*, encouraging inane puns about overexposure. Easier to buy *Sex* than have it, someone says. One artist announces he isn't going to Matisse, couldn't be bothered. I question if not going, because of crowds or cultural fetishization, is foolish; he demurs, explaining position more fully. I feel similarly, I tell him, but would not act on it, since it was a part of me I resisted and distrusted. Then repeat what my father used to intone when I was a child: "Si and Hi went to the circus. Si got hit with a rolling pin. Si said to Hi let's get even with the circus. We'll buy

two tickets and we won't go in." All looked at me strangely. What nursery rhymes did they learn, I wonder?

October 31 Halloween. Venture out even though once pledged never again, after having been hit with egg. Downtown filled with wanderers in garish makeup, though city silent as a communal grave; streets giant cemeteries with souls wandering about in the eerie quiet costumed as hatchet murderers, movie stars, animals. Our heathen carnival. Others standing near me pelted with eggs that rain down from above; I am unscathed. Small miracles abound. Evening amazing for the hush; characters dressed as TVs, other objects, but even masked no one seems dangerous. Most amazing of all, no one dressed as Matisse.

November 3 Raining. Election Day. Radio says rain is bad for the Democrats. Why? Statements like that annoying, precisely because one remembers them. Decide to do Matisse before or after voting. Lines will be long everywhere. Relatively small crowds at MoMA, I'm told by two guards who regard us all with a trying mixture of curiosity, revulsion, and boredom; those compelled to watch thousands of people every day must have a debased view of life. As I walk around imagine being incorporated into M's diary, the auto/biographical emphasized by chronological design/ order of installation. Crowd's comments: "He likes oranges." "He likes pots."

Matisse likes reading women, as well as undressed women, even partially undressed readers. But is "like" the right word? Fascination with women reading is a vast subject, not his but art's. Eyes averted, inaccessible, in another world, cerebral, unavailable, "givers of life" representing world/life before one was given life, perhaps. Funny to look at, really; thoughts about oblivion cluster mentally. Reference to 19th-century women being "given" literacy. Question: Is this image another woman (likeness) as masquerade? A study of self-consciousness or of self into consciousness? Will never mail postcard of a woman reading now without ambivalence.

What are goldfish, apart from the obvious-small orange penises. What is obviousness? What's simple/clear about M's having painted penises, if he did, in goldfish bowls, and elsewhere, over and over again? A friend tells me there's an essay about the goldfish whose point is, because M had red hair, goldfish are Matisse. Is that "le penis, c'est moi?" Hectic being in this goldfish bowl gazing at goldfish bowl gazing at goldfish and nudes. In thrall to M's lurid, hedonistic, frozen Moroccan moments, his plunge into cultural/sexual dubiousness, his pleasuring in foreign

exoticism. Domestic exoticism, the nudes in his studio, who became an abiding, enduring home away from the home (wife and children) he left behind in Paris after World War I.

M's "other" landscape, land as body, bodies of land, bodies to be landed on; Woman, not alone his vanishing point, though his Odalisques with their legs spread wide proclaim absence makes the art. Can't help punning. Actually am a pun, which most don't get. You don't understand me/the married man's joke. M was married: remember that, I tell myself, as I look at *Conversation*. Man stands on one side, woman on the other, a relationship on two planes separated by a window. G. K. Chesterton: "For views I look out the window. My opinions I keep to myself."

Lusty old M, filled with blood lust and sucking on blood oranges. Oranges and orange goldfish. Matisse paints himself seated, immobile before the sensual life he sets down on canvas. The delicious meal he serves up for himself, memorializes; he lets nothing come in his way, the objects he wants in front of him he places there, the world at the foot of his easel, the palette, his plate. M a pleasure seeker. His paintings beautiful, pleasurable. Their object, no doubt, pleasure. He wants "purity, serenity," but pleasure is not, as love is not, "pure," always messy, an admixture. How does one know pleasure? Pleasure seeks an object. Everything has an object; everything is an object. Sometimes an abject object, which is, it seems to me, the more I think about the Moroccan paintings, an appropriate idea. But what are the ideas one has when thinking about M's work? Is pleasure an idea when looking at a painting?

Two Italian men stand near, murmuring in that wonderful tongue, gazing with me at *Anemones in An Earthenware Vase* (1924). Italians walk away. Wearing red bandannas, like Matisse's Gypsies, and Levi's 501s. Jean jackets read: "Live the Legend."

Disdain M's dancers, dance to represent Life, Dance of Life. Uncomplicated overexuberance. Degas's dancers, at least, sometimes narcissistic, distracted bored. M's dancers like bad art, tired metaphors. Remind me of movies that try to be artful, so incorporate "art," have it on walls or include dialogue about art, especially set in a gallery. Matisse seats himself before the dance of life. One painting teacher I studied with said never sit while painting because it was lazy and you were at work.

On line to bathroom someone says, I think—or did I read it or dream it?—"M's trying to find the essence under the modernist illusion." Essence is modernist illusion.

An older man with beard keeps turning up in front of me. His head bent low, he cranes his neck to see the work on the walls, then hurries

Installation view, *Henri Matisse: A Retrospective*, Museum of Modern Art New York, 1992–93

A Drifting Mind

on, and reappears, bent down, worried, harried, deeply depressed. Seems to be an artist struck dumb by the Master. Taking to heart the greatness, the genius, of Matisse.

Am moving ahead of the crowd as much as possible and occasionally have chance to stand in front of a picture alone, but just for a brief moment. All of us here, trying to get a look at these paintings, even for a second and in some discomfort, brings to mind strongly the genius business, which keeps crossing me up. Why? Because finally I am looking at the work through that frame more than at/through anything else. So it's already seen, observed, served up and serving. What does it serve, ideologically, esthetically, economically, etc., to foster the myth of genius? Easier to understand it ideologically than, say, psychologically, except as cultural version of master/slave condition.

Think later and more about this exhibition in relation to Russian Constructivist show at Guggenheim, its emphasis on the many developing a collective visual language. One looks at or views (how is viewing different from looking? less invested, disinterested, disinvented?) that work differently, I think, because of context, which provokes/produces different thoughts from Matisse show. With its biographical trajectory can't stop being aware of Matisse the man, and am not interested in him.

Took longer to vote than to go through exhibition. Meet a friend on line. Discuss election and Matisse. Talk about pleasure and Matisse, to indulge one's pleasures, which pleasures at what time, and the hope for the man from Hope—to have more citizen pleasure.

Drink coffee while waiting. Hot coffee a pleasure. Some pleasures one has no guilt about. What makes it pleasurable, if/when it is, to look at art? Economic explanation not sufficient. Clinton wins; but Perot does pretty well, since it pays to advertise, for one thing, and he is such a cute, paranoid critter. More people vote this year than in the past 24, but still not many more than half the eligible. Commentators keep saying it's the end of cynicism, which bothers me as much as emphasis on male genius. Is doubt unhealthy? Is the American myth/dream of change and hope like the myth of genius? Serving different or same ends? Still, an avowed skeptic is not thrown off course so easily.

Criteria Against All Odds: Stefan Germer

Peter Geimer

The following text by the art historian and critic Stefan Germer (1958–98) outlines the author's art-critical benchmarks while also formulating a number of basic reflections on the role and function of art criticism. This is already conveyed in the title "How Do I Find My Way Out of This Labyrinth? On the Necessity and Impossibility of Criteria for Judging Contemporary Art." The paradoxical formulation is a reminder that no art criticism worthy of the name can dispense with firm criteria; and that conversely, the establishment of general, authoritative benchmarks or aesthetic norms has become problematic, even "impossible." By the nineties no one would still dare claim, as figures like Clement Greenberg had, that their own judgment held absolute validity. At the outset, moreover, Germer offers a reminder of the unavoidable narrowness of a single individual's position: "If critique is to have a function, it must dispense with the fiction that it is independent and unbiased and instead recognize that it assists in a cultural system over which it holds no control; a system which in fact holds control over it."

For Germer, this would be the end of the master narratives of modernity and, at the same time, also the end of the possibility of making normative justifications for artistic judgments. As soon as belief in any teleological development process in art had been extinguished, there were no longer any binding norms in whose name it would have been possible to say which direction art must move in next. The nub of the text is, however, not this diagnosis: it is rather the defiant "but still" that the author

immediately counters it with. That critique "assists in a cultural system" does not ultimately rob it of the ability to continue to make statements on good or bad art. And thus at the end of this text, which begins with a rejection of binding norms, criteria are in fact once again to be found"—a few of the notions that guide me in judging contemporary production."

Twenty years after they were written, some of these criteria appear to be showing their age. The demand for constant "self-reflexivity" in art, for example, has in the interim become an art-historical seal of quality, a discursive trump card, universally deployable without any need for the critic to justify their own rationale. This is not an objection to the need, as formulated by Germer, for criteria. On the contrary, referring to the weakening of formerly key criteria confirms Germer's argument that art criticism's benchmarks have no supratemporal validity. A further entry from Germer's catalog of criteria: "Against continuation of the self-evident." This does not aim only at a constant reorientation within current art production, it also targets a continual questioning of the significance and function of art in general. "History and the present teach us that the production of art is a profoundly suspect and obscure matter," he writes. "Any production that relies on the mere existence of the institution of 'art' or builds itself on the fact that there is a tradition that can be seamlessly continued, is threatened sooner or later with becoming irrelevant ... artistic production must each time be justified again from the beginning." In the implacability and severity of its style, this is perhaps formulated a little too normatively. There is ultimately no art-historical catechism that must be worked through in relentless self-questioning in order to rightfully be permitted to produce an artwork. But the fundamentality with which the question of art's significance and function is posed here is a better aid than a hackneyed appreciation of art or the ritualized rhetoric of an art that is inherently already critical or oppositional. Art criticism would then not be the critique of individual works; it would instead and concurrently also be the critique of art as a historic institution. It is no coincidence that the first sentence of Theodor W. Adorno's *Aesthetic Theory* echoes in Germer's self-description: "It is self-evident that nothing concerning art is self-evident anymore, not its inner life, not its relation to the world, not even its right to exist."

How Do I Find My Way Out of This Labyrinth? On the Necessity and Impossibility of Criteria for Judging Contemporary Art

Stefan Germer

excerpted, from a lecture delivered at *the Regeln der Kunst—
Criteria of Contemporary Art* symposium held in Prague, 1994

I. From the Norm to Longing for the Norm

It's a familiar thing. When two people converse about art, a third will lament how confusing it all has become, a fourth will groan that there are no longer any authoritative criteria, a fifth will even opine that we have arrived at an era of complete arbitrariness.

Each person would in fact be correct in their own way. Those writing about contemporary art proceed into a paradoxical situation. On the one hand, they have of course long known there is no longer any criterion that can be justified without further ado. And yet each person, in the moment they wish to write about art, must pretend to have at hand criteria whose legitimacy and universal applicability are beyond question.... Criticism's denial of its own limitations has worked effectively for a long time. This denial has allowed criticism to suppress both awareness of its own weaknesses and the dark premonition that each judgment is built on sand. This gave a feeling of omnipotence to the critic, whom we can thank for the master narratives that were able to narrate the history of modern art as if in a single breath:

> ... as a logical course of development that began in the nineteenth century and led, via the classical avant-gardes, into the present. There is no doubt as to the normative character of these narratives. Their founders were downright imbued with an awareness of the necessity to judge, praise, and denounce.

Critique was their key means of decreeing order. For the era of critique was never an empty, chronological one: it was rather an era of directed, teleological advancement. It was only the fact that it had been furnished with an index that reliably pointed toward the future that made of time a category that could be used to structure the artistic field. This directed, teleological time of critique permitted the compartmentalization of artistic production's confusing multiplicity. Within that which emerged simultaneously, it was suddenly possible to split the contemporary from the anachronistic.

The time of critique was imperial and spatially immersive, or better said, a time that destroyed space. For the imperative to set all the world's clocks to the same time—in other words to orient around what was being produced (and how) in Paris and later in New York or one of the other art-world metropoles—led to other locations becoming provincial or peripheral. This means: becoming places where the contemporary either only arrived late or—even worse!—not at all, such that they existed outside the global temporal order, but thus also beyond critical perception.

Time's homogenization reduced the space that had to be perceived. This gave critical judgment stability and—given that local differences were at most regarded as delays—worldwide applicability. This was very convenient for the critic. From that point on, observing a small selection of artistic production was sufficient for making globally valid judgments. Everything that did not correspond to the standards of the metropoles could be discarded as noncontemporary.

From this narrowing of perspective, the critical judgment won an incomparable authority. According to what we read in the heroic narratives of the modern, nothing was able to hold avant-garde critique back. It was, at least in its own mind, always on the right side of history: its prophecies inevitably became reality, and it seemed to by necessity win its case even in the face of any temporary adversities.

With these doubts about the master narratives of modernity, the relationship between time and space shifted. More precisely: space returned as a distinct dimension of contemplating art. In place of modernity's homogenized time, which minimized or obliterated local differences, there emerged a fragmentation of space led by the conviction that artistic creation in the former provinces could no longer be described within the categories of the metropoles and must instead be understood in terms of its own internal laws. This rediscovery and fragmentation of space is still ongoing. Over the coming years, I believe this will be among the key problems in our discussions on contemporary art.

The fragmentation of space caught hold of the metropoles and the former provinces in equal measure. With this, however, artistic production from countries long completely disappeared from art criticism's perceptions also came back into view. Artistic production would now (and continues to) be described via categories of difference and heterogeneity, rather than in terms of identity, universality, and homogeneity. These developments have changed both our view of the West and our notions of what transpires in the East. And they have moreover made us aware (if initially only in a rudimentary and superficial way) that our art-critical practice moves, now as ever, in the Northern Hemisphere:

Stefan Germer

... and thus that within the cultural realm, it reproduces relations of power and subordination between North and South, excluding large parts of the Trikont (Africa, Asia, and Latin America) from our considerations.

This means that fragmentation of space and collapse of the global temporal order have led to a change in perception. The expanded field of view this induced did not play out uniformly, however: it has a hierarchical character. Even despite all differentiation, the order of precedence is still West, East, South. At issue here is of course neither art, nor geography, but rather economic and political power: it is no coincidence that the hierarchization of perception corresponds to the relations of subordination that prevailed between the countries of the capitalist West, the countries formerly belonging to the Eastern Bloc, and lastly the states of Latin America, Africa, and Asia. In short, our perception of artistic production is hierarchized, and the hierarchies are determined by non-artistic factors. These relations of subordination must be kept in mind when speaking about fragmentation of space, as they determine the frontiers drawn by a strategy that relies on creating value from local differences.

This kind of strategy ultimately was the very first to create visibility for a range of artistic practices that had been developed beyond the metropoles. Decoupling from the temporal order of the metropoles was a prerequisite for the emergence and visibility of dissident approaches. It is characteristic of these practices that they see delay vis-à-vis production in the metropoles not as a disadvantage and rather as an opportunity to establish reflexive distance from metropolitan categories and criteria. This means they do not allow themselves to be drawn into in a race for novelty, innovation, or originality, as they know they would be bound by necessity to lose it. They also do not claim, however, that their own production has come to a standstill at a premodern level of innocence, that it is thus "primitive, but for that reason sincere and direct." They thus feed neither on the glorification of the foreign nor on the absolutization of the domestic.

They in fact exploit precisely this cultural difference between the two. They find their images, themes, and preoccupations in their own world of experience—in spheres previously either regarded as provincial or not perceived at all. These themes, artistic subjects, and obsessions are however addressed via devices of quote, irony, and allegory, and thus with approaches like those customary in the concurrent production of the metropoles....

Even if the number of differences and the diversity of local productions will certainly increase more strongly over the coming years, only a very small part of it will enjoy international reception and be able to be absorbed by the international art system. The reasons for this are obvious. Unlike the homogenized temporal order of the avant-garde, in which one criterion applied to all, the fragmented space of the postmodern demands that critics make themselves familiar, in each case, with the specific circumstances of the emergence of an artistic approach. Such a detailed differentiation of knowledge is best performed point by point; it is inconceivable on a global scale. The fragmentation of the artistic space will therefore necessarily be completed via a second movement: the reduction of complexity.

This term refers to a basic requirement in the organization of knowledge. No one can be familiar with the entire multiplicity of the forms of artistic production scattered across fragmented space. Regarding these approaches, it is still less possible for anyone to have an overview of the entire field, the history, or even the points of relation. This however closes off any possibility of understanding local art creation based on its own contingencies or of describing it in suitable categories. It would instead be necessary to simplify and to coarsen. This, however, would mean that no one would be allowed to begin with heterogeneous art production and would instead have to develop a schema—based on their own ideas, preconceptions, and needs—that can be thrown on top of this production. One of these attempts, as we saw during the eighties (and which is now repeating), was the coding of production into national categories.

The reference here was less to the specific circumstances of production or the local history and much rather to the existing international stereotype of any particular country. This path can evidently only be taken where there is a real possibility of putting international stereotypes to use. A series of German artists, Anselm Kiefer foremost among them, has successfully profited from a mixture of fascist politics, billowing mythos, and a Wagnerian craving—seen in many countries as a sign of a particularly German mentality—for grandiosity.

Schemes such as national codification of art production may be operable, but they ultimately remain arbitrary. In the fragmented space of postmodernity, criteria must remain discretionary. There is no norm, only a longing for the norm. There is no unambiguity, only a striving for unambiguity. It will not be possible to handle this situation discursively—this is to say, via the means of critical argument. Norms for the sphere of art production will in the future—per my thesis—be neither qualitatively determined nor able to claim absolute validity. If at all, they

Stefan Germer

will be decided not by reason and instead by institutional decree: i.e., by museums, art institutions, and exhibitions taking on, exhibiting, and thus sanctioning particular modes of artistic production.

The institutions feed on the desire for the norm. It gives them authority and raison d'être. Museum directors, exhibition organizers, or heads of collections may be able to justify their norms with just as little totality as critics, but this takes nothing away from their authority, as they are able to decree these norms in practice. They thus fulfill a task that critique is no longer able to (or that it can only fulfill to a very limited extent). Those that exhibit, collect, or buy perform an act of sanctioning that is stronger than any theoretical justification. They thereby profit from the normative power of the actual. This power lends evidence to their choices. When curators order, select, and assign authority, they produce within the artistic field the exact same clarity that the public hopes in vain to receive from critique. And they also have power to define—a power that the critics will sooner or later be forced to comply with.

This is of course not absolutely true of every institution. The power to decree artistic standards is unevenly distributed and exhibits obvious asymmetries. Whether an artistic subject's position can assert itself, and at what level—local, national, or global—relates only in highly conditional circumstances to how interesting or relevant that position is. It relates much more to where the position emerges and to the status of the institution working to assert that position. There is nothing conspiratorial about this kind of institutional sanctioning: no single gallerist, museum director, or head of an art institute is single handedly able to create a trend. Each of them depends on ratification of their selections by other institutions. The art world generates a system of reciprocal dependencies that defines the frontiers of a field of the relevant—i.e., that which is at any point in time exhibitable, discussable, etc.—and compels all participants to contain themselves to this field.

II. The Critic in the Art System

Why am I discussing this? Primarily to clarify to you that this notion of an independent, critical judgment is a fiction. Critics move within a system that monitors their movements and, to a certain degree, preordains them. It is not that we do not keep encountering artists whose work strikes us as being relevant and important; it is not that we are not being constantly confronted with forms of work that excite, confuse, or infuriate us. It is not that there are no discoveries to be made. We are living through one of the most confusing yet for that same reason most exciting moments in the history of art.

Criteria Against All Odds 297

But for all the excitement about the possibilities of this moment, it cannot be forgotten that in this of all situations, the critic's view and judgment remain limited. I have already tried to sketch out why this is the case. Critical judgment has, since the demise of the master narratives of modernity, lost its legitimating foundation and must labor to find its bearings within the fragmented space of postmodernity. And the institutional decrees have long since replaced the critics as the determiners of weight within the artistic field. Of their own accord, critics can no longer enforce their own will. They are increasingly more dependent on cultural validation systems that precede critics' gaze and that draw attention to themes, people, or approaches long before the critic appears on the scene. The seeing person has always already been seen by the cultural system. What subjectively seems to this person to be a discovery is often only the consummation of already-existing cultural validations.

What conclusions should a critic draw from this situation? I feel that like artists, critics must free themselves from the mythos of subjectivity that surrounds so many decisions in the sphere of art and which in fact is, as we know, a battered heirloom from the nineteenth century. If critique is to have a function, it must dispense with the fiction that it is independent and unbiased and instead recognize that it assists in a cultural system over which it holds no control; a system which in fact holds control over it.

III. From the Belly of the Whale: Some Observations

I am now ensnared in a trap. Everyone knows, of course, that I—even if I doubt the universal applicability of rules and declare that institutional sanctioning has taken the place of critical judgment—deal with art all the time. That I must—in face of all doubts—form a judgment. And thus employ yardsticks and criteria as a matter of necessity. In light of these limitations, I therefore wish to cease sidestepping and to describe to you a few of the notions that guide me in judging contemporary production. You will immediately recognize how these benchmarks were developed from my general evaluation of the situation in artistic production and critical discourse.

First: against continuation of the self-evident. History and the present teach us that art production is a profoundly suspect and obscure matter. Any production that relies on the mere existence of the institution of "art," or builds itself on the fact that there is a tradition that can be seamlessly continued, is threatened sooner or later with becoming irrelevant. If there is any tradition at all, it is that no tradition can be

Stefan Germer

continued unbroken. On the contrary: artistic production must each time be justified again from the beginning. This applies both to the fact that art is produced and to the choice of subjects, methods, and media. The old avant-garde ideology—which legitimates itself based on the mere fact of having created something new—has here long since ceased to be effective, for the new had already lost its value as legitimation of artistic creation at the moment the master narrative of modernity, which imagined the history of art as one of endless progress, broke apart.

Artistic creation can today be legitimated not based on novelty and instead only based on the thinking-through of history, possibilities, and determining conditions. Consequently, I am interested in works that do not suppress the dubious and that instead face up to it, assimilate it into themselves, address it as a topic, or reflect on it in their approaches. This can happen in various ways. We could begin with the medium itself and pursue painting not as a continuation of painting and rather as the systematic interrogation of its devices.

The second option starts with the general operational contexts in which art is produced, mediated, and received. This then brings the gallery system, the museums, gallery visitors, and collectors into the limelight.

My second maxim is thus: the current is not always and not necessarily the contemporary. This maxim is the logical consequence of the master narrative of modernity breaking apart. Only for as long as the history of art was conceived teleologically—i.e., that it was assumed to tread a path that must by necessity be followed and that leads to a definite goal (be this abstraction, flatness, or "the final image")—would it make sense to think in terms of progress and innovation. As both these concepts of course gained their importance only from the future. They alluded not to empty progress and instead to a targeted movement toward a utopian end state. For many avant-gardists, this state was the end of art. Modernity, which dreamed of the "final images," the "assimilation of art into life" and so forth, desired its own death. This alignment with death explains the pathos with which modernity was able to speak about the future: death lent an absolute character to its temporal order.

We have lost this orientation toward the future, the end of days, and utopia. As such, time has become for us—if not an empty category—then perhaps a relative one.

This is to say that in place of running ahead of death, all that remains to us is a kind of bad eternity. Presently, then, memory seems more important than the tomorrow. Not in the sense of an antiquarian revivification of the past and rather in the sense of uncovering possibilities

contained within artistic subject positions but unrealized at the time of their creation or first presentation. A number of the most interesting works from contemporary production owe their existence to the memory of concepts first attempted and conceived in the sixties and seventies but whose virulence only becomes visible with a certain distance and under transformed conditions.

Third: a location is of itself not a long-term basis. Otherwise put, even if fragmented space will generate the conditions in which we perceive art, we should be wary of absolutizing the local. Art may emerge under a specific local condition, but it is not necessarily received under these specific conditions. This means that the more an artistic production becomes bound to the context of its origin and must be explained on that basis (or can only be understood on that basis), the smaller its impact will be. In the long term, then, the appeal—for example—to local, regional, or national identities is suicidal, for it limits the reach of an artistic production from the very start and, in the worst case, identifies with the external ascription of stereotypes.

Attempts at hybridization—that is to say, projects that do not assume the "own" and the "other" to be factual entities and instead understand them as changeable positions within a reciprocal engagement—seem to me more promising and artistically productive than such a mode of ethnic separatism. There are no fundamental rules for what such mediation between the foreign and the domestic might look like: by necessity, this is ceded to the specific conditions of production. As a rule of thumb, it can still be said that an artist must combine nearsightedness and long-sightedness. On the one hand, this means developing a sense for what is required in that artist's specific situation, rather than being content with simply adopting solutions found elsewhere.

But on the other, that artist must develop an awareness of the current international possibilities of the medium. For only at the cost of provincialization is it possible to circumvent the history of art. Consequently, the production that emerges from these specific local conditions must likewise be oriented towards the approaches and theoretical currents of the international art world. Perhaps you now understand why I apportion particular importance to memory: it is able to guide the artist toward approaches that are particularly suitable for a specific project.

Fourth: as institutions play an increasingly stronger role in defining what art is, art production must take its own subordinations into greater consideration. This can happen in various ways: either by making critique of institutions the actual topic of the artistic work, or by using strategies that cannot be recognized as art production at first glance and

Stefan Germer

that thus evade the definition-giving grasp of institutions or bring the categories and the schema into doubt.

A third and final opportunity lies in using artistic approaches and modes of presentation to address social issues.

Almost by necessity, the institutional categorization of a work as "art" is thereby brought into doubt, as it can be read both as an artistic intervention and as a political or academic contribution to formulating (or solving) a particular problem.

My four maxims are then, in summary: first, breaking with what is established as self-evident; second, relativizing the pressure to be contemporary and activating memory; third, combining context-specific approaches with an awareness of internationally attained standards; and fourth, recognizing and addressing the institutional subordinations in which art production occurs today. I can of course not say whether this idea can be transferred over to the circumstances in which you find yourselves. I am not even sure whether I would want such transferability. Art-critical attempts to set definitions cannot be separated from the assertion of power, for which reason I would probably prefer your dissent to your agreement.

Decentering:
Igor Zabel

Maja and
Reuben Fowkes

Slovenian art critic Igor Zabel began his career in the eighties. During the next decade he became one of the most prominent critical voices in the newly independent country and an influential protagonist of the global art world. Born in 1958, he studied comparative literature, art history, and philosophy at the University of Ljubljana and worked from 1986 as a curator at the city's Moderna Galerija. In contrast to Ješa Denegri (see page 266), who is predominantly known as a critic, Zabel left equal marks in the fields of art history, art theory, exhibition curating, and art criticism before his life was cut short in 2005 through complications following a tragic accident.

As a curator, Zabel focused on Slovenian postwar art history, producing the museum's major chronological trilogy of exhibitions of Slovenian art and organizing the first retrospective of the neo-avant-garde artist group OHO. In 2000, he was the coordinator of Manifesta 3, the first manifestation of the Pan-European biennial to take place in a former Communist country, in the city of Ljubljana. In 2003 he was one of the curators of the main display of the Venice Biennial with an exhibition titled *Individual Systems*, challenging through his title and selections audience expectations that a curator with a post-socialist background should focus on collectivity. As a regular participant in the effervescent art conferences of the post-communist decade, he also vocally theorized relations between Eastern and Western art worlds. In a 1997 issue of *Art Press*, he posed the influential question, "If Eastern Europe is now called the

'former East,' why do we not also speak about 'the former West?'"

While Denegri worked in the fairly contained art scenes of socialist Yugoslavia, Zabel experienced the information explosion of the transnational connections of the globally emerging post-1989 art world. His understanding of the rapid changes brought by globalization to the prospects of artists from the "former East" can be gathered from comments in a column for the Slovenian daily *Delo* from 2001. While only a decade earlier as he noted, artists from Eastern Europe, Asia, or South America had to move to one of the "great centers" to achieve international recognition, today, "individual artists, institutions, and cultural spaces have a much shorter and easier road to being included in the fluid global network." Zabel's experience of the decentering and leveling of the hierarchies of the global art world reflect the atmosphere of confidence and optimism at the height of economic and cultural globalization.

Zabel wrote the text "Icons by Irwin" for the catalogue of *Retroprincip 1983–2003*, an international exhibition of the work of the Slovenian artist group that traveled to Künstlerhaus Bethanien in Berlin and the Museum of Contemporary Art in Belgrade. Analyzing Irwin's retroprinciple of eclectically reusing works by other artists as a strategy of reinterpretation and reactualization, he focused on the painting *Malevich Between Two Wars* (1984) and its juxtaposition of a suprematist motif of a cross and an image of Nazi sculpture. The critic identified the work as exemplary of the *Was ist Kunst* series in its demonstration of "the tension between traditional bourgeois painting, modernism, and totalitarian art," while exploring associations via Kazimir Malevich with the Orthodox tradition of icon painting and identifying echoes of structuralism in Irwin's gridlike display strategy. Through such critical contextualization, Zabel demonstrated the relevance to the contemporary global art world of practices that were originally conceived within the horizons of late socialist Yugoslavia.

The Soil in Which Art Grows

Igor Zabel

first published as "Humus, iz katerega raste umetnost" in *Delo*, June 11, 2001

Every other year (more or less), around the time when the International Exhibition of Contemporary Art, better known as the Venice Biennale, opens in Venice, that city is flooded with a particular type of people, a multitude who almost completely overshadow the usual Venetian population—the female Japanese tourists in their Miyake dresses and their spouses with the latest technological advances in digital image reproduction, the Americans in shorts and sneakers who tell the (slightly sneering) waiter, "Seenyoray, praygo oono cappucheeno," the German newlyweds being serenaded with "O, sole mio" by a raspy tenor in a gondola beneath the Bridge of Sighs, and last but not least those useless Slovenes and Poles, who do little more than add to the size of the crowd, leave trash around the city, and upset the mayor of Venice, who also happens to be a well-known philosopher [i.e. Massimo Cacciari, mayor of Venice from 1993 to 2000 and again from 2005 to 2010— *editor's note*].

It would be hard to describe this particular group, but they are unmistakable: you can tell them from their walk, their attitude, their conversation, and their clothes. They are a kind of closed world unto themselves, which has converged from around the globe and for a short time settled in the city. For a few days they occupy hotels, bars, and restaurants, wander the streets or rush to appointments they are already late for, carry bags filled with catalogues, greet each other exuberantly with hugs and kisses in every direction, pronounce their impressions loudly and pretentiously or, in muffled conversation, concoct various plans, exchange information on social events, and try to come up with an effective strategy for crashing the somewhat more exclusive parties. This is the world of contemporary art: artists, curators, gallerists, museum directors, exhibition organizers, critics, collectors, and everyone else who would like to become a part of this world as well as a whole group of people who have some (more or less vague) connection with contemporary art. Venice is not just an exhibition of contemporary artworks; it is also, especially, an exhibition, or presentation, of the art system itself, which, condensed into a few days in the limited space of its picturesque and theatrical venue, displays itself in its multilayered

and contradictory nature, in its most unpalatable aspects and loftiest achievements. Here you can get a clear idea about the workings of the complex system we call the contemporary art world. At every step it seems that you are confronted with a new and different perspective on it. You see the convulsive attempts of those who want to break out of anonymity; you witness the ruthlessness and colossal ambition of those who, to succeed, are willing to destroy anyone who gets in their way; you encounter mediocrity, stupidity, and affectation, but also, next to it, astonishing intelligence, articulateness, openness, and human warmth. Here are the new stars of the art world, exhausted by the attention they are getting and by the countless tasks they have to perform, while next to them are the disappointed stars of yesterday, whom only a few still notice. If you are a bit more attentive, you can see how certain countries have developed a successful strategy for gaining recognition for their artists and thus a dominant position for their culture. (Quite obviously, this is most clear to the powerful countries, who are therefore trying to preserve their influential position in world culture at a time when globalization has caused considerable shifts in the established structures. Their presentations show a clear cultural-political vision, strategy, and awareness. Some countries try, more or less successfully, to imitate them, while the presentations of others create an impression that is more negative than positive, demonstrating unfamiliarity with the contemporary art field and the total absence of a coherent cultural policy.) You can physically feel the dividing lines and hierarchies that crisscross this world; you can see how, besides that which is public and open to everyone, there is also something hidden and closed; you can feel the centers of power and the conflicts between them, but also the peripheral regions and their petty scheming. Sometimes, observing all the commotion and discord of the art world, which seems at times to hover somewhere in its own illusory reality, remote from ordinary real life, I ask myself if it makes any sense at all to be part of it. And I always tell myself that it does. This entire jumble is the soil from which art sprouts up. Everything in it that is bad or unpalatable is, perhaps, the price that must be paid for everything extraordinary and brilliant this world is able to give and produce. Because I work in a museum of modern and contemporary art, I see every day, as it were, that our work is not something discrete and autonomous; rather it is tightly and directly intertwined in this dense dynamic web, which crystallizes in artistic and critical achievements. As this multitude of "art professionals" pours through the exhibition halls and pavilions, now one, now another of them will suddenly stop before an artwork, forget their plans, appointments, and

schemes, and, captivated, take time to concentrate on nothing but the work. And these "epiphanies," these moments of revelation and sudden captivation may, perhaps, ultimately excuse even all the political strategizing and power games, all the shallowness, pretentiousness, and ruthlessness.

Greetings from the Provinces

Igor Zabel

first published as "Pozdrav iz provinz" in *Delo*, August 13, 2001

There was once a time when people knew exactly where the center of the art world was located and where the provinces were. The center was Paris, and the provinces were more or less everywhere else. Paris eventually lost its role as the center, but it was still quite clear where the center was. New York, of course. In recent times, however, things are no longer that clear. Today, traveling through the cultural centers of Europe, you get the curious feeling that you are going from province to province. Not because there is nothing exciting or important happening in these cities, but because none of them feels like a self-sufficient center. There is always the sense that the really important changes are happening elsewhere, that the exhibition program is a reflection of other centers, and so on. If, conscious of the fact that you hail from a province, you get excited about all the different things happening in Vienna, it won't be long before someone who lives there tells you that, yes, Vienna is certainly trying to develop into a strong center but all the same it's not a real metropolis. The past few years there has been a lot of talk about the great developments in Scandinavian art , but Scandinavian artists and critics continue to say that they work on the periphery of Europe, far from the heart of the action. I remember how surprised I was a few years ago, at a time when British art had truly become a global phenomenon, to hear artists, curators, and others in London talk about feeling relegated to the margins. In Paris, you can hear people complaining about how their city, once the world capital of new art, has been downgraded to a local center. In Berlin you will hear people say that Berlin's okay but it's still not New York. And in New York, they say that the New York art scene has lost its real energy and that the most interesting stuff is happening in other cities, in Chicago and Los Angeles.

But the people in those cities also have the feeling that, nevertheless, they are being somewhat pushed aside. Such feelings are, possibly, something more than just random subjective illusions; they may well be connected with all those processes that are gradually, and at a very deep level, transforming the global economy and political power relations, as well as relations in culture. We often hear that the processes of globalization are simply a front for the West, and especially for the USA, so it can assume a new colonial control over the entire world. But the fact that, for example, it is no longer possible to say with unshakable certainty which cities are the global centers of art and culture and that even in the biggest centers people feel they are dealing with local issues and that the truly interesting, truly new things are happening elsewhere tells us there might be a different way to understand globalization processes. Slavoj Žižek has somewhere stated the thesis that in the processes of globalization, multinational capital, freed from territorial localization and ties to a national base, acts as a force that subordinates the entire world to itself, so the issue is no longer the relationship between the colonial metropolis and the colony (the provinces), but rather that the flexible and unattached multi- and transnational centers of power are colonizing, as it were, the entire world. Of course, these are not questions I myself can talk about with competence. I mention them because, in my own experience in the contemporary art field, I have seen shifts that correspond with these ideas. The network of contemporary global art seems less and less localized, more and more dispersed throughout the world, and more and more flexible. New power centers are appearing that also act as a kind of interface between the local scene and the global network. The international art system influences local systems and languages and changes them, but we should not forget that in the process it, too, gradually changes. While artistic languages around the world are becoming more and more similar, they are also gradually becoming less specifically western or American. As a result of this ever greater dispersion, the role of the former cultural metropolises is changing and the distance between the periphery and the center is gradually diminishing. While today the centers remain only points—albeit critical ones—in a broader network, and are no longer the nucleus of the universe, the smaller active centers have suddenly become closer to the network of global art. Our own immediate experience confirms this. Even ten years ago it was significantly harder for artists from Eastern Europe, Asia, or South America to achieve international recognition unless they moved to one of the great centers. Today, individual artists, institutions, and cultural spaces have a much shorter and easier road to being included in

the fluid global network. (This does not mean that the systems that have been dismissing a large segment of global cultural production from the central domain of art and ascribing it only a kind of ethnographic value, all the while proclaiming western principles as the self-evident norm—have simply vanished; rather, there is today, perhaps, a mix of various relationships and powers that is slowly and gradually changing.) In our country, it seems, the most frequent response to the question of the globalizing processes in culture is to detect a threat—to our language, culture, independence, identity—and to feel, therefore, that we have to put in place strong protective mechanisms. I think it would be more useful, however, if we could also be more conscious of the great possibilities and advantages these processes offer us.

Tactics of Alienation:
Walid Sadek

Ghalya Saadawi

Writing in 2001 at the age of 35, artist and theorist Walid Sadek attempts to read and historicize art forms in Lebanon during the last decade of the twentieth century. He distinguishes the 1992 "San Balech" installation by Ziad Abillama as the instance of "a violent restart of the arts in the postwar period" through both its alien, fabricated objects and familiar, found war objects, and in its critical, excessively wordy textual elements. Cordoned off with wire on a public beach, the installation—which came with a verbose invitation card-cum-poster filled with Futurist and other sourced quotes and appropriated imagery, as well as a rarely-seen video not screened on site—was left to deteriorate. Sadek may have been wary of traditional art-historical periodizations because what had thus far been written about installation art (in one instance, according to Sadek, Abillama's work had been labeled inauthentic and even degenerate) and the task of the local art historian/critic had shortcomings. As Sadek argued, "...There[,] lies several aspects that locate installation art within the general trajectory of late modernist art, and situate it concurrently as an integral part of globalization...." There, Abillama's dead serious parody both fit and did not fit. A part of the trajectory of late modernism, yet diverging from it; unentranced by the spectacle and promise of globalization, Abillama's work grew out of it as a historical cut.

These two young artists, interlocutors and collaborators, had a difficult task ahead of them in the nineties. They were confronted with the immediate aftermath of a vicious internecine sectarian, class, and

geopolitical war, as the specter of a newly empowered global capitalism hung over and commodified postwar life, finding a new home for its globalized consumerism. Spanning the sixties until the early nineties, there were intermittent years of war and invasion, different in character and cause. They were officially declared ended with a signed accord whose false implementation did not address the structural causes of discord because those continue to rear their heads. Rather, the will to the Taef agreement after 1989 was geopolitically and economically motivated, and imposing both amnesty and private reconstruction as two poles that falsely banished the war as a "passing illness."

Coming from Christian upper-middle-class families, which they now mistrusted as a lineage, the two artists were also returnees from art schools in the US, where they had learned political lessons from structuralist and post-structuralist theory. This led them to write what one could consider a micro-manifesto in order to situate their forthcoming artistic task: "Territorializing our work. Claiming a stake for a production that is increasingly suspicious of Beauty ... Do not mistake this act of resistance as a call for authentic Lebanese art. This politicization of the territory aims at a deconstruction of ... what passes as proper, familial, familiar, and inherent to a unitary Self (be it a subject, a family or a nation)."

As such, Sadek's essay about Abillama's work and othernascent yet transient forms (postcards, posters, booklets, billboards, abandoned exhibition) is developed partly under the long shadow of Frankfurt School critical theory. Descriptions of the phantasmagoria of city life and the commodity form are deployed to illuminate the multimedia work that Abillama was attempting to construct, as well as the conditions prompting this form of art in the first instance. The form of appearance, which conceals the reality of human labor behind all commodities is the attempted critique of commodity fetishism and the phantasmagoric that Sadek locates in some of the strategies of "non-infatuation" (critical consciousness), "excavation" (genealogy not historicity) and "dispersion." Thus, possibly in an act of ideology critique, these were the devices that Abillama, Sadek himself, and to a degree a small coterie of young artists at the time were developing as part of their arsenal. The historical moment demanded other modes of artistic address. Addressing the problem of the inheritance of a long war, and concurrent national and sectarian myth-making, their early devices made possible this critique, as well as ruptured with once characteristic yet now concluded forms of modern war and prewar art, and even more academically-inclined art.

Suffice it to say that Sadek's essay is remarkable because it heralded and made sense of a fledgling formal language in Lebanese art that very few critics were able to achieve at the time; one that may have been fleeting but held much critical potency before it was indeed swept by the phantasmagoria of contemporary art under the aegis of the now famously euphemistic term, globalization. It was a short-lived moment in need of historicization, and this by a critic, theorist, and artist as lucid as Sadek.

From Excavation to Dispersion:
Configurations of Installation Art in Post-War Lebanon

Walid Sadek

from *Tamáss: Contemporary Arab Representations*, Beirut/Lebanon, 2002

Artistic and academic domains in Lebanon witnessed during the last decade of the Twentieth century, a rather conspicuous spread of an artistic theory and practice, generally labelled as founoun Tajheezeih or, to use the conventional anglo-saxon term, "Installation Art." During those years, now past, these artistic practices and its few but noticeable theoretical pronouncements accomplished a number of achievements and have since began to intimate on the one hand signs of critical laxity and indicate on the other certain alternative tendencies that may have been implicit in the fabric of its earliest manifestations. To speak of installation art in Lebanon – its rise and achievements, its decadence and transformations – requires a measure of presumption that goes hand in hand with the claims of this type of art practice. For if one examines the statements of some of its practitioners, one can note certain stances, often excessive in their enthusiasm and almost always so in their ambition, which tend towards a rhetorical tenor that is hard to justify when compared to their actual influence. Equally, one can observe in the reactions of this art's opponents, flagrant exaggerations, describing it as a foreign threat and as deliberately degenerate.[1] I would like to argue that within this somewhat contrived relationship, that is between the contentious tone of installation artists and their often sweeping critical statements and the haughty hold-over of their opponents – not completely devoid of curiosity – there lies several aspects that locates installation art within the general trajectory of a late modernist art, and situates it concurrently as an integral part of Globalization and its phantasmagorical extension[2]

1 Sec the interview with Maroun El-Hakim, the former head of the Association of Lebanese Anim, the daily *Al-Mustaqbal*, 17 December 1999.

2 The term "phantasmagoria" went into German from English, where it was first used in 1802 as the name invented for an exhibition of optical illusions produced chiefly by means of the magic lantern. Its negative connotations stem from Marx's use of the word to describe commodity fetishism. Marx argues that the form of the commodity diverges from the commodity itself as a result of the concealment of the fact that the commodity is the product of human labour: "It is nothing but a definite social relation between men themselves which assume here, for them, the phantasmagoric form of a relation between things." Not by Rodney Livingston, translator of the book *In Search of Wagner* (1952) by Theodor Adorno (Verso Publishers, 1991): 85.

in post-war Lebanon. Historians, hypothetical as they may be, would probably differ in sketching a course for installation art in Lebanon and in specifying the names of its main protagonists. But while the precise activity of such a historiographical endeavour is postponed along with its theoretical and political problematic (a task that is unavoidable in the long run), there is ample justification for a reading that takes the first installation work of Ziad Abillama, presented in August 1992, as a practical starting point for that task and its concomitant problematic. For there is in this work a sufficient condensation of ideas and methodological hybridisation for it to be considered a crucial event and a violent restart of the arts in the post-war period.

Abillama occupied for his first work a small stretch of beach on the coast of Antelias north of Beirut, between the "ABC" commercial superstores and the Antelias Bridge. From it he removed heaps of piled up rubbish, then enclosed it with steel posts and barbed wire, allowing but one access to the inside, which functioned as an entrance and an exit at the same time. On this beach, known successively as San Balech ("Saint-Free" following a custom in Christian areas to name beaches after saints) and then as Chat al General (or the "General's Beach" in honour of General Michel Aoun ousted in 1989 after the Taif accord which signalled the official termination of the Civil war), Abillama freed an open space out of what was previously a temporary dump for rubbish and waste products. And within this clearing he arranged a large and varied collection of machines, engines and equipment, collected out of scrap metal, discarded weapons and other remnants of military gear. Abillama says[3] that the positioning and exhibiting of this scrap metal, and especially the weapons, follow the process of reactivating the war within two extreme, equally bankrupt, poles of possibilities. The first is that of re-staging the theatricality of war's terror and the horror of its crushing steel, while the second is that of banishing war to the domains of nostalgia and history's myths. Between these two poles, dominant in the official political discourse and which confirm and fix the war as a passing illness, Abillama strains on the contrary to present the war in its synechdoches as a foundational moment in our historical "becoming". This effort of his is not free of implicit irony for it undermines the notion of becoming as a Western philosophical problematic, as it escorts it, with a disturbing analogy that mixes the forms of missiles with one of the principal course of Modernist aesthetics, as exemplified in the sculptures of Constantin Brancusi (1876–1957).

3 Ziad Abillama in conversation with Joyce Salloum and Walid Sadek, September 1992, videotape, 120 minutes.

Walid Sadek

The installation was accompanied by a poster, to which Abillama gave the title *Wherearethearabs?* on which he arranged, as a polemical map, a series of quotes pronounced by leading European artists and intellectuals ranging from racist categorisation of Arabs and their stagnant civilisation, to statements advocating an absolute modernity and the rule of speed, as in statements by the Dean of the Italian Futurists Filippo Tommaso Marinetti[4], or the French-born designer Raymond Loewy who says that "The axe handle, ploughshare, scalpel, ship's engine fan, and needle are all valid from an aesthetic point of view".[5] In parallel, the invitation card blurred the boundaries between the veracity of documents with parody by including putative clippings from local and international newspapers praising the talent and pioneering spirit of Abillama, describing him variously as a Gibran Khalil Gibran and as a long awaited innovator.

In this flood of critical, and often obscure, references, Abillama announced his eagerness to plunge into the phantasmagoria of our latest war, anticipating thereby the phantasmagoria of the re-emerging local consumer market. And even if his eagerness to take the plunge is equalled only by an inevitable haste in getting to grips with every facet of his ambitious project, he at least succeeded in presenting a number of suggestions which did accompany and weigh over the efforts of installationists who followed him; suggestions and challenges which most did miss or fail to overcome.

In this first work of his, Abillama insisted on advancing headlong towards the principal problematic of installation art and on confronting this art practice's resident anxiety and despised double, namely "theatricality".[6] He constructed his installation by proceeding to "hybridise his moulds" mixing critical discourse with forms borrowed from the markets of commercial consumption such as chairs, shopping trolleys and bars. And if his speech tended to rely heavily on a pressing critical tone, it is probably because speech for him is a critical factor and the single remnant of the language of art, while all the other elements of his work are culled from the implements of "collective killing" and packed in forms derived from the world of daily consumption. And in this unequal marriage, between critical speech and commercial forms, one can

4 "One must persecute, flog and torture anyone who sins against speed. Speed is pure by its very nature. If prayer signified to communicate with the divine, moving at great speed is a prayer." (From the poster accompanying the installation).
5 From the poster accompanying the installation.
6 See an essay on installation art by Tony Chakar entitled "Life from its margin", *An-Nahar* daily newspaper, the weekly literary supplement, no. 329, 27 June 1998.

understand the excess of Abillama's critical discoursing and his inces-
sant, sometimes didactic, distribution of printed statements throughout
his work: for it is due to a need to spread his discoursing and protect it
in the midst of a boundless and uncontrollable flood of pictures and
objects, collected from the daily commercial market and its phantasma-
gorical theatre. In discussing Wagner's operatic works, Theodor Adorno
wrote of phantasmagoria "as the point at which aesthetic appearance
becomes a function of the character of the commodity".[7] Or in other
words, as the impossibility of retrieving forms and reinjecting them
with those meanings produced by material human relations. Adorno
goes on to say that: "The absolute reality of the unreal is nothing but the
reality of a phenomenon that ... strives unceasingly to spirit away its own
origins in human labour ...", and therefore, according to this writer, the
phantasmagorical style recaptures with its impenetrable miracles the
inheritance of the magic powers that the romantics had assigned to the
transcendental spheres.[8]

In his enthusiasm to confront the phantasmagorical and the magic
of its dominant "theatricality", Abillama strongly indicated a need to
become complicit first with the "non-artistic" (with the implicit assump-
tion here that what is artistic is also critical), namely the magic of market
commercialism, and to subsequently engage it with critical speech.
And in this complex confrontation, the image re-unites with magic as
its original matrix and becomes art's nemesis and alluring siren. For
before it, we are defenceless, unable to distinguish between phantas-
magoria and dream, as in the example quoted by Adorno from the opera
Tannhauser, when the enchanted hero – forgetting that what he beholds

7 Theodor Adorno, *In Search of Wagner*, op. cit. pp. 85–96.
8 The reference to Adorno's text – which allows a reflection on of the persistent prob-
lematics of installation art, namely the theatrical – goes beyond the logic of an appeal
to authority. The reference goes also beyond a mere borrowing and importation of a
problematic that has define the course of this practice of installation art in Europe and
the United States. Rather, positioning the work of Abillama and the works of those who
followed him in the course of this problematic is precisely an attempt to deal with the
issue of renewal in post-war Lebanese art. The renewal here is understood on two levels:
the first is an attempt to catch up with developments in Western art after a long separa-
tion – (an argument that quickly lost its relevance with the maturity and succession of
works of installation art). The second, which indicated the resident advantages in the
form of installation art, is a precise critical operation aimed at linking one of the phases
of art and art criticism in the West with a local need to confront what is non-artistic,
i.e. the official operation to re-configure Lebanese society economically, socially and
politically. Accordingly the use of installation art allows art to exceed itself and move to-
ward the "theatrical", secede from its own local history and re-orientate itself towards:
a. the geo-political through "excavation", b. the ideological, through non-infatuation or
critical consciousness, c. the historial/mythical through transcience.

Walid Sadek

is of his own making and not some miraculous and independent apparition – exclaims: "Zu viel! zu viel! Oh dass ich nun erwache!" (Too much, too much! Oh that I now might waken!) (Act I, sc. 2).[9]

In statements printed and in precise details distributed throughout his work, Abillama strives to jolt us from an inadvertence that might lead us to the spoliation of enchantment. Thus he multiplies his interventions in the course of our incursion into his exhibition to the point of losing confidence in the spectator, and subtracting him from the interpretative equation. And yet it must be remembered that this often forced intervening derives not from a scepticism in the spectator or the other in general, but rather from an anxiety and a persistent doubt in Abillama's mind concerning art's ability to be still an effective means of communication. This anxiety, lacking in most works of installation art today, is his motive and justification. For example, at the entrance to his installation, and to provide electricity for his work, he used a generator which he selected for its particularly loud, crackling sound, and turned it tangentially into a perpetual alarm sound and a "scandalous" antidote to any enchantment or possible mesmerisation on the part of the spectators.

Abillama laid the groundwork in his first installation work for an unequal relationship, deemed necessary, between the artistic and the non-artistic. And he insisted on regarding art as a primarily critical and intrusive activity, manoeuvering disruptively amidst the politics of mass appeal and the logic of consumption and marketing. And if Abillama searched in this work of his for an "excavationist" relation, apparent in his choice of the time and place of his chosen location, he did so because he recognised the depth of the geo-political sorting out and demographic sifting imposed by the many successive Lebanese wars. Nonetheless, he maintained his excavationist method at the level of a temporary intervention and as a fleeting and transitory statement.[10] And this he practiced when he discarded most of the objects in his work on site leaving them after the closing date to disappear and wither gradually under rubble heaped by the bulldozers of new coastal resorts.

9 Theodor Adorno, *In Search of Wagner*, op. cit. p. 92.
10 "Territorializing our work. Claiming a stake for a production that is increasingly suspicious of Beauty. Bastard and unreliable, there grows a desire to slow-down, to reconsider what has been discarded as stagnant and unproductive. Do not mistake this act of resistance as a call for an authentic Lebanese art. This politicisation of the territory aims at a deconstruction of that "authentic instance"; of what passes a proper, familial, familiar and inherent to a univerity Self (be it a subject, a family or a nation)."
From a statement by Ziad Abillama and Walid Sadek, S.A.D exhibition (Société des Artistes Decorateurs, France), Beirut, Martyrs' Square, June 1995.

Three main characteristics are then present in the work of Ziad Abillama and have marked his succeeding works as well as some works by other artists.

1. Non-infatuation (or critical consciousness)
2. Excavation
3. Transience.

And if we were to examine closely the series of installations presented since 1992, we would notice how they would intersect with at least one of these three characteristics. A notable exception to this assessment is artist Nadim Karam, who managed to add up in his installation works, an enchanted infatuation, a blatant disregard for the politics and history of a place and an (artificial) permanence, for his metal constructions, or his "creatures", as he calls them, are still moving seasonally among exhibition halls and public spaces.[11]

Fredric Jameson argues that installation art is a work defined by "mixed media" where the "mix" comes first, and redefines the media involved by implication a posteriori.[12] And so, in opposition to works based on theories of *synaesthesia* in the literary field (Charles Baudelaire) or the *Gesamtkunstwerk* in the field of opera (Richard Wagner) where the artistic work aims at a comprehensive union and a transcendental composing of the arts in all its different branches, presuming for each an initial complete autonomy. There is in Jameson's remark an indication that goes well beyond an explicit criticism of a Modernism that stipulates the mutual independence of art forms and defines their essence on the basis of their ability to challenge the encroachments of "theatricality" (Michael Fried) and the duplicity of kitsch (Clement Greenberg). In foregrounding the characteristic of "mixing" over any prior definition of media, new possibilities are opened for installation art, especially if the most important "mixing" is seen not to be that of objects and media but that of the choice of the arena of intervention or the field of "mixing", so to speak. Hence, appears the gradual shift of installation art from its "installationist" mode – that is, constructional and excavationist and which relies on the particularities (even if only temporary) of a place –

11 Walid Sadek, "The Third Side: Nadim Karam's Creatures in City Centre", the daily newspaper *An-Nahar*, the weekly literary supplement, no. 349, 14 November 1998.
12 Fredric Jameson, "Postmodernism and Utopia", in *Utopia Post-Utopia: Configuration of Nature and Culture in Recent Sculpture and Photography* (Boston and London, 1988): 25.

to another mode whose basic characteristic is that of a floating intervention in an already existing non-artistic field.

Such a shift is already visible in a number of recent artistic works (1999-2000) which have begun to reduce explicitly the weight of their material and the combinations of their objects, in favour of a precise. light, or rather parasitical instrumentalization of the already existing and dominant epistemological networks, such as the informational, cultural, and distributional.

These works, such as *Al-Kasal* (Indolence, 1999)[13] takes advantage of its formal similarity with daily newspaper to mingle with the widespread daily routine of newspaper consumption. While other publications such as *Bigger than Picasso* (1999),[14] *The Water in the Café is Cold* (2000)[15] and *All That is Solid Melts into Air* (2000)[16] – start initially from within the boundaries of a cultural event to spread consequently in a network of readers that exceeds the framework of the event itself. While a work such as *I Don't Think People Leave Hamra Street* (2000)[17] appears on billboards like one image among many, denuded of its conventional status and authority as a work of art. And in this recent orientation there lies profound ambivalences caused in part by the chronic and tense co-habitation of divergent views concerning art and its social function in Lebanon.

For in the first place, this latest orientation of installation art is in clear contradiction with the assumptions and interests of official and dominant groups such as The Association of Lebanese Artists, which issued a panicked statement in November 1998[18] proclaiming its absolute opposition to Nadim Karam and his works, without of course mentioning him by name. And although lacking any serious critique of Karam's work, the statement calls for artistic purity and stresses concurrently the binding clarity of Lebanese national identity. As in the second

13 Bilal Khbeiz and Walid Sadek, *Al-Kasal* (Indolence), newspaper, offset, black and white, 35 x 50 cm, 12 pages, November 1999.
14 Walid Sadek, *Bigger than Picasso*, paper print, offset, colour, 7 × 10 cm, 64 pages, published by the Ayloul Festival for Contemporary Arts, Beirut, September 1999.
15 Bilal Khbeiz, *The Water in the Café is Cold*, print in on cardboard, offset, colour, 15 × 10.5cm, 19 cards, published by Ashkal Alwan, as part of the Hamra Street Project, November 2000.
16 Tony Chakar, *All that is Solid Melts into Air*, printed on paper, black and white, 95 × 67 cm, published by Ashkal Alwan, as part of the Hamra Street Project, November 2000.
17 Walid Sadek, *I Don't Think People Leave Hamra Street*, a billboard on the corner of Hamra Street and Sadat Street, Beirut, 3.5 × 4 meters, as part of the Hamra Street Project, Ashkal Alwan, November 2000.
18 "A statement by the Association of Lebanese Artists to the Lebanese Public", the daily newspaper *An-Nahar*, the weekly literary supplement, no. 349, 14 November 1998, p. 7.

clause of its statement where it demands "that exhibited works must be sculptures and monuments of value, made of solid materials that can resist time" (!) Also, this orientation towards a floating or "parasitical involvement" on the part of this recent direction in installation art is a shift away from the earlier excavationist tendency which implicates the work with a particular location as it is a move towards a more complex and fragmented relation within the field of intervention. For the characteristic of excavation, as practiced by Ziad Abillama and other artists, carries to some extent a retrospective view of modern art, in its earlier realistic orientation, and thereby contains an oppositional temperament to any attempt at levelling the particularities of place and erasing its binding memories. And because of this shift, this new direction is often read as a dubious surrender and a "pragmatic" alignment with the logic of globalization especially since this parasitic involvement or floating intervention tends to shoulder the challenge of a difficult complicity with the conditions of transactions and the dynamics of consumption and so in view of a slow dispersion and a furtive dissemination.

"Des couches innombrables d'idées, d'images, de sentiments sont tombées sur votre cerveau aussi doucement que la lumière. Il a semblé que chacune ensevelissait la précédente, mais aucune en réalité n'a péri." (Innumerable layers of ideas, images and feelings fell on your brain, gentle as light. It seemed that each one would bury its predecessor, but none really did perish.) (Charles Beaudelaire)

Intent and Dispersion
This parasitical interventionist tendency sketches the characteristics of new artistic practices in in which intent faces dispersion, a duality that gives these new works an inevitable and necessarily oscillation between criticality and indifference. Intent is present in these works through the precise selection of the place of execution and the means of parasitism. As for dispersion, it is one of the characteristic that distinguishes and distances these new works from installation art in general and from the excavationist principle in particular. For these works share the remarkable common characteristic of presenting their visual and literary enunciations at random, unconcerned whether they reach or miss their preferred target. This was first apparent in the piece *Al-Kasal*, then became more definite in the collection of postcards *The Water in the Café is Cold*. In these last, the writer choose an "arousing" language for two reasons. The first is a strong insistence on sexualising the narrator along a particularly revealing and pleasurable concoction of material

illusions to another body approximated but never defined. "Egon Schiele drew two lines, parallel and curved at the same time. Then he said: 'This is a woman.' He could not find a suitable colour for her, so he left the job of colouring her to the sun and the wind. I myself believe that she is a woman, and yet always have this suspicion that it might be a street."[19] While the second reason is an a priori preference on the part of the writer for a liberality and generosity in discourse bordering on irresponsibility; ideas that, even if not devoid of an internal logical coherence, appears inadvertent to the logics of discursive construction and to the principles of argumentation. For it is a writing that does not persuade a reader or mobilise an audience but rather is a horizontal writing primarily involved in sexualising the self: "Coffee is neither bitter nor sweet. It has no taste. It just has a sufficient effect and smell to make the memory of horses."[20]

As for choosing postcards for a medium, the writer seems to recall the behavioural pressures of individualism and confronts it with the infections and self-effacing dispersion of words. For in principle, when sending a postcard, we display our obedience to the ideology of individual identity. Sending a postcard is the embodiment of a successive chain of suppositions: They begin with an actual and completed individual sender to end with a receiver who is both the receiver's double and the receptacle of his trust. The postcard is individualism made into a spectacle, a revelation of the private, where there is no need to conceal or hide what words or images it may carry. What is primary is the meaning of the medium and its function, both well summarized by the rather generic and consensual images postcards usually carry.

On the other hand, Jacques Derrida suggests, in his book *La Carte postale* (1980), the possibility of a network of communication where circulation is without an end or destination, as a message is always addressed, "to whom it may concern".[21] Postcards carry in such a network the spread of an infection linking the language with the language user and the medium with the medium user so that the front of the postcard melts into the back: "It is not a female body and certainly not a glistening snake. But its edges are black and nothing explains the eye's inability to comprehend except to claim that it is magical. Because magic is nothing more than an apology for impotence. Death is dazzling, but it cannot be magical."[22] And in this mutual infection of sides and the

19 Bilal Khbeiz, *The Water in the Café is Cold*, op. cit.
20 Bilal Khbeiz, *The Water in the Café is Cold*, ibid.
21 See the essay by Gregory L. Ulmer, "The Object of Post-Criticism", in *The Anti-Aesthetic*, Hal Foster ed., 1983, pp. 104–107.

erasure of boundaries, the sender ebbs back into the isolation of a body and a hermetic pleasure, useless, except within an equivalent isolation and an imagined pleasure of another, dwelling in the mains of the text and its violence: "Speech is pure tyranny and incomparable violence. For speech, while unable to be a dialogue, is always destined to take the form of dialogue: a speaker and a listener exchanging roles."[23]

Works such as *The Water in the Café is Cold* are in need of art events that allow and guarantee them an initial platform from which to spread and fragment in countless individual readings and usages away from the didactic views and guidelines which often accompany and frame art events themselves. And in this primary need is a formal, though decisive, link with the cultural and artistic life of the city, both as a context to enter and a frame to exceed.

Transient Appropriation

The two publications *Bigger than Picasso* and *All that is Solid Melts into Air*, require, as Bilal Khbeiz's postcards do, an art event which can eventually release them into a network of readers that may go well beyond the boundaries and public of the event itself. Also, these two works oscillate between intent and dispersion through their use of the tactic of textual appropriation and their approach to the issue of the displacement and exploitation of borrowed meanings.

These two works have an underlying basis in protestation. The black pamphlet *Bigger than Picasso*, is at first level a protest directed at a monument in the form of an obelisk, presented to the Syrian President Hafez El Asaad and his army by the Lebanese government.[24] While Tony Chakar's publication *All that is Solid Melts into Air* opposes the logic of maps and its "cyclopean" eye, which reduces the complexities of urban experience and the dérive of its memories. The obelisk, like the conventions of "seeing" and "blindness" of maps, is a monument that claims perfection and consistency of expression, from which it derives its dreadful silence and its radical divorce from "the reign of foolishness" – that is, speech and its digressive meanings which scurry about in history's actualities and in its fragile weave: A monument, in a sense, is the authority of the dead and an "art without observers."[25]

22 Bilal Khbeiz, *The Water in the Café is Cold*, op. cit.
23 Bilal Khbeiz, *The Water in the Café is Cold*, op. cit.
24 An obelisk in the vicinity of the Kuwaiti Embassy in Beirut erected on the Avenue President Hafez El Assad which connects the Selim Salam Tunnel with the Corocille roundabout. The obelisk was unveiled on the 15th November 1998 under the auspices of the Lebanese Prime Minister Rafiq Hariri.
25 Paul Veyne, "The majority of monuments belong to the category of art without spectators", in Dario Gamboni, *The Destruction of Art* (London, 1997): 51.

The black booklet carries its protestation in the form of borrowed texts which are dutifully and irrelevantly referenced on the first page. It is in this borrowing of texts that lies the convergence between this particular tactic of appropriation and the characteristic of dispersion. For the displacing of texts and quotes is not an operation critically directed back towards their primary sources and origins but rather it is a temporary/transient appropriation and borrowing of available speech, whose objective is the construction of a vocality for a besieged subjectivity in a moment of protestation that does not conceal the process of its own construction but rather exposes its sutures. This borrowed speech cannot bear nor pretend to set up a confrontation between the producer of the booklet and the Syrian/Lebanese monument, and yet it permits the appearance, in the form of a flagrant and contiguous discrepancy, of one vocality and a silence. Displaced and borrowed speech prepares the ground for an acrobatic dance weaving on the monument's periphery a framework of repetitious and borrowed speech. Before the mummified logic of monument, speech dances, recalls inevitable decay, and disperses first, perhaps in wishful transience, back into its own ruin.

As for Tony Chakar, he borrows, for his map, extracts from several texts, from which he concocts one long and uninterrupted sentence which carries in its folds protestation, an adolescent delight in history's inevitable demise and an uneasy acceptance of the logic of maps. His richly constructed and borrowed text is punctuated by expressions that betray, for instance, a protesting temperament, as in: "geographical space is a methodological space. Our understanding of geographical space always passes through the mediation of a map. It is an understanding that disturbs, indeed it conflicts with the experience of the body in space and time. Unified time has been imposed with force of law while unified space has been imposed by maps."[26] We also find in Chakar's text an evocation of the allegory of the map which covers the whole territory of the empire (Jorge Luis Borges) – a map which became, "with the decline of the empire, worn out, then completely ruined, so that nothing remains of it but a few scraps in the desert."[27] We also find in his text, a reversal of this story (Jean Baudrillard): "The territory no longer precedes the map, nor does it survive it. It is nevertheless the map that precedes the territory, that engenders the territory, and if one must return to the fable today, it is the territory whose shreds slowly rot across the extent of the map. It is the real, and not the

26 Tony Chakar, *All That Is Solid Melts Into Air*, November 2000.
27 Tony Chakar, ibid.
28 Tony Chakar, ibid.

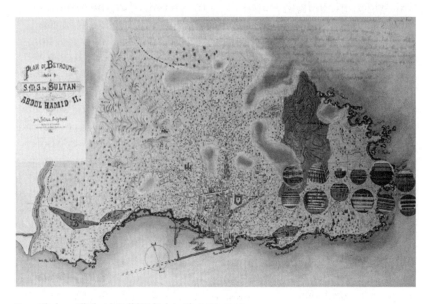

Tony Chakar, *All That is Solid Melts into Air*, 2000–2017

map, whose vestiges persist here and there in the deserts that are no longer those of the Empire, but ours. The desert of the real itself."[28]

The act of borrowing and appropriating in Chakar's work raises a question as to the method by which texts are selected and hence their ability to manoeuvre in their migration to the weave of another text. For unlike the borrowed texts collected in the booklet *Bigger than Picasso*, the text of the map carries some of the weight of its sources and the renown of their authors, from Borges and Barthes, to Marx to Beaudrillard. Moreover, and here lies perhaps one limitation of this game or temporary/transient appropriation, the texts carry, in their first form, more than one idea and more than one polemical transformation. For example, Baudrillard argues in the text from which Chakar appropriates, the view that the allegory of the map as told by Borges has become useless, even in its inverted form. And that perhaps the empire is all that remains of this allegory. Obviously, Baudrillard is arguing along his theory of simulation[29] whereby it is useless to ask about maps or territories. For something has disappeared: "The sovereign difference between one and the other, that constituted the charm of abstraction. Because it is difference that constitutes the poetry of the map and the charm of the territory, the magic of the concept and charm of the real."[30 and 31]

Walid Sadek

Tony Chakar strives to implement a difficult equation. He tries, in his borrowed textual construction, to address the map, define it and argue with it, while some parts of his text preserve the nerve of their origins as in this quotation from the Communist Manifesto: "All that is solid melts into air, all that is holy is profaned." Let it be clear though, that there is no connection between the difficulty of the text's construction in Chakar's map and his boldness in spoiling others' texts or his impudence in violating the literary reserve of great thinkers. The difficulty comes off rather in this tense attempt at persuading his readers that what he has appropriated is now not only relatively separated from its sources but also conveys other meanings in an alternative context. And so, the text of the map appears to hang on the edge of ambiguities, amidst an ocean of new intentions and a legacy of displaced meanings. And to return to the first proposition – which sees a confluence between the oscillation of intent and dispersion and this tactic of the temporary/transient appropriation of texts – Chakar's map seems ridden with anxiety. For if appropriating and displacing texts is an operation which aims at constructing a vocal subject, whether in opposition or in obedience, the map and its text here seem liable to a reversed appropriation which restores the texts to their "legitimate" authors and the map – by coincidence – to the Beirut Arabic Book Fair(!).[32] And in this liability, there is something like a sort of weightlessness that shifts the statement and its activity from its spatial condition to another, unstable, temporal one in which the words of Paul Virilio: "I abide, therefore I am" ring true.[33]

29 According to Jean Baudrillard, it is the fourth and final stage of the image, when it leaves the realm of appearances, that is, when it severs any relationship with reality and thereby becomes the pure image of itself or "simulacrum". See Jean Baudrillard, *Simulacra and Simulation* (Michigan, 1994); 6.

30 Jean Baudrillard, ibid., p. 2

31 Another text, included in the catalogue of the Hamra Street Project, accompanies the billboard/advertisement *I Don't Think People Leave Hamra Street*, presents a third variation and further problematic in this act of "temporary borrowing". This text, which relies partially on a succession of borrowed fragments, insists on evoking the work of "radical" writers (Gilles Deleuze, William Burroughs and Antonin Artaud) through purloined fragments from their texts. The narrator here disseminates the outlines of an enjoyment that reduces the depth of a street to an anal sphincter (fully articulate with a complete set of teeth) in an extravagant sexualisation and a scatalogical passion for a street an an urban myth.

32 In a delightful coincidence, Tony Chakar's map was being distributed during the Hamra Street project while the "original" coloured version of the map was on sale at the Beirut Arabic Book Fair in the Holiday Inn Hotel.

33 "La Troisiéme fenêtre", an interview with Paul Virilio in *Les Cahiers du Cinéma* 322, April 1981, p. 36.

Art Historiography:
Vardan Azatyan

Angela Harutyunyan

Art historian Vardan Azatyan's 2006 essay confronts the problematic aspects of historicization of contemporary art in Armenia. This short essay does several things at once: It diagnoses the locally specific conditions of historicization, or rather its lack; it develops a cultural theory of this lack; and finally, it proposes a model for critical historiography grounded in local conditions.

Azatyan tackles the problematic of historicization within the dialectic of memory and forgetting. This dialectic is seen as constituted through an ideologically charged process of selective preservation or conscious repression of historical memory. In addition, this dialectic evolves within the historical conditions of contemporary art that operates under a regime of urgency, a regime that itself defies historicization. His essay is a critical response to a "carefree" decade of actively evolving artistic and art-institutional practices that came to be grouped under the umbrella of "contemporary art" in post-Soviet Armenia. Only in the early 2000s did artists and institutions celebrating various anniversaries of their formation begin to confront the failure of documenting their own activities of the recent past.

In 2004, Azatyan, who was working at the Armenian Center for Contemporary Experimental Art (ACCEA), was commissioned to work on the publication of the institution's tenth-anniversary catalogue. This involved archiving the documentation preserved throughout the decade of the institution's activities. In this process, Azatyan published a critical reflection on the problematics of historicization

of contemporary art in Armenia. In the aftermath of this intervention, the project was canceled, since the founders of ACCEA were unable to come to terms with Azatyan's critique.

Azatyan situates the dialectic of memory and forgetting within the framework of the historical avant-gardes. Why then, does he take up the avant-gardist treatment of the past as a starting point to discuss contemporary art? Doesn't the temporal regime of the contemporary sublate the avant-garde's future-directed arrow in the perpetual reproduction of the present? I attribute Azatyan's historicization of contemporary art within a mnemonic dialectic of the avant-garde to the asynchronous nature of the reception of modernism and the avant-garde, and/as contemporary art in late Soviet years and in the post-Soviet condition. The avant-gardes (as in the historical avant-gardes) were erased by the Stalinist cultural policies of the thirties, yet modernism returned in various guises with the signifier "national" denoting an anti-establishment discourse in the sixties and seventies, in the aftermath of de-Stalinization. But most importantly, the unofficial and semi-official art practices in late Soviet Armenia later institutionalized as contemporary art, self-identified as avant-garde. The historical avant-gardes' negation of the past as well as its select references to tradition would haunt the mnemonic politics of Armenian contemporary artists and institutions. According to Azatyan, this temporal split between the pole of forgetting and rupture with the past on the one hand, and conservative references to tradition on the other, is embedded within the dialectic of the avant-garde itself. Azatyan looks at artworks, artistic gestures, and institutional practices first and foremost as diagnostic of this mnemonic dialectic.

The historicization of contemporary art in Armenia confronts several issues: contemporaneity operating in the regime of urgency defies historization, founders of the institution (ACCEA) identify their own practices with those of the institution, and finally the art historian is faced with the lack of documentation and the prevalence of oral narratives. Azatyan's own proposition for a historiographical model (a methodological proposition sensitive to the conditions that are being historicized and emerging from these very conditions) first implies a work of negation and calls for the deidentification of the past from history. For Azatyan, the historian narrates the past from the position of the present, wherein the present appears under a historical light. This bridges the gap between the historian understood as an antiquated scholar, and the critic who dwells only in the regime of the contemporary.

In a disclaimer to the republication of the text in 2008, Azatyan states that he would have revisited some of the premises in the original text, but that would be an encroachment on the text's historicity. With the same consideration of the situated history of Azatyan's intervention, we made only minor editorial corrections.

Toward a Dilemmatic Archive: Historicizing Contemporary Art in Armenia[1]

Vardan Azatyan

... to give oneself, as it were, a past a posteriori, out of which we may be descended in opposition to the one from which we are descended. It is always a dangerous attempt, because it is so difficult to find a borderline to the denial of the past ... Friedrich Nietzsche

Modernism implies two opposite but complementary attitudes towards the past. On one hand, avant-gardes establish themselves in opposition to the past, are hostile to tradition and see history as an artistic ballast to be jettisoned, and claim a trans-historicity—as in Futurism—which is in effect anti-historical. In extreme cases, this becomes historical rejectionism for the sake of originality.[2] At the same time, the avant-gardes claim to legitimize themselves in reference to traditions, and are read as intra-historical—as in Surrealism's referencing of Hieronymus Bosch—and in extreme cases are neo-traditionalist, as with German *Neue Sachlichkeit* (New Objectivity) in the 1920s.[3] In the first case, avant-gardes see themselves as creating a historical rupture; in the second case, in order to create this rupture, they need history. To me these attitudes are mnemonic attitudes related to remembering and forgetting. Thus, in the first case, I read these as strategies of forgetting, the latter perceived as an actively conscious process even though its aim is to placate the burden of memory. In the second case, I read the opposite process: in order to overcome the

1 This is a revised and shortened version of the text I wrote in 2006 as the introductory chapter for a documentary catalogue covering the past activities of the Armenian Center for Contemporary Experimental Art (ACCEA) I was compiling. The catalogue was to be comprised of the materials from ACCEA's archive and I was also involved in making the archive itself. Portions of the earlier version of this text were delivered in a form of lectures at *Festival Est Oest*, Die, France, September 20, 2006, as well as at the conference *Foundational Problems of Ethics: The Possibility of Criticism*, Yerevan, Armenia, March 17, 2007. In its earlier version was published in Armenian as "Memory and/or Oblivion: Historicizing Contemporary Art of Armenia," *A*, No .6, 2008, pp. 50–65. I am grateful to Angela Harutyunyan for making the English translation possible.
2 I have in mind the argument proposed by Rosalind Krauss in "The Originality of the Avant-Garde: A Postmodernist Repetition," *October*, vol. 18 (Autumn, 1981), pp. 47–66.
3 A programmatic discussion of the neo-traditionalist tendencies in modernism in inter-war years and their parallels with neo-conservative tendencies in the 1980s art world can be found in Buchloh, B. H. D. "Figures of Authority, Ciphers of Regression," in Buchloh, B. H. D, Guilbaut, S., Sorkin, D., eds., *Modernism and Modernity*, Nova Scotia, [1983] 2004, pp. 81–115.

hegemony of a hostile discourse in the present, the avant-gardes (re)call certain moments in history. But both cases lack a possibility for a critical history.

Here I discuss contemporary art in Armenia from the point of view of a mnemonic dialectic, which is key to understanding certain problems of its historiography.

Memory and Forgetting

Historical rejectionism, or the agenda of forgetting, is manifest in various forms throughout the history of contemporary art in Armenia since the early 1980s. For instance, the ideologue of the prominent contemporary art movement during the perestroika period, the 3rd Floor (1987–1990/1994), Arman Grigoryan—a champion of the aesthetics of Pop Art in Armenia—used the pseudonym Vandal after 1987 (see fig. on p. 335), positioning himself as a destroyer of traditional artistic and cultural values. Grigoryan continued to appear with this name until 1994, when his artistic practice entered into a new phase that took such vandalism to its extreme. Yet this very radicalization of his iconoclastic rhetoric is also its ending: in 1994 Grigoryan started a series of scratched canvases, which included scratchings of his graduation diploma paintings, his copy of a painting by Salvador Dali, and a canvas in Rembrandt's style from his student years. As if removing thick and heavy layers of traditional painting, Grigoryan sought to reach the bare surface of the canvas. Arguably Grigoryan's vandalism was a modernist trans-historical strategy of cleansing art from the tyranny of the nationalist and totalitarian burdens, and to start it anew.

I introduce two more examples of trans-historical vandalism embedded in the context of post-Soviet contemporary art in Armenia. David Kareyan's work of the late 1990s and early 2000s can be considered as one of the most radical instances of historical rejectionism here.

In 1997 Kareyan presented his spatial text *No More History*. The relief-like red gothic letters posted on the wall—which have great similarities with Grigoryan's letter fonts of *Vandal* since both artists were inspired by the aesthetics of heavy metal music—can be read as a counter-reaction against the nationalist tendency in mainstream media and educational institutions, one that tried to impose the ideology of the History of the Armenian People on the collective consciousness of this society. Such politics inherently results in antipathy towards history as such, to which Kareyan's universalistic rejection of history bears witness.

Second, Lusine Davidyan's photo-installation *My Blood Does Not Remember Your History* (2002) can be viewed as another reaction against

the new wave of nationalist history. However, as opposed to Kareyan's universalism this work is a critique of a specific model of history, historical racism, which connects historical memory with physiology. Thus Davidyan, unlike Kareyan, does not reject history as such but rejects one of its models.

The universal rejection of history as a strategy of forgetting has created major obstacles for the historiography of contemporary art in Armenia. The above examples indicate a confrontation by antihistorical strategies, within the mnemonic pole of forgetting. Now I turn to instances which belong to the opposite mnemonic pole: remembering. The latter, however, has been understood as being identical with neo-traditionalist moves towards the historical past.

In 1988, the political context in Armenia was boiling with anti-Soviet nationalist sentiments, inflamed by a popular movement demanding the separation of the region of Karabakh from Azerbaijan. There were massive demonstrations, marches, sit-ins, and hunger strikes. The crisis which started with the war with Azerbaijan over Nagorno-Karabakh, and a devastating earthquake in 1988, created an atmosphere of national(ist) unity, institutionalized in the emergent Republic of Armenia in 1991 (with the collapse of the Soviet Union). An outcome of these changes was that the Armenian diaspora regained an influence weakened during the Soviet times. Inspired by the reconstruction of a "fatherland," diaspora Armenians began to contribute to Armenian social and cultural re-formation. The Armenian Center for Contemporary Experimental Art (ACCEA) was one outcome of this process.

In this context, ACCEA's co-founder, Armenian-American artist Sonia Balassanian's artistic activities in Armenia since 1992 become significant. But it is important to clarify that the attitude of the Armenian diaspora towards national traditions is rather different from those who grew up in Soviet Armenia. National memory in Armenian diasporic consciousness is quite unlike the historical rejectionism practiced by the Soviet-Armenian artistic avant-gardes. If the national tradition spiced up with official Soviet ideology (an aspect of which was cultural regionalism) was a burden for the avant-gardists, the national tradition was a preserved kernel of national identity for the diaspora, now implanting itself in a foreign soil. As opposed to this, the Soviet Armenian artistic avant-gardes constantly strove to get rid of their national tradition.

Of specific interest to my argument here is the meeting of the two attitudes in Ballasanian's collaboration with those Soviet-Armenian artists who were at odds with the 3ʳᵈ Floor. The exhibitions *The Show of the Nine* (1992), *Identification* (1993) and *The Third Exhibition* (1994) served as the

basis for the foundation of ACCEA in October, 1994. The interaction of late-Soviet and post-Soviet Armenian discourses, and the diaspora-Armenian discourse, can be identified as key to ACCEA, and characterized by a tension between remembering and forgetting.

This polarization begins to emerge in interviews given by artists during *Identification*.[4] For Balassanian, the concept of the exhibition referred to issues related to identity, specifically to national or cultural identity; but for the late-Soviet Yeravan-based artists, the title referred to a problematic of conceptual art—art's identification with non-art discourses. If in the first case art relates to cultural-historical issues, in the second the issue at stake is that of art's disintegrating autonomy: the first evokes a historical/national consciousness; the second situates itself in the urgent regime of the present.

This antagonism between the mnemonic dialectics of forgetting and remembering reaches its apogee in two exhibitions at ACCEA in 1996. The first took place in April was titled *Work in Progress*. It offered a concept of art as a work in progress engaged in the flux of defining itself and capturing its future in the elusiveness of the present. Together with Balassanian, this exhibition was made possible by the efforts of a group of late-Soviet Yerevan based conceptual artists who disagreed with what they read as the aesthetisizing agenda of the 3rd Floor. These artists included Karen Andreasyan, Samvel Baghdasaryan and Manvel Baghdasaryan. In the autumn of the same year, after breaking with these artists, Balassanian organized an exhibition which seemed the opposite of *Work in Progress*, dedicated to the fifth anniversary of Armenia's political independence. The exhibition offered tribute to the Armenian nation-state. If the problematic posed in *Work in Progress* was situational, the agenda of the Festival of the 5th Anniversary was traditionalist. Moreover, for the first time an exhibition of contemporary art in Armenia hosted high-ranking representatives of Armenia's clerical and secular powers, the head of the Constitutional Court and the Catholicos (the head of the Armenian Church), who blessed ACCEA. Alongside contemporary artists' works, a choir chanted Armenian religious songs.

This exhibition was unprecedented: the tradition against which the Soviet Armenian avant-garde had positioned itself now penetrated the discourse of the avant-garde. But if this exhibition seemed to bridge

4 I discuss this exhibition and the different interviews given by Balassanian and Yerevan-based Karen Andreasyan in my "Between the Perestroika and the Neo-Liberal State: On the Dynamics of Artistic Subjectivization in Contemporary Art of Armenia," in N. Karoyan, D. Abensour, eds., *D'Arménie* (Quimper: Le Quartier, 2008) (in French and Armenian), pp. 47–56, pp. 137–146.

the gap between the avant-garde and the institutions of religious and national traditions,[5] Azat Sargsyan's performance during the Festival of the 5th Anniversary indicates the late-Soviet Armenian avant-garde's discontent with a neo-traditionalist conjoining of the avant-garde and national/religious discourse. The performance was directed against the presence of the head of the Armenian Church at ACCEA: the artist planned to restage the religious ceremony of feet-washing and scatter the water he used for washing his feet onto the audience. But Azat's performance took place the day after the Catholicos' visit—to avoid controversies. The possibility to reschedule the performance was provided by the fact that Balassanian had conceptualized the whole event as a festival which was comprised of not only visual arts but also theatre performances, so that Azat's performance could be shifted to the theatre section. So concord reigned after all.

This conception of a festival comprised of different branches of the arts became the core of ACCEA's institutional structure, with departments of music, visual arts, theatre and architecture (when contemporary art in the West increasingly deconstructed such categories). But the transition from an exhibition to a festival also marked two other changes. First, the emergence of interdisciplinarity brought with it postmodern eclecticism harboring the potential for neutralizing modernist radicalism (as in Azat's performance). And second, the transition marked the spectacularization of art at ACCEA, which became the motif of several other prominent artists affiliated with ACCEA. The institution's large exhibition halls and technical capacities (DVD players, projectors, etc) contributed to this spectacularization, in which the 3rd Floor's and ACCEA's aesthetic agendas met. For example, Arman Grigoryan enthusiastically embraced the Festival.

I emphasize that the Armenian avant-garde strategy of forgetting, and the diaspora strategy of remembering, supplement each other as markers of larger socio-political antagonisms. That is why the first inclines towards radical rejectionism and the second towards neotraditionalism. I argue that both these positions need to be revisited. Interestingly, in the context of the Festival a certain tactic of traditionalist remembering speaks of itself in the works of Armenian avant-garde artists who were either affiliated with the 3rd Floor or leaning towards its aesthetic agenda.

5 I discuss these exhibitions in relation to larger religious and nationalist discourses in Armenia in "On the Ruins of the Soviet Past: Some Thoughts on Religion, Nationalism and Artistic Avant-Gardes in Armenia," *Springerin*, Vol., 14, No. 4, 2008, pp. 38–41.

Loyal to the conceptual framework of the exhibition, Grigoryan and Kareyan positioned their works in a dialogue with a certain Armenian artistic tradition. Grigoryan had previously acted in the role of an anti-traditionalist vandal, and now offered a positive model of alternative painting in his work *I Love Armenican Painting*. Grigoryan's new project of optimistic painting was a mix of Pop Art and the painterly style of Armenian artist Martiros Saryan's early Fauve paintings of 1910s, with features from Fernand Léger's modernism. Grigoryan called this amalgamation Armenian Pop Art. It is significant that, unlike other Armenian pop artists from 1980s, Grigoryan coats the aesthetics of Pop Art with national connotations, explicitly adopting the neotraditionalist pole of the mnemonic dialectic. This transition from a negativist position of the Great Refusal—a term Grigoryan often used in his earlier writings[6]—to affirmation in Armenian Pop Art is evident in a change of his pseudonym from Vandal to Dr. Feel. Good.

Parallel to the shifts in Grigoryan's art, Kareyan, who presented a colorful text installation for the Festival, claimed in an interview that he was reasserting the Saryanesque tradition of Armenian painting, triggering a controversy in the conservative circles of the Armenian art world. On the one hand, Kareyan arguably promoted this controversy while, on the other, this controversy marked a shift in Kareyan's oeuvre from conceptual (textual) practices to spectacularized imagery. As this example shows, within the context of a contemporary art exhibition that pays tribute to national tradition, the two artists align themselves with the curator's position to work with the conventional issue of historical memory. Moreover, in 1997 Grigoryan wrote a review of the Festival with the symbolic title "The Catholicos Blessed the Armenian Avant-Garde" which begins as follows: "And with this blessing, a thousand-year cultural emptiness is filled with freedom," and that "the dilemma between cultural progressivism and national identity is resolved."[7]

It is important to mention that throughout the early to mid-1990s there was a level of cooperation between the contemporary art scene in Armenia and state authorities; Armenian officials who were the offspring of the perestroika reforms were former intellectuals, and contemporary art was officially promoted internationally. In 1995, five international representative exhibitions of Armenian contemporary art took place,

6 I am thankful to Angela Harutyunyan for reminding me of this.
7 Grigoryan, A., "The Catholicos Blessed the Armenian Avant-Garde," *Garoun*, 2, 1997, p. 93

at the Venice Biennale, and in Bochum, Nicosia, Moscow and Yerevan. These exhibitions were either supported by state authorities, or were connected to official institutions (with the exception of the show in Nicosia). It is against this backdrop that a need emerged to retrospectively summarize the tradition of alternative art in Armenia—hence the emergence of the first attempts to write[8] and draw[9] a history of Armenian contemporary art.

Institutions and Institutionalization

The motivation to historicize contemporary art in Armenia thus served representational purposes. Previously, Armenian artists were occupied with sporadic struggles to establish their own positions; given the sense of urgency of being involved in the present moment there was no need to revisit and reevaluate this moment historically. The exhibition celebrating ACCEA's 10th Anniversary in 2002, also curated by Balassanian, was an attempt to historicize contemporary art in Armenia, but it failed to revisit its history and, instead, foregrounded the history of Balassanian's own practice as a diaspora artist/curator in Armenia. For the first time an autonomous practice appeared in a historical perspective, or, more precisely contemporary art in Armenia was viewed in a perspective which granted autonomy to a specific type of practice within the field, a practice later institutionalized as ACCEA. To institutionalize the memory of contemporary art is problematic, not least from the attitude towards history which prevailed and still prevails on the artistic scene in Armenia. When contemporary art had a historical perspective, it was either affected by traditionalist rhetoric, or was produced to be representable (this meant a representation of the contemporary art scene in Armenia in general, or a representation of an artistic tendency and an institutional/individual practice). Representation has been the main motivation behind the need to historicize contemporary art in Armenia, and this has not been subjected to critical

analysis. But I would argue that the past, if not rethought, can never become history.

Stepan Veranyan, the former artistic director of ACCEA, assumed the task of archiving the institution's materials in 2002. Later, when he

8 The first such text was written by art critic Nazareth Karoyan for the exhibition in Bochum (whichwas not published it in the accompanying catalogue to the exhibition). See "In the Labyrinths of the Becoming of Alternative Tradition," *Garoun* 1, 1995, pp. 94–96 [Armenian].

9 I refer to a chart showing the developments in contemporary art in Armenia by Arman Grigoryan made in 1996 for an exhibition dedicated to the 10th anniversary of the 3rd Floor which, however, did not take place.

was sacked, archiving was suspended. In 2004 I reinitiated this task and the publication of the book covering ACCEA's history. The situation in which I found the materials, on the one hand, mirrored the effects of the rejectionist attitude towards history which I discussed above and, on the other, the ambition to historically propagate one's own individual practice. The archived materials resembled a pile of rubbish, covered in dust, scattered, and treating a critical review of an exhibition no differently from a telephone bill. This reflects that the strategy of remembering was considered as giving in to a reactionary conformism. But there is another, more prevalent mode in which the discourse of contemporary art in Armenian functions: that of oral stories.[10]

Telling Tales and Writing Histories

Stories are ephemeral, and depend upon the memory and eloquence of the interlocutor, on the mood of the story-teller, the place of utterance, the presence of addressees, and most importantly, upon the occasion which triggers the telling of a particular story. Further, the oral story turns the story-teller into the main character of the story's (performative) telling. Thus, contemporary art in Armenia currently materializes in two modes: representational survey texts and oral stories. In both cases, the past ceases to become history if (as Nietzsche tells us) history arises from the interests of the present when thinking, suffering and acting beings find it important to examine the past.[11] From this point of view, ironically, the most urgent problem facing contemporary art practitioners in Armenia is that of representation, or recognition.

I now outline a possible history of contemporary art in Armenia based on the model of ACCEA's history I had proposed, and founded on two related premises. First, the past has to be dissociated from history; the past as it is always remains inaccessible in that the only way to reach it is through a glance from the present. So history is the way the past lives in the present, and this constitutes the past's "lifestyle," as it were. This means that history is almost always the history of history. Second, the present is itself historical: it changes according to the needs of the time. So there are no trans-historical truths because truths emerge in the concrete historical circumstances of those who claim them. It is interesting that this perspective has been taken up not by art historians in Armenia but

10 "Oral Histories and Art History Survey Texts: the Case of Armenian Contemporary Art," paper delivered at the conference, conference *The Public Sphere: Between Contestation and Reconciliation*, October 25–27, 2005, Yerevan, Armenia.
11 Nietzsche, F. "On the Uses and Disadvantages of History for Life," book IV of *Untimely Meditations*, Cambridge, Cambridge University Press, 1997, pp. 57–124.

by artists, as in Hovhannes Margaryan's installation at *Work in Progress*. Through my reading of this work, I explore the methods of art historiography, linking the presence of history and the historicity of the present.

Margaryan's installation had three parts: a small text attached to the wall on the left; a photograph of a naked belly in the middle; and a mirror placed on the floor against the wall with text all over it. Formally, it resembles Joseph Kosuth's work *Three and One Chairs* (1965), but this resemblance is confined to the form. If Kosuth's aim was analytical-formalist, Margaryan lays claim to the Real. The conceptual message of this work is contained in a quotation from Oswald Spengler. Leaving aside Spengler's controversial philosophy, the quotation which attracted Margaryan's attention in the context of Armenia in 1996 was the following: "History is an image by the help of which man's imagination strives for the knowledge of the living being of the world in relation to his own life." These lines echo the idea that history is not a tradition of the old but an image of the past the purpose of which is to help people understand their present relation to the world. However, Margaryan simultaneously challenges Spengler's spiritualist understanding of history from a materialist, corporeal position: the photograph in the middle can be read as challenging the spiritualist implications in Spengler's work, since somewhat crudely it can be identified as the body image of history. Margaryan's work suggests that the way history is formed does not only depend upon the imagination but on the body as well. The dynamic between Spengler's text and the body image evolves in the third part of the installation, in the mirror—showing a random passage of a chronology of the Byzantine Empire. We know that Spengler paid a great deal of attention to chronology, which he called the numerical systematization of history—for him a process of spiritualization where historical reality was represented in the form of spiritual signs (numbers). Margaryan, at the same time, challenges two Spenglerian concepts: that chronology is the main method of constructing history, and that the latter is spiritual. In the first case the chronology presented by Margaryan is not merely random (which may denote mistrust towards chronological systematization). An attentive viewer would observe that the sentences are not complete: they are interrupted where the mirror finishes. For Margaryan chronology is an entirely conventional construct that has nothing to do with reality. His other critique refers to the spiritualization of chronology: it can never be impersonal or objective. This is revealed by placing the chronology on the mirror, so anyone standing in front of it can appear inside history (even that of the Byzantine Empire) with his or her body. Margaryan literally turns history into an image.

Vardan Azatyan

When the past appears under the light of the problems of the present, the historian must be aware of the pressing issues of the present, which is to consider his or her own conditions historically. At the same time, while looking at the past from the conditions of the present, he or she should attempt to find solutions for present problems, to make the past present. It is impossible to narrate or present the past itself, but what is possible is to model it in a way that will help the present. This blurs the distinction between the historian as an old-fashioned academic scholar and the critic as an up-to-date practitioner. Yet the paradigm of representation on which the image of the history of contemporary art in Armenia is constructed does not satisfy a need for self-awareness and critique, due to its institutionalization, its interactions with social/ institutional discourses (most importantly, the educational system), and the emergence of a new generation that would have a legitimate desire to know how contemporary art in Armenia emerged.

Taking into consideration the above-mentioned points, I have suggested a perspective to organize ACCEA's archive and book on its history, constructing ACCEA's past according to the paradigm of inside and outside, which is both flexible and schematic. To look at the past through the dialectic of inside/outside remains one of the most pressing

David Kareyan, *No More History*, 1997

Arman Grigoryan, *Vandal*, 1987

and dominant problems of the post-Soviet condition, despite the fact that many artists and critics argue that the boundary between inside and outside has disappeared with the collapse of the bipolar world order. But ACCEA as an institution was established in the context of Armenia's independence. This was a historical situation of opening up of the borders during which Armenian society, its politics and culture confronted the problem of inside and outside sharply. ACCEA came into being as a result of the interaction between the diaspora Armenian discourse constituting the outside vis-à-vis the Soviet, and the local scene constituting the inside vis-à-vis the diaspora. The inside/outside paradigm is also functional, since we deal with the institution as a spatial unit: the interrelation between the inside and outside of that spatiality is a main concern of institutional practice. Hence, inside refers to practices within ACCEA while outside refers to external reactions to these practices. The inside/outside paradigm can be helpful on another level, too: it refers to the interaction between ACCEA (as an inside) and larger artistic practices in Armenia (as an outside); and it can help to understand the relations of the local situation in Armenia (inside) to the conditions of both the Armenian diaspora and the international art context.

Coda: A Third Way

I mentioned two characteristics of a historian: his or her position is conditioned by his or her situation, and he or she is incapable of gaining access to the past as such. There is a third aspect of the work of the historian, as well: subjectivity, because a historical narrative is informed by the historian's interests. When I arrived at the idea of constructing ACCEA's history on the paradigm of inside and outside, I recalled that Hermann Hesse had a story with an identical title, "Inside and Outside".[12] I reflected on this coincidence until I suddenly understood that the basis for ACCEA's activities was formed precisely during the years when the Armenian translation of Hesse's stories was published, in 1991, under the title "Inside and Outside" chosen by the Armenian editors of the book. This was part of a series of Apollo Publications attached to the literary periodical *Garoun* which initiated the publication of modern foreign literature in Armenia, and which was the dream of the dissident intellectual circles in the Soviet era. As a teenager I was fascinated by the story, reading it in this Armenian translation. When I reread the story after working on the archive, I found that Hesse put the

12 For the English translation, see "Inside and Outside" (1920) in Hesse, H., *Stories of Five Decades*, New York, Farrar, Straus and Giroux, 1972, pp. 258–270.

Vardan Azatyan

problem in a way similar to the way late-Soviet intellectuals would like to see it, a position I shared as a teenager. Hesse's idea is that the pair of opposites inside and outside can be overcome. This is a point which for Armenian readers of the early 1990s would signify the post-cold-war or post-Soviet condition: "Nothing is outside, nothing is inside ... The distinction between inside and outside is habitual to our thinking, but not necessary. Our mind is capable of passing beyond the dividing line we have drawn for it. Beyond the pair of opposites of which the world consists, other, new insights begin."[13] In the end of the story Hesse's protagonist explains to his friend: "You have learned by your own experience that outside can become inside. You have been beyond the pair of opposites. It seemed a hell to you. Learn, my friend, that it is heaven!"[14] What fascinates me in Hesse's solution, and could have been missed in the late-Soviet-

Armenian reading of the story, is that his hero brings up another pair of opposites (heaven and hell) to overcome the opposition of inside and outside. So there is a logic of a certain metaphysical dialectic of good (heaven) and evil (hell) that threatens the attempts to overcome the dualism of inside and outside. This dialectic plays in the morbid rhetoric of hell in the case of Kareyan's *No More History* or Davidyan's evocation of blood, and in a cheerful rhetoric of neo-traditional heaven in the case of Grigoryan's *Armenican Painting*. In these cases, artists occupied certain positions in relation to history: rejectionist in the first two cases, and neotraditionalist in the last, which functioned in a politics of the desire to overcome the inside/outside opposition inherited from the Soviet Union. To me, Margaryan's installation stands out of this dialectic, since it addresses the relationship between an agent and his or her history, and is not caught up metaphysics. Margaryan's work is about ways of dealing with history, whereas the other cases are caught up inside the dilemma of history informed by the unease of inside and outside. Thus, the paradigm of inside and outside is an effective means to structure the history of a dilemmatic economy of contemporary art in Armenia.

13 Hesse, p. 263.
14 Hesse, p. 270.

Hatchet Job:
Julia Voss

Wolfgang Kemp

In German, we say *Verriss* for a negative, harsh, potentially devastating critique. In English, one term is "scathing review," but a more drastic designation is "hatchet job." The organizers of the yearly Hatchet Job Prize of the London-based journal *Omnivore* want to honor "critics who have the courage to overturn received opinion, and who do so with style." But "dullness, deference, lazy thinking, and received opinion," the faults that prevail in normal criticism according to the organizers, thrive just as well in a negative review as in a positive one. So, in doing a hatchet job it is not enough to amass negative adjectives, you must feel the need to better your opponent, at least in your own field, in writing, debate, and wit.

In Germany, various attempts to write the *Verriss* were rather forced and appeared against the grain of an engaged approach to contemporary art. Joseph Goebbels forbade art criticism and called the Nazi equivalent *Kunstbericht*—from 1933 to 1945, the word "Verriss" was taken literally and meant destruction. After 1945, modern and contemporary art had to be explained, supported, and endured, but not criticized. One of the reasons was the visual arts' affinity to money and institutional power. Once you were on the right side and had some clout you turned into what I call an "embedded critic," working not only for your newspaper, but also for galleries and exhibitions, writing prefaces for catalogues, becoming a *Kunstmanager* (art manager)—the word "curator" was more or less unknown in those days.

Julia Voss's review "Welche Welt will dieser Fürst regieren?" (What World Does this Prince Want to

Rule?) is from 2009, yet it remains current in respect to Markus Lüpertz's strong standing in the art scene. In addition, Voss covers an artist who after his one major style change in the eighties hasn't changed much: he'd delivered one church window, one public sculpture after another, and then tons of graphic art and paintings. The self-bestowed title that pops up in every cultural report is *Malerfürst* (painter prince), a term so cleverly used in the headline of her review.

The piece is witty, relentless, and has the important enduring drive that carries through, asking: what else could be wrong? And this touches the risk of every excellent hatchet job—that it can excel too much. I guess there are two types of *Verrisse*: the cool, sarcastic, analytical type, which painstakingly dissects the counterpart's ambitions and propositions, and the *Verriss* that pulses with a kind of indignation and disbelief in the pretense and cockiness of the artist in question.Voss has chosen the latter option. It's somewhat problematic that a close reading and dissection of one or two works is missing, an omission that is rather common in *Verrisse*. Voss could presuppose a certain knowledge of Lüpertz as a member of the Neue Wilde or Neo-expressionists and points out that the necessary provocation that every new movement needs is in this case based on precarious references to the German Nazi past and its reliance on a genuinely German style, Expressionism. The problem she faces is twofold. First we would need an understanding why a substantial movement like the Neue Wilde deteriorated so rapidly and totally (as did their precursors, the original Expressionists). Second, all of us suppose that art can be explained, analyzed, and appreciated. But vis-à-vis a public sculpture by Lüpertz you simply give up and concentrate on the artist's flamboyant personal style and the network of curators, dealers, and collectors that supports him and their investment. Not to forget the *Frankfurter Allgemeine Zeitung*, Voss's newspaper at the time the review was written, which through its online shop later began selling an edition of Lüpertz statuettes dedicated to the twelve signs of the zodiac. An artist born under the bullish sign of Taurus, as is Lüpertz, predicts a brilliant hatchet job.

What World Does this Prince Want to Rule?

Julia Voss

from *Frankfurter Allgemeine Zeitung*, October 13, 2009

His paintings are lessons in how a German artist can reliably fall into every trap that he confronts. An exhibition in Bonn showing Markus Lüpertz is the manifestation of a signature tragedy.

Lüpertz's story must be told. He was a painter, sculptor, and former rector of the Düsseldorf Academy of Fine Arts; a self-acclaimed genius; and an artist who actually exists in the world. This needs to be said because anyone who sees the show in the Bundeskunsthalle in Bonn quickly gets the impression of having seen something unreal or fictitious; the work of an artist that someone invented. One hundred and fifty paintings and sculptures have been brought together in Lüpertz's largest retrospective to date. The paintings' format is almost always oversize. A neoclassical temple was built to accommodate some of the works, the catalogue weighs several kilos, and Lüpertz's poems are on the wall.

His is the story of an artist who so reliably fell into every trap he encountered—as a person, a painter, and a German—that it becomes an entirely prime example, a case study, a lesson. It is not those artists who stand out from their historical moments who teach us something, but rather those who fit into history like a snail in its shell—and Lüpertz's shell is the German Federal Republic and the history of West German art after 1945.

We must begin this story in 1970 with a young Lüpertz. The artist, born in Bohemia in 1941, was then 29 years old. He studied at the Academy of Fine Arts in Düsseldorf, visited Paris, and began painting steel helmets in distemper paint.

Sinking Helmets I—Dithyrambic was what he called his monumental four-and-a-half meter painting. The round, green steel helmets with their slightly scary eye slits seem to shoot from the ground like mushrooms. They symbolize a time that the Federal Republic of Germany doesn't like to be reminded about, despite the fact that it persistently spills out from various cracks. The funniest Freudian slip was documented by the young art historian Martin Warnke, who worked as an exhibition guard in the then Dahlem-based Gemäldegalerie, and who was asked by a visitor: "Where is the painting *The Man with the Steel*

Helmet by Bernhard Dürer?" The Germans associated steel helmets with Dürer even more than they connected gold helmets to Rembrandt. In the meantime, the painting is no longer even considered to be a real Rembrandt, but that's another story.

Motivic Tourette's Syndrome
Lüpertz continued to paint steel helmets, always large and somewhere between insult and joke; a motivic Tourette's Syndrome that sparked controversy. Regarding art history, Lüpertz did what all of his colleagues did. In 1965, Gerhard Richter painted a man in a German army uniform entitled *Uncle Rudi*; that same year, Georg Baselitz began his Heroes series of mutilated soldiers in tattered uniforms. In 1969, Anselm Kiefer photographed himself in Italy and France with his hand in the Hitler salute. And even the much younger Martin Kippenberger still jokes in the title of an abstract painting from 1984, *With the Best Will in the World, I Can't See a Swastika*. Commenting on German history is the territory that every German artist has to cross at some point, like in a board game. It is also a trap, as the next round shows.

Like in the animal world, where individuals of different species sometimes socialize and enter mutually beneficial relationships, Lüpertz also lived in symbiosis—with the Cologne art dealer Michael Werner and Werner Hofmann, the art historian and later director of the Hamburger Kunsthalle.

Werner spun the threads forward, his gallery representing the new West German figuration, from Baselitz to Jörg Immendorff to Lüpertz. Even Robert Fleck, the director of the Bundeskunsthalle, reported at a press conference that it was Werner who a few years ago advised him to do something courageous—show Lüpertz. One would like to have advised Fleck to have "courage" explained to him by a more independent source.

While Werner was paving the way into the future, it was Hofmann who built Lüpertz a huge ramp into history. In 1977, he exhibited Lüpertz in the Hamburg Kunsthalle, and published an extensive catalogue text in which Lüpertz's motifs were traced back through art history through a monumental line of ancestors. This was the second trap, and this time it snapped shut.

On Commentaries in Art
From that point on, Lüpertz was forced to repeat himself. Like with many German painters, his paintings of steel helmets were above all a commentary, and a good one at that. The ambiguous humor of the mushrooming military attributes was somewhat lost, despite the fact that

Markus Lüpertz, *The Fallen Warrior*, 1994

Lüpertz exhibited together with Gugelhupf still lifes. One only has to look to England, however, to see why commentaries in art became a vicious circle for many German painters. While painters like Bridget Riley and David Hockney were grappling with the question of why one should still paint in the twentieth century—despite cinema, television, photography, colorful and gigantic billboards, or in other words, what the role of painting could be considering that the competing visual mediums have become so powerful—Lüpertz continued painting commentaries on art history.

Canvas after canvas, he produced paintings based on Picasso, on Corot, on Courbet, on Monet, on Marées. He borrowed motifs from art history, such as Goya's *The Third of May, 1808* from around 1814, which Manet and later Picasso copied. He painted it in wild brush strokes, but in his conception of painting, he resembles someone who found a transistor radio in the woods and sets about to mimetically recreate the form—the buttons, keys, switches, and displays—without ever considering how it functions on the inside. Lüpertz imitates art history: the master painter, the artistic genius, the grand gesture, including performances with canes and gaiters.

Julia Voss

The Lost Kingdom

Just as things that only look like radios do not automatically play music, fancy cladding and large formats do not make Lüpertz into a master painter. Looking back at history, one might find it unpleasant that artists let themselves be celebrated as geniuses, and hope for more modesty and less arrogance. But one thing that their performance certainly was not: a mere allegation. A Michelangelo, Raphael, Caravaggio, or an Artemisia Gentileschi were actually able to create the most impressive, colorful, and enduring paintings of their time. They were all masters, because painters had no rivals. There was no one who could do anything comparable.

This uncontested kingdom was lost, however. Throughout the nineteenth century one can observe how art stretches, eyeing the burgeoning competition, reacting to it, answering to it, and transforming itself. Photo cameras, film cameras, and cinema were on their way. Art conquered new fields. What it meant to be a painter in 1970 needed to be answered differently than in 1570. Lüpertz's critical engagement with the changing conditions as academy rector consisted of making life difficult for the photography class led by Bernd and Hilla Becher. There was a scandal in 2008 when photographer Andreas Gursky called Lüpertz's masterly ways a "tragedy."

Not society, German history, nor a malicious art system knocked the scepter from the painter's hand. They were simply born in another time, and the best of them still find excellent answers today as to why we need painting. Why, for example, we need to see a landscape from Hockney's eyes, or to learn from Riley what seeing means, what tricks perception plays on us, and why things are not what they seem.

The signature tragedy of West German artists is assuming there is an authority everywhere, someone who forbids you from doing something, and to revolt against this. This is why German motifs are exhibited, alleging that this is a taboo. One paints figuratively, with the allegation that it's forbidden today.

One refers to themselves as a master artist with the claim that our time evokes greatness. But because in reality no one forbids German artists any of this, the references to art history turn into junk, and the genius act into a carnival costume.

Bridging Borders: Helia Darabi

Anita Hosseini

The Iranian artist and art critic Helia Darabi has already dealt with the question of how art criticism and art analysis should be carried out when the focus is no longer on forms and styles in her dissertation titled *Approaches and Methods of Art Analysis: A Study of Didactic Metacriticism.* Her iconological and art-sociological perspective includes theoretical approaches such as formalism, Marxism, psychoanalysis, feminism, and many others. As a lecturer at the Tehran University of Art, she strives to convey to her students that artworks always originate from an environment, a history, and a thematic background that assigns them to an underlying or starting point even before they are produced. Consequently, she aims to expand art education in Iran to include the sphere of art theory and art history with a particular focus on both its own and the Western art world and historiography.

Darabi's descriptions and analyses of artistic positions, but also those of the status of Iranian art and its institutionalization in museums, are also based on the way in which the artworks are located and rooted in the political, historical, and social environment. Her texts offer a glimpse into the Iranian art scene, which is determined and regulated by state censorship, as illustrated by the annexed commentary *Teheran: Dispatch.* The strong financial and ideational support of artists, whose paintings are reminiscent of the Iran-Iraq war and the fallen soldiers, even depicting them as martyrs, leads to a trivialization of the war, as it makes this motif a fashionable theme that many artists follow because of its market relevance. While portraits of

war martyrs are regularly exhibited, exhibitions of art by young artists working in other genres are rare. The latter represent other perspectives and voice their status, opinion, thoughts, and ideas through media like photography, video art, digital and multimedia installations, but also in Conceptual Art. The lively and colorful gallery scene in the major cultural centers Tehran and Isfahan is more likely to give them a stage. However, Darabi criticizes these enthusiastic artists for sometimes being guided more by the desire to use a certain medium than by the fact that they feel that this particular medium is suitable for the themes they have chosen. Here too, fashions determine art practice, but these are the fashions of the "Farangi" (the Westerners), which are not appropriated but adopted. Darabi's art-critical approach bridges "the West and the rest." She confronts Western theory with Iranian history, juxtaposes artworks from both regions, links perspectives, and examines historical and transcultural influences. But she always remains critical. In this way, she creates a visibility for the oscillating moments and interweaves Western perspectives with Iranian practices and the history surrounding the artists. She demonstrates that the art world is a global one, even if it is nationalized, restricted, and limited under certain conditions. Following this idea, Darabi also examines works by artists living in the diaspora.

In the following writings focusing on the productive potential of exile, Darabi describes transnational and dynamic processes on in-betweenness. She chooses three artists as examples—painter Wahed Khakdan, digital and media artist Parastou Forouhar, and installation and video artist Mandana Moghaddam—who work in different media and highlight how the quest and longing for the abandoned homeland lead to an idea of a citizen of the world. This potential is based on the visual language of art, which takes up global themes while addressing and touching people in their own worlds, despite their different cultural and historical backgrounds.

Found in Translation: Exile as a Productive Experience in the Work of Iranian Artists

Helia Darabi

from *NuktaArt, Biannual Contemporary Art Magazine of Pakistan*, November 2010

Displacement from an original homeland and being relocated in a new place develops a new identity which crosses national borders and boundaries. Stuart Hall defines the diaspora experience "not by essence or purity, but by the recognition of a necessary heterogeneity and diversity; by a conception of 'identity' which lives with and through, not despite, difference; by hybridity."[1] Diaspora identities are therefore those constantly producing and reproducing themselves through transformation and difference. Diaspora focuses on transnational and dynamic processes, and puts "emphasis on contingency, indeterminacy and conflict."[2] This way, diaspora involves a conception of identity that avoids the essentialism of much of the discussion on ethnic and cultural identities. When it comes to art, this situation may end up in outstanding artistic expression. This article is an attempt to examine some productive aspects of this hybridity in the works of several Iranian contemporary artists living in exile.[3]

In his groundbreaking investigation on Iranian cinema in exile, Hamid Naficy observes the inspiring role of this condition of indeterminacy and in-betweenness. He applies Arnold van Gennep's early twentieth-century concept of 'liminality' to the modern migration and exilic culture that he investigates.[4] For him, "liminality and incorporation involve ambivalence, resistances, slippages, dissimulations, doubling, and even subversions of the cultural codes of *both* the home and host societies."[5]

1 Hall, Stuart, "Cultural Identity and Diaspora", in J. Rutherford (ed.), *Identity: Community, Culture, Difference*, London, Lawrence and Wishart, 1990, p. 235.
2 Gilory, Paul, "Diaspora and the Detours of Identity", in K. Woodward (ed.), *Identity and Difference*, London, Sage, 1997, p. 334.
3 I have used the term 'exile' to refer to the situation of Iranian diaspora, as the majority of them have migrated due to a toxic political situation and inconsistencies in the aftermath of Islamic Revolution in 1979. This is generally referred to as the post-revolutionary experience of *ghorbat*. However, the alienation of homeland may equally occur to many Iranian intellectuals remaining in the country; as the system, relying on ideology, have turned their homeland to a place almost unrecognizable for them.

To be in transnationality is to belong to neither of the two modes of dystopia or utopia. The authority of transnationals as filmmaking authors is derived from their position as subjects inhabiting transnational and exilic spaces, where they travel in the slip-zone of fusion and admixture. What results is an agonistic liminality of selfhood and location which is characterized by oscillation between extremes of hailing and haggling. This turns exile and transnationalism into a contentious state of syncretic impurity, intertexuality, even imperfection.[6]

Naficy further argues that this situation makes the exiled artist freed from old and new constraints. The situation of being "deterritorialized" turns out to be a "passionate source of creativity and dynamism" marking their productions with "iconographie hybridities, doublings, and splittings.... The resulting tensions and ambivalence produce the complexity and multidimensionality so characteristic of great art."[7] This way, the exiled artists' status as liminal hybrids and syncretic multiples enables them to "form a global class that transcends their original or current social and cultural locations. Such figures tend to have more in common with their exilic counterparts at home or in the host county. It is a relationship that is not so much based on shared originary facts (birth, nationality, color, race, gender) than on adherence to a common imaginary construction. Discourse thus replaces biology."[8]

Naficy's observation on Iranian filmmakers in exile is also true about visual art. Unlike predominant hegemonic representational systems, Iranian artists in exile do not seek to validate and essentialize East and West. They avoid using indigenous elements to make their work responding to reductionist expectations. Far from prevalent sentimental attitude of *vatan parasti* (worship of homeland), their work reveals a tendency to assimilation, integration and accommodation.

Wahed Khakdan (painter, b. 1950), Parastou Forouhar (digital and media artist, b. 1962) and Mandana Moghaddam (installation and video artist, b. 1962) are three Iranian diaspora artists—among many—who,

4 See Naficy, Hamid, *The Making of Exile Cultures: Iranian Television in Los Angeles*, University of Minnesota Press, 2003; Naficy, Hamid, "Phobic Spaces and Liminal Panics: Independent Transnational Film Genre", in *Multiculturalism, Postcoloniality, and Transnational Media*, Ella Shohat, Robert Stam (eds.), Rutgers, the State University, NJ, 2003; and Naficy, Hamid, *An Accented Cinema: Exilic and Diasporic Filmmaking*, Princeton University Press, 2001.

5 Naficy, H., *The Making of Exile Cultures*, p. 8.

6 Naficy, H., "Phobic Spaces and Liminal Panics: Independent Transnational Film Genre", in *Multiculturalism, Postcoloniality, and Transnational Media*, Ella Shohat, Robert Stam (eds), Rutgers, the State University, NJ, 2003, pp. 207–208.

7 Ibid, p. 223.

8 Naficy, H. (see note 5), p. 2.

despite their notable diversity of strategies, are related in their hybrid, ambivalent and indirect references to their homeland and their implied banishment. Their state of liminality and hybridity leads to the use of fragmentation, *bricolage* and multiple spaces to refer to the in-between exile situation. Their liminal state allows them to assimilate and modify Western approaches, growing a particularly productive opportunity to create, in order to comment upon issues of nostalgia, alienation, memory and loss.

Wahed Khakdan: A World in Between

Wahed Khakdan was born in 1950 in Iran. His father was a prominent film and theatre stage designer. As early as two years old, Wahed became fascinated with painting material. Frequently visiting cinematic sites designed by his father, young Wahed was mesmerized by accessories, furniture, trees, etc. all made out of paper. An attic room in the house, always full of old objects, statues, toys, suitcases, etc., became his secret source of inspiration which still haunts his mind and constitutes his major subject matter: the accumulations of objects which either fill the whole picture plane or occupy a considerable part of the composition. He later studied at Art School and then at the Academy of Fine Arts in Tehran. He moved to Germany in 1984.

His individual experience of homeland, tightly bound to drama and storytelling, has reflected in his complex, hyperrealistic paintings. A reflective yearning for the past is manifested in his deeply nostalgic approach to a lost utopia, while his transnational situation has led to assimilation of Western traditional painting devices. Accumulation, immobility and restricted space mark his compositions. Frequent reference to scattered letters and suitcases highlight the exile experience. The objects do not immediately suggest their country of origin. Sofas, sewing machine, the teddy bear, the hobby horse, the dismantled doll, letters and their stamps, suitcases and labels on them, the recurrent letter A, even the poses in the photographs do not bring Iran into mind, but are rather associated with a European culture; say, Russian.[9]

The selected works are among the earlier ones made in exile. *The Forgotten Testament* (1989) shows an accumulation of various objects on a table and a shelf. The suitcase almost occupies the whole table. The

9 Actually, the artist's grandfather, who was from Azerbaijan, moved to Russia and married a Russian woman who gave birth to Wahed's father, who, in his turn, learnt stage and set design from a Russian couple. This could further contribute to the hybridity and the presence of European iconography in Khakdan's work.

Helia Darabi

airplane, the letters, the tied box and the shoes refer to the journey; the open scissors representing the break from homeland and the beginning of the liminal state. The binoculars point to distant horizons, the crayons to the creative act; and, in a depressing manner, the dolly and the teddy bear have been moved to a pot and the disbanded doll falls with its face down on the table. The worn wall and the dark interior are reminiscent of the artist's memories of military service in a most deprived area in Iran, an experience which made a lifelong impact on his work.

The symbolism of Khakdan's iconography can be thus cultural or individual. Some objects are further associated with a certain individual memory, like the iron, carrying the memory of a friend having been tortured by iron in prison. Direct hints to drama, art and fantasy are frequently recognizable through puppets and painting frames. Severe longing for home and endeavor to preserve every piece of memory is unmistakable, even in the artist's painstaking reconstruction of every particle of dirt and dust.

"As the longing (Gr. *algia*) for home *(nostos)*, nostalgia is defined as the longing for a home that no longer exists, or, never existed."[10] In *The Future of Nostalgia*, Svetlana Boym identifies at least two types of nostalgia: restorative and reflective. "Restorative nostalgia focuses on

Wahed Khakdan, *The Forgotten Testament*, 1989

nostos and aims to reconstruct the lost home, often in association with religious or nationalist revivals. However, 'reflective' nostalgia dwells on *algia*, and has no place of habitation. It is embodied in the essence of movement, not destination."[11]

Khakdan's nostalgic approach is a reflective one. It is focused on individual stories that value details and signs. It "cherishes shattered fragments of memory and temporalizes space."[12]

While "restorative" nostalgia takes itself dead seriously, reflective nostalgia can be ironic and humorous. It deals with memories rather than actual return to a place of origin or truth. In the same way, Khakdan does not seek to restore his historical and individual past. Rather, for him, home becomes a changing and ambiguous location, simultaneously situated in Iran and Germany, past and present, dream and reality, mediated and housed in the structure of his canvases.

Parastou Forouhar, Hybridity vs. Fundamentalism
Though I have not tried to address class and gendered facets within the diaspora problematic, I still find it helpful to remind that the productive role of exile circumstances particularly in the work of women artists have been much pointed out. As Linda Nochlin observes, "[f]or some artists, getting away from home and its restrictions has led to a successful art career."[13] According to her, displacement can be strikingly productive – especially for women – as exile could act as an escape from the constraints of their home cultures. Although women may be "empowered by retaining home traditions, but they may also be quick to abandon them when they are no longer strategies of survival."[14]

Here I examine the work of two Iranian female artists in exile, based on the notions of hybridity and displacement. Homi Bhabha's "cosmopolitan rootless but routed intellectual" can hardly see better embodiment in Iranian contemporary art than Parastou Forouhar, one as Stuart Hall argues: [T]he "exiled intellectual seems, at least for the time being, to fulfill that dream of a universal category, cutting across geographical cultural boundaries."[15]

Born and raised in an intellectual family, the daughter to opposition leaders Dariush and Parvaneh Forouhar, Parastou graduated from the

10 Boym, Svetlana, *The Future of Nostalgia*, New York: Basic Books, 2001, p. xiii.
11 Ibid, p. 22.
12 Ibid, p. 49.
13 Nochlin, Linda, "Art and the Conditions of Exile: Men/Women, Emigration/Expatriation", *Poetics Today*, vol. 17, no. 3, 1996, p. 3 18.
14 See: Anthias, Floya, *Ethnicity, Class, Gender and Migration*, Aldershot: Avebury, 1992.
15 Naficy, H. (see note 5), p. 2.

Faculty of Fine Arts, University of Tehran, moved to Germany in 1991 and now lives and works in Frankfurt. Her art, including installations combining Iranian and Islamic motifs with contemporary modes of expression, took much a sharper tone after the murder of her parents commissioned by the Iranian secret service. *Thousand and One Days* (2003) is a wall covered with decorative wallpaper. Closer examination, however, reveals shocking detail in the apparently casual pattern: scenes of torture rendered into schematic computer drawings. She has reprocessed these images in various installations and multimedia pieces, i.e. projected into a well-like construction (*Spielmannzuge*, 2008) or printed onto otherwise cheerful balloons (*I Surrender*, 2009). The shock and distress resulted by the confrontation with the abstracted scenes of torture, however, is by no means diminished.

Forouhar has also made some series of comics narrating the story of her frequent visits to administrative buildings in her struggle to clarify her parents' case (*Take Off Your Shoes*, 2004). Bearded men and veiled women, together with a lot of witty observations regarding the iconography of the Islamic republic, dominate these comics rendered in a Western style.

Through a motivating study,[16] Amy Malek has used Naficy's notion of liminality to discuss the work of Marjane Satrapi, an Iranian artist living in France. Part of her observation can be applied to certain aspects of Parastou Forouhar's work, regarding her use of Western genres of comics and memoir as a "blend of traditionally Western genres with Iranian history, culture, and storytelling."[17] From another aspect, Katrin Bettina Müller puts Parastou's assimilation of western culture in this way: "Forouhar's work, with its manifold references to German culture and to Greek mythology as the so called cradle of western civilisation, adopts a wealth of significations by which western society constructs and defines its identity."[18]

In another piece, *Hair*, created with Phyllis Kiehl, Parastou Forouhar openly refers to her hybrid strategy. In this photograph, the two women stand side by side and exchange their tresses, i.e. holding each other's hair like a veil in front of their mouths. Again, for the Berlin Biennial 2001, she devised a poster showing the hideous, faceless back of a man's

16 See Amy Malek, "Memoir as Iranian Exile Cultural Production: A Case Study of Marjane Satrapi's Persepolis Series", in *Iranian Studies*, vo. 39, no. 3, September 2006. 17 Ibid, p. 378.
18 Müller, K. B., "On the Waves of Writing", Culturebase.net, International Artists Database, May 2003.

head in a chador. This curious mélange was a shocking comment on Islamic fundamentalist vocabulary. This state of uncertainty and ambivalence is also observed by Annette Tietenberg:

> Forouhar, who had to learn the pain of finding a place in the ambivalence of signs, confronts us with an art that combines horror and beauty, past and present, the unknown and the familiar. In the knowledge of political control over the ornament, she has never stopped loving the soft, rhythmic line of her mother tongue and the suggestive Persian patterns that in the repetition and variations of their individual motifs demonstrate a small piece of infinity.[19]

As seen above, with all her hybrid and cosmopolitan attitude, the notion of homeland has never stopped nourishing Parastou's work: "I began to build a sanctuary of illusions round the notion 'homeland'," writes Parastou Forouhar, "and since then the mirage of my homeland has shimmered to me from afar, as if through the letters of my mother tongue, which spread out gently, rhythmically and invitingly."[20]

Mandana Moghaddam: Beyond the Notion of 'Other'

All cultures are located in place and time. "Exile culture is located at the intersection and in the interstices of other cultures. Exile discourse must therefore not only deal with the problem of location but also the continuing problematic of multiple locations".[21] This is the same problematic which fosters Mandana Moghaddam's work in exile. Migration has provided her with new perceptions of place as well as the relationship of places.

The epistemology of displacement makes the essence of *The Well* (2009), an interactive project in which symbolic wells, equipped with microphones and speakers are installed in different cities around the world and connected via the internet. Random, ordinary passersby gather around these wells and find the opportunity to talk to their counterparts in another city in the farthest places of the world. The first well was executed in Gothenburg, Sweden, the artist's residence. It was supposed to be connected with another one in Tehran – the artist's home city – where it faced the disagreement of officials. The second well was then built in Incheon, South Korea. Other wells were later constructed in Bangalore and New Delhi, and the project still goes on.

19 Tietenberg, Annette, "Thousand and one day", *Nafas Art Magazine* (online), April 2003.
20 Quoted in Müller, Katrin Bettina, "On the Waves of Writing", Culturebase.net, International Artists Database (online), May 2003.
21 Naficy, H. (see note 5), p. 2.

What is interesting about the well is that it connects people without any intervention. As the artist states: "the average man on the street in different countries never knows what their fellow citizens around the globe think. Whatever they know about each other is through 'mainstream media'. It is surprising how little we know about each other; west is foreign to east and south is absolutely unknown to north".[22]

Moghaddam had previously followed the same theme in *Exile* (1998), a piece installed in Gothenburg and then in Tehran. Part of the installation was a telephone ringing every few minutes, randomly connecting people in the gallery with someone else in the world. Here, we again encounter an attempt to construct a link free from conventional definitions. Her earlier exile experiments with mirrors installed in certain parts of the architecture to confuse viewers about their spatial situation, and also the *Chelgis* series, comprising a hovering huge black of cernent and a figure all made up of nothing but hair, are other examples of her interest in hybrid, liminal situations.

Naficy's liminality and Homi Bhabha's hybridity both refers to identity that occurs in the space between cultural borders. Here, hybridity represents a "third space", which "displaces the histories that constitute it, and sets up new structures of authority, new political initiatives."[23]

Dariush Moaven Doust has put this transnational trait in Moghaddam's work this way:

> The intelligence of the artist consists in his or her capacity to contain and materialize the ceaseless movements between these seemingly heterogeneous spaces without losing out of sight the universal issues that the heterogeneity both evokes and questions.... MandanaMoghaddam's work surpasses the framework of interplay between particular cultural identities and their affective outputs. The discontinuities pertaining to historical, gender-based and geopolitical boundaries are the raw material for an imagination beyond the imaginary representation of the Other.[24]

One can argue that, each time she begins with an attempt to construct a connection to "home," she ends up in a global discourse. She constructs

22 See Mandana Moghaddam in wordpress.com.
23 Homi Bhabha in response to Jonathan Rutherford in "The Third Space: Interview with Homi Bhabha," in *Identity: Community, Culture, Difference*, London, 1990, p. 211.
24 Moaven Doust, Dariush, Intellectual property of Dariush Moaven Doust, Analytical Forum.
25 "For those living abroad the clocks stop at the hour of exile", Alexander Herzen, quoted in: Boym, Svetlana, *The Future of Nostalgia*, New York: Basic Books, 2001, p. 327.

a bridge, mediation, a "third space" to challenge the concrete ideas of insider/outsider, self/Other, and author/audience.

The artists chosen for this essay cannot help being affected by trauma and displacement. The idea of a home and a homeland is always present in the backdrop of the work. However, their work is by no means confined to mourning for a lost homeland, or a constant "waiting to go home." Rather, their state of liminality has enabled them to develop new hybrid cultural forms, their multiple worldviews having been reflected in their manifold attitude. Their clocks have not stopped at the hour of exile.[25] Migration has granted them the opportunity to recognize, tolerate and appreciate the state of ambivalence and intertextuality characteristic of a translational identity.

Dispatch: Tehran

Helia Darabi

from *Art Asia Pacific*, No. 81, November/December 2012

On the afternoon of June 14, 2009, the municipality of Tehran declared the presence of three million protestors in the streets of Iran's capital, a number unprecedented in a political demonstration. Mahmoud Ahmadinejad—against whose disputable reelection people were protesting, apart from upholding vigorous restrictions on freedom of speech and failed economic programs, had faithfully continued the Islamic Revolution's initial restrictive cultural agenda in the first four years of his presidency.

The IRI government's policy towards art and culture was indomitable from the beginning. The definition of arts in the primary and secondary school curricula was, and remains, limited to calligraphy, still-life drawing and graphic design fundamentals, and, remarkably, the word "music" has been totally absent from the school texts and programs. When it comes to the practice of art, the Ministry of Culture and Islamic Guidance keeps a tight rein on all exhibitions, events and performances, and displays extreme sensitivity to nudity, open political remarks or anything that might capture the larger public's attention.

In the field of visual art, after the post-revolutionary phase of "social realist painting" during the 1980s—this is also the period of the eight-year war with Iraq—there came a long-lasting tendency toward abstraction,

both in art education and practice. Maybe this mode was easier to evade the official constraints. Or perhaps it was an attempt to stay up-to-date with Western trends, of which abstraction was still considered an outstanding achievement. It was at the turn of the millennium that the strategies of visual representation underwent a crucial shift; and in a sweeping movement, the art scene of Tehran embraced various new artistic media and reflected on socio-political and everyday issues.

This new movement received support from Tehran's Museum of Contemporary Art, which in its heyday—chaired by Alireza Sami Azar (1998-2005)—hosted several "New Art" exhibitions as well as retrospectives of prominent Iranian figures of modern art. MoCA's ambitious exhibition program culminated in 2005 with an exhibition of the highlights of its collection, the most extensive anthology of 19th and 20th century art outside the West, compiled by the former queen. It was also the first time Iran sent representatives to Venice Biennale since the revolution.

These progressions did not last long. After the return of the conservatives to power, not only did MoCA stop its progressive agenda, but also many artists decided to boycott all governmental programs. After 2009, this boycott pact became explicit and was published as a signed agreement in some major national newspapers. Now there was actually no interaction between the practicing artists and the formal institutions that could plan, organize, and support artistic events. The art scene of Tehran had to depend completely on private galleries, many of which were naturally motivated by their own financial benefits. Today Iran's gallery culture is considerably developed, and the art scene is so lively that makes it actually impossible for an individual to follow every event. In galleries like Azad, Aun, Aaran, Etemad, Khak and Mohsen, Friday evenings are witness to plentiful openings: multimedia group exhibitions, performances and happenings alongside more traditional media. However, this quantity often does not bring up quality. A sense of hastiness and self-absorption along with a lack of theoretical support seems to prevail in most of these events.

Apart from a trendy fashion for new media, the emergence of a vigorous art market in Dubai was also a major driving force behind the ever-increasing number of galleries opening in Tehran. The works by Iranian artists brought incredible, regionally unprecedented prices/figures in Bonhams, Christie's and other auction houses in Dubai; breaking records in some cases. These figures, in a lack of strong infrastructure and the absence of any national and institutional support for arts, grabbed the headlines and came to define the Iranian contemporary art scene. Soon, however, the unquenchable call for calligraphy, exotic

material, decoration and gold, made it clear that the major part of practicing artists in Iran who were engaged with social critiques and political commentaries, will never find a way to this market.

On the other hand, the global interest in the region, due to its tragic geopolitical state of affairs, is also gradually being translated into high sales-figures in regional auctions. This makes it even more difficult to refer to socio-political issues. "Exoticism," a term frequently heard nowadays in debates and discussions, both locally and globally, began to encompass not only calligraphy and exotic imagery but also any rendering of local situation and particularities; i.e. some artists, dispossessed of attention at home, are driven to play victims to better sell their local "exotic" issues. However, for the artists who are supposed to reflect on their lived experience, issues like compulsory hijab, with its massive impact on the whole nation's everyday life and its determinative effect on the existence and quality of any local event, could not be overlooked whatsoever. The question of exoticism thus remains up for debate.

In the face of its dynamism and abundance, the art scene of Tehran has received little theoretical attention, both locally and globally. Today, a large number of artists and scholars immigrate to find freer circumstances, to seek a global audience or to develop their theoretical framework. However, the large Iranian diaspora, spread throughout Europe and North America, also suffers from a lack of meeting place and community awareness. In a famous quote, Archimedes says: "Give me a lever and a place to stand, and I shall move the world." The Iranian artistic and intellectual diaspora might have the lever, but they have no place to stand, and the local artists who have the place, lack the lever. Therefore, nothing seems to be going to move in Tehran.

Through the Digital Looking Glass: Hito Steyerl

Ying Sze Pek

In many of her essays, most of them published online since the late naughts, artist, filmmaker, and writer Hito Steyerl drew attention to the contemporary art world's vast global network and complex workings. Combative and even antagonistic, these deeply researched and keenly anatomized exposés of art-world malpractices are a class act in writing as finger-pointing. Contemporary art is no better than "degenerate art" when oligarchs and authoritarian governments amass artworks that purport to critique sociopolitical inequities, Steyerl asserts in "If You Don't Have Bread."

How might we understand Steyerl's widely circulated writings in relation to her purpose-built video installations, such as the centerpiece of the German pavilion at the 2015 Venice Biennale, *Factory of the Sun*? Is it contradictory that Steyerl authors limitlessly mobile digital texts while creating artworks that demand in-person viewing? Rather than suggest inconsistency, Steyerl's writings and video works make up two faces of a dispersed oeuvre (to reference Seth Price's 2002 art-world manifesto "Dispersion"), a distributed quality shared by the art practices of a multigenerational group of artists who work with internet tropes. The distributed character of Steyerl's oeuvre traces the shifting stakes of artistic practices of institutional critique. That is, Steyerl's writings can be considered a form of artwork that reflects on the systems and conditions of art production in which it is situated. These essays are at home in the very art world that Steyerl takes to task. In addition to aiming her barbs at art-hoarding

despots, then, Steyerl decries the two-facedness of the category "political art" in which her work is considered. To reference a familiar paradox of contemporary art criticism, Steyerl's missives can be viewed through the notion of immanent critique with which critics compellingly theorized institutional critique: when the "work" of the artwork is to contextualize art's workings, there is no vantage of transcendence from which the artist can assess her bearings. Steyerl both aligns herself with and antagonizes the "theoryworld," the troubling "theory-art alliance" (to evoke terms coined by philosopher Susan Buck-Morss) that at once supports and critiques contemporary art's production.

In "If You Don't Have Bread," Steyerl nonetheless raises the call for "a quite extensive expansion of institutional critique"—a response to transformations in the art world's systems and institutions with the digitization of economic and social life. Correspondingly, Steyerl's essays frame qualities of internet writing. With a predeliction for puns and inversions, her disclosures and analyses are configured as run-on lists of proper nouns and neologisms. These witticisms are bon mots on the way toward concepts, terms, that are distinctly memorable, even if rhetorically exaggerated. Steyerl has reflected on how she engages "post-Fordist" subjects as potential viewers of her videos, who "more or less have to work all the time—and, when they are in luck, watch for a moment." The same can be said of her literary audience. Such readers work from and with the very devices and interfaces that provide them access to her writing. Honed

to the senses and psyches of those who scroll over the texts on handy mobile screens, while perhaps streaming television episodes—this is writing that holds its own in the digital environment.To borrow Kenneth Goldsmith's analysis of internet writing, Steyerl's essays reflect "the quantity of language that surrounds us, and about how difficult it is to render meaning from such excesses." When navigating Steyerl's writing, there are so many junctures in which the reader can insert herself; so many footnotes to follow. Each text is a microcosm that embodies the swerves of the internet's rabbit holes and, in the best cases, prompts the reader's awareness and exploration—as well as its recirculation and rewriting. "Daesh antiquities trade" is a Google search away on the next browser tab, and "Arsedaq" just begs to be hashtagged.

Politics of Art: Contemporary Art and the Transition to Post-Democracy

Hito Steyerl

excerpted, from *e-flux journal*, December 2010

A standard way of relating politics to art assumes that art represents political issues in one way or another. But there is a much more interesting perspective: the politics of the field of art as a place of work.[1] Simply look at what it does—not what it shows.

Amongst all other forms of art, fine art has been most closely linked to post-Fordist speculation, with bling, boom, and bust. Contemporary art is no unworldly discipline nestled away in some remote ivory tower. On the contrary, it is squarely placed in the neoliberal thick of things. We cannot dissociate the hype around contemporary art from the shock policies used to defibrillate slowing economies. Such hype embodies the affective dimension of global economies tied to ponzi schemes, credit addiction, and bygone bull markets. Contemporary art is a brand name without a brand, ready to be slapped onto almost anything, a quick face-lift touting the new creative imperative for places in need of an extreme makeover, the suspense of gambling combined with the stern pleasures of upper-class boarding school education, a licensed playground for a world confused and collapsed by dizzying deregulation. If contemporary art is the answer, the question is: How can capitalism be made more beautiful?

But contemporary art is not only about beauty. It is also about function.

What is the function of art within disaster capitalism? Contemporary art feeds on the crumbs of a massive and widespread redistribution of wealth from the poor to the rich, conducted by means of an ongoing class struggle from above.[2] It lends primordial accumulation a whiff

1 I am expanding on a notion developed by Hongjohn Lin in his curatorial statement for the Taipei Biennial 2010. Hongjohn Lin, "Curatorial Statement," in *10TB Taipei Biennial Guidebook* (Taipei: Taipei Fine Arts Museum, 2010), 10–11.
2 This has been described as a global and ongoing process of expropriation since the 1970s. See David Harvey, *A Brief History of Neoliberalism* (Oxford: Oxford University Press, 2005). As for the resulting distribution of wealth, a study by the Helsinki-based World Institute for Development Economics Research of the United Nations University (UNU-WIDER) found that in the year 2000, the richest 1 percent of adults alone owned 40 percent of global assets. The bottom half of the world's adult population owned 1 percent of global wealth.

of postconceptual razzmatazz. Additionally, its reach has grown much more decentralized—important hubs of art are no longer only located in the Western metropolis. Today, deconstructivist contemporary art museums pop up in any self-respecting autocracy. A country with human rights violations? Bring on the Gehry gallery!

The Global Guggenheim is a cultural refinery for a set of post-democratic oligarchies, as are the countless international biennials tasked with upgrading and reeducating the surplus population.[3] Art thus facilitates the development of a new multipolar distribution of geopolitical power whose predatory economies are often fueled by internal oppression, class war from above, and radical shock and awe policies.

Contemporary art thus not only reflects, but actively intervenes in the transition towards a new post-Cold War world order. It is a major player in unevenly advancing semiocapitalism wherever T-Mobile plants its flag. It is involved in mining for raw materials for dual-core processors. It pollutes, gentrifies, and ravishes. It seduces and consumes, then suddenly walks off, breaking your heart. From the deserts of Mongolia to the high plains of Peru, contemporary art is everywhere. And when it is finally dragged into Gagosian dripping from head to toe with blood and dirt, it triggers off rounds and rounds of rapturous applause.

Why and for whom is contemporary art so attractive? One guess: the production of art presents a mirror image of post-democratic forms of hypercapitalism that look set to become the dominant political post-Cold War paradigm. It seems unpredictable, unaccountable, brilliant, mercurial, moody, guided by inspiration and genius. Just as any oligarch aspiring to dictatorship might want to see himself. The traditional conception of the artist's role corresponds all too well with the self-image of wannabe autocrats, who see government potentially—and dangerously—as an art form. Post-democratic government is very much related to this erratic type of male-genius-artist behavior. It is opaque, corrupt, and completely unaccountable. Both models operate within male bonding structures that are as democratic as your local mafia chapter. Rule of law? Why don't we just leave it to taste? Checks and balances? Cheques

3 While such biennials span from Moscow to Dubai to Shanghai and many of the so-called transitional countries, we shouldn't consider post-democracy to be a non-Western phenomenon. The Schengen area is a brilliant example of post-democratic rule, with a whole host of political institutions not legitimized by popular vote and a substantial section of the population excluded from citizenship (not to mention the Old World's growing fondness for democratically-elected fascists). The current exhibition "The Potosí-Principle," organized by Alice Creischer, Andreas Siekmann, and Max Jorge Hinderer, highlights the connection between oligarchy and image production from another historically relevant perspective.

Hito Steyerl

and balances! Good governance? Bad curating! You see why the contemporary oligarch loves contemporary art: it's just what works for him....

Here is the bad news: political art routinely shies away from discussing all these matters.[4] Addressing the intrinsic conditions of the art field, as well as the blatant corruption within it—think of bribes to get this or that large-scale biennial into one peripheral region or another—is a taboo even on the agenda of most artists who consider themselves political. Even though political art manages to represent so-called local situations from all over the globe, and routinely packages injustice and destitution, the conditions of its own production and display remain pretty much unexplored. One could even say that the politics of art are the blind spot of much contemporary political art.

Of course, institutional critique has traditionally been interested in similar issues. But today we need a quite extensive expansion of it.[5] Because in contrast to the age of an institutional criticism, which focused on art institutions, or even the sphere of representation at large, art production (consumption, distribution, marketing, etc.) takes on a different and extended role within post-democratic globalization. One example, which is a quite absurd but also common phenomenon, is that radical art is nowadays very often sponsored by the most predatory banks or arms traders and completely embedded in rhetorics of city marketing, branding, and social engineering.[6] For very obvious reasons, this condition is rarely explored within political art, which is in many cases content to offer exotic self-ethnicization, pithy gestures, and militant nostalgia.

I am certainly not arguing for a position of innocence.[7] It is at best illusory, at worst just another selling point. Most of all it is very boring. But I do think that political artists could become more relevant if they were to confront these issues instead of safely parade as Stalinist realists, CNN situationists, or Jamie-Oliver-meets-probation-officer social

4 There are of course many laudable and great exceptions, and I admit that I myself may bow my head in shame, too.

5 As is also argued in the reader *Institutional Critique*, eds. Alex Alberro and Blake Stimson (Cambridge, MA: The MIT Press, 2009). See also the collected issues of the online journal *transform*.

6 Recently on show at Henie Onstad Kunstsenter in Oslo was "Guggenheim Visibility Study Group," a very interesting project by Nomeda and Gediminas Urbonas that unpacked the tensions between local (and partly indigenist) art scenes and the Guggenheim franchise system, with the Guggenheim effect analyzed in detail in a case study. Also see Joseba Zulaika, *Guggenheim Bilbao Museoa: Museums, Architecture, and City Renewal* (Reno: Center for Basque Studies, University of Nevada, 2003). Another case study: Beat Weber, Therese Kaufmann, "The Foundation, the State Secretary and the Bank – A Journey into the Cultural Policy of a Private Institution," See also Martha Rosler, "Take the Money and Run? Can Political and Socio-critical Art 'Survive'?" *e-flux journal*, issue 12, and Tirdad Zolghadr, "11th Istanbul Biennial," *Frieze*, November 1, 2009.

Installation view, Hito Steyerl, *Factory of the Sun*, 2015

engineers. It's time to kick the hammer-and-sickle souvenir art into the dustbin. If politics is thought of as the Other, happening somewhere else, always belonging to disenfranchised communities in whose name no one can speak, we end up missing what makes art intrinsically political nowadays: its function as a place for labor, conflict, and ... fun—a site of condensation of the contradictions of capital and of extremely entertaining and sometimes devastating misunderstandings between the global and the local.

The art field is a space of wild contradiction and phenomenal exploitation. It is a place of power mongering, speculation, financial engineering, and massive and crooked manipulation. But it is also a site of commonality, movement, energy, and desire. In its best iterations it is a terrific cosmopolitan arena populated by mobile shock workers, itinerant salesmen of self, tech whiz kids, budget tricksters, supersonic

7 This is evident from this text's placement on e-flux as an advertisement supplement. The situation is furthermore complicated by the fact that these ads may well flaunt my own shows. At the risk of repeating myself, I would like to emphasize that I do not consider innocence a political position, but a moral one, and thus politically irrelevant. An interesting comment on this situation can be found in Luis Camnitzer, "The Corruption in the Arts / the Art of Corruption," published in the context of The Marco Polo Syndrome, a symposium at the House of World Cultures in April, 1995.

Hito Steyerl

translators, PhD interns, and other digital vagrants and day laborers. It's hard-wired, thin-skinned, plastic-fantastic. A potential commonplace where competition is ruthless and solidarity remains the only foreign expression. Peopled with charming scumbags, bully-kings, almost-beauty-queens. It's HDMI, CMYK, LGBT. Pretentious, flirtatious, mesmerizing.

If You Don't Have Bread, Eat Art!: Contemporary Art and Derivative Fascisms

Hito Steyerl

excerpted, from *e-flux journal*, October 2016

Degenerate Art

Predictably, this leads to resentment and outright anger. Art is increasingly labeled as a decadent, rootless, out-of-touch, cosmopolitan urban elite activity. In one sense, this is a perfectly honest and partly pertinent description.[1] Contemporary art belongs to a time in which everything goes and nothing goes anywhere, a time of stagnant escalation, of serial novelty as deadlock. Many are itching for major changes, some because the system is pointless, harmful, 1 percent-ish, and exclusive, and many more because they finally want in.

On the other hand, talk of "rootless cosmopolitans" is clearly reminiscent of both Nazi and Stalinist propaganda, who relished in branding dissenting intellectuals as "parasites" within "healthy national bodies." In both regimes this kind of jargon was used to get rid of minority intelligentsia, formal experiments and progressive agendas; not to improve access for locals or improve or broaden the appeal of art. The "anti-elitist" discourse in culture is at present mainly deployed by conservative elites, who hope to deflect attention from their own economic privileges by relaunching of stereotypes of "degenerate art."

So if you are hoping for new opportunities with the authoritarians, you might find yourself disappointed.

Authoritarian right-wing regimes will not get rid of art-fair VIP lists or make art more relevant or accessible to different groups of people. In no

1 I very much agree with Ben Davis's excellent text "After Brexit, Art Must Break Out of Its Bubble," *Artnet News*, June 28, 2016.

way will they abolish elites or even art. They will only accelerate inequalities, beyond the fiscal-material to the existential-material. This transformation is not about accountability, criteria, access, or transparency. It will not prevent tax fraud, doctored markets, the Daesh antiquities trade, or systemic underpay. It will be more of the same, just much worse: less pay for workers, less exchange, fewer perspectives, less circulation, and even less regulation, if such a thing is even possible. Inconvenient art will fly out the window—anything non-flat, non-huge, or remotely complex or challenging. Intellectual perspectives, expanded canons, nontraditional histories will be axed—anything that requires an investment of time and effort instead of conspicuous money. Public support swapped for Instagram metrics. Art fully floated on some kind of Arsedaq. More fairs, longer yachts for more violent assholes, oil paintings of booty blondes, abstract stock-chart calligraphy. Yummy organic superfoods. Accelerationist designer breeding. Personalized one-on-one performances for tax evaders. Male masters, more male masters, and repeat. Art will take its place next to big-game hunting, armed paragliding, and adventure slumming.

Yay for expensive craft and anything vacuous that works in a chain-hotel lobby. Plastiglomerate marble, welded by corporate characters banging on about natural selection. Kits for biological "self-improvement." Crapstraction, algostraction, personalized installations incorporating Krav Maga lessons. Religious nailpaint will slay in all seasons, especially with a Louis Vuitton logo. Hedge-fund mandalas. Modest fashion. Immodest fashion. Nativist mumbo jumbo. Genetically engineered caviar in well-behaved ethnic pottery. Conceptual plastic surgery. Racial plastic surgery. Bespoke ivory gun handles. Murals on border walls. Good luck with this. You will be my mortal enemy.

Just like institutional critique was overtaken by a neoliberal Right that went ahead and simply abolished art institutions, the critique of contemporary art and claims for an exit from this paradigm are dwarfed by their reactionary counterparts. The reactionary exit—or acceleration of stagnation—is already well underway. Algorithmic and analogue market manipulation, alongside the defunding, dismantling, and hollowing-out of the public and post-public sector,[2] transforms what sometimes worked as a forum for shared ideas, judgment, and experimentation into HNWI interior design. Art will be firewalled within isolationist unlinked canons, which can easily be marketed as national, religious, and fully biased histories.

2 By "post-public" I mean semi-public corporate ventures like biennials and many institutions and museums.

The Cultural Logic of Financialization: Melanie Gilligan

Holger Kuhn

Since 2008, the New York-based artist Melanie Gilligan has been investigating what it means to live under the conditions of contemporary capitalism through a number of filmic miniseries. What modes of subjectivation and collective forms of life emerge in a world characterized by the financialization of practically all aspects of life, by post-Fordist conditions of labor, by governmental biopolitics, and by large-scale data surveillance and its algorithmic analysis? Before she started working as a filmmaker, Gilligan had addressed these questions in some pieces of art criticism. Since 2003, she has published several reviews and essays in *Mute*, and since 2005, she has written several exhibition reviews for *Texte zu Kunst* and *Artforum*. Among these, two texts in particular stand out. "Derivative Days. Notes on Art, Finance, and the Unproductive Forces" was first published in 2008 in *Texte zur Kunst*. The article delineates a kind of "derivative condition" prevalent in the financial industry as well as in contemporary art. Here it is not material production, but rather the speculative circulation of fragmented and newly consolidated securitized assets (in the financial industry) and of cultural semantics (in art) that emerge as the shared basis for financial and artistic activity. The other text—which is republished here in a slightly abridged form—first appeared in *Artforum* in 2007. In this article, she identifies a "performative condition" that unites contemporary art and capitalism. She observes that performative practices have proliferated in the art world in recent years, and identifies this process as a cultural symptom of

the flexibilization and precarization of working conditions under the guise of so-called immaterial labor.

These texts are characterized by a distinctive way of reading cultural processes. Instead of focusing on content, they concentrate on the grammar, forms, or deformations or even the political syntax of a rather wide range of artistic works. These appear as symptoms, and as effects, but also as generators and amplifiers of economic processes. Shortly before the financial quakes of 2008, Gilligan focused on derivatives and performance as the "cultural logic" (Fredric Jameson) of late capitalism in general. Gilligan's text can be situated within three debates on political art and its capacity for critique. I would like to highlight the artist's particular reorientations as models of contemporary art criticism. First, the diagnosis of a performative imperative is a variant of earlier diagnoses which had identified a participatory turn or social turn, and which had been widely discussed since the nineties. In 2006, also in *Artforum*, Claire Bishop explained how these turns led to an ethical turn in art criticism, toward a form of judgment that employs moral, political, or ethical criteria in lieu of aesthetic criteria. Gilligan, however, looks particularly at the question of aesthetic practices and their interplay with economic and political conditions.

Second, by the end of the nineties it had become the norm to regard artistic modes of life as exemplarily precarized. Artists were considered inhabitants of a project-oriented cité, whose performative acts no longer produced artworks and who would thereby express the antinomies of the post-Fordist world. Gilligan expands this view, however. The performative as cultural logic characterizes not only the acts of artists, but also those of the spectators, and indeed the formal syntax of entire exhibitions and even the gestures of critical theory. Precisely because this phenomenon spreads itself so widely, it is both possible and necessary to examine the underlying social forms of labor.

Third, Gilligan restages an argument that Luc Boltanski and Ève Chiapello popularized around 2000, in which they claim that what they call artistic critique (which criticizes processes of standardization, disciplinization, and the loss of authenticity) had been co-opted by the new spirit of capitalism, a process that began already in the sixties. Creativity, flexibility, the integration of emotional, affective, and performative skills are not only attributes of artists, but are characteristic of the job requirements for every mid-level employee. In Michel Foucault's words, people are becoming "entrepreneurs of themselves." It is precisely these forms of critique that rely on the flexibilization of subjects that have been appropriated by late capitalism. This does not mean, however, that critique is futile or doomed to failure from the start. Rather, it is the thorn that challenges critique, as Gilligan demonstrates in her writing and film series.

The Beggar's Pantomine: Performance and its Appropriations

Melanie Gilligan

excerpted, from *Artforum*, November 2011

Few aphorisms are more famous than the redoubtable "History repeats itself, the first time as tragedy, the second time as farce"—an observation typically attributed to Karl Marx. In fact, however, this assertion is merely a paraphrasing of the political philosopher. Opening his 1852 study of "bourgeois revolution," *The Eighteenth Brumaire of Louis Bonaparte*, Marx writes: "Hegel remarks somewhere that all great world-historic facts and personages appear, so to speak, twice. He forgot to add: the first time as tragedy, the second time as farce." What is obscured in the popularized adage, then, is the specifically *theatrical* character of Marx's original formulation (along with some of its wry nuance). In addition to referencing two dramatic genres, tragedy and farce, he says that personages "appear," as if they were making grand entrances on the world stage. And later in the same essay, Marx invokes still other theatrical tropes, noting that "epochs of revolutionary crisis ... anxiously conjure up the spirits of the past, ... borrowing from them names, battle slogans, and costumes in order to present this new scene in world history in time-honored disguise and borrowed language." Indeed, he observes, the French Revolution of 1789 "draped itself alternately in the guise of the Roman Republic and the Roman Empire," while the Revolution of 1848 "knew nothing better ... than to parody, now 1789, now the revolutionary tradition of 1793–95."

While perhaps clichéd, the entire opening passage of *The Eighteenth Brumaire*, with its almost campy imagery of republicans festooned in the trappings of imperial Rome, might have a useful afterlife today as an allegory for contemporary art. It's not too far-fetched to suggest that here we find a rather clear figuring of the tangled present-day relations of history and theater—or better, of politics and performance. In the latter field, adopting the "guise" of bygone "revolutionary traditions"—re-creating iconic historical works, particularly those of the 1960s and '70s—has lately become standard practice. The most prominent recent manifestation of this impulse is probably Marina Abramović's "Seven Easy Pieces," a series of performances that took place in 2005 at the Solomon R. Guggenheim Museum in New York, where the artist restaged seven works epitomizing the transgressive ethos of the Conceptual era—

among them, Vito Acconci's *Seedbed*, 1972; Valie Export's *Action Pants: Genital Panic*, 1969; and Bruce Nauman's *Body Pressure*, 1974. But Abramović's endeavor is only the apotheosis of a much broader international trend where, for example, an artist such as Catherine Sullivan incorporates into her theatrical performances (on stage and in film) elements of John Ford's seventeenth-century tragedy *'Tis Pity She's a Whore* and the 1964 Fluxus Festival in Aachen, Germany; where the New York–based Clifford Owens performs the work of Fluxus member Benjamin Patterson; and where the collective Continuous Project reenact art-world panel discussions from decades before, as they did in the recent exhibition *"Wieder und Wider*: Performance Appropriated" at Vienna's Museum Moderner Kunst Stiftung Ludwig—to say nothing of more general gestures toward art history by Lucy McKenzie and Paulina Olowska in their salon-cum-bar and performances evoking the early modernist avant-garde, and by Daria Martin in her films reflecting the strong influence of modern performance and dance....

If, to return to the example of Abramović's "Seven Easy Pieces," to be a spectator at the Guggenheim was to feel keenly the disjunction between actions performed then and now, then what was the implication of such self-reflexive historicization? Whereas, say, the original *Seedbed* was a famously awkward piece to experience—the gallery visitor uncomfortably aware of Acconci's masturbatory pleasure below the floorboards—at the Guggenheim this piece seemed less disquieting, with any sense of taboo neutralized by the audience's and institution's general approbation. The radical content of the work was kept intact, but to reassuring rather than transformative effect—creating a pronounced difference from Acconci's original, and so forcing us to ask what creative and critical potential there might be in such "conjuring of the spirits." For Marx, some historical repetitions succeed in "glorifying ... new struggles," others merely in "parodying ... the old." Is there an analogous distinction to be made here? Which practices involving reenactments might be retrograde withdrawals from new aesthetic and political struggles, and which others are catalysts for them?

In seeking to answer these questions, we might start by noting that the apparent urge to revisit avant-garde performance has coincided with a radical diffusion of performativity itself. In recent years, the definition of performance art has expanded exponentially. The sphere of ostensibly traditional object-production now overflows with practices considered performative by dint of their execution or content; performance almost seems on the verge of achieving objecthood itself (judging by such recent indicators as a conference at London's Showroom gallery last May

Melanie Gilligan

dedicated to "the performance of new sculpture," or, also in London, "Absence Without Leave," an exhibition at Victoria Miro Gallery focused on "performance as a material"). But performativity is more widely seen as inhering in the general comportment of artists, who are appraised, and praised, for their construction of a role. Here one thinks of Maurizio Cattelan and Jeff Koons, and especially of that exemplar of the contemporary-artist-as-performer, Kippenberger, who is lauded for self-consciously enacting an obsession with, and sardonic distance from, his own career.

At the same time, with the ascendance of relational and dialogic modes in particular, social interactions that may not actually involve the artist have come to be frequently redeployed in a range of practices that escape such appellations, yet are framed as performative. Social situations become readymades, if often very much "assisted" in Duchamp's sense of the term (as in, say, Carlos Amorales's Mexican wrestling match). "Actions and Interruptions," an event presented in London at Tate Modern one weekend last March, bespoke the continuing prevalence of such strategies while offering some representative instances: Into the museum's cultural-tourism maelstrom were inserted various actions closely resembling the everyday behavior of gallery visitors, with several too likelife even to garner an audience. Roman Ondák's *Good Feelings in Good Times*, 2003, for instance—a queue leading nowhere—was camouflaged between actual, but similarly interminable, queues for elevators, tickets, and Carsten Höller's slides. Elsewhere, Nina Jan Beier and Marie Jan Lund's *Clap in Time (All the People at Tate Modern)*, 2007, planted groups of people throughout the museum; commencing to clap wildly at an appointed time, they inspired other visitors, who had no idea what they were applauding, to follow suit. A common conceptual underpinning of work in this vein is a particular notion of the spectator's activation—a dimension that has given rise, in turn, to a kind of paradox. Artists (and dramaturges) throughout the twentieth century sought to disrupt modern performance and theater's dualism of actor versus spectator; now, they not only ask for an active spectator but also insist that such a viewer has, in fact, become a performer—and so must regard his or her own actions as, well, acting. (In this last point lies a crucial distinction from, say, Michael Fried's famous formulation of theatricality, in which the viewer completes the work.) Not that we necessarily consider ourselves to be acting while standing in line at the Tate—or, for that matter, while climbing through a dirty fridge in a Christoph Büchel installation or embarking on a Janet Cardiff walking tour—but nevertheless, conventions of artmaking and viewing have

shifted to elicit from the spectator a dramatic sense of self-conscious reflection....

Performance has lately acquired a central status in institutional programming, and occupies a similarly important place at art fairs, where it fills a critical inter-shopping-relaxation niche as the free aperitif that whets the appetite for the billed dish of painting and sculpture—the sexy supplement that makes everything else seem less run-of-the-mill. In each case, performance is valued for its potential to reimport a desired immediacy, albeit one often accompanied by caveats acknowledging the ubiquity of mediation. Yet in these contexts, the immediacy and immateriality of performance—once counterstrategies against commodification—aid rather than inhibit its functioning within the market. The medium has clearly moved past its historically antispectacular mission. By this logic, the spectator who is conscripted as performer is also conscripted as commercial-corporate functionary. We can all fairly say, "*Le Spectacle, c'est moi!*"

While such dialectics of immediacy and mediation have of course always haunted performance, today they may be of greater consequence. Many contemporary theorists argue that performance has become a pervasive quality of everyday life—which would suggest that art, whatever its historical returns, may be rehearsing broader cultural trends. A consideration of one key turn in performance history—the transition from the West's medieval model of theater to its modern one—offers some historical context, while resonating intriguingly with contemporary notions of all-pervasive performativity.

In the Middle Ages, a spectator at a play might sit on the stage or perambulate below it, socializing audibly and sometimes directly addressing the actors, who might well respond in turn. This porous relation between the stage and the audience, of course, is no longer common—largely due to the writings of Enlightenment philosopher Denis Diderot. One of the major modernizers of the theater, he devoted considerable energy to a critique of the medieval model, advocating its replacement with the naturalistic illusions that we now think of as theater's most entrenched conventions: the imaginary fourth wall; the actors who behave as if the audience is not there; and the spectators who sit passively in darkness. It is somewhat jarring, then, to come across the following passage in Diderot's 1762 dialogue *Rameau's Nephew*:

Whoever needs someone else is a beggar and takes up a position. The king takes up a position before his mistress and before God; he performs his pantomime step. The minister goes through the paces

Melanie Gilligan

of prostitute, flatterer, valet, or beggar in front of his king. The crowds of ambitious people dance your positions in hundreds of ways, each more vile than the others, in front of the minister. The noble abbé in his bands of office and his long cloak goes at least once a week in front of the agent in charge of the list of benefices. Good heavens, what you call the beggar's pantomime is what makes the world go round.

It appears that in its new role as art-world entertainment, performance art itself has "taken up a position" in Diderot's sense. (Notably, the French *position*, which may also be translated as *posture*, connotes artifice to a greater degree than its English cognate.) When most artists are considered performers of one kind or another, it becomes all too easy to imagine the art world as a similar and teeming tableau of actors. Indeed, looking at the work of Tamy Ben-Tor—who in her own performances assumes a succession of art-world positions, caricaturing figures like the deathly bland artist-in-residence or the relational artist who makes pad thai—one might speculate that at least one artist has already conceived of such a tableau, and made it her subject. But what is most striking here is that Diderot, so intent on bracketing theater as a sphere separate from, and other than, that of everyday experience, seemed nonetheless to be grappling with the sense that theater was somehow rampantly unbracketed—that we are all potentially performing, all the time. And unlike Shakespeare's "All the world's a stage," Diderot's conception of all-encompassing performativity is not abstract, metaphorical, existential; it is structural, social, economic. The "we" in Diderot's construction is not universal—his kings, ministers, and abbés, already invested with a degree of power that they struggle to maintain or increase, occupy a specific stage. Their backdrop is recognizably that of a nascent meritocracy where capitalism is introducing a new instability into the social order, imposing the imperative to compete and then unloosing the "ambitious crowds." Embedded, then, in the origins of modern theater is a prescient awareness of where the economic developments unfolding in the eighteenth century might lead. The fourth wall was perhaps intended to hold back, like a dam, an encroaching performative imperative inherent in modernity.

If this is the case, then the consensus would seem to be that the dam has now burst, as theorists across disciplines have identified a generalized condition of performativity in contemporary labor—one emerging from the current regime of production, which produces and exploits communication and social relations in addition to conventional, tangible commodities. From the service sector to the white-collar firm, the social

performance and communication skills of employees (e.g., "Have a nice day!") are under close scrutiny and are often scripted. And we have our latter-day *philosophe* to parse some of the broader implications. Italian philosopher Paolo Virno, in describing this regime of production, which he calls post-Fordist, theorizes similarities between politics and performance: Both are communicative and require the presence of others as well as frequent improvisation, while as activities neither produces a physical finished product. For Virno, these similarities coalesce around the idea of "virtuosity." As he defines it, a virtuoso is any performer whose "*activity ... finds its own fulfillment (that is, its own purpose) in itself,*" and who doesn't produce "an object which would survive the performance.... One could say that every political action is *virtuosic.*" However, Virno asserts that, in the current economy, labor has also become virtuosic (it is communicative; it requires the presence of others; etc.). Capital now reproduces qualities of political action as labor—and what this points toward is a neutralization of politics itself. At present, Virno suggests, "Political action ... seems, in a disastrous way, like some superfluous duplication of the experience of labor."

Of course, Virno and Antonio Negri's theorizations of immaterial labor notwithstanding, much of the world is still very much engaged in Fordist or, indeed, pre-Fordist production: The physical "finished product" shows no signs of evanescing. In concrete terms, the notion of immaterial labor and Negri's "cognitariat" both refer to relatively affluent workers in Western economies. But to the extent that post-Fordism is a significant tendency in contemporary capitalism, this economic regime and the arguments that address it are a significant influence on contemporary art. It hasn't escaped observers that art production today, particularly its recent performative turn, echoes the move away from creation of tangible goods and toward the production or transmission of social relations.... Extrapolating, we could say that the gung-ho return to performance in the art world also participates in a certain duplication of the experience of (immaterial) labor—a proximity that threatens to annul whatever political dimension a given performance may possess.

Virno's theorization of virtuosity, a key reference point in current art criticism, contrasts quite starkly with what might be called its chief competition—Jacques Rancière's thought on politics and performance (which was examined in the March 2007 issue of *Artforum*). To briefly summarize: For Rancière, power is a function of what he terms "the distribution [or partition] of the sensible"—the social order that recognizes certain people or things as visible or perceptible and others as invisible or imperceptible. In any given society at any given moment, he

says, there are always those who are invisible, nameless, denied a place in this order, a group he terms "the part of no part." He describes political action as the constitution of an artificial, which is to say, theatrical, sphere, in which "the part of no part" performs in order to *become visible*, appropriating roles that are normally unavailable to them. (Rancière offers the example of nineteenth-century workers casting themselves as lovers of "high" literature.) The part of no part carries out these appropriations in fleeting, provisional ways, effecting transitory destabilizations of the order of the sensible—since any stable, long-term incursions would simply constitute a new, equally constrictive order. This model counters more conventional understandings of political action as direct and unmediated behavior, and—in opposition to Diderot's array of beggars' pantomimes or Virno's ranks of laboring virtuosos—affirms the emancipatory qualities of role-play, much as Judith Butler does in her well-known discussions of performativity and gender. Rancière further designates the spectacle itself as the arena in which visibility, or equality, is fought for. He argues against Guy Debord's account of the spectacle as a realm of appearances that separates subjects from themselves: For Rancière, subjects/spectators are never wholly immersed in the spectacle, but retain a critical distance, actively and consciously engaging with what they see. This orientation toward the spectacle and belief in the possibilities embodied in performance align Rancière with a great deal of contemporary artistic production.

By way of a case study, we might look at Catherine Sullivan's video installation *The Chittendens*, 2005, which figures, with remarkable succinctness, the intersections of performance, labor, and politics that Virno and Rancière take up in their different ways. Taking a disused office building for the work's setting and her title from the name of an insurance firm, Sullivan directs a group of sixteen actors to perform a rapidly alternating sequence of "attitudes"—feigned emotional and physical responses ranging from the laconically understated ("mild amusement," "smelling roses") to the histrionic ("militant's last stand," "falling to pieces"). Like Marx's republicans, the actors are literally draped in the costumes of a heroic past—in this case, America's. There are a nineteenth-century sailor and a naval officer; a Southern belle; a swimmer and a muscleman from the early twentieth century; and a number of office workers in period clothing of various decades. All embody bathetic, or farcical, repetition. The actors go through their manic and comical paces in a convulsive, syncopated order scripted to emulate Fluxus scores, in a state of perpetual role traversal, not "glorifying … new struggles," but "parodying … the old." By serializing this stream

Marina Abramović, *Seven Easy Pieces*, Solomon R. Guggenheim Museum, 2005

of hyperbolic action, Sullivan severs any naturalistic link between the actors and their acts; instead we find a schizophrenic typology of hollow personae. Though these characters certainly are not working in any conventional sense, the office, and by extension the communicative post-Fordist labor performed there, is the horizon by which their activity is defined....

Sullivan associates the atomized quality of the performances in *The Chittendens* with a specifically American drive toward individualism and self-determination, which she in turn blames for the present abysmal state of American politics. However, no political dimension appears to open up in these performances, which simply offer the spectacular mirror image of a post-Fordist demand for frequent and, as it were, surplus transformation. Of course, one could say that precisely therein lies the work's criticality, but such mimesis makes for watered-down criticism. More to the point is the degree to which Sullivan's characters seem almost to satirize the model of Rancièrean political struggle. Clearly situated within spectacle and adopting multiple roles, they nevertheless represent not the philosopher's "part of no part," but the American middle class, past and present (as immaterial laborers). This disjunction resonates with a crucial discrepancy within Rancière's thought:

Melanie Gilligan

Without taking economic conditions into account, it is difficult to see how "the part of no part"—the working class, immigrant laborers, slum dwellers—can actually stage an appropriation of roles without being condemned to enact the infinite repetition of their performances, much like the *Chittendens*' actors, effecting, over and over, fugitive redistributions of the sensible. In this sense, Rancière's notion of fleeting political events and transitory roles coincides perhaps too well with a model of accumulation dependent on movement, flexibility, and performative labor. Philosopher Peter Hallward puts it bluntly, noting that "Rancière ... came to embrace the rhetoric of mobility and liminality at precisely the moment when newly mobile, 'fragmentary' ... forms of production deprived them of any clear critical purchase."

Also working to undermine the critical traction of Rancière's ideas is the fact that redistributions and disruptions of the sensible are a primary operation of contemporary commerce. Advertising and media thrive on disruptive frisson; reorderings and subversions of existing visual, affective, and semiotic codes (e.g., guerrilla marketing) can generate revenue. The same logic is manifest in fields as diverse as urban planning (the adoption of Situationist-style psychogeography in gentrification strategies) and finance (financial instruments that derive profit from market instability). This is not to say that the political possibilities of assuming appropriated roles are foreclosed, nor does it mean that exceptional political and aesthetic events that qualify as true redistributions of the sensible cannot exist. One might even counter these caveats by arguing that for Rancière, the above examples would simply constitute aspects of the existing present order, rather than redistributions that reconfigure said order. Yet under deregulated, decentralized late capitalism, reclassifications and rearticulations of established representations are the norm, not the exception. Although Rancière seeks to vitiate modernist critiques of spectacle and spectatorship, contemporary artworks that attempt to reorganize conventional roles by activating the spectator evince a logic of performative redistribution similar to his own, functioning, more often than not, as explicit allegories for wider social reactivations and for participatory politics; and while such allegories poignantly suggest a longing for agency and empowerment, they look tragically flimsy in light of the difficulties of transforming existing roles within today's *theatrum mundi*—in which roles may indeed be frequently reordered, but without really altering the script. Performative redistributions (a category into which, say, Acconci's original *Seedbed* might fall) are absorbed and instrumentalized not only in the art world but in a wider social field greatly influenced by aesthetic strategies of unsettling and

critique. This fact, although it does not negate concepts like Rancière's, certainly makes their formulation trickier.

It seems fair to say, then, that both performative imperatives as illuminated by Virno and performative reorderings of the social field as theorized by Rancière are essential ingredients of contemporary capitalism. Much performance art at the moment appears influenced by the former, and uncertain how or whether to achieve the latter.... Also perhaps worth considering anew is performance's status as a specifically *communicative* medium. No matter how much it approaches the level of *Gesamtkunstwerk*, performance will always make for relatively rudimentary spectacle and will necessarily foreground language and movement—the basic tools of communication. In one striking passage in *The Eighteenth Brumaire*, Marx interjects a linguistic metaphor among the theatrical ones: Referring to the 1848 revolution—for him, a failed parody of 1789—he observes that "the phrase went beyond the content." But in the social revolution of the future, the one he hopes will come to pass, "the content goes beyond the phrase." Performance's communicative status corresponds, of course, with the post-Fordist paradigm—the medium speaks the social language of its time. But it has the capacity to exceed the constraints of the conditions that generated it, stretching that lingua franca, going beyond the phrase.

Camp and Credit Cards:
Takashi Kashima

Yuriko Furuhata

In the early nineties, a relatively unknown American "marine artist" and amateur surfer Christian Riese Lassen (born in 1956) gained notoriety in Japan. His original works were sold widely at department stores as well as his flagship gallery in the center of Tokyo. Even outside urban areas, replicas of his dolphin paintings circulated as posters. A critical reevaluation by art critic Takashi Kashima explores the curious popularity of Lassen's artwork in nineties Japan. This allows a historicization of Lassen's multimedia marketing strategy and shows the blurred boundary between art and the market in relation to a comparable phenomenon of "New Academism" that commodified the circulation of critical theory in eighties Japan.

Lassen is a commercial artist whose marketing strategies embed the logic of mechanical reproduction, as Walter Benjamin put it. Lassen sells his paintings alongside associated merchandise that are mass-produced reproductions of his paintings in the forms of ordinary objects: posters, T-shirts, jigsaw puzzles, cups, computer-mouse trackpads, and so forth. As the following essay suggests, Lassen was relentless in attracting Japanese buyers for his artwork, which included an aggressive strategy of conspicuous street solicitations by gallery attendants. Like Takashi Murakami, Lassen collaborated with upscale commodity brands such as Lamborghini, for whom he painted luxury cars. To better understand the conditions of possibility for Lassen's unique reception in early-nineties Japan and to situate this in relation to the changing authority of art crit-

icism, it is helpful to note another parallel historical phenomenon: the rise of the colloquially-monikered New Academism in eighties Japan marks a moment of the unprecedented commercialization of critical theory or criticism as commodity. This is evinced by popular translations and interpretations of French theorists through the publication of books including Akira Asada's *Structure and Power: Beyond Semiotics* (1983), a work that became a commercial bestseller, propelling its author to celebrity status.

This importation of critical theory took a very different route in North America, where it was limited to circulation within academia, as exemplified by publications such as the journal *October* and its school of highbrow, Conceptual Art-focused criticism in New York. This impact spilled over to Japan from the eighties onward, and shaped much of the institutional discursive milieu of contemporary art criticism. Influenced by *October*-style critical discourse, Japanese art historians have not taken Lassen seriously. In this sense the recent publication of the anthology *Lassen to wa nandatta noka (What Was Lassen)?* edited by Yuki Harada (2013) signals a historical reappraisal of the cultural impact of lowbrow art, which is more in line with the New Academism's approach to the popularization of theory.

Lastly, we may read Lassen's ongoing popularity in Japan in light of the recent nostalgia of eighties and nineties popular culture and of Japan's "bubble era" speculative economy. This is evident in the spread of internet-based subcultures such as Vaporwave and Seapunk. These music and fashion subcultures circulating in North America and Japan often feature visual elements that resonate with Lassen's marine art (e.g. the images of dolphins).

To conclude, we may be tempted to dismiss Lassen's work as naïve, tacky, and kitschy, given its tendency toward New Age cosmic spiritualism mixed with surfer fashion and the gaudy souvenir aesthetics of aquatic theme parks such as SeaWorld in Florida. But it is precisely these elements that compel us to reflect on the resonance between his work and the familiar art critical concepts of kitsch and camp. The current revival and reappraisal of Lassen's work and its cultural impact, as marked by the publication of the anthology, thus fit the sensibility of camp that appropriates popular and mass cultural objects from a bygone era. His work is excessively decorative, unabashedly commercial, and extremely gaudy; it rides heavily on the waves of New Age spirituality. Lassen's critical rediscovery in the twenty-tens amidst a broad nostalgia for the nineties by the general public as well as Japanese critics and curators suggests a need to rethink the future of art criticism in light of the current wave of nostalgia, camp, and the ongoing commodification of art and critical theory.

This Excess Called Lassen: What Is it That Art History Cannot Write?

Takashi Kashima

from *Lassen to wa nandatta noka (What Was Lassen?)*, 2013

Introduction

It was like being hypnotized. A young woman in a body-hugging dress was showing me a painting, whispering in my ear, "Look! It's like it's alive! You can have the ocean in your room! It's like a dream," and as I heard her say that, the hypnotic feeling overcame me.

"Come on in, you can look for free!" I'd been solicited like this on the street by a woman wearing an orange mesh vest how many times by now? I could see the showroom was decorated with vivid prints that looked like the work of Christian Riese Lassen (born in 1956), but I'd never brought myself to enter it. Truth be told, I'd heard that a credit contract lurked beneath those solicitous words, so I'd never even considered it.[1]

I was in no position to sincerely respond to each and every proposition that came my way amid this advertisement-plastered urban space anyway. That was the real reason why I pretended as if I couldn't hear or see, and hurried past. To us, the word "Lassen" was yet another advertisement competing for our attention, making the prospect of looking at his work itself a con rather than a pro.

In this piece, I will be looking less at Lassen's works, but rather at the meanings we assigned to him at the time. I am doing this to figure out what it might be that Lassen's work illuminates within our society.

Original Art Purchasing and Credit Contracts

Lassen began becoming well-known in Japan in the early nineties. Born in California in 1956 and relocating with his parents to Maui, Hawaii, when he was eleven, Lassen became known first for the Marine Art Series paintings he presented in the mid-eighties, which were said to possess "a fresh, vivid use of color and a finely detailed realism that gives the impression that the whole picture is floating up toward the viewer." He was popular mainly with "men and women in their thirties" (the "bubble" generation born in the sixties), with the Shibuya branch of

1 "A new religion of pictures: the hidden underbelly of the crazy boom in ¥80,000 'luxury posters' by popular artist C. Lassen," *Shūkan Bunshun*, December 1, 1994, p. 124.

the department store Tokyu Hands reportedly selling "eighty posters a month" of his—at ¥9,800 a pop.[2]

Amid this boom, Art Vivant, with whom Lassen had signed a distribution contract, opened a "Galerie Musée" in the floor beneath the Shibuya 109 building in 1990, and the next year they mounted an exhibition of Lassen's "mystical marine art, filled with schools of fish and images of the sea," thus "capturing the hearts of young women with these fantasy pictures." Further, Lassen's paintings, with their "unique compositional split between the world underwater and the world above" possessed the special characteristic of "showing not only schools of vividly hued tropical fish swimming through the water, but also views of the coastal landscape or whales leaping up from the crashing waves," and "young couples were a common sight at the exhibition venue."[3]

What is important about these exhibitions was that they sold not just mass-produced posters, but also works that were "prints." In terms of selling prints, the precedent set by the well-known Japanese silkscreen artist Hiro Yamagata played a vital role, his vivid blue-based prints anticipating Lassen's arrival to the scene. Yamagata's work went for "between ¥400,000 and ¥800,000 per print, with the most expensive pieces going for ¥1,600,000," but they were nonetheless bought by "people in their twenties and thirties" using "credit," and, together with "prints by the artists C. Lassen and T. McKnight," constituted a "burgeoning market totaling upwards of two hundred billion yen."[4] Further, buyers at the time differentiated between the posters and the "real thing," quoted saying, for example, "I love the sea, and I'd been interested in Lassen for a while, so I bought a poster for around ¥10,000. But I know it's nothing like the real thing! I'd do anything to get one of those!"[5] In other words, there was a strong distinction being made between "copies and originals" when it came to works by Lassen and Yamagata, and enjoying that distinction itself became commercialized.

The result was the emergence of a social problem. According to the June 8, 1994 edition of the *Asahi Shimbun* newspaper, "the National Consumer Affairs Center of Japan reported that the amount of people

2 "For those who express themselves via interior décor featuring different art posters (bestsellers)," *Nikkei Ryūtsū Shimbun*, April 18, 1991, p. 21.

3 "An art-surf painter emerges from the sea and gains popularity (consumer information)," *Nikkei Ryūtsū Shimbun*, July 11, 1991, p. 23.

4 "Faith in the original: signed original prints gain popularity, young fans spending a month's salary (culture: thoughts on art and money 2)," *Asahi Shimbun*, June 8, 1994, evening edition, p. 7.

5 "A new religion of pictures: the hidden underbelly of the crazy boom in ¥80,000 'luxury posters' by popular artist C. Lassen," *Shūkan Bunshun*, December 1, 1994, p. 216.

Takashi Kashima

seeking help for debts related to art purchases rose sharply from around 200 cases in 1989 to 1,214 cases by 1993," and that "almost all these cases involved young people in their twenties." In the majority of these cases, the concerned parties had "entered into a credit contract after receiving a lengthy explanation, but repayment had become too burdensome and they wished to be released from the contract." Further, "the names of the artists involved were not tabulated, but the names Lassen and Yamagata frequently came up."[6] Additionally, according to the buyer whose testimony was quoted at the beginning of this article, "my monthly net salary amounts to ¥110,000. The next day, I woke up and realized I'd made an impossible purchase. I requested to be let out of the contract, but was told 'the manager isn't here at the moment,' and then later, that 'the item has already been ordered, so there's nothing more we can do.'"[7] For us, then, owning a Lassen was less about a pure interest in art (is it a copy or an original?) than about getting roped into an impossible purchase that came with this sort of "credit contract."

Lifestyle: The Blond Playboy

So what was it that we were seeing when we looked at Lassen? When he first became a subject of interest in Japan, Lassen's allure was said to "reside in his love for nature and his human emotion."[8] People were also drawn to the fantastically colored images of "clear light, glittering waves, and the lively animals of the sea," as well as "the grand natural beauty of Maui in Hawaii"; Lassen's works were said to "make the viewer feel the magnificence of the ocean."[9] They were thus valued less for their particular aesthetic vision, but rather as part of a vague, generalized response to "nature."

Lassen made many trips to Japan, visiting shopping malls across the country. According to a contemporary account, the master of ceremonies would address crowds of more than 300 people, telling them, "Okay everyone, you've been waiting and waiting for this, but now, at long last, the master is about to arrive!" And then "Lassen, tall and lanky, with long blond hair, would step onto stage, about an hour later than advertised." After this, the master of ceremonies would continue, whipping up the crowd by saying, "Please don't crowd him! The master will now sign

6 See note 4.
7 See note 5, p. 214.
8 For those who express themselves via interior décor featuring different art posters (bestsellers)," *Nikkei Ryūtsū Shimbun*, April 18, 1991, p. 21.
9 Tadao Kano, *Yūrakuchū* column: Lassen's paintings, Mainichi Shimbun, March 12, 1993, evening edition, p. 9.

prints and posters and pose for pictures only for those who have made a purchase. Please keep firm hold of your numbered ticket and line up in an orderly fashion!"[10] It would not be too much to say that what was being purchased was not only the art, but the image of the man himself.

This mode of consuming the man along with his art no doubt had something to do with his reputed status as a pro surfer. Even as he was rumored to speak freely with dolphins, it was almost entirely unknown what his atelier back in Hawaii looked like. Or rather, the fact that his atelier was actually in a hotel in Tokyo. "During long stays in Japan, he would bring his painting tools with him and set up an atelier in his hotel room, producing art as he listened to his favorite music. This would happen, for example, at the Westin Hotel Tokyo in Ebisu."[11] This only added to the artist's seductive image: "When Lassen stayed in Japan, he would take up residence in a suite in a luxury hotel downtown. He would use the room as an atelier, as well as invite girls he liked to join him."[12]

Due to accounts like these, two ways of seeing Lassen emerged. One was as a surfer-artist who loved nature, and the other was as a surfer-artist who loved Japan(ese girls). The former was described like this: "In the morning, if the weather was good, he would check the waves and dive in if they were good, and then he would return to his room in the afternoon to paint. If the weather was bad, he would spend all day inside painting. It was an ideal lifestyle for someone like him, who lived in Hawaii and loved the surf so much."[13] In this way, Lassen was consumed as the image of a kind of lifestyle. The latter way of seeing him was described in this way: "He liked this particular hotel (author's note: a luxury hotel in Roppongi), so he used this suite when he came to Japan. He used the room as an atelier, with his painting tools everywhere. Though I don't think he really ended up painting all that much...."[14] Lassen as blond-haired playboy thus emerged as another image to be consumed.

The Logic of Capital and Lassen's Overall Development
It's not difficult to understand the reason, in light of this sequence of events, why Lassen's works have been largely ignored by art critics who might use words to identify his work's unique qualities, however difficult

10 See note 5, p. 215.
11 "Christian Lassen: the artist who paints the heartbeat of the ocean,"
Fujin Kūron, August 1997, p. 72.
12 "Master C. Lassen's party with his harem of thirty beautiful girls,"
FLASH, January 6–13, 2009, p. 112.
13 "Hawaii, surf, and rock-n-roll," *SWITCH*, December 1998.
14 "Master C. Lassen's secret hotel love: an adult film star!" *FRIDAY*, December 1998.

it might be to do so. But what is quite interesting is how the very fact that Lassen was left hanging without a proper aesthetic evaluation facilitated the various ways his career would develop.

For example, in 1990, Lassen began his environmental protection activism by setting up the SeaVision Foundation. Subsequently, when there was a crude oil spill involving a Russian oil tanker in 1997, he sold ¥1,000 "commemorative exhibition badges, pledging to donate a portion of the profits to his foundation so it could be used to help clean up the spill."[15] Even now, though, in 2013, the Foundation doesn't seem to have done anything else, content to simply repeat the story of this fundraiser in its promotional materials.

Moreover, the distinction between "original and copy" started to blur for Lassen due to the boom in jigsaw puzzles,[16] as well as (the then) Sumitomo Bank attempting to attract new customers during the age of liberalized finance by offering "cash cards and passbooks decorated with dolphins and whales as drawn by the popular American artist Christian Riese Lassen."[17] A "healing" CD-ROM themed around "comfort" and "ease" called *Christian Lassen Selection* (Victor Entertainment, 1997) was produced, and it included not only his images in its booklet, but also "a song by Lassen himself, featuring his vocals, called 'Everything You Do.'"[18] Lassen's overall development had thus begun to slip beyond the constraints of mere art criticism.

The result was Lassen's emergence as something more than just a "surfer-artist." No one could stop Lassen from talking about his musical ambitions, an aspect of his evolution that illuminates the structure of the society we all live in: "Right then, the dolphin looked over at me. I felt he possessed something that resembled what I possessed. The sea is my inspiration, and surfing is an art that becomes more and more refined as you do it and are purified by it.... I don't have any clear idea of what kind of pictures I will paint now. My passion is now focused primarily on music.... I'd love to play a show in Japan."[19]

15 "Next month in Kanazawa: an exhibition of original works by Christian Lassen to help support oil spill cleanup," *Asahi Shimbun*, April 18, 1997, Fukui edition, p. 15.

16 "Popularity expands for jigsaw puzzles featuring pictures that can substitute for fascinating posters (bestsellers special: popular and new products)," *Nikkei Ryūtsū Shimbun*, May 7, 1994, p. 6.

17 "Information file: products: cash cards and passbooks featuring illustrations by famous painter," *Asahi Shimbun*, June 5, 1997, evening edition, p. 14.

18 "A new variation on the comfort of modern easy listening: a CD of healing songs," ibid.

19 "American painter Christian Riese Lassen oversees CD production, will next debut his band," *Sankei Shimbun*, June 2, 1997, evening edition, p. 11.

"Many women come to see my exhibitions, it's true. I've definitely had more opportunities these days to meet women.... Right now, I'm recording an album.... It's rock-n-roll. I think it's going to come out in March of next year.... My favorite rock and roller is Bon Jovi. I would love to become "Japan's Bon Jovi.""[20]

Right after this, Lassen starred in the 1997 film *I Am the Earth*. Lassen describes the movie: "It is as children that we develop our love of nature, and our hatred for its destruction. I want as many of the children of Japan as possible to see this movie."[21] However, it seems to have made this kind of impression: "It's not really an interesting movie. It looks plain and the story is simplistic. If it were screened normally, no one would come watch it."[22]

One term for the drive to baselessly differentiate things from other, pre-existing things and thus shore up a sense of self might be "the logic of capital," and if we accept this definition, we can see how Lassen's pursuit of variation via constant movement from one form of media to the next illuminates the concrete workings of capital's logic as it operates in Japan. Starting with the distinction between poster and print, then moving on to the proliferation of accessories of all sorts, and finally the production of music and film, we can see the transformation from "sign" to "environment" unfold before our very eyes. This is the reason why Lassen was as ubiquitous as advertisements in urban spaces, and it's precisely because we notice this aspect of his being that we intentionally look away from him.

That said, this kind of development has produced another effect, one inaccessible to those who have become adults. "My dream is to become a famous artist. An artist like Christian Lassen, painting bright colored images that make people say 'ah!' when they see them. Then, I want to become a world-renowned celebrity!"[23] Or, "I like the pictures Christian Lassen paints. Lassen's colors are so bright and beautiful, they always

20 "A month of strengthening the love for animals"—thanks to Mr. Lassen, this tour of art exhibitions and meet-and-greets has become wildly popular, but ... couldn't he say a word on this dolphin boom? "It's all a bit weird!" *Shūkan Playboy*, September 2, 1997, p. 55.

21 "A heart that loves nature begins in childhood": the press release for the first appearance in a film by master 'marine art' painter," *Asahi Shimbun*, May 19, 1998, Hiroshima edition, p. 26.

22 "Self-funded theater run (from the box office window)," *Asahi Shimbun*, July 16, 1997, evening edition, p. 2.

23 "Dreams: Matsuba Yūya (Chiba/fourth-year Kawado elementary-school student)," *Mainichi Shimbun*, December 17, 1995, Chiba edition, p. 19.

24 "'What I'm wild about now!' Morimoto Shiori, third-year Shizuoka junior high school student," *Mainichi Shimbun*, April 30, 2005, Shizuoka edition, p. 21.

move me! One day I want to paint pictures that will make people feel the same way."[24] In this other society, where credit contracts becoming a social problem don't have to be thought of as having anything to do with anyone personally, Lassen can circulate as this kind of subject to naïvely discuss.

Even as there exists a contradiction between "what adults notice" and "how children respond," it is the stubborn resistance to thinking seriously about him as an artist in both responses that constitutes the most interesting aspect of Lassen's Japanese reception. For this reason, Lassen does not belong in the annals of art history. He's an embodiment of excess, uncontainable by art history. He's like an advertisement, and precisely due to this, he's an intentionally ignored presence. What we can learn from Lassen is the answer to the question, "What is it that art history cannot write?"

Nearly Unbiased:
Patrick Mudekereza

Julia Grosse

Patrick Mudekereza is a curator and critic based in Lubumbashi, Democratic Republic of the Congo (DRC). He is a cofounder of the Lubumbashi Biennale (Rencontres Picha) in Lubumbashi, and the director of the independent art center Waza. I have always been an admirer of this writing, as it consistently manages to absolutely engage with an artwork or an exhibition on a deeply personal level, and at the same time never fails to place it all within a broader critical context and discourse. Being close, while keeping a respectful distance.

In early 2018, the ifa (Institute for Foreign Relations in Germany) asked Mudekezera to write a review of a solo show by artist Wolfgang Tillmans, which took place in Kinshasa, DRC. *Fragile* was planned as an ifa touring exhibition, with the first stop organized in cooperation with the Goethe-Institut, the Musée d'Art Contemporain et Multimédias, and the Académie des Beaux-Arts in Kinshasa. The show featured more than 200 of Tilmans's works created between 1986 and 2018.

What is interesting and important is that Mudekereza decided to open his argumentation by looking at the setting and status quo: a highly successful white European artist showing his work on the African continent. Mudekereza begins by focusing on the fact that traveling exhibitions from a "Western" context normally seem to suddenly "stop traveling" any further when it comes to areas outside the usual art-world hemisphere of London, Los Angeles, Oslo, Frankfurt, and so forth. The critic provokes the question why there are in fact so few shows in African museums exhibiting the

work of contemporary artists from a Western perspective. Why do works by Anne Imhof or Wade Guyton, to name just two of the bigger players, never reach capital cities in Africa? Transportation and insurance challenges? Fears about conservation?

In this regard, Tillmans's ambitious exhibition in Kinshasa can certainly be seen as an exception. What is refreshing about Mudekereza's review and closer look at Tillmans's selected works is that the hyperinfluential artist is suddenly being analyzed by a critic who is considering the work from an almost neutral, unbiased perspective. He is looking at the oeuvre of a photographer, and not at the work of Wolfgang Tillmans. At one point Mudekezera even remarks, "This photo, whose trivial character is undeniable, asks us to question the relationship between image, technology, and the turmoil these cause over time in our everyday lives."

Also intriguing is that Mudekereza produces a review by truly looking at the work without hoping to see his own internalized ideas or clichés confirmed. He rather comes to conclusions about an image by describing it very precisely. Mudekereza sketches a vivid scene in which Tillmans's protagonists seem to initially dissolve in the trees, but the camera manages to play with the light in order to let parts of their bodies emerge. Mudekereza discovers and observes the "same feeling of materiality, one of almost physical contact" in Tillmans's *Anders pulling splinter from his foot* (2004) and *Anders (Brighton Arcimboldo)* (2005), where he beautifully elaborates on the notion of proximity and materiality through which we, as spectators, are suddenly forced to feel like intruders entering an intimate context captured in a picture. It seems to be this feeling that leads Mudekereza to an almost empathetic conclusion on Tillmans's work: "This materiality expressed through the photography of bodies translates the instant captured by Tillmans. For him, each photo is an act of love, respect, and a form of embrace between himself and his photographic subjects."

Here again, Mudekereza holds his respectful distance while at the same time absolutely managing to grasp the special aura of Tillmans's early oeuvre, expressed in an almost upbeat tone. Being close and excited while keeping a respectful distance, translated into art-critical writing, makes Mudekereza's text so enjoyable to read and experience.

Homage: Djilatendo
Remixing Africa, Again

Patrick Mudekereza

from *Contemporary And (C&)*, December 24, 2015

The Congolese painter Djilatendo, who first exhibited in Brussels in 1929, is the subject of renewed attention in Europe. This recall is not without meditation or dilemma.

The exhibition *Patterns for (Re)cognition* at the Kunsthalle Basel, which ran from 13 February to 25 May 2015, was described as "the largest exhibition to date" of the work of Vincent Meessen, but also as the largest show yet of the abstract artwork of Djilatendo. If the exhibition leaflet spares no superlatives about its coverage of both artists, it still does not accord them the same status. On the one hand, there is Vincent Meessen, the rising Belgian artist who represented his country at the 56th Venice Biennale and, on the other, Djilatendo, an obscure Congolese artist who died in the late 1950s and whose work was dusted off from the archives of the Royal Library of Belgium, which had been unaware of its collection's riches. The show is more than an homage to the Congolese artist. Inscribed in Meessen's more recent approach, it allows us to reexamine modernity and its colonial baggage using the tools of Western critical thought. That last line ought to raise eyebrows. What response, exactly, is opened up by examining the problem of colonial denial once again in another time, another context, but always with Western conceptual tools?

The exhibition was built around watercolors by Djilatendo, who is seen as one of the forerunners of modern Congolese art, along with Albert Lubaki and lesser-known figures such as Massalai and Ngoma. Together, they formed the group known as the "illustrators of the Congo," which Europe "discovered" in the late 1920s by way of Georges Thiry (a colonial officer in the Belgian Congo) and Gaston-Denys Périer (an official in the colonial administration in Belgium). From 1929 to 1936, they put on exhibitions in Geneva (Geneva Ethnography Museum), Brussels (the First National Salon of Negro Art and an exhibition of popular art at the Royal Museums of Fine Arts), Anvers, Rome (Exhibition of Colonial Art), and Paris. Their watercolors, inspired by the practice of painting on huts, were produced on Thiry's orders and dispatched,

without fail, to Europe. They only encountered qualified success upon arrival.

Djilatendo was a tailor living in Ibanc, a locality near the current city of Kananga, located in Lulua province at the center of the Democratic Republic of Congo. His work included paintings of figurative scenes illustrating his vision of modernity (cars, airplanes, characters in European dress carrying umbrellas, etc.), but also abstract watercolors. He illustrated the book *L'éléphant qui marchait sur les œufs* (The Elephant Who Walked on Eggs), the first publication of folktales transcribed by a Congolese author named Badibanga.

In *Patterns for (Re)cognition*, Vincent Meessen places Djilatendo's abstract watercolors in dialogue with tests by André Ombredane, a French psychologist who introduced cognitive tests aimed at identifying the best "ethnicities" or choosing hired hands for colonial industry. The films were made by Robert Maistriaux, to whom Meessen pays fairly little regard, apart from the credits for the video on Ombredane's Congo TAT test. Maistriaux wrote the treatise *L'intelligence noire et son destin* (Black Intelligence and Its Destiny), published in 1957—four years after the video shown at the exhibition—containing hard pronouncements about the intelligence of the groups subjected to the tests, especially those living "in the bush." We read, for example, that: "In essence, the black man's early childhood takes place in an environment intellectually inferior to anything we can imagine in Europe." (p. 191)

The tests, designed in part to measure the test-taker's ability to respond to abstract shapes, were used to demonstrate these assertions. Vincent Meessen's demonstration runs contrary to this pseudo-intellectual approach by referencing Djilatendo's abstract work from 1920 to 1940. In an interview from 22 July 2015, Meessen explained: "Seeing how this connection to intelligence was drawn, one cannot help connecting it to abstract art that was produced at the same time and had an incredible boom in Europe."

Meessen is also interested in the transition from painting on huts to painting on paper and the introduction of the signature, which marks the birth of the artist as an individual and speaks to a production opening up to the art market. Djilatendo signed his work in many ways: ThselaTendu, tshelatendu, tshe latendu, Tshela tendu, Thelatedu, tshielatendu, thielatedo, Tshalo Ntende, and so on. Based on work by the German scholar Kathrin Langenhol, Meessen counted a total of forty-two spellings of Djilatendo. He was likewise interested in the signature's placement on the painting and notes that the artist attempts to repeat a motif until he reaches a transformative shape—which is where he signs

Installation view, Thela
Thendu (Djilatendo),
Patterns for (Re)cognition,
Kunsthalle Basel, 2015

his own name in one of its manifold spellings. Elsewhere in the same
interview, Meessen said: "He is ordered to ensure the artwork's authen-
ticity. It is my firm belief that he is making a conscious gesture, playing
with the colonial criterion of fixity as a trait of the modern artist. And
even if he did not do so consciously, the artist was at times foiling the
alphabet, the tool of identification imposed on him, and the ensuing
fixity. Thus he enabled himself to travel in his work."

With the two iterations of the exhibition, Meessen changed the name
of the artist with whom he was co-exhibiting. At the Kiosk in Ghent, it was
Tshiela Ntendu. At the Kunsthalle in Basel, it is Thela Tendu. It seems to
me that in renouncing the more or less established spelling of Djilatendo
and in modifying the name in the exhibition's publicity, he is diluting the
artist's identity when in fact the artist intended to multiply it.

In addition, the Swiss version of the exhibition, which distributes
around thirty watercolors among five rooms, never entirely devotes the
space to the expression of Djilatendo, who is invariably subjugated to
other voices, all of them Western. The first room places them in dialogue
with the films about Ombredane's tests. The second highlights their
commonalities with the paintings of Paul Klee and their Kuba identity.
The third returns to Ombredane's publications. The fourth is devoted to

Patrick Mudekereza

revisiting Jan Vansina, the patriarch of oral history who met Djilatendo in 1953. In the fifth room, Meessen opted to exhibit his own work, covering the entire floor and creating dialogue with the space. It is as if, in order to find its place in modernity, this Congolese voice needs Western "backing" or interpretation, endorsing its place in the hallowed halls.

I note with satisfaction the varying approach taken by the following project, *Personnes et les autres* (Persons and Others), presented at the Venice Biennale. There, Vincent Meessen shares an encounter with Joseph M'Belolo Ya M'Piku, a Congolese member of the Situationist International, and brings to life a text he composed in May 1968.

All of this reminds us of the great task that remains before us: to rewrite the history, the histories, of art or thought, according to the perspectives of colonized peoples. Meessen reminds us of the necessity of profound, ongoing work of rethinking, rewriting, and, to paraphrase V. Y. Mudimbe, *Reprendre*.

Wolfgang Tillmans at the Échangeur

Patrick Mudekereza

from *Wolfgang Tillmans: Fragile*, 2018

It is said that an exhibition which manages to find many museums to host it "works well." It is also said that a museum which hosts many exhibitions "works well." Yet among the dynamic networks of these "good workers," parasitic connections can emerge, disruptive breaks which question the relationship between an institution's cultural offer and its wider ecosystem, links which invite us to stop for a moment and interrogate our surroundings. By engaging with them, such connections can shed light on reforms which cultural institutions need not just to "work well" but also to ensure that the public becomes a driving part of an institution's outlook and development.

In this context, exhibiting Wolfgang Tillmans at the Échangeur Museum in Kinshasa presents an interesting challenge. On the one hand, because Tillmans is an insider, which allows him to share in the power of the institution; on the other, because his artistic practice points to a kind of interior or everyday dimension that undermines the image of a "spectacular" exhibition and brings it back to the realm of the individual and the quotidian, thereby encouraging a crucial political debate.

In other words, because his institutional status, which may at first appear as an unlikely, perhaps risky, factor, contains the germ of an ambition able to arouse bold effects.

Going Where Travelling Exhibitions Do Not

The globalisation of contemporary art is often praised for bringing to light regions of the world little represented until recently. Despite this, travelling exhibitions have remained concentrated in Europe and North America. What forays into China and Asia, and to some extent Brasil, do exist, have done so mostly because the latter countries have taken on the museums of the former. The 2007 exhibition *Africa Remix, The Contemporary Art of a Continent* was thus very proud to land at the Johannesburg Art Gallery in South Africa. The 2015 exhibition *Rise and Fall of Apartheid*, put on in Munich two years later, was originally presented at Museum Africa, also in South Africa. To my knowledge, the experiences of these two Johannesburg museums constitute the only African stopovers of such travelling mega-exhibitions. However, it is also the case that these dealt exclusively with Africa. One of the exhibition commissioners would later explain to me that this was above all due to the cost of insuring individual works, each coming close to the annual budget of one of our museums. One might have added that museums in Africa face a struggle for survival and may therefore have other, perhaps more pressing, priorities.

Parallel to this, large African capitals such as Lagos and Kinshasa, as well as their respective countries, have become important sites of experimentation for contemporary artists, whether new or established. From very controversial projects, such as that of Renzo Martens, quite rightly described by the French urbanist Tristan Guilloux as representing a "cynical turn," to the constant featuring of Belgian, Swiss, German, or French artists, there has been no shortage of contemporary artistic production on the subject of Congo. Nevertheless, few artists have "dared" to engage with the very public that makes it possible for them to display their projects in the form of an actual exhibition. The example of the rather stormy discussion at the Goma cinema festival on the occasion of the presentation of the photo and video installation exhibition *The Enclave* by the Irish artist Richard Mosse was notable in its rarity. What would the *kinois* have made of the distortions in meaning in the translation of the song "Soki Lelo Okeyi" by Papa Wemba, icon of Congolese song deceased in 2014, in Carsten Höller's video installation *Fara Fara* at the 2015 Venice Biennale?[1]

Congo seems to make for great cultural exports, but exhibitions do not necessarily return there. There is, in this sense, a form of content

Patrick Mudekereza

extraction very similar to that of the mining industry, but without the return of manufactured products for domestic consumption to compensate.[2]

The Échangeur Museum: The Unfinished Extraordinary

Yet Kinshasa does have a Museum of Contemporary Art and Multimedia installed in a very special building: the Échangeur Tower. This architectural project, built at the behest of president Mobutu Sese Seko at the peak of his glory in the early 1970s, was first conceived to house the Museum of the Zairean Nation, and assigned to Olivier-Clément Cacoub, a Franco-Tunisian architect who had already designed the gardens of the presidential park at Mont Ngaliema where the Institute of National Museums was located. Cacoub seems to have been in the favour of the president, who had already asked him to build his Gbadolite palace in his native region of Équateur. For the Échangeur, he envisioned a tall tower that would be "the highest monumental spire in the world," with various associated urban planning projects, such as facilitating the flow of traffic into the capital.

Cacoub was the architect of several ambitious projects: the building of the Houphouët-Boigny Foundation for Peace Research, the presidential palaces at Yaoundé and Yamoussoukro, and so on. He was also known for other controversial projects, some of which were never completed. This was the case with the Échangeur, which was to remain unfinished and make the traffic worse rather than facilitating it. Mobutu and Cacoub's project, which was supposed to celebrate the "Zairean nation" in all its magnificence, never materialised. After the death of the architect, the disappearance of the Cacoub archives made the resalvaging of the project difficult. Only a few entrepreneurs who had worked on the site were still there to testify for the original plans.

While Korean aid later made possible the rebuilding of the Lumumba statue in 2001, the other sites would have to wait for small-scale redevelopment by a Chinese company to appear less run down. Egyptian aid, offered on the occasion of the Francophone summit hosted in Kinshasa in 2012, added projector equipment to screen a film about the Nile, considered a cousin of the Congo river which flows only a few kilometers away. With this latter acquisition, and some canvases from the modern and contemporary art collection of the National Museums Institute of

1 The song in Lingala which talks about separation was completely modified to explain the duels between kinois musicians. The expression *ko batela* (to keep), for example, was transformed into "battle." This does not seem like an intentional mistake.
2 One must nonetheless keep in mind the international exchanges that have sometimes put on exhibitions mostly led by independent initiatives or cooperative institutions.

Congo, the project's "museum" phase was launched. Other cooperation institutions began to use the building to host exhibitions, with some offering redecoration, others additional equipment.

The Échangeur was thus given a new life, with little care for the original plans. Upstaging the towers of the city's commercial centre, it is the Échangeur which has become for the kinois the unofficial symbol of the Congolese capital, as well as appearing in some official logos. And since no one really knows what it was supposed to be for in the first place, it has become a space where the most diverse ideas and intentions can be projected, a sort of factory of imaginaries mixing science fiction narratives with histories of torture squads of all regimes. It has also become a place of pride for the dissenting quarter of Limete, with black smoke from burning tires rising around it during protests as if it were a chimney. Finally, it has also become a kind of imaginary interchange (*échangeur*) or an interchange of imaginaries presiding over the gates of Kinshasa like an abandoned fortress.

If the project clearly shows its imperfections and its incomplete character materially, it succeeds in its psychological impact. And if a contemporary art museum must convey the dynamics of its host, what better place in Kinshasa for this tower to be thrown, both grand and decadent, phallic and eunuch-like, a hollow totem where all can see their pride, shame and anger reflected?

The Oeuvre of Wolfgang Tillmans: The Unexpected Infra-Ordinary

For Wolfgang Tillmans, a museum project necessarily has a certain architectural complexity. Defending Herzog & de Meuron's extension project at Tate Modern in London, which he describes as being of "unbelievable complexity," he remarks: "One doesn't just build a box, but an idea." In another interview, however, he warns against certain approaches by "dishonest" architects who disrespect users by not taking their intentions sufficiently seriously. Architectural works, like those of exhibitions, are accomplished through the respectful and honest materialisation of an idea and consist in presenting a responsible offer to public consciousness.

Tillmans's approach seeks to capture this complexity of things. He describes his work as an "amplifier of ideas, things and subjects which he believes in and cares about."

But the terms "amplification" and "complexity" should not cause confusion and suggest a search for the extraordinary. On the contrary, it is an approach that aims to expose the banal, to highlight what may at first appear as normal. For example, the photo *Sendeschluss/End of Broadcast*,

2014, presents a shot of the interference on an analog screen that is not receiving a signal. This photo, whose trivial character is undeniable, asks us to question the relationship between image, technology and the turmoil these cause over time in our everyday lives. In the same manner, Tillman's portraits stress not the expressivity of faces but the way in which "bodies encountering other bodies" bring us back to the materiality, profound sensuality and even vulnerability of our own bodies. Observing the photo *Lutz and Alex sitting in the trees* one sees half-covered bodies which at first seem dissolved into the trees. Yet on further inspection one discovers the way the muscles are brought to light, their grace and firmness, as if the bodies were emerging from their raincoats in order to reach our eyes. This same feeling of materiality, one of almost physical contact, is expressed in the portraits of Anders, a recurring model in Tillmans's work, such as in *Anders pulling splinter from his foot* or *Anders (Brighton Arcimboldo)*. In the first, he can be seen sitting on a stool with one foot on the ground and the other, which he holds in his hands, resting on his thigh. What emerges here is a sort of proximity which makes us feel like intruders within their intimate world, but without an easy play on eroticism.

This materiality expressed through the photography of bodies translates the instant captured by Tillmans. For him, each photo is an act of love, respect and a form of embrace between himself and his photographic subjects.

Tillmans also displays a striking love for a material he considers essential: paper. For him, paper is not only a support for the image, but an object in its own right. In the images entitled *Paper Drop* he presents images on folded photographic paper in the form of abstract sculptures. But he also uses newspaper pages, photocopies and all kinds of image formats. If Tillmans can be considered as the photographer who has marked the passage of photography into contemporary art—notably by becoming the first photographer to win the Turner Prize—his approach to photographic practice appears to desacralise this very medium. The photograph, become work of art, can also return to being a banal object, and inversely the object can become photograph.

Everything lies in the manner of presenting the paper, the quality of the paper, its size as well as its positioning within the exhibition space.

Through his subjects, the way of treating them and the means of presentation, the work of Tillmans corresponds to what Elvira Dyangani Ose, speaking of the way in which social relations are redefined within public space through artistic actions, has called the "poetics of the infra-ordinary." Even if the African projects she describes

(Hug de Sello Pesa, Chimurenga Library and Bessengue City) occupy public spaces that are radically different from those in which exhibitions of Tillmans normally take place, the latter's approach is primarily situated within the register of the infra-ordinary as defined by the French author Georges Perec who inspired Dyangani Ose:

> The daily papers talk of everything except the daily. The papers annoy me, they teach me nothing. What they recount doesn't concern me, doesn't ask me questions and doesn't answer the questions I ask or would like to ask. What's really going on, what we're experiencing, the rest, all the rest, where is it? How should we take account of, question, describe what happens every day and recurs every day: the banal, the quotidian, the obvious, the common, the ordinary, the infra-ordinary, the background noise, the habitual?[3]

The project *truth study center* (2005–2015) seems to be a direct response to this search for the infra-ordinary. By associating his photos, shot on modest formats and placed on tables, with newspapers, letters, everyday objects, he presents a vision of truth that is much more complex than that of the news, scientific works and religious dogmas. He thus places the notion of "truth," now no longer absolute, on the side of what one directly lives rather than of what one learns.

But exhibiting Tillmans in Kinshasa remains in the realm of the unexpected. Exhibiting an artist whose message has a connection with the Congolese public upon the sole register of personal expression and the amplification of the everyday may seem futile to many international sponsors and even local cultural actors. And if the Universal Declaration of Human Rights states that everyone has a right "to enjoy the arts" (Article 27), this does not translate into great international interventions, except in cases where art expresses a direct link with humanitarian activities in the areas of health or basic freedoms.

Tillmans at the Échangeur: A Platform for Resistance?

The project *truth study center* starts with a simple question: "What's wrong with redistribution?" This question, related to the distribution of wealth, can also be applied to power, knowledge or, more broadly, to overcoming differences whatever these may be. Tillmans in this way is able to use the exhibition space as a platform for resistance.

3 Georges Perec, 'Approaches to What?' (1973), in *Species of Spaces and Other Pieces*, trans. by John Sturrock (London: Penguin, 1999), pp. 209–211.

Patrick Mudekereza

This commitment to a just world is demonstrated not only at the level of content, but also of the very form of the exhibition. Tillmans, who curates his own exhibitions, is very careful to avoid what he calls "the language of importance," the tendency for a photograph to take up increasingly more space and visibility in all the exhibitions because it is supposed to have more value. He bypasses all hierarchy in the presentation of the exhibition by constantly adapting the format of every photograph, their arrangements and hanging.

As the Échangeur Tower reminds us, Kinshasa is a city of power and displays of force. How can an equitable and respectful encounter between the work of the artist and the public be created in the shadow of this tower, which is not necessarily used to this kind of photographic exhibition? How can one create a means of mediation which makes it possible to read it beyond the codes of contemporary art and the history of photography? How can one look at it as a human experience rather than as a German exhibition in Congo? How can one see it as an immersion in the everyday rather than as a triumphant celebration of the art world?

I don't have a pragmatic answer to these questions, but I'd like to think that the public who comes to the exhibition can have a feeling of being at home and see their own everyday life amplified and sublimated. I also hope that the hospitality of the space can draw from the experience of an alternative location like Between Bridges, the space created by Tillmans at the entrance to his London studio, and later also in Berlin, while also being as precise and considered as that of Tate Modern. And if the exhibition does not seem African enough, too European, or that it excessively emphasises this or that difference, it would be incumbent upon it to undertake a new anthropological reflection on itself rather than on others—or, to paraphrase Perec again, to undertake an "endontic" anthropology instead of quests for the "exotic."

Retroactivity:
Peter Richter

Andreas Beyer

Peter Richter's review of *Zarte Männer in der Skulptur der Moderne* (Delicate Men in Modern Sculpture) at the Georg Kolbe Museum in Berlin seems to be an exemplary piece of contemporary art criticism. It deals with an aesthetic experience and proves that the author is aware of his own, astute sensual perception, both inside and outside the museum. It operates recollectively, and at the same time succeeds in translating the effects of an elapsed artistic phenomenon into the present. It is a witty, irreverent text that combines density and learning with brisk *sprezzatura*—a blueprint of how art (historical) criticism could and should work.

Richter's subject is a historical one: sculptures of young, fine-boned men, created by mainly German sculptors from the eighteen-eighties up to 1940. But the article deals not only with a past aesthetic phenomenon; it appeared on the occasion of a contemporary staging of the sculptures in question, a retrospective within a present-day perspective in its curation, presentation, and framing.

Like many of his colleagues currently working in German newspaper feuilletons, the author Peter Richter is an academic, a trained art historian, and a writer of fiction. This grounding, along with a journalistic presence of mind, makes him more closely discern the objects both reflectively and sensually. The article proceeds in three distinct movements, as it were:

The Addressee
Richter introduces a dialogue partner when referring to polemical allegations against the curator, Julia Wallner, on why she would not

show "normal men." This "normal man," who frequently appears as a vis-à-vis in critiques, becomes Richter's counterpart. The author also describes this "normal man" in physical terms to emphasize what he is targeting in his entire review: the fact that this exhibition does not allow the viewer to deduce cultural or social normativity can simplify from it—neither in an affirmative nor in a renunciatory way. He confirms that art is in fact the "decidedly other," as Theodor W. Adorno put it.

Reference to the World

Richter reminds us that the penchant for the "tender" man was a sort of reaction, a defiance of the still dominant aesthetic climate of the Bismarck era's industrial and military obesity. Richter emphasizes the apparent disruption between the artistic evocation of the "lyrical portraits" of young men in Renaissance art by such artists as Giorgione and Titian and the "ideal man" of the epoch—the violent Renaissance condottiere, the strong-willed, heroic man of action. That this *Renaissancism*, fostered by art historian Jacob Burckhardt's projection, was undermined by contemporary sculpture's aesthetic practice is one of the insights of Richter's article, and Richter certainly also attributes erotic potential to these figures. Quoting Ellen Key, he refers to the fundamental change in both the scientific and the aesthetic discovery of the no longer only metaphorical esteem of youth. The reactions prove that the present is not an innocent bystander of art history.

Contemporary Climate

It is notably the erotic potential that Richter sees at the origin of the attacks launched by the "normal men," which might not be directly comparable to the discussions on Balthus's paintings of young girls, but rather correlates to the current atmosphere. Richter also discerns a latter-day homophobic resentment, which to him is simultaneously "an attack on heterosexuals who strive to be slender and appear youthful, and who practice empathy" against the preference of "muscle mass" by "young machos," and the new physical trend of "spornosexuality"—a synthesis of "sport" and "porn."

It is a twist of fate that the Georg Kolbe Museum originally planned to present a show on "Strong Men" by Nazi sculptors like Arno Breker or Josef Thorak, and that only the failure to raise the necessary funding led to the *Zarte Männer* exhibition. But perhaps this lack of funding expresses not only political but also aesthetic preferences. And thus the exhibition on the "delicate men" might unintentionally embody the current zeitgeist—and even some physical normativity. Be it as it may, Richter's review is a felicitous encounter with art, both sensuous and intellectual, entertaining and erudite, combining art-historical expertise with aesthetic sensitivity. Just like one favors a critique that does not simply judge from the outside, but reacts with body and soul.

Male Morals

Peter Richter

from *Süddeutsche Zeitung*, September 23, 2015

A Berlin exhibition celebrates narrow-chested, tender young men in German sculpture around the time of World War I—and provides the present era with food for thought.

We've reached the point at which the director of Berlin's Georg Kolbe Museum receives hate mail when announcing an exhibition *Zarte Männer in der Skulptur der Moderne* (Delicate Men in Modern Sculpture). One of the several things their writers wanted to know was—why couldn't she exhibit "normal men?" The only adequate response being, of course, what exactly should that look like, especially in today's Germany? After all, few male sculptors, and even fewer female ones, have addressed the topics of bulging bellies, hunched backs, and cheap shoes.

What is on view in this valuable exhibition, however, are many sculptures from the period before and after World War I depicting delicate, lanky figures that seem to be more the bodies of adolescents than those of grown men, often with melancholic, vulnerable dispositions. These youths would have been called ephebic or even sylphidic at the humanist grammar schools of the time. Back then, generals—and Expressionist writers of patricidal literature—happily sent such schools' pupils to their slaughter on the front. In their writings, these pupils had to repeatedly rebel against their cold-hearted ancestors by ultimately jumping from windows, embracing the universe all the while.

Military Might? Slender and Lean Were Very Popular around World War I
The earliest works on display in the Kolbe Museum are from the eighteen-eighties, the latest from 1940. Almost all of them are by male artists—only a few were made by the female sculptor Renée Sintenis—and nearly all of them were from Germany, with the exception of the boys hugging themselves, by Belgian artist George Minne (Minne was well-known for the narcissistic figures around his Minne Fountain in Hagen, commissioned by patron Karl Ernst Osthaus). There was clearly a major market for slender male figures in imperial Germany and the Weimar Republic. What is remarkable, however, is how long this favor lasted under National Socialism, even under hostile conditions.

The former residence and studio of the Saxony-born sculptor Georg Kolbe in Berlin's Westend, the Kolbe Museum has always been a charming place to spend an easygoing Sunday afternoon viewing modern sculptures or simply drinking coffee under the pines in the sun-drenched garden. Recent thematic temporary exhibitions have turned the institution into one of the most relevant addresses in Berlin in terms of content, due to the crossover between the classical art-historical objects and contemporary discourse.

In the spring, this discourse concerned itself with the first generation of women sculptors in Berlin, which, perplexingly enough, often dealt with the representation of animals. Next on should have been a show about strong men: the artistic depiction of hulking muscles in the service of militarism and racial tropes. There was no funding for this exhibition, however, which is how these counterparts came into view—thank goodness. The classical heroic figures that Nazi-courted sculptors like Arno Breker and Josef Thorak pumped up on steroids, leading to Herculean National Socialists, are more relevant today as a document of an ideology than as art.

This relevance is unequivocally different when it comes to these "delicate" men, as the museum has dubbed them. Some of the most

Installation view, works by Karl Albiker, George Minne, and Ernst Wenck in *Zarte Männer in der Skulptur der Moderne* (Delicate Men in Modern Sculpture), Georg Kolbe Museum, 2018

significant sculptural achievements of modernism in Germany, by Wilhelm Lehmbruck or Georg Kolbe himself, are celebrations of "lepto-some" or "asthenic" bodies, as psychiatrist Ernst Kretschmer called this lanky, narrow-chested, small-headed body type back then. The fact that he associated this physiognomy with qualities such as intellectual sensitivity and caprice certainly played a role in the popularity of this physical type at a moment in which nervousness was as much a status symbol for the educated classes as lactose intolerance is today.

One knows this particularly from literature, and the exhibition catalogue dedicates an entire essay to *hommes fragiles*, from Rainer Maria Rilke to Thomas Mann as well as Heinrich, who page after page are elaborated upon with deep sensitivity. Whoever expects the military might that Klaus Theweleit describes in his 1994 book *Male Fantasies* to be consistent around the time of World War I might have succumbed to one themselves, because apart from the ironclad *Freikorps* types, there has rarely been such a wave of passionate or elegiac enthusiasts, at least in the arts.

That the Germans started to develop this considerable weakness for the lean and lanky shortly after founding the empire is only surprising until this surprise takes a look at itself, so to speak. The beer-bellied nature of the industrialists' villas and Bismarck towers was only one side of Wilhelminism. Almost everything that is still culturally relevant today, from Nietzsche to nudism to vegetarianism, originated more in opposition to these.

The Desire for the Fine-Boned in German Art Meets Homophobic Resentment

It seems that much of what provokes phenomenological commotion here is particularly a problem of reception. This was the case at the time when the objects were produced, but also before then. In her dissertation on the "lyrical portraits of men" from the early sixteenth century, the art historian Marianne Koos drew attention to how little the dreamy-looking young men of Giorgione, Titian, and their circle wanted to resemble the image of the glory-addicted and "all-around violent people" with "compelling personal power" and "very intense willpower" of the Renaissance, as described by art historian Jacob Burckhardt. The Basel-based scholar had Donatello's tableaus of military generals in mind, and with relative certainty the era's industrialists in the back of his mind. Giorgione's and Tizian's lyrical youths must have seemed like the Buddenbrooks's useless descendants. But even during Burckhardt's lifetime, the frail men from the Berlin exhibition had moved in behind the Neo-Renaissance facades of the Wilhemian era.

Peter Richter

This began exactly when, via mass production, the bronze foundries revived the type of classical sculptures that emphasized the tender and intimate, rather than the expansive and powerful (and these fit better in a bourgeois living room than a palace's staircase). While the empire outfitted itself with powerful caryatids in exterior, public spaces—the figures that always had to carry entire balconies on their heads—interiors were marked by a notable desire for the delicate. Inside, only those classical types were reproduced that suited more domestic needs. One encounters a ganymede or boys balancing on balls, reminiscent of the old personifications of *occasio*, i.e. the opportunity or occasion, which is a fitting subject for a merchant's chest of drawers. The German empire's most commercially successful sculptural figure under the emperor, the Republic, and the Nazis was Jeremias Christensen's *Boy of the Mountain*. Obviously it was supposed to be reminiscent of Michelangelo's Florentine *David*, although this association is one of David to Goliath, so to speak. Even the figure's erotic potential is in bonsai format, due in no small part to the modest loincloth.

This would change to an extent, however, with the dawning of the "century of the child," as the Swedish educator Ellen Key termed it in 1904. It was a time in which youth and childhood would experience an increasingly profound appreciation beyond mere metaphor. Just as how for centuries the scantily or not at all clad female figures had to personify all sorts of abstractions that were more likely tied to earthly needs, the slender bodies of the boys of early modern German sculpture were certainly admired and collected for reasons beyond their allegorical dimensions.

It could well be that some of the angry letters to the Kolbe Museum took this as their point of reference. In light of recent discussions regarding the nude girls in the paintings of die Brücke and Balthus, it would be rather surprising if there were no discussions about the nude boys in bronze. While an exhibition about these "delicate men in modern sculpture" has its roots in the depths of art history, it becomes particularly explosive through current reactions; which in this case are a revealing indicator of today's cultural climate.

Spornosexual—Today's Gangster Rappers and Soccer Players Want to be Thin, Delicate, and Defined

Included in this discussion's complexity is also the fact that the homophobic resentment expressed in the hostile reactions is also an attack on heterosexuals who strive to be slender and appear youthful, and who practice empathy. The assumption that "sensitive men" is an automatic reference to homosexuality misses the simple fact that on

your average Christopher Street Day today, there is more muscle mass per square meter than in Arnold Schwarzenegger's film *Pumping Iron*. It also ignores that the ideal of slim-hipped youth is held in high regard among the most prepotent of water-pipe pashas and gangster rappers. In fact, one of the young men recently on trial in Essen for raping a series of female schoolmates in the Ruhr region noted how important it was that everyone in their gang was very thin.

A few years ago, the term "spornosexual" replaced the consumerist "metrosexual" in men's magazines. One was no longer meant to look like David Beckham, but rather be thin and defined, like Cristiano Ronaldo. That Ronaldo appears to so many as alien as the many tears shed on today's soccer fields, this unrestrained, open sensitivity and reckless psychological tenderness is in part reflected in the ruthlessness into which this new sensitivity sometimes turns in the universities. This is perhaps more a question of morality than a question of aesthetics or generation.

It would be an injustice to this wonderful exhibition to derive something socially or culturally normative from its subject, as assumed by the anonymous letters of complaint. If this were really the intention, perhaps the next thing would be to mount an exhibition about composure and introspection; with Aristide Maillol's female nudes, for example.

Troll:
Anonymous

Miriam Rasch

It was in the dark days of early 2016 that, seemingly out of nowhere, the Dutch literary world got a wake-up call that was spectacular in its mundanity. An anonymous blogger entered the online scene, calling herself the "Reader of the Nation" or "Reader Laureate," using *lezeres*, the Dutch pronoun indicating her gender. She claimed to represent the somewhat older, female reader who's responsible for keeping book sales up and literary evenings viable, even if she's mocked by writers in op-eds about white-haired ladies gathering in public libraries, and, worse, completely ignored by publishers and their marketing gurus.

For months, this critic of the critics managed to keep a hold on the weekly book-review supplements in national newspapers and magazines. She did this first by tallying facts as if she were an actual accountant: counting articles dedicated to male and female authors, and the number of male and female critics writing them. The undeniable bias that the numbers presented week after week was shocking. Some of the newspapers that count as most influential when it comes to cultural criticism tallied female contributions of less than ten percent in both categories. No wonder this nameless woman with her reading glasses—which made her so clearly see what escaped everyone else's attention—caused a bit of a scandal in the small Dutch literary landscape.

Using a very simple tactic, this critique of criticism revealed many conceptual things. On the surface, the Reader was counting and creating spreadsheets, but this was immediately linked to the feminist

movement, not through a celebrity but through a character representing an older, unfashionable woman. The harsh reality of the highbrow cultural domain was thus exposed by means of a fictional character that never let down her guard—a practice that relates to the genre of fictocriticism, without becoming academic or elitist. The fictional character of the Reader is rather one of the "common book lover," giving her a populist ring, while at the same time referring to a discourse of identity politics and consciousness-raising. It was an example of activist critique per se; not directed at calling out specific perpetrators, but as a proposal for change in the media landscape at large. The anonymous collective behind the Reader exposed wrongs without claiming victory. In this sense, it took online trolling to new levels—levels that since have remained largely uncharted.

Remarkably, the trolling practices took immediate effect. Well, at least for a little while, the statistics fluctuated a bit. Did something change in the long run, too? Probably less so. Gender inequality in the literary world is systemic, as it is everywhere. It took another year for #MeToo to take off, which seemed more intent on personal transgressions than addressing structural problems. Even now, years later, little has changed. Every now and then, as a sparse intervention, scandal arises around a male critic abusing his position of power. No one is really surprised when it happens.

Just as suddenly as she entered the public imagination, the Reader of the Nation disappeared again in 2017. Of course, there was speculation on who was hiding behind the nom de plume. But it was never officially clear who spent their weekends counting these reviews and handing out virtual prizes to the worst contenders. The original blog is now offline, the web page stating "the authors have deleted this site." For a project that took the paradoxical status of online anonymity to an extreme, in an age when such anonymous trolling is mostly associated with masculinity, toxic or not, it is a befitting end. It is also a sad one. The Reader did not disappear because the battle was won; she had merely shown the absurdity of the war.

Through My Reading Glasses

Reader Laureate

from *De Groene Amsterdammer*, March 2, 2016

The world of books is like a sloping football table where the balls roll almost automatically into the goal at the boys' end. The Netherlands needs a female "Reader Laureate." Allow me to introduce myself.

You don't know me, but you'd recognize me immediately. I'm the woman sitting opposite you in the train, her nose buried in a book. Sensible shoes and reading glasses. Studies of the future of the book trade refer to me as "the middle-aged woman"—i.e., the part of society that actually buys books and reads them. I am the literature-loving and economic lifeblood of the entire Dutch book business. And, by extension, of a large part of the country's cultural sector, because I also go to the theater, have a newspaper subscription, use my annual museum pass intensively, and keep a cinema ticket strip card in my handbag.

These days I am not generally treated with much respect. For all I know, the grand directors of cultural institutes might be looking right through me as they seek audiences with more social importance—or just younger ones. Authors like to write ironic columns about book meetings "out in the sticks," where my questions are as tiresome as they are predictable. I could retort that most Dutch authors, too, are rather more predictable than they think, but I will politely keep those kind of grumbles to myself. There are more important issues in the world, after all, and I still have the minutes to read for an upcoming volunteer meeting.

It might be the disorder being wreaked by climate change, or the so-called "identity politics" that has lit firecrackers under the establishment, but these days I seem to be seeing things much more clearly, as if my reading glasses turned out to have hidden powers. Have a look at this, my glasses will say, planted firmly on my nose, as I read that Esther Gerritsen wrote the Book Week gift book this year. Take a good look at an organization like the CPNB. Shouldn't this book propaganda club be treating you—the middle-aged woman—like a queen of literature? But the CPNB can't even take female *writers* seriously, let alone female readers. Gerritsen is, after all, only the second woman to have been selected as the author of the Book Week gift book in the past fifteen years. What if all the women in the Netherlands collectively stopped buying any books

at all during Book Week, and kept up the boycott until the CPNB solemnly promised to choose a female author for the gift book, fifty percent of the time?

Sometimes my reading glasses start dancing. My eyes jump from the literary supplements to the opinion pages, and from there to Twitter, and from Twitter to a jumble of heated arguments about who does or doesn't have a right to speak in the public debate, and what actual motives underlie this apparently obvious distinction. That's when I start seeing the gaping lacunae. How can it be, for instance, that in 2016 our national literary champions do not include a single feminist author with a prominent voice and position? Are Dutch critics still reeling from the impact of Anja Meulenbelt's 1976 feminist classic? And why is everyone talking about "diversity" when the latest cohort of white literary talents were all fished, to loud cheers, from upscale canalside homes?

My spiteful specs give me no peace, forcing me to analyze stereotypical images and rhetorical clichés. I start to notice patterns in text and image, discovering for instance that the marketing strategy of many publishers is hardly more sophisticated than the pink/blue scheme of a Bart Smit toy shop folder. A male author's bloodied face glares at you from the jacket of his first book in a blatant attempt to impart some street cred to the hard-to-sell short story genre. Another book cover uses an axe as a phallic symbol. Authors stereotypically write how "men's friendships" and "men's lives" are mostly about sultry silence, and their books are invariably given a blue cover. Men fight, chop wood, and say nothing, an image almost identical to that shown in infantilizing Axe deodorant advertisements.

As I curl up happily on the sofa on a Sunday afternoon and peruse the literary supplements, I find it harder and harder to ignore: the world of books is like a sloping football table where the balls roll almost automatically into the goal at the boys' end. Not always, of course—look, Niña Weijers is getting a prize! Janita Monna is reviewing a collection of poems! And only last week the supplement opened with a piece by the rising star Lize Spit! I know, I know. But my grumpy glasses are quick to point out the patterns behind these individual cases, and tell me to fetch my calculator. I have started tallying in authoritative literary sections (eight in all), opened Facebook and Twitter accounts (@lezdesvad, #lekkertellen, join me) and started noting my findings in a blog. The results? Women are structurally given fewer opportunities to speak, and male critics predominate, almost all the time. I've been doing this only for a month so far, but it looks as if books by female authors are given a paltry twenty percent of the overall column inches in literary sections. Some

of these sections divide space much more evenly between male and female authors, but others devote as little as five percent of their space to women; one such was the literary supplement of venerated newspaper *De Volkskrant*, by no means an unimportant player in the literary world. Even the indie weekly *De Groene Amsterdammer* is often at fault.

The argument you hear is always, "We don't set out to underrepresent women; we select only on the basis of quality—and whether someone is male, female, white, black or anything in between doesn't matter." I am no longer persuaded by this argument. "Quality" is not a matter of objective fact.

Take a typical character in a Dutch novel: a somewhat lonely older man venting gloomily on the superficiality of contemporary culture. This kind of male figure often makes me want to laugh, but there are plenty of critics who can be deeply moved by him. How come? Simple, because their reading involves identification. Don't get me wrong, I have no issue with recognition playing a role for the literary critic; it actually strikes me as very human. But precisely because reading is always a mixture of aesthetic experience, analytic distance *and* identification, critical diversity is crucial—not just diversity of people, but of referential frameworks. Today, too many critics have spent too long measuring everything against "The Big Three,"[1] the occasional outsider throwing in Wolkers and Kellendonk.

The weary complaint is often heard that while it would be great to have more women, they just can't be found. At first sight this seems like a solid argument, but it means that the male-female ratios in the catalogues of publishing houses, on the nomination lists for literary prizes and in juries are the kind of things I wouldn't dare take home if they were school reports. Matters are not much better in the rest of the cultural sector; take a look at the programming of music festivals, for instance, and at how the jobs are often allocated in cultural organizations: the men in management, the women in logistics. And this is just the cultural sector. I haven't even considered the lack of women in top business jobs and in science.

The fact that the situation is universally appalling does not give those in key positions the excuse to behave as if it were beyond their power to change it. Every majority position is also one of a dominance that can be used for good. At the De Geus publishing house, Eric Visser gave himself the job of ensuring that half of the authors they published were women.

1 The writers W. F. Hermans, Harry Mulisch, and Gerard van het Reve are a famous literary trio in the Netherlands, but little known outside the country.

He succeeded, and it resulted neither in economic loss nor an artistically inferior pool. So you're a critic, and no one is sending you work by women? Then ask a publisher for it! Jann Ruyters is doing this already; at the newspaper *Trouw* she is clearly striving for a more equal ratio, successfully, and without sacrificing any of the quality of the *Letter en Geest* section.

The critical gaze always needs a mirror. In the absence of a rich variety of differing opinions, criticism can easily congeal into a newly "self-evident" norm that gets irritable when other perspectives enter the field. My reading glasses are not mine alone, but fit a broad and checkered variety of noses, all doing their best to get a sharper image of the extraordinarily multifaceted nature of our world. I'm not just sitting opposite you in the train; look over there, in the next compartment. That's me too—and behind you, and in the first-class carriage. Maybe you wear my reading glasses too, from time to time.

The fact is that the huge variety of interests and positions in the reading public is being structurally underestimated. This is why I, the middle-aged woman, have decided to come out from the shadows of my own unobtrusiveness and to invent my own honorary title. I hereby anoint myself the country's female reader, its lectora laureata: the Reader Laureate. As Reader Laureate I will be talking back to the literary world, the newspaper and magazine editors, the media-makers and the cultural institutes.

The editors of De Groene Amsterdammer *do not know the Reader Laureate's real name.*

Gender apartheid: literary supplements #lekkertellen
January 24, 2016

The weekly tally

Ah, the arts and culture supplements. What could be more tempting than to wrap yourself up in your expensive woolen blanket from the NRC webshop and devour everything that the cultural Netherlands and Flanders have to offer? Delicious, all that high culture with a spicy pinch of pop! But the Reader Laureate is starting to splutter her good wine to see the abysmal relationship between men and women in these supplements. Not only is it mostly the men who get to spout their ink; all too often the subject matter, too, has a tail. I briefly considered simply throwing all the paper supplements onto the crackling logs of my open fire, out of pure exasperation, but then I put on my reading glasses and began a careful tally.

From now on, the Reader Laureate will be making a weekly inventory of the newspapers and awarding a Leaden Reading Glasses prize to the literary supplement that gives the least space to women (middle-aged or otherwise). Although there is no clear balance across the cultural supplements as a whole, I will restrict myself to the literary supplements of the *NRC Handelsblad*, *Trouw*, *De Volkskrant*, *Het Parool*, *De Standaard*, *Vrij Nederland*, and *De Groene Amsterdammer*. Care to join the counting? #lekkertellen

Overview

First off, the overall picture and the figures:

Naam	rec-M	rec-v	rec-TOT.	% rec-V	rec-M	bespr-M	bespr-V	bespr-TOT.	% besp-V	% V-TOT.
week 3-2016										
NRC	13	1	14	7.14%	26	28	3	31	9.68%	8.89%
Volkskrant	9	6	15	40.00%	20	20	2	22	9.09%	21.62%
de Standaard	6	2	8	25.00%	14	14	0	14	0.00%	9.09%
Vrij Nederland	3	0	3	0.03%	3	3	0	3	0.00%	0.00%
Groene Amsterd.	3	3	6	50.03%	8	8	4	12	33.33%	38.89%
Trouw	9	7	16	43.75%	18	18	5	23	21.74%	30.77%
Het parool	5	2	7	28.57%	7	7	1	8	12.50%	20.00%
	48	19	67	28.35%	59	99	14	113	12.39%	18.33%

- In this week's literary supplements, **not a single** male critic wrote anything about a female author (fiction or nonfiction).* Female reviewers did write about men.
- Of all the reviews/literary columns/interviews, **twelve percent** were devoted to a female author and **eighty-eight percent** to male authors (in all, ninety-nine pieces were about men and fourteen about women).
- Two literary supplements made **no mention whatsoever** of female authors: *De Standaard* and *Vrij Nederland*.
- **Not one** of the literary supplements opened by putting a female author in the spotlight. Books written by women almost always appeared only in the middle of the section, or later.
- **Twenty-eight percent** of all the articles were written by a female journalist.
- With the exception of *Trouw*, not one of the literary supplements opened with an article written by a woman.

Now, some quick profiles of the different supplements:
"So much Literature! The women couldn't match this"
According to *De Standaard*, gentlemen writers provided a particularly large supply of material this week (posthumously or otherwise).
I counted fourteen reviews, of which a grand total of zero (yes: zero) were about a book written by a woman. Thankfully, there was a discussion of a French comic strip about breasts, entitled *Ontboezemingen* ("getting it off my chest").**
"Hello papa with your pipe and slippers, hellooo pipe-slip-pipe"
With the VSB Poetry Prize in mind, this week the *NRC Handelsblad* focused on poetry. And well, there aren't that many women in poetry, are there? Three female authors were discussed, along with twenty-eight male ones. (I haven't counted the remainders, but there, too, the *NRC* literary supplement energetically pursued its policy: five men were discussed, and zero women). Those old boys must really enjoy each other's company. In all, fourteen pieces appeared in this week's *NRC* literary supplement; just one was written by a woman. In hard figures: seven percent of the articles were written by a woman, and about nine percent were about women.

* To be clear: I did not count the box sections that listed ten poetry collections/books; I considered only full-length reviews of new books.
** To be even clearer: I did not count Naema Tahir's letter to Hanif Kureishi. If I had, the final tally would have been one woman.

"Woman, know your place"
De Volkskrant could only bring itself to talk about a female author after presenting six long pieces about male authors, written by male reviewers. The review—written, naturally, by a woman—was the only one to consider the work of a female author. A clear case of "the lady reviewers will get their turn after the gentlemen have spoken." On the last page is an interview with Paulien Cornelisse, prefaced by a list of new books, all written by men. In hard figures: nine percent of the supplement was about women, and ninety-one percent was about men.

"Jeroen, Carel, and Jamal[2] have a big adventure"
At *Vrij Nederland* they were probably still so deeply in shock about the dismantling of the once-successful paper (who will not remember the *Republiek der Letteren* as an authoritative supplement?) that they neither wrote about women authors, nor had any women write a piece.

"Musing on Knausgård"
Last Thursday women were also a tiny minority in the *PS* supplement of *Het Parool*. Astrid Lampe was the only female author to be discussed. All the reviewers were male, except when children's books were being dealt with (sigh). Still, there was a fascinating column by a male reviewer who wondered where the Dutch Knausgård was. Three guesses how many Dutch female artists were mentioned in that column? Ha! Right the first time!

"Piet missed something"
In terms of its own critics, *De Groene Amsterdammer* was a happy exception: its male/female reviewer ratio was a perfect fifty-fifty. I still have one complaint: in his critical piece on the VSB Poetry Prize, Piet Gerbrandy expressed his shock at all the ways the nominations were wrong—but he failed to note its lopsided male-female ratio. The only nominated poet who tickled his fancy was Boskma. In the rest of this section the men discuss the men, the women discuss the women.

"Things can be different (well ...)"
With regard to the male/female interviewer ratio, *Trouw* was also a welcome exception. Although most of the pieces were written by men (nine compared to seven), female critics were allowed to open the section with large pieces. We live in hope that in the coming weeks the ratios between the authors reviewed will also be more balanced (this week was a disappointment: eighteen male authors, five female).

2 Jeroen Vullings (literary critic), Carel Peeters (editor), and Jamal Ouariachi (writer)

Consumer advice

Are you, too, a middle-aged woman who is keeping the book market alive by buying books and reading them? The best thing you could do would be to boycott all of the literary supplements until the country's critics promise to mend their ways. After all, the current situation is absolutely appalling. If you cannot do without, then give your money to Trouw and *De Groene Amsterdammer*, where female reviewers, at least, are given a prominent place. (Here's a tip: Opzij also has a review section.)

And this week's Leaden Reading Glasses award goes to ...

In absolute figures, *Vrij Nederland* scored lowest of all: not a single woman was either reviewer or reviewed. However, *De Standaard*, *De Volkskrant*, *NRC Handelsblad* and *Het Parool* also scored so lamentably badly that they were all worthy recipients of the Leaden Reading Glasses. The jury could not decide on a final winner.

Queering:
Adwait Singh

Rebecca John

"Friendly reminder: two wrongs don't make a right! If you really feel the pain of the past, then you'd ensure that no one should have to go through that pain again." Adwait Singh, a young independent curator and art theorist based in New Delhi, does not hide their critical standpoint: their analysis of political circumstances not only informs their clear statements on social media platforms like the one quoted above from February 7, 2020, written in the context of the Citizenship Amendment Act (CAA), which was passed by the Indian parliament at the end of 2019 as a Hindutva effort to cast Muslims as illegal immigrants; it also shapes Singh's art-critical writing in a way that has been unusual in the Indian contemporary art world for too long.

The tone that Singh chooses for their "friendly reminders" on Facebook also resonates in their art critique. It oscillates between irony, sharp political analysis, displays of personal feelings and hope for a possible queer-feminist future. In December 2018, at the height of the #MeToo movement in India's art scene, Singh was among those who had taken a clear stand against sexual harassment in the Indian art world by signing a joint statement promoting safe spaces within the South Asian arts community. Staying with this trouble in their writing for Indian art magazines is equally powerful and brave in a contemporary art scene like the Indian one, where the #MeToo movement enabled a long-overdue discussion of hushed structures of power abuse, but had to receive a discouraging setback on October 1, 2019, when Delhi's High Court ordered Facebook to

remove posts alleging sexual harassment by artist Subodh Gupta.

Singh's essay "Staying With the Sirens," written several months before the #MeToo movement erupted in October 2018, retrospectively casts an interesting light on these debates. The critic starts with Max Horkheimer and Theodor W. Adorno's reading of the myth of Odysseus in *The Dialectic of Enlightenment*. After unfolding the metaphor of the Siren's song as the dangerous "pull of the past on the present," Singh describes the hauntology and sensuous relationship with the past that is perceptible in artworks by Mariam Ghani and Jacolby Satterwhite to then boldly ask: "Why disadvantage ourselves by resisting the infinite cunning of the Siren's song? ... Why not stay with the Sirens awhile and learn to befriend them." Even though Singh interpreted the Sirens as metaphor for the colonized "Other" threatening the patriarchal order, reading their text from today's standpoint makes the reader aware of the Sirens in the Indian #MeToo discourse that were very close to entangle the patriarchs, who for now have found their way to plug their ears.

Singh's text "Cracks in the Wall" from December 2019 is a review of Ayesha Singh's solo exhibition *It Was Never Concrete* at Delhi's Shrine Empire Gallery, which ran from August 23 to September 28, 2019. The exhibition, as well as Singh's text, can be read as another "friendly reminder" of repeating histories, in this case the Hindu-Muslim conflict. As a critical comment on the current Hindu-nationalist government, their anti-minority ideology and violent reshaping of the country's history as a "Hindu nation," Singh highlights the exhibition's references to a long history of transcultural exchange in the region. This entanglement of histories is especially visible in Delhi's syncretic architecture—accentuated in Ayesha Singh's architectural drawings *Hybrid Amalgamations*— which defies any cultural puritanism.

"Into the Light," a review of Salman Toor's solo exhibition *I Know a Place* in Nature Morte, New Delhi (on view December 16, 2019–January 4, 2020), is a joyful plunge into Toor's depictions of urban homosocial bonhomie. The artist creates a scenery of tipsy gatherings "somewhere between Lahore and New York," in an imagined world of normalized and unalienated brown queer life. Published two months before the spread of COVID-19 was declared a global pandemic, when the women-led Shaheen Bagh protest against the CAA and the police brutality around it was still active, the writer could not yet know that Toor's dream of queer conviviality would soon recede into even further distance. And yet, when the time of worldwide lockdowns arrived, Singh's optimism, which shines through in the art critique described above, still formed the undertone of their social media posts, hoping that "our newfound captivity can unite us in an empathetic outreach towards all the old birds born and raised in conditions of captivity."

Staying With the Sirens. On the Resilience of the Past

Adwait Singh

from *Resilience: Artist in Residence*, February 22–March 14, 2018

In their book *Dialectic of Enlightenment*, one of the seminal texts on Critical Theory issuing from the Frankfurt School, Max Horkheimer and Theodor W. Adorno explicate the classical Greek myth of Odysseus' overcoming of the Sirens. Odysseus orders his men to plug their ears whilst having himself bound to the mast of the ship to resist the allure of the Sirens' song. Drawing an analogy between the forward motion of the vessel that helps Odysseus escape his terrible fate in the allegory, to the linear flight of the arrow of time, Horkheimer and Adorno suggest that the Enlightenment's tripartite division of time into past, present, and future was "intended to liberate the present moment from the power of the past by banishing the latter beyond the absolute boundary of the irrecoverable and placing it, as usable knowledge, in the service of the present. The urge to rescue the past as something living, instead of using it as the material of progress, has been satisfied only in art, in which even history, as a representation of past life, is included."[1]

This unfettering of the present from the past and the secure shelving of the latter as an epistemically distinct category from where it could continue to service the present in a regulated manner has now been exposed as a historically specific ruse to hegemonize the temporal rhythms binding the colonial subjects. In its triumphant march of progress, the colonial apparatus attempted to neutralize all the dissonances, thereby, obfuscating the historical contingency characterizing the production of its truth, marketed as manifest destiny – timeless and natural. Under this scheme, all that designed to resist/disrupt the incessant beat of civilization was branded as backward or the 'other', to be retained at a safe distance lest it seeks to dissolve the difference, thereby jeopardizing the "unity" and *status quo* of those that the system privileged.

Explaining the arresting effects of the phantasmagoria sung by the Sirens, Horkheimer and Adorno write, "Sirens threaten the patriarchal order, which gives each person back their life only in exchange for their full measure of time … Sirens know everything that has happened, they

1 Horkheimer, Max and Theodor W. Adorno, *Dialectic of Enlightenment: Philosophical Fragments*. Ed. Gunzelin Schmid Noerr, Trans. Edmund Jeffcott. USA: The Board of Trustees of the Leland Stanford Junior University, 2002 (1944).

demand the future as its price, and their promise of a happy homecoming is a deception by which the past entraps a humanity filled with longing."[2] In this way, the Enlightenment constructed the past as an entity that one dabbled in only at the considerable peril of melancholic entrapment or regression. The Sirens were allowed to commune only through the medium of art as long as it did "not insist on being treated as knowledge, and thus exclude itself from praxis."[3] However, the allure of the Sirens' song and the pull of the past on the present is not to be underestimated.

The ways of the Sirens are more devious than immediately apparent and an undead, resilient past continues to nest in the present. It bursts to open the seams of history to reincarnate in the present moment as a hauntological presence demanding restitution, as a camp with its love for and revival of outmoded styles, modes, and identities, as Freudian 'deferred actions',[4] psychosomatic eruptions and stigmata.

Sirens are essentially composite creatures, and their utilization as figures for the past needs to reflect this polyvocal, multitudinous, and multivalent quality. In fact, one of the etymological roots of the word situates its meaning as 'binder or entangler' proleptically doubling the preventive measures undertaken on Odysseus' vessel, whereby he is bound to the mast to circumvent the binding by the Sirens. Here the two operative connotations of the word 'binding' are revealing. The past entangles or implicates a subject, demanding her to attend to it. Equally, the past binds her, in the sense of retroactively constituting and situating her identity and position in the present. Apparently, Odysseus' formula of dealing with the entanglement in the past is to contrive a counter binding that enables him to brush against the past without plumbing too deep, for this last could mean an unbinding of the ego. Elizabeth Freeman has similarly located the monstrosity of Frankenstein[5] in the very specificity of his corporeality presenting a variegated patchwork of various dead bodies and temporalities and the resultant property of being a free conduit for the past:

> In sum, Frankenstein's monster is monstrous because he lets history too far in, going so far as to embody it instead of merely feeling it, even to embody the historicity of the body revealed when erotic contact with the past produces sensations that are unintelligible by present sexual and gender codes.[6]

2 Ibid.
3 Ibid.
4 Regurgitations of an undigested past experience materialising as a hysterical physical gesture.
5 The eponymous monster in Mary Shelley's novel *Frankenstein*.

Adwait Singh

In the end, it is the weight of history that proves too much for the feeling monster, prompting him to organize his own funeral. For, with the knowledge of the past comes sympathy, an effect that Frankenstein discovers to be utterly unassimilable and incomprehensible in his given reality. Freeman upholds that an encounter with the past can shed light on the performativity of the present moment, allowing us to attend to the episodes, entities, and ephemera that have been systematically repressed/side-lined by the dominant systems and accounts, to bind the wounds of history and attend to the dead. In view of this, it is my suspicion and provocation, that something could come of heeding the call of the Sirens, of tarrying, lingering and dallying with the past, of living with it in the present. For, often as not, the best recourse in the face of a virulent, super-resilient strain is to let it run its course and be rewarded with an immunity. Besides, there could be more positive effects/benefits to fully embracing the past.

Jacques Derrida, in his *Spectres of Marx*, points out the temporal aporia instituted by ghosts in the linear timeline. What is the temporal origin proper to ghosts, for they seem, paradoxically, both to return from the past in that they are projections of a person already dead and are yet, first registered in the present where they make their apparitional debut? This ambiguity of origination is what Derrida terms hauntology. In that they are neither fully present nor past, it is possible to perceive specters as immaterial protractions of a future that was discounted unceremoniously. The Gothic thus emerges as a viscous ectoplasm smeared all over the present moment, a lingering 'pastness' that drags down the present, a hauntological trace demanding to be read and released, a futurity waiting to be unblocked through reparations in the present. In fact, according to Derrida, Marx proscribes an ethics of responsibility towards the dead and the historical moments that could not come to fruition in its own time.[7] Similarly, Freeman advocates the mining of the present "for signs of undetonated energy from past revolutions"[8] that can be reverse engineered to curate desirable, functional futures.

Mariam Ghani's *Glass House Home Movies* (2013), a work comprising a four-in-one channel video and a five channel interactive audio, transposes the hauntological trace of a traumatic collective past onto the artist's body which feels inexplicably compelled to re-perform it. *Glass House Home Movies* references two key historical moments, lived vicariously through mediated reports both geographically and

6 Freeman, Elizabeth, *Time Binds: Queer Temporalities, Queer Histories.*
Durham and London: Duke University Press, 2010, 104.

temporally removed, that have left an imprint on the American artist with an Afghani-Lebanese heritage. The first is the Siege of Beirut (1982) by the Israeli forces, as documented by Jennifer Fox's *Beirut: The Last Home Movie* (1987) that recounts the various chapters of the Lebanese Civil War (1975–1990), from the vantage of a Gaby Bustros, hailing from the local nobility, who continues to dwell in her 200-year-old ancestral home despite the enveloping war. The second is the US bombing of Afghanistan (2001) glimpsed through the official military footage. In Ghani's work, this mediated memory, interspersed with detergent commercials, appropriated clips from televised news, soap operas, and canonical performance art, is staged as a crisis of domesticity for the security cameras installed in the artist's studio apartment in Brooklyn. The video attempts to remember and comprehend the distress occasioned by the two civil-wars beleaguering the respective countries of origin of the artist's parents, that must have inveigled into the family life, coloring its psychic economy. The artist's body serves as a repository and channel for this embattled past, wherefrom it emerges as compulsive sweepings of the kitchen floor, sleepless nights spent twisting and turning in bed, methodical attempts to eat and drink, helpless staring at the clock, the subconscious shattering of glass and the urge to clean it. The reference to a glass house in the title as well as the appearance of broken shards in each frame indexes the spooked brittleness characterizing the cyclical, domestic time that teeters on the verge of a breakdown, in the face of compression by the national historical time. The rockets fired in another place, register their displaced impact as shattered glass in the artist's household; each fragment inviting her to brush her fingers against it and let the oozing blood suture the geo-temporal gap as well as the gaping wound in history. Here, the body serves as the screen on which the drama of distant civil-wars is replayed and therein, as a means for parsing, re-inscribing and reclaiming that history.

The Brooklyn-based, queer American artist Jacolby Satterwhite uses digital technologies to animate the drawings and songs of his late mother Patricia Satterwhite, that are subsequently assembled into personal mythologies. The distinctive latticed and cross-hatched drawings of utilitarian objects, that were both a symptom of as well as a palliative for his mother's psychological condition, are traced and rendered into 3D objects using the animation software Maya. Intended as the

7 Jacques Derrida, *Spectres of Marx: The State of the Debt, the Work of Mourning, and the New International*. Trans. Peggy Kamuf. New York: Routledge, 2006.
8 Elizabeth Freeman, *Time Binds: Queer Temporalities, Queer Histories*. Durham and London: Duke University Press, 2010, 16,

Adwait Singh

final send-off to a matriarchal memory, the single-channel music video *Blessed Avenue* currently on view at the Gavin Brown's Enterprise, NYC, is accompanied by an array of merchandise modeled after Patricia's drawings, dispensed from a 'souvenir shop', labeled simply "Pat's". The art historian and curator Jack McGrath in the accompanying exhibition text explains, "It leverages a son's cultural capital to drive the economic circuits from which his parent was systematically excluded."[9]

The realization of Patricia's designs in this manner seems to be a posthumous reparative gesture towards a discriminatory past, a fitting memorial to the memory of a Black, working-class mother who always dreamed of having a QVC line. Patricia's legacy thus revived, supplies the oneiric, hedonistic setting for small cabals of libertines engaged in a laissez-faire of fantasies and desires. The avatars populating these digital dioramas are characterized by a degree of fungibility suitable to the orgiastic rites and sadomasochistic rituals that they partake of, experiences that are often attended by a surrender of agency and individuality. Set to the tune of acid house with incorporated bits from Patricia's acapella compositions, the gyrating bodies, enchained to larger apparatuses with placenta-like contraptions, appear to power this micro-universe through their bacchantic labors. Towards the end of the video, the voguing assemblages leave their bondage-factory-cum-arcade-like confines to do an aerial recce of a post-diluvian world, heralding a queer time.

In mining his mother's repertoire for tropes that can aid the inauguration of queer futurities grounded in fabulated mythologies, the artist employs a creative archaeology that favors "positive affects" such as idylls, wet dreams, recollections of pleasures and touches to forge a link to the past. This erotic relationship with the bygone, a sensuous, tactile mode of apprehending history that looks beyond predominant canonical and "scientific" approaches, is what Freeman terms "erotohistoriography."[10]

Erotohistoriography permits us to perceive time in nonlinear, anachronistic, non-genealogical ways, thereby admitting the possibility of alternate modes of sociality and intimacy disavowed by the extant heteronormative codes and chronobiopolitics. It illuminates alternate pathways to a productive partnership with the past that does not proceed by arm-twisting it into submission, or rely on negative figurations such as wounds and melancholia, but attempts instead, to formulate deliciously queer modalities of thinking with the past. This then has been the modest undertaking of this text. Why disadvantage ourselves by resisting

9 See https://www.galleriesnow.net/shows/jacolby-satterwhite-blessed-avenue/.

the infinite cunning of the Sirens' song? Why not allow ourselves to give into its sweet call and turn to look back upon the past for what might be gleaned there? Why not stay with the Sirens awhile and learn to befriend them.

Cracks in the Wall

Adwait Singh

from *Art India. The Art News Magazine of India*, December 2019

Ayesha Singh's solo at Delhi's Shrine Empire Gallery *It Was Never Concrete* from the 23rd of August to the 28th of September conjures a strange archaeological terrain of collapsed histories, or perhaps an antique shop where a mixed bag of motley monuments from different times parley across the same shelf. The gaze meanders through an architectural maze of hybridised arches and cornices, delineated as black metal frames that break up the white space, vaguely connoting the syncretic skyline of this ancient city, finally alighting on a swinging kinetic sculpture espied through a broad vertical slit in a temporary wall.

Two zoomorphic wooden brackets, the kind one would recall from temple interiors in South India, joust and collide in an eternal merry-go-round, leaving behind a trail of dust and broken fragments. Titled *Frayed Continuum*, the work proffers a poetic preamble to the exhibition. The twin figures go faster and wilder as they shed their ideological weight. The torqued dynamism of the sculptures is an obvious reference to historical recycling and continuity whilst the settled remains on the floor offer a much more ambiguous reading and can variously signify constructive friction that would eventually cancel out difference, or historical casualties caught between warring ideologies. As such, this material slough is open to interpretation as exhausted cultural difference or the ruins of a desecrated past repurposed into an eclectic present. Or perhaps both at the same time.

The exhibition title, as the curatorial note by Anushka Rajendran suggests, is a reminder of the fact that even reinforced concrete is vulnerable to wear, in addition to signalling the transience of our built architecture

10 Elizabeth Freeman, *Time Binds: Queer Temporalities, Queer Histories*. Durham and London: Duke University Press, 2010.

at large, as well as the susceptibility of the emblems of power to subversion. One of the panels from the series *Capital Formation* that photo-documents projected prompts on public spaces, reads 'I appropriate their Corinthian, they appropriate my chai' while the following words appear against the backdrop of a brightly lit Rashtrapati Bhavan in another:

a plaster cast,
of a Roman copy,
of a Greek ideal,
of a local custom.

These words, when viewed in the light of the exhibition title, question the cultural puritanism that pervades the current political atmosphere, revealing and revelling in the rich multiculturalism (literalised by a series of composite architectural drawings *Hybrid Amalgamations* elsewhere in the exhibition) that is writ all over the syncretic urban landscape of Delhi, pointing to a bustling history of intercultural exchange long before globalisation became a thing. Taken together with the injunction 'Let's repeat the definition of an empire' projected onto a police barricade, these textual provocations indicate the recursion of imperial tropes and their modification by modernities time after time. The curatorial note doesn't quite stop at situating these tokens of hegemonic posturing within physical spaces of the city either, extending these well over to the soft architecture of social media and advertising imagery as well as their intersection with algorithms of power. One hears alarming reports of unauthorised data mining and big data being employed by various corporate and political players to identify and influence their targeted audiences, just as one hears an echo of symbols and regalia of authorities past in our day to day material expressions and aspirations. All this points to the simple fact that although the modalities of power might have changed the directionality and nature of power have not.

The dispersed message that one gleans from these writings on the wall is poetically assimilated by three stacks of commonplace yellow posters squatting on a dais of concrete building blocks right in the middle of the charcoal grey room. This instigation titled *Capital Formation/ No Exit Nation*, conceived by the artist in collaboration with Rajendran and artist Jyothidas KV, comprises several copies of the eponymous poem translated across three predominant Indian languages – Hindi, Urdu and English – to be taken and disseminated by gallery visitors. The

performative text that mimics the same collaged aspect as the rest of the exhibition, leaves one with an impression of various architectural units acting as transferred epithets for extant no-exit containments, exclusionary politics, economic disparity and social segregation. The shifting metaphor of the wall recurs throughout the poem and takes on different physical attributes and socio-economic connotations, doubtless to instantiate the multiple locales where the poem would pop up through audience intervention. As the site-responsive import of this work sinks in, slowly and out of the mismatched corners of the city imported into the gallery, a third understanding of the title 'It was never concrete' starts forming. One wades through a thickening sense of treachery as the failed promise of neo-liberal modernity – growth and the neutralisation of difference – dawns. Just like its favoured material – concrete – the promise of modernity has proved to be far from perfect as borne out by the numerous grievous cracks that have appeared in its façade. Once through this doorway of understanding, it becomes impossible to see the exhibition in any other light.

Into the Light

Adwait Singh

from *Art India. The Art News Magazine of India*, January 2020

My immediate thought upon encountering Salman Toor's works at his first solo exhibition in Nature Morte, New Delhi, held from the 16th of December to the 4th of January, was, "How pretty!" 'Pretty' of course acquires a special ring in the context of queer aesthetics. It reclaims shallowness as a field of intensified affect like an artificial diamond decorating the décolletage of a drag queen, catching and multiplying the jubilant glory of the wearer in its faux depths. 'Pretty' packs all the pith and poetry of an emoticon. What might otherwise come across as kitschy, in the hands of Toor transforms into self-aware camp, or a loving assemblage of styles from the past that become crucial in issuing queer subjectivities and aesthetics. 'Pretty' thus, despite its light application, forms the mainstream of queer desire and subjective validation. To say that Toor's works are pretty, is then to summon a wealth of delicate queer feelings hid under the appropriated superficiality of the moniker. And it is with a coterie of bubbling emotions and the knowledge of secret

joys that a queer gaze grazes the textures of Toor's plushily rendered turtle necks, denims and vintage jackets enwrapping the languid bodies of his subjects nursing stolen moments of same-sex intimacy.

The exhibition title *I Know a Place* could be taken as a banal proposition to make away to a private spot for erotic dalliances as is common usage with young disenfranchised couples in India, queer or otherwise, or something a little more poetic, as in a general avowal of a safe space found in the company of close friends or a lover. Either way, it is a gesture of elopement, an invitation to steal away to a timeless cove beyond moral and legal judgement. The differently-sized oil on canvases inside the exhibition, pitch the idea of a safe place as fictional vistas that reveal scenes of homosocial bonhomie, tipsy merriment, languid repose, playtime, luncheons, musical evenings and friendly gatherings, presumably set between Lahore and New York (where the artist is based).

In a work titled *Late Night Gathering* we are privy to a scene skimmed from the fag-end of a house party, where a male figure has passed out on a sofa in his underwear as the guests are making to leave. This motif is repeated in *The Convalescent* where the unclad invalid reposes on a green sofa, overlooked by two caregivers or companions, who are sharing some screen time. Scenes such as these speak of a certain level of comfort and

Salman Toor,
Mehfil/Party,
2019

privilege enjoyed by present-day urban queer set-ups. However, Toor's works go one step further in installing this comfortable picture of queer domesticity. By appropriating the idiom of Western master painters as well as the heterosexual familial frames from modern advertising imagery, and by painting his subjects in somewhat dated garb and interiors, the artist attempts a trans-historical intervention that seeks to garner normalisation for brown queer relationships and lifestyles characterising his current diasporic context by steeping these representations in an imagined past. Moreover, by situating his dandies in the hipster milieu of the East Village, the artist seems to be negotiating a deliberate break from stereotypical representations of brown subjects in the mainstream of American media. The restrained sensuality of amorous couplings, in what appears to be a nod to an eastern sensibility, illustrates the possibility of claiming the space of queer romance on non-homonormative grounds.

In *The Confession*, we see two men out on a well-lit balcony, screened from the crowd, hands pressed to heart to emphasise the sincerity of the confession. *Mehfil/Party* and *After Party* both portray entwined queer bodies arranged like calligraphy, chatting animatedly or kissing contently. Elsewhere, one observes the making of a queer pastime as in *The Queen* where a bunch of children are playing dress-up before a tent

Salman Toor, *The Queen*, 2019

Adwait Singh

pitched in a lawn, or the interruption of one by the unexpected visit from a long-faced friend. All these frames can pose as authentic alternatives to homonormative depictions of queer engagements and sexualities, in that they linger on the non-events, or the quotidian fillers of queer time. Even moments of interface with that potentially alienating and solipsistic device—the smart phone—are salvaged in Toor's hands as tender episodes of huddled sociality. The world as seen through Toor's lens is a radically empathetic world where children can cross-dress without censure and brown queer men can entertain the thought of having unabashed and fulfilling same-sex couplings that are not painfully aware of their deviation from the norm always; it is a world where a man with limp wrists incites not invective but indulgence.

In a post-Stonewall world where civil partnerships and gay marriages have become increasingly common, one still lives in the cold shadow of the closet, and loneliness remains a killer at large. It is indeed surprising that Toor's works evince no signs of this baggage and sometimes one despairs that they are no more than romanticised depictions of a bourgeois queer lifestyle. However, in this instance, I am willing to argue, and against the wisdom of multiple queer theorists, that there's value in permeating visions of a normalised and unalienated queer life even if a heteronormative frame is held as the metric of that validation. Besides, Toor's current body of work seems self-aware of this new-found freedom as well as its precarious ground in that it reflexively flashes back into traumatic episodes from the everyday past. Works such as *The Beating, Ambush II*, and *Immigration Men*, furnish reminders of the violent underpinnings to frivolity that meets the eye. In view of this, the little privileges are more readily forgiven as dogged resolutions, however fraught, to rise above one's circumstance, to bury the violence of being, deep (or should I say shallow?) in the din of newly affordable pleasures.

Culture and Capital:
Claire Bishop

Anna Kipke

Claire Bishop has a style of writing art criticism that is similar to tearing a bandage off your skin—it leaves you shaking for a brief moment, but it greatly accelerates the healing process. In her writings on the opening of the hybrid exhibition and performance space the Shed in New York, Bishop sets an example for art criticism in the twenty-first century with her broadened perspective on cultural politics, situating art and culture at the heart of the new "economy of enrichment" (Arnaud Esquerre/ Luc Boltanski). While Bishop's writing aligns with the tradition of institutional critique, her approach provides the tools with which to trace the strategies of value creation.

In part of her essay, Bishop, an art historian and critic, reviews the venue's opening week in 2018. The days were filled with a program of performances, lectures, and panel discussions. The Shed is the primary cultural institution in the Hudson Yards, a redeveloped luxury real-estate district in Manhattan, which is one of the largest, most expensive private construction projects in the United States. Financed with taxpayer money (comprising $75 million of the $500 million budget), the Shed is located in a district known for its population of high net worth individuals. Bishop's line of argumentation starts with an essay titled "What is the New Ritual Space of the 21st Century?" published in the Shed's inaugural booklet, in which the German art historian Dorothea von Hantelmann reflects on ritual spaces since antiquity. Von Hantelmann envisions the contemporary ritual space as an interplay of gatherings with a combination of opening hours and appointments

embedded in a flexible, transformable architecture. Von Hantelmann's vision is congruent with the architecture and concept of the Shed deriving from Cedric Price's Fun Palace, a structure that was designed but not built in London in the sixties. Bishop analyzes how this Fun Palace idea is drained of its specific agitprop-theater context and social agenda.

Bishop exposes von Hantelmann's essay as an attempt at intellectual justification, but Bishop's text transcends the critique of neoliberalism and its dogma of adaptability and flexibility as manifested in the Shed's architecture, concept, and surroundings. She rather extends the discussion to the question of cultural institutions being at the center of social control in times of accelerated gentrification, the weakening of public services, and the accumulation of private equity. The rules of conduct in this privately-owned public space (no food outside, refreshments available only with credit or debit card) are examples of those mechanisms of control.

First, what contemporary art criticism—or, to be more inclusive, art writing or journalism—can see exemplified in Bishop is an understanding and examination of the network of public, cultural, and economic agents as the driving force of this new form of capitalism, in which luxury tourism as well as artistic and cultural activities are key elements. Second, in her discussion of von Hantelmann's essay, Bishop illustrates how the strategies of value creation work by turning back to history and culture in geographical and temporal shifts. Last, Bishop's writing is a call to realize one's own positionality at the core of these processes of value creation in the economy of enrichment.

What comes after the shock? Taking risks is an option, as critic Barry Schwabsky stated in *The Brooklyn Rail* in 2012: "… if you are not risking meaning—that is, both putting accepted meanings at risk and taking the risk of producing new, controvertible meanings—then in my view you are not practicing criticism." The work starts now.

Palace in Plunderland: Claire Bishop on the Shed

Claire Bishop

from *Artforum*, September 2018

It's hard these days to stand out as a performance space in New York. Every arts venue in the city seems to be developing a hybrid visual art and performance program: the Whitney Museum of American Art, the New Museum, the Museum of Modern Art and MoMA PS 1, the Park Avenue Armory, Performance Space New York. Even the Metropolitan Museum of Art had a performing arts series. So what's a new cultural venue to do? One idea is to make it really, really big—say, two hundred thousand square feet. Another might be to hire Diller Scofidio + Renfro to design an eye-catching structure with some kind of unusual architectural feature—like a telescoping glass outer shell that can extend to cover the nearby plaza and provide another seventeen thousand square feet of climate-controlled performance space. Welcome to the Shed, due to open next spring in Hudson Yards on the west side of Manhattan.

A third strategy for making an entrance into this already saturated field is to commission a manifesto that provides a historical rationale for your presence. To this end, German art historian Dorothea von Hantelmann has penned the essay "What Is the New Ritual Space for the 21st Century?" Published in May as a booklet to accompany the venue's two-week preopening program, von Hantelmann's text, a reflection on communal spaces since antiquity, serves as intellectual justification for the Shed's existence and technological gimmickry.

Von Hantelmann's writing has long been devoted to the conjunction of exhibitions, public space, and performativity. In this latest essay, she asks: If theater was the ritual space par excellence of antiquity, the church was the ritual space of medieval Europe, and the museum was the ritual space of industrial societies, what is the paradigmatic one for today? Von Hantelmann understands ritual space to be an arena in which society communicates, enacts, and maintains its cosmology. *Theater* is organized by what she calls "the appointment" (an implicit social contract that the audience will show up at a specified time and place to attend a performance, a church service, a political event, etc.); the term *museum*, by contrast, designates experiences structured around "opening hours" (the agora, the shopping mall, the museum itself). The former is collective but, as a social space, too rigidly conformist; it is "the

one (or the few) who speaks to the many." The latter is individualized, but lacks social cohesion; in the museum, "the many communicate with the many." As such, it corresponds to the fundamental values of modern Western society: "the individual, the object, the market, progress, pluralism." The problem today, she argues, is that this ideology of atomization and discreteness (the autonomy of works of art, taxonomies of display, the privileging of the visual, etc.) is not conducive to long-term social connections.

The ideal new ritual space, then, will rework exhibition conventions in three key ways. First, it will overcome the primacy of the visual to accommodate what von Hantelmann calls an "interplay of gatherings"—in other words, the institution will also present music, poetry, dance, theater, and so on. Second, its organizers won't choose between the appointment and opening hours, but rather will offer a combination of both. Third, the space will have a protean topology—a movable, transformable structure that can be architecturally adjusted to accommodate different formats over the course of the day.

What real-world institution could possibly realize this vision of the paradigmatic twenty-first-century ritual space? Obviously, the Shed. Yet von Hantelmann coyly avoids such an explicit claim. Instead, she looks backward, suggesting that the archetype of the twenty-first-century's ritual space is, in fact, Cedric Price's Fun Palace, designed in the mid-1960s, but never built. It has been cited by architect Liz Diller as an inspiration for the Shed, and it's a frequent touchstone for curator Hans Ulrich Obrist, the fledgling institution's senior program adviser.[1]

The Fun Palace is the art world's go-to example for utopian architecture. Viewed simply as an architectural plan, the Fun Palace seems like an appropriate model for this kind of space: It was designed as a multidisciplinary venue (its consultants included Buckminster Fuller and Yehudi Menuhin) and has a flexible, modular structure that could be adapted by its users to their needs. Its numerous ambitious features—including a moving catwalk, gantry crane, inflatable conference hall, ventilation tracks, sewage purification, and gigantic adjustable blind shading a rally platform—nevertheless proved too expensive and impractical to realize.[2] But the Fun Palace wasn't just a physical shell: Conceived with progressive theater director Joan Littlewood, it was intended to be an interactive environment with a social agenda, retraining working-class East Londoners to engage with new technology in a fusion of entertainment and

1 Among the many Obrist references to Cedric Price, I could cite his Swiss Pavilion at the 2014 Venice Architecture Biennale, "A stroll through a fun palace."

education.[3] "Learn how to handle tools, paint, babies, machinery, or just listen to your favorite tune," Littlewood suggested. "Try starting a riot or beginning a painting—or just lie back and stare at the sky."[4] Von Hantelmann's characterization of the Fun Palace substantially reorients it away from the agit-prop street-theater context of '60s London to better fit our current society: in her words, "large, concentrated groups of people, individualization, flexibilization, constant change, and the increasing involvement of consumers."[5] It's a staggering rhetorical shift that takes up what is most proto-neoliberal in Price (the mantra of flexibility) and rebrands it as prosumerism.

Again and again, von Hantelmann emphasizes adaptability as if it were a goal in its own right. Collectivity is rejected as too homogenizing (perhaps too socialist?), while individualism is jettisoned in favor of smaller "groups of people" (like-minded customers of a similar income bracket?). As Ben Davis of *Artnet* points out in his own critique of the Shed, von Hantelmann seems to have a historical blind spot when it comes to the long and loving relationship between the bourgeoisie and the kind of cultural space she is describing. Her rhetoric is drained of any class consciousness: Social friction and inequality are smoothed over to facilitate a neo-Habermasian public sphere to which everyone has equal access through the democratic miracle of opening hours. There is no capitalist superstructure to be challenged; the goal is simply to forge moments of benign togetherness and conversation—perhaps along the lines of clusters of people in a park, as in the last image of the visual essay that opens her booklet, or the events in the preopening program, "Prelude to The Shed."

The same ideological gloss can be seen in the architects' reinterpretation of user-generated flexibility as an enormous tectonic foreskin.

2 The Fun Palace became a point of reference for the Centre Pompidou (1977), designed as a multiarts space with a flexible architecture that also turned out to be far too expensive to fully realize. In 1976, a smaller, cheaper version of the Fun Palace was constructed as a community center in North London. The InterAction Centre in Kentish Town had a ludic architecture based around a long structural truss that supported temporary configurations of containers and cabins. It was demolished in 2003.

3 As Stanley Mathews recounts, "The working class population of East London could use cranes and prefabricated modules to assemble learning and leisure environments, creating spaces where they might escape everyday routine and embark on a journey of creativity and personal development." Stanley Mathews, "Cedric Price—From 'Brain Drain' to the 'Knowledge Economy,'" *Architectural Design*, January–February 2006.

4 Joan Littlewood, cited in Ian Youngs, "Joan Littlewood's 'Fun Palace' Idea Realized 50 Years On," BBC News, October 4, 2014.

5 Dorothea von Hantelmann, *What Is the New Ritual Space for the 21st Century?* (New York: The Shed, 2018), 50.

The Shed, Hudson Yards, New York

As described in the *Financial Times*, "With the press of a button, a beautiful steel skein resting on the body of the 8-story building glides forward on 6 feet tall wheels to increase the size of the auditorium to Grand Central Terminal proportions. The seating can go every which way, or disappear for standing crowds."[6] This is clearly a very different type of operation than Littlewood's progressive "laboratory of fun" and "university of the streets." Influenced by cybernetic theory, Price conceived the Fun Palace as a self-regulating environment in which visitors would adapt the spaces and walls to their own needs, forming an architectural feedback loop. The Shed, by contrast, will be programmed by a team headed by impresario Alex Poots, formerly of Manchester International Festival and the Park Avenue Armory, where he became known for pricey, high-end spectacle. He proudly refers to the Shed as "the most flexible space ever made."[7]

6 Apollinaire Scherr, "A Prelude to The Shed, Hudson Yards, New York—
'An Impressive Roster,'" *Financial Times*, May 4, 2018.
7 Poots, cited in Calvin Tomkins, "Alex Poots: Performance-Art Impresario,"
New Yorker, December 5, 2016.

Hudson Yards, where the Shed is situated, is a huge rezoning and redevelopment site in the windswept former rail yards between Thirtieth and Thirty-Fourth Streets in Manhattan. It's an area that has already been "improved" by the High Line, a former railroad track turned privately funded strip of elevated walkway that has its own relentless program of visual and performance art events. The site epitomizes luxury real-estate development: It's a sprouting conglomeration of high-rise steel and glass skyscrapers containing offices, retail space, hotels, and, of course, exquisitely expensive apartments. The folly adorning the center of this redevelopment, the Vessel, is a ludicrous $200 million hybrid of architecture and sculpture by the British designer Thomas Heatherwick. *The Wall Street Journal* refers to Hudson Yards' investors as "a who's-who list of big-name global financial institutions."

"Prelude to The Shed" occupied an empty lot across Tenth Avenue, between Thirtieth and Thirty-First Streets. The performances took place in and around another flexible structure, this one by Nigerian architect Kunlé Adeyemi. Perhaps unsurprisingly, the centerpiece of the program was Tino Sehgal, who uses many of von Hantelmann's arguments to explain the production of social space in his "situations," while she, in turn, positions his work as the culmination of her 2010 book *How to*

Roderick George and Josh Johnson dance at "Prelude to the Shed," 2018

Claire Bishop

Do Things with Art. Adeyemi's walls, which doubled as seats, could be pushed together to create a dark room in which Sehgal's *This Variation*, 2012, was performed, or sporadically opened for the staging of a William Forsythe duet on the plaza outside or for dance battles by the d.r.e.a.m. Ring dancers. In the mornings, *Schema for a School*—an experiment in "new models for teaching and learning" run by artist Asad Raza and Princeton academics D. Graham Burnett and Jeff Dolven—was held for a preselected group of students. In the evenings, the structure was used for music performances, lectures, and panel discussions with participants ranging from Azealia Banks to Richard Sennett. Meanwhile, on the plaza, three assistants wheeled trolleys containing facsimiles of Price's architectural drawings, including a proposal for a "wind sleeve" at Hudson Yards in the late 1990s; interested members of the public could engage the trolley-pushers in limited conversation about the drawings.

"Prelude to The Shed" was exactly the kind of hybrid performance-space-as-exhibition that von Hantelmann takes as the starting point in her essay. Some elements of the program were continuous, some events were held at given times, with everything merging in a flux of different genres of dance, performance, contemporary art, and popular culture. On the afternoon I attended, the program scrolled smoothly through four or five elements within thirty minutes. While these transitions were well done, the total impression was less of a new ritual space than of quality decoration for an area where a cozy pied-à-terre will set you back $12 million. In this context, the Price trolleys offered the memory of participatory architecture in the register of defanged ancient history, rather than as a way to put critical pressure on actual real estate. A *Schema for a School* is one thing; the more radical proposition would be a cultural institution that includes within its architecture crucial services like a public school, day care, or a branch of the New York Public Library.

The construction of yet another enormous venue for culture feels like the harbinger of a horrible new world in which all public services are drained of resources but every High Net Worth Individual can evade taxes by pouring a fraction of their profits into a cultural project that enhances their social status. The über-wealthy once gave a percentage of their riches to the church; today they give them to flexible and adaptable visual art/performance spaces. Before leaving office in 2013, New York City Mayor Michael Bloomberg earmarked $75 million for the Shed. But taxpayers' money shouldn't be used to bolster supersize spectacle (underwritten by wealthy corporations seeking their own tax breaks) at a

cultural institution that plans to gain revenue by renting out its space to New York Fashion Week. This structure—and its superstructure—isn't going to yield the kind of social gathering described by von Hantelmann. (For that, we should look to more socially oriented projects, like the magnificent SESC Pompéia in São Paulo, which offers leisure facilities for workers: theaters, an exhibition space, gymnasiums, a swimming pool, a library, cafés, and workshops all buzz with convivial activity.)

Historically, ritual spaces have served to paper over class differences, subsuming them in the name of a higher unity (religion, nation, culture, etc.). Ritual spaces are carefully curated, and the FAQ page on the website for "Prelude to The Shed" gives a taste of the social control behind it: no outside food or beverages, no chairs or blankets, no flags or signs, no pets, no selfie sticks, no umbrellas, refreshments available for purchase only with a credit or debit card (no cash transaction). It's the familiar jargon of pops—privately owned public spaces. The space might ostensibly be open to all, but participation is invitation-only. One can only imagine the security response if a group of street dancers descended on the Shed's plaza unannounced and a crowd of spectators grew around them.

The sheer scale of the Shed—both physical and financial—means that the problem of its social role is accordingly magnified, even though it's no singular aberration, but the new normal. The same forces that birthed this monster (supply-side predation, accelerated gentrification, speculative construction) have of course also spurred expansion fever and the development of hybrid programming at other venues in the city—and across the whole country. In 2019, MoMA will relaunch itself as an expanded museum with 30 percent more gallery space, including "a state-of-the-art studio and performance center" to "support a broad range of experimental programming." This is ironic, given that the museum's current show is dedicated to Judson Dance Theater, which reshaped the history of choreography from the basement gymnasium of a late-nineteenth-century church. New York produced much of its best art when the city was a bankrupt ruin. This is not a romanticization of poverty, just an acknowledgment that radical experimentation doesn't need seventeen thousand square feet of high-tech retractable pavilion.

The architecture of a space matters less than how it is used—this should be obvious to anyone. The Shed's fine line between culture and control underscores that spaces today don't need to be curated, but occupied. The surge of occupations that have taken place since 2011 have something in common with von Hantelmann's performance exhibitions, at least formally: They are not governed by the appointment or opening hours, and are durational and provisional. Yet food, chairs,

blankets, selfie sticks, and protest signs are welcome. And unlike a cultural event, embodied assembly has the capacity to constitute a people, as Judith Butler reminds us: Occupations are not window dressing for real-estate investment, but the forging of alliances among disparate groups who enact and oppose precarity.[8] New York doesn't need another curated cultural venue. We need to reclaim public assembly.

8 Judith Butler, *Notes Toward a Performative Theory of Assembly* (Cambridge, MA: Harvard University Press, 2015).

Merging:
Enos Nyamor

Yvette Mutumba

Enos Nyamor is a writer and cultural journalist from Nairobi, Kenya. I first encountered Nyamor's work in 2016 when he participated in a writing workshop for young art critics facilitated by *Contemporary And (C&)* in Nairobi. Nyamor has an education in information systems and technology and a passion for the visual arts. In many of his texts, he merges these divergent backgrounds by thoughtfully and critically looking at the connections between art and (digital) technologies. He is particularly interested in how these effect artistic visions as well as cultural identities. Being able to bring these aspects together is a skill that certainly makes Nyamor stand out on his way of becoming one of the leading art critics of his generation. Although his formal education did not provide much input and space for critical thinking and writing, particularly regarding arts and culture, he has managed to carve out his own writing practice of an outspoken critical analysis. I therefore consider Nyamor's critical position as an important voice, which manages to put forward a very specific perspective of a Nairobi-based, young writer who has to confront very different challenges than a writer based in Berlin or New York. At the same time, he is able to step out of his specific context by connecting it to universally relevant issues. In 2019 Enos was awarded a fellowship at the Akademie Schloss Solitude, an established residency program in Stuttgart, Germany, which provided him with the opportunity to fully delve into his writing. One of the many texts he wrote during this time is a contemplation

on our hypermediatized world and its effects on cultural journalism. This short essay does not necessarily fall in line with his other writings, which are predominantly critical reviews and examinations of exhibitions or debates about developments and perceptions of specific artistic practices. Still, this text makes sense within the context of an anthology of art criticism, as Nyamor sets a frame here by asking important questions that apply to anyone who is delving into (art) critical writing today.

His essay "In a Hypermediatized World. Visions of Cultural Journalism" reminds us of the distorting impact of digitality and how, in relation to that, the media affect individuals and societies: "The digital stampede has heralded the creation of a borderless and virtual world. It is a nation with an ever-growing population." Nyamor furthermore rightly points out how the shift from analogue to digital is not only a push for new structures, formats, and languages, but also "a source of confusion"—an aspect not often considered when it comes to art criticism. Digging deeper into the idea of mediatization of culture he concludes that this is "almost a natural reaction to the multiplication of platforms...."

In that context he determines that cultural producers, here particularly singling out intellectuals and educators, fear that digitality's impact will result in a decline of critical thinking. By specifying this fear, he points at a basic problem that still accompanies the amalgamation of digital and analogue culture. But as he rightly argues that with "every new communication technology, from the printing press, photographs, radio transmitters, and to television, the fear of overindulgence has always loomed." What does this mean for cultural journalism? Nyamor suggests that there is not really one answer to that question apart from the fact that it "as a field, is embarking on a restive, inconsistent future."

In a Hypermediatized World. Visions of Cultural Journalism.

Enos Nyamor

from *Schlosspost*, Akademie Schloss Solitude, 2019

The onset of digital media continues to distort ways in which individuals and societies relate. We exist in a media-saturated world. Methods of information gathering, production, distribution, and generation have drastically changed. As such, there is the urgent need for those involved in the interpretation of cultural artifacts – visual objects, texts, and performances – to respond with fresh perspectives. Here, Enos Nyamor explores the visions of cultural journalism in a hypermediatized world.

We may all be facing different storms from time to time, but we are obviously sailing in the same boat – the boat of digital posthumanism. More than in any other period in documented human civilization, the digital infrastructure has become the central nerve in social production and reproduction. Across oceans, mountains, and deserts, the digital conflagration spreads like wildfire, consuming and altering all that dare splay in its path. Everywhere are digital traces: images, texts, sounds, or a combination of these three elements.

The digital stampede has heralded the creation of a borderless and virtual world. It is a nation with an ever-growing population. But the radical shift from the physical to the virtual has been a source of confusion for the traditional systems that were constructed to last a thousand years, but are now becoming obsolete. With the neoliberal approach, industrious entrepreneurs have experimented with ways of appropriating the common property that is the internet; and political authorities have reacted with laws and technologies of control. But how elusive are these laws and controls, how sustainable are these approaches in an increasingly cybernetic world?

Yet, indeed, the status quo has every reason to be vigilant, because power is never as secure as it is portrayed. Digital technologies, with their capacity to liberate from control, are a form of subversion, and diminish the ubiquity of the rulers and ability to instill fear. Suddenly, everyday life is in a contest with political narratives. The role of politicians is

waning, and so is their hold on the type of information that media houses can produce, and the knowledge that the masses can consume. This form of nonlinear distribution of knowledge is openly subversive and disrupts the vertical power assembly – the core value in every bureaucratic system.

And so is the radical transformation in the process of dissemination of information. Within a political context, these can be pieces of propaganda that are essential in inspiring action and influencing the decision-making process. Every political franchise, without exception, thrives on the capacity to manipulate information. However, the new media has steadily suggested death to the centralization of knowledge, and so the end of political control of the fourth estate. Practically, this shift upsets the concept of the mediatization of politics – the central notion in mass communication and traditional press.

With the multiplication of information distribution platforms, and with the possibilities of local assemblies, mediatization of politics is constantly waning. The essence of the umbrella term "mediatization," of course, is the capacity of the media or the press to shape political narratives, and the resultant adjustments on account of political influences. But the emergence of horizontal assemblies, or, in concrete terms, the promise of horizontal assemblies, is likely to dislocate the significance of a universal political platform. This reorganization presents the key feature in a protean digital world, where knowledge is constantly produced and discarded.

While it remains a contested subject, horizontal assemblies are to become significant, and these are to be connected through digital infrastructures. The current challenges of fake news, for example, constantly lead to evolution. Underneath these impediments arises the demand for self-organization.[1] Communities are to constantly produce and reproduce social structures in a way that transcends the orthodox systems. This

self-organizing future, although volatile, would lead to a new form of mediatization, which of course is the mediatization of culture and everyday life.

It is possible that attaining such systems can be a long process, but mediatization of culture is almost a natural reaction to the multiplication of platforms, as well as the local agencies that do not demand intrusion by a centralized administrative system. Even today, social media, for instance, has become a source of information for the mainstream media. Here is a classic case of digital culture supplying the media with information, and, in return, the media reacting and adjusting the approaches to information gathering, processing, and distribution.

But, then, new media function on layers of algorithms, some of which are independent of human action and decisions. Because the machines or the algorithms have the power of decision-making, they highlight a posthumanist world – a world that is not only constructed on human intellect but also the acceptance of the "others." In this case, others can include the environment, nonhuman creatures, and even other realities.[2] These are realities that are bound to divided selves, and acknowledgment that human senses are insufficient and limited. The five senses are only possible for humans, but there can be other ways of sensing the world. And once such vision percolates into the universal narrative, it marks the beginning of a posthuman world.

Away from the weight of humanism and posthumanism, the dominance of mediatization of culture in everyday life can arise from it being anodyne, without resolving to be so. In contrast, the concept of political correctness is harmless, but every instance can inspire a spiral of assumptions, and even obfuscation of true feelings and thoughts. The political climate today is indicative of the dangers of obfuscation. While the citizenry in some nations in the Global North is openly against fundamentalism, the popularity of conservative leadership – whose policies are isolationist and pejorative – has swelled.

1 Michael Hardt and Antonio Negri. *Assembly*, Oxford University Press, 2017.
2 Rosi Braidotti. *The Posthuman*, Polity Press, 2013.

Enos Nyamor

Thus, cultural journalism, as a field, is embarking on a restive, inconsistent future. Perhaps this is because of the unpredictability and the chaos that new media present. The restructuring process will remain tenuous. But societies are often self-organizing. Ultimately, it will be possible to produce and reproduce virtual communities – societies founded on the acknowledgment of divided selves. And cultural journalism will be the means of exploring the idea of satellite and virtual communities, because of the unpretentious critical foundation.

In a hypermediatized world, the idea of succumbing to digital speed persists. Images and texts and sounds flood collective and individual consciousness. The massive explosion in the reproduction of information has compelled a division of attention. Constant notifications and interconnected devices and sensors overwhelm individual attention. The primary fear for intellectuals and educators alike is that such digital culture is likely to lead to a decline in critical thinking, that the collision of information is prone to weaken reasoning. But with every new communication technology, from the printing press, photographs, radio transmitters, and to television, the fear of overindulgence has always loomed. With all its uncertainties, the digital age is not an exception.

All illustrations: Sophie-Charlotte Opitz, *Digital Storm*, 2019

Follow the Money: Aruna D'Souza

David Mielecke

Aruna D'Souza intervenes in the politics of inequality by taking the constitutive connection between art production and social relations as the subject of her writing. Drawing on contemporary examples, she emphasizes the historical and institutional contingency of inequality and underlines the problematic nature of Western hegemony. D'Souza's art criticism thus situates itself beyond the complicity of modern institutions, such as the museum that brings domination with it.

Discussing a provocative MoMA PS1 exhibition on mass incarceration, D'Souza poses a question avoided by the institution itself, namely that of how museums are funded from the profits generated by the prison system. Illustrating her point by way of current conditions in the United States, in which about two-thirds of the population—213 million people, a large portion of whom are BIPOC (Black, Indigenous, People of Color) and Latinx—are directly or indirectly affected by the prison system, D'Souza argues that alongside economization of imprisonment, deprivation of liberty intensifies existing social asymmetries. "Mass incarceration" is thus a term to be understood quite literally. As an exercise of domination, indeed as a "new form of plantation," mass incarceration reproduces the same exploitative, discriminatory structures that characterize modes of social perception every bit as much as they do the museum as an institution. The coexistence of an "inside" and "outside" is thus fundamentally called into question. Using examples such as Jesse Krimes's *Apokaluptein: 16389067* (2010–13), D'Souza demonstrates the extent to

which the tangible reality of deprived freedom is materially and ideationally inscribed into art production: the work appears on individual bedsheets that the artist stole from the laundry room during his stay in prison and then worked on. Prisoners produce bedsheets of this kind and various other goods for extremely low wages of no more than $1.15 per hour. D'Souza thus emphasizes the media conditions resulting from various artistic manifestations of inequality. Seen as a modern ethnographic "tool," photography here plays an ambivalent role, as D'Souza demonstrates with artists Isaac Julien and Wendy Red Star. Julien refers to the abolitionist Frederick Douglass, who espoused the potentials of photography "as a tool in the fight against slavery, racism, and segregation." In the nineteenth century, Douglass effectively and publicly challenged cliched and hegemonic modes of representation. Bringing together his own video and image production with archival images from different eras, Julien's montage technique vividly visualizes the contemporary relevance of those historical struggles.

Red Star, on the other hand, dismantles historical and stereotyping photographic representations of the Apsáalooke people—a Native American group to which she belongs. Using the tools of digital image manipulation, enlargement, and labeling, the artist appropriates and reinterprets the kinds of objectifying, late nineteenth and early twentieth century "documentary photographs" taken by the "white man." Multidimensional portraits are thus created, some of them as standing figures. In encountering museum visitors as equals, D'Souza sees a reversal of the circumstances that should also take place beyond the museum.

By focusing on the conditions in which art production is grounded and on the questions posed by artists— understanding the latter broadly as social agents—D'Souza's art criticism withdraws from the disciplinary limitations of a pure art historiography. Her published writings are not systematically aimed at an exclusive art audience, and as a result they reach greater effectiveness. Much of her written work appears online, freely viewable without access restrictions. The texts selected here comprise three reviews from *4Columns*, an arts criticism website that D'Souza has been regularly contributing to since 2016. She uses social media as a space in which dialogue, conversations, and critiques can unfold beyond museum and academic hierarchies. She also writes for old media, meaning that her thought is present for and accessible to a broad, heterogenous public. In a 2018 interview on her book *Whitewalling: Art, Race & Protest in 3 Acts*, she remarked that "people are using it, as I'd hoped, as a way to have all sorts of discussions both inside and outside the art world."

Reviews from *4Columns*

Aruna D'Souza

from *4columns.com*

Issac Julien, March 29, 2019

In a video installation, the artist and filmmaker ruminates on Frederick Douglass—and his meaning for us today.

To contend with the meaning and legacy of Frederick Douglass, as the British artist-filmmaker Isaac Julien does in his video installation *Lessons of the Hour* (2019), is to contend with the aesthetic, conceptual, and political meanings of photography. The abolitionist and orator escaped slavery in 1838, fought for its end, and spent the rest of his life lecturing all over the US and Europe to bring attention to the long, slow, and ongoing process of freedom for black Americans. He was, too, the most photographed American of the nineteenth century; to further his political message, he took advantage of the newly invented medium to shape his own image, posing for some 160 portraits and widely distributed carte de visite pictures. (He was not alone in this: Sojourner Truth, Harriet Tubman, and other activists of the age were also using photography as a tool in the fight against slavery, racism, and segregation.) As photography became cheaper and more widely available, Douglass argued in his writings and speeches, it would allow for all black people to picture themselves *as they were*, as full citizens who defied the ugly stereotypes created (often by means of photography, as well) to control and dehumanize them.

The twenty-eight-minute *Lessons of the Hour*, arrayed on ten differently sized screens mounted at various heights and angles and arranged in a semicircle, uses one lens-based technology (film, here shot both in analog and digital) to explore another (photography). Visually, it is signature Julien: like his lush, sensual *Looking for Langston*, a 1989 meditation on black queer experience in the Harlem Renaissance, or the enigmatic *Western Union: Small Boats*, a 2007 film installation following North African migrants across the Mediterranean, *Lessons* is breathtakingly beautiful, rich in color, and scored in the most evocative way. At the beginning of the film, an actor portraying Douglass walks to a podium in a nineteenth-century lecture theater, wearing a royal blue coat; on most

of the screens we see him from the back, on some others from the front. The words the actor delivers—at first to a rapt, largely white audience and then intermittently as background narration while other images appear onscreen—are passages from three of Douglass's most significant speeches: "What to the Slave Is the Fourth of July" (1852), "Lecture on Pictures" (1861), and "Lessons of the Hour" (1894).

After some minutes, these lecture hall shots give way to others, in which characters move with such slow deliberation that they hover between cinema and tableaux vivant: Douglass leading a horse through a field of tall, yellow grass; his first wife, Anna Murray Douglass, carefully, even mournfully, sewing the blue coat that Douglass wears; his second wife, the white abolitionist Helen Pitts, writing in her study, looking like something out of a Vermeer painting; the English activists Anna and Ellen Richardson, reading from their diaries while arranging rocks on the beach to spell out anti-slavery slogans; Douglass and Anna Murray in a train car, chugging their way across country; the black photographer J. P. Ball—the man with whom Douglass collaborated to fashion his public image—in Ball's studio, demonstrating his instruments and optical devices to visitors.

But no matter the beauty of these representations, or the raw delight of the archival films and photographs that make momentary appearances in this fragmented montage-in-space, we are repeatedly pulled back to harsh realities. Over shots of Douglass walking through a stand of trees in full autumn glory with birds whistling in the distance, we hear a foreboding score (by composer Paul Gladstone Reid), and then Douglass's words describing the unbearable violence of lynching. One screen cuts to a black-and-white image of hands hoisting a heavy load with a rope, and then dark-skinned feet dangling. At another point, screens suddenly switch, each at the sound of a whip's crack, from images of Douglass and his circle as cosmopolitan moderns—using the latest technologies, ranging from the sewing machine to the steam engine to the camera, sitting in fashionable salons, treated with respect and even reverence—to those of cotton fields, bolls being picked from thorny bushes by disembodied hands. The effect is simultaneously, and troublingly, brutal and gorgeous.

These harsh realities are not contained in the past. Julien's project blurs the boundaries between the era of slavery and its aftermath, as is only fitting, considering his subject. When Douglass delivered his final speech, "Lessons of the Hour," in Washington, DC twenty-nine years after the legal end of slavery in 1865, he spoke of the ways in which emancipation was a process both fraught and incomplete—black people still weren't free while physical, economic, and psychological violence

continued. Back then, Douglass was speaking of sharecropping, lynching, segregation, and proposals to send freed slaves back to Africa; now, Julien points out, it is the power of the surveillance state to police and kill black people that stands in the way of equality and justice.

This idea is evoked even before we lay eyes on *Lessons of the Hour* itself. The film is installed in a darkened room at the back of the gallery; before we see it, we pass through a room of more than sixty photographs of various sizes, hung directly on the walls or on metal and wooden armatures that look vaguely like something used for museum storage. These include cinematic stills, old-fashioned-looking (but recently made) tintypes of the film's actors in character, and found nineteenth-century photos that the artist has recast as an imaginary archive of Ball's studio output—both simulacral and real relics of the past. But they also include a tightly hung grouping of thirty-two black-and-white images connected to Julien's early 1983 film *Who Killed Colin Roach?* about the unexplained death of a black man at a police station in London. The pictures are here titled *Lessons of the Hour London*, tying them firmly to Douglass's arguments of more than a century past.

In a similar move, the video installation creates stark contrasts between scenes of Douglass and others confidently posing in Ball's studio, controlling their self-imaging, and grainy, black-and-white FBI footage and video clips of the civil unrest that took place in Baltimore in 2015, sparked by the death of Freddie Gray while in police custody. In the film's opening scenes, Douglass intones that image making is even more potent than lawmaking to change the direction of his country. When you notice that his audience is composed both of people dressed in Victorian garb as well as those in today's fashions, the implication is clear: his are the lessons of *our* hour, his is a manifesto for *our* resistance, his is a call for us to reclaim the power of representation.

Wendy Red Star, September 3, 2020

The Apsáalooke artist manipulates archival photos to explore her tribe's past.

In his new book on Indigenous sound, *Hungry Listening*, Dylan Robinson notes that when the Stó:lō people in what is now called British Columbia first encountered white settlers in the mid-nineteenth century, they dubbed them "starving persons"—in part because they were literally starving, and in part because they were driven by a craving for gold.

Aruna D'Souza

Likewise, in other Native languages, white people were understood to operate according to an extractive logic—a predilection to take from the land and its people what they needed to satisfy not simply their needs but their desires, to take without thought for consequence. Even as the new white settlers went about attempting to annihilate Native civilizations, people like the ethnographer and photographer Edward Curtis embarked upon a mission to mine their cultures, using the camera as his tool to record and consume, with the partial understanding of the white man, introducing stereotypes and flattening complex worldviews as much as documenting a living culture on the brink of extermination.

Wendy Red Star's work often aims to restore that which was looted in this form of knowing—to put back into images of the past some of what the camera, or more precisely the white gaze, had stripped away. Her current show at Mass MoCA is titled *Apsáalooke: Children of the Large-Beaked Bird*—the name of her own tribe, which settlers imperfectly translated into English as "Crow"—and centers around archival photographs taken by the US Department of the Interior and the Bureau of Ethnography related to three tribal delegations to Washington DC in 1873, 1880, and the early 1900s. Red Star manipulates the images in various ways: blowing them up to wall size, creating life-sized and larger-than-life-sized cutouts of individual figures that stand around the gallery, and, perhaps most engagingly, annotating them using a red marker, allowing the figures to speak back to the settler's rapacious gaze.

Déaxitchish/Pretty Eagle (2014) hangs at the entrance to the show, which is installed in the museum's Kidspace, the site of some of Mass MoCA's most engaging exhibitions. It is an archival pigment print of a man who went to Washington in 1880, and who by 1886 was recognized as one of the leading chiefs of the Crow Tribe. Red Star uses her marker to outline the main contours of Pretty Eagle's figure and to trace the details of the ermine fringe on his clothing, the lush beads around his neck, the rings on his fingers, the war axe in his hand, and so on. Her notations describe the significance of his attire and facts about his person—"Ermine on shirt, captured gun," "6 ft," "1885 Crow Census / Pretty Eagle, age 41 / wife: Pretty Shield / son: Holds His Enemy / daughters: Brings Good Things and Sings." But they veer, too, toward the stomach-turning fate of so many Indigenous peoples in an era in which they were seen only as obstacles to North American settlers' expansionism and treated as such. Here, the voice shifts from the neutral, "objective" tone of the researcher to a first-person address: "My remains, along with sixty other tribal members were stolen from their burial sites ... My body sold to a collector for $500.00 and kept for 72 years at the American Museum

of Natural History. My people brought my remains back to Crow Country on June 4, 1994 …" The offering of such details to this and several other images imbue a specificity and even agency to the portrait subjects that is deeply moving—these men are not types anymore, but people.

In the next room, in addition to more annotated portraits, an enlarged group photo of the 1873 delegation appears on the back wall; Red Star was especially drawn to the image because it was the only one she found from that trip that included women—wives of the tribal leaders. In front of it, facing the entrance as if welcoming us into a ceremonial space, are cardboard cutouts of tribal leaders that took part in one of the later delegations; leaning against the wall are even larger blowups of others, a number of whom wear suits and ties and close-cropped hairstyles instead of braids and elaborately decorated buckskins. The simple arrangement functions to position us, the viewers, as their guests—now meeting on their terms.

The third gallery of Kidspace is a mixed-use studio in which children and adult visitors are invited to do hands-on activities in relation to the artworks on display. Here, in vitrines and framed on the wall, is one of Red Star's playful propositions about what it would be like to see the world through an Indigenous lens, and to value Native forms of knowledge. When a man named Medicine Crow went with the 1880 delegation to Washington, he made drawings of the non-native animals he saw at a circus: a lion, a red catfish, "a spotted mule" (zebra), an "elk with big back on him" (camel), and so on. (They were preserved by a clerk at the Bureau of Indian Affairs.) Working with a toy manufacturer, Red Star has created plushy stuffed animals (all dated 2020) based on some of the drawings, which are at the same time filled with innocent wonder and very precise in their observation.

Red Star's research into the past is inextricably tied to the survival of her culture in the present and future. A sound-and-image piece consisting of the artist's father speaking the names of various animals in his Apsáalooke language as slides of pictures made by young visitors in response to the descriptions translated into English appear on a small monitor is particularly charming. (What would a creature called "Scoots Along the Ground" look like to someone first hearing the term?) It is an important adjunct to Medicine Crow's descriptive project almost a century and a half before, after years of US effort to extinguish Native languages by removing children from their families and putting them in residential schools so that they would not be able to learn their mother tongues and the histories their parents and elders would have otherwise communicated to them through spoken word and song.

Aruna D'Souza

In galleries dominated by black-and-white and sepia images punctuated by red markings, two photographic murals stand out for their technicolor glory: *Indian Summer—Four Seasons* (2006) and *Apsáalooke Feminist #2* (2016). The first shows the artist, attired in Crow regalia, sitting in an ersatz mountain landscape—Astroturf, cutout deer, fake flowers, fake foliage, fake everything—in a way that evokes cheesy natural-history museum dioramas and 1950s Hollywood westerns. The second depicts Red Star and her young daughter, again dressed in elk-tooth dresses, sitting, chins cupped in hands, on a modern couch draped with what look to be mass-market blankets and throw pillows that nod to generic Plains Indian motifs. The background is a computer manipulation of a striped trading blanket. In both, the gentle humor of the contrast between the very vital figures of the artist and her daughter and the deadening stereotypes that surround them is a stark corrective to the manner in which Indigenous cultures are often treated in this country as a vestige of the past. Red Star's work is, as much as anything, a history of our present.

Marking Time, October 9, 2020

A MoMA PS1 show confronts the US's prison system.

One of the most striking works in the exhibition *Marking Time: Art in the Age of Mass Incarceration* is a fifteen-by-forty-foot mural painted on thirty-nine bedsheets mounted to the wall. The top register of this makeshift canvas depicts a clear blue sky dotted with angel-like figures rendered in gouache and colored pencil; the middle register shows a distant landscape with burning buildings, oversized women, and a giant Warhol soup can; the bottom is dense and dark, crowded with blocks of ghostly images. Those images are in fact found photos and text from books, magazines, and newspapers that have been transferred, Rauschenberg-style, to the sheets, using hair gel and a spoon. If the painting is a depiction of heaven, earth, and hell, this is a hell filled with war zones and political protests and human suffering and dictators and Beyoncé and Degas and Jean-Michel Basquiat and Velázquez and Chanel clothes and Patek Philippe jewel-encrusted watches and Christie's auction catalogs and—because what would hell be without him—Donald Trump.

The artist who made this work, *Apokaluptein 16389067* (2010–13)—Jesse Krimes—did so while he was incarcerated. The sheets that served as Krimes's canvas were manufactured under the auspices of UNICOR, a forced-labor program that pays negligible wages. He worked on one

sheet at a time over the course of three years, clandestinely transporting each out, once painted, via mail; it was only upon his release in 2014 that he was able to see them all pieced together. As the rest of us argue over whether this or that blue-chip artist is being censored or limited in their artistic freedom, thinking about the conceptual and material inventiveness of Krimes's work, and the literal loss of freedom that might have resulted if his activities had been discovered, is appropriately humbling.

Guest curated by Dr. Nicole Fleetwood, and accompanied by a book of the same title published by Harvard University Press, *Marking Time: Art in the Age of Mass Incarceration* is the result of Fleetwood's long engagement with artists working in and out of prisons around the country. The exhibition goes well beyond showing us the talent that exists among those currently in correctional institutions (nearly 2.2 million, an inordinate number of whom are Black and Latinx) or demonstrating the resourcefulness of people who are living in the most debasing conditions in expressing their humanity and creativity, although it does do both. More importantly, by including currently incarcerated artists, formerly incarcerated artists, and artists who have never been incarcerated but whose work has engaged with this issue, it is designed to demonstrate that there is no inside and outside when it comes to mass

Sable Elyse Smith,
Pivot II, 2019
(part of the artist's ongoing
Pivot series)

Aruna D'Souza

incarceration. While it is shocking that the US imprisons people at a rate five times higher than the rest of the world, even more stunning is that the number of people who have formerly been in prison, have been convicted of a felony, have a criminal record, or have an immediate family member who has ever been imprisoned is 213 million—which means that two-thirds of the US population is directly caught up in the carceral system.

This expanded view of incarceration's impact is poignantly addressed in Sable Elyse Smith's *Pivot I* (2019). Smith's father has been in prison since she was ten. A wall label notes that she was never allowed to wear the color blue when she visited him because it represented unfreedom—the color of police uniforms, her father's state-issued clothing, and prison furniture. Her work asks us to reflect upon the ways the color can be reclaimed to signify freedom: the vast sky, often unseeable by people like her dad, or the sea, or the blues (as in Black music and aesthetics). With *Pivot I*, Smith transforms six cobalt stools, usually bolted down to the floors of oppressive prison visiting rooms, into an oversized play object: a multipronged starburst connected by a gray cube at the center, like something a child might make with her Tinkertoys.

Marking Time's critical approach to "inside" and "outside" complicates questions of "guilt" (and therefore deserving of imprisonment) and "innocence," too. In her book, Fleetwood notes that she chooses not to disclose the reason for the artists' incarceration (unless they specifically request it) because definitions of criminality are mutable and socially and politically constructed. The gap between "incarcerated" and "guilty" is underlined by Maria Gaspar's inkjet prints of a Google Earth tour of Chicago's Cook County Jail, whose largely Black inmates have been detained not because they've been convicted of a crime, but because they cannot afford cash bail (*Wretched and Paramount I* to *VI*, 2014–16). American Artist's *I'm Blue, 2* and *I'm Blue, 3*, both from 2019, nod to the mechanisms of criminalization and the question of who is culpable and who is victimized. The artist mounts police ballistic shields to the front of school desks and fills the desks' wire baskets with books, mostly written by retired officers, addressing how hard police work is on their emotional well-being; the piece suggests the ways in which we are indoctrinated to sympathize with members of a system that perpetrates violence on Black and brown communities in the name of law and order. Meanwhile, Jared Owens's triptych *Ellapsium: master & Helm* (2016) includes an abstracted but unmistakable rendering of a famous 1788 image of Africans imprisoned in the hold of a slave ship; next to it, *The Go Back* (2020) incorporates a found piece of signage that he has

modified to read something like "40 acres / 40 years / Classic." The references to slavery, and the idea of prisons as a new form of plantation—or as the New Jim Crow, as legal scholar and civil-rights lawyer Michelle Alexander puts it—point up how incomplete the project of emancipation is.

The conceptual and formal sophistication of the work on view is no great surprise; most of the incarcerated artists here are trained in some fashion, before, during, or after serving their sentences. These are not, in that sense, "outsider" artists except in the way they have been isolated from the larger art world by the fact of incarceration itself. The point is driven home explicitly by the inclusion of correspondence between the artist Billy Sell (who died while in solitary confinement in 2013) and his art tutor Treacy Ziegler, in which the two discuss his aesthetic and emotional concerns. But it appears elsewhere, too: the covers from museum exhibition catalogs that Krimes uses in his work; the Old Masters–inspired technique of George Anthony Morton's portrait drawing (*Mars*, 2016), which won him a prize from the Florence Academy of Art, where he studied after his release; the 2008 acrylic-on-canvas painting of San Quentin's art studio depicted by Ronnie Goodman; or the pages from art-history textbooks collaged onto the surface of Russell Craig's massive *Self Portrait II* from 2020.

If the discipline of art history and studio art training are self-reflexively present in *Marking Time*, the framing conditions of the museum are, sadly, not. The opening wall text of the exhibition lists the many organizations and activist groups that participated in realizing the show—including the Art for Justice Fund, a philanthropy devoted to ending mass incarceration established by MoMA PS1 board chairperson Agnes Gund. But nowhere is there mention of how museums are funded from the profits generated by the prison system—museums including MoMA, where Larry Fink, chairman of BlackRock, an investment firm that is a major shareholder in for-profit prisons and ICE detention centers, sits on the board.

The Series:
Jennifer Higgie

Julia Voss

Art critic Jennifer Higgie first posted on her Instagram account on July 16, 2013. The social media platform was still just a few years old, and Higgie's initial image received sixteen likes. Viewing it today means scrolling down for quite some time before the photography of Emmy Hemmings appears. A German artist, writer, and actor, Hemmings was one of the founders of the Dada movement. In the shot, she holds up a Dada doll. The year is 1917.

Since that first entry, the London-based Australian art critic Higgie has posted an image connected to a female artist almost every day. The images can be of the artists themselves, or of one of their works. Over time, Higgie's accompanying texts have become more extensive and the number of viewers has skyrocketed: nearly eight years and several thousand posts later, Higgie's @bowdownpodcast (renamed @jennifer_higgie in spring 2021) has almost 50,000 followers. The feed has also been supplemented with a podcast, as the name suggests. For a steadily growing audience, Higgie explains and celebrates the art history of women across centuries and continents, from the Middle Ages to the present, from Mexico City, New Orleans, Tokyo, and Sydney to Delhi, Dakar, Florence, Stockholm, and Moscow.

Higgie's trenchant texts are not only informative but narrative; they address distinctive aspects of oeuvre and biography illuminatingly and personally, with readers learning the reasons for Higgie's excitement about an artist and how she situates the work within art history.

The revolution is based on evolution: day after day, works are layered upon works, and bit by bit, the many small parts come together and ultimately alter the larger panorama. Rather than lamenting "no great woman artists," as art historian Linda Nochlin did in her renowned 1971 essay, Higgie assembles dozens of great women artists. Over the years hundreds, even thousands of them.

Higgie's example has been instructive. Also on Instagram, at @greatwomenartists, curator, broadcaster, and art historian Katy Hessel has likewise posted a daily image of a female artist since 2015, reaching an audience of 200,000 followers. Her posts are also accompanied by a weekly podcast. Higgie's Instagram project is an outstanding example of an art criticism that works with the digital world's tools and has thus found a new form. As the former co-editor and erstwhile editor-at-large of the London-based art journal *Frieze* and member of numerous juries, including that of the Turner Prize, Higgie is intimately acquainted with traditional forms of art criticism. She additionally writes works of fiction including the novel *Bedlam*, the children's book *There's Not One*, and the screenplay for the film *I Really Hate My Job*. So what distinguishes Instagram's format from an analogue form of art criticism? Two features are particularly notable. First, the relationship between text and image is inverted. It is not writing that stands in the foreground of Higgie's critical work—it is rather work on the visual; the compilation of images that coalesce to compose a female art history. The primary task is thus not to translate image into language, but to add appropriate text to an arrangement of images. Second, the point of her critical practice lies in its serial production. Streaming services have long recognized consumers' preference for serialized content, and Higgie has successfully brought the notion of the series into art criticism. For her, this form is also a research tool—her book *The Mirror and the Palette: Rebellion, Revolution, and Resilience: 500 Years of Women's Self-Portraits* appeared in 2021. Many sections of it refer to works she had previously posted to Instagram with accompanying commentary. "No two women are the same," Higgie writes in her book's introduction, an insight that a glance at her Instagram account beautifully demonstrates.

@jennifer_higgie

from Instagram, March 12, 2021[1]

A 1940 self-portrait @smithsonian by the great African American artist & star of the Harlem Renaissance, Loïs Mailou Jones (1905–1998), whose life & work I discuss at length in my forthcoming book 'The Mirror & the Palette'. An excerpt: 'From the outset, Loïs sizzled with energy. She enrolled in evening classes @mfaboston, had her first exhibition at the age of 17, received a scholarship to the Boston Museum School & was awarded a design certificate in 1927. She worked as an assistant to the dress designer & professor Grace Ripley, discovered African costumes & masks & "quickly incorporated their unique qualities into her own art". She enrolled in graduate courses at the Boston Designers Art School & began selling her designs to New York companies. But Loïs was frustrated: 'Only the name of the design was known, never the artist. That bothered me because I was doing all of this work & not getting any recognition. I realised I would have to think seriously about changing my profession if I were to be known by name.'

This she achieved by focusing her considerable talents on painting. She had applied for a teaching position at the Boston Museum School, where, despite having excelled as a student, she was patronisingly advised by the director, Henry Hunt Clarke, "to travel south to help her people". Not one to be deterred, she founded the art department at Palmer Memorial Institute in North Carolina; within two years she had organised an exhibition of the students' work, which was seen by Professor James V. Herring who, in 1930, was establishing the fine arts department at @Howard1867. He offered Loïs a job. For the next 47 years she taught art & design to generations of students, many of whom – such as Elizabeth Catlett, Howardena Pindell and Alma Thomas – were to become prominent in their field. After a long & inspiring career – including years in Paris and Haiti, and research trips throughout Africa – Loïs died in 1998 at the age of 92. She was renowned: her work was collected by major museums & the focus of retrospectives. On 29 July 1984, Loïs Jones Day was proclaimed in Washington, DC. Bow down #loismailoujones #themirrorandthepalette @wnbooks

1 See https://www.instagram.com/p/CMUL4vFHwzW/.

Biographies

Monique Bellan studied Islamic studies in Bonn and holds a Ph.D. in Arabic studies from the Freie Universität Berlin. She is a researcher in the project Lebanon's Art World at Home and Abroad (LAWHA), Beirut.

Andreas Beyer is an art historian, curator, author, and spokesperson of the international research project Bilderfahrzeuge: Aby Warburg's Legacy and the Future of Iconology. He is a professor of early modern art history.

Beatrice von Bismarck is an art historian, curator, and art critic. She is a professor of art history and visual culture at the Academy of Fine Arts, Leipzig.

Sabeth Buchmann is an art historian, art critic, and professor of modern and postmodern art and head of the Institute of Art Theory and Cultural Studies at the Academy of Fine Arts in Vienna.

Juli Carson is a professor of art at the University of California, Irvine. She also directs the critical and curatorial area in the Department of Art.

Parul Dave Mukherji studied art history in Baroda, Santiniketan and holds a Ph.D. in Indology from Oxford University. She is a professor at the School of Arts and Aesthetics, Jawaharlal Nehru University, New Dehli.

Maja and Reuben Fowkes are curators, critics, and art historians. They are the founders of the Translocal Institute for Contemporary Art and codirectors of the Postsocialist Art Centre at the Institute of Advanced Studies at the University College, London.

Yuriko Furuhata is an author, associate professor, and William Dawson Scholar of Cinema and Media History in the Department of East Asian Studies at McGill University, Montreal.

Peter Geimer is an art historian. He holds the chair of Modern and Contemporary Art History at Freie Universität Berlin.

Johannes Grave is an art historian, author, and professor of modern art history at the Friedrich Schiller University, Jena.

Isabelle Graw is an art historian, art critic, journalist, and curator. She is a professor of art theory at the Städelschule, Frankfurt am Main.

Julia Grosse is a columnist, journalist, editor, and lecturer. She is the cofounder and artistic director of the platform *Contemporary &*.

Angela Harutyunyan is a curator, editor, and author. She is also an associate professor of art history at the American University of Beirut.

Valerie Hortolani studied in Marburg and Berlin and has worked as an assistant curator at Kunstsammlung Nordrhein-Westfalen, Düsseldorf, and curator at Museum Barberini, Potsdam. Since 2021, she has been a project manager at Hatje Cantz.

Anita Hosseini is a research associate of the research group Bilderfahrzeuge – Aby Warburg's Legacy and the Future of Iconology at the Warburg Institute in London. In 2015, she received her Ph.D. in art history from Leuphana University Lüneburg.

Camilo Sarmiento Jaramillo is an assistant professor at the School of Human Sciences, Universidad del Rosario, Bogotá.

Rebecca John studied art history and visual studies at Humboldt University of Berlin and Jawaharlal Nehru Univeristy, New Delhi. Since 2019, she has been a Ph.D. candidate in the DFG Research Training Group "Cultures of Critique" at Leuphana University Lüneburg.

Monica Juneja is an art historian and professor. She has held the chair of Global Art History of the Asia and Europe in a Global Context cluster at the Ruprecht-Karls-University Heidelberg since 2009.

Wolfgang Kemp is an author, editor, and professor of art history. He has been a visiting professor at Leuphana University Lüneburg since 2011.

Anna Kipke is a writer and researcher with a focus on the theory and history of form, critique, materiality and spirituality in modern and contemporary art. She studied Cultural Studies at Leuphana University Lüneburg.

Holger Kuhn is an art historian, author, and a postdoctoral researcher at the DFG Research Training Group "Cultures of Critique" at Leuphana University Lüneburg.

Valerija Kuzema studied art history in Leipzig, Winnipeg, and Berlin. She has been associated with the DFG Research Training Group "Cultures of Critique" at Leuphana University Lüneburg since 2020.

Oona Lochner is an art historian, art critic, and research assistant at the Institute of Philosophy and Sciences of Art at Leuphana University Lüneburg. She is a Ph.D. candidate in the Research Training Group "Cultures of Critique."

Florencia Malbrán is a curator of contemporary art and art critic. She holds a Ph.D. from Rosario National University, Argentina, and a M.A. from the Center for Curatorial Studies, Bard College, New York.

Astrid Mania is an art critic and editor. Since 2017 she has been a professor for art criticism and modern art history at the University of Fine Arts, Hamburg.

Stephanie Marchal is a professor of art history with a focus on art criticism and modernist visual arts at the Ruhr University, Bochum.

Isabel Mehl is an art critic and research assistant in Stephanie Marchal's department at Ruhr University, Bochum. In 2020, she received her Ph.D. as a member of the DFG Research Training Group "Cultures of Critique" at Leuphana University Lüneburg.

David Mielecke studies cultural sciences with a focus on performative forms of critique at Leuphana University Lüneburg. He is a researcher in the DFG Research Training Group "Cultures of Critique."

Yvette Mutumba is a curator, editor, and art historian. She has been curator-at-large at the Stedelijk Museum in Amsterdam since 2020.

Azu Nwagbogu is a curator. He is the founder and director of the African Artists' Foundation (AAF) and the LagosPhoto Festival.

Ying Pek is a doctoral candidate in the Department of Art & Archaeology at Princeton University. She researches modern and contemporary art with a focus on

Europe. From 2017 to 2019 she was a visiting researcher at the DFG Research Training Group "Cultures of Critique."

Ana Teixeira Pinto is a writer, theory tutor, and cultural theorist. She teaches at the Dutch Art Insitute and is a visiting professor at the Academy of Fine Arts (AdBK) Nuremberg.

Miriam Rasch is a writer and researcher focusing on the philosophy of technology, ethics, and language. She works for the Institute of Network Culture at Amsterdam's Polytechnic University.

Malte Rauch received his M.A. in philosophy from The New School for Social Research, New York. He is a Ph.D. candidate in the Research Training Group "Cultures of Critique" at Leuphana University Lüneburg.

Ghalya Saadawi is a writer and senior lecturer at the Centre for Research Architecture, Department of Visual Cultures at Goldsmiths University of London, and theory tutor at the Dutch Art Institute.

Thorsten Schneider is an author and art historian with a transdisciplinary background. He is a Ph.D. candidate in the DFG Research Training Group "Cultures of Critique" at Leuphana University Lüneburg.

Beate Söntgen is a professor of art history at the Institute of Philosophy and Art Sciences at Leuphana University Lüneburg. She is the spokesperson of the DFG Research Training Group "Cultures of Critique."

Margarete Vöhringer holds the Materiality of Knowledge chair at the Georg-August-University, Göttingen.

Julia Voss is an art critic, scientific historian, and journalist. She is also an honorary professor at the Institute of Philosophy and Art Sciences at Leuphana University Lüneburg.

Sarah Wilson is an art historian, curator, and writer whose interests extend from postwar and Cold War Europe and the USSR to contemporary global art.

Michael F. Zimmermann is an historian of art and the visual who holds the chair of art history at the Catholic University Eichstatt-Ingolstadt.

Bibliography

Alloway, Lawrence. "Network: The Art World Described as a System." In Alloway, Lawrence. *Network: Art and the Complex Present, Michigan*, 1984. First published in *Artforum* (September 1972).

Azatyan, Vardan. "Toward a Dilemmatic Archive: Historicizing Contemporary Art in Armenia." *A* 6 (2008).

Barthes, Roland. "Réquichot and His Body." In *Responsibility of Forms: Critical Essays on Music, Art, and Representation*. Abbreviated and corrected by Sarah Wilson. Translated by Richard Howard. Berkeley et al., 1973. First published in French in *Bernard Réquichot*, exh. cat. 1973.

Bataille, Georges. "André Breton, Tristan Tzara, Paul Éluard." In *Georges Bataille: Œuvres Complètes*, 1. Edited by Michel Foucault. Paris et al., 1970. Translated by Matthew James Scown as "André Breton, Tristan Tzara, Paul Éluard."

Bataille, Georges. "Les Pieds Nickelés." In *Georges Bataille: Œuvres Complètes*, 1. Edited by Michel Foucault. Paris et al., 1970. Translated by Matthew James Scown as "Nickelplated Feet."

Bataille, Georges. "Joan Miró: peintures récentes." In *Georges Bataille: Œuvres Complètes*, 1. Edited by Michel Foucault. Paris et al., 1970. Translated by Matthew James Scown as "Joan Miró: Recent Paintings."

Bennett, Bob. "The Development of Nigerian Architecture, Pre-History to Colonial Role: An Overview." *New Culture: A Review of Contemporary African Arts*, 1.3 (February 1979).

Bishop, Claire. "Palace in Plunderland: Claire Bishop on The Shed." *Artforum*, 57.1 (September 2018).

Brentano, Clemens and Achim von Arnim. "In Front of a Friedrich Seascape with Capuchin Monk." *Art Journal*, 33.3 (1974) and Heinrich von Kleist, "Feelings before Friedrich's Seascape", transl. by Philip B. Miller. First published as von Kleist, Heinrich. *Berliner Abendblätter*, 12th sheet (October 13, 1810). In Jordan, Lothar, and Schultz, Hartwig, eds. *Empfindungen vor Friedrichs Seelandschaft*. Kleist-Museum, Frankfurt (Oder), 2004.

Coomaraswamy, Ananda K. *The Indian Craftsman*. London, 1909.

Coomaraswamy, Ananda K. "Why Exhibit Works of Art?" *Studies in Comparative Religion*, 5.3 (1971). First published in *New Blackfriars*, 23.271 (1942).

Darabi, Helia. "Found in Translation: Exile as a Productive Experience in the Work of Iranian Artists." *NuktaArt, Biannual Contemporary Art Magazine of Pakistan*, 5 (November 2010).

Darabi, Helia. "Tehran: Dispatch." *Art Asia Pacific*, 81 (November/December 2012).

Denegri, Ješa, interview by Ervin Dubrović. "A New Turnaround." *Rival*, 1–2, Rijeka (1989), trans. Graham McMaster.

Diderot, Denis. "Chardin" (1763). In *Diderot's Selected Writings*. Edited by Lester G. Crocker. Translated by Derek Coltman. New York, 1966.

Diderot, Denis. "Greuze. Salon de 1763." In Chouillet, Jacques ed. *Essais sur la peinture. Salons de 1759, 1761, 1763. Nouvelle édition 2007*. Paris, 1984. Translated by Matthew James Scown as "Greuze. Salon of 1763."

Diderot, Denis. "Young Girl Crying Over Her Dead Bird." In *Diderot on Art. The Salon of 1765 and Notes on Painting*, 1. transl. by John Goodman. New Haven et. al., 1995.

D'Souza, Aruna. "Isaac Julien," *www.4Columns.org* (March 29, 2019).

D'Souza, Aruna. "Wendy Red Star," www.4Columns.org (September 3, 2020).

D'Souza, Aruna, "Marking Time," www.4Columns.org (September 3, 2020).

Fry, Roger. "The Futurists." In *A Roger Fry Reader*, edited by Christopher Reed, Chicago/London, 1996.

Fry, Roger. "The Case of the late Sir Lawrence Alma Tadema, O.M." In *A Roger Fry Reader*, edited by Christopher Reed, Chicago/London, 1996.

Fry, Roger. "Independent Gallery: Vanessa Bell and Othon Friesz." In *A Roger Fry Reader*, edited by Christopher Reed, Chicago/London, 1996.

Germer, Stefan. "Wie finde ich mich aus diesem Labyrinth? Über die Notwendigkeit und Unmöglichkeit von Kriterien zur Beurteilung zeitgenössischer Kunst (1994)." In *Germeriana: Unveröffentlichte oder übersetzte Schriften von Stefan Germer zur zeitgenössischen und modernen Kunst*, edited by Julia Bernard (Jahresring 46). Cologne, 1999. Translated by Matthew James Scown as "How Do I Find My Way Out of This Labyrinth? On the Necessity and Impossibility of Criteria for Judging Contemporary Art."

Gilligan, Melanie. "The Beggar's Pantomime: Performance and its Appropriation." *Artforum* (Summer 2007).

Gorsen, Peter. "Prolegomena zu einer hedonistischen Aufklärung." In *Ausgewählte Schriften 2. Transformierte Alltäglichkeit oder Transzendenz der Kunst*. Frankfurt (Main), 1981. First published in idem. *Das Bild Pygmalions: Kultursoziologische Essays*. Hamburg, 1969. Translated by Matthew James Scown as "Prolegomena to a Hedonistic Enlightenment."

Hakim, Victor. "Amin ElBasha à Dar El Fan." *La Revue du Liban et de l'Orient Arabe*, 485 (1968). Translated by Matthew James Scown as "Amin ElBasha at Dar El Fan."

Hakim, Victor. "Juliana Seraphim chez Cassia." *La Revue du Liban et de l'Orient Arabe*, 572 (1969). Translated by Matthew James Scown as "Juliana Seraphim at Cassia."

Hakim, Victor. "Fadi Barrage à Dar El Fan." *La Revue du Liban et de l'Orient Arabe*, 686 (1972). Translated by Matthew James Scown as "Fadi Barrage at Dar El-Fan."

Hakim, Victor. "Huguette Caland au Contact Art Gallery." *La Revue du Liban et de l'Orient Arabe*, 734 (1972), p. 78. Translated by Matthew James Scown as "Huguette Caland at the Contact Art Gallery."

Higgie, Jennifer, "Loïs Mailou Jones (1905–1998)." In *Series Instagram@bowdownpodcast*: https://www.instagram.com/p/CMUL4vFHwzW/.

Josephson, Mary. "Warhol: The Medium as Cultural artifact." *Art in America*, 59.3 (May/June 1971). Also published in Fischer, Thomas, and Astrid Mania, eds. *A Mental Masquerade – When Brian O'Doherty Was a Female Art Critic: Mary Josephon's Collected Writings*. Leipzig, 2019.

Kashima, Takashi. "Lassen to iu kajō sa: bijutsushi wa nani o kaku koto ga dekinai no ka." In Haranda, Yûki, ed. *Lassen to wa nandatta noka (What Was Lassen?)*. Tokyo, 2013. Translated by Brian Richard Bergstrom as "This Excess Called Lassen: What is it That Art History Cannot Write?"

Lang, Lothar. "Annotationen über Leipziger Malerei, mit neuerlichem Hinweis auf Tübke." In Lang, Elke, ed. *Begegnung und Reflexion. Kunstkritik in der Weltbühne*. Berlin, 2016, pp. 195–201. First published in *Die Weltbühne*, 50 (1965). Translated by Katherine Vanovitch as "Annotations on Painting in Leipzig, with an Update on Tübke (1965)."

Lang, Lothar. "Hermann Glöckner." In *Begegnungen im Atelier*. Berlin, 1975. Translated by Katherine Vanovitch as "Hermann Glöckner."

Lang, Lothar. "Die Hans-Grundig-Ausstellung." In Lange, Elke, ed. *Begegnung und Reflexion. Kunstkritik in der Weltbühne.* Berlin, 2016. First published in *Die Weltbühne*, 41 (1973). Translated by Katherine Vanovitch as "The Hans Grundig Exhibition."

Lang, Lothar. "Harald Metzkes in der Nationalgalerie." In Lang, Elke, ed. *Begegnung und Reflexion. Kunstkritik in der Weltbühne.* Berlin, 2016. First published in *Die Weltbühne*, 2 (1978). Translated by Katherine Vanovitch as "Harald Metzkes at the Nationalgalerie."

Lang, Lothar. "Fragmente zur Kunstkritik." In *Bildende Kunst*, 4 (1979). Translated by Katherine Vanovitch as "Fragments on Art Criticism."

Masotta, Oscar. "Yo cometí un Happening." In Álvarez, Jorge, ed. *Happenings.* Buenos Aires, 1967. Translated by Brian Holmes as "I Committed a Happening."

Meier-Graefe, Julius. "Manet: Kameraden der Realität." In idem. *Entwicklungsgeschichte der Modernen Kunst in drei Bänden*, 2. Munich, 1915. Translated by Matthew James Scown and Kimberly Bradley as "Fellows in Reality."

Mudekereza, Patrick. "Rethinking. Remixing Africa, Again. ' *Contemporary And (C&)* (December 24, 2015).

Mudekereza, Patrick. "Wolfgang Tillmans à l'Échangeur." Translated as "Wolfgang Tillmans at the Échangeur." In *Wolfgang Tillmans: Fragile*, edited by Institut für Auslandsbeziehungen (ifa), exh. cat. Musée d'Art Contemporain et Multimédias. Kinshasa, et al., 2018.

Nyamor, Enos. "In a Hypermediatized World: Visions of Cultural Journalism," *Histories – An Everyday Practice: Schlosspost*, 5 (March 12, 2019).

Ponge, Francis. "Bemerkungen zu den Geiseln von Fautrier." *Texte zur Kunst*, Frankfurt (Main), 1946. Translated by Manuela Kölke as "Notes on Hostages, Paintings by Fautrier."

Raven, Arlene. "Two lines of sight and an unexpected connection: Helen Mayer and Newton Harrison." *High Performance*, 40 (1987).

Richter, Peter. "Knabenmoral." *Süddeutsche Zeitung*, September 23, 2018. Translated by Stuart L. A. Moss as "Male Morals."

Rodchenko, Alexander. "Against the Synthetic Portrait, for the Snapshot (1928)." In Philipps, Christopher, ed. *Photography in the Modern Era: European Documents and Critical Writings, 1913–1940.* New York, 1989.

Sadek, Walid. "From Excavation to Dispersion: Configurations of Installation Art in Post-War Lebanon." In Fundació Antoni Tàpies and Catherine David, eds. *Tamas: Contemporary Arab Representations.* Barcelona, 2002.

Sauzeau-Boetti, Annemarie. "Negative Capability as Practice in Women's Art." *Studio International. Journal of Modern Art: Italian Art Now* (January/February 1976).

Sekula, Allan. "On the Invention of Photographic Meaning." *Artforum*, 13.8, (January 1975). Also published in idem. *Photography against the Grain.* London, 1984/2016.

Singh, Adwait. "Staying with the Sirens. On the Resilience of the Past." In *Resilience: Artist in Residence.* Residency catalogue, Silo – Art and Rural Latitude (February 22 – March 14, 2018).

Singh, Adwait. "Cracks in the Wall." *Art India: The Art News Magazine of India* (December 2019).

Singh, Adwait. "Into the Light." *Art India: The Art News Magazine of India* (January 2020).

Sinker, Mark. "Loving The Alien in Advance of the Landing." *Wire* 96 (February 1992).

Steyerl, Hito. "Politics of Art: Contemporary Art and the Transition to Post-Democracy." *e-flux journal* (December 2010).

Tillman, Lynne. "The Matisse Pages from Madame Realism's Diary." *Art in America*, 81.5 (May 1993).

Traba, Marta. *Dos decadas vulnerables en las artes plasticas latinoamericanas 1950/1970*. Mexico, 1973.
Translated by Frances Riddle as "Two Decades of Vulnerability in Latin American Visual Arts: 1950/1970."

Tretyakov, Sergei. "Fotozametki." *Novyi Lef*, 8 (1928).
Translated by John E. Bowlt as "Photo-Notes (1928)." In Philipps, Christopher, ed. *Photography in the Modern Era: European Documents and Critical Writings, 1913–1940*. New York, 1989.

Tretyakov, Sergei. *Работа Виктора Пальмова Н. Асеев и С. Третьяков: Художник В. Пальмов*. Чита, 1922 (*N. Aseev i S. Tretyakov, Khudozhnik V. Palmov*. Chita, 1922).
Translated by Bela Shayevich as "The Work of Victor Palmov (1922)."

van Heerikhuizen, Femke. "Door mijn leesbril." *De Groene Amsterdammer*, 9 (March 2, 2016).
Translated by Ralph de Rijke as "Through my Reading Glasses."

Vidales, Luis. "La Pintura Colombiana." *El Tiempo: Suplemento Literario*, Bogotá (April 19, 1942).
Translated by Tiziana Laudato as "Colombian Painting."

Vidales, Luis. "La Estética de Nuestro Tiempo." *Espiral. Revista de Artes y Letras*, 1, Bogotá (April 1944).
Translated by Tiziana Laudato as "The Aesthetic of our Time."

Voss, Julia. "Markus Lüpertz: Welche Welt will dieser Fürst regieren?" *Frankfurter Allgemeine Zeitung*, October 13, 2009.
Translated by Angela Anderson as "What World Does This Prince Want to Rule?"

Zabel, Igor. "Humus, iz katerega raste umetnost." *Delo* (June 11, 2001).
Translated by Rawley Grau as "The Soil in Which Art Grows."

Zuckerkandl, Bertha. "Die Klimt-Affäre: Anlässlich der Zurückziehung der Universitätsbilder. (April 12, 1905)." In *Zeitkunst: Wien 1901–1907*. Vienna et al., 1908.
Translated by Matthew James Scown as "The Klimt Affair: On the Occasion of the Withdrawal of the University Paintings (April 12, 1905)."

Index of Names

Colophon

Editors: Beate Söntgen, Julia Voss

Leuphana University Lüneburg

Coordinator: (rights, authors, translations, research) Catharina Berents-Kemp

Editorial assistants: Jette Berend, Marie Lynn Jessen, David Mielecke, Katharina Tchelidze

Office manager: Stephanie Braune

Hatje Cantz

Managing editor: Lena Kiessler

Project manager: Kimberly Bradley

Copyediting: Kimberly Bradley

Graphic design: Neil Holt

Photo research: Kimberly Bradley
Jennifer Bressler

Translations (commentaries):
Angela Anderson: Holger Kuhn, Beate Söntgen (Diderot, Fry); Matthew James Scown: Sabeth Buchmann, Peter Geimer, Stephanie Marchal, David Mielecke, Thorsten Schneider, Margarethe Vöhringer, Julia Voss (Zuckerkandl, Higgie), Foreword and Introduction;
Katherine Vanovitch: Valerie Hortolani, Valerija Kuzema (Tretyakov, Lang)
Source text translators listed in bibliography.

Indexing: Jochen Fassbender

Typeface: Arnhem

Production: Vinzenz Geppert

Reproductions: Repromayer, Reutlingen

Printing and binding: GRASPO CZ, A.S

Published by
Hatje Cantz Verlag GmbH
Mommsenstraße 27
10629 Berlin
www.hatjecantz.de
A Ganske Publishing Group Company

ISBN 978-3-7757-5074-5 (Print)
ISBN 978-3-7757-5092-9 (eBook)

Printed in the Czech Republic

Photo credits

Frontispiece: © Anna Reinhardt / VG Bild-Kunst, Bonn, 2022; p. 27 © akg-images, The State Hermitage Museum. Saint Petersburg; p. 28 © akg-images, Scottish National Gallery; p. 32 akg-images, Musée de Louvre; p. 33 © akg-images, Erich Lessing; p. 41 Photo: Kristina Mösl, Francesca Schneider © Staatliche Museen zu Berlin, Nationalgalerie; p. 45 Wikimedia Commons; p. 49 Courtesy the author; p. 67 © akg-images; p. 79 akg-images; p. 89 Reproduced with the kind permission of Letterform Archive; p. 122, Photo © Chris Doullgeris, Basil & Elise Goulandris Foundation Collection; VG Bild-Kunst, Bonn, 2022; p. 135 akg-images, VG Bild-Kunst, Bonn, 2022; p. 149 from *Happenings* (ed. Jorge Álvarez, Buenos Aires, 1967); p. 163 Courtesy the author; p. 180 The Andy Warhol Foundation for the Visual Arts and the Artists' Rights Society; p. 197 © Alexander Liberman Photography Archive, Getty Research Institute, Los Angeles, 2000.R.19; p. 214 © akg-images/ World History Archive / VG Bild-Kunst, Bonn, 2022; p. 228 Granger Historical Picture Archive / Alamy Stock Photo; p. 229 © akg-images; p. 231 © akg-images / Science Source; p. 240 Photo: Renato Ghiazza, Courtesy Archivio Fondazione Merz, Torino; © SIAE; pp. 254, 259, 260: Courtesy Newton Harrison; pp. 271–72 Courtesy the artists; p. 281 akg-images / Jazz Archiv Hamburg / Hardy Schiffler; p. 289 Photographer: Mali Olatunji (copyright: The Museum of Modern Art, New York). Photographic Archive. The Museum of Modern Art Archives, New York. Object Number: IN1633.42 / VG Bild-Kunst, Bonn, 2022; p. 322 Courtesy Tony Chakar; p. 335 Courtesy Vardan Azatyan; p. 342 Wikimedia Commons / VG Bild-Kunst, Bonn, 2022; p. 349 Courtesy Wahed Khakdan; p. 362 Photo: Manuel Reinartz, image courtesy of the Artist, Andrew Kreps Gallery, New York and Esther Schipper, Berlin, VG Bild-Kunst, Bonn, 2022; p. 374 Photo: Kathryn Carr © Marina Abramovic and Guggenheim Museum, VG Bild-Kunst, Bonn, 2022; p. 390 Photo: Philipp Hänger / Kunsthalle Basel; p. 401 Photo: Enric Duch, Georg Kolbe Museum Berlin; p. 425 Courtesy Nature Morte, New Delhi (Collection Kiran Nadar Museum of Art, New Delhi); p. 426 Courtesy Nature Morte, New Delhi (private collection); p. 433 Photo: Iwan Baan, courtesy Diller Scofidio and Renfro, New York; p. 434 Stephanie Berger; pp. 441–43: © Sophie-Charlotte Opitz, courtesy the artist and Akademie Schloss Solitude; p. 452 Courtesy Sable Elyse Smith, JTT, and Carlos/Ishikawa; p. 454 Courtesy Smithsonian American Art Museum.

All efforts were made to trace copyright holders to all images and texts. In the case of omissions or queries, please contact contact@hatjecantz.de.

Funded by the Deutsche Forschungsgemeinschaft (DFG, German Research Foundation) – Projectnumber 2114.